P9-BJL-571

Praise for AN AUTOBIOGRAPHY

"A delightful autobiography. . . . Warm, witty and discerning."
—*Los Angeles Times*

"Wonderfully easy to read and engrossing."
—*The Times* (London)

"A wonderful book—written with a delight in the
gradual unfolding of seventy-five years through the eyes
of an exceptional old lady and writer."
—*Financial Times* (London)

"Agatha Christie's most absorbing mystery—
the story of her own unusual life. She has put it all on record:
her early romances; a broken (and a happy) marriage;
strange events on the path to roaring success."
—*Daily Mail* (London)

"Charming and informative . . . an important primary source."
—*Mystery Scene*

Praise for Agatha Christie

"Agatha Christie is no longer one of my favorite writers.
She is now one of my favorite people."
—*Chicago Tribune*

"'I always wanted to be Agatha Christie when I grew up.
I still do."
—J.A. Jance

"I suffer nostalgia for the world of
Agatha Christie as I remember it."
—Gregory Maguire

AN AUTOBIOGRAPHY

THE AGATHA CHRISTIE COLLECTION

The Man in the Brown Suit
The Secret of Chimneys
The Seven Dials Mystery
The Mysterious Mr. Quin
The Sittaford Mystery
Parker Pyne Investigates
Why Didn't They Ask Evans?
Murder Is Easy
The Regatta Mystery and Other Stories
And Then There Were None
Towards Zero
Death Comes as the End
Sparkling Cyanide
The Witness for the Prosecution and
 Other Stories
Crooked House
Three Blind Mice and Other Stories
They Came to Baghdad
Destination Unknown
Ordeal by Innocence
Double Sin and Other Stories
The Pale Horse
Star over Bethlehem: Poems and
 Holiday Stories
Endless Night
Passenger to Frankfurt
The Golden Ball and Other Stories
The Mousetrap and Other Plays
The Harlequin Tea Set

The Hercule Poirot Mysteries

The Mysterious Affair at Styles
Murder on the Links
Poirot Investigates
The Murder of Roger Ackroyd
The Big Four
The Mystery of the Blue Train
Peril at End House
Lord Edgware Dies
Murder on the Orient Express
Three Act Tragedy
Death in the Clouds
The A.B.C. Murders
Murder in Mesopotamia
Cards on the Table
Murder in the Mews
Dumb Witness
Death on the Nile

Appointment with Death
Hercule Poirot's Christmas
Sad Cypress
One, Two, Buckle My Shoe
Evil Under the Sun
Five Little Pigs
The Hollow
The Labors of Hercules
Taken at the Flood
The Under Dog and Other Stories
Mrs. McGinty's Dead
After the Funeral
Hickory Dickory Dock
Dead Man's Folly
Cat Among the Pigeons
The Clocks
Third Girl
Hallowe'en Party
Elephants Can Remember
Curtain: Poirot's Last Case

The Miss Marple Mysteries

The Murder at the Vicarage
The Body in the Library
The Moving Finger
A Murder Is Announced
They Do It With Mirrors
A Pocket Full of Rye
4:50 from Paddington
The Mirror Crack'd from Side to Side
A Caribbean Mystery
At Bertram's Hotel
Nemesis
Sleeping Murder
Miss Marple: The Complete Short
 Stories

The Tommy and Tuppence Mysteries

The Secret Adversary
Partners in Crime
N or M?
By the Pricking of My Thumbs
Postern of Fate

Memoirs

An Autobiography
Come, Tell Me How You Live

Agatha Christie

AN AUTOBIOGRAPHY

wm

WILLIAM MORROW
An Imprint of HarperCollins*Publishers*

AGATHA CHRISTIE® AN AUTOBIOGRAPHY™. Copyright © 1977 Agatha Christie Limited (a Chorion company). All rights reserved. Introduction copyright © 2010 by Mathew Prichard.

AN AUTOBIOGRAPHY. Copyright © 1977. Published by permission of G.P. Putnam's Sons, a member of Penguin Group (USA) Inc. All rights reserved. Printed in the United States of America. No part of this book may be used or reproduced in any manner whatsoever without written permission except in the case of brief quotations embodied in critical articles and reviews. For information, address HarperCollins Publishers, 195 Broadway, New York, NY 10007.

HarperCollins books may be purchased for educational, business, or sales promotional use. For information, please e-mail the Special Markets Department at SPsales@harpercollins.com.

First published in Great Britain in 1977 by Collins and in hardcover in 2011 by HarperCollins Publishers, New York.

FIRST WILLIAM MORROW PAPERBACK EDITION PUBLISHED 2012.

Library of Congress Cataloging-in-Publication Data has been applied for.

ISBN 978-0-06-220457-8

21 22 23 OV/LSC 10 9 8

CONTENTS

INTRODUCTION

by Mathew Prichard

My grandmother always told us that she regarded writing her autobiography as an indulgence. I think particularly the first part of the book was a complete labour of love. Agatha had a very happy and memorable childhood and she loved writing about that, so much so that she almost couldn't stop herself. Naturally, however, she was being bullied every year to write her 'Christie for Christmas', as her publishers used to call her novels, and until she had finished that she didn't really feel able to do anything else.

The 1950s, the time when my grandmother was compiling her autobiography, were an extremely busy and fruitful time for her. She never really got distracted by the big events like *The Mousetrap* and *Witness for the Prosecution* being put on the stage in London, or by the publicity campaigns for her increasingly famous stories, such as for her fiftieth book, *A Murder is Announced*, in 1950. All these things went on, yet every year she would make a point of writing a few thousand words of her life story and then probably rather reluctantly put it aside and start what she would call 'real work' again. It was a long, drawn-out business. A lot of people I know have found the autobiography so fascinating they couldn't put it down – it probably took them a couple of weeks to read, yet it took my grandmother 15 years to write.

When I say 'write', I suppose I always knew that she dictated her autobiography, but I didn't know about the process of how she did it. And then, when we were clearing out my grandmother's home of Greenway in Devon shortly after my mother died, amongst all the books, scripts and papers that were in what we called the Fax Room at the top of the stairs, I found an old cardboard box containing an obsolete Grundig Memorette reel-to-reel dictation machine and a lot of tapes in little cardboard boxes which had obviously been posted to and fro between my grandmother and her secretary. My first thought was that these were not going to be much use because they were probably 50 or 60 years old at least and we may never get the machine working again.

I was however acutely conscious that we had very few instances of Agatha Christie's voice on tape. Only a handful of recordings of her voice were known to exist – including a 1955 interview for the BBC and a 1974 recording for the Imperial War Museum sound archive about her experiences in a World War I dispensary, where she learned so much about the poisons that would later feature in her books. I don't pretend to be mechanically-minded and I didn't for one moment believe that anybody could resurrect any fascinating material from this old box of tapes. Luckily a friend of mine, Eurion Brown, is a genius with electronics and took everything away and rigged up a way of playing and transferring the tapes. After a few weeks of hearing nothing from him, he rang me up one Friday morning and said, 'I think I've cracked it!' So I rushed into my local town of Cowbridge and after 50 or 60 years there was my grandmother's voice again.

I cannot tell you how evocative that moment was for me. I was very fond of her, and the sound of her voice was almost eerie. She had little mannerisms, like a very slight cough in the middle of sentences, which I had forgotten about – after all, it is over 30 years since she died, and all this came flooding back to me. And in the middle of some of these tapes suddenly you hear this little *'woof!'* as her dog barks, and it's just like being back at Wallingford.

I have played extracts from the tapes to various people who knew Agatha Christie when she was alive and they all say the same thing: it makes a great difference to your appreciation of her autobiography when you hear her speaking these things. I think a lot of people are amazed when they hear the passion and emotion that sometimes goes into what my grandmother says. In fact, one of the first people I played a bit to was my son, James, who was too young to remember his great-grandmother very well. I don't consider my son a particularly emotional person, but he said, 'Goodness me, I don't think you realise the significance of what you've got!'

I've got used to it now, but it is a year or more since this process began. The only tragedy in some ways is that my grandmother couldn't keep all the tapes. Being an economical person, I think she had a certain number of reels and when her typist had finished transcribing them she obviously sent them back and my grandmother re-used the same ones, therefore erasing the earlier chapters, which is why we only have recordings from the last quarter of the book.

I am therefore delighted that the recovery of these tapes has enabled us to re-publish my grandmother's autobiography, complete with some of

the colour illustrations that only previously appeared in the first edition, and in doing so to be able to share with the wider public some of the high-lights from the tapes. The CD accompanying this book contains a selec-tion of excerpts in which Agatha Christie talks mainly about her life as a writer, which ironically is probably of more interest to the rest of us than it was to her. But listening to her as she spontaneously commits her mem-ory to print is something special, even if it was on domestic equipment that was never intended to produce professional archive recordings. Despite their age and poor sound quality, I very much hope that you will enjoy hearing her – and I am sure you will read *An Autobiography* in a new light. It is a book that, like so many things in life, just gets better with age.

Mathew Prichard
Pwllywrach
December 2009

PREFACE

Agatha Christie began to write this book in April 1950; she finished it some fifteen years later when she was 75 years old. Any book written over so long a period must contain certain repetitions and inconsistencies and these have been tidied up. Nothing of importance has been omitted, however: substantially, this is the autobiography as she would have wished it to appear.

She ended it when she was 75 because, as she put it, 'it seems the right moment to stop. Because, as far as life is concerned, that is all there is to say.' The last ten years of her life saw some notable triumphs – the film of *Murder on the Orient Express*; the continued phenomenal run of *The Mousetrap*; sales of her books throughout the world growing massively year by year and in the United States taking the position at the top of the best-seller charts which had for long been hers as of right in Britain and the Commonwealth; her appointment in 1971 as a Dame of the British Empire. Yet these are no more than extra laurels for achievements that in her own mind were already behind her. In 1965 she could truthfully write . . . 'I am satisfied. I have done what I want to do.'

Though this is an autobiography, beginning, as autobiographies should, at the beginning and going on to the time she finished writing, Agatha Christie has not allowed herself to be too rigidly circumscribed by the strait-jacket of chronology. Part of the delight of this book lies in the way in which she moves as her fancy takes her; breaking off here to muse on the incomprehensible habits of housemaids or the compensations of old age; jumping forward there because some trait in her childlike character reminds her vividly of her grandson. Nor does she feel any obligation to put everything in. A few episodes which to some might seem important – the celebrated disappearance, for example – are not mentioned, though in that particular case the references elsewhere to an earlier attack of amnesia give the clue to the true course of events. As to the rest, 'I have remembered, I suppose, what I wanted to remember', and though she describes her parting from her first husband with moving dignity, what she usually wants to remember are the joyful or the amusing parts of her existence.

Few people can have extraced more intense or more varied fun from life, and this book, above all, is a hymn to the joy of living.

If she had seen this book into print she would undoubtedly have wished to acknowledge many of those who had helped bring that joy into her life; above all, of course, her husband Max and her family. Perhaps it would not be out of place for us, her publishers, to acknowledge *her*. For fifty years she bullied, berated and delighted us; her insistence on the highest standards in every field of publishing was a constant challenge; her good-humour and zest for life brought warmth into our lives. That she drew great pleasure from her writing is obvious from these pages; what does not appear is the way in which she could communicate that pleasure to all those involved with her work, so that to publish her made business ceaselessly enjoyable. It is certain that both as an author and as a person Agatha Christie will remain unique.

FOREWORD

Nimrud is the modern name of the ancient city of Calah, the military capital of the Assyrians. Our Expedition House is built of mud-brick. It sprawls out on the east side of the mound, and has a kitchen, a living – and dining-room, a small office, a workroom, a drawing office, a large store and pottery room, and a minute darkroom (we all sleep in tents). But this year one more room has been added to the Expedition House, a room that measures about three metres square. It has a plastered floor with rush mats and a couple of gay coarse rugs. There is a picture on the wall by a young Iraqi artist, of two donkeys going through the Souk, all done in a maze of brightly coloured cubes. There is a window looking out east towards the snow-topped mountains of Kurdistan. On the outside of the door is affixed a square card on which is printed in cuneiform BEIT AGATHA (Agatha's House).

So this is my 'house' and the idea is that in it I have complete privacy and can apply myself seriously to the business of writing. As the dig proceeds there will probably be no time for this. Objects will need to be cleaned and repaired. There will be photography, labelling, cataloguing and packing. But for the first week or ten days there should be comparative leisure.

It is true that there are certain hindrances to concentration. On the roof overhead, Arab workmen are jumping about, yelling happily to each other and altering the position of insecure ladders. Dogs are barking, turkeys are gobbling. The policeman's horse is clanking his chain, and the window and door refuse to stay shut, and burst open alternately. I sit at a fairly firm wooden table, and beside me is a gaily painted tin box with which Arabs travel. In it I propose to keep my typescript as it progresses.

I *ought* to be writing a detective story, but with the writer's natural urge to write anything but what he should be writing, I long, quite unexpectedly, to write my autobiography. The urge to write one's autobiography, so I have been told, overtakes everyone sooner or later. It has suddenly overtaken me.

On second thoughts, autobiography is much too grand a word. It suggests a purposeful study of one's whole life. It implies names, dates and places in tidy chronological order. What I want is to plunge my hand into a lucky dip and come up with a handful of assorted memories.

Life seems to me to consist of three parts: the absorbing and usually enjoyable present which rushes on from minute to minute with fatal speed; the future, dim and uncertain, for which one can make any number of interesting plans, the wilder and more improbable the better, since – as nothing will turn out as you expect it to do – you might as well have the fun of planning anyway; and thirdly, the past, the memories and realities that are the bedrock of one's present life, brought back suddenly by a scent, the shape of a hill, an old song – some triviality that makes one suddenly say 'I remember . . .' with a peculiar and quite unexplainable pleasure.

This is one of the compensations that age brings, and certainly a very enjoyable one – to remember.

Unfortunately you often wish not only to remember, but also to *talk* about what you remember. And this, you have to tell yourself repeatedly, is boring for other people. Why should they be interested in what, after all, is *your* life, not theirs? They do, occasionally, when young, accord to you a certain historical curiosity.

'I suppose,' a well-educated girl says with interest, 'that you remember *all* about the Crimea?'

Rather hurt, I reply that I'm not quite as old as that. I also repudiate participation in the Indian Mutiny. But I admit to recollections of the Boer War – I should do, my brother fought in it.

The first memory that springs up in my mind is a clear picture of myself walking along the streets of Dinard on market day with my mother. A boy with a great basket of stuff cannons roughly into me, grazing my arm and nearly knocking me flat. It hurts. I begin to cry. I am, I think, about seven years old.

My mother, who likes stoic behaviour in public places, remonstrates with me.

'Think,' she says, 'of our brave soldiers in South Africa.'

My answer is to bawl out: 'I don't want to be a brave soldier. I want to be a cowyard!'

What governs one's choice of memories? Life is like sitting in a cinema. Flick! Here am I, a child eating éclairs on my birthday. Flick! Two years have passed and I am sitting on my grandmother's lap, being

solemnly trussed up as a chicken just arrived from Mr Whiteley's, and almost hysterical with the wit of the joke.

Just moments – and in between long empty spaces of months or even years. Where was one then ? It brings home to one Peer Gynt's question: 'Where was I, myself, the whole man, the true man?'

We never know the whole man, though sometimes, in quick flashes, we know the true man. I think, myself, that one's memories represent those moments which, insignificant as they may seem, nevertheless represent the inner self and oneself as most really oneself.

I am today the same person as that solemn little girl with pale flaxen sausage-curls. The house in which the spirit dwells, grows, develops instincts and tastes and emotions and intellectual capacities, but I myself, the true Agatha, am the same. I do not know the whole Agatha. The whole Agatha, so I believe, is known only to God.

So there we are, all of us, little Agatha Miller, and big Agatha Miller, and Agatha Christie and Agatha Mallowan proceeding on our way – where ? That one doesn't know – which, of course, makes life exciting. I have always thought life exciting and I still do.

Because one knows so little of it – only one's own tiny part – one is like an actor who has a few lines to say in Act I. He has a type-written script with his cues, and that is all he can know. He hasn't read the play. Why should he? His but to say 'The telephone is out of order, Madam' and then retire into obscurity.

But when the curtain goes up on the day of performance, he will hear the play through, and he will be there to line up with the rest, and take his call.

To be part of something one doesn't in the least understand is, I think, one of the most intriguing things about life.

I like living. I have sometimes been wildly despairing, acutely miserable, racked with sorrow, but through it all I still know quite certainly that just to *be* alive is a grand thing.

So what I plan to do is to enjoy the pleasures of memory – not hurrying myself – writing a few pages from time to time. It is a task that will probably go on for years. But why do I call it a *task*? It is an indulgence. I once saw an old Chinese scroll that I loved. It featured an old man sitting under a tree playing cat's cradle. It was called 'Old Man enjoying the pleasures of Idleness.' I've never forgotten it.

So having settled that I'm going to enjoy myself, I had better, perhaps, begin. And though I don't expect to be able to keep up chronological continuity, I can at least try to begin at the beginning.

PART I

ASHFIELD

O ! ma chère maison ; mon nid, mon gîte
Le passé l'habite . . . O ma chère maison

I

One of the luckiest things that can happen to you in life is to have a happy childhood. I had a very happy childhood. I had a home and a garden that I loved; a wise and patient Nanny; as father and mother two people who loved each other dearly and made a success of their marriage and of parenthood.

Looking back I feel that our house was truly a happy house. That was largely due to my father, for my father was a very agreeable man. The quality of agreeableness is not much stressed nowadays. People tend to ask if a man is clever, industrious, if he contributes to the well-being of the community, if he 'counts' in the scheme of things. But Charles Dickens puts the matter delightfully in *David Copperfield*:

'Is your brother an agreeable man, Peggotty?' I enquired cautiously.

'Oh what an agreeable man he is!' exclaimed Peggotty.

Ask yourself that question about most of your friends and acquaintances, and you will perhaps be surprised at how seldom your answer will be the same as Peggotty's.

By modern standards my father would probably not be approved of. He was a lazy man. It was the days of independent incomes, and if you had an independent income you didn't work. You weren't expected to. I strongly suspect that my father would not have been particularly good at working anyway.

He left our house in Torquay every morning and went to his club. He returned, in a cab, for lunch, and in the afternoon went back to the club, played whist all afternoon, and returned to the house in time to dress for dinner. During the season, he spent his days at the Cricket Club, of which he was President. He also occasionally got up amateur theatricals. He had an enormous number of friends and loved entertaining them. There was one big dinner party at our home every week, and he and my mother went out to dinner usually another two or three times a week.

It was only later that I realized what a much loved man he was. After his death, letters came from all over the world. And locally tradesmen, cabmen, old employees – again and again some old man would come up to me and say: 'Ah! I remember Mr Miller well. I'll never forget him. Not many like him nowadays.'

Yet he had no outstanding characteristics. He was not particularly intelligent. I think that he had a simple and loving heart, and he really cared for his fellow men. He had a great sense of humour and he easily made people laugh. There was no meanness in him, no jealousy, and he was almost fantastically generous. And he had a natural happiness and serenity.

My mother was entirely different. She was an enigmatic and arresting personality – more forceful than my father – startlingly original in her ideas, shy and miserably diffident about herself, and at bottom, I think, with a natural melancholy.

Servants and children were devoted to her, and her lightest word was always promptly obeyed. She would have made a first class educator. Anything she told you immediately became exciting and significant. Sameness bored her and she would jump from one subject to another in a way that sometimes made her conversation bewildering. As my father used to tell her, she had no sense of humour. To that accusation she would protest in an injured voice: 'Just because I don't think certain stories of yours are funny, Fred . . .' and my father would roar with laughter.

She was about ten years younger than my father and she had loved him devotedly ever since she was a child of ten. All the time that he was a gay young man, flitting about between New York and the South of France, my mother, a shy quiet girl, sat at home, thinking about him, writing an occasional poem in her 'album,' embroidering a pocket-book for him. That pocket-book, incidentally, my father kept all his life.

A typically Victorian romance, but with a wealth of deep feeling behind it.

I am interested in my parents, not only because they *were* my parents, but because they achieved that very rare production, a happy marriage. Up to date I have only seen four completely successful marriages. Is there a formula for success? I can hardly think so. Of my four examples, one was of a girl of seventeen to a man over fifteen years her senior. He had protested she could not know her mind. She replied that she knew it perfectly and had determined to marry him some three years back! Their married life was further complicated by having first one and then the other mother-in-law living with them – enough to wreck most alliances. The wife is calm with a quality of deep intensity. She reminds me a little of my mother without having her brilliance and intellectual interests. They have three children, all now long out in the world. Their partnership has lasted well over thirty years and they are still devoted. Another was that of a young man to a woman fifteen years older than himself – a widow. She refused him for many years, at last accepted him, and they lived happily until her death 35 years later.

My mother Clara Boehmer went through unhappiness as a child. Her father, an officer in the Argyll Highlanders, was thrown from his horse and fatally injured, and my grandmother was left, a young and lovely widow with four children, at the age of 27 with nothing but her widow's pension. It was then that her elder sister, who had recently married a rich American as his second wife, wrote to her offering to adopt one of the children and bring it up as her own.

To the anxious young widow, working desperately with her needle to support and educate four children, the offer was not to be refused. Of the three boys and one girl, she selected the girl; either because it seemed to her that boys could make their way in the world while a girl needed the advantages of easy living, or because, as my mother always believed, she cared for the boys more. My mother left Jersey and came to the North of England to a strange home. I think the resentment she felt, the deep hurt at being unwanted, coloured her attitude to life. It made her distrustful of herself and suspicious of people's affection. Her aunt was a kindly woman, good-humoured and generous, but she was imperceptive of a child's feelings. My mother had all the so-called advantages of a comfortable home and a good education – what she lost and what nothing could replace was the carefree life with her brothers in *her own home*. Quite often I have seen in correspondence columns enquiries from

anxious parents asking if they ought to let a child go to others because of 'the advantages she will have which I cannot provide – such as a first-class education'. I always long to cry out: Don't let the child go. Her own home, her own people, love, and the security of belonging – what does the best education in the world mean against that?

My mother was deeply miserable in her new life. She cried herself to sleep every night, grew thin and pale, and at last became so ill that her aunt called in a doctor. He was an elderly, experienced man, and after talking to the little girl he went to her aunt and said: 'The child's home-sick.' Her aunt was astonished and unbelieving. 'Oh no,' she said. 'That couldn't possibly be so. Clara's a good quiet child, she never gives any trouble, and she's quite happy.' But the old doctor went back to the child and talked to her again. She had brothers, hadn't she? How many? What were their names? And presently the child broke down in a storm of weeping, and the whole story came out.

Bringing out the trouble eased the strain, but the feeling always remained of 'not being wanted'. I think she held it against my grandmother until her dying day. She became very attached to her American 'uncle'. He was a sick man by then, but he was fond of quiet little Clara and she used to come and read to him from her favourite book, *The King of the Golden River*. But the real solace in her life were the periodical visits of her aunt's stepson – Fred Miller – her so-called 'Cousin Fred'. He was then about twenty and he was always extra kind to his little 'cousin'. One day, when she was about eleven, he said to his stepmother:

'What lovely eyes Clara has got!'

Clara, who had always thought of herself as terribly plain, went upstairs and peered at herself in her aunt's large dressing-table mirror. Perhaps her eyes *were* rather nice . . . She felt immeasurably cheered. From then on, her heart was given irrevocably to Fred.

Over in America an old family friend said to the gay young man, 'Freddie, one day you will marry that little English cousin of yours.'

Astonished, he replied, 'Clara? She's only a child.'

But he always had a special feeling for the adoring child. He kept her childish letters and the poems she wrote him, and after a long series of flirtations with social beauties and witty girls in New York (among them Jenny Jerome, afterwards Lady Randolph Churchill) he went home to England to ask the quiet little cousin to be his wife.

It is typical of my mother that she refused him firmly.

'Why?' I once asked her.

'Because I was dumpy,' she replied.

An extraordinary but, to her, quite valid reason.

My father was not to be gainsaid. He came a second time, and on this occasion my mother overcame her misgivings and rather dubiously agreed to marry him, though full of misgivings that he would be 'disappointed in her'.

So they were married, and the portrait that I have of her in her wedding dress shows a lovely serious face with dark hair and big hazel eyes.

Before my sister was born they went to Torquay, then a fashionable winter resort enjoying the prestige later accorded to the Riviera, and took furnished rooms there. My father was enchanted with Torquay. He loved the sea. He had several friends living there, and others, Americans, who came for the winter. My sister Madge was born in Torquay, and shortly after that my father and mother left for America, which at that time they expected to be their permanent home. My father's grandparents were still living, and after his own mother's death in Florida he had been brought up by them in the quiet of the New England countryside. He was very attached to them and they were keen to see his wife and baby daughter. My brother was born whilst they were in America. Some time after that my father decided to return to England. No sooner had he arrived than business troubles recalled him to New York. He suggested to my mother that she should take a furnished house in Torquay and settle there until he could return.

My mother accordingly went to look at furnished houses in Torquay. She returned with the triumphant announcement: 'Fred; I've bought a house!'

My father almost fell over backwards. He still expected to live in America.

'But why did you do that?' he asked.

'Because I liked it,' explained my mother.

She has seen, it appeared, about 35 houses, but only one did she fancy, and that house was for sale only – its owners did not want to let. So my mother, who had been left £2000 by my aunt's husband, had appealed to my aunt, who was her trustee, and they had forthwith bought the house.

'But we'll only be there for a year,' groaned my father, 'at *most*.'

My mother, whom we always claimed was clairvoyant, replied that they could always sell it again. Perhaps she saw dimly her family living in that house for many years ahead.

'I loved the house as soon as I got into it,' she insisted. 'It's got a wonderfully peaceful atmosphere.'

The house was owned by some people called Brown who were Quakers, and when my mother, hesitatingly, condoled with Mrs Brown on having to leave the house they had lived in so many years, the old lady said gently:

'I am happy to think of thee and thy children living here, my dear.'

It was, my mother said, like a blessing.

Truly I believe there *was* a blessing upon the house. It was an ordinary enough villa, not in the fashionable part of Torquay – the Warberrys or the Lincombes – but at the other end of the town the older part of Tor Mohun. At that time the road in which it was situated led almost at once into rich Devon country, with lanes and fields. The name of the house was Ashfield and it has been my home, off and on, nearly all my life.

For my father did not, after all, make his home in America. He liked Torquay so much that he decided not to leave it. He settled down to his club and his whist and his friends. My mother hated living near the sea, disliked all social gatherings and was unable to play any game of cards. But she lived happily in Ashfield, and gave large dinner parties, attended social functions, and on quiet evenings at home would ask my father with hungry impatience for local drama and what had happened at the club today.

'Nothing,' my father would reply happily.

'But surely, Fred, *someone* must have said something interesting?'

My father obligingly racks his brains, but nothing comes. He says that M— is still too mean to buy a morning paper and comes down to the club, reads the news there, and then insists on retailing it to the other members. 'I say, you fellows, have you seen that on the North West Frontier . . .' etc. Everyone is deeply annoyed, since M— is one of the richest members.

My mother, who has heard all this before, is not satisfied. My father relapses into quiet contentment. He leans back in his chair, stretches out his legs to the fire and gently scratches his head (a forbidden pastime).

'What are you thinking about, Fred?' demands my mother.

'Nothing,' my father replies with perfect truth.

'You *can't* be thinking about *nothing*!'

Again and again that statement baffles my mother. To her it is unthinkable. Through her own brain thoughts dart with the swiftness of

swallows in flight. Far from thinking of nothing, she is usually thinking of three things at once.

As I was to realise many years later, my mother's ideas were always slightly at variance with reality. She saw the universe as more brightly coloured than it was, people as better or worse than they were. Perhaps because in the years of her childhood she had been quiet, restrained, with her emotions kept well below the surface, she tended to see the world in terms of drama that came near, sometimes, to melodrama. Her creative imagination was so strong that it could never see things as drab or ordinary. She had, too, curious flashes of intuition – of knowing suddenly what other people were thinking. When my brother was a young man in the Army and had got into monetary difficulties which he did not mean to divulge to his parents, she startled him one evening by looking across at him as he sat frowning and worrying. 'Why, Monty,' she said, 'you've been to moneylenders. Have you been raising money on your grand-father's will? You shouldn't do that. It's better to go to your father and tell him about it.'

Her faculty for doing that sort of thing was always surprising her family. My sister said once: 'Anything I don't want mother to know, I don't even *think* of, if she's in the room.'

II

Difficult to know what one's first memory is. I remember distinctly my third birthday. The sense of my own importance surges up in me. We are having tea in the garden – in the part of the garden where, later, a hammock swings between two trees.

There is a tea-table and it is covered with cakes, with my birthday cake, all sugar icing and with candles in the middle of it. Three candles. And then the exciting occurrence – a tiny red spider, so small that I can hardly see it, runs across the white cloth. And my mother says: 'It's a *lucky* spider, Agatha, a lucky spider for your birthday . . .' And then the memory fades, except for a fragmentary reminiscence of an interminable argument sustained by my brother as to how many éclairs he shall be allowed to eat.

The lovely, safe, yet exciting world of childhood. Perhaps the most absorbing thing in mine is the garden. The garden was to mean more and more to me, year after year. I was to know every tree in it, and attach a special meaning to each tree. From a very early time, it was divided in my mind into three distinct parts.

There was the kitchen garden, bounded by a high wall which abutted on the road. This was uninteresting to me except as a provider of raspberries and green apples, both of which I ate in large quantities. It was the kitchen garden but nothing else. It offered no possibilities of enchantment.

Then came the garden proper – a stretch of lawn running downhill, and studded with certain interesting entities. The ilex, the cedar, the Wellingtonia (excitingly tall). Two fir-trees, associated for some reason not now clear with my brother and sister. Monty's tree you could climb (that is to say hoist yourself gingerly up three branches). Madge's tree, when you had burrowed cautiously into it, had a seat, an invitingly curved bough, where you could sit and look out unseen on the outside world. Then there was what I called the turpentine tree which exuded a sticky strong-smelling gum which I collected carefully in leaves and which was 'very precious balm'. Finally, the crowning glory, the beech tree – the biggest tree in the garden, with a pleasant shedding of beech-nuts which I ate with relish. There was a copper beech, too, but this, for some reason, never counted in my tree world.

Thirdly, there was the wood. In my imagination it looked and indeed still looms as large as the New Forest. Mainly composed of ash trees, it had a path winding through it. The wood had everything that is con-nected with woods. Mystery, terror, secret delight, inaccessibility and distance . . .

The path through the wood led out on to the tennis or croquet lawn at the top of a high bank in front of the dining-room window. When you emerged there, enchantment ended. You were in the everyday world once more, and ladies, their skirts looped up and held in one hand, were playing croquet, or, with straw boater-hats on their heads, were playing tennis.

When I had exhausted the delights of 'playing in the garden' I returned to the Nursery wherein was Nursie, a fixed point, never changing. Perhaps because she was an old woman and rheumatic, my games were played around and beside, but not wholly *with*, Nursie. They were all make-believe. From as early as I can remember, I had various companions of my own choosing. The first lot, whom I cannot remember except as a

name, were 'The Kittens'. I don't know now who 'The Kittens' were, and whether I was myself a Kitten, but I do remember their names: Clover, Blackie and three others. Their mother's name was Mrs Benson.

Nursie was too wise ever to talk to me about them, or to try to join in the murmurings of conversation going on round her feet. Probably she was thankful that I could amuse myself so easily.

Yet it was a horrible shock to me one day when I came up the stairs from the garden for tea to hear Susan the housemaid saying:

'Don't seem to care for toys much, does she? What *does* she play with?'

And Nursie's voice replying:

'Oh she plays that she's a kitten with some other kittens.'

Why is there such an innate demand for secrecy in a child's mind? The knowledge that *anyone* – even Nursie – knew about The Kittens upset me to the core. From that day on I set myself never to murmur aloud in my games. The Kittens were *My* Kittens and only mine. No one must know.

I must, of course, have had toys. Indeed, since I was an indulged and much loved child, I must have had a good variety of them, but I do not remember any, except, vaguely, a box of variegated beads, and stringing them into necklaces. I also remember a tiresome cousin, an adult, insisting teasingly that my blue beads were green and my green ones were blue. My feelings were as those of Euclid: 'which is absurd', but politely I did not contradict her. The joke fell flat.

I remember some dolls: Phoebe, whom I did not much care for, and a doll called Rosalind or Rosy. She had long golden hair and I admired her enormously, but I did not play much with her. I preferred The Kittens. Mrs Benson was terribly poor, and it was all very sad. Captain Benson, their father, had been a Sea Captain and had gone down at sea, which was why they had been left in such penury. That more or less ended the Saga of the Kittens except that there existed vaguely in my mind a glorious finale to come of Captain Benson not being dead and returning one day with vast wealth just when things had become quite desperate in the Kittens' home.

From the Kittens I passed on to Mrs Green. Mrs Green had a hundred children, of whom the important ones were Poodle, Squirrel and Tree. Those three accompanied me on all my exploits in the garden. They were not quite children and not quite dogs, but indeterminate creatures between the two.

Once a day, like all well brought-up children, I 'went for a walk'. This I much disliked, especially buttoning up my boots – a necessary preliminary. I lagged behind and shuffled my feet, and the only thing that got me through was Nursie's stories. She had a repertoire of six, all centred on the various children of the families with which she had lived. I remember none of them now, but I do know that one concerned a tiger in India, one was about monkeys, and one about a snake. They were very exciting, and I was allowed to choose which I would hear. Nursie repeated them endlessly without the least sign of weariness.

Sometimes, as a great treat, I was allowed to remove Nursie's snowy ruffled cap. Without it, she somehow retreated into private life and lost her official status. Then, with elaborate care, I would tie a large blue satin ribbon round her head – with enormous difficulty and holding my breath, because tying a bow is no easy matter for a four-year-old. After which I would step back and exclaim in ecstasy: 'Oh Nursie, you *are* beautiful!'

At which she would smile and say in her gentle voice:

'Am I, love?'

After tea, I would be put into starched muslin and go down to the drawing-room to my mother to be played with.

If the charm of Nursie's stories were that they were always the same, so that Nursie represented the rock of stability in my life, the charm of my mother was that her stories were always different and that we practically never played the same game twice. One story, I remember, was about a mouse called Bright Eyes. Bright Eyes had several different adventures, but suddenly, one day, to my dismay, my mother declared that there were no more stories about Bright Eyes to tell. I was on the point of weeping when my mother said: 'But I'll tell you a story about a Curious Candle.' We had two instalments of the Curious Candle, which was, I think, a kind of detective story, when unluckily some visitors came to stay and our private games and stories were in abeyance. When the visitors left and I demanded the end of the Curious Candle, which had paused at a most thrilling moment when the villain was slowly rubbing poison into the candle, my mother looked blank and apparently could remember nothing about the matter. That unfinished serial still haunts my mind. Another delightful game was 'Houses', in which we collected bath towels from all over the house and draped them over chairs and tables so as to make ourselves residences, out of which we emerged on all fours.

I remember little of my brother and sister, and I presume this is

because they were away at school. My brother was at Harrow and my sister at Brighton at the Miss Lawrences' School which was afterwards to become Roedean. My mother was considered go-ahead to send her daughter to a *boarding school*, and my father broad-minded to allow it. But my mother delighted in new experiments.

Her own experiments were mostly in religion. She was, I think, of a naturally mystic turn of mind. She had the gift of prayer and contemplation, but her ardent faith and devotion found it difficult to select a suitable form of worship. My long-suffering father allowed himself to be taken to first one, now another place of worship.

Most of these religious flirtations took place before I was born. My mother had nearly been received into the Roman Catholic church, had then bounced off into being a Unitarian (which accounted for my brother never having been christened), and had from there become a budding Theosophist, but took a dislike to Mrs Besant when hearing her lecture. After a brief but vivid interest in Zoroastrianism, she returned, much to my father's relief, to the safe haven of the Church of England, but with a preference for 'high' churches. There was a picture of St. Francis by her bed, and she read *The Imitation of Christ* night and morning. That same book lies always by my bed.

My father was a simple-hearted, orthodox Christian. He said his prayers every night and went to Church every Sunday. His religion was matter-of-fact and without heart-searchings – but if my mother liked hers with trimmings, it was quite all right with him. He was, as I have said, an agreeable man.

I think he was relieved when my mother returned to the Church of England in time for me to be christened in the Parish Church. I was called Mary after my grandmother, Clarissa after my mother, and Agatha as an afterthought, suggested on the way to the church by a friend of my mother's who said it was a nice name.

My own religious views were derived mainly from Nursie, who was a Bible Christian. She did not go to Church but read her Bible at home. Keeping the Sabbath was very important, and being worldly was a sore offence in the eyes of the Almighty. I was myself insufferably smug in my conviction of being one of the 'saved'. I refused to play games on Sunday or sing or strum the piano, and I had terrible fears for the ultimate salvation of my father, who played croquet blithely on Sunday afternoons and made gay jokes about curates and even, once, about a bishop.

My mother, who had been passionately enthusiastic for education for

girls, had now, characteristically, swung round to the opposite view. No child ought to be allowed to read until it was eight years old: better for the eyes and also for the brain.

Here, however, things did not go according to plan. When a story had been read to me and I liked it, I would ask for the book and study the pages which, at first meaningless, gradually began to make sense. When out with Nursie, I would ask her what the words written up over shops or on hoardings were. As a result, one day I found I was reading a book called *The Angel of Love* quite successfully to myself. I proceeded to do so out loud to Nursie.

'I'm afraid, Ma'am,' said Nursie apologetically to mother the next day, 'Miss Agatha can *read*.'

My mother was much distressed – but there it was. Not yet five, but the world of story books was open to me. From then on, for Christmas and birthdays I demanded books.

My father said that, as I could read, I had better learn to write. This was not nearly so pleasant. Shaky copybooks full of pothooks and hangers still turn up in old drawers, or lines of shaky B's and R's, which I seem to have had great difficulty in distinguishing since I had learned to read by the look of *words* and not by their letters.

Then my father said I might as well start arithmetic, and every morning after breakfast I would set to at the dining-room window seat, enjoying myself far more with figures than with the recalcitrant letters of the alphabet.

Father was proud and pleased with my progress. I was promoted to a little brown book of 'Problems'. I loved 'Problems'. Though merely sums in disguise, they had an intriguing flavour. 'John has five apples, George has six; if John takes away two of George's apples, how many will George have at the end of the day?' and so on. Nowadays, thinking of that problem, I feel an urge to reply: 'Depends how fond of apples George is.' But then I wrote down 4, with the feeling of one who has solved a knotty point, and added of my own accord, 'and John will have 7.' That I liked arithmetic seemed strange to my mother, who had never, as she admitted freely, had any use for figures, and had so much trouble with household accounts that my father took them over.

The next excitement in my life was the gift of a canary. He was named Goldie and became very tame, hopping about the nursery, sometimes sitting on Nursie's cap, and perching on my finger when I called him. He was not only my bird, he was the start of a new secret Saga. The chief

personages were Dickie and Dicksmistress. They rode on chargers all over the country (the garden) and had great adventures and narrow escapes from bands of robbers.

One day the supreme catastrophe occurred. Goldie disappeared. The window was open, the gate of his cage unlatched. It seemed likely he had flown away. I can still remember the horrible, dragging length of that day. It went on and on and on. I cried and cried and cried. The cage was put outside the window with a piece of sugar in the bars. My mother and I went round the garden calling, 'Dickie, Dickie, Dickie'. The housemaid was threatened with instant dismissal by my mother for cheerfully remarking, 'Some cat's got him, likely as not,' which started my tears flowing again.

It was when I had been put to bed and lay there, still sniffing spasmodically and holding my mother's hand, that a cheerful little cheep was heard. Down from the top of the curtain pole came Master Dickie. He flew round the nursery once and then entered his cage. Oh that incredulous wonder of delight! All that day – that unending miserable day – Dickie had been up the curtain pole.

My mother improved the occasion after the fashion of the time.

'You see,' she said, 'how silly you have been? What a *waste* all that crying was? *Never* cry about things until you are sure.'

I assured her that I never would.

Something else came to me then, besides the joy of Dickie's return, the strength of my mother's love and understanding when there was trouble. In the black abyss of misery, holding tight to her hand had been the one comfort. There was something magnetic and healing in her touch. In illness there was no one like her. She could give you her own strength and vitality.

III

The outstanding figure in my early life was Nursie. And round myself and Nursie was our own special world, The Nursery.

I can see the wallpaper now – mauve irises climbing up the walls in an endless pattern. I used to lie in bed at night looking at it in the firelight or the subdued light of Nursie's oil lamp on the table. I thought it was beautiful. Indeed, I have had a passion for mauve all my life.

Nursie sat by the table sewing or mending. There was a screen round my bed and I was supposed to be asleep, but I was usually awake, admiring the irises, trying to see just *how* they intertwined, and thinking up new adventures for the Kittens. At nine-thirty, Nursie's supper tray was brought up by Susan the housemaid. Susan was a great big girl, jerky and awkward in her movements and apt to knock things over. She and Nursie would hold a whispered conversation, then, when she had gone, Nursie would come over and look behind the screen.

'I thought you wouldn't be asleep. I suppose you want a taste?'

'Oh, yes please, Nursie.'

A delicious morsel of juicy steak was placed in my mouth. I cannot really believe that Nursie had steak every night for supper, but in my memories steak it always is.

One other person of importance in the house was Jane our cook, who ruled the kitchen with the calm superiority of a queen. She came to my mother when she was a slim girl of nineteen, promoted from being a kitchenmaid. She remained with us for forty years and left weighing at least fifteen stone. Never once during that time had she displayed any emotion, but when she finally yielded to her brother's urgings and went to keep house for him in Cornwall, the tears rolled silently down her cheeks as she left. She took with her one trunk – probably the trunk with which she had arrived. In all those years she had accumulated no possessions. She was, by today's standards, a wonderful cook, but my mother occasionally complained that she had no imagination.

'Oh dear, what pudding shall we have tonight? *You* suggest something, Jane.'

'What about a nice stone pudding, Ma'am?'

A stone pudding was the only suggestion Jane ever vouchsafed, but for some reason my mother was allergic to the idea and said no, we wouldn't have that, we'd have something else. To this day I have never known what a stone pudding was – my mother did not know either – she just said that it sounded dull.

When I first knew Jane she was enormous – one of the fattest women I have ever seen. She had a calm face, hair parted in the middle – beautiful, naturally wavy dark hair scraped back into a bun in the nape of her neck. Her jaws moved rhythmically all the time because she was invariably eating something – a fragment of pastry, a freshly-made scone, or a rock cake – it was like a large gentle cow everlastingly chewing the cud.

Splendid eating went on in the kitchen. After a large breakfast, eleven

o'clock brought the delights of cocoa, and a plate of freshly-made rock cakes and buns, or perhaps hot jam pastry. The midday meal took place when ours was finished, and by etiquette the kitchen was *taboo* until 3 o'clock had struck. I was instructed by my mother that I was *never* to intrude during the kitchen lunchtime: 'That is their own time, and it must not be interrupted by us.'

If by some unforeseen chance – a cancellation of dinner guests for instance – a message had to be conveyed, my mother would apologise for disturbing them, and, by unwritten law, none of the servants would rise at her entrance if they were seated at table.

Servants did an incredible amount of work. Jane cooked five-course dinners for seven or eight people as a matter of daily routine. For grand dinner parties of twelve or more, each course contained alternatives – two soups, two fish courses, etc. The housemaid cleaned about forty silver photograph frames and toilet silver *ad lib*, took in and emptied a 'hip bath' (we had a bathroom but my mother considered it a revolting idea to use a bath others had used), brought hot water to bedrooms four times a day, lit bedroom fires in winter, and mended linen etc. every afternoon. The parlourmaid cleaned incredible amounts of silver and washed glasses with loving care in a papier mâché bowl, besides providing perfect waiting at table.

In spite of these arduous duties, servants were, I think, actively happy, mainly because they knew they were appreciated – as *experts*, doing expert work. As such, they had that mysterious thing, prestige; they looked down with scorn on shop assistants and their like.

One of the things I think I should miss most, if I were a child nowadays, would be the absence of servants. To a child they were the most colourful part of daily life. Nurses supplied platitudes; servants supplied drama, entertainment, and all kinds of unspecified but interesting knowledge. Far from being slaves they were frequently tyrants. They 'knew their place', as was said, but knowing their place meant not subservience but pride, the pride of the professional. Servants in the early 1900s were highly skilled. Parlourmaids had to be tall, to look smart, to have been perfectly trained, to have the right voice in which to murmur: 'Hock or sherry?' They performed intricate miracles of valeting for the gentlemen.

I doubt if there is any such thing as a *real* servant nowadays. Possibly a few are hobbling about between the ages of seventy and eighty, but otherwise there are merely the dailies, the waitresses, those who 'oblige', domestic helpers, working housekeepers, and charming young women

who want to combine earning a little extra money with hours that will suit them and their children's needs. They are amiable amateurs; they often become friends but they seldom command the awe with which we regarded our domestic staff.

Servants, of course, were not a particular luxury – it was not a case of only the rich having them; the only difference was that the rich had more. They had butlers and footmen and housemaids and parlourmaids and between-maids and kitchen-maids and so on. As you descended the stages of affluence you would arrive eventually at what is so well described in those delightful books of Barry Pain, *Eliza* and *Eliza's Husband*, as 'The girl'.

Our various servants are far more real to me than my mother's friends and my distant relations. I have only to close my eyes to see Jane moving majestically in her kitchen, with vast bust, colossal hips, and a starched band that confined her waist. Her fat never seemed to trouble her, she never suffered from her feet, her knees or her ankles, and if she had blood pressure she was quite unaware of it. As far as I remember she was never ill. She was Olympian. If she had emotions, she never showed them; she was prodigal neither of endearments nor of anger; only on the days when she was engaged in the preparation of a large dinner-party a slight flush would show. The intense calm of her personality would be what I should describe as 'faintly ruffled' – her face slightly redder, her lips pressed tight together, a faint frown on her forehead. Those were the days when I used to be banished from the kitchen with decision. 'Now, Miss Agatha, I have no time today – I've got a lot on hand. I'll give you a handful of raisins and then you must go out in the garden and not come and worry me any more.' I left immediately, impressed, as always, by Jane's utterances.

Jane's principal characteristics were reticence and aloofness. We knew she had a brother, otherwise we knew little of her family. She never talked about them. She came from Cornwall. She was called 'Mrs Rowe', but that was a courtesy title. Like all good servants, she knew her place. It was a place of command, and she made it clear to those working in the house that she was in charge.

Jane must have taken pride in the splendid dishes she cooked, but never showed it or spoke of it. She accepted compliments on her dinner on the following morning with no sign of gratification, though I think she was definitely pleased when my father came out into the kitchen and congratulated her.

Then there was Barker, one of our housemaids, who opened up to me yet another vista of life. Barkers' father was a particularly strict Plymouth Brother, and Barker was very conscious of sin and the way she had broken away in certain matters. 'Damned to all Eternity I shall be, no doubt of it,' she would say, with a kind of cheerful relish. 'What my father would say, I don't know, if he knew I went to Church of England services. What's more, *I enjoyed them.* I enjoyed the Vicar's sermon last Sunday, and I enjoyed the singing too.'

A child who came to stay was heard by my mother saying scornfully one day to the parlourmaid: 'Oh! *you're* only a servant!' and was promptly taken to task.

'Never let me hear you speak like that to a servant. Servants must be treated with the utmost courtesy. They are doing skilled work which you could not possibly do yourself without long training. And remember they cannot answer back. You must always be polite to people whose position forbids *them* to be rude to *you*. If you are impolite, they will despise you, and rightly, because you have not acted like a lady.'

'To be a little lady' was well rammed home in those times. It included some curious items.

Starting with courtesy to dependents, it went on to such things as: 'Always leave something on your plate for Lady Manners.' 'Never drink with your mouth full.' 'Remember never to put two halfpenny stamps on a letter unless it is a bill to a tradesman.' And, of course 'Put on clean underclothes when you are going on a railway journey in case there should be an accident.'

Tea-time in the kitchen was often a social reunion. Jane had innumerable friends, and one or two of them dropped in nearly every day. Trays of hot rock cakes came out of the oven. Never since have I tasted rock cakes like Jane's. They were crisp and flat and full of currants, and eaten hot they were Heaven. Jane in her mild bovine way was quite a martinet; if one of the others rose from the table, a voice would say: 'I haven't finished yet, Florence,' and Florence, abashed, would sit down again murmuring, 'I beg your pardon, Mrs Rowe.'

Cooks of any seniority were always 'Mrs'. Housemaids and parlourmaids were supposed to have 'suitable' names – e.g. Jane, Mary, Edith, etc. Such names as Violet, Muriel, Rosamund and so on were not considered suitable, and the girl was told firmly, 'Whilst you are in my service you will be called "Mary".' Parlourmaids, if of sufficient seniority, were often called by their surnames.

Friction between 'the nursery' and 'the kitchen' was not uncommon, but Nursie, though no doubt standing on her rights, was a peaceable person and respected and consulted by the young maids.

Dear Nursie – I have a portrait of her hanging in my house in Devon. It was painted by the same artist who painted the rest of my family, a painter well known at that time – N. H. J. Baird. My mother was somewhat critical of Mr Baird's pictures: 'He makes everybody look so *dirty*,' she complained. 'All of you look as if you hadn't washed for *weeks*!'

There is something in what she said. The heavy blue and green shadows in the flesh tints of my brother's face do suggest a reluctance to use soap and water, and the portrait of myself at sixteen has a suggestion of an incipient moustache, a blemish from which I have never suffered. My father's portrait, however, is so pink and white and shining that it might be an advertisement for soap. I suspect that it gave the artist no particular pleasure to paint, but that my mother had vanquished poor Mr Baird by sheer force of personality. My brother's and sister's portraits were not particularly like, my father's was the living image of him, but was far less distinctive as a portrait.

Nursie's portrait was, I am sure, a labour of love on Mr Baird's part. The transparent cambric of her frilled cap and apron is lovely, and a perfect frame for the wise wrinkled face with its deep set eyes – the whole reminiscent of some Flemish Old Master.

I don't know how old Nursie was when she came to us, or why my mother should have chosen such an old woman, but she always said: 'From the moment Nursie came, I never had to worry about you – I knew you were in good hands.' A great many babies had passed through those hands – I was the last of them.

When the census came round, my father had to register the names and ages of everyone in the house.

'Very awkward job,' he said ruefully. 'The servants don't like you asking them their ages. And what about Nursie?'

So Nursie was summoned and stood before him, her hands folded in front of her snowy apron and her mild old eyes fixed on him inquiringly.

'So you see,' explained my father, after a brief résumé of what a census was, 'I have to put down everyone's age. Er – what shall I put down for you?'

'Whatever you like, Sir,' replied Nursie politely.

'Yes, but – er – I have to *know*.'

'Whatever you think best, Sir.' Nursie was not to be stampeded.

His own estimate being that she was at least seventy-five, he hazarded nervously: "Er – er – fifty-nine? Something like that?'

An expression of pain passed across the wrinkled face.

'Do I really look as old as that, Sir?' asked Nursie wistfully.

'No, no – Well, what *shall* I say?'

Nursie returned to her gambit.

'Whatever you think *right*, Sir,' she said with dignity.

My father thereupon wrote down sixty-four.

Nursie's attitude has its echoes in present times. When my husband, Max, was dealing with Polish and Yugoslav pilots during the last war, he encountered the same reaction.

'Age?'

The pilot waves his hands amiably: 'Anything you please – twenty, thirty, forty – it does not matter.'

'And where were you born?'

'Anywhere you like. Cracow, Warsaw, Belgrade, Zagreb – as you please.'

The ridiculous unimportance of these factual details could not be more clearly stressed.

Arabs are much the same.

'Your father is well?'

'Oh yes, but he is *very* old.'

'How old?'

'Oh a very old man – ninety, ninety—five.'

The father turns out to be just short of fifty.

But that is how life is viewed. When you are young, you are *young*; when you are in vigour you are a '*very* strong man'; when your vigour begins to fail, you are *old*. If old, you might as well be as old as possible.

On my fifth birthday, I was given a dog. It was the most shattering thing that ever happened to me; such unbelievable joy, that I was unable to say a word. When I read that well-known cliché 'so and so was struck dumb' I realize that it can be a simple statement of fact. *I* was struck dumb – I couldn't even say thank-you. I could hardly look at my beautiful dog. Instead I turned away from him. I needed, urgently, to be alone and come to terms with this incredible happiness. (I have done the same thing frequently during my later life. Why is one so idiotic?) I think it was the lavatory to which I retired – a perfect place for quiet meditation,

where no one could possibly pursue you. Lavatories were comfortable, almost residential apartments in those days. I closed the heavy mahogany shelf-like seat, sat on it, gazed unseeingly at the map of Torquay that hung on the wall, and gave myself up to realization.

'I have a dog . . . a dog It's a dog of my own . . . my very own dog It's a Yorkshire terrier . . . my dog . . . my very own dog'

My mother told me later that my father had been much disappointed by the reception of his gift.

'I thought the child would love it.' he said. 'She doesn't seem to care about it at all.'

But my mother, always understanding, said that I needed a little time. 'She can't quite take it in yet.'

The four-month-old Yorkshire terrier puppy, meantime, had wandered out disconsolately into the garden, where he attached himself to our gardener, a grumpy man called Davey. The dog had been bred by a jobbing gardener, and at the sight of a spade being pressed into the earth he felt that here was a place where he could feel at home. He sat down on the garden path and watched the digging with an attentive air.

Here in due course I found him and we made acquaintance. We were both shy, and made only tentative advances to each other. But by the end of the week Tony and I were inseparable. His official name, given him by my father, was George Washington – Tony, for short, was my contribution. Tony was an admirable dog for a child – he was good-natured, affectionate, and lent himself to all my fancies. Nursie was spared certain ordeals. Bows of ribbon and general adornments were now applied to Tony, who welcomed them as a mark of appreciation and occasionally ate bits of them in addition to his quota of slippers. He had the privilege of being introduced into my new secret saga. Dickie (Goldie the canary) and Dicksmistress (me) were now joined by Lord Tony.

I remember less of my sister in those early years than of my brother. My sister was nice to me, while my brother called me Kid and was lofty – so naturally I attached myself to him whenever he permitted it. The chief fact I remember about him was that he kept white mice. I was introduced to Mr and Mrs Whiskers and their family. Nursie disapproved. She said they smelt. They did, of course.

We already had one dog in the house, an old Dandy Dinmont called Scotty, which belonged to my brother. My brother, named Louis Montant after my father's greatest friend in America, was always known

as Monty, and he and Scotty were inseparable. Almost automatically, my mother would murmur: 'Don't put your face down on the dog and let him lick you, Monty.' Monty, flat on the floor by Scotty's basket, with his arm wreathed lovingly round the dog's neck, would pay no attention. My father would say: 'That dog smells terrible!' Scotty was then fifteen, and only a fervent dog-lover could deny the accusation. 'Roses!' Monty would murmur lovingly. 'Roses! That's what he smells of – roses.'

Alas, tragedy came to Scotty. Slow and blind, he was out walking with Nursie and myself when, crossing the road, a tradesman's cart dashed round a corner, and he was run over. We brought him home in a cab and the vet was summoned, but Scotty died a few hours later. Monty was out sailing with some friends. My mother was disturbed at the thought of breaking the news to him. She had the body put in the wash-house and waited anxiously for my brother's return. Unfortunately, instead of coming straight into the house as usual, he went round to the yard and into the wash-house, looking for some tools he needed. There he found Scotty's body. He went straight off again and must have walked round for many hours. He got home at last just before midnight. My parents were understanding enough not to mention Scotty's death to him. He dug Scotty's grave himself in the Dogs' Cemetery in a corner of the garden where each family dog had his name in due course on a small headstone.

My brother, given, as I have said, to remorseless teasing, used to call me the 'scrawny chicken'. I obliged him by bursting into tears every time. Why the epithet infuriated me so I do not know. Being somewhat of a cry baby I used to trail off to Mother, sobbing out, 'I *aren't* a scrawny chicken, arm I, Marmee?' My mother, unperturbed, would merely say: 'If you don't want to be teased, *why* do you go trailing after Monty all the time?'

The question was unanswerable, but such was my brother's fascination for me that I could not keep away. He was at an age when he was highly scornful of kid sisters, and found me a thorough nuisance. Sometimes he would be gracious and admit me to his 'workshop', where he had a lathe, and would allow me to hold pieces of wood and tools and hand them to him. But sooner or later the scrawny chicken was told to take herself off.

Once he so highly favoured me as to volunteer to take me out with him in his boat. He had a small dinghy which he sailed on Torbay. Rather to everyone's surprise I was allowed to go. Nursie, who was still with us

then, was dead against the expedition, being of the opinion that I would get wet, dirty, tear my frock, pinch my fingers and almost certainly be drowned. 'Young gentlemen don't know how to look after a little girl.'

My mother said that she thought I had sense enough not to fall overboard, and that it would be an experience. I think also she wished to express appreciation of Monty's unusual act of unselfishness. So we walked down the town and on to the pier. Monty brought the boat to the steps and Nursie passed me down to him. At the last moment, mother had qualms.

'You are to be careful, Monty. Very careful. And don't be out long. You *will* look after her, won't you?'

My brother, who was, I imagine, already repenting of his kindly offer, said briefly, 'She'll be all right'. To me he said, 'Sit where you are and keep still, and for goodness sake don't touch anything.'

He then did various things with ropes. The boat assumed an angle that made it practically impossible for me to sit where I was and keep still as ordered, and also frightened me a good deal, but as we scudded through the water my spirits revived and I was transported with happiness.

Mother and Nursie stood on the end of the pier, gazing after us like figures in a Greek play, Nursie almost weeping as she prophesied doom, my mother seeking to allay her fears, adding finally, probably remembering what a bad sailor she herself was, 'I don't expect she'll ever want to go again. The sea is quite choppy.'

Her pronouncement was true enough. I was returned shortly afterwards, green in the face, having 'fed the fishes' as my brother put it, three times. He landed me in high disgust, remarking that women were all the same.

IV

It was just before I was five years old that I first met fear. Nursie and I were primrosing one spring day. We had crossed the railway line and gone up Shiphay lane, picking primroses from the hedges, where they grew thickly.

We turned in through an open gate and went on picking. Our basket was growing full when a voice shouted at us, angry and rough:

'Wot d'you think you're doing 'ere?'

He seemed to me a giant of a man, angry and red-faced.

Nursie said we were doing no harm, only primrosing.

'Trespassing, that's what you're at. Get out of it. If you're not out of that gate in one minute, I'll boil you alive, see?'

I tugged desperately at Nursie's hand as we went. Nursie could not go fast, and indeed did not try to do so. My fear mounted. When we were at last safely in the lane I almost collapsed with relief. I was white and sick, as Nursie suddenly noticed.

'Dearie,' she said gently, 'you didn't think he *meant* it, did you? Not to boil you or whatever it was?'

I nodded dumbly. I had visualised it. A great steaming cauldron on a fire, myself being thrust into it. My agonised screams. It was all deadly real to me.

Nursie talked soothingly. It was a way people had of speaking. A kind of joke, as it were. Not a nice man, a very rude, unpleasant man, but he hadn't meant what he said. It was a joke.

It had been no joke to me, and even now when I go into a field a slight tremor goes down my spine. From that day to this I have never known so real a terror.

Yet in nightmares I never relived this particular experience. All children have nightmares, and I doubt if they are a result of nursemaids or others 'frightening' them, or of any happening in real life. My own particular nightmare centred round someone I called 'The Gunman'. I never read a story about anyone of the kind. I called him The Gunman because he carried a gun, not because I was frightened of his shooting me, or for any reason connected with the gun. The gun was part of his appearance, which seems to me now to have been that of a Frenchman in grey-blue uniform, powdered hair in a queue and a kind of three-cornered hat, and the gun was some old-fashioned kind of musket. It was his mere presence that was frightening. The dream would be quite ordinary – a tea-party, or a walk with various people, usually a mild festivity of some kind. Then suddenly a feeling of uneasiness would come. There was someone – someone *who ought not to be there* – a horrid feeling of fear: and then I would see him – sitting at the tea-table, walking along the beach, joining in the game. His pale blue eyes would meet mine, and I would wake up shrieking: 'The Gunman, the Gunman!'

'Miss Agatha had one of her gunman dreams last night,' Nursie would report in her placid voice.

'Why is he so frightening, darling?' my mother would ask. 'What do you think he will do to you?'

I didn't know why he was frightening. Later the dream varied. The Gunman was not always in costume. Sometimes, as we sat round a tea-table, I would look across at a friend, or a member of the family, and I would suddenly realise that it was *not* Dorothy or Phyllis or Monty, or my mother or whoever it might be. The pale blue eyes in the familiar face met mine – under the familiar appearance. *It was really the Gunman.*

At the age of four I fell in love. It was a shattering and wonderful experience. The object of my passion was one of the Dartmouth cadets, a friend of my brother's. Golden-haired and blue-eyed, he appealed to all my romantic instincts. He himself could have had no idea of the emotions he aroused. Gloriously uninterested in the 'kid sister' of his friend Monty, he would probably have said, if asked, that I disliked him. An excess of emotion caused me to go in the opposite direction if I saw him coming, and when seated at the dining-table, to keep my head resolutely turned away. My mother took me gently to task.

'I know you're shy, dear, but you must be polite. It's so rude to turn your head away from Philip all the time, and if he speaks to you, you only mutter. Even if you dislike him, you must be polite.'

Dislike him! How little anyone knew. When I think of it now, how supremely satisfying early love can be. It demands nothing – not a look nor a word. It is pure adoration. Sustained by it, one walks on air, creating in one's own mind heroic occasions on which one will be of service to the beloved one. Going into a plague camp to nurse him. Saving him from fire. Shielding him from a fatal bullet. Anything, indeed, that has caught the imagination in a story. In these imaginings there is never a happy ending. You yourself are burnt to death, shot, or succumb to the plague. The hero does not even know of the supreme sacrifice you have made. I sat on the nursery floor, and played with Tony, looking solemn and priggish, whilst inside my head a glorious exultation swirled in extravagant fancies. The months passed. Philip became a midshipman and left the *Britannia*. For a short while his image persisted and then dwindled. Love vanished, to return three years later, when I adored hopelessly a tall dark young Army captain who was courting my sister.

Ashfield was home and accepted as such; Ealing, however, was an excitement. It had all the romance of a foreign country. One of its principal joys was its lavatory. It had a splendidly large mahogany

lavatory seat. Sitting on it one felt exactly like a Queen on her throne, and I rapidly translated Dicksmistress into Queen Marguerite, and Dickie became her son, Prince Goldie, the heir to the throne. He sat at her right hand on the small circle which enclosed the handsome Wedgwood plug handle. Here in the morning I woud retreat, sit bowing, giving audience, and extending my hand to be kissed until summoned angrily to come out by others wishing to enter. On the wall there hung a coloured map of New York City, also an object of interest to me. There were several American prints in the house. In the spare bedroom was a set of coloured prints for which I had a deep affection. One, entitled 'Winter Sports', depicted a very cold-looking man on a sheet of ice, dragging up a fish through a small hole. It seemed rather a melancholy sport to me. On the other hand, Grey Eddy, the trotter, was fascinatingly dashing.

Since my father had married the niece of his stepmother (his American father's English second wife), and since he called her Mother whilst his wife continued to call her Auntie, she was usually known officially as Auntie-Grannie. My grandfather had spent the last years of his life going to and fro between his business in New York and its English branch in Manchester. His had been one of the 'success stories' of America. A poor boy from a family in Massachusetts, he had come to New York, been engaged more or less as an office boy, and had risen to be a partner in the firm. 'Shirtsleeves to Swivel-chair in Three Generations' had certainly come true in our family. My grandfather made a big fortune. My father, mainly owing to trust in his fellow men, let it dwindle away, and my brother ran through what was left of it like a flash of lightning.

Not long before he died my grandfather had bought a large house in Cheshire. He was a sick man by then, and his second wife was left a widow comparatively young. She lived on in Cheshire for a while, but finally bought a house in Ealing, which was then still practically in the country. As she often said, there were fields all around. However, by the time I came to visit her this seemed hard to believe. Rows of neat houses spread in every direction.

Grannie's house and garden had a tremendous fascination for me. I divided the nursery into several 'territories'. The front part had been built out with a bay window and had a gay striped drugget on the floor. This part I christened the Muriel Room (possibly because I had been fascinated by the term Oriel window). The back part of the nursery, covered with a Brussels carpet, was the Dining Hall. Various mats and pieces of linoleum were allocated by me to different rooms. I moved, busy

and important, from one room of my house to another, murmuring under my breath. Nursie, peaceful as ever, sat stitching.

Another fascination was Auntie-Grannie's bed, an immense mahogany four-poster closely hemmed in with red damask curtains. It was a feather bed, and early in the morning I would arrive before being dressed and climb in. Grannie was awake from six o'clock onwards, and always welcomed me. Downstairs there was the drawing-room, crowded to repletion with marquetry furniture and Dresden china, and perpetually shrouded in gloom because of the conservatory erected outside. The drawing-room was only used for parties. Next to the drawing-room was the morning-room, where almost invariably a 'sewing-woman' was ensconced. Now that I come to think of it, sewing-women were an inevitable accompaniment of a household. They all had a certain resemblance to each other in that they were usually very refined, in unfortunate circumstances, treated with careful courtesy by the mistress of the house, and the family, and with no courtesy at all by the servants, were sent in meals on trays, and – as far as I can remember – were unable to produce any article of clothing that fitted. Everything was either too tight everywhere or else hung on one in loose folds. The answer to any complaint was usually: 'Ah yes, but Miss James has had such an unfortunate life.'

So, in the morning-room, Miss James sat and sewed with patterns all around her, and a sewing-machine in front of her.

In the dining-room, Grannie passed her life in Victorian contentment. The furniture was of heavy mahogany with a central table and chairs all round it. The windows were thickly draped with Nottingham lace. Grannie sat either at the table, in a huge leather-backed carver's chair, writing letters, or else in a big velvet armchair by the fireplace. The tables, sofa, and some of the chairs were taken up with books, books that were meant to be there and books escaping out of loosely tied-up parcels. Grannie was always buying books, for herself and for presents, and in the end the books became too much for her and she forgot to whom she had meant to send them – or else discovered that 'Mr Bennett's dear little boy had, unnoticed by her, now reached the age of eighteen and was no longer eligible for *The Boys of St. Guldred's* or *The Adventures of Timothy Tiger*.

An indulgent playmate, Grannie would lay aside the long scratchy-looking letter she was writing (heavily crossed 'to save notepaper') and enter into the delightful pastime of 'a chicken from Mr Whiteley's'. Needless to say, I was the chicken. Selected by Grannie with appeals to

the shopman as to whether I was really young and tender, brought home, trussed up, skewered (yells of delight from my skewered self), put in the oven, done to a turn, brought on the table dished up, great show of sharpening the carving-knife, when suddenly the chicken comes alive and 'It's Me!' – grand climax – to be repeated *ad lib.*

One of the morning events was Grannie's visit to the store-cupboard which was situated by the side door into the garden. I would immediately appear and Grannie would exclaim, 'Now what can a little girl want here?' The little girl would wait hopefully, peering into the interesting recesses. Rows of jars of jam and preserves. Boxes of dates, preserved fruits, figs, French plums, cherries, angelica, packets of raisins and currants, pounds of butter and sacks of sugar, tea and flour. All the household eatables lived there, and were solemnly handed out every day in anticipation of the day's needs. Also a searching inquiry was held as to exactly what had been done with the previous day's allocation. Grannie kept a liberal table for all, but was highly suspicious of *waste*. Household needs satisfied, and yesterday's provender satisfactorily accounted for, Grannie would unscrew a jar of French plums and I would go gladly out into the garden with my hands full.

How odd it is, when remembering early days, that the weather seems constant in certain places. In my nursery at Torquay it is always an autumn or winter afternoon. There is a fire in the grate, and clothes drying on the high fireguard, and outside there are leaves swirling down, or sometimes, excitingly, snow. In the Ealing garden it is always summer – and particularly hot summer. I can relive easily the gasp of dry hot air and the smell of roses as I go out through the side door. That small square of green grass, surrounded with standard rose-trees, does not seem small to me. Again it was a world. First the roses, very important; any dead heads snipped off every day, the other roses cut and brought in and arranged in a number of small vases. Grannie was inordinately proud of her roses, attributing all their size and beauty to 'the bedroom slops, my dear. Liquid manure – nothing like it! *No one* has roses like mine.'

On Sundays my other grandmother and usually two of my uncles used to come to midday dinner. It was a splendid Victorian day. Granny Boehmer, known as Granny B., who was my mother's mother, would arrive about eleven o'clock, panting a little because she was very stout, even stouter than Auntie-Grannie. After taking a succession of trains and omnibuses from London, her first action would be to rid herself of her buttoned boots. Her servant Harriet used to come with her on these

occasions. Harriet would kneel before her to remove the boots and substitute a comfortable pair of woolly slippers. Then with a deep sigh Granny B. would settle herself down at the dining-room table, and the two sisters would start their Sunday morning business. This consisted of lengthy and complicated accounts. Granny B. did a great deal of Auntie-Grannie's shopping for her at the Army and Navy Stores in Victoria Street. The Army and Navy Stores was the hub of the universe to the two sisters. Lists, figures, accounts were gone into and thoroughly enjoyed by both. Discussions on quality of the goods purchased took place: 'You wouldn't have cared for it, Margaret. Not good quality material, very rawny – not at all like that last plum colour velvet.' Then Auntie-Grannie would bring out her large fat purse, which I always looked upon with awe and considered as an outward and visible sign of immense wealth. It had a lot of gold sovereigns in the middle compartment, and the rest of it was bulging with half-crowns and sixpences and an occasional five shilling piece. The accounts for repairs and small purchases were settled. The Army and Navy Stores, of course, was on a deposit account – and I think that Auntie-Grannie always added a cash present for Granny B's time and trouble. The sisters were fond of each other, but there was also a good deal of petty jealousy and bickering between them. Each enjoyed teasing the other, and getting the better of her in some way. Granny B. had, by her own account, been the beauty of the family. Auntie-Grannie used to deny this. 'Mary (or Polly, as she called her) had a pretty face, yes,' she would say. 'But of course she hadn't got the *figure* I had. Gentlemen like a figure.'

In spite of Polly's lack of figure (for which, I may say, she amply made up later – I have never seen such a bust) at the age of sixteen a captain in the Black Watch had fallen in love with her. Though the family had said that she was too young to marry, he pointed out that he was going abroad with his regiment and might not be back in England for some time, and that he would like the marriage to take place straight away. So married Polly was at sixteen. That, I think, was possibly the first point of jealousy. It was a love match. Polly was young and beautiful and her Captain was said to be the handsomest man in the regiment.

Polly soon had five children, one of whom died. Her husband left her a young widow of twenty-seven – after a fall from his horse. Auntie-Grannie was not married until much later in life. She had had a romance with a young naval officer, but they were too poor to marry and he turned to a rich widow. She in turn married a rich American with one son.

She was in some ways frustrated, though her good sense and love of life never deserted her. She had no children. However, she was left a very rich widow. With Polly, on the other hand, it was all she could do to feed and clothe her family after her husband's death. His tiny pension was all she had. I remember her sitting all day in the window of her house, sewing, making fancy pin-cushions, embroidered pictures and screens. She was wonderful with her needle, and she worked without ceasing, far more, I think, than an eight-hour day. So each of them envied the other for something they did not have. I think they quite enjoyed their spirited squabbles. Erupting sounds would fill the ear.

'Nonsense, Margaret, I never heard such nonsense in my life!' 'Indeed, Mary, let me tell you – ' and so on. Polly had been courted by some of her dead husband's fellow officers and had had several offers of marriage, but she had steadfastly refused to marry again. She would put no one in her husband's place, she said, and she would be buried with him in his grave in Jersey when her time came.

The Sunday accounts finished, and commissions written down for the coming week, the uncles would arrive. Uncle Ernest was in the Home Office and Uncle Harry secretary of the Army and Navy Stores. The eldest uncle, Uncle Fred, was in India with his regiment. The table was laid and Sunday midday dinner was served.

An enormous joint, usually cherry tart and cream, a vast piece of cheese, and finally dessert on the best Sunday dessert plates – very beautiful they were and are: I have them still; I think eighteen out of the original twenty-four, which is not bad for about sixty odd years. I don't know if they were Coalport or French china – the edges were bright green, scalloped with gold, and in the centre of each plate was a different fruit – my favourite was then and always has been the Fig, a juicy-looking purple fig. My daughter Rosalind's has always been the Gooseberry, an unusually large and luscious gooseberry. There was also a beautiful Peach, White Currants, Red Currants, Raspberries, Strawberries, and many others. The climax of the meal was when these were placed on the table, with their little lace mats on them, and finger bowls, and then everyone in turn guessed what fruit their plate was. Why this afforded so much satisfaction I cannot say, but it was always a thrilling moment, and when you had guessed right you felt you had done something worthy of esteem.

After a gargantuan meal there was sleep. Aunti-Grannie retired to her secondary chair by the fireplace – large and rather low-seated. Granny B.

would settle on the sofa, a claret-coloured leather couch, buttoned all over its surface, and over her mountainous form was spread an Afghan rug. I don't know what happened to the uncles. They may have gone for a walk, or retired to the drawing-room, but the drawing-room was seldom used. It was impossible to use the morning-room because that room was sacred to Miss Grant, the present holder of the post of sewing-woman. 'My dear, such a sad case,' Grannie would murmur to her friends. 'Such a poor little creature, deformed, *only one passage*, like a *fowl*.' That phrase always fascinated me, because I didn't know what it meant. Where did what I took to be a corridor come in?

After everyone except me had slept soundly for at least an hour – I used to rock myself cautiously in the rocking-chair – we would have a game of Schoolmaster. Both Uncle Harry and Uncle Ernest were splendid exponents of Schoolmaster. We sat in a row, and whoever was school-master, armed with a newspaper truncheon, would pace up and down the line shouting out questions in a hectoring voice: 'What is the date of the invention of needles?' 'Who was Henry VIII's third wife?' 'How did William Rufus meet his death?' 'What are the diseases of wheat?' Anyone who could give a correct answer moved up; those correspondingly dis-graced moved down. I suppose it was the Victorian forerunner of the quizzes we enjoy so much nowadays. The uncles, I think, disappeared after that, having done their duty by their mother and their aunt. Granny B. remained, and partook of tea with Madeira cake; then came the terrible moment when the buttoned boots were brought forth, and Harriet started on the task of encasing her in them once more. It was agonising to watch, and must have been anguish to endure. Poor Granny B.'s ankles had swollen up like puddings by the end of the day. To force the buttons into their holes with the aid of a button-hook involved an enormous amount of painful pinching, which forced sharp cries from her. Oh! those buttoned boots. *Why* did anyone wear them? Were they recommended by doctors? Were they the price of a slavish devotion to fashion? I know boots were said to be good for children's ankles, to *strengthen* them, but that could hardly apply in the case of an old lady of seventy. Anyway, finally encased and pale still from the pain, Granny B. started her return by train and bus to her own residence in Bayswater.

Ealing at that time had the same characteristics as Cheltenham or Leamington Spa. The retired military and navy came there in large

quantities for the 'healthy air' and the advantage of being so near London. Grannie led a thoroughly social life – she was a sociable woman at all times. Her house was always full of old Colonels and Generals for whom she would embroider waistcoats and knit bedsocks: 'I hope your *wife* won't object,'' she would say as she presented them. 'I shouldn't like to cause *trouble!*' The old gentlemen would make gallant rejoinders, and go away feeling thoroughly doggish and pleased with their manly attractions. Their gallantry always made me rather shy. The jokes they cracked for my amusement did not seem funny, and their arch, rallying manner made me nervous.

'And what's the little lady going to have for her dessert? Sweets to the sweet, little lady. A peach now? Or one of these golden plums to match those golden curls?'

Pink with embarrassment, I murmured that I would like a peach please.

'And which peach? Now then, choose.'

'Please,' I murmured, 'I would like the biggest and the bestest.'

Roars of laughter. All unaware, I seemed to have made a joke.

'You shouldn't *ask* for the biggest, ever,' said Nursie later. 'It's greedy.'

I could admit that it was greedy, but why was it *funny*?

As a guide to social life, Nursie was in her element.

'You must eat up your dinner quicker than that. Suppose now, that you were to be dining at a ducal house when you grow up?'

Nothing seemed more unlikely, but I accepted the possibility.

'There will be a grand butler and several footmen, and when the moment comes, they'll clear away your plate, *whether you've finsihed or not.*'

I paled at the prospect and applied myself to boiled mutton with a will.

Incidents of the aristocracy were frequently on Nursie's lips. They fired me with ambition. I wanted, above everything in the world, to be the Lady Agatha one day. But Nursie's social knowledge was inexorable.

'That you can never be,' she said.

'Never?' I was aghast.

'Never,' said Nursie, a firm realist. 'To be the Lady Agatha, you have to be born it. You have to be the daughter of a Duke, a Marquis, or an Earl. If you marry a Duke, you'll be a Duchess, but that's because of your husband's title. It's not something you're born with.'

It was my first brush with the inevitable. There are things that cannot be achieved. It is important to realise this early in life, and very good for you. There are some things that you just cannot have – a natural curl in

your hair, black eyes (if yours happen to be blue) or the title of Lady
Agatha.

On the whole I think the snobbery of my childhood, the snobbery of
birth that is, is more palatable than the other snobberies: the snobbery of
wealth and intellectual snobbery. Intellectual snobbery seems today to
breed a particular form of envy and venom. Parents are determined that
their offspring shall shine. 'We've made great sacrifices for you to have a
good education,' they say. The child is burdened with guilt if he does
not fulfil their hopes. Everyone is so sure that it is all a matter of op-
portunity – not of natural aptitude.

I think late Victorian parents were more realistic and had more con-
sideration for their children and for what would make a happy and
successful life for them. There was much less keeping up with the
Joneses. Nowadays I often feel that it is for one's *own* prestige that one
wants one's children to succeed. The Victorians looked dispassionately
at their offspring and made up their minds about their capacities. A.
was obviously going to be 'the pretty one'. B. was 'the clever one'. C. was
going to be plain and was definitely *not* intellectual. Good works would
be C.'s best chance. And so on. Sometimes, of course, they were wrong,
but on the whole it worked. There is an enormous relief in not being
expected to produce something that you haven't got.

In contrast to most of our friends, we were not really well off. My
father, as an American, was considered automatically to be 'rich'. All
Americans were supposed to be rich. Actually he was merely comfortably
off. We did not have a butler or a footman. We did not have a carriage and
horses and a coachman. We had three servants, which was a minimum
then. On a wet day, if you were going out to tea with a friend, you walked
a mile and a half in the rain in your machintosh and your goloshes. A
'cab' was never ordered for a child unless it was going to a real party in
a perishable dress.

On the other hand, the food that was served to guests in our house was
quite incredibly luxurious compared to present-day standards – indeed
you would have to employ a chef and his assistant to provide it! I came
across the menu of one of our early dinner parties (for ten) the other day.
It began with a choice of thick or clear soup, then boiled turbot, or fillets
of sole. After that came a sorbet. Saddle of mutton followed. Then,
rather unexpectedly, Lobster Mayonnaise. Pouding Diplomatique and
Charlotte Russe were the sweets and then dessert. All this was produced
by Jane, single-handed.

Nowadays, of course, on an equivalent income, a family would have a car, perhaps a couple of dailies, and any heavy entertaining would probably be in a restaurant or done at home by the wife.

In our family it was my sister who was early recognised as 'the clever one'. Her headmistress at Brighton urged that she should go to Girton. My father was upset and said 'We can't have Madge turned into a blue-stocking. We'd better send her to Paris to be "finished".' So my sister went to Paris, to her own complete satisfaction since she had no wish whatever to go to Girton. She certainly had the brains of the family. She was witty, very entertaining, quick of repartee and successful in every-thing she attempted. My brother, a year younger than her, had enormous personal charm, a liking for literature, but was otherwise intellectually backward. I think both my father and my mother realised that he was going to be the 'difficult' one. He had a great love of practical engineering. My father had hoped that he would go into banking but realised that he did not have the capacity to succeed. So he took up engineering – but there again he could not succeed, as mathematics let him down.

I myself was always recognised, though quite kindly, as 'the slow one' of the family. The reactions of my mother and my sister were unusually quick – I could never keep up. I was, too, very inarticulate. It was always difficult for me to assemble into words what I wanted to say. 'Agatha's so terribly *slow*' was always the cry. It was quite true, and I knew it and accepted it. It did not worry or distress me. I was resigned to being always 'the slow one'. It was not until I was over twenty that I realised that my home standard had been unusually high and that actually I was quite as quick or quicker than the average. Inarticulate I shall always be. It is probably one of the causes that have made me a writer.

The first real sorrow of my life was parting with Nursie. For some time one of her former nurselings who had an estate in Somerset had been urging her to retire. He offered her a comfortable little cottage on his property where she and her sister could live out their days. Finally she made her decision. The time had come for her to quit work.

I missed her terribly. Every day I wrote to her – a short badly-written ill-spelt note: writing and spelling were always terribly difficult for me. My letters were without originality. They were practically always the same: 'Darling Nursie. I miss you very much. I hope you are quite well. Tony has a flea. Lots and lots of love and kisses. From Agatha.'

My mother provided a stamp for these letters, but after a while she was moved to gentle protest.

'I don't think you need write *every* day. Twice a week, perhaps?'

I was appalled.

'But I *think* of her every day. I *must* write.'

She signed, but did not object. Nevertheless she continued gentle suggestion. It was some months before I cut down correspondence to the two letters a week suggested. Nursie herself was a poor hand with a pen, and in any case was too wise, I imagine, to encourage me in my obstinate fidelity. She wrote to me twice a month, gentle nondescript epistles. I think my mother was disturbed that I found her so hard to forget. She told me afterwards that she had discussed the matter with my father, who had replied with an unexpected twinkle: 'Well, you remembered me very faithfully as a child when I went to America.' My mother said that that was quite different.

'Did you think that I would come back and marry you one day when you were grown up?' he asked.

My mother said, 'No, indeed,' then hesitated and admitted that she *had* had her day-dream. It was a typically sentimental Victorian one. My father was to make a brilliant but unhappy marriage. Disillusioned, after his wife's death he returned to seek out his quiet cousin Clara. Alas, Clara, a helpless invalid, lay permanently on a sofa, and finally blessed him with her dying breath. She laughed as she told him – 'You see,' she said, 'I thought I shouldn't look so dumpy lying on a sofa – with a pretty soft wool cover thrown over me.'

Early death and invalidism were as much the tradition of romance then as toughness seems to be nowadays. No young woman then, as far as I can judge, would ever own up to having rude health. Grannie always told me with great complacence how delicate she had been as a child, 'never expected to live to maturity'; a slight knock on the hand when playing and she fainted away. Granny B., on the other hand, said of her sister: 'Margaret was always perfectly strong. *I* was the delicate one.'

Auntie-Grannie lived to ninety-two and Granny B. to eight-six, and personally I doubt if they were ever delicate at all. But extreme sensibility, constant fainting fits, and early consumption (a decline) were fashionable. Indeed, so imbued with this point of view was Grannie that she frequently went out of her way to impart mysteriously to my various young men how terribly delicate and frail I was and how unlikely to reach old age. Often, when I was eighteen, one of my swains would say

anxiously to me, 'Are you sure you won't catch a chill? Your grandmother told me how delicate you are!' Indignantly I would protest the rude health I had always enjoyed, and the anxious face would clear. 'But why does your grandmother say you're delicate?' I had to explain that Grannie was doing her loyal best to make me sound interesting. When she herself was young, Grannie told me, young ladies were never able to manage more than a morsel of food at the dinner-table if gentlemen were present. Substantial trays were taken up to bedrooms later.

Illness and early death pervaded even children's books. A book called *Our White Violet* was a great favourite of mine. Little Violet, a saintly invalid on page one, died an edifying death surrounded by her weeping family on the last page. Tragedy was relieved by her two naughty brothers, Punny and Firkin, who never ceased getting themselves into mischief. *Little Women*, a cheerful tale on the whole, had to sacrifice rosy-faced Beth. The death of Little Nell in *The Old Curiosity Shop* leaves me cold and slightly nauseated, but in Dickens's time, of course, whole families wept over its pathos.

That article of household furniture, the sofa or couch, is associated nowadays mainly with the psychiatrist – but in Victorian times it was the symbol of early death, decline, and romance with a capital R. I am inclined to the belief that the Victorian wife and mother cashed in on it pretty well. It excused her from much household drudgery. She often took to it in the early forties and spent a pleasant life, waited on hand and foot, given affectionate consideration by her devoted husband and ungrudging service by her daughters. Friends flocked to visit her, and her patience and sweetness under affliction were admired by all. Was there really anything the matter with her? Probably not. No doubt her back ached and she suffered from her feet as most of us do as life goes on. The sofa was the answer.

Another of my favourite books was about a little German girl (naturally an invalid, crippled) who lay all day looking out of the window. Her attendant, a selfish and pleasure-loving young woman, rushed out one day to view a procession. The invalid leaned out too far, fell and was killed. Haunting remorse of the pleasure-loving attendant, white-faced and grief-stricken for life. All these gloomy books I read with great satisfaction.

And there were, of course, the Old Testament stories, in which I had revelled from an early age. Going to church was one of the highlights of the week. The parish church of Tor Mohun was the oldest church in

Torquay. Torquay itself was a modern watering place, but Tor Mohun was the original hamlet. The old church was a small one, and it was decided that a second, bigger church was needed for the parish. This was built just about the time that I was born, and my father advanced a sum of money in my infant name so that I should be a founder. He explained this to me in due course and I felt very important. 'When can I go to church?' had been my constant demand – and at last the great day came. I sat next to my father in a pew near the front and followed the service in his big prayer-book. He had told me beforehand that I could go out before the sermon if I liked, and when the time came he whispered to me, 'Would you like to go?' I shook my head vigorously and so remained. He took my hand in his and I sat contentedly, trying hard not to fidget.

I enjoyed church services on Sunday very much. At home previously there had been special story-books only allowed to be read on Sundays (which made a treat of them) and books of Bible stories with which I was familiar. There is no doubt that the stories of the Old Testament are, from a child's point of view, rattling good yarns. They have that dramatic cause and effect which a child's mind demands: Joseph and his brethren, his coat of many colours, his rise to power in Egypt, and the dramatic finale of his forgiveness of the wicked brothers. Moses and the burning bush was another favourite. David and Goliath, too, has a sure-fire appeal.

Only a year or two ago, standing on the mound at Nimrud, I watched the local bird-scarer, an old Arab with his handful of stones and his sling, defending the crops from the hordes of predatory birds. Seeing his accuracy of aim and the deadliness of his weapon, I suddenly realised for the first time that it was *Goliath* against whom the dice were loaded. David was in a superior position from the start – the man with a long-distance weapon against the man who had none. Not so much the little fellow against the big one, as brains versus brawn.

A good many interesting people came to our house during my young days, and it seems a pity that I do not remember any of them. All I recall about Henry James is my mother complaining that he always wanted a lump of sugar broken in two for his tea – and that it really was affectation, as a small knob would do quite as well Rudyard Kipling came, and again my only memory is a discussion between my mother and a friend as to why he had ever married Mrs Kipling. My mother's friend ended by saying, 'I know the reason. They are the perfect complement to each other.' Taking the word to be 'compliment' I though it a very obscure remark, but as Nursie explained one day that to ask you to marry him

was the highest compliment a gentleman could pay a lady, I began to see the point.

Though I came down to tea-parties, I remember, in white muslin and a yellow satin sash, hardly anyone at the parties remains in my mind. The people I imagined were always more real to me than the flesh and blood ones I met. I do remember a close friend of my mother's, a Miss Tower, mainly because I took endless pains to avoid her. She had black eyebrows and enormous white teeth, and I thought privately that she looked exactly like a wolf. She had a habit of pouncing on me, kissing me vehemently and exclaiming, 'I could eat you!' I was always afraid she would. All through my life I have carefully abstained from rushing at children and kissing them unasked. Poor little things, what defence have they? Dear Miss Tower, so good and kind and so fond of children – but with so little idea of their feelings.

Lady MacGregor was a social leader in Torquay, and she and I were on happy, joking terms. When I was still in the perambulator she had accosted me one day and asked if I knew who she was? I said truthfully that I didn't. 'Tell your Mama,' she said, 'that you met Mrs Snooks out today.' As soon as she had gone, Nursie took me to task. 'That's Lady MacGregor, and you know her quite well.' But thereafter I always greeted her as Mrs Snooks and it was our own private joke.

A cheerful soul was my godfather, Lord Lifford, then Captain Hewitt. He came to the house one day, and hearing Mr and Mrs Miller were out said cheerfully, 'Oh, that's all right. I'll come in and wait for them,' and attempted to push past the parlourmaid. The conscientious parlourmaid slammed the door in his face and rushed upstairs to call to him from the conveniently situated lavatory window. He finally convinced her that he was a friend of the family – principally because he said, 'And I know the window you're speaking from, it's the W.C.' This proof of topography convinced her, and she let him in, but retired convulsed with shame at his knowledge that it was the lavatory from which she had been speaking.

We were very delicate about lavatories in those days. It was unthinkable to be seen entering or leaving one except by an intimate member of the family; difficult in our house, since the lavatory was halfway up the stairs and in full view from the hall. The worst, of course, was to be inside and then hear voices below. Impossible to come out. One had to stay immured there until the coast was clear.

Of my own childish friends I do not remember much.

There were Dorothy and Dulcie, younger than I was; stolid children
with adenoids, whom I found dull. We had tea in the garden and ran
races round a big ilex tree, eating Devonshire cream on 'tough cakes'
(the local bun). I cannot imagine *why* this pleased us. Their father,
Mr B., was my father's great crony. Soon after we came to live in Tor-
quay, Mr B. told my father that he was going to be married. A wonderful
woman, so he described her, 'And it frightens me, Joe' – my father was
always called Joe by his friends – 'it positively frightens me how that
woman loves me!'

Shortly afterwards a friend of my mother's arrived to stay, seriously
perturbed. Acting as companion to someone at a hotel in North Devon,
she had come across a large, rather handsome young woman, who in a
loud voice was conversing with a friend in the hotel lounge.

'I've landed my bird, Dora,' she boomed triumphantly. 'Got him to
the point at last, and he's eating out of my hand.'

Dora congratulated her, and marriage settlements were freely discussed.
Then the name of Mr B. was mentioned as the duly landed bridegroom.

A great consultation was held between my mother and father. What, if
anything, was to be done about this? Could they let poor B. be married
for his money in this shameful way? Was it too late? Would he believe
them if they told him what had been overheard.

My father, at last, made his decision. B. was not to be told *anything*.
Tale-telling was a mean business. And B. was not an ignorant boy. He
had chosen with his eyes open.

Whether Mrs B. had married her husband for money or not, she made
him an excellent wife, and they appeared to be as happy together as
turtle-doves. They had three children, were practically inseparable, and a
better home life could not be found. Poor B. eventually died of cancer
of the tongue, and all through his long painful ordeal his wife nursed him
devotedly. It was a lesson, my mother once said, in not thinking you
know what's best for other people.

When one went to lunch or tea with the B.'s the talk was entirely of food.

'Percival, my love,' Mrs B. would boom, 'some more of this excellent
mutton. Deliciously tender.'

'As you say, Edith, my dear. Just one more slice. Let me pass you the
caper sauce. Excellently made. Dorothy, my love, some more mutton?'

'No, thank you, papa.'

'Dulcie? Just a small slice from the knuckle – so tender.'

'No, thank you, mamma.'

I had one other friend called Margaret. She was what might be termed a semi-official friend. We did not visit each other's homes (Margaret's mother had bright orange hair and very pink cheeks; I suspect now that she was considered 'fast' and that my father would not allow my mother to call), but we took walks together. Our nurses, I gathered, were friends. Margaret was a great talker and she used to cause me horrible embarrassment. She had just lost her front teeth and it made her conversation so indistinct that I could not take in what she said. I felt it would be unkind to say so, so I answered at random, growing more and more desperate. Finally Margaret offered to 'tell me a story'. It was all about 'thome poithoned thweets', but what happened to them I shall never know. It went on incomprehensibly for a long time and Margaret ended up triumphantly with, 'Don't you think thatth a loverly thtory?' I agreed fervently. 'Do you think thee really ought to – ' I felt questioning on the story would be too much for me to bear. I broke in with decision. 'I'll tell *you* a story now, Margaret.' Margaret looked undecided. Evidently there was some knotty point in the poisoned sweets story that she wanted to discuss, but I was desperate.

'It's about a – a – peach-stone,' I improvised wildly. 'About a fairy who lived in a peach-stone.'

'Go on,' said Margaret.

I went on. I spun things out till Margaret's gate was in sight.

'That's a very nice story,' said Margaret appreciatively. 'What fairy book does it come out of?'

It did not come out of any fairy book. It came out of my head. It was not, I think, a particularly good story. But it had saved me from the awful unkindness of reproaching Margaret for her missing teeth. I said that I could not quite remember which fairy book it was in.

When I was five years old, my sister came back 'finished' from Paris. I remember the excitement of seeing her alight at Ealing from a four-wheeler cab. She wore a gay little straw hat and a white veil with black spots on it, and appeared to me an entirely new person. She was very nice to her little sister and used to tell me stories. She also endeavoured to cope with my education by teaching me French from a manual called *Le Petit Précepteur*. She was not, I think, a good teacher and I took a fervant dislike to the book. Twice I adroitly concealed it behind other books in the bookshelf; it was a very short time, however, before it came to light again.

I saw that I had to do better. In a corner of the room was an enormous glass case containing a stuffed bald-headed eagle which was my father's pride and glory. I insinuated *Le Petit Précepteur* behind the eagle into the unseen corner of the room. This was highly successful. Several days passed and a thorough hunt failed to find the missing book.

My mother, however, defeated my efforts with ease. She proclaimed a prize of a particularly delectable chocolate for whoever should find the book. My greed was my undoing. I fell into the trap, conducted an elaborate search round the room, finally climbed up on a chair, peered behind the eagle, and exclaimed in a surprised voice: 'Why, there it is!' Retribution followed. I was reproved and sent to bed for the rest of the day. I accepted this as fair, since I had been found out, but I considered it unjust that I was not given the chocolate. That had been promised to whoever found the book, and *I* had found it.

My sister had a game which both fascinated and terrified me. This was 'The Elder Sister'. The thesis was that in our family was an elder sister, senior to my sister and myself. She was mad and lived in a cave at Corbin's Head, but sometimes she came to the house. She was indistinguishable in appearance from my sister, except for her voice, which was quite different. It was a frightening voice, a soft oily voice.

'You know who I am, don't you, dear? I'm your sister Madge. You don't think I'm anyone else, do you? You wouldn't think *that*?'

I used to feel indescribable terror. Of course I knew really it was only Madge pretending – but was it? Wasn't it perhaps true? That voice – those crafty sideways glancing eyes. It *was* the elder sister!

My mother used to get angry. 'I won't have you frightening the child with this silly game, Madge.'

Madge would reply reasonably enough: 'But she *asks* me to do it.'

I did. I would say to her: 'Will the elder sister be coming soon?'

'I don't know. Do you want her to come?'

'Yes – yes, I do . . .'

Did I really? I suppose so.

My demand was never satisfied at once. Perhaps two days later there would be a knock at the nursery door, and the voice:

'Can I come in, dear? It's your elder sister . . .'

Many years later, Madge had still only to use the Elder Sister voice and I would feel chills down my spine.

Why did I *like* being frightened? What instinctive need is satisfied by terror? Why, indeed, do children like stories about bears, wolves and

witches? Is it because something rebels in one against the life that is too *safe*? Is a certain amount of danger in life a need of human beings? Is much of the juvenile delinquency nowadays attributable to the fact of too much security? Do you instinctively need something to combat, to overcome – to, as it were, prove yourself to yourself? Take away the wolf from Red Riding Hood and would any child enjoy it? However, like most things in life, you want to be frightened a little – but not too much.

My sister must have had a great gift for story-telling. At an early age her brother would urge her on. 'Tell it me again.'

'I don't want to.'

'Do, do!'

'No, I don't want to.'

'Please. I'll do anything.'

'Will you let me bite your finger?'

'Yes.'

'I shall bite it hard. Perhaps I shall bite it right off!'

'I don't mind.'

Madge obligingly launches into the story once more. Then she picks up his finger and bites it. Now Monty yells. Mother arrives. Madge is punished.

'But it was a bargain,' she says, unrepentant.

I remember well my first written story. It was in the nature of a melodrama, very short, since both writing and spelling were a pain to me. It concerned the noble Lady Madge (good) and the bloody Lady Agatha (bad) and a plot that involved the inheritance of a castle.

I showed it to my sister and suggested we could act it. My sister said immediately that she would rather be the bloody Lady Madge and I could be the noble Lady Agatha.

'But don't you want to be the good one?' I demanded, shocked. My sister said no, she thought it would be much more fun to be wicked. I was pleased, as it had been solely politeness which had led me to ascribe nobility to Lady Madge.

My father, I remember, laughed a good deal at my effort, but in a kindly way, and my mother said that perhaps I had better not use the word bloody as it was not a very nice word. 'But she *was* bloody,' I explained. 'She killed a lot of people. She was like bloody Mary, who burnt people at the stake.'

Fairy books played a great part in life. Grannie gave them to me for birthdays and Christmas. *The Yellow Fairy Book, The Blue Fairy Book,*

and so on. I loved them all and read them again and again. Then there
was a collection of animal stories, also by Andrew Lang, including one
about Androcles and the Lion. I loved that too.

It must have been about then that I first embarked on a course of
Mrs Molesworth, the leading writer of stories for children. They lasted
me for many years, and I think, on re-reading them now, that they are
very good. Of course children would find them old-fashioned nowadays,
but they tell a good story and there is a lot of characterization in them.
There was *Carrots, Just a little Boy*, and *Herr Baby* for very young
children, and various fairy story tales. I can still re-read *The Cuckoo
Clock* and *The Tapestry Room*. My favourite of all, *Four Winds Farm*, I
find uninteresting now and wonder why I loved it so much.

Reading story-books was considered slightly too pleasurable to be
really virtuous. No story-books until after lunch. In the mornings you
were supposed to find something 'useful' to do. Even to this day, if I sit
down and read a novel after breakfast I have a feeling of guilt. The same
applies to cards on a Sunday. I outgrew Nursie's condemnation of cards
as 'the Devil's picture books', but 'no cards on Sundays' was a rule of
the house, and in after years when playing bridge on a Sunday I never
quite threw off a feeling of wickedness.

At some period before Nursie left, my mother and father went to
America and were away some time. Nursie and I went to Ealing. I must
have been several months there, fitting in very happily. The pillar of
Grannie's establishment was an old, wrinkled cook, Hannah. She was as
thin as Jane was fat, a bag of bones with deeply lined face and stooped
shoulders. She cooked magnificently. She also made homebaked bread
three times a week, and I was allowed in the kitchen to assist and make
my own little cottage loaves and twists. I only fell foul of her once, when
I asked her what giblets were. Apparently giblets were things nicely
brought up young ladies did *not* ask about. I tried to tease her by running
to and fro in the kitchen saying, 'Hannah, what are giblets? Hannah, for
the third time, what are giblets?' etc. I was removed by Nursie in the
end and reproved, and Hannah would not speak to me for two days. After
that I was much more careful how I transgressed her rules.

Some time during my stay at Ealing I must have been taken to the
Diamond Jubilee for I came across a letter not long ago written from
America by my father. It is couched in the style of the day, which was
singularly unlike my father's spoken words – letter-writing fell into a

definite and sanctimonious pattern, whereas my father's speech was usually jolly and slightly ribald.

You must be very very good to dear Auntie-Grannie, Agatha, because remember how very very good she has been to you, and the treats she gives you. I hear you are going to see this wonderful show which you will never forget, it is a thing to be seen only once in a lifetime. You must tell her how very grateful you are; how wonderful it is for you, I wish I could be there, and so does your mother. I know you will never forget it.

My father lacked the gift of prophecy, because I *have* forgotten it. How maddening children are! When I look back to the past, what do I remember? Silly little things about local sewing-women, the bread twists I made in the kitchen, the smell of Colonel F.'s breath – and what do I forget? A spectacle that somebody paid a great deal of money for me to see and remember. I feel very angry with myself. What a horrible, ungrateful child!

That reminds me of what I think was a coincidence so amazing that one is so inclined to say it could never have happened. The occasion must have been Queen Victoria's funeral. Both Auntie-Grannie and Granny B. were going to see it. They had procured a window in a house somewhere near Paddington, and they were to meet each other there on the great day. At five in the morning, so as not to be late, Grannie rose in her house at Ealing, and in due course got to Paddington Station. That would give her, she calculated, a good three hours to get to her vantage point, and she had with her some fancy-work, some food and other necessities to pass the hours of waiting once she arrived there. Alas, the time she had allowed herself was not enough. The streets were crammed. Some time after leaving Paddington Station she was quite unable to make further headway. Two ambulance men rescued her from the crowd, and assured her that she couldn't go on. 'I must, but I must!' cried Grannie, tears streaming down her face. 'I've got my room, I've got my seat; the two first seats in the second window on the second floor, so that I can look down and see everything. I must!' 'It's impossible, Ma'am, the streets are jammed, nobody has been able to get through for half an hour.' Grannie wept more. The ambulance man kindly said, 'You can't see anything, I am afraid, Ma'am, but I'll take you down this street to where our ambulance is and you can sit there, and they will make you a nice cup of tea.' Grannie went with them, still weeping. By the ambulance was sitting a figure not unlike herself, also weeping, a monumental figure

in black velvet and bugles. The other figure looked up – two wild cries rent the air: 'Mary!' 'Margaret!' Two gigantic bugle-shaking bosoms met.

V

Thinking over what gave me most pleasure in my childhood I should be inclined to place first and foremost, my hoop. A simple affair, in all conscience, costing – how much? Sixpence? A shilling? Certainly not more.

And what an inestimable boon to parents, nurses, and servants. On fine days, Agatha goes out into the garden with her hoop and is no more trouble to anyone until the hour for a meal arrives – or, more accurately, until hunger makes itself felt.

My hoop was to me in turn a horse, a sea monster, and a railway train. Beating my hoop round the garden paths, I was a knight in armour on a quest, a lady of the court exercising my white palfrey, Clover (of The Kittens) escaping from imprisonment – or, less romantically, I was engine driver, guard, or passenger, on three railways of my own devising.

There were three distinct systems: the Tubular Railway, with eight stations and circling three quarters of the garden; the Tub Railway, a short line, serving the kitchen garden only and starting from a large tub of water with a tap under a pine tree; and the Terrace Railway, which encircled the house. Only a short while ago I came across in an old cupboard a sheet of cardboard on which sixty odd years before I had drawn a rough plan of all these railways.

I cannot conceive now *why* I so enjoyed beating my hoop along, stopping, calling out 'Lily of the Valley Bed. Change for the Tubular Railway here. Tub. Terminus. All change.' I did it for hours. It must have been very good exercise. I also practised diligently the art of throwing my hoop so that it returned to me, a trick in which I had been instructed by one of our visiting naval officer friends. I could not do it at all at first, but by long and arduous practice I got the hang of it, and was thereafter immensely pleased with myself.

On wet days there was Mathilde. Mathilde was a large American Rocking Horse which had been given to my sister and brother when they were children in America. It had been brought back to England and now,

a battered wreck of its former self, *sans* mane, *sans* paint, *sans* tail, etc., was ensconced in a small greenhouse which adjoined the house on one side – quite distinct from The Conservatory, a grandiloquent erection, containing pots of begonias, geraniums, tiered stands of every kind of fern, and several large palm trees. This small greenhouse, called, I don't know why, K.K. (or possibly Kai Kai?) was bereft of plants and housed instead croquet mallets, hoops, balls, broken garden chairs, old painted iron tables, a decayed tennis net and Mathilde.

Mathilde had a splendid action – much better than that of any English rocking horse I have ever known. She sprang forwards and back, upwards and down, and ridden at full pressure was liable to unseat you. Her springs, which needed oiling, made a terrific groaning, and added to the pleasure and danger. Splendid exercise again. No wonder I was a skinny child.

As companion to Mathilde in Kai Kai was Truelove – also of transatlantic origin. Truelove was a small painted horse and cart with pedals. Presumably from long years of disuse, the pedals were no longer workable. Large applications of oil might have done the trick – but there was an easier way of making Truelove serviceable. Like all gardens in Devon, our garden was on a slope. My method was to pull Truelove to the top of a long grassy slope, settle myself carefully, utter an encouraging sound, and off we went; slowly at first, gathering momentum whilst I braked with my feet, so that we came to rest under the monkey puzzle at the bottom of the garden. Then I would pull Truelove back up to the top and start down once more.

I discovered in later years that it had been a great source of amusement to my future brother-in-law to see this process enacted, for sometimes an hour at a time, always in perfect solemnity.

When Nursie left I was, naturally, at a loss for a playmate. I wandered disconsolately about until the hoop solved my problem. Like all children I went round trying to induce people to play with me – first my mother, then the servants. But in those days, if there was no one whose business it was to play with children then the child had to play by itself. The servants were good-natured, but they had their work to do – plenty of it – and so it would be: 'Now run away, Miss Agatha. I've got to get on with what I'm doing.' Jane was usually good for a handful of sultanas, or a slice of cheese, but suggested firmly that these should be consumed in the garden.

So it was that I made my own world and my own playmates. I really

do think that it was a good thing. I have never, all through my life, suffered from the tedium of 'nothing to do'. An enormous number of women do. They suffer from loneliness and boredom. To have time on their hands is a nightmare and not a delight. If things are constantly being done to amuse you, naturally you expect it. And when nothing is done for you, you are at a loss.

I suppose it is because nearly all children go to school nowadays, and have things arranged for them, that they seem so forlornly unable to produce their own ideas in holiday time. I am always astonished when children come to me and say: 'Please. I've nothing to do.' With an air of desperation I point out:

'But you've got a lot of toys, haven't you?'

'Not really.'

'But you've got two trains. And lorries, and a painting set. And blocks. Can't you play with some of them?'

'But I can't play by *myself* with them.'

'Why not? I know. Paint a picture of a bird, then cut it out and make a cage with the blocks, and put the bird in the cage.'

The gloom brightens and there is peace for nearly ten minutes.

Looking back over the past, I become increasingly sure of one thing. My tastes have remained fundamentally the same. What I liked playing with as a child, I have liked playing with later in life.

Houses, for instance.

I had, I suppose, a reasonable amount of toys: a dolls' bed with real sheets and blankets and the family building bricks, handed down by my elder sister and brother. Many of my playthings were extemporised. I cut pictures out of old illustrated magazines and pasted them into scrapbooks made of brown paper. Odd rolls of wallpaper were cut and pasted over boxes. It was all a long, leisurely process.

But my principal source of indoor amusement was undoubtedly my dolls' house. It was the usual type of painted affair, with a front that swung open, revealing kitchen, sitting-room and hall downstairs, two bedrooms and bathroom upstairs. That is, it began that way. The furniture was acquired, piece by piece. There was an enormous range of dolls' furniture in the shops then, quite cheap in price. My pocket money was, for those days, rather large. It consisted of what copper coins father happened to have in his possession every morning. I would visit him in his dressing-room, say good morning, and then turn to the dressing-table

to see what Fate had decreed for me on that particular day. Twopence? Fivepence? Once a whole elevenpence! Some days, no coppers at all. The uncertainty made it rather exciting.

My purchases were always much the same. Some sweets – *boiled sweets*, the only kind my mother considered healthy – purchased from Mr Wylie who had a shop in Tor. The sweets were made on the premises, and as you came in through the shop door you knew at once what was being made that day. The rich smell of boiling toffee, the sharp odour of peppermint rock, the elusive smell of pineapple, barleysugar (dull), which practically didn't smell at all, and the almost overpowering odour when pear drops were in process of manufacture.

Everything cost eightpence a pound. I spent about fourpence a week – one pennyworth of four different kinds. Then there was a penny to be donated for the Waifs and Strays (money-box on the hall table); from September onwards a few pence were salted away to save up for such Christmas presents as would be bought, not made. The rest went towards the furnishing and equipping of my dolls' house.

I can still remember the enchantment of the things there were to buy. Food, for instance. Little cardboard platters of roast chicken, eggs and bacon, a wedding cake, a leg of lamb, apples and oranges, fish, trifle, plum pudding. There were plate baskets with knives, forks and spoons. There were tiny sets of glasses. Then there was the furniture proper. My drawing-room had a suite of blue satin chairs, to which I added by degrees a sofa and a rather grand gilded armchair. There were dressing-tables with mirrors, round polished dinner-tables, and a hideous orange brocade dining-room suite. There were lamps and epergnes and bowls of flowers. Then there were all the household implements, brushes and dustpans, brooms and pails and kitchen saucepans.

Soon my dolls' house looked more like a furniture storehouse.

Could I – could I, possibly – have *another* dolls' house?

Mother did not think that any little girl ought to have two dolls' houses. But why not, she suggested, inspired, use a *cupboard*. So I acquired a cupboard, and it was a wild success. A big room at the top of the house, originally built on by my father to provide two extra bedrooms, was so much enjoyed in its bare state by my sister and brother as a playroom that that is what it remained. The walls were more or less lined with books and cupboards, the centre conveniently free and empty. I was allotted a cupboard with four shelves, part of a built-in fitment against the wall. My mother found various nice pieces of wall-

paper which could be pasted on the shelves as carpets. The original dolls' house stood on top of the cupboard, so that I now had a six-storied house.

My house, of course, needed a family to live in it. I acquired a father and mother, two children and a maid, the kind of doll that has a china head and bust and malleable sawdust limbs. Mother sewed some clothes on them, from odd bits of stuff she had. She even fixed with glue a small black beard and moustache to the face of the father. Father, mother, two children and a maid. It was perfect. I don't remember their having any particular personalities – they never became people to me, they existed only to occupy the house. But it really looked *right* when you sat the family round the dinner table. Plates, glasses, roast chicken, and a rather peculiar pink pudding were served at the first meal.

An additional enjoyment was housemoving. A stout cardboard box was the furniture van. The furniture was loaded into it, it was drawn round the room by a string several times, and then 'arrived at the new house'. (This happened at least once a week.)

I can see quite plainly now that I have continued to play houses ever since. I have gone over innumerable houses, bought houses, exchanged them for other houses, furnished houses, decorated houses, made structural alterations to houses. Houses! God bless houses!

But to go back to memories. What odd things really, when one collects them all together, one *does* remember out of one's life. One remembers happy occasions, one remembers – very vividly, I think – fear. Oddly enough pain and unhappiness are hard to recapture. I do not mean exactly that I do not remember them – I can, but without *feeling* them. Where they are concerned I am in the first stage. I say, 'There was Agatha being terribly unhappy. There was Agatha having toothache.' But I don't *feel* the unhappiness or the toothache. On the other hand, one day the sudden smell of lime trees brings the past back, and suddenly I remember a day spent near the lime trees, the pleasure with which I threw myself down on the ground, the smell of hot grass, and the suddenly lovely feeling of summer; a cedar tree nearby and the river beyond . . . The feeling of being at one with life. It comes back in that moment. Not only a remembered thing of the mind but the feeling itself as well.

I remember vividly a field of buttercups. I must have been under five, since I walked there with Nursie. It was when we were at Ealing, staying with Auntie-Grannie. We went up a hill, past St. Stephen's Church. It

was then nothing but fields, and we came to one special field, crammed with golden buttercups. We went to it – that I do know – quite often. I don't know if my memory of it is of the first time we went there or a later occasion, but the loveliness of it I do remember and feel. It seems to me that for many years now I have never seen a field of buttercups. I have seen a few buttercups *in* a field, but that is all. A great field full of golden buttercups in early summer is something indeed. I had it then, I have it with me now.

What has one enjoyed most in life? I daresay it varies with different people. For my own part, remembering and reflecting, it seems that it is almost always the quiet moments of everyday life. Those are the times, certainly, when *I* have been happiest. Adorning Nursie's old grey head with blue bows, playing with Tony, making a parting with a comb down his broad back, galloping on what I feel to be real horses across the river my fancy has set in the garden. Following my hoop through the stations of the Tubular Railway. Happy games with my mother. My mother, later, reading Dickens to me, gradually getting sleepy, her spectacles half falling off her nose and her head dropping forward, and myself saying in an agonised voice. 'Mother, you're going to *sleep*', to which my mother with great dignity replies, 'Nothing of the kind, darling. I am not in the *least* sleepy!' A few minutes later she would be asleep. I remember feeling how ridiculous she looked with her spectacles slipping off her nose and how much I loved her at that moment.

It is a curious thought, but it is only when you see people looking ridiculous, that you realise just how much you love them! Anyone can admire somebody for being handsome or amusing or charming, but that bubble is soon pricked when a trace of ridicule comes in. I should give as my advice to any girl about to get married: 'Well now, just imagine he had a terrible cold in his head, speaking through his nose all full of b's and d's, sneezing, eyes watering. What would you feel about him?' It's a good test, really. What one needs to feel for a husband, I think, is the love that is tenderness, that comprises affection, that will take colds in the head and little mannerisms all in its stride. Passion one can take for granted.

But marriage means more than a lover – I take an old-fashioned view that *respect* is necessary. Respect – which is not to be confused with admiration. To feel admiration for a man all through one's married life would, I think, be excessively tedious. You would get, as it were, a

mental crick in the neck. But respect is a thing that you don't have to think about, that you know thankfully is there. As the old Irish woman said of her husband, 'Himself is a good head to me'. That, I think, is what a woman needs. She wants to feel that in her mate there is integrity, that she can depend on him and respect his judgment, and that when there is a difficult decision to be made it can safely lie in his hands.

It is curious to look back over life, over all the varying incidents and scenes – such a multitude of odds and ends. Out of them all what has mattered? What lies behind the selection that memory has made? What makes us choose the things that we have remembered? It is as though one went to a great trunk full of junk in an attic and plunged one's hands into it and said, 'I will have this – and this – and this.'

Ask three or four different people what they remember, say of a journey abroad and you will be surprised at the different answers you get. I remember a boy of fifteen, a son of friends of ours, who was taken to Paris as part of his spring holidays. When he returned, some fatuous friend of the family said, with the usual jovial accent inflicted on the young, 'Well, my boy, and what impressed you most in Paris? What do you remember about it?' He replied immediately: 'The chimneys. The chimneys there are quite different from chimneys on houses in England.'

From his point of view it was a perfectly sensible remark. Some years later he started studying as an artist. It was, therefore, a visual detail that really impressed him, that made Paris different from London.

So, too, another memory. This was when my brother was invalided home from East Africa. He brought with him a native servant, Shebani. Anxious to show this simple African the glories of London, my brother hired a car and, sitting in it with Shebani, drove all round London. He displayed to him Westminster Abbey, Buckingham Palace, the Houses of Parliament, the Guildhall, Hyde Park and so on. Finally, when they had arrived home, he said to Shebani, 'What did you think of London?' Shebani rolled his eyes up. 'It is wonderful, Bwana, a wonderful place. Never did I think I would see anything like it.' My brother nodded a satisfied head. 'And what impressed you most?' he said. The answer came without a moment's thought. 'Oh, Bwana, shops full of *meat*. Such wonderful shops. Meat hanging in great joints all over *and nobody steals them*, nobody rushes and pushes their way there and snatches. No, they pass by them in an orderly fashion. How rich, how great a country must be to have all this meat hanging in shops open to the streets. Yes, indeed, England is a wonderful place. London a wonderful city.'

Point of view. The point of view of a child. We all knew it once but we've travelled so far away from it that it's difficult to get back there again. I remember seeing my own grandson Mathew when he must have been, I suppose, about two and a half. He did not know I was there. I was watching him from the top of the stairs. He walked very carefully down the stairs. It was a new achievement and he was proud of it, but still somewhat scared. He was muttering to himself, saying: 'This is Mathew going down stairs. This is Mathew. Mathew is going down stairs. This is Mathew going down stairs.'

I wonder if we all start life thinking of ourselves, as soon as we can think of ourselves at all, as a separate person, as it were, from the one observing. Did I say to myself once, 'This is Agatha in her party sash going down to the dining-room?' It is as though the body in which we have found our spirit lodged is at first strange to us. An entity, we know its name, we are on terms with it, but are not as yet identified fully with it. We are Agatha going for a walk, Mathew going down stairs. We see ourselves rather than *feel* ourselves.

And then one day the next stage of life happens. Suddenly it is no longer 'This is Mathew going down stairs.' Suddenly it has become *I* am going down stairs. The achievement of 'I' is the first step in the progress of a personal life.

PART II

'GIRLS AND BOYS COME OUT TO PLAY'

I

Until one looks back on one's own past one fails to realise what an extraordinary view of the world a child has. The angle of vision is entirely different to that of the adult, everything is out of proportion.

Children can make a shrewd appraisal of what is going on around them, and have a quite good judgment of character and people. But the *how* and the *why* of things never seems to occur to them.

It must have been when I was about five years old that my father first became worried about financial affairs. He had been a rich man's son and had taken it for granted that an assured income would always come in. My grandfather had set up a complicated series of trusts to come into effect when he died. There had been four trustees. One was very old and had, I think, retired from any active connection with the business, another shortly went into a mental asylum, and the other two, both men of his own age, died shortly afterwards. In one case the son took on. Whether it was sheer inefficiency or whether in the course of replacement somebody managed to convert things to his own use I do not know. At any rate the position seemed to get worse and worse.

My father was bewildered and depressed, but not being a businesslike man he did not know what to do about it. He wrote to dear old So-and-So and dear old Somebody Else, and they wrote back, either reassuring him or laying the blame on the state of the market, depreciation and other things. A legacy from an elderly aunt came in about this time and, I

66

should imagine, tided him over a year or two, whilst the income that was due and should have been paid to him never seemed to arrive.

It was at about this time, too, that his health began to give way. On several occasions he suffered what were supposed to be heart attacks, a vague term that covered almost everything. The financial worry must, I think, have affected his health. The immediate remedy seemed to be that we must economise. The recognised way at that particular time was to go and live abroad for a short while. This was not, as nowadays, because of income tax – income tax was, I should imagine, about a shilling in the pound – but the cost of living was much less abroad. So the procedure was to let the house with the servants, etc., at a good rent, and go abroad to the South of France, staying at a fairly economical hotel.

Such a migration happened, as far as I remember, when I was six years old. Ashfield was duly let – I think to Americans, who paid a good price for it – and the family prepared to set off. We were going to Pau in the South of France. I was, of course, very much excited by this prospect. We were going, so my mother told me, where we should see mountains. I asked many questions about these. Were they very, very high? Higher than the steeple of St. Marychurch? I asked with great interest. It was the highest thing I knew. Yes, mountains were much, much higher than that. They went up for hundreds of feet, thousands of feet. I retired to the garden with Tony, and munching an enormous crust of dry bread obtained from Jane in the kitchen set to work to think this out, to try to visualise mountains. My head went back, my eyes stared up at the skies. That was how mountains would look – going up, up, up, up, up until lost in the clouds. It was an awe-inspiring thought. Mother loved mountains. She had never cared for the sea, she told us. Mountains, I felt sure, were to be one of the greatest things in my life.

One sad thing about going abroad was that it meant a parting between me and Tony. Tony was not, of course, being let with the house; he was being boarded out with a former parlourmaid called Froudie. Froudie, who was married to a carpenter and lived not far away, was quite prepared to have Tony. I kissed him all over and Tony responded by licking me frantically all over my face, neck, arms and hands.

Looking back now, the conditions of travel abroad then seem extraordinary. There were, of course, no passports or any forms to fill in. You bought tickets, made sleeping-car reservations, and that was all that had to be done. Simplicity itself. But the Packing! (Only capital letters would explain what packing meant.) I don't know what the luggage of

the rest of the family consisted of; I do have a fair memory of what my mother took with her. There were, to begin with, three round-top trunks. The largest stood about four feet high and had two trays inside. There were also hat boxes, large square leather cases, three trunks of the type called cabin trunks and trunks of American manufacture which were often to be seen at that time in the corridors of hotels. They were large, and I should imagine excessively heavy.

For a week at least before departure my mother was surrounded by her trunks in her bedroom. Since we were not well off by the standards of the day, we did not have a lady's maid. My mother did the packing herself. The preliminary to it was what was called 'sorting'. The large wardrobes and chests of drawers stood open while my mother sorted amongst such things as artificial flowers, and an array of odds and ends called 'my ribbons' and 'my jewellery'. All these apparently required hours of sorting before they were packed in the trays in the various trunks.

Jewellery did not, as nowadays, consist of a few pieces of 'real jewellery' and large quantities of costume jewellery. Imitation jewellery was frowned on as 'bad taste', except for an occasional brooch of old paste. My mother's valuable jewellery consisted of 'my diamond buckle, my diamond crescent and my diamond engagement ring'. The rest of her ornaments were 'real' but comparatively inexpensive. Nevertheless they were all of intense interest to all of us. There was 'my Indian necklace', 'my Florentine set', 'my Venetian necklace', 'my cameos' and so on. And there were six brooches in which both my sister and myself took a personal and vivid interest. These were 'the fishes', five small fish in diamonds, 'the mistletoe', a tiny diamond and pearl brooch, 'my parma violet', an enamel brooch representing a parma violet, 'my dogrose', also a flower brooch, a pink enamelled rose with clusters of diamond leaves round it, and 'my donkey', prime favourite, which was a baroque pearl mounted in diamonds as a donkey's head. They were all earmarked for the future on my mother's demise. Madge was to have the parma violet (her favourite flower), the diamond crescent and the donkey. I was to have the rose, the diamond buckle and the mistletoe. This earmarking of possessions for the future was freely indulged in by my family. It conjured up no sad feelings about death, but merely a warm appreciation of the benefits to come.

At Ashfield the whole house was crowded with oil paintings bought by my father. To crowd oil paintings as closely as you could on your walls was the fashion of the day. One was marked down for me – a large paint-

ing of the sea, with a simpering young woman catching a boy in a net in it. It was my highest idea of beauty as a child, and it is sad to reflect how poorly I thought of it when the time came for me to sort out pictures to sell. Even for sentiment's sake I have not kept any of them. I am forced to consider that my father's taste in pictures was consistently bad. On the other hand every piece of furniture he ever bought is a gem. He had a passion for antique furniture, and the Sheraton desks and Chippendale chairs that he bought, often at a very low figure since at that time bamboo was all the rage, are a joy to live with and possess, and appreciated so much in value that my mother was able to keep the wolf from the door after my father died by selling a good many of the best pieces.

He, my mother and my grandmother all had a passion for collecting china. When Grannie came to live with us later she brought her collection of Dresden and Capo di Monte with her, and innumerable cupboards were filled with it at Ashfield. In fact, fresh cupboards had to be built to accommodate it. There is no doubt that we were a family of collectors and that I have inherited these attributes. The only sad thing is that if you inherit a good collection of china and furniture it leaves you no excuse for *starting* a collection of your own. The collector's passion, however, has to be satisfied, and in my case I have accumulated quite a nice stock of papier-mâché furniture and small objects which had not figured in my parents' collections.

When the day came I was so excited that I felt quite sick and completely silent. When really thrilled by anything, it always seems to deprive me of the powers of speech. My first clear memory of going abroad was when we stepped on to the boat at Folkestone. My mother and Madge took the Channel crossing with the utmost seriousness. They were bad sailors and retired immediately to the ladies' saloon to lay themselves down, close their eyes and hope to get across the intervening water to France without the worst happening. In spite of my experience in small dinghies I was convinced that *I* was a good sailor. My father encouraged me in this belief, so I remained on deck with him. It was, I imagine, a perfectly smooth crossing, but I gave the credit not to the sea but to my own power of withstanding its motion. We arrived at Boulogne and I was glad to hear father announce, 'Agatha's a perfectly good sailor'.

The next excitement was going to bed in the train. I shared a compartment with my mother and was hoisted up on to the top bunk. My mother always had a passion for fresh air, and the steam heat of the *wagon lits* carriages was agony to her. All that night it seemed to me I

woke up to see mother with the window pushed down and her head out, breathing great gasps of night air.

Early the next morning we arrived at Pau. The Hotel Beausejour bus was waiting so we piled into it, our eighteen pieces of luggage coming separately, and in due course arrived at the hotel. It had a large terrace outside it facing the Pyrenees.

'There!' said father. 'See? There are the Pyrenees. The snow mountains.'

I looked. It was one of the great disillusionments of my life, a disillusionment that I have never forgotten. Where was that soaring height going up, up, up into the sky, far above my head – something beyond contemplation or understanding? Instead, I saw, some distance away on the horizon, what looked like a row of teeth standing up, it seemed, about an inch or two from the plain below. *Those?* Were those *mountains?* I said nothing, but even now I can still feel that terrible disappointment.

II

We must have spent about six months at Pau. It was an entirely new life for me. My father and mother and Madge were soon caught up in a whirl of activity. Father had several American friends staying there, he made a lot of hotel acquaintances, and we also had brought letters of introduction to people in various hotels and pensions.

To look after me, mother engaged a kind of daily nursery governess – actually an English girl, but one who had lived in Pau all her life and who spoke French as easily as English, if not, in fact, rather better. The idea was that I should learn French from her. This plan did not turn out as expected. Miss Markham called for me every morning and took me for a walk. In its course she drew my attention to various objects and repeated their names in French. '*Un chien.*' '*Une maison.*' '*Un gendarme.*' '*Le boulanger.*' I repeated these dutifully, but naturally when I had a question to ask I asked it in English and Miss Markham replied in English. As far as I can remember I was rather bored during my day; interminable walks in the company of Miss Markham, who was nice, kind, conscientious and dull.

My mother soon decided that I should never learn French with Miss

Markham, and that I must have regular French lessons from a French-woman who would come every afternoon. The new acquisition was called Mademoiselle Mauhourat. She was large, buxom and dressed in a multiplicity of little capes, brown in colour.

All rooms of that period were overcrowded, of course. There was too much furniture in them, too many ornaments and so on. Mlle Mauhourat was a flouncer. She flounced about the room, jerking her shoulders, gesticulating with her hands and elbows, and sooner or later she invariably knocked an ornament off the table and broke it. It became quite a family joke. Father said, 'She reminds me of that bird you had, Agatha. Daphne. Always big and awkward and knocking her seed pans over.'

Mlle Mauhourat was particularly full of gush, and gush made me feel shy. I found it increasingly difficult to respond to her little cooing squeals of: '*Oh, la chère mignonne! Quelle est gentille, cette petite! Oh, la chère mignonne! Nous allons prendre des leçons très amusantes, n'est ce pas?*' I looked at her politely but with a cold eye. Then, receiving a firm look from my mother, I muttered unconvincingly, '*Oui, merci*', which was about the limit of my French at that time.

The French lessons went on amiably. I was docile as usual, but apparently bone-headed as well. Mother, who liked quick results, was dissatisfied with my progress.

'She's not getting on as she should, Fred,' she complained to my father.

My father, always amiable, said, 'Oh, give her time, Clara, give her time. The woman's only been here ten days.'

But my mother was not one to give anybody time. The climax came when I had a slight childish illness. It started, I suppose, with local flu and led to catarrhal trouble. I was feverish, out of sorts, and in this convalescent stage with still a slight temperature I could not stand the sight of Mlle Mauhourat.

'Please,' I would beg, 'please don't let me have a lesson this afternoon. I don't want to.'

Mother was always kind enough when there was real cause. She agreed. In due course Mlle Mauhourat, capes and all, arrived. My mother explained that I had a temperature, was staying indoors, and perhaps it would be better not to have a lesson that day. Mlle Mauhourat was off at once, fluttering over me, jerking her elbows, waving her capes, breathing down my neck. '*Oh, la pauvre mignonne, la pauvre petite mignonne.*' She would read to me, she said. She would tell me stories. She would amuse '*la pauvre petite*'.

I cast the most agonising glances at mother. I couldn't bear it. I couldn't bear another moment of it! Mlle Mauhourat's voice went on, high-pitched, squeaky – everything I most disliked in a voice. My eyes implored: 'Take her away. Please take her *away*.' Firmly, my mother drew Mlle Mauhourat towards the door.

'I think Agatha had better be kept quite quiet this afternoon,' she said. She ushered Mlle Mauhourat out, then she returned and shook her head at me. 'It's all very well,' she said, 'but you must not make such terrible *faces*.'

'Faces?' I said.

'Yes. All that grimacing and looking at me. Mlle Mauhourat could see perfectly that you wanted her to go away.'

I was upset. I had not meant to be impolite.

'But, Mummy,' I said, 'those weren't *French* faces that I was making. They were *English* faces.'

My mother was much amused, and explained to me that making faces was a kind of international language which was understood by people of all countries. However, she told my father that Mlle Mauhourat was not being much of a success and she was going to look elsewhere. My father said it would be just as well if we did not lose too many more china ornaments. He added, 'If I were in Agatha's place, *I* should find that woman insupportable, just as she does.'

Freed from the ministrations of Miss Markham and Mlle Mauhourat, I began to enjoy myself. Staying in the hotel was Mrs Selwyn, the widow or perhaps the daughter-in-law of Bishop Selwyn, and her two daughters, Dorothy and Mary. Dorothy (Dar) was a year older than I was, Mary a year younger. Pretty soon we were inseparable.

Left to myself I was a good, well-behaved and obedient child, but in company with other children I was only too ready to engage in any mischief that was going. In particular we three plagued the life out of the unfortunate waiters in the *table d'hôte*. One evening we changed the salt to sugar in all of the salt cellars. Another day we cut pigs out of orange peel and placed them on everyone's plate just before the *table d'hôte* bell was rung.

Those French waiters were the kindliest men I'm ever likely to know. In particular there was Victor, our own waiter. He was a short square man with a long jerking nose. He smelt to my mind, quite horribly (my first acquaintance with garlic). In spite of all the tricks that we played upon him, he seemed to bear no malice and, indeed, went out of his way to be

kindly to us. In particular, he used to carve us the most glorious mice out of radishes. If we never got into serious trouble for what we did, it was because the loyal Victor never complained to the management or to our parents.

My friendship with Dar and Mary meant far more to me than any of my former friendships. Possibly I was now of an age when co-operative enterprise was more exciting than doing things alone. We got up to plenty of mischief together and enjoyed ourselves thoroughly all through those winter months. Of course we often got into trouble through our pranks, but on only one occasion did we really feel righteous indignation at the censure that fell upon us.

My mother and Mrs Selwyn were sitting together happily talking when a message was brought by the chambermaid. 'With the compliments of the Belgian lady who lived in the other block of the hotel. Did Mrs Selwyn and Mrs Miller know that their children were walking round the fourth floor parapet?'

Imagine the senation of the two mothers as they stepped out into the courtyard, looked up and caught sight of three cheerful figures balancing themselves on a parapet about a foot in width and walking along it in single file. The idea that there was any danger attached to it never entered our heads. We had gone a little far in teasing one of the chambermaids and she had managed to inveigle us into a broom cupboard and then shut the door on us from outside, triumphantly turning the key in the lock. Our indignation was great. What could we *do*? There was a tiny window, and sticking her head out of it Dar said she thought possibly that we could wriggle through and then walk along the parapet, round the corner and get in at one of the windows along there. No sooner said than done. Dar squeezed through first, I followed, and then Mary. To our delight we found it was quite easy to walk along the parapet. Whether we looked down the four storeys below I don't know, but I don't suppose, even if we had, that we would have felt giddy or been likely to fall. I've always been appalled by the way children can stand on the edge of a cliff, looking down with their toes over the edge, with no sense of vertigo or other grown-up complaints.

In this case we had not to go far. The first three windows, as I remember, were shut, but the next one, which led into one of the public bathrooms, was open, and we had gone in through this to be met to our surprise with the demand, 'Come down at once to Mrs Selwyn's sitting-room.' Both mothers were excessively angry. We could not see *why*. We

were all banished to bed for the rest of the day. Our defence was simply not accepted. And yet it was the truth.

'But you never told us,' we said, each in turn. 'You never told us that we *weren't* to walk round the parapet.'

We withdrew to bed with a strong feeling of injustice.

Meanwhile, my mother was still considering the problem of my education. She and my sister were having dresses made for them by one of the dressmakers of the town, and there, one day, my mother was attracted by the assistant fitter, a young woman whose main business was to put the fitted garment on and off and hand pins to the first fitter. This latter was a sharp-tempered, middle-aged woman, and my mother, noticing the patient good-humour of the young girl's manner, decided to find out a little more about her. She watched her during the second and third fitting and finally retained her in conversation. Her name was Marie Sijé, she was twenty-two years of age. Her father was a small café proprietor and she had an elder sister, also in the dressmaking establishment, two brothers and a little sister. Then my mother took the girl's breath away by asking her in a casual voice if she would care to come to England. Marie gasped her surprise and delight.

'I must of course talk to your mother about it,' said my mother. 'She might not like her daughter to go so far away.'

An appointment was arranged, my mother visited Madame Sijé, and they went into the subject thoroughly. Only then did she approach my father on the subject.

'But, Clara,' protested my father, 'this girl isn't a governess or *anything* of that kind.'

My mother replied that she thought Marie was just the person they needed. 'She knows no English at all, not a word of it. Agatha will *have* to learn French. She's a really sweet-natured and good-humoured girl. It's a respectable family. The girl would like to come to England and she can do a lot of sewing and dressmaking for us.'

'But are you sure about this, Clara?' my father asked doubtfully.

My mother was always sure.

'It's the perfect answer,' she said.

As was so often the case with my mother's apparently unaccountable whims, this proved to be true. If I close my eyes I can see dear Marie today as I saw her then. Round, rosy face, snub nose, dark hair piled up in a chignon. Terrified, as she later told me, she entered my bedroom on the first morning having primed herself by laboriously learning the

English phrase with which to greet me: 'Good morning, mees. I hope you are well.' Unfortunately, owing to Marie's accent I did not understand a word. I stared at her suspiciously. We were, for the first day, like a couple of dogs just introduced to each other. We said little and eyed each other in apprehension. Marie brushed my hair – very fair hair always arranged in sausage-curls – and was so frightened of hurting me that she hardly put the brush through the hair at all. I wanted to explain to her that she must brush much harder, but of course it was impossible as I did not know the right words.

How it came about that in less than a week Marie and I were able to converse I do not know. The language used was French. A word here and a word there, and I could make myself understood. Moreover, at the end of the week we were fast friends. Going out with Marie was fun. Doing anything with Marie was fun. It was the beginning of a happy partnership.

In the early summer it grew hot in Pau, and we left, spending a week at Argeles and another at Lourdes, then moving up to Cauterets in the Pyrenees. This was a delightful spot, right at the foot of the mountains. (I had got over my disappointment about mountains now, but although the position at Cauterets was more satisfactory you could not really look a long way up.) Every morning we had a walk along a mountain path which led to the spa, where we all drank glasses of nasty water. Having thus improved our health we purchased a stick of *sucre d'orge*. Mother's favourite was aniseed, which I could not bear. On the zigzag paths by the hotel I soon discovered a delightful sport. This was to toboggan down through the pine trees on the seat of my pants. Marie took a poor view of this, but I am sorry to say that from the first Marie was never able to exert any authority over me. We were friends and playmates, but the idea of doing what she told me never occurred to me.

Authority is an extraordinary thing. My mother had it in full measure. She was seldom cross, hardly ever raised her voice, but she had only gently to pronounce an order and it was immediately fulfilled. It always was odd to her that other people had *not* got this gift. Later, when she was staying with me after I was first married and had a child of my own, I complained how tiresome some little boys were who lived in the next house and who were always coming in through the hedge. Though I ordered them away, they would not go.

'But how extraordinary,' said my mother. 'Why don't you just tell them to go away?'

I said to her, 'Well, you try it.' At that moment the two small boys arrived and were preparing as usual to say, 'Yah. Boo. Shan't go,' and throw gravel on the grass. One started pelting a tree and shouting and puffing. My mother turned her head.

'Ronald,' she said. 'Is that your name?'

Ronald admitted it was.

'Please don't play so near here. I don't like being disturbed,' said my mother. 'Just go a little further away.'

Ronald looked at her, whistled to his brother, and departed immediately.

'You see, dear,' said my mother, 'it's *quite* simple.'

It certainly was for her. I really believe that my mother would have been able to manage a class of juvenile delinquents without the least difficulty.

There was an older girl at the hotel in Cauterets, Sybil Patterson, whose mother was a friend of the Selwyns. Sybil was the object of my adoration. I thought her beautiful, and the thing I admired about her most was her budding figure. Bosoms were much in fashion at that time. Everyone more or less had one. My grandmother and great-aunt had enormous jutting shelves, and it was difficult for them to greet each other with a sisterly kiss without their chests colliding first. Though I took the bosoms of grown-up people for granted, Sybil's possession of one aroused all my most envious instincts. Sybil was fourteen. How long should I have to wait until I, too, could have that splendid development? Eight years? Eight years of skinniness? I longed for these signs of female maturity. Ah well, patience was the only thing. I must be patient. And in eight years' time, or seven perhaps, if I was lucky, two large rounds would miraculously spurt forth on my skinny frame. I only had to *wait*.

The Selwyns were not at Cauterets as long as we were. They went away, and I then had the choice of two other friends: a little American girl, Marguerite Prestley, and another, Margaret Home, an English girl. My father and mother were great friends by now with Margaret's parents, and naturally they hoped that Margaret and I would go about and do things together. As is usual in these cases, however, I had an enormous preference for the company of Marguerite Prestley, who used what were to me extraordinary phrases and odd words that I had never heard before. We told each other stories a good deal, and there was one story of Marguerite's which entailed the dangers encountered on meeting a *scarrapin* which thrilled me.

'But what *is* a scarrapin?' I kept asking.

Marguerite, who had a nurse called Fanny whose southern American drawl was such that I could seldom understand what she said, gave me a brief description of this horrifying creature. I applied to Marie but Marie had never heard of scarrapins. Finally I tackled my father. He had a little difficulty, too, at first, but at last realisation dawned on him and he said, 'I expect what you mean is a *scorpion*.'

Somehow the magic then departed. A scorpion did not seem nearly so horrifying as the imagined scarrapin.

Marguerite and I had quite a serious dispute on one subject, which was the way babies arrived. I assured Marguerite that babies were brought by the angels. This had been Nursie's information. Marguerite, on the other hand, assured me that they were part of a doctor's stock-in-trade, and were brought along by him in a black bag. When our dispute on this subject had got really heated, the tactful Fanny settled it once and for all.

'Why, that's just the way it is, honey,' she said. 'American babies come in a doctor's black bag and English babies are brought by the angels. It's as simple as that.'

Satisfied, we ceased hostilities.

Father and Madge made a good many excursions on horseback, and in answer to my entreaties one day I was told that on the morrow I should be allowed to accompany them. I was thrilled. My mother had a few misgivings, but my father soon overruled them.

'We have a Guide with us,' he said, 'and he's quite used to children and will see to it that they don't fall off.'

The next morning the three horses arrived, and off we went. We zigzagged along up the precipitous paths, and I enjoyed myself enormously perched on top of what seemed to me an immense horse. The Guide led it up, and occasionally picking little bunches of flowers, handed them to me to stick in my hatband. So far all was well, but when we arrived at the top and prepared to have lunch, the Guide excelled himself. He came running back to us bringing with him a magnificent butterfly he had trapped. '*Pour la petite mademoiselle*,' he cried. Taking a pin from his lapel he transfixed the butterfly and stuck it in my hat! Oh the horror of that moment! The feeling of the poor butterfly fluttering, struggling against the pin. The agony I felt as the butterfly fluttered there. And of course I couldn't *say* anything. There were too many conflicting loyalties in my mind. This was a kindness on the part of the Guide. He had brought it to me. It was a special kind of present. How could I hurt his

feelings by saying I didn't like it? How I wanted him to take it off!
And all the time, there was the butterfly, fluttering, dying. That horrible
flapping against my hat. There is only one thing a child can do in these
circumstances. I cried.

The more anyone asked me questions the more I was unable to reply.
'What's the matter?' demanded my father. 'Have you got a pain?'
My sister said, 'Perhaps she's frightened at riding on the horse.'
I said No and No. I wasn't frightened and I hadn't got a pain.
'Tired,' said my father.
'No,' I said.
'Well, then, what is the matter?'
But I couldn't say. Of course I couldn't say. The Guide was standing
there, watching me with an attentive and puzzled face. My father said
rather crossly:
'She's too young a child. We shouldn't have brought her on this
expedition.'
I redoubled my weeping. I must have ruined the day for both him and
my sister, and I knew I was doing so, but I couldn't stop. All I hoped and
prayed was that presently he, or even my sister, would *guess* what was the
matter. Surely they would look at that butterfly, they would see it, they
would say, 'Perhaps she doesn't like the butterfly on her hat.' If *they*
said it, it would be all right. But I couldn't *tell* them. It was a terrible day.
I refused to eat any lunch. I sat there and cried, and the butterfly flapped.
It stopped flapping in the end. That ought to have made me feel better.
But by that time I had got into such a state of misery that nothing *could*
have made me feel better.

We rode down again, my father definitely out of temper, my sister
annoyed, the Guide still sweet, kindly and puzzled, Fortunately, he did
not think of getting me a second butterfly to cheer me up. We arrived back,
a most woeful party, and went into our sitting-room where mother was.
'Oh dear,' she said, 'what's the matter? Has Agatha hurt herself?'
'I don't know,' said my father crossly. 'I don't know what's the matter
with the child. I suppose she's got a pain or something. She's been
crying ever since lunch-time, and she wouldn't eat a thing.'
'What is the matter, Agatha?' asked my mother.
I couldn't tell her. I only looked at her dumbly while tears still rolled
down my cheeks. She looked at me thoughtfully for some minutes, then
said, 'Who put that butterfly in her hat?'
My sister explained that it had been the Guide.

'I see,' said mother. Then she said to me, 'You didn't like it, did you? It was alive and you thought it was being hurt?'

Oh, the glorious relief, the wonderful relief when somebody knows what's in your mind and tells it to you so that you are at last released from that long bondage of silence. I flung myself at her in a kind of frenzy, thrust my arms round her neck and said, 'Yes, yes, yes. It's been flapping. It's been *flapping*. But he was so kind and he meant to be kind. I couldn't *say*.'

She understood it all and patted me gently. Suddenly the whole thing seemed to recede in the distance.

'I quite see what you felt,' she said. 'I know. But it's over now, and so we won't talk about it any more.'

It was about this time that I became aware that my sister had an extraordinary fascination for the young men in her vicinity. She was a most attractive young woman, pretty without being strictly beautiful, and she had inherited from my father a quick wit and was extremely amusing to talk to. She had, moreover, a great deal of sexual magnetism. Young men went down before her like ninepins. It was not long before Marie and I had made what might in racing parlance be called a book on the various admirers. We discussed their chances.

'I think Mr Palmer. What do you think, Marie?'

'*C'est possible. Mais il est trop jeune.*'

I replied that he was about the same age as Madge, but Marie assured me that that was '*beaucoup trop jeune*'.

'Me,' said Marie, 'I think the Sir Ambrose.'

I protested, 'He's years and years older than she is, Marie.' She said, perhaps, but it made for stability if a husband was older than his wife. She also added that Sir Ambrose would be a very good '*parti*', one of which any family would approve.

'Yesterday,' I said, 'she put a flower as a buttonhole in Bernard's coat.' But Marie did not think much of the young Bernard. She said he was not a '*garçon sérieux*'.

I learnt a lot about Marie's family. I knew the habits of their cat and how it was able to walk about among the glasses in the café and curl down asleep in the middle of them without ever breaking one. I knew that her sister, Berthe, was older than her and a very serious girl, that her little sister Angele was the darling of the whole family. I knew all the tricks the two boys played and how they got into trouble. Marie also confided to

me the proud secret of the family, that once their name had been Shije instead of Sijé. Though unable to see whence this pride came in – and indeed I do not even now – I fully concurred with Marie and congratulated her on having this satisfactory ancestry.

Marie occasionally read me French books, as did my mother. But the happy day arrived when I picked up *Mémoires d'un Âne* myself and found, on turning the pages, that I was able to read it alone just as well as anyone could have read it to me. Great congratulations followed, not least from my mother. At last, after many tribulations, I knew French. I could read it. Occasionally I needed explanations of the more difficult passages, but on the whole I had arrived.

At the end of August we left Cauterets for Paris. I remember it always as one of the happiest summers I have ever known. For a child of my age it had everything. The excitement of novelty. Trees – a recurring factor of enjoyment all through my life. (Is it possibly symbolic that one of my first imaginary companions was called Tree?) A new and delightful companion, my dear snub-nosed Marie. Expeditions on mules. Exploring steep paths. Fun with the family. My American friend Marguerite. The exotic excitement of a foreign place. 'Something rare and strange . . .' How well Shakespeare knows. But it is not the items, grouped together and added up, that linger in my memory. It is Cauterets – the place, the long valley, with its little railway and its wooded slopes, and the high hills.

I have never been back there. I am glad of that. A year or two ago, we contemplated taking a summer holiday there. I said, unthinkingly: '*I should like to go back*.' It was true. But then it came to me that I could *not go back*. One cannot, ever, go back to the place which exists in memory. You would not see it with the same eyes – even supposing that it should improbably have remained much the same. What you have had you have had. 'The happy highways where I went, And shall not come again . . .'

Never go back to a place where you have been happy. Until you do it remains alive for you. If you go back it will be destroyed.

There are other places I have resisted going back to. One is the shrine of Sheikh Adi in Northern Iraq. We went there on my first visit to Mosul. There was a certain difficulty of access then; you had to get a permit, and to stop at the police post at Ain Sifni under the rocks of the Jebl Maclub.

From there, accompanied by a policeman, we walked up a winding path. It was spring, fresh and green, with wild flowers all the way. There was a mountain stream. We passed occasional goats and children. Then

we reached the Yezidi shrine. The peacefulness of it comes back – the flagged courtyard, the black snake carved on the wall of the shrine. Then the step carefully *over*, not *on* the threshold, into the small dark sanctuary. There we sat in the courtyard under a gently rustling tree. One of the Yezidees brought us coffee, first carefully spreading a dirty table-cloth. (This, proudly, as showing that European needs were understood.) We sat there a long time. Nobody forced information on us. I knew, vaguely, that the Yezidees were devil worshippers, and the Peacock Angel, Lucifer, is the object of their worship. It always seems strange that the worshippers of Satan should be the most peaceful of all the varying religious sects in that part of the world. When the sun began to get low, we left. It had been utter peace.

Now I believe, they run tours to it. The 'Spring Festival' is quite a tourist attraction. But I knew it in its day of innocence. I shall not forget it.

III

From the Pyrenees we went to Paris and then to Dinard. It is irritating to find that all I remember of Paris is my bedroom in the hotel, which had richly painted chocolate-coloured walls on which it was quite impossible to see mosquitoes.

There were myriads of mosquitoes. They pinged and whined all night, and our faces and arms were covered with bites. (Extremely humiliating to my sister Madge, who minded a good deal about her complexion at this period of her life.) We were only in Paris a week, and we seemed to spend all our time attempting to kill mosquitoes, anointing ourselves with various kinds of peculiar smelling oils, lighting incense cones by the bed, scratching bites, dropping hot candle grease on them. Finally, after vehement representations to the hotel management (who persisted in saying there were not really *any* mosquitoes), the novelty of sleeping under a mosquito net remains an event of the first importance. It was August and boiling hot weather, and under a net it must have been hotter still.

I suppose I must have been shown some of the sights of Paris, but they have left no mark on my mind. I do remember that I was taken to the Tour Eiffel as a treat, but I imagine that, like my first view of mountains,

it did not come up to expectation. In fact the only souvenir of our stay there seemed to be a new nickname for me. '*Moustique.*' No doubt justified.

No, I am wrong. It was on that visit to Paris that I first became acquainted with the forerunners of the great mechanical age. The streets of Paris were full of those new vehicles called '*Automobiles.*' They rushed madly along (by present-day standards probably quite slowly, but then they only had to compete with the horse), smelling, hooting, driven by men with caps and goggles and full of motoring equipment. They were bewildering. My father said they would be everywhere soon. We did not believe him. I surveyed them without interest, my own allegiance firmly given to all kinds of trains.

My mother exclaimed sadly, 'What a pity Monty is not here. He would *love* them.'

It seems odd to me looking back now at this stage of my life. My brother seems to disappear from it completely. He was there, presumably, coming home for the holidays from Harrow, but he does not exist as a figure any longer. The answer is, probably, that he took very little notice of me at this point. I learnt only later that my father was worried about him. He was superannuated from Harrow, being quite unable to pass his exams. I think he went first to a ship-building yard on the Dart, and afterwards up north, to Lincolnshire. Reports of his progress were disappointing. My father received blunt advice. 'He'll never get anywhere. You see, he can't do mathematics. You show him anything practical and it's all right; he's a good practical workman. But that's all he'll ever be in the engineering line.'

In every family there is usually one member who is a source of trouble and worry. My brother Monty was ours. Until the day of his death he was always causing someone a headache. I have often wondered, looking back, whether there is any niche in life where Monty would have fitted in. He would certainly have been all right if he had been born Ludwig II of Bavaria. I can see him sitting in his empty theatre, enjoying opera sung only for him. He was intensely musical, with a good bass voice, and played various instruments by ear, from penny whistles to piccolo and flute. He would never have had the application, though, to become a professional of any kind, nor, I think, did the idea ever enter his head. He had good manners, great charm, and throughout his life was surrounded by people anxious to save him worry or bother. There was

always someone ready to lend him money and to do any chores for him. As a child of six, when he and my sister received their pocket money, the same thing invariably happened. Monty spent his on the first day. Later in the week he would suddenly push my sister into a shop, quickly order three pennyworth of a favourite sweet and then look at my sister, daring her not to pay. Madge, who had a great respect for public opinion, always did. Naturally she was furious about it and quarrelled with him violently afterwards. Monty would merely smile at her serenely and offer her one of the sweets.

This attitude was one he adopted throughout his life. There seemed to be a natural conspiracy to slave for him. Again and again various women have said to me, 'You know you don't really *understand* your brother Monty. What he needs is sympathy.' The truth was that we understood him only too well. It was impossible, mind you, not to feel affection for him. He recognised his own faults with the utmost frankness, and was always sure that everything was going to be different in future. He was, I believe, the only boy at Harrow who was allowed to keep white mice. His housemaster, in explaining this, said to my father, 'You know he really seems to have such a deep love of natural history that I thought he should be allowed this privilege.' The family opinion was that Monty had no love of natural history at all. He just wished to keep white mice!

I think, on looking back, that Monty was a very interesting person. A slightly different arrangement of genes and he might have been a great man. He just lacked *something*. Proportion? Balance? Integration? I don't know.

The choice of a career for him settled itself. The Boer War broke out. Almost all the young men we knew volunteered – Monty, naturally, among them. (He had occasionally condescended to play with some toy soldiers I had, drawing them up in line of battle and christening their commanding officer Captain Dashwood. Later, to vary the routine, he cut off Captain Dashwood's head for treason while I wept.) In some ways my father must have felt relief – the Army might provide a career for him – especially just at this moment when his engineering prospects were so doubtful.

The Boer War, I suppose, was the last of what one might describe as the 'old wars', the wars that did not really affect one's own country or life. They were heroic story-book affairs, fought by brave soldiers and gallant young men. They were killed, if killed, gloriously in battle. More often they came home suitably decorated with medals for gallant feats

performed on the field. They were tied up with the outposts of Empire, the poems of Kipling, and with the bits of England that were pink on the map. It seems strange today to think that people – girls in particular – went around handing our white feathers to young men whom they considered were backward in doing their duty by dying for their country.

I remember little of the outbreak of the South African War. It was not regarded as an important war – it consisted of 'teaching Kruger a lesson'. With the usual English optimism it would be 'all over in a few weeks'. In 1914 we heard the same phrase. 'All over by Christmas.' In 1940, 'Not much point in storing the carpets with mothballs.' – this when the Admiralty took over my house – 'It won't last over the winter.'

So what I remember is a gay atmosphere, a song with a good tune – 'The Absent-Minded Beggar' – and cheerful young men coming up from Plymouth for a few days' leave. I can remember a scene at home a few days before the 3rd Battalion of the Royal Welsh Regiment was to sail for South Africa. Monty had brought a friend up from Plymouth, where they were stationed at the moment. This friend, Ernest Mackintosh, always called by us for some reason Billy, was to remain a friend and far more of a brother than my real brother to me all my life. He was a young man of great gaiety and charm. Like most of the young men around, he was more or less in love with my sister. The two boys had just got their uniforms, and were intensely intrigued by puttees which they had never seen before. They wound the puttees round their necks, bandaged their heads with them and played all sorts of tricks. I have a photograph of them sitting in our conservatory with puttees round their necks. I transferred my girlish hero-worship to Billy Mackintosh. A photograph of him stood by my bed in a frame with forget-me-nots on it.

From Paris we went to Dinard in Brittany.

The principal thing that I remember about Dinard is that I learnt to swim there. I can rememer my incredulous pride and pleasure when I found myself striking out for six spluttering strokes on my own without submerging.

The other thing I remember is the blackberries – never were there such blackberries, great big fat juicy ones. Marie and I used to go out and pick baskets of them, and eat masses of them at the same time. The reason for this profusion was that the natives of the countryside believed them to be deadly poison. '*Ils ne mangent pas des mûres.*' said Marie wonderingly. 'They say to me "*vous allez vous empoisonner*".' Marie and

I had no such inhibitions, and we poisoned ourselves happily every afternoon.

It was in Dinard that I first took to theatrical life. Father and mother had a large double bedroom with an enormous bow window, practically an alcove, across which curtains were drawn. It was a natural for stage performances. Fired by a pantomime I had seen the previous Christmas, I pressed Marie into service and we gave nightly representations of various fairy stories. I chose the character I wished to be and Marie had to be everybody else.

Looking back, I am filled with gratitude at the extraordinary kindness of my father and mother. I can imagine nothing more boring than to come up every evening after dinner and sit for half an hour watching and applauding whilst Marie and I strutted and postured in our home-improvised costumes. We went through the Sleeping Beauty, Cinderella, Beauty and the Beast and so forth. I was fondest of the part of principal boy, and borrowing my sister's stockings in an attempt to produce tights I marched around and declaimed. The performance was, of course, always in French, as Marie could not speak English. What a good-natured girl she was. Only once did she strike, and that for a reason I simply could not fathom. She was to be Cinderella, and I insisted on her taking her hair down. One really cannot imagine Cinderella with a chignon on top of her head! But Marie, who had enacted the part of the Beast without murmuring, who had been Red Riding Hood's grandmother – Marie, who had been good fairies, bad fairies, who had been wicked old women, who had enacted a street scene where she spat into the gutter in a most realistic fashion saying in argot *'Et bien crache!'* which incidentally convulsed my father with mirth – Marie suddenly refused with tears to enact the part of Cinderella.

'*Mais, pourquoi, pas,* Marie?' I demanded. 'It is a very good part. It is the heroine. It is Cinderella the whole play is about.'

Impossible, said Marie, impossible that she should enact such a role. To take her hair down, to appear with her hair loose on her shoulders before Monsieur! That was the crux. To appear with her hair down before Monsieur was to Marie unthinkable, shocking. I yielded, puzzled. We concocted a kind of hood that went over Cinderella's chignon, and all was well.

But how extraordinary taboos are. I remember one of my friends' children – a pleasant, amiable little girl of about four. A French nursery governess arrived to look after her. There was the usual hesitation as to

whether the child would 'get on' with her or not, but everything appeared to be perfect happiness. She went out with her for a walk, chatted, showed Madeleine her toys. Everything seemed to be going perfectly. Only at bedtime did tears arise when Joan refused firmly to let Madeleine give her her bath. Her mother, puzzled, gave in on the first day, since she could understand that the child was perhaps not quite at home with the strangers yet. But this refusal continued for two or three days. All was peace, all was happiness, all was friendship, until bed and bath time. It was not till the fourth day that Joan, weeping bitterly and burying her head in her mother's neck, said, 'You don't *understand*, Mummy. You don't seem to *understand*. How *can* I show my *body* to a foreigner ?'

So it was with Marie. She could strut about in trousers, show quite a lot of leg in many roles, but she could not take her hair down in front of Monsieur.

I imagine, to begin with, our theatrical performances must have been extremely funny, and my father at least got a great deal of enjoyment out of them. But how boring they must have become! Yet my parents were far too kind to tell me frankly that they couldn't be bothered to come up every night. Occasionally they let themselves off by explaining that friends were dining and so they would not be able to come upstairs, but on the whole they stuck it nobly – and how I, at least, enjoyed performing before them.

During the month of September that we stayed in Dinard my father was happy to find some old friends there – Martin Pirie and his wife and two sons, who were finishing off their holidays. Martin Pirie and my father had been at school together at Vevey, and close friends ever since. Martin's wife, Lilian Pirie, I still think of as one of the most outstanding personalities I have ever known. The character that Sackville West drew so beautifully in *All Passion Spent* has always struck me as a little like Mrs Pirie. There was something faintly awe-inspiring in her, slightly aloof. She had a beautiful, clear voice, delicate features and very blue eyes. The movements of her hands were always beautiful. I think Dinard was the first time I ever saw her, but from then on I saw her at frequent intervals, and I knew her up to the age of eighty odd when she died. All that time my admiration and respect for her increased.

She was one of the few people I have met whom I consider had a really interesting mind. Each of her houses was decorated in a startling and original manner. She did the most beautiful embroidered pictures, there was never a book or a play she had not read or seen, and she always had

something telling to say about them. Nowadays I suppose she would have embarked upon some career, but I wonder, if she had done so, whether the impact of her personality would have been as great as it actually was.

Young people always flocked to her house and were happy to talk to her. To spend an afternoon with her, even when she was well over seventy, was a wonderful refreshment. I think she had, more perfectly than anyone I have ever known, the art of leisure. You found her sitting in a high-backed chair in her beautiful room, usually engaged with some needle-work of her own design, some interesting book or other by her side. She had the air of having time to talk with you all day, all night, for months on end. Her criticisms were caustic and clear. Although she would talk about any abstract subject under the sun she seldom indulged in personalities. But it was her beautiful speaking voice that attracted me most. It is such a rare thing to find. I have always been sensitive to voices. An ugly voice repels me where an ugly face would not.

My father was delighted to see his friend Martin again. My mother and Mrs Pirie had much in common, and immediately engaged, if I remember rightly, in a frenzied discussion about Japanese art. Their two boys were there – Harold, who was at Eton, and Wilfred, who I suppose must have been at Dartmouth, as he was going into the Navy. Wilfred was later to be one of my dearest friends, but all I remember about him from Dinard was that he was said to be the boy who always laughed out loud whenever he saw a banana. This made me look at him with close attention. Naturally, neither of the boys took the least notice of me. An Eton schoolboy and a naval cadet would hardly demean themselves by paying attention to a little girl of seven.

From Dinard we moved on to Guernsey, where we spent most of the winter. As a birthday present I was given a surprise of three birds of exotic plumage and colouring. These were named Kiki, Tou-tou and Bébé. Shortly after arrival in Guernsey, Kiki, who was always a delicate bird, died. He had not been long enough in my possession for his decease to occasion violent grief – in any case, Bébé, who was an enchanting small bird, was my favourite – but I certainly enjoyed myself in a lavish way over the obsequies of Kiki. He was splendidly buried in a cardboard box with a lining of satin ribbon supplied by my mother. An expedition was then made out of the town of St. Peter Port to an upland region where a spot was chosen for the funeral ceremonies, and the box was duly buried with a large knot of flowers placed upon it.

All that of course was highly satisfactory, but it did not end there. *'Visiter la tombe de Kiki'* became one of my favourite walks.

The great excitement in St. Peter Port was the flower market. There were lovely flowers of every kind and very cheap. According to Marie it was always the coldest and windiest day when, after inquiring, 'And where shall we go for a walk today, Mees?' Mees would reply with gusto, *'Nous allons visiter la tombe de Kiki.'* Terrible sighs from Marie. A two-mile walk and a great deal of cold wind! Nevertheless, I was adamant. I dragged her to the market, where we purchased exciting camellias or other flowers, and then we took the two-mile walk lashed by wind and frequently rain as well, and placed the floral bouquet with due ceremony upon Kiki's grave. It must run in one's blood to enjoy funerals and funeral observances. Where indeed would archaeology be if it had not been for this trait in human nature? If I was ever taken for a walk in my youth by anyone other than nurses – one of the servants, for instance – we invariably went to the cemetery.

How happy are those scenes in Paris at Père Lachaise, with whole families attending family tombs and making them beautiful for All Souls Day. Honouring the dead is indeed a hallowed cult. Is there behind it some instinctive means of avoiding grief, of becoming so interested in the rites and ceremonies that one almost forgets the departed loved one? I do know this, that however poor a family may be the first thing they save for is their funeral. A sweet old dear who worked for me at one time said, 'Ah, hard times, dearie. Hard times indeed they've been. But one thing, however short I've gone and all the rest of us, I've got my money saved to bury me decent and I'll never touch that. No, not even if I go hungry for days!'

IV

I sometimes think that in my last incarnation, if the theory of reincarnation is right, I must have been a dog. I have a great many of the dog's habits. If anybody is undertaking anything or going anywhere I always want to be taken with them and do it too. In the same way, when returning home after this long absence I acted exactly like a dog. A dog always runs all round the house examining everything, sniffing here, sniffing there, finding out by its nose what has been going on, and visiting all its

'best spots'. I did exactly the same. I went all round the house, then went out in the garden and visited my pet spots there: the tub, the see-saw tree, my little secret post overlooking the road outside in a hiding place up by the wall. I found my hoop and tested its condition, and took about an hour to satisfy myself that all was exactly as it had been before.

The greatest change had taken place in my dog, Tony. Tony had been a small, neat Yorkshire terrier when we went away. He was now, owing to Froudie's loving care and endless meals, as fat as a balloon. She was completely Tony's slave, and when my mother and I went to fetch him home Froudie gave us a long dissertation on how he liked to sleep, what exactly he had to be covered with in his basket, his tastes in food, and what time he liked his walk. At intervals she broke off her conversation with us to speak to Tony. 'Mother's lovely,' she said. 'Mother's handsome.' Tony looked very appreciative at these remarks, but nevertheless seemed to take them as no more than his due. 'And he won't eat a morsel,' said Froudie proudly, 'unless you give it him by hand. Oh no, I have to feed him every single little piece myself.'

I noticed a look in my mother's face, and I could see that Tony was not going to receive quite that treatment at home. We took him home with us in the hired cab which we had got for the occasion, plus his bedding and the rest of his possessions. Tony, of course, was delighted to see us, and licked me all over. When his dinner was prepared and brought, Froudie's warning was proved true. Tony looked at it, looked up at my mother and at me, moved a few steps away and sat down, waiting like a *grand seigneur* to have each morsel fed to him. I gave him a piece and he accepted it graciously, but my mother stopped that.

'It's no good,' she said. 'He will have to learn to eat his dinner properly, as he used to do. Leave his dinner down there. He'll go and eat it presently.'

But Tony did not go and eat it. He sat there. And never have I seen a dog more overcome with righteous indignation. His large, sorrowful, brown eyes went round the assembled family and back to his plate. He was clearly saying, 'I *want* it. Don't you see? I want my *dinner*. Give it to me.' However, my mother was firm.

'Even if he doesn't eat it today,' she said, 'he will tomorrow.'

'You don't think he'll starve?' I demanded.

My mother looked thoughtfully at Tony's immensely broad back.

'A little starvation,' she said, 'would do him a world of good.'

It was not till the following evening that Tony capitulated, and then

he saved his pride by eating his dinner when nobody was in the room. After that there was no further trouble. Days of being treated like a Grand Duke were over, and Tony obviously accepted the fact. Still, he did not forget that for a whole year he had been the beloved darling of another house. Any word of reproof, any trouble he got into, and immediately he would sneak off and trot down to Froudie's house, where he obviously told her that he was not properly appreciated. The habit persisted for quite a long time.

Marie was now Tony's nurse-attendant, in addition to her other duties. It was amusing to see Marie arrive when we were playing downstairs in the evening, an apron tied round her waist, saying politely, '*Monsieur Toni pour le bain*.' Monsieur Tony would immediately try to get down on all fours and slide under the sofa, since he had a poor opinion of the weekly bath. Extracted, he was carried off, his tail drooping and his ears down. Marie would report proudly later on the amount of fleas that were floating on top of the Jeyes fluid.

I must say that now dogs do not seem to have nearly as many fleas as they did in my young days. In spite of baths, brushing and combing, and large amounts of Jeyes fluid, all our dogs always seemed to be full of fleas. Perhaps they frequented stables and played with other flea-ridden dogs more than they do now. On the other hand they were less pampered, and they did not seem to live at the vets as much as dogs do today. I don't remember Tony ever being seriously ill, his coat seemed always in good condition, he ate his meals, which were the scraps from our own dinner, and little fuss was made about his health.

But much more fuss is made about children now than was then the case. Temperatures, unless they were high, were not taken much notice of. A temperature of 102, sustained for twenty-four hours, would probably involve a visit from the doctor, but anything under that was given little attention. Occasionally, after a surfeit of green apples one might have what was termed a bilious attack. Twenty-four hours in bed with starvation usually cured that quite easily. Food was good and varied. I suppose there was a tendency to keep young children on milk and starch far too long, but certainly I, from a young age, had tastes of the steak that was sent up for Nursie's supper, and under-done roast beef was one of my favourite meals. Devonshire cream, too, was eaten in quantities; so much nicer than cod liver oil, my mother used to say. Sometimes one ate it on bread and sometimes with a spoon. Alas! You never see real Devonshire cream in Devon nowadays – not as it used to be – scalded and

taken off the milk in layers with its yellow top standing in a china bowl. There is no doubt about it, my favourite thing has been, is, and probably always will be, *cream*.

Mother, who craved for variety in food as well as in everything else, used from time to time to have a new craze. One time it was 'there's more nourishment in an egg'. On this slogan we had eggs at practically every meal till father rebelled. There was also a fishy period, when we lived on sole and whiting and improved our brains. However, having made the round of the food diets, mother usually returned to the normal; just as, having dragged father through Theosophy, the Unitarian church, a near miss of becoming a Roman Catholic, and a flirtation with Buddhism, she returned at last to the Church of England.

It was satisfactory to come home and find everything just as usual. There was only one change, and that was for the better. I now had my devoted Marie.

I suppose that until I dipped a hand into my bag of remembrances I had never actually *thought* about Marie – she was just Marie, part of my life. To a child the world is simply what is happening to him or her: and that includes the people in it – whom they like, whom they hate, what makes them happy, what makes them unhappy. Marie, fresh, cheerful, smiling, always agreeable, was a much appreciated member of the household.

What I wonder now is what it meant to *her*? She had been, I think, very happy during the autumn and winter that we spent travelling in France and the Channel Islands. She was seeing places, the life in the hotels was pleasant, and, strangely enough, she liked her young charge. I would, of course, like to think that she liked me because I was *me* – but Marie was genuinely fond of children, and would have liked any child that she was looking after, short of one or two of those infantile monsters that one does encounter. I was certainly not particularly obedient to her; I don't think the French have the capacity for enforcing obedience. In many ways I behaved disgracefully. In particular I hated going to bed, and invented a splendid game of leaping round all the furniture, climbing up on wardrobes, down from the tops of chests of drawers, completing the circuit of the room without ever once touching the floor. Marie, standing in the doorway, would moan: 'Oh, *Mees, Mees! Madame votre mère ne serait pas contente!' Madame ma mère* certainly did not know what was going on. If she had made an unexpected appearance, she would have raised her eyebrows, said, 'Agatha! Why are you not in bed?' and

within three minutes I *would* have been in bed, scurrying there, without any further word of admonition. However, Marie never denounced me to authority; she pleaded, she sighed, but she never reported me. On the other hand, if I did not give her obedience, I *did* give her love. I loved her very much.

On only one occasion do I really remember having upset her, and that was entirely inadvertent. It happened after we had come back to England, in the course of an argument on some subject or other which was proceeding quite amicably. Finally, in exasperation, and wishing to prove my point of view, I was saying: '*Mais, ma pauvre fille, vous ne savez donc pas les chemins de fer sont . . .*' At this point, to my utter amazement, Marie suddenly burst into tears. I stared at her. I had no idea what was the matter. Then words came amongst the sobs. Yes – she was indeed a '*pauvre fille*'. Her parents were poor, not rich like those of Mees. They kept a café, where all the sons and daughters worked. But it was not *gentille*, it was not *bien élevée* of her dear Mees to reproach her with her poverty.

'But, Marie,' I expostulated, 'Marie, I didn't mean that *at all*.' It seemed impossible to explain that no idea of poverty had been in my mind, that '*ma pauvre fille*' was a mere expression of impatience. Poor Marie had been hurt in her feelings, and it took at least half an hour of protestations, caresses, and reiterated assurances of affection before she was soothed. After that, all was healed between us. I was terribly careful in future *never* to use that particular expression.

I think that Marie, established at our house in Torquay, felt lonely and homesick for the first time. No doubt in the hotels where we had stayed there had been other maids, nurses, governesses, and so on – cosmopolitan ones – and she had not felt the separation from her family. But here in England she came in contact with girls of her own age, or at any rate of not much more than her own age. We had at that time, I think, a youngish housemaid and a parlourmaid of perhaps thirty. But their point of view was so different from Marie's that it must have made her feel a complete alien. They criticised the plainness of her clothes, the fact that she never spent any money on finery, ribbons, gloves, all the rest of it.

Marie was receiving what were to her fantastically good wages. She asked Monsieur every month if he would be so kind as to remit practically the whole of her pay to her mother in Pau. She herself kept a tiny sum. This was to her natural and proper; she was saving up for her *dot*,

that precious sum of money that all French girls at that time (and perhaps now, I do not know) industriously put by as a dowry – a necessity for the future, for lacking it they may easily not get married at all. It is the equivalent, I suppose, of what we call in England 'my bottom drawer', but far more serious. It was a good and sensible idea, and I think in vogue nowadays in England, because young people want to buy a house and therefore both the man and the girl save money towards it. But in the time I am speaking of, girls did not save up for marriage – that was the man's business. He must provide a home and the wherewithal to feed, clothe and look after his wife. Therefore the 'girls in good service' and the lower class of shop-girls, considered the money they earned was their own to use for the frivolous things of life. They bought new hats, and coloured blouses, an occasional necklace or brooch. One might say, I suppose, that they used their wages as courting money – to attract a suitable male of the species. But here was Marie, in her neat little black coat and skirt, and her little toque and her plain blouses, never adding to her wardrobe, never buying anything unnecessary. I don't think they meant to be unkind, but they laughed at her; they despised her. It made her very unhappy.

It was really my mother's insight and kindness that helped her through the first four or five months. She was homesick, she wanted to go home. My mother, however, talked to Marie, consoled her, told her that she was a wise girl and doing the right thing, that English girls were not as far-seeing and prudent as French girls. She also, I think, had a word with the servants themselves and with Jane, saying that they were making this French girl unhappy. She was far away from home, and they must think what it would be like if *they* were in a foreign country. So after a month or two Marie cheered up.

I feel that, at this point, anyone who has had the patience to read so far will exclaim: 'But didn't you have any lessons to do?'

The answer is, 'No, I did not.'

I was, I suppose, nine years old by now, and most children of my age had governesses – though these were engaged, I fancy, largely from the point of view of child care, to exercise and supervise. What they taught you in the way of 'lessons' depended entirely on the tastes of the individual governesses.

I remember dimly a governess or two in friends' houses. One held complete faith in Dr Brewer's *Child's Guide to Knowledge* – a counterpart

of our modern 'Quiz'. I retain scraps of knowledge thus acquired – 'What are the three diseases of wheat?' 'Rust, mildew, and soot.' Those have gone with me all through life – though unfortunately they have never been of practical use to me. 'What is the principal manufacture in the town of Redditch?' 'Needles.' 'What is the date of the Battle of Hastings?' '1066.'

Another governess, I remember, instructed her pupils in natural history, but little else. A great deal of picking of leaves and berries and wild flowers went on – and a suitable dissection of the same. It was incredibly boring. 'I do hate all this pulling things to pieces,' confided my small friend to me. I entirely agreed, and indeed the word Botany all through my life has made me shy like a nervous horse.

My mother had gone to school in her own youth, to an establishment in Cheshire. She sent my sister Madge to boarding school but was now entirely converted to the view that the best way to bring up girls was to let them run wild as much as possible; to give them good food, fresh air, and not to force their minds in any way. (None of this, of course, applied to boys: boys had to have a strictly conventional education.)

As I have already mentioned, she had a theory that no child should be allowed to read until it was eight. This having been frustrated, I was allowed to read as much as I pleased, and I took every opportunity to do so. The schoolroom, as it was called, was a big room at the top of the house, almost completely lined with books. There were shelves of children's books – *Alice in Wonderland* and *Through the Looking Glass*, the earlier, sentimental Victorian tales which I have already mentioned, such as *Our White Violet*, Charlotte Yonge's books, including *The Daisy Chain*, a complete set, I should think, of Henty, and, besides that, any amount of school-books, novels, and others. I read indiscriminately, picking up anything that interested me, reading quite a lot of things which I did not understand but which nevertheless held my attention.

In the course of my reading I found a French play which father discovered me reading. 'How did you get hold of *that*?' he asked, picking it up, horrified. It was one of a series of French novels and plays which he usually kept carefully locked up in the smoking-room for the perusal of adults only.

'It was in the school-room,' I said.

'It shouldn't have been there,' said father. 'It should have been in my cupboard.'

I relinquished it cheerfully. Truth to tell, I had found it somewhat

difficult to understand. I returned happily to reading *Mémoires d'un Âne*, *Sans Famille*, and other innocuous French literature.

I suppose I must have had lessons of *some* kind, but I did not have a governess. I continued to do arithmetic with my father, passing proudly through fractions to decimals. I eventually arrived at the point where so many cows ate so much grass, and tanks filled with water in so many hours – I found it quite enthralling.

My sister was now officially 'out', which entailed parties, dresses, visits to London, and so on. This kept my mother busy, and she had less time for me. Sometimes I became jealous, feeling that Madge had all the attention. My mother had had a dull girlhood herself. Though her aunt was a rich woman, and though Clara had travelled to and fro across the Atlantic with her, she had seen no reason to give her a social début of any kind. I don't think my mother was socially minded, but she did yearn, as any young girl might, to have a great many prettier clothes and dresses than she had. Auntie-Grannie ordered herself very expensive and fashionable clothes at the best dressmakers in Paris, but she always considered Clara as a child, and more or less dressed her as such. The awful sewing women again! My mother was determined that *her* daughters should have all the pretty-pretties and frivolities of life that she herself had missed. Hence her interest and delight in Madge's clothes, and later in mine.

Mind you, clothes were clothes in those days! There was a great deal of them, lavish both in material and in workmanship. Frills, ruffles, flounces, lace, complicated seams and gores: not only did they sweep the ground and have to be held up in one hand elegantly as you walked along, but they had little capes or coats or feather boas.

There was also hairdressing: hairdressing, too, really was hairdressing in those times – no running a comb through it and that was that. It was curled, frizzed, waved, put in curlers overnight, waved with hot tongs; if a girl was going to a dance she started doing her hair at least two hours earlier and the hairdressing would take her about an hour and a half, leaving her about half an hour to put on her dress, stockings, slippers and so on.

This was not, of course, my world. It was the grown-ups' world, from which I remained aloof. Nevertheless, I was influenced by it. Marie and I discussed the *toilettes* of the Mademoiselles and our special favourites.

It so happened that in our particular road there were no next-door neighbours with children of my age. So, as I had done at a younger age, I once more arranged a set of friends and intimates of my own – in

succession to Poodle, Squirrel and Tree, and the famous Kittens. This time I invented a school. This was not because I had any desire myself to go to school. No, I think that The School constituted the only background into which I could conveniently fit seven girls of varying ages and appearances, giving them different backgrounds instead of making them a family, which I did not want to do. The School had no name – it was just The School.

The first girls to arrive were Ethel Smith and Annie Gray. Ethel Smith was eleven and Annie was nine. Ethel was dark, with a great mane of hair. She was clever, good at games, had a deep voice, and must have been rather masculine in appearance. Annie Gray, her great friend, was a complete contrast. She had pale flaxen hair, blue eyes, and was shy and nervous and easily reduced to tears. She clung to Ethel, who protected her on every occasion. I liked them both, but my preference was for the bold and vigorous Ethel.

After Ethel and Annie, I added two more: Isabella Sullivan, who was rich, golden-haired, brown-eyed, and beautiful. She was eleven years of age. Isabella I did not like – in fact I disliked her a good deal. She was 'worldly'. ('Worldly' was a great word in the story-books of the time: pages of *The Daisy Chain* are devoted to the worries in the May family because of Flora's worldliness.) Isabel was certainly the quintessence of worldliness. She gave herself airs, boasted about being rich, and had clothes that were far too expensive for her and too grand for a girl of her age. Elsie Green was her cousin. Elsie was rather Irish; she had dark hair, blue eyes, curls, and was gay and laughed a good deal. She got on quite well with Isabel, but sometimes ticked her off. Elsie was poor; she wore Isabel's cast-off clothes, which sometimes rankled, but not much, because Elsie was easy-going.

With these four I got on well for some time. They travelled on the tubular railway, they rode horses, they did gardening, they also played a great deal of croquet. I used to arrange tournaments and special matches. My great hope was that Isabel would *not* win. I did everything short of cheating to see that she did not win – that is, I held her mallet for her carelessly, played quickly, hardly aimed at all – yet somehow the more carelessly I played, the more fortunate Isabel seemed to be. She got through impossible hoops, hit balls from right across the lawn, and nearly always finished as winner or runner-up. It was most annoying.

After a while I thought it would be nice to have some younger girls at the school. I added two six-year-olds, Ella White and Sue de Verte. Ella

was conscientious, industrious and dull. She had bushy hair, and was good at lessons. She did well in Dr Brewer's *Guide to Knowledge*, and played quite a fair game of croquet. Sue de Verte was curiously colourless, not only in appearance – she was fair, with pale blue eyes – but also in character: Somehow I couldn't *see* or *feel* Sue. She and Ella were great friends, but though I knew Ella like the back of my hand Sue remained fluid. I think this is probably because Sue was really *myself*. When I conversed with the others, I was always Sue conversing with them, not Agatha; and therefore Sue and Agatha became two facets of the same person, and Sue was an observer, not really one of the dramatis personae. The seventh girl to be added to the collection was Sue's step-sister, Vera de Verte. Vera was an immense age – she was thirteen. She was not at the moment beautiful, but she was going to be a raving beauty in the future. There was also a mystery about her parentage. I had half-planned various futures for Vera of a highly romantic nature. She had straw-coloured hair and forget-me-not blue eyes.

An additional help to 'the girls' were bound copies of Royal Academy pictures which my grandmother had in the house in Ealing. She promised that they should belong to *me* one day, and I used to spend hours looking at them in wet weather, not so much for artistic satisfaction as for finding suitable pictures of 'the girls'. A book that had been given me as a Christmas present, illustrated by Walter Crane – *The Feast of Flora* – represented flower pictures in human form. There was a particularly lovely one in it of forget-me-nots wreathed round a figure who was definitely Vera de Verte. Chaucer's Daisy was Ella, and the handsome Crown Imperial striding along was Ethel.

'The girls', I may say, stayed with me for many years, naturally changing their characters as I myself matured. They participated in music, acted in opera, were given parts in plays and musical comedies. Even when I was grown up I spared them a thought now and then, and allocated them the various dresses in my wardrobe. I also designed model gowns for them in my mind. Ethel, I remember, looked *very* handsome in a dress of dark blue tulle with white arum lilies on one shoulder. Poor Annie was never given much to wear. I was fair to Isabel, though, and gave her some extremely handsome gowns – embroidered brocades, and satins usually. Even now, sometimes, as I put away a dress in a cupboard, I say to myself: 'Yes, that would do well for Elsie, green was always her colour.' 'Ella would look very nice indeed in that three-piece jersey suit.' It makes me laugh when I do it, but there 'the girls' *are* still, though,

unlike me, they have not grown old. Twenty-three is the oldest I have ever imagined them.

In the course of time I added four more characters: Adelaide, who was the oldest of all, tall, fair and rather superior; Beatrice, who was a merry, dancing, little fairy, the youngest of them all; and two sisters, Rose and Iris Reed. I became rather romantic about those two. Iris had a young man who wrote poetry to her and called her 'Iris of the Marshes', and Rose was very mischievous, played tricks on everybody, and flirted madly with all the young men. They were, of course, in due time married off, or remained unmarried. Ethel never married but lived in a small cottage with the gentle Annie – very appropriate, I think now: it's exactly what they would have done in real life.

Soon after our return from abroad the delights of the world of music were opened to me by Fräulein Uder. Fräulein Uder was a short, wiry, formidable, little German woman. I don't know why she was teaching music in Torquay, I never heard anything of her private life. My mother appeared one day in the Schoolroom with Fräulein Uder in tow, explaining she wanted Agatha to start learning the piano.

'Ach!' said Fräulein Uder with a rich German sound, though she spoke English perfectly. 'Then we will at once to the piano go.' To the piano we went – the schoolroom piano, of course, not the grand piano in the drawing-room.

'Stand there,' commanded Fräulein Uder. I stood as placed to the left of the piano. 'That,' she said, thumping the note so hard that I really thought something might happen to it, 'is C Major. You understand? That is the note C. This is the scale of C Major.' She played it. 'Now we go back and play the chord of C, like that. Now again – the scale. The notes are C, D, E, F, G, A, B, C. You understand?'

I said yes. As a matter of fact I knew that much already.

'Now,' said Fräulein Uder, 'you will stand there where you cannot see the notes and I play first C, then another note, and you shall tell me what the second is.'

She hit C, and then hit another note with equal force.

'What is that? Answer me.'

'E,' I said.

'Quite right. Good. Now we will try again.'

Once more she thumped C, and then another note. 'And that?'

'A,' I hazarded.

'Ach, that it first class. Good. This child is musical. You have the ear, yes. Ach, we shall get on famously.'

I certainly got off to a good start. I don't think, to be honest, I had the least idea what the other notes were she was playing. I think it must have been an inspired guess. But anyway, having started on those lines we went ahead with plenty of good will on either side. Before long the houses resounded with scales, arpeggios, and in due course the strains of *The Merry Peasant*. I enjoyed my music lessons enormously. Both father and mother played the piano. Mother played Mendelssohn's *Songs Without Words* and various other 'pieces' that she had learned in her youth. She played well, but was not, I think, a passionate music lover. My father was naturally musical. He could play anything by ear, and he played delightful American songs and negro spirituals and other things. To *The Merry Peasant* Fräulein Uder and I added *Träumerei*, and other of Schumann's delicate little tunes. I practised with zeal for an hour or two a day. From Schumann I proceeded to Greig, which I loved passionately – *Erotique* and the *First Rustle of Spring* were my favourites. When I finally progressed to being able to play the Peer Gynt *Morgen* I was transported with delight. Fräulein Uder, like most Germans, was an excellent teacher. It was not all playing of pleasant tunes; there were masses of Czerny's Exercises, about which I was not quite so zealous, but Fräulein Uder was having no nonsense. 'You must the good grounding have,' she said. 'These exercises, they are the reality, the necessity. The tunes, yes, they are pretty little embroideries, they are like flowers, they bloom and drop off, but you must have the roots, the strong roots and the leaves.' So I had a good deal of the strong roots and the leaves and an occasional flower or two, and I was probably much more pleased with the result than the others in the house, who found so much practising somewhat oppressive.

Then there was also dancing-class, which took place once a week, at something grandiosely called the Athenaeum Rooms, situated over a confectioner's shop. I must have started going to dancing-class quite early – five or six, I think – because I remember that Nursie was still there and took me once a week. The young ones were started off with the polka. Their approach to it was to stamp three times: right, left, right – left, right, left – thump, thump, thump – thump, thump, thump. Very unpleasant it must have been for those having tea at the confectioner's underneath. When I got home I was slightly upset by Madge, who said that that was not how the polka was danced. 'You slide one foot, bring the next up to it, and then the first,' she said, 'like this.' I was rather

puzzled, but apparently it was Miss Hickey's, the dancing-mistress's idea of getting the rhythm of the polka before you did the steps.

Miss Hickey, I remember, was a wonderful if alarming personality. She was tall, stately, had a pompadour of grey hair beautifully arranged, long flowing skirts, and to waltz with her – which happened, of course, much later – was a terrifying experience. She had one pupil teacher of about eighteen or nineteen, and one of about thirteen called Aileen. Aileen was a sweet girl, who worked hard, and whom we all liked very much. The older one, Helen, was slightly terrifying, and only took notice of the really good dancers.

The procedure of dancing-class was as follows. It started with what were called 'expanders', which exercised your chest and arms. They were a sort of blue ribbon elastic with handles. You stretched these vigorously for about half an hour. There was then the polka, which was danced by all once they had graduated from thump, thump, thump – the older girls in the class dancing with the younger ones. 'Have you seen me dance the polka? Have you seen my coat-tails fly?' The polka was merry and unattractive. Then you had the grand march, in which, in pairs, you went up the middle of the room, round the sides, and into various figures of eight, the seniors leading, the juniors following up. You had partners for the march whom you engaged yourself, and a good deal of heart-burning took place over this. Naturally, everybody wished to have as partner either Helen or Aileen, but Miss Hickey saw to it that there were no particular monopolies. After the march the smaller ones were removed to the junior room, where they learned the steps of either the polka or, later, the waltz, or steps in their fancy dances at which they were particularly maladroit. The seniors did their fancy dance under the eye of Miss Hickey in the big room. This consisted of either a tambourine dance, a Spanish castanet dance, or a fan dance.

Talking of the fan dance, I once mentioned to my daughter, Rosalind, and her friend Susan, when they were girls of eighteen or nineteen, that I used to do a fan dance in my youth. Their ribald laughter puzzled me.

'You didn't really, mother, did you? A fan dance! Susan, she did a fan dance!'

'Oh,' said Susan, 'I always thought that Victorians were so particular.'

It dawned on us soon, however, that by a fan dance we did not mean exactly the same thing.

After that the seniors sat out and the juniors did their dance, which was the Sailor's Hornpipe or some gay little folk dance, not too difficult.

Finally we entered into the complications of The Lancers. We were also taught the Swedish Country Dance, and Sir Roger de Coverley. These last were especially useful because when you went to parties you were not shamed by ignorance of such social activities.

At Torquay we were almost entirely girls. When I went to dancing-class in Ealing there was quite a number of boys. This I think was when I was about nine, very shy, and not as yet adept in dancing. A boy of considerable charm, probably a year or two older than I was, came up and asked me to be his partner in The Lancers. Upset and downcast, I said that I couldn't dance The Lancers. It seemed to me hard; I had never seen so attractive a boy. He had dark hair, merry eyes, and I felt at once that we were going to be soul-mates. I sat down sadly when The Lancers began, and almost immediately Mrs Wordsworth's representative came up to me. 'Now, Agatha, we can't have anyone sitting out.'

'I don't know how to dance The Lancers, Mrs Wordsworth.'

'No, dear, but you can soon learn. We must find you a partner.'

She seized a freckled boy with a snub nose and sandy hair; he also had adenoids. 'Here you are. Here is William.' During The Lancers, when we were engaged in visiting, I came up against my first love and his partner. He whispered to me, in dudgeon: 'You wouldn't dance with *me*, and here you are. It is very unkind of you.' I tried to tell him that I couldn't help it, that I had thought I couldn't dance The Lancers but I was told I had to – but there is not time when you are visiting in The Lancers to enter into explanations. He continued to look reproachfully at me until the end of the dancing-class. I hoped I might meet him the following week, but alas I never saw him again: one of life's sad love stories.

The waltz was the only dance I learned that was going to be useful to me through life, and I have never really liked waltzing. I do not like the rhythm, and I always used to get exceedingly giddy, especially when honoured by Miss Hickey. She had a wonderful sweep round in the waltz, which practically took you off your feet, and which left you at the end of the performance with your head reeling, hardly able to stand up. But I must admit that it was a beautiful sight to watch her.

Fräulein Uder disappeared from my life; I don't know where or when. Perhaps she went back to Germany. She was replaced a little later by a young man called, as far as I remember, Mr Trotter. He was the organist of one of the churches; was rather a depressing teacher, and I had to adopt an entirely different style. I had to sit practically on the floor, with my hands reaching upward to get to the keys of the piano, and everything

had to be played from the wrist. Fräulein Uder's method, I think, must have been to sit high and play from the elbows. One was more or less poised above the piano so as to be able to come down on the keys with maximum power. Very satisfactory!

V

It must have been shortly after our return from the Channel Isles that the shadow of my father's illness began to be felt. He had not been well abroad, and had twice consulted a doctor. The second doctor had propounded a somewhat alarmist view, namely that my father suffered from a kidney disease. After our return to England he consulted our own doctor, who did not agree with that diagnosis and who sent him to a specialist. After that, the shadow was there, faint, felt only by a child as one of those atmospheric disturbances which are to the psychic world as an approaching thunderstorm is to the physical one.

Medical science seemed to be of little use. Father went to two or three specialists. The first one said it was definitely a heart condition. I don't remember the details of it now; I only remember listening to my mother and sister talking, and the words 'an inflammation of the nerves surrounding the heart,' which sounded to me very frightening. Another doctor who was consulted put it down entirely to gastric trouble.

At increasingly short intervals my father had attacks of pain and breathlessness during the night, and my mother sat up with him, altering his position and giving him such medicaments as had been ordered by the last doctor.

As always there was a pathetic belief in the last doctor whom we had consulted, and the latest regime or treatment that we adopted. Faith does a lot – faith, novelty, a dynamic personality in a doctor – but it cannot in the end deal with the real organic complaint that is at the bottom of it.

Most of the time my father was his usual cheerful self, but the atmosphere of our home altered. He still went to the club, spent his summer days at the cricket ground, came back with amusing stories – was the same kindly personality. He was never cross or irritable, but the shadow of apprehension was there – also felt, of course, by my mother, who made

valiant attempts to reassure my father and to tell him that he looked better, felt better, *was* better.

At the same time the shadow of financial worry darkened. The money from my grandfather's will had been invested in house property in New York, but the buildings were leasehold, not freehold. By now, apparently, they were in a part of the city where the land would have been valuable, but the buildings were worth practically nothing. The owner of the land was, I gather, unco-operative – an elderly woman of seventy odd, who appeared to have a stranglehold, preventing any development or improvement. The income that should have come over seemed always to be swallowed up in repairs or taxation.

Catching scraps of conversation which seemed to me of dramatic import, I hurried upstairs and announced to Marie in the best manner of Victorian stories that we were ruined. Marie did not seem to me as distressed as I thought she ought to have been, however, she must have attempted some condolence with my mother, who came to me with some annoyance.

'Really, Agatha, you must *not* repeat things in an exaggerated way. We are *not* ruined. We are just badly off for the time being and will have to economise.'

'*Not* ruined?' I said, deeply chagrined.

'Not ruined,' said my mother firmly.

I must admit that I was disappointed. In the many books I had read ruin happened frequently, and was treated as it should be treated – seriously. There would be threats of blowing out one's brains, a heroine leaving a rich mansion in rags, and so on.

'I forgot you were even in the room,' said my mother. 'But you understand, no repeating of things that you overhear.'

I said I would not, but I felt injured because only a short time before I had been criticised for *not* telling what I had overheard of another incident.

Tony and I had been seated under the dining-room table one night just before dinner. It was a favourite place of ours, suitable for the playing of adventures in crypts, dungeons, and the like.

We were hardly daring to breathe, so that the robbers who had imprisoned us should not hear us – this was not true of Tony who was fat and panted – when Barter, the housemaid who assisted the parlourmaid at dinner, came in with the tureen of soup which she placed on the sideboard hot plate. She lifted the lid and inserted the big soup ladle.

Ladling out a spoonful, she took some swigs from it. Lewis, the parlour-maid, came in and said: 'I am just going to ring the gong –' then broke off and exclaimed, 'Why, Louie, whatever *are* you doing?'

'Just refreshing myself,' said Barter, with a hearty laugh. 'Mm, not bad soup,' and she took another swig.

'Now, you put that back and the lid on,' said Lewis, shocked. 'Really!'

Barter laughed her fat good-natured chuckle, put back the ladle, replaced the lid, and departed to the kitchen for the soup plates as Tony and I emerged.

'Is it good soup?' I inquired with interest, as I prepared to take myself off.

'Oh, I never! Miss Agatha, you give me such a fright, you did.'

I was mildly surprised, but never mentioned it until one day a couple of years later. My mother, talking to Madge, mentioned our former housemaid, Barter. I suddenly broke into the conversation, saying, 'I remember Barter. She used to drink soup out of the tureen in the dining-room before you all came into dinner.'

This caused lively interest on the part of both my mother and Madge. 'But why didn't you ever *tell* me?' asked mother. I stared at her. I couldn't see the point.

'Well,' I said, 'it seemed –' I hesitated, mustering all my dignity, and proclaimed: 'I don't care for parting with information.'

After that it was always a joke brought up against me. '*Agatha doesn't like parting with information.*' It was true enough. I didn't. Unless they struck me as apposite or interesting, I tucked away any scraps of information that came to me, locked them up, as it were, in a file inside my head. This was incomprehensible to the rest of my family, who were all extrovert talkers. If asked to keep a secret they never by any chance remembered to do so! It made them all much more entertaining than I was.

If Madge went to a dance or to a garden party, when she came back she had quantities of amusing things to tell. Indeed my sister was an entertaining person in every way – wherever she went things happened to her. Even later in life, going down the village to do a little marketing, she would come back with something extraordinary that had occurred or something somebody had said. These things were not untruths, either – there was always a good foundation of fact, but worked up by Madge to make a better story.

I, on the contrary, presumably taking after my father in this respect,

when asked if anything amusing had happened, would immediately say, 'Nothing'. 'What was Mrs So-and-so wearing at the party?' 'I don't remember.' 'Mrs S. has done up her drawing-room again I hear; what colour is it now?' 'I didn't look.' 'Oh, Agatha, you really are *hopeless*, you never notice *anything*.'

I continued on the whole to keep my own counsel. I don't think I meant to be secretive. It just seemed to me that most things didn't matter – so why keep talking about them? Or else I was so busy conducting the conversations and quarrels of 'the girls' and inventing adventures for Tony and myself that I could not pay attention to the small affairs going on round me. It took something like a rumour of ruin to get me really aroused. Undoubtedly I was a dull child, with every prospect of growing up to be the kind of person who is most difficult to integrate properly in a party.

I have never been good at parties – and never much enjoyed them. I suppose there *were* children's parties, but I don't think there were nearly as many then as there are nowadays. I do remember going to tea with friends and friends coming to tea with me. That I did enjoy – and do nowadays. Set Parties, I think, in my youth only happened round Christmas time. I seem to remember one fancy-dress party and another at which there was a conjuror.

I fancy my mother was anti-party, being of the opinion that children got too hot, over-excited and over-eaten, and frequently came home and were sick from all three causes. She was probably right. At any children's parties of any size that I have gone to, I have come to the conclusion that at least a third of the children are not really enjoying themselves.

A party is controllable up to twenty in number – beyond that, I should say, it is dominated by a lavatory complex! Children who want to go to the lavatory, who don't like to say they want to go to the lavatory, leave going to the lavatory till the last minute, and so on. If the lavatories are inadequate to deal with large quantities of children who all want to use them at once, chaos and some regrettable incidents ensue. I remember one little girl of only two whose mother had been persuaded, against the advice of her experienced Nanny, to bring her child to one party. 'Annette is so sweet, she must come. I'm sure she will enjoy it, and we'll all take *great* care of her.' As soon as they got to the party her mother, to be on the safe side, marched her to a potty. Annette, worked up to a fever of excitement, was quite unable to do her little performance. 'Oh, well, perhaps she doesn't really want to go,' said the mother

hopefully. They came downstairs and when a conjuror was producing things of every kind from his ears and his nose, and making the children laugh, and they were all standing round shouting and clapping their hands, the worst happened.

'My dear,' said an elderly aunt, recounting this to my mother. 'You really have never seen anything like it – poor child. Right in the middle of the floor. Just like a *horse*, it was!'

Marie must have left some time before my father's death – possibly a year or two. She had contracted to come for two years to England, but she stayed on at least a year after. She was homesick for her family and, also, I think, being sensible and practical, realised it was time for her to think in a serious French way about marriage. She had saved up a very nice little *dot* from her wages, and so, with tears, fond embraces to her 'dear Mees', Marie went, and left me very lonely.

We had, however, before she departed, come to an agreement on the subject of my sister's future husband. That, as I have said, had been one of our continual sources of speculation. Marie's selection had been firmly '*le Monsieur blond*'.

My mother, as a girl living with her aunt in Cheshire, had had a school-friend to whom she was much devoted. When Annie Browne married James Watts and my mother married her step-cousin Frederick Miller the two girls agreed that they would never forget each other and that they would always exchange letters and news. Although my grandmother left Cheshire for London, the two girls still kept in touch with each other. Annie Watts had five children – four boys and a girl – mother, of course, had three. They exchanged photographs of their children at various ages, and sent presents to them at Christmas.

So when my sister was going on a visit to Ireland, to make up her mind whether she was going to get engaged to a certain young man who was anxious to marry her, my mother mentioned Madge's journey to Annie Watts, and Annie begged Madge to come and stay at Abney Hall in Cheshire, on her way back from Holyhead. She would so much like to see one of mother's children.

Madge, therefore, having had a good time in Ireland and having decided that she did *not* want to marry Charlie P. after all, broke her journey back and stayed with the Watts family. The eldest son, James, who was then twenty-one or twenty-two, and was still at Oxford, was a quiet fair-haired young man. He had a soft low voice and did not speak much, and

he paid much less attention to my sister than most young men did. She found this so extraordinary that it excited her interest. She took a good deal of trouble over James, but was not sure what effect she had made. Anyway, after she came home, desultory correspondence took place between them.

Actually James had been bowled over by her from the first moment she appeared, but it was not in his nature to display such emotion. He was shy and reserved. He came to stay with us the following summer. I took a great fancy to him at once. He was kind to me, always treating me seriously, and not making silly jokes or talking to me as though I was a little girl. He treated me as an individual, and I became devoted to him. Marie also thought well of him. So 'le Monsieur blond' was constantly discussed between us in the sewing room.

'I don't think they really seem to care for each other very much, Marie.'

'Ah, *mais oui*, he thinks of her a great deal, and he watches her when she is not looking. Oh yes, *il est bien épris*. And it would be a good marriage, very sensible. He has the good prospects, I hear, and is *tout à fait un garçon serieux*. He will make a very good husband. And Mademoiselle, she is gay, witty, full of fun and laughter. It will suit her well to have a quiet and steady husband, and he will appreciate her because she is so different.'

The person who didn't like him, I think, was my father, but I believe that is almost inevitable with the fathers of charming and gay daughters – they want somebody much better than could ever have been born at all. Mothers are supposed to feel the same about their sons' wives. As my brother never married, my mother was not affected that way.

I must say, she never considered that her daughters' husbands were good enough for them, but she admitted herself that that was a failing on her part rather than a failing on theirs. 'Of course,' she said, 'I can't think *any* man would be good enough for either of my two daughters.'

One of the great joys in life was the local theatre. We were all lovers of the theatre in my family. Madge and Monty went practically every week and usually I was allowed to accompany them. As I grew older it became more and more frequent. We went to the pit stalls always – the pit itself was supposed to be 'rough'. The pit cost a shilling and the pit stalls, which were two rows of seats in front, behind about ten rows of stalls, were where the Miller family sat, enjoying every kind of theatrical entertainment.

I don't know whether it was the first play I saw, but certainly among the first was *Hearts are Trumps*, a roaring melodrama of the worst type. There was a villain in it, the wicked woman was called Lady Winifred, and there was a beautiful girl who had been done out of a fortune. Revolvers were fired, and I clearly remember the last scene, when a young man hanging by a rope from the Alps cut the rope and died heroically to save either the girl he loved or the man whom the girl he loved loved. I remember going through this story point by point. 'I suppose,' I said, 'that the really bad ones were Spades' – father being a great whist player, I was always hearing talk of cards – 'and the ones who weren't quite so bad were Clubs. I think perhaps Lady Winifred was a Club – because she repented – and so did the man who cut the rope on the mountain. And the diamonds –' I reflected. 'Just worldly,' I said, in my Victorian tone of disapproval.

One of the great yearly events was the Torquay Regatta, which took place on the last Monday and Tuesday in August. I started saving up for it at the beginning of May. When I say I remember the Regatta I do not so much mean the yacht racing as the Fair which accompanied it. Madge, of course, used to go with father to Haldon Pier to watch the sailing, and we usually had a house party staying for the Regatta Ball in the evening. Father, mother and Madge used to go to the Regatta Yacht Club tea in the afternoon, and all the various functions connected with sailing. Madge never did more sailing than she could help, because she was, throughout her life, an incurably bad sailor. However, a passionate interest was taken in our friends' yacht. There were picnics and parties, but this was the social side of the Regatta in which I was too young to participate.

My looked-forward-to joy in life was the Fair. The merry-go-rounds, where you rode on horses with manes, round and round and round, and a kind of switchback where you tore up and down slopes. Two machines blared music, and as you came round on the horses and the switchback cars, the tunes combined to make a horrible cacophony. Then there were all the shows – the Fat Woman; Madame Arensky, who told the Future; the Human Spider, horrible to look at; the Shooting Gallery, where Madge and Monty spent always a great deal of time and money. And there were coconut shies, from which Monty used to obtain large quantities of coconuts and bring them home to me. I was passionately fond of coconut. I was given a few shies at the coconuts myself, gallantly allowed so far forward by the man in charge that I sometimes actually managed to

knock a coconut off. Coconut shies were *proper* coconut shies then. Nowadays there are still shies, but the coconuts are so arranged in a kind of saucer that nothing but the most stupendous mixture of luck and strength would topple one. Then one had a sporting chance. Out of six shots you usually got one, and Monty once got five.

The hoop-las, the Kewpie dolls, the pointers and all those things had not arrived yet. There were various stalls that sold things. My particular passion was what were known as penny monkeys. They cost a penny, and they were fluffy little representations of monkeys on a long pin which you stuck into your coat. Every year I purchased six to eight of these, and added them to my collection – pink, green, brown, red, yellow. As the years went by it became more difficult to find a different colour or a different pattern.

There was also the famous nougat, which only appeared at the Fair. A man stood behind a table chopping nougat from an enormous pink and white block in front of him. He yelled, shouted, and offered bits for auction. 'Now, friends, sixpence for a stupendous piece! All right, love, cut it in half. Now then, what about that for fourpence?' and so on and so on. There were some ready-made packets which you could buy for twopence, but the fun was entering the auction. 'There, to the little lady there. Yes, twopence halfpenny to you.'

Goldfish did not arrive as a novelty in the Regatta until I was about twelve. It was a great excitement when they did. The whole stall was covered with goldfish bowls, one fish in each, and you threw ping-pong balls for them. If a ball lodged in the mouth of one of the bowls, the goldfish was yours. That, like the coconuts, was fairly easy to begin with. The first Regatta they appeared we got eleven between us, and bore them home in triumph to live in the Tub. But the price had soon advanced from a penny a ball to sixpence a ball.

In the evening there were fireworks. Since we could not see them from our house – or only the very high rockets – we usually spent the evening with some friends who lived just over the harbour. It was a nine o'clock party, with lemonade, ices and biscuits handed round. That was another delight of those days that I miss very much, not being of an alcoholic persuasion – the garden parties.

The garden parties of pre-1914 were something to be remembered. Everyone was dressed up to the nines, high-heeled shoes, muslin frocks with blue sashes, large leghorn hats with drooping roses. There were lovely ices – strawberry, vanilla, pistachio, orange-water and raspberry-

water was the usual selection – with every kind of cream cake, of sandwich, of éclair, and peaches, muscat grapes, and nectarines. From this I deduce that garden parties were practically always held in August. I don't remember any strawberries and cream.

There was a certain pain in getting there, of course. Those who hadn't got carriages took a hired cab if they were aged or infirm, but all the young people walked a mile and a half to two miles from different parts of Torquay; some might be lucky and live near, but others were always bound to be a good way away, because Torquay is built on seven hills. There is no doubt that walking up hills in high-heeled shoes, holding up one's long skirt in one's left hand and one's parasol in the right, was something of an ordeal. It was worth it, however, to get to the garden party.

My father died when I was eleven. His health had got slowly worse, but his illness seems never to have been precisely diagnosed. There is no doubt that constant financial worry weakened his resistance to illness of any kind.

He had been at Ealing, staying with his stepmother for about a week, and seeing various friends in London who might be able to help him find some kind of job. Finding jobs was not an easy thing to do at that particular date. Either you were a lawyer or a doctor or managed an estate, were in one of the services, or were a barrister, but the great world of business did not provide the livelihood that we expect of it nowadays. There were big financial banking houses, such as Pierpont Morgan's, and others in which my father had some acquaintances, but everyone was of course a professional – either you belonged to one of the banking houses and had been in it ever since you were a boy, or you did not. My father, like most of his contemporaries, was not trained for anything. He did a great deal of charitable work, and other things that would nowadays provide a paid position, but it was very different then.

His financial position was perplexing to him, and indeed perplexed his executors after his death. It was a question of where the money left by my grandfather had disappeared to. My father had lived well within his supposed income. It was there on paper, but it was never there in fact, and there always seemed to be plausible excuses to explain this and to show that this default would only be temporary – just a matter of special repairs. The estate was no doubt mismanaged by the Trustees and by their successors, but it was too late to remedy that.

He worried, the weather was cold, he caught a bad chill, and double pneumonia developed. My mother was sent for to Ealing, and presently Madge and I followed her there. He was by then very ill. My mother never left him, night or day. We had two hospital nurses in the house. I wandered about, unhappy and frightened, praying earnestly that father might get well again.

One picture remains etched in my mind. It was afternoon. I was standing on the half landing. Suddenly the door of father and mother's bedroom opened. My mother came out in a kind of rush, her hands held to her head over her eyes. She rushed from there into the adjoining room and shut the door behind her. A hospital nurse came out and spoke to Grannie, who was coming up the stairs. 'It's all over,' she said. I knew then that my father was dead.

They did not take a child to the funeral of course. I wandered about the house in a queer state of turmoil. Something awful had happened, something that I had never envisaged *could* happen. The blinds of the house were pulled down, the lamps were lit. In the dining-room, in her big chair, Grannie sat writing endless letters, in her own peculiar style. From time to time she shook her head sadly.

Except when she got up to go to the funeral, my mother lay in her room. She did not eat anything for two days, because I heard Hannah commenting on the fact. I remember Hannah with gratitude. Dear old Hannah, with her worn, lined face. She beckoned me to the kitchen and told me she needed someone to help her mix pastry. 'They were very devoted,' said Hannah, again and again. 'It was a good marriage.'

Yes, it was indeed a good marriage. I found among various old things, a letter written by my father to my mother, possibly only three or four days before his death. He wrote of how he longed to return to her at Torquay; nothing satisfactory had been arranged in London, but he felt, he said, he would forget it all when he was back with his dearest Clara again. He went on to say that he had told her often before but he wanted to tell her again how much she meant to him. 'You have made all the difference in my life,' he said. 'No man ever had a wife like you. Every year I have been married to you I love you more. I thank you for your affection and love and sympathy. God bless you, my dearest, we shall soon be together again.'

I found this letter in an embroidered pocket-book. It was the pocket-book my mother had worked for him as a young girl and sent to him in

America. He had always kept it, and in it he kept two poems she had written him. My mother added this letter to it.

The house at Ealing had a somewhat ghoulish character these days. It was full of whispering relatives – Granny B, uncles, the wives of uncles, courtesy aunts, Grannie's old lady cronies – they all half-whispered, sighed, shook their heads. And everyone wore heavy black – I too had black clothes. I must say my mourning clothes were about the only consolation to me at that time. I felt important, worth-while and part of things when I put on my black clothes.

Then there were more whispers of 'Really, Clara *must* be made to rouse herself.' At intervals Grannie would say, 'Wouldn't you like to read this letter I've had from Mr B. or Mrs C.? Such a beautiful letter of condolence, really I think you would feel *most* touched by it.' My mother would say fiercely, 'I don't want to see it'.

She opened her own letters but threw them aside almost immediately. Only one she treated differently. 'Is that from Cassie?' Grannie asked. 'Yes, Auntie, it's from Cassie.' She folded it up and put it in her bag. 'She understands,' she said, and she went out of the room.

Cassie was my American godmother, Mrs Sullivan. I had probably seen her as a small child, but I only remember her when she came to London about a year later. She was a wonderful person: a little woman with white hair and the gayest, sweetest face imaginable, bursting with vitality, with a strange joyousness about her – yet she had had one of the saddest lives possible. Her husband, to whom she was devoted, had died quite young. She had had two lovely boys, and they too had died, paralysed. 'Some nursemaid,' said my grandmother, 'must have let them sit on the damp grass.' Really, I suppose, it must have been a case of polio – not recognised at that time – which was always called rheumatic fever, the result of *damp*, and which resulted in crippling paralysis. Anyway, her two children had died. One of her grown-up nephews, who was staying in the same house, also had suffered from paralysis and remained crippled for life. Yet, in spite of her losses, in spite of everything, Aunt Cassie was gay, bright, and full of more human sympathy than anyone I have ever known. She was the one person mother longed to see at that time. 'She understands, it is no good making consoling phrases at people.'

I remember that I was used as an emissary by the family, that somebody – perhaps Grannie, or perhaps one of my aunts – took me aside and murmured that I must be my mamma's little comforter, that I must go

into the room where my mother was lying and point out to her that father was happy now, that he was in Heaven, that he was at peace. I was willing – it was what I believed myself, what surely everyone believed. I went in, a little timid, with the vague feeling which children have when they are doing what they have been *told* is right, and what they *know* is right, but which they feel may, somehow or other, for a reason that they don't know, be *wrong*. I went timidly up to mother and touched her. 'Mummy, father is at peace now. He is happy. You wouldn't want him back, would you?'

Suddenly my mother reared up in bed, with a violent gesture that startled me into jumping back. 'Yes, I would,' she cried in a low voice. 'Yes, I would. I would do anything in the world to have him back – anything, anything at all. I'd force him to come back, if I could. I want him, I want him back *here*, now, in this world with *me*.'

I shrank away, rather frightened. My mother said quickly, 'It's all right, darling. It's all right. It's just that I am not – not very well at present. Thank you for coming.' And she kissed me and I went away consoled.

PART III

GROWING UP

I

Life took on a completely different complexion after my father's death. I stepped out of my child's world, a world of security and thoughtlessness, to enter the fringes of the world of reality. I think there is no doubt that from the man of the family comes the stability of the home. We all laugh when the phrase comes, 'Your father knows best,' but that phrase does represent what was so marked a feature of later Victorian life. Father – the rock upon which the home is set. Father likes meals punctually; Father mustn't. be worried after dinner; Father would like you to play duets with him. You accept it all unquestioningly. Father provides meals; Father sees that the house works to rule; Father provides music lessons.

Father took great pride and pleasure in Madge's company as she grew up. He enjoyed her wit and her attractiveness; they were excellent companions to each other. He found in her, I think, some of the gaiety and humour my mother probably lacked – but he had a soft spot in his heart for his little girl, the afterthought, little Agatha. We had our favourite rhyme:

> Agatha-Pagatha my black hen,
> She lays eggs for gentlemen,
> She laid six and she laid seven,
> And one day she laid eleven!

Father and I were very fond of that particular joke.

But Monty, I think, was really his favourite. His love for his son was more than he would feel for any daughter. Monty was an affectionate boy,

114

and he had great affection for his father. He was, alas, unsatisfactory from the point of view of making a success of life, and father was unceasingly worried about this. In a way, I think, his happiest time, where Monty was concerned, was after the South African War. Monty obtained a commission in a regular regiment, the East Surreys, and went straight from South Africa, with his regiment, to India. He appeared to be doing well and to have settled down in his army life. In spite of father's financial worries, Monty at least was one problem removed for the time being.

Madge married James Watts about nine months after my father's death, though a little reluctant to leave mother. Mother herself was urgent that the marriage should take place, and that they should not have to wait longer. She said, and truly I think, that it would be even more difficult for her to part with Madge as time went on and their companionship drew them closer. James's father was anxious for him to marry young. He was just leaving Oxford, and would go straight into the business, and he said it would be happier for him if he could marry Madge and settle down in their own home. Mr Watts was going to build a house for his son on part of his land, and the young couple could settle down there. So things were arranged.

My father's American executor, Auguste Montant, came from New York and stayed with us a week. He was a large stout man, genial, very charming, and nobody could have been kinder to my mother. He told her frankly that father's affairs were in a bad mess, and that he had been extremely ill advised by lawyers and others who had pretended to act for him. A lot of good money had been thrown after bad by trying to improve the New York property by half-hearted measures. It was better, he said, that a good deal of the property should be abandoned altogether to save taxes. The income that was left would be very small. The big estate my grandfather had left had disappeared into thin air. H. B. Claflin & Co., the firm in which my grandfather had been partner, would still provide Grannie's income, as the widow of a partner, and also a certain income for mother, though not a large one. We three children, under my grandfather's will, would get, in English currency, £100 a year each. The rest of the vast amount of dollars had been also in property, which had gone down hill and fallen derelict, or had been sold off in the past for far too little.

The question arose now whether my mother could afford to live on at Ashfield. Here, I think, mother's own judgment was better than anyone

else's. She thought definitely that it would be a bad thing to stay on. The house would need repairs in the future, and it would be difficult to manage on a small income – possible but difficult. It would be better to sell the house and to buy another smaller house somewhere in Devonshire, perhaps near Exeter, which would cost less to run and would leave a certain amount of money from the exchange to add to income. Although my mother had no business training or knowledge, she had really quite a lot of common sense.

Here, however, she came up against her children. Both Madge and I, and my brother, writing from India, protested violently against selling Ashfield, and begged her to keep it. We said it was our home and we couldn't bear to part with it. My sister's husband said he could always spare mother a small addition to her income. If Madge and he came down in the summers they could help with the running expenses. Finally, touched I think by my violent love for Ashfield, mother gave in. She said at any rate we would try how we got on.

I now suspect that mother herself had never really cared for Torquay as a place to live. She had a great passion for cathedral towns, and she had always been fond of Exeter. She and my father sometimes went for a holiday touring various cathedral towns – to please her, I think, not my father – and I believe she rather enjoyed the idea of living in a much smaller house near Exeter. However, she was an unselfish person, and fond of the house itself, so Ashfield continued to be our home, and I continued to adore it.

To have kept it on was not a wise thing, I know that now. We could have sold it and bought a much more manageable house. But though my mother recognised that at the time, and must indeed have recognised it very much better later, yet I think she was content to have had it so. Because Ashfield has meant something to me for so many years. It has been there, my background, my shelter, the place where I truly belong. I have never suffered from the absence of roots. Though to hold on to it may have been foolish, it gave me something that I value, a treasure of remembrance. It has also given me a lot of trouble, worry, expense, and difficulties – but surely for everything you love you have to pay some price?

My father died in November, my sister's marriage took place the following September. It was quiet, with no reception afterwards, owing to the mourning still observed for my father's death. It was a pretty wedding and took place in old Tor church. With the importance of being

first bridesmaid I enjoyed it all immensely. The bridesmaids all wore white, with white wreaths of flowers on their heads.

The wedding took place at eleven in the morning, and we had the wedding breakfast at Ashfield. The happy couple were blest not only with lots of lovely wedding presents but with every variety of torture that could have been thought up by my boy cousin Gerald and myself. All through their honeymoon rice fell out of every garment they removed from suit-cases. Satin shoes were tied on to the carriage in which they drove away, and chalked on the back, *after* it had first been carefully examined to make sure that nothing of the kind had occurred, were the words 'Mrs Jimmy Watts is a first-class name'. So off they drove to a honeymoon in Italy.

My mother retired to her bed exhausted and weeping, and Mr and Mrs Watts to their hotel – Mrs Watts no doubt also to weep. Such appears to be the effect of weddings on mothers. The young Wattses, my cousin Gerald and I were left to view each other with the suspicion of strange dogs, and try to decide whether or not we were going to like each other. There was a great deal of natural antagonism at first between Nan Watts and me. Unfortunately, but in the fashion of the day, we had each been given harangues about the other by our respective families. Nan, who was a gay boisterous tomboy, had been told now nicely Agatha always behaved, 'so quiet and polite'. And while Nan had my decorum and general solemnity praised to her *I* had been admonished on the subject of Nan, who was said to be 'never shy, always answered when she was spoken to – never flushed, or muttered, or sat silent'. We both therefore looked at each other with a great deal of ill-will.

A sticky half-hour ensued, and then things livened up. In the end we organised a kind of steeple-chase round the school-room, doing wild leaps from piled-up chairs and landing always on the large and somewhat elderly chesterfield. We were all laughing, shouting, screaming, and having a glorious time. Nan revised her opinion of me – here was some-body anything but quiet, shouting at the top of her voice. I revised my opinion of Nan as being stuck-up, talking too much, and 'in' with the grown-ups. We had a splendid time, we all liked each other, and the springs of the sofa were permanently broken. Afterwards there was a snack meal and we went to the theatre, to *The Pirates of Penzance*. From that time the friendship never looked back and continued intermittently all through out lives. We dropped it, picked it up, and things seemed just the same when we came together again. Nan is one of the friends I miss

most now. With her, as with few others, I could talk together of Abney and Ashfield and the old days, the dogs, and the pranks we played, and our young men, and the theatricals we got up and acted in.

After Madge's departure the second stage of my life began. I was a child still, but the first phase of childhood had ended. The brilliance of joy, despair of sorrow, the momentous importance of every day of one's life: those things are the hallmark of childhood. With them go security and the complete lack of thought for the morrow. We were no longer the Millers – a family. We were now just two people living together: a middle-aged woman and an untried, naive girl. Things *seemed* the same, but the atmosphere was different.

My mother had bad heart attacks since my father's death. They came on her with no warning, and nothing that the doctors gave her helped. I knew for the first time what it was to feel anxiety for other people, whilst at the same time being a child still, so that my anxiety was naturally exaggerated. I used to wake up at night, my heart beating, sure that mother was dead. Twelve or thirteen may be a natural time of anxiety. I knew, I think, that I was being foolish and giving way to exaggerated feelings, but there it was. I would get up, creep along the corridor, kneel down by my mother's door with my head to the hinge, trying to hear her breathing. Very often I was quickly reassured – a welcome snore rewarded me. Mother had a special style of snoring, beginning daintly and *pianissimo* and working up to a terrific explosion, after which she would usually turn over and there would be no repetition of the snoring for at least another three quarters of an hour.

If I heard a snore then, delighted, I went back to bed and to sleep; but if there happened to be none, I remained there, crouching in miserable apprehension. It would have been far more sensible if I had opened the door and walked in to reassure myself, but somehow that does not seem to have occurred to me, or possibly mother always locked her door at night.

I did not tell mother about these terrible fits of anxiety, and I don't think she ever guessed at them. I used also to have fears, when she had gone out into the town, that she might have been run over. It all seems silly now, so unnecessary. It wore off gradually, I think, and probably lasted only for a year or two. Later I slept in father's dressing-room, off her bedroom, with the door slightly ajar, so that if she did have an attack in the night I could go in, raise her head, and fetch her brandy and sal

volatile. Once I felt that I was on the spot, I no longer suffered from the awful pangs of anxiety. I was, I suppose, always over-burdened with imagination. That has served me well in my profession – it must, indeed, be the basis of the novelist's craft – but it can give you some bad sessions in other respects.

The conditions of our life changed after my father's death. Social occasions practically ceased. My mother saw a few old friends but nobody else. We were very badly off and had to economise in every way. It was, of course, all we could do to keep up Ashfield. My mother no longer gave luncheon or dinner parties. She had two servants instead of three. She tried to tell Jane that we were now badly off and that she would have to manage with two young, inexpensive maids, but she stressed that Jane, with her magnificent cooking, could command a large salary, and that she ought to have it. Mother would look about and find Jane a place where she would get good wages and also have a kitchenmaid under her. 'You deserve it,' said mother.

Jane displayed no emotion; she was eating at the time, as usual. She nodded her head slowly, continued to chew, then said: 'Very well, Ma'am. Just as you say. You know best.'

The next morning, however, she reappeared. 'I'd just like a word with you, Ma'am. I've been thinking things over and I would prefer to stay here. I quite understand what you said, and I would be prepared to take less wages, but I have been here a very long time. In any case, my brother's been urging me to come and keep house for him and I have promised I will do so when he retires; that will probably be in four or five year's time. Until then I would like to stay here.'

'That is very, very good of you,' said my mother, emotionally. Jane, who had a horror of emotion, said, 'It will be convenient,' and moved majestically from the room.

There was only one drawback to this arrangement. Having cooked in one way for so many years, Jane could not stop cooking in the same strain. If we had a joint it was always an enormous roast. Colossal beefsteak pies, huge tarts, and gargantuan steam puddings would be put on the table. Mother would say, 'Only enough for *two*, remember, Jane,' or 'Only enough for four,' but Jane could never understand. Jane's own scale of hospitality was terribly expensive for the household; every day of the week, seven or eight of her friends were wont to arrive for tea, and eat pastries, buns, scones, rock cakes and jam tarts. In the end, in desperation, seeing the household books mounting up, my mother said

gently that perhaps, as things were different now, Jane would have one day a week when she could have her friends. This would save a certain amount of waste, in case a lot was cooked and then people did not turn up. Thenceforward Jane held court on Wednesdays only.

Our own meals was now very different from the normal three-or four-course feasts. Dinners were cut out altogether, and mother and I had a macaroni cheese or a rice pudding or something like that in the evening. I'm afraid this saddened Jane a great deal. Also, little by little, mother managed to take over the ordering, which formerly had been done by Jane. It had been one of my father's friend's great delights, when staying in the house, to hear Jane ordering on the telephone in her deep bass Devonshire voice: 'And I want six lobsters, *hen* lobsters, and prawns – not less than . . .' It became a favourite phrase in our family. 'Not less than' was not only used by Jane but also by a later cook of ours, Mrs Potter. What splendid days for the tradesmen those were!

'But I've always ordered twelve fillets of sole, Ma'am,' Jane would say, looking distressed. The fact that there were not enough mouths to devour twelve fillets of sole, not even counting a couple in the kitchen, never appeared to enter her head.

None of these changes were particularly noticeable to me. Luxury or economy mean little when you are young. If you buy boiled sweets instead of chocolates the difference is not noticeable. Mackerel I had always preferred to sole, and a whiting with its tail in its mouth I thought a most agreeable looking fish.

My personal life was not much altered. I read enormous quantities of books – worked through all the rest of Henty, and was introduced to Stanley Weyman (what glorious historical novels they were. I read *The Castle Inn* only the other day and thought how good it was.)

The Prisoner of Zenda was my opening to romance, as it was for many others. I read it again and again. I fell deeply in love – not with Rudolf Rassendyll, as might have been expected, but with the real king imprisoned in his dungeon and sighing. I yearned to succour him, to rescue him, to assure him that I – Flavia, of course – loved *him* and not Rudolf Rassendyll. I also read the whole of Jules Verne in French – *Le Voyage au Centre de la Terre* was my favourite for many months. I loved the contrast between the prudent nephew and the cocksure uncle. Any book I really liked I read over again at monthly intervals; then, after about a year, I would be fickle and choose another favourite.

There were also L. T. Meade's books for girls, which my mother disliked very much; she said the girls in them were vulgar and only thought of being rich and having smart clothes. Secretly, I rather liked them, but with a guilty feeling of being vulgar in my tastes! Some of the Hentys mother read aloud to me, though she was slightly exasperated by the length of the descriptions. She also read a book called *The Last Days of Bruce*, of which both she and I approved heartily. By way of lessons, I was put on to a book called *Great Events of History*, of which I had to read one chapter and answer the questions about it set in a note at the end. This was a very good book. It taught a lot of the main events that happened in Europe and elsewhere, which one could link on to the history of the Kings of England, from Little Arthur onwards. How satisfactory to be firmly told So-and-So was a bad king; it has a kind of Biblical finality. I knew the dates of the Kings of England and the names of all their wives – information that has never been much use to me.

Every day I had to learn how to spell pages of words. I suppose the exercise did me some good, but I was still an extraordinarily bad speller and have remained so until the present day.

My principal pleasures were the musical and other activities into which I entered with a family called Huxley. Dr Huxley had a vague but clever wife. There were five girls – Mildred, Sybil, Muriel, Phyllis and Enid. I came between Muriel and Phyllis, and Muriel became my special friend. She had a long face and dimples, which is unusual in a long face, pale golden hair, and she laughed a great deal. I joined them first in their weekly singing-class. About ten girls took part in singing part-songs and oratorios under the direction of a singing-master, Mr Crow. There was also 'the orchestra'; Muriel and I both played mandolines, Sybil and a girl called Connie Stevens the violin, Mildred the 'cello.

Looking back on the day of the orchestra, I think the Huxleys were an enterprising family. The stuffier of the old inhabitants of Torquay looked slightly askance at 'those Huxley girls', mainly because they were in the habit of walking up and down The Strand, which was the shopping centre of the town, between twelve and one, first three girls, arm in arm, then two girls and the governess; they swung their arms, and walked up and down, and laughed and joked, and, cardinal sin against them, *they did not wear gloves*. These things were social offences at that time. However, since Dr Huxley was by far the most fashionable doctor in Torquay, and Mrs Huxley was what is known as 'well connected', the girls were passed as socially acceptable.

It was a curious social pattern, looking back. It was snobbish, I suppose; on the other hand, a certain type of snobbishness was much looked down upon. People who introduced the aristocracy into their conversation too frequently were disapproved of and laughed at. Three phases have succeeded each other during the span of my life. In the first the questions would be: 'But who *is* she, dear? Who are her *people*? Is she one of the *Yorkshire* Twiddledos? Of course, they are badly off, very badly off, but *she* was a *Wilmot*.' This was to be succeeded in due course by: 'Oh yes, of course they *are* pretty dreadful, but then they are terribly *rich*.' 'Have the people who have taken The Larches got money?' 'Oh well, then we'd better call.' The third phase was different again: 'Well, dear, but are they *amusing*?' 'Yes, well of course they are not well off, and nobody knows where they came from, but they are very *very* amusing.' After which digression into social values I had better return to the orchestra.

Did we make an awful noise, I wonder? Probably. Anyway, it gave us a lot of fun and increased our musical knowledge. It led on to something more exciting, which was the getting up of a performance of Gilbert and Sullivan.

The Huxleys and their friends had already given *Patience* – that was before I joined their ranks. The next performance in view was *The Yeomen of the Guard* – a somewhat ambitious undertaking. In fact I am surprised that their parents did not discourage them. But Mrs Huxley was a wonderful pattern of aloofness, for which, I must say, I admire her, since parents were not particularly aloof then. She encouraged her children to get up anything they liked, helped them if they asked for help, and, if not, left them to it. *The Yeomen of the Guard* was duly cast. I had a fine strong soprano voice, about the only soprano they had, and I was naturally in the seventh heaven at being chosen to play Colonel Fairfax.

We had a little difficulty with my mother, who was old-fashioned in her views about what girls could or could not wear on their legs if they were to appear in public. Legs were legs, definitely indelicate. For me to display myself in trunk hose, or anything of *that* kind, would, my mother thought, be most indecorous. I suppose I was thirteen or fourteen by then, and already five foot seven. There was, alas, no sign of the full rich bosom that I had hoped for when I was at Cauterets. A Yeoman of the Guard's uniform was adjudged all right, though it had to be made with unusually

baggy plus-four trousers, but the Elizabethan gentleman presented more difficulties. It seems to me silly nowadays, but it was a serious problem then. Anyway, it was surmounted by my mother saying that it would be all right, but I must wear a disguising cloak thrown over one shoulder. So a cloak was managed out of a piece of turquoise blue-velvet among Grannie's 'pieces'. (Grannie's pieces were kept in various trunks and drawers, and comprised all types of rich and beautiful fabrics, remnants which she had bought in various sales over the last twenty-five years and had now more or less forgotten about.) It is not terribly easy to act with a cloak draped over one shoulder and flung over the other, in such a way that the indelicacies of one's legs were more or less hidden from the audience.

As far as I remember I felt no stage fright. Strangely enough for a terribly shy person, who very often can hardly bring herself to enter a shop and who has to grit her teeth before arriving at a large party, there was one activity in which I never felt nervous at all, and that was singing. Later, when I studied both piano and singing in Paris, I lost my nerve completely whenever I had to play the piano in the school concert but if I had to sing I felt no nervousness at all. Perhaps that was due to my early conditioning in 'Is life a boon?' and the rest of Colonel Fairfax's repertoire. There is no doubt that *The Yeomen of the Guard* was one of the highlights of my existence. But I can't help thinking that it's as well that we didn't do any more operas – an experience that you really enjoyed should never be repeated.

One of the odd things in looking back is that, while you remember how things arrived or happened, you never know how or why they disappeared or came to a stop. I cannot remember many scenes in which I participated with the Huxleys after that time, yet I am sure there was no break in friendship. At one time we seemed to be meeting every day, and then I would find myself writing to Lully in Scotland. Perhaps Dr Huxley left to practise elsewhere, or retired? I don't remember any definite leave-taking. I remember that Lully's terms of friendship were clearly defined. 'You can't be my *best* friend,' she explained, 'because there are the Scottish girls, the McCrackens. They have *always* been our best friends. Brenda is *my* best friend, and Janet is *Phyllis's* best friend; but you can be my second-best friend.' So I was content with being Lully's second-best friend, and the arrangement worked well, since the 'best friends', the McCrackens, were only seen by the Huxleys at intervals of, I should say, roughly two years.

II

It must, I think, have been some time in March that my mother remarked that Madge was going to have a baby. I stared at her. 'Madge, have a *baby*?' I was dumbfounded. I cannot imagine why I shouldn't have thought of Madge having a baby – after all, it was happening all round one – but things are always surprising when they happen in one's own family. I accepted my brother-in-law, James, or Jimmy, as I usually called him, enthusiastically, and was devoted to him. Now here was something entirely different.

As usual with me, it was some time before I could take it in. I probably sat with my mouth open for quite two minutes or more. Then I said, 'Oh – that *will* be exciting. When is it coming? Next week?'

'Not quite as soon as that,' said my mother. She suggested a date in October.

'October?' I was deeply chagrined. Fancy having to wait all that time. I can't remember very clearly what my attitude to sex was then – I must have been between twelve and thirteen – but I don't think I any longer accepted the theories of doctors with black bags or heavenly visitants with wings. By then I had realised it was a physical process, but without feeling much curiosity or, indeed, interest. I had, however, done a little mild deduction. The baby was first *inside* you, and then in due course it was *outside* you; I reflected on the mechanism, and settled on the navel as a focal point. I couldn't see what that round hole in the middle of my stomach was *for* – it didn't seem to be for anything else, so clearly it *must* be something to do with the production of a baby.

My sister told me years afterwards that she had had very definite ideas; that she had thought that her navel was a keyhole, that there was a key that fitted it, which was kept by your mother, who handed it over to your husband, who unlocked it on the wedding night. It all sounded so sensible that I don't wonder she stuck firmly to her theory.

I took the idea out into the garden and thought about it a good deal. Madge was going to have a baby. It was a wonderful concept, and the more I thought about it the more I was in favour of it. I was going to be an aunt – it sounded very grown up and important. I would buy it toys, I

would let it play with my dolls' house, I would have to be careful that Christopher, my kitten, didn't scratch it by mistake. After about a week I stopped thinking about it; it was absorbed into various daily happenings. It was a long time to wait until October.

Some time in August a telegram took my mother away from home. She said she had to go and stay with my sister in Cheshire. Auntie-Grannie was staying with us at the time. Mother's sudden departure did not surprise me much, and I didn't speculate about it, because whatever mother did she did suddenly, with no apparent forethought or preparation. I was, I remember, out in the garden on the tennis lawn, looking hopefully at the pear-trees to see if I could find a pear which was ripe. It was here that Alice came out to fetch me. 'It's nearly lunch-time and you are to come in, Miss Agatha. There is a piece of news waiting for you.'

'Is there? What news?'

'You've got a little nephew,' said Alice.

A nephew?

'But I wasn't going to have a nephew till October!' I objected.

'Ah, but things don't always go as you think they will,' said Alice. 'Come on in now.'

I came in to the house and found Grannie in the kitchen with a telegram in her hand. I bombarded her with questions. What did the baby look like? Why had it come now instead of October? Grannie returned answers to these questions with the parrying art well known to Victorians. She had, I think, been in the middle of an obstetric conversation with Jane when I came in, because they lowered their voices and murmured something like: 'The other doctor said, let the labour come on, but the specialist was quite firm.' It all sounded mysterious and interesting. My mind was fixed entirely on my new nephew. When Grannie was carving the leg of mutton, I said:

'But what does he look like? What colour is his hair?'

'He's probably bald. They don't get hair at once.'

'*Bald*,' I said, disappointed. 'Will his face be very red?'

'Probably.'

'How big is he?'

Grannie considered, stopped carving, and measured off a distance on the carving knife.

'Like that,' she said. She spoke with the absolute certainty of one who knew. It seemed to me rather small. All the same the announcement

made such an impression on me that I am sure if I were being asked an associative question by a psychiatrist and he gave me the key-word 'baby' I would immediately respond with 'carving-knife'. I wonder what kind of Freudian complex he would put that answer down to.

I was delighted with my nephew. Madge brought him to stay at Ashfield about a month later, and when he was two months old he was christened in old Tor church. Since his godmother, Norah Hewitt, could not be there, I was allowed to hold him and be proxy for her. I stood near the font, full of importance, while my sister hovered nervously at my elbow in case I should drop him. Mr Jacob, our Vicar, with whom I was well acquainted, since he was preparing me for confirmation, had a splendid hand with infants at the font, tipping the water neatly back and off their forehead, and adopting a slightly swaying motion that usually stopped the baby from howling. He was christened James Watts, like his father and grandfather. He would be known as Jack in the family. I could not help being in rather a hurry for him to get to an age when I could play with him, since his principal occupation at this time seemed to be sleeping.

It was lovely to have Madge home for a long visit. I relied on her for telling me stories and providing a lot of entertainment in my life. It was Madge who told me my first Sherlock Holmes story, *The Blue Carbuncle*, and after that I had always been pestering her for more. *The Blue Carbuncle*, *The Red-Headed League* and *The Five Orange Pips* were definitely my favourites, though I enjoyed all of them. Madge was a splendid storyteller.

She had, before her marriage, begun writing stories herself. Many of her short stories were accepted for *Vanity Fair*. To have a Vain Tale in *Vanity Fair* was considered quite a literary achievement in those days, and father was extremely proud of her. She wrote a series of stories all connected with sport – *The Sixth Ball of the Over*, *A Rub of the Green*, *Cassie Plays Croquet*, and others. They were amusing and witty. I re-read them about twenty years ago, and I thought then how well she wrote. I wonder if she would have gone on writing if she had not married. I don't think she ever saw herself seriously as a writer, she would probably have preferred to be a painter. She was one of those people who can do almost anything they put their mind to. She did not, as far as I remember, write any more short stories after she married, but about ten or fifteen years later she began to write for the stage. *The Claimant* was produced by Basil Dean of the Royal Theatre with Leon Quartermayne and Fay

Compton in it. She wrote one or two other plays, but they did not have London productions. She was also quite a good amateur actress herself, and acted with the Manchester Amateur Dramatic. There is no doubt that Madge was the talented member of our family.

I personally had no ambition. I knew that I was not very good at anything. Tennis and croquet I used to enjoy playing, but I never played them well. How much more interesting it would be if I could say that I always longed to be a writer, and was determined that someday I would succeed, but, honestly, such an idea never came into my head.

As it happened, I *did* appear in print at the age of eleven. It came about in this way. The trams came to Ealing – and local opinion immediately erupted into fury. A terrible thing to happen to Ealing; such a fine residential neighbourhood, such wide streets, such beautiful houses – to have *trams* clanging up and down! The word Progress was uttered but howled down. Everyone wrote to the Press, to their M.P., to anyone they could think of to write to. Trams were common – they were noisy – everyone's health would suffer. There was an excellent service of brilliant red buses, with Ealing on them in large letters, which ran from Ealing Broadway to Shepherds Bush, and another extremely useful bus, though more humble in appearance, which ran from Hanwell to Acton. And there was the good old-fashioned Great Western Railway; to say nothing of the District Railway.

Trams were simply not needed. But they came. Inexorably, they came, and there was weeping and gnashing of teeth – and Agatha had her first literary effort published, which was a poem I wrote on the first day of the running of the trams. There were four verses of it, and one of Grannie's old gentlemen, that gallant bodyguard of Generals, Lt.-Colonels, and Admirals, was persuaded by Grannie to visit the local newspaper office and suggest that it should be inserted. It was – and I can still remember the first verse:

> When first the electric trams did run
> In all their scarlet glory,
> 'Twas well, but ere the day was done,
> It was another story.

After which I went on to deride a 'shoe that pinched'. (There had been some electrical fault in a 'shoe', or whatever it was, which conveyed the electricity to the trams, so that after running for a few hours they broke down.) I was elated at seeing myself in print, but I cannot say that it led me to contemplate a literary career.

In fact I only contemplated one thing – a happy marriage. About that I had complete self-assurance – as all my friends did. We were conscious of all the happiness that awaited us; we looked forward to love, to being looked after, cherished and admired, and we intended to get our own way in the things which mattered to us while at the same time putting our husbands' life, career and success before all, as was our proud duty. We didn't need pep pills or sedatives; we had belief and joy in life. We had our own personal disappointments – moments of unhappiness – but on the whole life was *fun*. Perhaps it is fun for girls nowadays – but they certainly don't *look* as if it is. However – a timely thought – they may enjoy melancholy; some people do. They may enjoy the emotional crises that seem always to be overwhelming them. They may even enjoy anxiety. That is certainly what we have nowadays – anxiety. My contemporaries were frequently badly off and couldn't have a quarter of the things they wanted. Why then did we have so much enjoyment? Was it some kind of sap rising in us that has ceased to rise now? Have we strangled or cut it off with education, and, worse, anxiety over education; anxiety as to what life holds for you.?

We were like obstreperous flowers – often weeds maybe, but nevertheless all of us growing exuberantly – pressing violently up through cracks in pavements and flagstones, and in the most inauspicious places, determined to have our fill of life and enjoy ourselves, bursting out into the sunlight, until someone came and trod on us. Even bruised for a time, we would soon lift a head again. Nowadays, alas, life seems to apply weed killer (selective!) – we have no chance to raise a head again. There are said to be those who are 'unfit for living'. No one would ever have told *us* we were unfit for living. If they had, we shouldn't have believed it. Only a murderer was unfit for living. Nowadays a murderer is the one person you *mustn't* say is unfit for living.

The real excitement of being a girl – of being, that is, a woman in embryo – was that life was such a wonderful gamble. *You didn't know what was going to happen to you.* That was what made being a woman so exciting. No worry about what you should be or do – Biology would decide. You were waiting for The Man, and when the man came, he would change your entire life. You can say what you like, that is an exciting point of view to hold at the threshold of life. What will happen? 'Perhaps I shall marry someone in the Diplomatic Service . . . I think I should like that; to go abroad and see all sorts of places . . .' Or: 'I don't think I would like to marry a sailor; you would have to spend such a lot of

time living in seaside lodgings.' Or: 'Perhaps I'll marry someone who builds bridges, or an explorer.' The whole world was open to you – not open to your *choice*, but open to what Fate *brought* you. You might marry *anyone*; you might, of course, marry a drunkard or be very unhappy, but that only heightened the general feeling of excitement. And one wasn't marrying the profession, either; it was the *man*. In the words of old nurses, nannies, cooks and housemaids: 'One day Mr Right will come along.'

I remember when I was very small seeing one of mother's prettier friends being helped to dress for a dance by old Hannah, Grannie's cook. She was being laced into a tight corset. 'Now then, Miss Phyllis,' said Hannah, 'brace your foot against the bed and lean back – I'm going to pull. Hold your breath.'

'Oh Hannah, I can't bear it, I can't really. I can't *breathe*.'

'Now don't you fret, my pet, you can breathe all right. You won't be able to eat much supper, and that's a good thing, because young ladies shouldn't be seen eating a lot; it's not delicate. You've got to behave like a proper young lady. You're all right. I'll just get the tape measure. There you are – nineteen and a half. I *could* have got you to nineteen . . .'

'Nineteen and a half will do quite well,' gasped the sufferer.

'You'll be glad when you get there. Suppose this is the night that Mr Right's coming along? You wouldn't like to be there with a thick waist, would you, and let him see you like that?'

Mr Right. He was more elegantly referred to sometimes as 'Your Fate'.

'I don't know that I really want to go to this dance.'

'Oh yes, you do, dear. Think! You might meet Your Fate.'

And of course that *is* what actually happens in life. Girls go to something they wanted to go to, or they didn't want to go to, it doesn't matter which – and there is their Fate.

Of course, there were always girls who declared they were not going to marry, usually for some noble reason. Possibly they wished to become nuns or to nurse lepers, to do something grand and important, above all self-sacrificial. I think it was almost a necessary phase. An ardent wish to become a nun seems to be far more constant in Protestant than in Catholic girls. In Catholic girls it is, no doubt, more vocational – it is recognised as one of the ways of life – whereas for a Protestant it has some aroma of religious mystery that makes it very desirable. A hospital nurse was also considered a heroic way of life, with all the prestige of Miss Nightingale behind it. But marriage was the main theme; whom you were going to marry the big question in life.

E

By the time I was thirteen or fourteen I felt myself enormously advanced in age and experience. I no longer thought of myself as protected by another person. I had my own protective feelings. I felt responsible for my mother. I also began to try to know myself, the sort of person I was, what I could attempt successfully, and the things I was no good at and that I must not waste time over. I knew that I was not quick-witted; I must give myself time to look at a problem carefully before deciding how I would deal with it.

I began to appreciate time. There is nothing more wonderful to have in one's life, than time. I don't believe people get enough of it nowadays. I was excessively fortunate in my childhood and youth, just *because* I had so much time. You wake up in the morning, and even before you are properly awake you are saying to yourself: 'Now, what shall I do with today?' You have the choice, it is there, in front of you, and you can plan as you please. I don't mean that there were not a lot of things (duties, we called them) I had to do – of course there were. There were jobs to be done in the house: days when you cleaned silver photograph frames, days when you darned your stockings, days when you learnt a chapter of *Great Events in History*, a day when you had to go down the town and pay all the tradesmen's bills. Letters and notes to write, scales and exercises, embroidery – but they were all things that lay in my choice, to arrange as I pleased. I could plan my day, I could say, 'I think I'll leave my stockings until this afternoon; I will go down town in the morning and I will come back by the other road and see whether that tree had come into blossom yet.'

Always when I woke up, I had the feeling which I am sure must be natural to all of us, a joy in being alive. I don't say you feel it consciously – you don't – but there you *are*, you are *alive*, and you open your eyes, and here is another day; another step, as it were, on your journey to an unknown place. That very exciting journey which is your life. Not that it is necessarily going to be exciting *as* a life, but it will be exciting to you because it is *your* life. That is one of the great secrets of existence, enjoying the gift of life that has been given to you.

Not every day is necessarily enjoyable. After the first delightful feeling of 'Another day! How wonderful!' you remember you have to go to the dentist at 10.30, and that is not nearly so good. But the *first* waking feeling has been there, and that acts as a useful booster. Naturally, a lot depends on temperament. You are a happy person, or you are of a melancholic disposition. I don't know that you can do anything about *that*. I think it

is the way one is made – you are either happy until something arises to make you unhappy or else you are melancholy until something distracts you from it. Naturally happy people can be unhappy and melancholic people enjoy themselves. But if I were taking a gift to a child at a christening that is what I would choose: a naturally happy frame of mind.

There seems to me to be an odd assumption that there is something meritorious about working. Why? In early times man went out to hunt animals in order to feed himself and keep alive. Later, he toiled over crops, and sowed and ploughed for the same reason. Nowadays, he rises early, catches the 8.15, and sits in an office all day – still for the same reason. He does it to feed himself and have a roof over his head – and, if skilled and lucky, to go a bit further and have comfort and entertainment as well.

It's economic and necessary. But why is it *meritorious*? The old nursery adage used to be 'Satan finds some mischief still for idle hands to do'. Presumably little Georgie Stephenson was enjoying idleness when he observed his mother's tea-kettle lid rising and falling. Having nothing at the moment to do, he began to have ideas about it . . .

I don't think necessity is the mother of invention – invention, in my opinion, arises directly from idleness, possibly also from laziness. *To save oneself trouble.* That is the big secret that has brought us down the ages hundreds of thousands of years, from chipping flints to switching on the washing up machine.

The position of women, over the years, has definitely changed for the worse. We women have behaved like mugs. We have clamoured to be allowed to work as men work. Men, not being fools, have taken kindly to the idea. Why support a wife? What's wrong with a wife supporting *herself*? She *wants* to do it. By Golly, she can go on doing it!

It seems sad that having established ourselves so cleverly as the 'weaker sex', we should now be broadly on a par with the women of primitive tribes who toil in the fields all day, walk miles to gather camel-thorn for fuel, and on trek carry all the pots, pans and household equipment on their heads, whilst the gorgeous, ornamental male sweeps on ahead, unburdened save for one lethal weapon with which to defend his women.

You've got to hand it to Victorian women; they got their menfolk where they wanted them. They established their fraility, delicacy, sensibility – their constant need of being protected and cherished. Did they lead miserable, servile lives, downtrodden and oppressed? Such is not

my recollection of them. All my grandmothers' friends seem to me in retrospect singularly resilient and almost invariably successful in getting their own way. They were tough, self-willed, and remarkably well-read and well-informed.

Mind you, they admired their men enormously. They genuinely thought men were splendid fellows – dashing, inclined to be wicked, easily led astray. In daily life a woman got her own way whilst paying due lip service to male superiority, so that her husband should not lose face.

'Your father knows best, dear,' was the public formula. The real approach came privately. 'I'm sure you are *quite* right in what you said, John, but I wonder if you have considered . . .'

In one respect man was paramount. He was the Head of the House. A woman, when she married, accepted as her destiny *his* place in the world and *his* way of life. That seems to me sound sense and the foundation of happiness. If you can't face your man's way of life, don't take that job – in other words, don't marry that man. Here, say, is a wholesale draper; he is a Roman Catholic; he prefers to live in a suburb; he plays golf and he likes to go for holidays to the sea side. *That* is what you are marrying. Make up your mind to it and like it. It won't be so difficult.

It is astonishing how much you can enjoy almost everything. There are few things more desirable than to be an acceptor and an enjoyer. You can like and enjoy almost any kind of food or way of life. You can enjoy country life, dogs, muddy walks; towns, noise, people, clatter. In the one there is repose, ease for nerves, time for reading, knitting, embroidery, and the pleasure of growing things. In the other theatres, art galleries, good concerts, and seeing friends you would otherwise seldom see. I am happy to say that I can enjoy almost everything.

Once when I was travelling by train to Syria, I was much entertained by a fellow traveller's dissertation on the stomach.

'My dear,' she said, 'never give in to your stomach. If a certain thing doesn't agree with you, say to yourself "Who's going to be master, me or my stomach?"'

'But what do you actually do about it?' I asked with curiosity.

'Any stomach can be trained. Very small doses at first. It doesn't matter what it is. Eggs, now, used to make me sick, and toasted cheese gave me the most terrible pains. But just a spoonful or two of boiled egg two or three times a week, and then a little more scrambled egg and so on. And now I can eat any amount of eggs. It's been just the same with toasted cheese. Remember this, *your stomach's a good servant, but a bad master.*'

I was much impressed and promised to follow her advice, and I have done so – though it has not presented much difficulty, my stomach being definitely a servile one.

III

When my mother had gone abroad with Madge to the South of France after my father's death, I remained at Ashfield under the tranquil eye of Jane for three weeks by myself. It was then that I discovered a new sport and new friends.

Roller-skating on the pier was a pastime much in vogue. The surface of the pier was extremely rough, and you fell down a good deal, but it was great fun. There was a kind of concert-room at the end of the pier, not used in winter of course, and this was opened as a kind of indoor rink. It was also possible to skate at what was grandly called the Assembly Rooms, or the Bath Saloons, where the big dances took place. This was much more high-class, but most of us preferred the pier. You had your own skates and you paid twopence for admission, and once on the pier you skated! The Huxleys could not join me in this sport because they were engaged with their governess during the morning, and the same held for Audrey. The people I used to meet there were the Lucys. Although grown up, they had been very kind to me, knowing that I was alone at Ashfield because the doctor had ordered my mother abroad for change and rest.

Although I felt rather grand on my own, one could get weary of that feeling. I enjoyed ordering the meals – or thinking I was ordering the meals. Actually we always had for lunch exactly what Jane had made up her mind we were going to have beforehand, but she certainly put up a good show of considering my wildest suggestions. 'Could we have roast duck and meringues?' I would ask and Jane would say yes, but she was not sure about the ordering of the duck, and that perhaps meringues – there were no whites of egg at the moment, perhaps we had better wait until some day when we had used the yolks for something else; so that in the end we had what was already sitting in the larder. But dear Jane was very tactful. She always called me Miss Agatha and allowed me to feel that I was in an important position.

It was then that the Lucys suggested that I should come down and

skate with them on the pier. They more or less taught me to stand up on my skates, and I loved it. They were, I think, one of the nicest families I have ever known. They came from Warwickshire, and the family's beautiful house, Charlecote, had belonged to Berkeley Lucy's uncle. He always thought that it ought to have come to him but instead of that it had gone to his uncle's daughter, her husband taking the name of Fairfax-Lucy. I think the whole family felt very sad that Charlecote was not theirs, though they never said anything about it, except amongst themselves. The oldest daughter, Blanche, was an extraordinarily handsome girl – she was a little older than my sister and had been married before her. The eldest son, Reggie, was in the army but the second son was at home – about my brother's age – and the next two daughters, Marguerite and Muriel, known to all as Margie and Noonie, were also grown-up. They had rather slurred lazy voices that I found very attractive. Time as such meant nothing to them.

After skating for some time, Noonie would look at her watch and say, 'Well, did you ever, look at the time now. It's half-past one already.'

'Oh dear,' I said. 'It will take me twenty minutes at least to walk home.'

'Oh you'd better not go home, Aggie. You come home with us and have lunch. We can ring up Ashfield.'

So I would go home with them, and we would arrive about half-past two to be greeted by Sam the dog – 'Body like a barrel, breath like a drainpipe,' as Noonie used to describe him – and somewhere there would be some kind of meal being kept hot and we would have it. Then they would say it was a pity to go home yet, Aggie, and we would go into their school-room and play the piano and have a sing-song. Sometimes we went on expeditions to the Moor. We would agree to meet at Torre station and take a certain train. The Lucys were always late, and we always missed the train. They missed trains, they missed trams, they missed everything, but nothing rattled them. 'Oh well,' they would say, 'what does it matter? There'll be another one by and by. It's never any good *worrying*, is it?' It was a delightful atmosphere.

The high spots in my life were Madge's visits. She came down every August. Jimmy came with her for a few days, then he had to get back to business, but Madge stayed on to about the end of September, and Jack with her.

Jack, of course, was a never-ending source of enjoyment to me. He was a rosy-cheeked golden-haired little boy, looking good enough to eat, and indeed we sometimes called him '*le petit brioche*'. He had a most

uninhibited nature, and did not know what silence was. There was no question of bringing Jack out and making him talk – the difficulty was to hush him down. He had a fiery temper and used to do what we called 'blow up'; he would first get very red in the face, then purple, then hold his breath, till you really thought he was going to burst, then the storm would happen!

He had a succession of Nannies, all with their own peculiarities. There was one particularly cross one, I remember. She was old, with a great deal of untidy grey hair. She had much experience, and was about the only person who could really daunt Jack when he was on the warpath. One day he had been very obstreperous, shouting out 'You idiot, you idiot, you idiot' for no reason whatever, rushing to each person in turn. Nannie finally reproved him, telling him that if he said it any more he would be punished. 'I can tell you what I'm going to do,' said Jack. 'When I die I shall go to Heaven and I shall go straight up to God and I shall say "You idiot, you idiot, you idiot".' He paused, breathless, to see what this blasphemy would bring forth. Nannie put down her work, looked over her spectacles at him, and said without much interest: 'And do you suppose that the Almighty is going to take any notice of what a naughty little boy like you says?' Jack was completely deflated.

Nannie was succeeded by a young girl called Isabel. She for some reason was much addicted to throwing things out of the window. 'Oh drat these scissors,' she would suddenly murmur, and fling them out on to the grass. Jack, on occasions, attempted to help her. 'Shall I throw it out of the window, Isabel?' he would ask, with great interest. Like all children, he adored my mother. He would come into her bed early in the morning and I would hear them through the wall of my room. Sometimes they were discussing life, and sometimes my mother would be telling him a story – a kind of serial went on, all about mother's thumbs. One of them was called Betsy Jane and the other Sary Anne. One of them was good, the other was naughty, and the things they did and said kept Jack in a gurgle of laughter the whole time. He always tried to join in conversation. One day when the Vicar came to lunch there was a momentary pause. Jack suddenly piped up. 'I know a very funny story about a bishop,' he said. He was hastily hushed by his relations, who never knew *what* Jack might come out with that he had overheard.

Christmas we used to spend in Cheshire, going up to the Watts'. Jimmy usually got his yearly holiday about then, and he and Madge used to go to St. Moritz for three weeks. He was a very good skater, and so it

was the kind of holiday he liked most. Mother and I used to go up to
Cheadle, and since their newly-built house, called Manor Lodge, was
not ready yet, we spent Christmas at Abney Hall, with the old Wattses
and their four children and Jack. It was a wonderful house to have
Christmas in if you were a child. Not only was it enormous Victorian
Gothic, with quantities of rooms, passages, unexpected steps, back
staircases, front staircases, alcoves, niches – everything in the world that
a child could want – but it also had three different pianos that you could
play, as well as an organ. All it lacked was the light of day; it was re-
markably dark, except for the big drawing-room with its green satin
walls and its big windows.

Nan Watts and I were fast friends by now. We were not only friends
but drinking companions – we both liked the same drink, *cream*, ordinary
plain, neat cream. Although I had consumed an enormous amount of
Devonshire cream since I lived in Devonshire, raw cream was really more
of a treat. When Nan stayed with me at Torquay, we used to visit one of
the dairies in the town, where we would have a glass of half milk and half
cream. When I stayed with her at Abney we used to go down to the home
farm and drink cream by the half-pint. We continued these drinking
bouts all through our lives, and I still remember buying our cartons of
cream in Sunningdale and coming up to the golf course and sitting outside
the club house waiting for our respective husbands to finish their rounds
of golf, each drinking our pinta cream.

Abney was a glutton's paradise. Mrs Watts had what was called her
store-room off the hall. It was not like Grannie's store-room, a kind of
securely-locked treasure house from which things were taken out. There
was free access to it, and all round the walls were shelves covered with
every kind of dainty. One side was entirely chocolates, boxes of them, all
different, chocolate creams in labelled boxes . . . There were biscuits,
gingerbread, preserved fruits, jams and so on.

Christmas was the supreme Festival, something never to be forgotten.
Christmas stockings in bed. Breakfast, when everyone had a separate
chair heaped with presents. Then a rush to church and back to continue
present opening. At two o'clock Christmas Dinner, the blinds drawn
down and glittering ornaments and lights. First, oyster soup (not relished
by me), turbot, then boiled turkey, roast turkey, and a large roast sirloin
of beef. This was followed by plum pudding, mince pies, and a trifle full
of sixpences, pigs, rings, bachelors' buttons and all the rest of it. After
that, again, innumerable kinds of dessert. In a story I once wrote, *The*

Affair of the Christmas Pudding, I have described just such a feast. It is one of those things that I am sure will never be seen again in this generation; indeed I doubt nowadays if anyone's digestion would stand it. However, *our* digestions stood it quite well then.

I usually had to vie in eating prowess with Humphrey Watts, the Watts son next to James in age. I suppose he must have been twenty-one or twenty-two to my twelve or thirteen. He was a very handsome young man, as well as being a good actor and a wonderful entertainer and teller of stories. Good as I always was at falling in love with people, I don't think I fell in love with him, though it is amazing to me that I should *not* have done so. I suppose I was still at the stage where my love affairs had to be romantically impossible – concerned with public characters, such as the Bishop of London and King Alfonso of Spain, and of course with various actors. I know I fell deeply in love with Henry Ainley when I saw him in *The Bondman*, and I must have been just getting ripe for the K.O.W.s (Keen on Wallers), who were all to a girl in love with Lewis Waller in *Monsieur Beaucaire*.

Humphrey and I ate solidly through the Christmas Dinner. He scored over me in oyster soup, but otherwise we were neck and neck. We both first had roast turkey, then boiled turkey, and finally four or five slashing slices of sirloin of beef. It is possible that our elders confined themselves to only one kind of turkey for this course, but as far as I remember old Mr Watts certainly had beef as well as turkey. We then ate plum pudding and mince pies and trifle – I rather sparingly of trifle, because I didn't like the taste of wine. After that there were the crackers, the grapes, the oranges, the Elvas plums, the Carlsbad plums, and the preserved fruits. Finally, during the afternoon, various handfuls of chocolates were fetched from the store-room to suit our taste. Do I remember being sick the next day? Having bilious attacks? No, never. The only bilious attacks I ever remember were those that seized me after eating unripe apples in September. I ate unripe apples practically every day, but occasionally I must have overdone it.

What I do remember was when I was about six or seven years old and had eaten mushrooms. I woke up with a pain about eleven o'clock in the evening, and came rushing down to the drawing-room, where mother and father were entertaining a party of people, and announced dramatically: 'I am going to die! I am poisoned by mushrooms!' Mother rapidly soothed me and administered a dose of ipecacuanha wine – always kept

in the medicine cupboard in those days – and assured me that I was not due to die this time.

At any rate I never remember being ill at Christmas. Nan Watts was just the same as I was; she had a splendid stomach. In fact, really, when I remember those days, everyone seemed to have a pretty good stomach. I suppose people had gastric and duodenal ulcers and had to be careful, but I cannot remember anybody living on a diet of fish and milk. A coarse and gluttonous age? Yes, but one of great zest and enjoyment. Considering the amount that I ate in my youth (for I was always hungry) I cannot imagine how I managed to remain so thin – a scrawny chicken indeed.

After the pleasurable inertia of Christmas afternoon – pleasurable, that is, for the elders: the younger ones read books, looked at their presents, ate more chocolates, and so on – there was a terrific tea, with a great iced Christmas cake as well as everything else, and finally a supper of cold turkey and hot mince pies. About nine o'clock there was the Christmas Tree, with more presents hanging on it. A splendid day, and one to be remembered till next year, when Christmas came again.

I stayed at Abney with my mother at other times of year, and always loved it. There was a tunnel in the garden, underneath the drive, which I found useful in whatever historical romance or drama I was enacting at the moment. I would strut about, muttering to myself and gesticulating. I daresay the gardeners thought that I was mental, but I was only getting into the spirit of the part. It never occurred to me to write anything down – and I was quite indifferent to what any gardeners thought. I occasionally walk about nowadays muttering to myself – trying to get some chapter that won't 'go' to come right.

My creative abilities were also engaged by embroidery of sofa cushions. Cushions were most prevalent at that time, and embroidered cushion-covers always welcome. I went in for an enormous bout of embroidery in the autumn months. To begin with I used to buy transfers, iron them off on the squares of satin, and start embroidering them in silks. Disliking the transfers in the end as being all the same, I then began to take flower pictures off china. We had some big Berlin and Dresden vases with beautiful bunches of flowers on them, and I used to trace over these, draw them out, and then try to copy the colours as closely as possible. Granny B. was very pleased when she heard I was doing this; she had spent so much of her life in embroidery that she was glad to think a grand-daughter

took after her in that way. I did not reach her heights of fine embroidery, however; I never actually embroidered landscapes and figures, as she did. I have two of her fire screens now, one of a shepherdess, the other of a shepherd and shepherdess together under a tree, writing or drawing a heart on the bark of it, which is exquisitely done. How satisfying it must have been for the great ladies in the days of the Bayeux Tapestry, in the long winter months.

Mr Watts, Jimmy's father, was a person who always made me feel unaccountably shy. He used to call me 'dream-child', which made me wriggle in agonised embarrassment. 'What is our dream-child thinking of?' he used to say. I would go purple in the face. He used to make me play and sing sentimental songs to him, too. I could read music quite well, so he would often take me to the piano and I would sing his favourite songs. I didn't like them much, but at least it was preferable to his conversation. He was an artistic man, and painted landscapes of moors and sunsets. He was also a great collector of furniture, particularly old oak. In addition he and his friend Fletcher Moss took good photographs, and published several books of photographs of famous houses. I wish I had not been so stupidly shy, but I was of course at the age when one is particularly self-conscious.

I much preferred Mrs Watts, who was brisk, cheerful, and completely factual. Nan, who was two years older than I was, went in for being an *'enfant terrible'*, and took a special pleasure in shouting, being rude, and using swear words. It upset Mrs Watts when her daughter fired off *damns* and *blasts*. She also disliked it when Nan used to turn on her and say: 'Oh don't be such a *fool*, Mother!' It was not the sort of thing that she had ever envisaged a daughter of hers saying to her, but the world was just entering into an age of plain speaking. Nan revelled in the role she was playing, though really, I believe, she was quite fond of her mother. Ah well, most mothers have to go through a period in which their daughters put them through the mill in one way or another.

On Boxing Day we were always taken to the pantomime in Manchester – and very good pantomimes they were. We would come back in the train singing all the songs, the Watts rendering the comedian's songs in broad Lancashire. I remember us all bawling out: *'I was born on a Friday, I was born on a Friday, I was born on a Friday when* (crescendo!) *my mother wasn't at 'ome!'* Also: *'Watching the trains coom in, watching the trains go out, when we'd watched all the trains coom in, we watched the*

trains go OUT.' The supreme favourite was sung by Humphrey as a melancholy solo: *'The window, The window, I've pushed it through the window. I have no pain, dear Mother now, I've pushed it through the window.'*

The Manchester pantomime was not the earliest I was taken to. The first I ever saw was at Drury Lane, where I was taken by Grannie. Dan Leno was Mother Goose. I can still remember that pantomime. I dreamt of Dan Leno for weeks afterwards – I thought he was the most wonderful person I had ever seen. And there was an exciting incident that night. The two little Royal princes were up in the Royal Box. Prince Eddy, as one spoke of him colloquially, dropped his programme and opera glasses over the edge of the box. They fell in the stalls quite near where we were sitting, and, oh delight, not the Equerry but Prince Eddy *himself* came down to retrieve them, apologising very politely, saying that he did hope they hadn't hurt anyone.

I went to sleep that night indulging in the fantasy that one day I would marry Prince Eddy. Possibly I could save his life from drowning first . . . A grateful Queen would give her Royal Consent. Or perhaps there would be an accident – he would be bleeding to death, I would give a blood transfusion. I would be created a Countess – like the Countess Torby – and there would be a Morganatic Marriage. Even for six years old, however, such a fantasy was a little too fantastic to last.

My nephew Jack once arranged a very good Royal alliance of his own at about the age of four. 'Supposing, Mummy,' he said, 'you were to marry King Edward. I should become Royalty.' My sister said there was the Queen to be thought of, and a little matter of Jack's own father. Jack rearranged matters. 'Supposing the Queen died, and supposing that Daddy' – he paused to put it tactfully – 'supposing that Daddy – er – wasn't there, and then supposing that King Edward was to – just to *see you* . . .' Here he stopped, leaving it to the imagination. Obviously King Edward was going to be struck all of a heap, and in next to no time Jack was going to be the King's stepson.

'I was looking in the prayer-book during the sermon,' Jack said to me, about a year later. 'I've been thinking of marrying you when I am grown up, Ange, but I've been looking in the prayer-book and there is a table of things in the middle, and I see that the Lord won't let me.' He sighed. I told him that I was flattered that he should have thought of such a thing.

It is astonishing how you never really change in your predilections. My nephew Jack, from the days when he went out with a nursemaid, was always obsessed by things ecclesiastical. If he disappeared from sight you could usually find him in a church, gazing admiringly at the altar. If he was given coloured plasticine the things he made were always triptychs, crucifixes, or some kind of ecclesiastical adornment. Roman Catholic churches in particular fascinated him. His tastes never changed, and he read more ecclesiastical history than anyone I have ever known. When he was about thirty, he finally entered the Roman Catholic Church – a great blow to my brother-in-law, who was what I can only describe as the perfect example of a 'Black Protestant'. He would say, in his gentle voice: 'I'm not prejudiced, I really am *not* prejudiced. It's just that I can't help noticing that all Roman Catholics are the most terrible liars. It's not prejudice, it just *is* so.'

Grannie was a good example of a Black Protestant too, and got much enjoyment out of the wickedness of the Papists. She would lower her voice and say: 'All those beautiful girls disappearing into convents – *never seen again.*' I am sure she was convinced that all priests selected their mistresses from special convents of beautiful girls.

The Watts were non-conformist, Methodist I think, which perhaps may have led to this tendency to regard Roman Catholics as representatives of 'the Scarlet Woman of Babylon'. Where Jack got his passion for the Roman Catholic Church I cannot think. He doesn't seem to have inherited it from anyone in his family, but it was there, present always from his early years. Everybody took a great interest in religion in my young days. Disputes about it were full and colourful, and sometimes heated. One of my nephew's friends said to him later in life: 'I really can't think, Jack, why you can't be a cheerful heretic like everyone else, it would be so much more peaceful.'

The last thing on earth that Jack could ever imagine being was peaceful. As his nursemaid said, on one occasion, when she had spent some time finding him: 'Why Master Jack wants to go into churches, I can't imagine. It seems such a funny thing for a child to want to do.' Personally, I think he must have been a reincarnation of a medieval churchman. He had, as he grew older, what I might call a churchman's face – not a monk's face, certainly not a visionary's – the kind of churchman versed in ecclesiastical practices and able to acquit himself well at the Council of Trent – and to be quite sound on the exact number of angels able to dance on the point of a needle.

IV

Bathing was one of the joys of my life, and has remained so almost until my present age; in fact I would still enjoy it as much as ever but for the difficulties attendant on a rheumatic person getting herself into the water, and, even more difficult, out again.

A great social change came when I was about thirteen. Bathing as I first remember it was strictly segregated. There was a special Ladies' Bathing-Cove, a small stony beach, to the left of the Bath Saloons. The beach was a steeply sloping one, and on it there were eight bathing machines in the charge of an ancient man, of somewhat irascible temper, whose non-stop job was to let the machine up and down in the water. You entered your bathing machine – a gaily-painted striped affair – saw that both doors were safely bolted, and began to undress with a certain amount of caution, because at any moment the elderly man might decide it was your turn to be let down into the water. At that moment there would be a frantic rocking, and the bathing machine would grind its way slowly over the loose stones, flinging you about from side to side. In fact the action was remarkably similar to that of a Jeep or Land Rover nowadays, when traversing the more rocky parts of the desert.

The bathing machine would stop as suddenly as it had started. You then proceeded with your undressing and got into your bathing-dress. This was an unaesthetic garment, usually made of dark blue or black alpaca, with numerous skirts, flounces and frills, reaching well down below the knees, and over the elbow. Once fully attired, you unbolted the door on the water side. If the old man had been kind to you, the top step was practically level with the water. You descended and there you were, decorously up to your waist. You then proceeded to swim. There was a raft not too far out, to which you could swim and pull yourself up and sit on it. At low tide it was quite near; at high tide it was quite a good swim, and you had it more or less to yourself. Having bathed as long as you liked, which for my part was a good deal longer than any grown-up accompanying me was inclined to sanction, you were signalled to come back to shore – but as they had difficulty in getting at me once I was safely on the raft, and I anyway proceeded to swim

in the opposite direction, I usually managed to prolong it to my own pleasure.

There was of course no such thing as sunbathing on the beach. Once you left the water you got into your bathing machine, you were drawn up with the same suddenness with which you had been let down, and finally emerged, blue in the face, shivering all over, with hands and cheeks died away to a state of numbness. This, I may say, never did me any harm, and I was as warm as toast again in about three-quarters of an hour. I then sat on the beach and ate a bun while I listened to exhortations on my bad conduct in not having come out sooner. Grannie, who always had a fine series of cautionary tales, would explain to me how Mrs Fox's little boy ('such a lovely creature') had gone to his death of pneumonia, entirely from disobeying his elders and staying in the sea too long. Partaking of my currant bun or whatever refreshment I was having, I would reply dutifully, 'No, Grannie, I won't stay in as long next time. But actually, Grannie, the water was really *warm.*'

'Really warm, was it indeed? Then why are you shivering from head to foot? Why are your fingers so blue?'

The advantage of being accompanied by a grown-up person, especially Grannie, was that we would go home in a cab from the Strand, instead of having to walk a mile and a half. The Torbay Yacht Club was stationed on Beacon Terrace, just above the Ladies' Bathing-Cove. Although the beach was properly invisible from the Club windows, the sea around the raft was not, and, according to my father, a good many of the gentlemen spent their time with opera glasses enjoying the sight of female figures displayed in what they hopefully thought of as almost a state of nudity! I don't think we can have been sexually very appealing in those shapeless garments.

The Gentlemen's Bathing-Cove was situated further along the coast. There the gentlemen, in their scanty triangles, could disport themselves as much as they pleased, with no female eye able to observe them from any point whatever. However, times were changing: mixed bathing was being introduced all over England.

The first thing mixed bathing entailed was wearing far more clothing than before. Even French ladies had always bathed in stockings, so that no sinful bare legs could be observed. I have no doubt that, with natural French *chic*, they managed to cover themselves from their necks to their wrists, and with lovely thin silk stockings outlining their beautiful legs, looked far more sinfully alluring than if they had worn a good old short-

skirted British bathing dress of frilled alpaca. I really don't know why legs were considered so improper: throughout Dickens there are screams when any lady thinks that her ankles have been observed. The very word was considered daring. One of the first nursery axioms was always uttered if you mentioned those pieces of your anatomy: 'Remember, the Queen of Spain has no legs.' 'What does she have instead, Nursie?' '*Limbs*, dear, that is what we call them; arms and legs are limbs.'

All the same, I think it would sound odd to say: 'I've got a spot coming on one of my limbs, just below the knee.'

Which reminds me of a friend of my nephew's, who described an experience of her own as a little girl. She had been told that her godfather was coming to see her. Having not heard of such a personage before, she had been thrilled by the notion. That night, at about one a.m., after waking and considering the matter for some time, she spoke into the darkness:

'Nanny, I've got a godfather.'

'Urmrp.' Some indescribable sound answered her.

'Nanny,' a little louder, 'I've got a *godfather*.'

'Yes, dear, yes, very nice.'

'But, Nanny, I've got a' – *fortissimo* – 'GODFATHER.'

'Yes, yes, turn over, dear, and go to sleep.'

'But, Nanny' – *molto fortissimo* – 'I *HAVE* GOT A GODFATHER!'

'Well, *rub* it, dearie; *rub* it!'

Bathing-dresses continued to be very pure practically up to the time I was first married. Though mixed bathing was accepted by then, it was still regarded as dubious by the older ladies and more conservative families. But progress was too strong, even for my mother. We often took to the sea on such beaches as were given over to the mingling of the sexes. It was allowed first on Tor Abbey Sands and Corbin's Head Beach, which were more or less main town beaches. We did not bathe there – anyway – the beaches were supposed to be too crowded. Then mixed bathing was allowed on the more aristocratic Meadfoot Beach. This was another good twenty minutes away, and therefore made your walk to bathe rather a long one, practically two miles. However, Meadfoot Beach was much more attractive than the Ladies' Bathing-Cove: bigger, wider, with an accessible rock a good way out to which you could swim if you were a strong swimmer. The Ladies' Bathing-Cove remained sacred to segregation, and the men were left in peace in their dashing triangles.

As far as I remember, the men were not particularly anxious to avail themselves of the joys of mixed bathing; they stuck rigidly to their own private preserve. Such of them as arrived at Meadfoot were usually embarrassed by the sight of their sisters' friends in what they still considered a·state of near nudity.

It was at first the rule that I should wear stockings when I bathed. I don't know how French girls kept their stockings on: I was quite unable to do so. Three or four vigorous kicks when swimming, and my stockings were dangling a long way beyond my toes; they were either sucked off altogether or else wrapped round my ankles like fetters by the time I emerged. I think that the French girls one saw bathing in fashion-plates owed their smartness to the fact that they never actually swam, only walked gently into the sea and out again to parade the beach.

A pathetic tale was told of the Council Meeting at which the question of mixed bathing came up for final approval. A very old Councillor, a vehement opponent, finally defeated, quavered out his last plea:

'And all I say is, Mr Mayor, if this 'ere mixed bathing is carried through, that there will be decent partitions in the bathing machines, *'owever low.'*

With Madge bringing down Jack every summer to Torquay, we bathed practically every day. Even if it rained or blew a gale, it seems to me that we still bathed. In fact, on a rough day I enjoyed the sea even more.

Very soon there came the great innovation of trams. One could catch a tram at the bottom of Burton Road and be taken down to the harbour, and from there it was only about twenty minutes' walk to Meadfoot. When Jack was about five, he started to complain. 'What about taking a cab from the tram to the beach?' 'Certainly not,' said my sister, horrified. 'We've come down all this way in a tram, haven't we? Now we walk to the beach.'

My nephew would sigh and say under his breath, 'Mum on the stingy side again!'

In retaliation, as we walked up the hill, which was, bordered on either side with Italianate villas, my nephew, who, at that age, never stopped talking for a moment, would proceed with a kind of Gregorian chant of his own, which consisted of repeating the names of all the houses we passed: 'Lanka, Pentreave, The Elms, Villa Marguerita, Hartly St. George.' As time went on, he added the names of such occupants as he knew, starting with 'Lanka, Dr G. Wreford; Pentreave, Dr Quick;

Villa Marguerita, Madam Cavallen; The Laurels, don't know,' and so on. Finally, infuriated, Madge or I would tell him to shut up.

'Why?'

'Because we want to talk to each other, and we can't talk to each other if you are talking the whole time and interrupting us.'

'Oh, very well.' Jack lapsed into silence. His lips were moving, how-ever, and one could just hear in faint breath: 'Lanka, Pentreave, The Priory, Torbay Hall . . .' Madge and I would look at each other and try to think of something to say.

Jack and I nearly drowned ourselves one summer. It was a rough day; we had not gone as far as Meadfoot, but instead to the Ladies' Bathing-Cove, where Jack was not yet old enough to cause a tremor in female breasts. He could not swim at that time, or only a few strokes, so I was in the habit of taking him out to the raft on my back. On this particular morning we started off as usual, but it was a curious kind of sea – a sort of mixed swell and chop – and, with the additional weight on my shoulders, I found it almost impossible to keep my mouth and nose above water. I was swimming, but I couldn't get any breath into myself. The tide was not far out, so that the raft was quite close, but I was making little progress, and was only able to get a breath about every third stroke.

Suddenly I realised that I could not make it. At any moment now I was going to choke. 'Jack,' I gasped, 'get off and swim to the raft. You're nearer that than the shore.' 'Why?' said Jack. 'I don't want to.' 'Please – do – ' I bubbled. My head went under. Fortunately, though Jack clung to me at first, he got shaken off and was able therefore to proceed under his own steam. We were quite near the raft by then, and he reached it with no difficulty. By that time I was past noticing what anyone was doing. The only feeling in my mind was a great sense of indignation. I had always been told that when you were drowning the whole of your past life came before you, and I had also been told that you heard beautiful music when you were dying. There was no beautiful music, and I couldn't think about anything in my past life; in fact I could think of nothing at all but how I was going to get some breath into my lungs. Everything went black and – and – and the next thing I knew was violent bruises and pains as I was flung roughly into a boat. The old Sea-Horse, crotchety and useless as we had always thought him, had had enough sense to notice that somebody was drowning and had come out in the boat allowed him for the purpose. Having thrown me into the boat, he took a few more strokes to the raft and grabbed Jack, who resisted loudly saying,

'I don't want to go in yet. I've only just *got* here. I want to play on the raft. I won't come in!' The assorted boatload reached the shore, and my sister came down the beach laughing heartily and saying, 'What *were* you doing? What's all this fuss?'

'Your sister nearly drowned herself,' said the old man crossly: 'Go on, take this child of yours. We'll lay her out flat, and we'll see if she needs a bit of punching.'

I suppose they gave me a bit of punching, though I don't think I had quite lost consciousness.

'I can't see how you knew she was drowning. Why didn't she shout for help?'

'I keeps an eye. Once you goes down you can't shout – water's comin' in.'

We both thought highly of the old Sea-Horse after that.

The outside world impinged much less than it had in my father's time. I had my friends and my mother had one or two close friends whom she saw, but there was little social interchange. For one thing mother was very badly off; she had no money to spare for social entertainments, or indeed for paying cab fares to go to luncheons or dinners. She had never been a great walker, and now, with her heart attacks, she got out little, as it was impossible in Torquay to go anywhere without going up or down hill almost immediately. I had bathing in the summer, roller-skating in the winter and masses of books to read. There, of course, I was constantly making new discoveries. Mother read me Dickens aloud at this point and we both enjoyed it.

Reading aloud started with Sir Walter Scott. One of my favourites was *The Talisman*. I also read *Marmion* and *The Lady of the Lake*, but I think that both mother and I were highly pleased when we passed from Sir Walter Scott to Dickens. Mother, impatient as always, did not hesitate to skip when it suited her fancy. 'All these descriptions,' she would say at various points in Sir Walter Scott. 'Of course they are very good, and literary, but one can have too many of them.' I think she also cheated by missing out a certain amount of sob-stuff in Dickens, particularly the bits about Little Nell.

Our first Dickens was *Nicholas Nickleby*, and my favourite character was the old gentleman who courted Mrs Nickleby by throwing vegetable marrows over the wall. Can this be one of the reasons why I made

Hercule Poirot retire to grow vegetable marrows? Who can say? My favourite Dickens of all was *Bleak House*, and still is.

Occasionally we would try Thackeray for a change. We got through *Vanity Fair* all right, but we stuck on *The Newcombes* – 'We ought to like it,' said my mother, 'everyone says it is his best.' My sister's favourite had been *Esmond*, but that too we found diffuse and difficult; indeed I have never been able to appreciate Thackeray as I should.

For my own reading, the works of Alexandre Dumas in French now entranced me. *The Three Musketeers*, *Twenty Years After*, and best of all, *The Count of Monte Christo*. My favourite was the first volume, *Le Château d'If*, but although the other five volumes occasionally had me slightly bewildered the whole colourful pageant of the story was entrancing. I also had a romatic attachment to Maurice Hewlett: *The Forest Lovers*, *The Queen's Quair*, and *Richard Yea-and-Nay*. Very good historical novels they are, too.

Occasionally my mother would have a sudden idea. I remember one day when I was picking up suitable windfalls from the apple-tree, she arrived like a whirlwind from the house. 'Quickly,' she said, 'we are going to Exeter.'

'Going to Exeter,' I said surprised. 'Why?'

'Because Sir Henry Irving is playing there, in *Becket*. He may not live much longer, and you *must* see him. A great actor. We've just time to catch the train. I have booked a room at the hotel.'

We duly went to Exeter, and it was indeed a wonderful performance of *Becket* which I have never forgotten.

The theatre had never stopped being a regular part of my life. When staying at Ealing, Grannie used to take me to the theatre at least once a week, sometimes twice. We went to all the musical comedies, and she used to buy me the score afterwards. Those scores – how I enjoyed playing them! At Ealing, the piano was in the drawing-room, and so fortunately I did not annoy anyone by playing several hours on end.

The drawing-room at Ealing was a wonderful period piece. There was practically no room in it to move about. It had a rather splendid thick Turkey carpet on the floor, and every type of brocaded chair; each one of them uncomfortable. It had two, if not three, marquetry china cabinets, a large central candelabra, standard oil lamps, quantities of small whatnots, occasional tables, and French Empire furniture. The light from the window was blocked by a conservatory, a prestige symbol that was a must, as in all self-respecting Victorian houses. It was a very

cold room; the fire was only lit there if we had a party; and nobody as a rule went into it except myself. I would light the brackets on the piano, adjust the music-stool, breathe heavily on my fingers, and start off with *The Country Girl* or *Our Miss Gibbs*. Sometimes I allotted rôles to 'the girls', sometimes I was myself singing them, a new and unknown star.

Taking my scores to Ashfield, I used to play them in the evenings in the school-room, (also an icy cold room in winter). I played and I sang. Mother often used to go to bed early, after a light supper, about eight o'clock. After she had had about two and a half hours of me thumping a piano overhead, and singing at the top of my voice, she could bear it no longer, and used to take a long pole, which served for pushing the windows up and down, and rap frantically on the ceiling with it. Regretfully I would abandon my piano.

I also invented an operetta of my own called *Marjorie*. I did not compose it exactly, but I sang snatches of it experimentally in the garden. I had some vague idea that I might really be able to write and compose music one day. I got as far as the libretto, and there I stuck. I can't remember the whole story now, but it was all slightly tragic, I think. A handsome young man with a glorious tenor voice loved desperately a girl called Marjorie, who equally naturally did not love him in return. In the end he married another girl, but on the day after his wedding a letter arrived from Marjorie in a far country saying that she was dying and had at last realised that she loved him. He left his bride and rushed to her forthwith. She was not quite dead when he arrived – alive enough at any rate to raise herself on one elbow and sing a splendid dying love song. The bride's father arrived to wreak vengeance for his deserted daughter, but was so affected by the lovers' grief that he joined his baritone to their voices, and one of the most famous trios ever written concluded the opera.

I also had a feeling that I might like to write a novel called *Agnes*. I remember even less of that. It had four sisters in it: Queenie, the eldest, golden-haired and beautiful, and then some twins, dark and handsome, finally Agnes, who was plain, shy and (of course) in poor health, lying patiently on a sofa. There must have been more story than this, but it has all gone now. All I can remember is that Agnes's true worth was recognised at last by some splendid man with a black moustache whom she had loved secretly for many years.

The next of my mother's sudden ideas was that perhaps, after all, I wasn't being educated enough, and that I had better have a little school-

ing. There was a girls' school in Torquay kept by someone called Miss Guyer, and my mother made an arrangement that I should go there two days a week and study certain subjects. I think one was arithmetic, and there was also grammar and composition. I enjoyed arithmetic, as always, and may even have begun algebra there. Grammar I could not understand in the least: I could not see *why* certain things were called prepositions or what verbs were supposed to *do*, and the whole thing was a foreign language to me. I used to plunge happily into composition, but not with real success. The criticism was always the same: my compositions were too fanciful. I was severely criticised for not keeping to the subject. I remember – 'Autumn' – in particular. I started off well, with golden and brown leaves, but suddenly, somehow or other, a *pig* got into it – I think it was possibly rooting up acorns in the forest. Anyway, I got interested in the pig, forgot all about autumn, and the composition ended with the riotous adventures of Curlytail the Pig and a terrific Beechnut Party he gave his friends.

I can picture one teacher there – I can't recall her name. She was short and spare, and I remember her eager jutting chin. Quite unexpectedly one day (in the middle, I think, of an arithmetic lesson) she suddenly launched forth on a speech on life and religion. 'All of you,' she said, 'every *one* of you – will pass through a time when you will face despair. If you never face despair, you will never have faced, or become, a Christian, or known a Christian life. To be a Christian you must face and accept the life that Christ faced and lived; you must enjoy things as he enjoyed things; be as happy as he was at the marriage at Cana, know the peace and happiness that it means to be in harmony with God and with God's will. But you must also know, as he did, what it means to be alone in the Garden of Gethsemane, to feel that all your friends have forsaken you, that those you love and trust have turned away from you, and that *God Himself* has forsaken you. Hold on then to the belief that that is *not* the end. If you love, you will suffer, and if you do not love, you do not know the meaning of a Christian life.'

She then returned to the problems of compound interest with her usual vigour, but it is odd that those few words, more than any sermon I have ever heard, remained with me, and years later they were to come back to me and give me hope at a time when despair had me in its grip. She was a dynamic figure, and also, I think, a *fine* teacher; I wish I could have been taught by her longer.

Sometimes I wonder what would have happened if I had continued

with my education. I should, I suppose, have progressed, and I think I should have been entirely caught up in mathematics – a subject which has always fascinated me. If so, my life, would certainly have been very different. I should have been a third or fourth-rate mathematician and gone through life quite happily. I should probably not have written any books. Mathematics and music would have been enough to satisfy me. They would have engaged my attention, and shut out the world of imagination.

On reflection, though, I think that you are what you are going to be. You indulge in the fantasies of, 'If so-and-so had happened, I should have done so-and-so', or, 'If I had married So-and-so, I suppose I should have had a totally different life.' Somehow or other, though, you would always find your way to your own pattern, because I am sure you *are* following a pattern: your pattern of your life. You can embellish your pattern, or you can scamp it, but it is *your* pattern and so long as you are following it you will know harmony, and a mind at ease with itself.

I don't suppose I was at Miss Guyer's more than a year and a half; after that my mother had another idea. With her usual suddenness she explained that I was now going to Paris. She would let Ashfield for the winter, we would go to Paris; I might perhaps start at the same *pension* at which my sister had been, and see how I liked it.

Everything went according to plan; mother's arrangements always did. She carried them out with the utmost efficiency, and bent everyone to her will. An excellent let was obtained for the house; mother and I packed all our trunks (I don't know that there were quite so many round-topped monsters as there had been when we went to the South of France, but there were still a goodly number), and in next to no time we were settled in the Hôtel d'Iéna, in the Avenue d'Iéna in Paris.

Mother was laden with letters of introduction and the addresses of various *pensionnats* and schools, teachers and advisers of all kinds. She had things sorted out before long. She heard that Madge's *pensionnat* had changed its character and gone downhill as the years passed – Mademoiselle T. herself had either given up or was about to give up – so my mother merely said we could try it for a bit, and see. This attitude towards schooling would hardly be approved of nowadays, but to my mother trying a school was exactly like trying a new restaurant. If you looked inside you couldn't tell what it was like; you must try it, and if you didn't like it the sooner you moved from it the better. Of

course then you had not to bother with G. C. E. School Certificate, O levels, A levels and serious thoughts for the future.

I started at Mademoiselle T.'s, and stayed there for about two months, until the end of the term. I was fifteen. My sister had distinguished herself on arriving, when she was dared by some other girl to jump out of a window. She had immediately done so – and arrived slap in the middle of a tea-table round which Mademoiselle T. and distinguished parents were sitting. 'What hoydens these English girls are!' exclaimed Mademoiselle T. in high displeasure. The girls who had egged her on were maliciously pleased, but they admired her for her feat.

My entry was not at all sensational. I was merely a quiet mouse. By the third day I was in misery with homesickness. In the last four or five years I had been so closely attached to my mother, hardly ever leaving her, that it was not unnatural that the first time I really went away from home I should feel homesick. The curious thing was that I didn't know what was the matter with me. I just didn't want to eat. Every time I thought of my mother, tears came into my eyes and ran down my cheeks. I remember looking at a blouse which mother had made – extremely badly – with her own fingers, and the fact that it *was* made badly, that it did not fit, that the tucks were uneven, made me cry all the more. I managed to conceal these feelings from the outside world, and only wept at night into my pillow. When my mother came to fetch me the following Sunday I greeted her as usual, but when we got back to the hotel I burst into tears and flung my arms round her neck. I am glad to say that at least I did not ask her to take me away; I knew quite well that I had to stop there. Besides, having seen mother I felt that I wasn't going to be homesick any more; I knew what was the matter with me.

I had no recurrence of homesickness. Indeed, I now enjoyed my days at Mademoiselle T.'s very much. There were French girls, American girls, and a good many Spanish and Italian girls – not many English. I liked the company of the American girls especially. They had a breezy interesting way of talking and reminded me of my Cauterets friend, Marguerite Prestley.

I can't remember much about the work side of things – I don't think it can have been very interesting. In history we seemed to be doing the period of the Fronde, which I knew pretty well from the reading of historical novels; and in geography I have been mystified for life by learning the provinces of France as they were in the time of the Fronde

rather than as they are now. We also learnt the names of the months as they were during the French Revolution. My faults in French dictation horrified the mistress in charge so much she could hardly believe it. *'Vraiment, c'est impossible'*, she said. *'Vous, qui parlez si bien le français, vous avez fait vingt-cinq fautes en dictée, vingt-cinq!'*

Nobody else had made more than five. I was quite an interesting phenomenon by reason of my failure. I suppose it was natural enough under the circumstances, since I had known French entirely by talking it. I spoke it colloquially but, of course, entirely by ear, and the words *été* and *était* sounded exactly the same to me: I spelt it one way or the other purely by chance, hoping I might have hit upon the right one. In some French subjects, literature, recitation, and so on, I was in the top class; as regards French grammar and spelling I was practically in the bottom class. It made it difficult for my poor teachers – and I suppose shaming for me – except that I can't feel that I really *cared*.

I was taught the piano by an elderly lady called Madame Legrand. She had been there for a great many years. Her favourite method of teaching the piano was to play *à quatre mains* with her pupil. She was insistent on pupils being taught to read music. I was not bad at reading music, but playing it with Madame Legrand was something of an ordeal. We both sat on the bench-like music seat and, as Madame Legrand was extremely well-covered, she took up the greater part of it and elbowed me away from the middle of the piano. She played with great vigour, using her elbows, which stuck out slightly a-kimbo, the result being that the unfortunate person who was playing the other two hands had to play with one elbow stuck tightly to her side.

With a certain natural craftiness I managed nearly always to play the *bass* side of the duet. Madame Legrand was led into this the more easily because she so enjoyed her own performance, and naturally the treble gave her a far better chance of pouring her soul into the music. Sometimes for quite a long time, owing to the vigour of her playing and her absorbtion in it, she failed to realise that I had lost my place in the bass. Sooner or later I hesitated over a bar, got one behind, tried to catch up, not sure where I was, and then tried to play such notes as would accord with what Madame Legrand was playing. Since, however, we were reading music I could not always anticipate this intelligently. Suddenly, as the hideous cacophany we were making dawned upon her, she would stop, raise her hands in the air and exclaim: *'Mais qu'est-ce que vous jouez là, petite? Que c'est horrible!'* I couldn't have agreed with her more –

horrible it was. We would then start again at the beginning. Of course, if I was playing the treble my lack of coordination was noticed at once. However, as a whole, we got on well. Madame Legrand puffed and snorted a great deal the whole time she played. Her bosom rose and fell, groans sometimes came from her; it was alarming but fascinating. She also smelt rather high, which was not so fascinating.

There was to be a concert at the end of the term, and I was scheduled to play two pieces, one the third movement from the *Sonata Pathétique* of Beethoven, and the other a piece called *Serenade d'Aragona*, or something like that. I took a scunner to the *Serenade d'Aragona* straight away. I found extraordinary difficulty in playing it – I don't know why; it was certainly much easier than the Beethoven. Though my playing of the Beethoven came on well, the *Serenade d'Aragona* continued to be a very poor performance. I practised it ardently, but I seemed to make myself even more nervous. I woke up at night, thinking I was playing, and all sorts of things would happen. The notes of the piano would stick, or I would find I was playing an organ instead of the piano, or I was late in arriving, or the concert had taken place the night before . . . It all seems so silly when one remembers it.

Two days before the concert I had such high fever that they sent for my mother. The doctor could find no cause for it. However, he gave it as his view that it would be much better if I did not play at the concert, and if I were removed from the school for two or three days until the concert was over. I cannot tell you of my thankfulness, though at the same time I had the feeling of somebody who has failed at something they had been determined to accomplish.

I remember now that at an arithmetic exam at Miss Guyer's school I had come out bottom, though I had been top of the class all the week previously. Somehow, when I read the questions at the exam my mind shut up and I was unable to think. There are people who can pass exams, often high up, after being almost bottom in class; there are people who can perform in public much better than they perform in private; and there are people who are just the opposite. I was one of the latter. It is obvious that I chose the right career. The most blessed thing about being an author is that you do it in private and *in your own time*. It can worry you, bother you, give you a headache; you can go nearly mad trying to arrange your plot in the way it should go and you know it could go; *but* – you do not have to stand up and make a fool of yourself in public.

I returned to the *pensionnat* with great relief and in good spirits. Immediately I tried to see if I could now play the *Serenade d'Aragona*. I certainly played it better than I had ever done before, but the performance was still poor. I went on learning the rest of the Beethoven sonata with Madame Legrand, who, though disappointed in me as a pupil who might have done her credit, was still kind and encouraging and said I had a proper sense of music.

The two winters and one summer that I spent in Paris were some of the happiest days I have ever known. All sorts of delightful things happened all the time. Some American friends of my grandfather whose daughter sang in Grand Opera lived there. I went to hear her as Marguerite in *Faust*. At the *pensionnat*, they did not take girls to hear *Faust* – the subject was not supposed to be '*convenable*' for '*les jeunes filles*'. I think people tended to be rather optimistic over the easy corruption of *les jeunes filles*; you would have to have far more knowledge than *jeunes filles* did in those days to know anything improper was going on at Marguerite's window. I never understood in Paris why Marguerite was suddenly in her prison. Had she, I wondered, stolen the jewellery? Certainly pregnancy and the death of the child never even occurred to me.

We were taken mostly to the Opéra Comique. *Thäis, Werther, Carmen, La Vie Bohème, Manon. Werther* was my favourite. At the Grand Opera House I heard *Tannhäuser* as well as *Faust*.

Mother took me to dressmakers, and I began to appreciate clothes for the first time. I had a pale grey *crêpe de Chine* semi-evening dress made, which filled me with joy – I had never had anything so grown-up-looking before. It was sad that my bosom was still unco-operative, so that I had to have a lot of ruffles of *crêpe de Chine* hurriedly tucked into the bodice, but I was still hopeful that one day a couple of truly womanly bosoms, firm, round and large, would be mine. How lucky that vision into the future is spared to us. Otherwise I should have seen myself at thirty-five, with a round womanly bosom well-developed, but, alas, everybody else going about with chests as flat as boards, and if they *were* so unfortunate as to have bosoms, tightening them out of existence.

Through the introductions mother had brought, we went into French society. American girls were welcomed always to the Faubourg St. Germain and it was acceptable for the sons of the French aristocracy to marry rich Americans. Though I was far from rich, my father was known to have been American, and all Americans were supposed to have some

money. It was a curious, decorous, old-world society. The Frenchmen I
met were polite, very *comme il faut* – and nothing could have been duller
from a girl's point of view. However, I learnt French phraseology of the
politest kind. I also learnt dancing and deportment, with someone called,
I think (though it seems improbable), Mr Washington Lob. Mr Wash-
ington Lob was the closest thing to Mr Turveydrop that I can imagine.
I learnt the Washington Post, the Boston, and a few other things, and I
also learnt the various usages of cosmopolitan society. 'Suppose now, you
were about to sit down by an elderly married lady. How would you sit?'
I looked at Mr Washington Lob with blank eyes. 'I should – er – sit,'
I said puzzled.

'Show me.' He had some gilt chairs there, and I sat down in a gilt chair,
trying to hide my legs as much as possible underneath the chair.

'No, no, that is impossible. That will never do,' said Mr Washington
Lob. 'You turn slightly sideways, that is enough, not more; and as you
sit down you are leaning slightly to the right, so you bend your left knee
slightly, so that it is almost like a little bow as you sit.' I had to practise
this a good deal.

The only things I really hated were my drawing and painting lessons.
Mother was adamant on that subject; she would *not* let me off: 'Girls
should be able to do water-colours.'

So very rebelliously, twice a week, I was called for by a suitable young
woman (since girls did not go about alone in Paris) and taken by metro or
bus to an *atelier* somewhere near the flower-market. There I joined a class
of young ladies, painting violets in a glass of water, lilies in a jar, daffodils
in a black vase. There would be terrific sighs as the lady in charge came
round. '*Mais vous ne voyez rien,*' she said to me. 'First you must start with
the *shadows*: do you not see? Here, and here, and *here* there are shadows.'

But I never saw the shadows; all I saw were some violets in a glass of
water. Violets were mauve – I could match the shade of mauve on my
palette, and I would then paint the violets a flat mauve. I quite agree that
the result did not look like a bunch of violets in a glass of water, but I did
not see, and I don't think have ever seen, what does make shadows look
like a bunch of violets in water. On some days, to ease my depression, I
would draw the table legs or an odd chair in perspective, which cheered
me up, but which did not go down at all well with my instructress.

Though I met many charming Frenchmen, strangely enough I did
not fall in love with any of them. Instead I conceived a passion for the

reception clerk in the hotel, Monsieur Strie. He was tall and thin, rather like a tapeworm, with pale blond hair and a tendency to spots. I really cannot understand what I saw in him. I never had the courage to speak to him, though he occasionally said '*Bonjour, Mademoiselle*' as I passed through the hall. It was difficult to have fantasies about Monsieur Strie. I imagined myself sometimes nursing him through the plague in French Indo-China, but it took much effort to keep that vision going. As he finally gasped out his last breath he would murmur: 'Mademoiselle, I always adored you in the days at the hotel' – which was all right as far as it went, but when I noticed Monsieur Strie writing industriously behind the desk the following day it seemed to me extremely unlikely that he would ever say such a thing, even on his deathbed.

We passed the Easter holidays going on expeditions to Versailles, Fontainebleau, and various other places, and then, with her usual suddenness, mother announced that I should not be returning to Mademoiselle T.'s.

'I don't think much of that place,' she said. 'No interesting teaching. It's not what it was in Madge's time. I am going back to England, and I have arranged that you shall go to Miss Hogg's school at Auteuil, Les Marroniers.'

I can't remember feeling anything beyond mild surprise. I had enjoyed myself at Mademoiselle T.'s, but I didn't particularly want to go back there. In fact it seemed more interesting to go to a new place. I don't know whether it was stupidity on my part or amiability – I like to think, of course, that it was the latter – but I was always prepared to like the next thing that came along.

So I went to Les Marroniers, which was a good school but extremely English. I enjoyed it, but found it dull. I had quite a good music teacher, but not as much fun as Madame Legrand had been. As everyone talked English all the time, in spite of the fact that it was strictly forbidden, nobody learned much French.

Outside activities were not encouraged, or indeed perhaps even allowed, at Les Marroniers, so at last I was to shake myself free of my detested painting and drawing lessons. The only thing I missed was passing through the flower-market, which really had been heavenly. It was no surprise to me at the end of the summer holidays when my mother suddenly said to me at Ashfield that I was not going back to Les Marroniers. She had had a new idea for my education.

V

Grannie's doctor, Dr Burwood, had a sister-in-law who kept a small establishment for 'finishing' girls in Paris. She only took twelve to fifteen girls, and they were all studying music or taking courses at the Conservatoire or the Sorbonne. How did I like that idea? my mother asked. As I have said, I welcomed new ideas; in fact my motto might have been established by then as 'Try anything once'. So in the autumn I went to Miss Dryden's establishment, just off the Arc de Triomphe in the Avenue du Bois.

Being at Miss Dryden's suited me down to the ground. For the first time I felt that what we were doing was really interesting. There were twelve of us. Miss Dryden herself was tall, rather fierce, with beautifully arranged white hair, an excellent figure, and a red nose, which she was in the habit of rubbing violently when she was angry. She had a dry, ironic form of conversation that was alarming but stimulating. Assisting her was a French coadjutor, Madame Petit. Madame Petit was very French, temperamental, highly emotional, remarkably unfair, and we were all devoted to her, and not nearly so much in awe of her as we were of Miss Dryden.

It was, of course, much more like living in a family, but a serious attitude was taken towards our studies. There was an emphasis on music, but we had plenty of interesting classes of all kinds. We had people from the Comédie Française, who gave us talks on Molière, Racine and Corneille, and singers from the Conservatoire, who sang the airs of Lully and Glück. We had a dramatic class where we all recited. Luckily we did not have so many '*dictées*' here, so my spelling faults were not quite so noticeable, and since my spoken French was better than the others' I enjoyed myself thoroughly reciting the lines of *Andromaque*, feeling myself indeed that tragic heroine as I stood and declaimed: '*Seigneur, toutes ces grandeurs ne me touchent plus guère*'.

I think we all rather enjoyed ourselves at the drama class. We were taken to the Comédie Française and saw the classic dramas and several modern plays as well. I saw Sarah Bernhardt in what must have been one of the last roles of her career, as the golden pheasant in Rostand's *Chan-*

tecler. She was old, lame, feeble, and her golden voice was cracked, but she was certainly a great actress – she held you with her impassioned emotion. Even more exciting than Sarah Bernhardt did I find Réjane. I saw her in a modern play, *La Course aux Flambeaux*. She had a wonderful power of making you feel, behind a hard repressed manner, the existence of a tide of feeling and emotion which she would never allow to come out into the open. I can still hear now, if I sit quiet a minute or two with my eyes closed, her voice, and see her face in the last words of the play: '*Pour sauver ma fille, j'ai tué ma mère,*' and the deep thrill this sent through one as the curtain came down.

It seems to me that teaching can only be satisfactory if it awakens some response in you. Mere information is no good, it gives you nothing more than you had before. To be talked to about plays by *actresses*, repeating words and speeches from them; to have real singers singing you *Bois Epais* or an aria from Glück's *Orphée* was to bring to life in you a passionate love of the art you were hearing. It opened a new world to me, a world in which I have been able to live ever since.

My own serious study was music, of course, both singing and piano. I studied the piano with an Austrian, Charles Fürster. He occasionally came to London and gave recitals. He was a good but frightening teacher. His method was to wander round the room as you played. He had the air of not listening, looked out of the window, smelt a flower, but all of a sudden, as you played a false note or phrased something badly, he would swing round with the alaerity of a pouncing tiger and cry out: '*Hein, qu'est-ce que vous jouez là, petite, hein? C'est atroce.*' It was shattering to the nerves at first, but one got used to it. He was a passionate addict of Chopin, so that I learnt mostly Chopin Etudes and Waltzes, the *Fantaisie Impromptue*, and one of the Ballades. I knew I was getting on well under his teaching, and it made me happy. I also learned the Sonatas of Beethoven, as well as several light, what he called 'drawing-room pieces', a Romance of Fauré, the Barcarolle of Tchaikowski, and others. I practised with real assiduity, usually about seven hours a day. I think a wild hope was springing up within me – I don't know that I ever let it quite come into my consciousness, but it was there in the background – that perhaps I could be a pianist, could play at concerts. It would be a long time and hard work, but I knew that I was improving rapidly.

My singing lessons had begun before this period. My teacher was a Monsieur Boué. He and Jean de Reszke were supposed at that time to be the two leading singing teachers of Paris. Jean de Reszke had been a

famous tenor and Boué an operatic baritone. He lived in an apartment five flights up with no lift. I used to arrive at the fifth storey completely out of breath, as indeed was only natural. The apartments all looked so alike that you lost count of the storeys you had climbed, but you always knew when you were getting to Monsieur Boué's because of the wall-paper on the stairs. On the last turn, was an enormous grease mark which had a rough resemblance to the head of a cairn terrier.

When I arrived I would be immediately greeted with reproaches. What did I mean by breathing fast like that? Why did I have to be out of breath? Someone my age should spring upstairs, without panting. Breathing was everything. 'Breathing is the whole of singing, you should know that by now.' He would then reach for his tape measure, which was always at hand. This he would put round my diaphragm and then urge me to breathe in, hold it, and then breathe out as completely as possible. He would calculate the difference between the two measurements, nodd-ing his head occasionally and saying: '*C'est bien, c'est bien*, it advances. You have a good chest, an excellent chest. You have splendid expansion, and what is more, I will tell you something, you will never have the consumption. That is a sad thing for some singers; they get the con-sumption, but with you no. As long as you practise your breathing, all will be well with you. You like beefsteak?' I said yes, I was extremely fond of beefsteak. 'That is good too; that is the best food for a singer. You cannot eat large meals, or eat often, but I say to my opera singers you will have at three o'clock in the afternoon a large steak and a glass of stout; after that *nothing* till you sing at nine o'clock.'

We then proceeded to the singing lesson proper. The *voix de tête*, he said, was very good, it was perfect, properly produced and natural, and my chest notes were not too bad; but the *médium*, the *médium* was extremely weak. So to begin with I was to sing mezzo-soprano songs to develop *le médium*. At intervals he would get exasperated with what he called my English face. 'English faces,' he said, 'have no expression! They are not mobile. The skin round the mouth, it does not move; and the voice, the words, everything, they come from the back of the throat. That is very bad. The French language has got to come from the *palate*, from the roof of the mouth. The roof of the mouth, the bridge of the nose, *that* is where the voice of the *médium* comes from. You speak French very well, very fluently, though it is unfortunate you have not the English accent but the accent of the Midi. Why do you have the accent of the Midi?'

I thought for a minute, and then I said perhaps because I had learnt French from a French maid who had come from Pau.

'Ah, that explains it,' he said. 'Yes, that is it. It is the accent *méridional* that you have. As I say, you speak French fluently, but you speak it as though it were English because you speak it from the back of your throat. You must move your lips. Keep your teeth close together, but move your *lips*. Ah, I know what we shall do.'

He would then tell me to stick a pencil in the corner of my mouth and articulate as well as possible while I was singing, without letting the pencil drop out. It was extraordinarily difficult at first, but in the end I managed it. My teeth clamped the pencil and my lips then had to move a great deal to make the words come out at all.

Boué's fury was great one day when I brought in the air from *Samson et Delilah*, '*Mon coeur s'ouvre à ta voix*', and asked him if I could possibly learn it, as I had enjoyed the opera so much.

'But what is this you have here?' he said, looking at the piece of music. 'What is this? What *key* is it in? It is in a transposed key.'

I said I had bought the version for a soprano voice.

He shouted with rage: 'But Delilah is not a soprano part. It is a *mezzo* part. Do you not know that if you sing an air from an opera, it must always be sung in the key it was written in? You cannot transpose for a soprano voice what has been written for a mezzo voice – it puts the whole emphasis wrong. Take it away. If you bring it in the proper mezzo key, yes, you shall learn it.'

I never dared sing a transposed song again.

I learned large quantities of French songs, and a lovely Ave Maria of Cherubini's. We debated for some time how I was to pronounce the Latin of that. 'The English pronounce Latin in the Italian way, the French have their own way of pronouncing Latin. I think, since you are English, you had better sing it in the Italian pronunciation.'

I also sang a good many of Schubert's songs in German. In spite of not knowing German this was not too difficult; and I sang songs in Italian, of course. On the whole I was not allowed to be too ambitious, but after about six months or so of study I was allowed to sing the famous aria from *La Bohème* '*Te Gelida Manina*' and also the aria from *Tosca*, '*Vissi d'arte*'.

It was indeed a happy time. Sometimes, after a visit to the Louvre, we were taken to have tea at Rumpelmayer's. There could be no delight in life for a greedy girl like tea at Rumpelmayer's. My favourites were those

glorious cakes with cream and marron piping of a sickliness which was incomparable.

We were taken of course, for walks in the Bois – a very fascinating place. One day, I remember, when we were going in a neat crocodile, two by two, along a deeply wooded path, a man came out from behind some trees – a classic case of indecent exposure. We must all have seen him, I think, but we all behaved in a decorous manner as if we had noticed nothing unusual – possibly we may have been not quite sure of what it was we *had* seen. Miss Dryden, herself, who was in charge of us that day, sailed along with the iron-clad belligerence of a battleship. We followed her. I suppose the man, whose upper half was very correct, with black hair and pointed beard and a very smart cravat and tie, must have spent his day wandering about the darker places of the Bois so as to surprise decorous young ladies from *pensionnats*, walking in a croco-dile, wishing perhaps to add to their knowledge of life in Paris. I may add that, as far as I know, not one of us mentioned this incident to any of the other girls; there was not so much as a giggle. We were all splen-didly modest in those days.

We had occasional parties at Miss Dryden's, and on one occasion a former pupil of hers, an American woman now married to a French Vicomte, arrived with her son, Rudy. Rudy might have been a French baron, but in appearance he was a thoroughly American college boy. He must have blenched a little at the sight of twelve nubile girls looking at him with interest, approbation, and possible romance in their eyes.

'I've got my work cut out shaking hands round here,' he declared in a cheerful voice. We all met Rudy again the next day at the Palais de Glace, where some of us were skating and some learning to skate. Rudy was again determinedly gallant, anxious not to let his mother down. He skated several circuits of the rink with those of us who were able to stand up. I, as so often in these matters, was unlucky. I had only just begun to learn, and on my first afternoon had succeeded in throwing the skating instructor. This, I may say, had made him extremely angry. He had been held up to the ridicule of his colleagues. He prided himself on being able to hold up *anyone*, even the stoutest American lady, and to be floored by a tall thin girl must have infuriated him. He took me out for my turn as seldom as possible after this. Anyway I didn't think I would risk being pioneered by Rudy round the rink – I should probably throw *him* too, and then *he* would have been annoyed.

Something happened to me at the sight of Rudy. We only saw him on

those few occasions, but they marked a point of transition. From that moment forward I stepped out of the territory of hero-worship. All the romantic love I had felt for people real and unreal – people in books, people in the public eye, actual people who came to the house – finished at that moment. I no longer had the capacity for selfless love or the wish to sacrifice myself on their behalf. From that day I began to think of young men only as young men – exciting creatures whom I would enjoy meeting, and among whom, some day, I should find my husband (Mr Right in fact). I did not fall in love with Rudy – perhaps I might have, if I had met him often – but I did suddenly feel *different*. I had become one of the world of females on the prowl! From that moment, the image of the Bishop of London, who had been my last object of hero-worship, faded from my mind. I wanted to meet *real* young men, *lots* of real young men – in fact there couldn't be too many of them.

I am hazy now as to how long I remained at Miss Dryden's – a year, perhaps eighteen months, I do not think as long as two years. My volatile mother did not propose any further changes of educational plan; perhaps she did not hear of anything that excited her. But I think really that she had an intuitive knowledge that I had found what satisfied me. I was learning things that mattered, that built themselves into me as part of an interest in life.

One dream of mine faded before I left Paris. Miss Dryden was expecting an old pupil of hers, the Countess of Limerick, who herself was a very fine pianist, a pupil of Charles Fürster's. Usually the two or three girls who were studying the piano would give an informal concert on these occasions. I was one of them. The result was catastrophic. I was nervous beforehand, but not unusually so, no more than would be natural, but as soon as I sat down at the piano inefficiency overwhelmed me like a tide. I played wrong notes, my tempo went, my phrasing was amateur and ham-handed – I was just a mess.

Nobody could have been kinder than Lady Limerick. She talked to me later and said she had realised how nervous I had been, and that one did get these fits of what really qualified as stage-fright. Perhaps I would get over them later when I became more experienced in playing before an audience. I was grateful for those kind words, but I knew myself that there was more to it than that.

I continued to study, but before I finally went home I asked Charles Fürster frankly whether he thought that by hard work and application I could one day be a professional pianist. He, too, was kind, but he told

me no lies. He said that he thought I had not the temperament to play in public, and I knew he was right. I was grateful to him for telling me the truth. I was miserable about it for a while, but I tried hard not to dwell on it more than I could help.

If the thing you want beyond anything cannot be, it is much better to recognise it and go forward, instead of dwelling on one's regrets and hopes. Such a rebuff coming early helped me for the future; it taught me that I had not the kind of temperament for exhibition of any kind. I can describe what it seemed like by saying that I could not control my *physical* reaction.

PART IV

FLIRTING, COURTING, BANNS UP, MARRIAGE

(*Popular Victorian Game*)

I

Soon after I came home from Paris, my mother had a serious illness. In the usual manner of doctors, it was diagnosed as appendicitis, para-typhoid, gallstones and a few more things. Several times she had been on the brink of being carted off to the operating-table. Treatment did not improve her condition – she was constantly having relapses, and various different operations were mooted. My mother was an amateur doctor herself. When her brother Ernest had been working as a medical student, she had helped him with mounting enthusiasm. She would have made a far better doctor than he would. In the end he had to give up the idea owing to the fact that he could not stand the sight of blood. By that time mother was practically as fully trained as he was – and would not have minded blood, wounds, or any other physical offences to the eye. I noticed that, whenever we went to the dentist together, my mother ignored the *Queen* or *The Tatler* and immediately seized *The Lancet* or the *British Medical Journal* if it was anywhere about on the table.

Finally losing patience with her medical attendants, she said, 'I don't think they *know* – I don't know myself. I think the great thing is to get out of the doctors' hands.'

She succeeded in finding yet another doctor who was what you might call the biddable kind, and was soon able to announce that he had advised

sunshine and a warm dry climate. 'We will go to Egypt for the winter,' she informed me.

Once more we set about letting the house. It was fortunate that the expenses of travelling must have been fairly low in those days, and that the cost of living abroad seemed easily covered by the high rent asked for Ashfield. Torquay was of course at that period still a *winter* resort. Nobody went there during the summer, and people who lived there always went away then to avoid 'the terrible heat'. (I can't imagine what this terrible heat could be: nowadays I always find South Devon extremely cold in the summer.) Usually they went up to the moor and took houses there. Father and mother did that once, but they found it so hot on the moor that father hired a dog-cart and drove back into Torquay to sit in his own garden practically every afternoon. Anyway, Torquay was then the Riviera of England, and people paid large rents for furnished villas there, during quite a gay winter season with concerts in the afternoons, lectures, occasional dances, and a great deal of other social activity.

I was now ready to 'come out'. My hair was 'up', which at that period meant done in the Grecian style, with large knots of curls high up on the back of the head and a kind of fillet round it. It was really a becoming style, particularly suited to evening dress. My hair was very long – I could sit on it easily. This for some reason was considered something to be proud of in a woman, though what it actually *meant* was that your hair was completely unmanageable and was always coming down. To counteract this, hairdressers created what was called a *postiche* – a large false knot of curls, with your own hair pinned away as tight to your head as possible, and the *postiche* pinned to that.

'Coming-out' was a thing of great importance in a girl's life. If you were well off, your mother gave a dance for you. You were supposed to go for a season in London. Of course the season was by no means the commercial and highly organised racket it has become in the last twenty or thirty years. The people you asked to your dance then, and the people to whose dances you went, were your personal friends. There was always a slight difficulty in scraping up enough men; but the dances were on the whole informal affairs, or else there were charity balls, to which you took a large party.

Of course, there could be nothing like that in my life. Madge had had her coming-out in New York and been to parties and dances there, but father had not been able to afford a London season for her, and there was certainly no question of *my* having one now. But my mother was anxious

that I should have what was considered a young girl's birthright, that is to say that she should emerge like a butterfly from a chrysalis, from a schoolgirl to a young lady of the world, meeting other girls and plenty of young men, and, to put it plainly, be given her chance of finding a suitable mate.

Everyone made a point of being kind to young girls. They asked them to house-parties, and they arranged pleasant theatre evenings for them. You could rely on all your friends to rally round. There was nothing approaching the French system of shielding daughters and permitting them to meet only a selected few *partis*, who would all make suitable husbands, who had committed their follies and sown their young men's wild oats, and who had sufficient money or property to keep a wife. This system was, I think, a good one; it resulted, certainly, in a high percentage of happy marriages. The English belief that young French girls were forced to marry rich old men was quite untrue. A French girl could make her choice, but it was definitely a limited choice. The rackety, wild-living young man, the charming *mauvais sujet* whom she would doubtless have preferred, was never allowed to enter her orbit.

In England that was not so. Girls went out to dances and met all kinds of young men. Their mothers were there, too, sitting wearily as chaperones, but mothers were fairly helpless. Of course, people were reasonably careful about the young men with whom they allowed their daughters to associate, but there was still a wide field of choice, and girls were notorious for preferring undesirable young men, and even going so far as to get engaged to them or having what was termed an 'understanding'. 'Having an understanding' was a really useful term; by it parents avoided the friction of bad feeling over refusing to accept their daughter's choice. 'You are very young still, dear, and I am sure Hugh is quite charming, but he also is young and has not established himself yet. I see no reason why you should not have an *understanding* and should meet occasionally, but no letters and *no* formal engagement.' They then worked behind the scenes to try to produce a suitable young man so that he might distract the girl's mind from the first one. This often happened. Direct opposition would, of course, have made the girl cling frantically to her first choice, but having it authorised took away some of the glamour, and as most girls are capable of being sensible they quite often changed their minds.

Owing to the fact that we were badly off, my mother saw that it was going to be difficult for me to enter society on the usual terms. Her choice of Cairo as a convalescent centre for herself was, I think, made mainly

on my behalf, and was a good one. I was a shy girl, not brilliant socially; if I could be familiarized with dancing, talking to young men, and all the rest of it, as an everyday thing, it would be the best way of giving me some worth-while experience.

Cairo, from the point of view of a girl, was a dream of delight. We spent three months there, and I went to five dances every week. They were given in each of the big hotels in turn. There were three or four regiments stationed in Cairo; there was polo every day; and at the cost of living in a moderately expensive hotel all this was at your disposal. A good many people went out there for the winter, and many of them were mothers and daughters. I was shy at first, and remained shy in many ways, but I was passionately fond of dancing and I danced well. Also I liked young men, and I soon found they liked me, so everything went well. I was just seventeen – Cairo as Cairo meant nothing to me – girls between eighteen and twenty-one seldom thought of anything but young men, and very right and proper, too!

The art of flirtation is lost nowadays, but then it was in full swing, and was an approximation, I think, to what the old troubadours called 'le pays du tendre'. It is a good introduction to life: the half-sentimental-half-romantic attachment that grows up between what I think of now in my advanced age as 'girls and boys'. It teaches them something of life and of each other without having to pay too violent or disillusioning a price. I certainly don't remember any illegitimate babies among my friends or their families. No, I am wrong. It was not a pretty story: a girl whom we knew went to spend her holidays with a schoolfriend, and was seduced by the schoolfriend's father, an elderly man with a nasty reputation.

Sexual attachments would have been difficult to enter into because young men had a high opinion of young girls, and adverse public opinion would have affected them as well as the girls. Men had *their* sexual fun with married women, usually a good deal older than themselves, or else with 'little friends' in London, about whom no one was supposed to know. I do remember one incident when I was staying in a house-party in Ireland later. There were two or three other girls and young men, soldiers mostly, in the house, and one of the soldiers left abruptly one morning, saying he had had a telegram from England. This was patently untrue. Nobody knew the cause, but he had confided in a much older girl, whom he knew well and whom he considered able to appreciate his dilemma. Apparently he had been asked to accompany one of the girls to a dance

some little distance away to which the others had not been invited. He duly drove her there, but on the way the girl suggested that they should stop at a hotel and engage a room. 'We shall arrive at the dance a bit late,' she said, 'but nobody notices, I find – I've often done it.' The young man was so horrified that, having refused the suggestion he felt it quite impossible to meet her again the next day. Hence his abrupt departure.

'I could hardly believe my ears – she seemed such a nicely brought up girl, quite young, nice parents, and everything. Just the sort of girl one would feel one would want to marry.'

Those were still great days for the purity of young girls. I do not think we felt in the least repressed because of it. Romantic friendships, tinged certainly with sex or the possibility of sex, satisfied us completely. Courtship is, after all, a recognised stage in all animals. The male struts and courts, the female pretends not to notice anything, but is secretly gratified. You know it is not yet the real thing, but it is a kind of apprenticeship. The troubadours were quite right when they made their songs about the *pays du tendre*. I can re-read *Aucassin and Nicolette* always, for its charm, its naturalness and its sincerity. Never again, after your youth, do you have that particular feeling: the excitement of friendship with a man; that sense of being in affinity, of liking the same things, of the other one saying what *you* have just been thinking. A great deal of it is illusion, of course, but it is a wonderful illusion, and I think it ought to have its part in every woman's life. You can smile at yourself later, saying, 'I was really rather a young fool.'

However, in Cairo I didn't even get as far as falling slightly in love. I had too much to do. There was so much going on, and so many attractive, personable young men. The ones that did stir my heart were men of about forty, who kindly danced with the child now and again, and teased me as a pretty young thing, but that was all. Society decreed that you should not dance more than two dances on your programme with the same man in an evening. It was possible, occasionally, to stretch this to three, but the sharp eyes of the chaperones were then upon you.

One's first evening dresses, of course, were a great joy. I had one of pale green chiffon with little lace frills, and a white silk one, rather plainly made, and a rather gorgeous one of deep turquoise blue taffeta, the material for which Grannie had unearthed from one of her secret remnant chests. It was a magnificent piece of stuff, but alas, having been in storage for so many years, it was unable to stand the Egyptian climate, and one evening in the course of a dance it split up the skirt, down the

sleeves and round the neck, and I had to retire hurriedly to the Ladies'
Cloakroom.

Next day we went to one of the Levantine dressmakers of Cairo. They
were very expensive: my own dresses, bought in England, had been
cheap. Still, I did get a lovely dress; it was a shot pale pink satin, and had
a bunch of pink rose-buds on one shoulder. What *I* wanted, of course,
was a black evening dress; all girls wanted a black evening dress to make
them look mature. All their mothers refused to let them have them.

A young Cornishman, called Trelawny, and a friend of his, both in the
6oth Rifles, were my chief partners. One of the older men, a Captain
Craik, who was engaged to a nice American girl, brought me back to my
mother after a dance one night and said, 'Here's your daughter. She has
learnt to dance. In fact she dances beautifully. You had better try to
teach her to talk now.' It was a justified reproach. I had still, alas, no
conversation.

I was good-looking. My family, of course, laugh uproariously whenever
I say that I was a lovely girl. My daughter and her friends, particularly,
say: 'But, Mother, you *couldn't* have been. Look at those awful old
photographs!' It is true that some of the photographs of those days are
pretty terrible, but that, I think, is due to the clothes, which are not yet
quite old enough to have become *period*. Certainly at that time we were
wearing monstrous hats, practically a yard across, of straw, ribbon,
flowers, and large veils. Studio portraits were often taken in hats like
this, sometimes tied with a ribbon under the chin; or sometimes you
were shown with a much-frizzled head of hair, holding an enormous
bunch of roses like a telephone receiver up to your ear. Looking at my
early photographs, one, taken before I came out, with two long pigtails,
sitting, for God knows what reason, at a spinning-wheel, is quite attrac-
tive. As one young man said to me once, 'I like the Gretchen one, very
much.' I suppose I did look rather like Marguerite in *Faust*. There was
one nice one of me in Cairo in one of my plainer hats, an enormous dark
blue straw with one pink rose. It makes an attractive angle round the
face, and is not so overladen with ribbons as most. Dresses were, on the
whole, fussy and frilly.

I soon became mad about polo, and used to watch it every afternoon.
Mother tried to broaden my mind by taking me occasionally to the
Museum, and also suggested we should go up the Nile and see the glories
of Luxor. I protested passionately, with tears in my eyes, 'Oh no, mother,
oh no, don't let's go away *now*. There's the fancy dress dance on Monday,

and I promised to go on a picnic to Sakkara on Tuesday . . .' and so on
and so forth. The wonders of antiquity were the last thing I cared to see,
and I am very glad she did not take me. Luxor, Karnak, the beauties of
Egypt, were to come upon me with wonderful impact about twenty years
later. How it would have spoilt them for me if I had seen them then with
unappreciative eyes.

There is no greater mistake in life than seeing things or hearing them
at the wrong time. Shakespeare is ruined for most people by having been
made to learn it at school; you should see Shakespeare as it was written
to be seen, played on the stage. There you can appreciate it quite young,
long before you take in the beauty of the words and of the poetry. I
took my grandson, Mathew, to *Macbeth* and *The Merry Wives of Windsor*
at Stratford when he was, I think, eleven or twelve. He was very ap-
preciative of both, though his comment was unexpected. He turned to
me as we came out, and said in an awe-struck voice, 'You know, if I
hadn't know beforehand that that was *Shakespeare*, I should *never* have
believed it.' This was clearly meant to be a testimonial to Shakespeare,
and I took it as such.

Macbeth having been a success with Mathew, we proceeded to *The
Merry Wives of Windsor*. In those days it was done, as I am sure it was
meant to be, as good old English slap-stick – no subtlety about it. The
last representation of the *Merry Wives* I saw – in 1965 – had so much
arty production about it that you felt you had travelled very far from a
bit of winter sun in Windsor Old Park. Even the laundry basket was no
longer a laundry basket, full of dirty washing: it was a mere symbol made
of raffia! One cannot really enjoy slapstick farce when it is symbolised.
The good old pantomime custard trick will never fail to rouse a roar of
laughter, so long as custard appears to be actually applied to a face! To
take a small carton with Birds Custard Powder written on it and de-
licately tap a cheek – well, the *symbolism* may be there, but the farce is
lacking. The *Merry Wives of Windsor* went down well indeed with
Mathew, I am glad to say – particular delight being taken over the Welsh
schoolmaster.

I think there is nothing more delightful than introducing the young to
things that we ourselves have long taken for granted, and have taken for
granted in a particular way. Max and I went on a motor tour of the
castles of the Loire once with my daughter, Rosalind, and one of her
friends. The friend measured all the castles we saw by one criterion only:
she would look round with experienced eyes and say, 'They could really

have made whoopee here, couldn't they?' I had never thought of the castles of the Loire in terms of making whoopee before, but again it was a shrewd observation. The old kings and noblemen of France did indeed use their castles for whoopee. The moral (since I was brought up always to find morals) is that you are never too old to learn. There is always some new point of view being shown you unexpectedly.

This seems to have led me a long way from Egypt. One thing does so lead to another; but why shouldn't it? That winter in Egypt, I now see, solved a great many problems in our life. My mother, faced with the difficulty of having to provide social life for a young daughter, with next to no money to do it on, discovered a solution, I overcame my awkwardness. In the language of my time, 'I knew how to behave'. Our way of life now is so different that it seems almost impossible to explain.

The trouble is that girls today know nothing of the art of flirtation. Flirtation, as I have said, was an art carefully cultivated by girls of my generation. We knew the rules back to front. It was true that in France no young girl was ever left alone with a young man, but in England that was certainly not so. You went for a walk with a man, you went out riding with a man – but you did not go to a dance alone with a young man: either your mother sat there, or some other bored dowager, or appearances were satisfied by a young married woman being in your party. But having kept the rules, and having danced with a young man, you then strolled out in the moonlight or wandered into the conservatory, and charming *têtes à têtes* could take place without decorum being abandoned in the eyes of the world.

Managing your programme was a difficult art, and one that I was not particularly good at. Say you start off at a party: A, B, C are three girls, D, E, F are three young men. You must at least dance with each of those young men twice – probably, you will go to supper with one of them, unless he or you particularly wish to avoid that. The rest of the programme is open for you to arrange to your satisfaction. There are plenty of young men lined up there, and at once some of them – the ones you don't particularly want to see – approach you. Then the tricky bit begins. You try to prevent them seeing that your programme is as yet not filled up at all, and say doubtfully that you could manage number fourteen. The difficulty is to strike the right balance. The young men you do want to dance with are here somewhere, but if they are late coming up your programme may be already filled. On the other hand, if you tell enough lies to the first young men you will be left with gaps in your programme,

and they may not be filled by the right young men. Then you will have to sit out some dances and be a wallflower. Oh, the agony when the young man you have secretly been waiting for suddenly appears, having been looking wildly for you in all the wrong places! You have to tell him sadly, 'I have only got the second extra and number ten.'

'Oh, surely you can do better than that?' he pleads.

You look at your programme, and consider. Cutting dances is not a nice act. It is disapproved of, not only by hostesses and mothers, but also by young men themselves. They sometimes take revenge by cutting dances themselves in return. Perhaps in looking down your programme you see the name of some young man who has behaved badly to you, who has come up late, who has talked more to another girl at supper than to you. If so, you sacrifice him properly. Just occasionally, in desperation, you sacrifice a young man because he dances so abominably that it is really agony for your feet. But that I hardly ever liked to do, because I was tender-hearted, and it seemed unkind to treat so badly a poor young man who was almost certain to be treated badly by everyone else. The whole thing was really as intricate as the steps of a dance. In some ways it was great fun, but in others rather nerve-racking. At any rate one's manners did improve with practice.

Going to Egypt was a great help to me. I don't think anything else would have removed my natural *gaucherie* so soon. It was certainly a wonderful three months for a girl. I got to know at least twenty or thirty young men reasonably well. I went to, I suppose, between fifty and sixty dances; but I was too young and enjoying myself far too much to fall in love with anybody, which was lucky. I did cast languishing eyes on a handful of bronzed middle-aged colonels, but most of these were already attached to attractive married women – the wives of other men – and had no interest in young and insipid girls. I was somewhat plagued by a young Austrian count of excessive solemnity, who paid me serious attention. Avoid him as much as I could, he always sought me out and engaged me for a waltz. The waltz, as I have said, is the one dance I dislike, and the count's waltzing was of the most superior kind – that is, it consisted very largely of reversing at top speed, which rendered me so giddy that I was always afraid I would fall down. Reversing had been considered by Miss Hickey's dancing-class as not quite nice, so I had not had sufficient practice in it.

The count would then say that he would like the pleasure of a little conversation with my mother. This was, I suppose, his way of showing

that his attentions were honourable. Of course, I had to take him to my mother, who was sitting against the wall, enduring the penance of the evening – for to her it certainly was a penance. The count sat down beside her and entertained her very solemnly for, I should think, at least twenty minutes. Afterwards, when we got home, my mother said to me crossly. 'What on earth induced you to bring over that little Austrian to talk to me? I couldn't get rid of him.' I assured her that I couldn't help it, that he had insisted. 'Oh well, you must try and do better, Agatha,' said my mother. 'I can't have young men being brought up to talk to me. They only do it to be polite, and to make a good impression.' I said he was a dreadful man. 'He is nice-looking, well-bred, and a good dancer,' said my mother, 'but I must say that I found him a complete bore.'

Most of my friends were young subalterns, and our friendships were absorbing but non-serious. I watched them playing polo, goaded them if they had not done well or applauded if they had, and they showed off before me to the best of their ability. I found it rather more difficult to talk to the slightly older men. A great many names are forgotten by this time, but there was a Captain Hibberd who used to dance with me fairly often. It was quite a surprise to me when my mother said nonchalantly on the boat when we were sailing back from Cairo to Venice: 'You know Captain Hibberd wanted to marry you, I suppose?'

'What?' I said, startled. 'He never proposed to me or said *anything*.'

'No, he said it to me,' answered mother.

'To you?' I said in astonishment.

'Yes. He said he was very much in love with you, and did I think you were too young? Perhaps he ought not to speak of it to you, he said.'

'And what did you say?' I demanded.

'I told him I was quite sure you were not in love with him, and that it was no good his going on with the idea,' she said.

'Oh mother!' I exclaimed indignantly. 'You didn't!'

Mother looked at me in great surprise. 'Do you mean to say you did like him?' she demanded. 'Would you have considered marrying him?'

'No, of course not,' I said. 'I don't want to marry him *at all*, and I'm not in love with him, but I really do think, mother, that you might let me have my own proposals.'

Mother looked rather startled; then she admitted handsomely that she had been wrong. 'It's quite a long time, you see, since I was a girl myself,' she said. 'But I do see your point of view. Yes, one does like to have one's own proposals.'

I was annoyed about it for some time. I wanted to know what it felt like to be proposed to. Captain Hibberd was good-looking, not boring, danced well, was well off – it was a pity that I could not consider marrying him. I suppose, as is so often the case, that if you are not attracted to a young man, but he is attracted to you, he is at once put out of court by the fact that men, when they are in love, invariably manage to look like a somewhat sick sheep. If a girl is attracted to such a man she feels flattered by this appearance, and does not hold it against him; if she has no interest she dismisses him from her mind. This is one of the great injustices of life. Women, when they fall in love, look ten times as good-looking as normally: their eyes sparkle, their cheeks are bright, their hair takes a special glow; their conversation becomes much wittier and more brilliant. Other men, who have never noticed them before, then start to take a second look.

That was my first, highly unsatisfactory proposal of marriage. My second came from a young man six foot five high. I had liked him very much, and we had been good friends. He did not think of approaching me through my mother, I am glad to say. He had more sense than that. He managed to get home on the same boat as I did, sailing from Alexandria to Venice. I felt sorry that I was not fonder of him. We continued to write letters to one another for a short time; but then he was posted to India, I think. If I had met him when I was a little older I might perhaps have cared for him.

While I am on the subject of proposals, I wonder if men were specially given to proposing in my young days. I cannot help feeling that some of the proposals I and my friends had were entirely unrealistic. I have a suspicion that if I had accepted the offers they would have been dismayed. I once tackled a young naval lieutenant on this point. We had been walking home from a party in Torquay when he suddenly blurted out his proposal of marriage. I thanked him and said no, and added, 'And I don't believe you really want to, either.'

'Oh I do, I do.'

'I don't believe it,' I said. 'We have only known each other about ten days, and I don't see why you want to get married so young in any case. You know it would be very bad for your career.'

'Yes, well, of course, that's true in a way.'

'So it's really an awfully silly thing to go and propose to a girl like that. You must admit that yourself. What made you do it?'

'It just came over me,' said the young man. 'I looked at you and it just came over me.'

'Well,' I said, 'I don't think you had better do it again to anyone. You must be more careful.'

We parted on kindly prosaic terms.

II

In describing my life I am struck by the way it sounds as though I and everybody else were extremely rich. Nowadays you certainly would have to be rich to do the same things, but in point of fact nearly all my friends came from homes of moderate income. Most of their parents did not have a carriage or horses, they certainly had not yet acquired the new automobile or motorcar. For that you *did* have to be rich.

Girls had usually not more than three evening dresses, and they had to last you for some years. Your hats you painted with a shilling bottle of hat paint every season. We walked to parties, tennis parties and garden parties, though for evening dances in the country we would of course hire a cab. In Torquay there were not many private dances except at Christmas or Easter. People tended to invite guests to stay and make up a party to go to the Regatta Ball in August, and usually some other local dance in one of the bigger houses. I went to a few dances in London during June and July – not many because we did not know many people in London. But one would go occasionally to subscription dances, as they were called, making up a party of six. None of this called for much expenditure.

Then there were the country house parties. I went, nervously the first time, to some friends in Warwickshire. They were great hunting people. Constance Ralston Patrick, the wife, did not hunt herself: she drove a pony carriage to all the meets and I drove with her. My mother had forbidden me strictly to accept a mount or ride. 'You really don't know very much about riding,' she pointed out. 'It would be fatal if you went and injured somebody's valuable horse.' However, nobody offered me a mount – perhaps it was as well.

My riding and hunting had been confined to Devonshire, which meant scrabbling over high banks rather like Irish hunting, in my case mounted

on a horse from a livery stable which was used to fairly unskilful riders on its back. The horse certainly knew more than I did, and I was quite content to leave it to Crowdy, my usual mount, a rather dispirited strawberry roan, who managed to get himself successfully over the banks of Devon. Naturally, I rode sidesaddle – hardly any woman rode astride at that time. You feel wonderfully safe on a side-saddle, your legs clasped round pommels. The first time I ever tried to ride astride I felt more unsafe than I could have believed possible.

The Ralston Patricks were very kind to me. They called me 'The Pinkling' for some reason – I suppose because I so often had pink evening dresses. Robin used to tease The Pinkling a lot, and Constance used to give me matronly advice with a slight twinkle in her eye. They had a delightful small daughter, about three or four years old when I first went there, and I used to spend a good deal of time playing with her. Constance was a born match-maker, and I realise now that she produced during the course of my visits several nice and eligible men. I sometimes got a little unofficial riding too. I remember one day I had had a gallop round the fields with a couple of Robin's friends. Since this had happened at a moment's notice, and I had not even got into a riding-habit but was in an ordinary print frock, my hair was not up to the strain. I still wore, as all girls did, the *postiche* attachment. Riding back down the village street, my hair collapsed completely, and curls dropped off at intervals all the way. I had to go back on foot to pick them up. Unexpectedly this produced a rather pleasing reaction in my favour. Robin told me afterwards that one of the leading lights of the Warwickshire Hunt had said to him approvingly, 'Nice girl you've got staying with you. I like the way she behaved when all that false hair fell off; didn't mind a bit. Went back and picked it all up and roared with laughter. Good sport, she was!' The things that made a good impression on people are really very odd.

Another of the delights of staying with the Ralston Patricks was that they had a motor car. I cannot tell you the excitement that this produced in 1909. It was Robin's pet delight and treasure, and the fact that it was temperamental and broke down constantly made his passion for it all the greater. I remember one day we made an excursion to Banbury. Starting out was rather like equipping an expedition to the North Pole. We took large furry rugs, extra scarves to wrap round the head, baskets of provisions, and so on. Constance's brother Bill, Robin and I made the expedition. We said a tender farewell to Constance; she kissed us all,

urged us to be careful, and said she would have plenty of hot soup and home comforts waiting for us *if* we returned. Banbury, I may say, was about twenty-five miles from where they lived, but it was treated as though it was Land's End.

We proceeded seven miles quite happily, cautiously at about twenty-five miles an hour, but free from trouble. However, that was only the beginning. We did eventually get to Banbury, after changing a wheel and trying to find a garage somewhere, but garages were few and far between in those days. At last we got home, about seven o'clock in the evening, exhausted, frozen to the marrow, and frantically hungry, having finished all the provisions long before. I still think of it as one of the most adventurous days of my life! I had spent a great deal of it sitting on a bank by the roadside, in an icy wind, urging on Robin and Bill as, with the manual of instruction open beside them, they struggled with tyres, spare wheel, jacks, and various other pieces of mechanism of which they had had, up till then, no personal knowledge.

One day my mother and I went down to Sussex and lunched with the Barttelots. Lady Barttelot's brother, Mr Ankatell, was also lunching, and he had an enormous and powerful automobile of the kind which in my memory seems to be about 100 feet long and hung with enormous tubes all over the outside. He was a keen motorist, and offered to drive us back to London. 'No need to go by train – beastly things, trains. I'll drive you back.' I was in the seventh heaven. Lady Barttelot lent me one of the new motoring caps – a sort of flat thing halfway between a yachting cap and that worn by a German Officer of the Imperial staff, – which was tied down with motoring veils. We got into the monster, extra rugs were piled round us, and off we went like the wind. All cars were open at that time. To enjoy them one had to be pretty hardy. But then, of course, one *was* hardy in those days – practising the piano in rooms with no fires in the middle of winter inured you against icy winds.

Mr Ankatell did not contain himself to the twenty miles an hour that was the usual 'safe' speed – I believe we went forty or fifty m.p.h. through the roads of Sussex. At one moment he started up in the driving seat exclaiming: 'Look back! Look back! Look back behind that hedge! Do you see that fellow hiding there? Ah, the wretch! The villain! It's a police trap. Yes, the villains, that's what they do: hide behind a hedge and then come out and measure the time.' From fifty we dropped to a crawl of ten miles an hour. Enormous chuckles from Mr Ankatell. 'That dished him!'

I found Mr Ankatell a somewhat alarming man, but I loved his automobile. It was bright red – a frightening, exciting monster.

Later I went to stay with the Barttelots for Goodwood Races. I think that was the only country house visit that I did not enjoy. It was entirely a racing crowd staying there, and racing language and terms were incomprehensible to me. To me racing meant standing about for hours wearing an unmanageable flowery hat, pulling on six hat-pins with every gust of wind, wearing tight patent-leather shoes with high heels, in which my feet and ankles swelled horribly in the heat of the day. At intervals I had to pretend enormous enthusiasm as everyone shouted 'They're off!' and stood on tiptoe to look at quadrupeds already out of sight.

One of the men asked me kindly if he should put something on for me. I looked terrified. Mr Ankatell's sister, who was acting as hostess, at once ticked him off. 'Don't be silly,' she said, 'the girl is *not* to bet.' Then she said kindly to me, 'I tell you what. You shall have five shillings on whatever *I* back. Pay no attention to these others.' When I discovered that they were betting £20 or £25 each time my hair practically stood on end! But hostesses were always kind to girls in money matters. They knew that few girls had any money to throw about. Even the rich ones, or the ones who came from rich homes, had only moderate dress allowances – £50 or £100 a year. So hostesses looked after the girls carefully. They were sometimes encouraged to play bridge, but if so someone always 'carried them', and was responsible for their debts if they lost. This kept them from feeling out of it, and at the same time ensured that they didn't lose sums of money which they could not afford to lose.

My first acquaintance with racing did not enthral me. When I got home to mother I said that I hoped I would never hear the words 'They're off!' again. When a year had passed, however, I had become quite a keen racing fan, and knew something about the runners. I stayed later with Constance Ralston Patrick's family in Scotland, where her father kept a small racing stable, and there I was initiated more fully into the sport and was taken to several small race meetings, which I soon found to be fun.

Goodwood, of course, had been more like a garden party – a garden party going on for far too long. Moreover there was a lot of ragging going on; a kind of ragging I had not been used to. People broke up each other's rooms, threw things out of the windows, and shouted with laughter. There were no other girls there; they were mostly young married women in the racing set. One old Colonel of about sixty came barging into my

room and crying, 'Now then, let's have a bit of fun with Baby!' took out one of my evening dresses from the cupboard – it *was* rather a babyish one, pink with ribbons – and threw it out of the window saying, 'Catch, catch, here is a trophy from the youngest member of the party!' I was terribly upset. Evening dresses were great items in my life; carefully tended and preserved, cleaned, mended – and here it was being thrown about like a football. Mr Ankatell's sister, and one of the other women, came to the rescue, and told him that he was not to tease the poor child. I was really thankful to leave this party. Still, it no doubt did me good.

Amongst other House Parties I remember an enormous one at a country house rented by Mr and Mrs Park-Lyle – Mr Park-Lyle used to be referred to as 'The Sugar King'. We had met Mrs Park-Lyle out in Cairo. She was, I suppose, fifty or sixty at the time, but from a short distance she looked like a handsome young woman of twenty-five. I had never seen much make-up in private life before. Mrs Park-Lyle certainly put up a good show with her dark, beautifully-arranged hair, exquisitely enamelled face (almost comparable with that of Queen Alexandra), and the pink and pale blue pastel shades which she wore – her whole appearance a triumph of art over nature. She was a woman of great kindliness, who enjoyed having lots of young people in her house.

I was rather attracted to one of the young men there – later killed in the 1914–18 war. Though he took only moderate notice of me, I had hopes of becoming better acquainted. In this I was foiled, however, by another soldier, a gunner, who seemed continually to be at my elbow, insisting on being my partner at tennis and croquet, and all the rest of it. Day by day my mounting exasperation grew. I was sometimes extremely rude to him; he didn't seem to notice. He kept asking me if I had read this book or that, offering to send them to me. Would I be in London? Would I care to go and see some polo? My negative replies had no effect upon him. When the day came for my departure I had to catch a fairly early train because I had to go to London first and then take another train on to Devon. Mrs Park-Lyle said to me after breakfast 'Mr S.' – I can't remember his name now – 'is going to drive you to the station.'

Fortunately that was not very far. I would have much preferred to have gone in one of the Park-Lyle cars – naturally the Park-Lyles had a fleet of cars – but I presume Mr S. had suggested driving me to our hostess, who had probably thought *I* would like it. How little she knew! However, we arrived at the station, the train came in, an express to London, and Mr. S. ensconced me in the corner seat of an empty second-class carriage.

I said goodbye to him, in friendly tones, relieved to be seeing the last of him. Then just as the train started he suddenly caught at the handle, opened the door, and leapt in, closing it behind him. 'I'm coming to London, too,' he said. I stared at him with my mouth open.

'You haven't got any luggage with you.'

'I know, I know – it doesn't matter.' He sat down opposite me, leant forward, his hands on his knees, and gazed at me with a kind of ferocious glare. 'I meant to put it off till I met you again in London. I can't wait. I have to tell you now. I am madly in love with you. You must marry me. From the first moment I saw you, coming down to dinner, I knew that you were the one woman in the world for me.'

It was some time before I could interrupt the flow of words, and say with icy coldness: 'It is very kind of you, Mr S., I am sure, and I deeply appreciate it, but I am afraid the answer is no.'

He protested for about five minutes, finally urging that we should at least leave it, so that we could be friends and meet again. I said that I thought it was much better that we shouldn't meet again, and that I would not change my mind. I said it with such finality that he was forced to accept it. He leant back in his seat and gave himself up to gloom. Can you imagine a worse time to propose to a girl? There we were, shut up in an empty carriage – no corridors then – going to London, two hours at least, and having arrived at such an impasse in the conversation that there was nothing for us to say. Neither of us had anything to read. I still dislike Mr S. when I remember him, and have no proper feeling of gratitude such as one was always taught should be felt for a good man's love (Grannie's maxim). I am sure he was a good man – perhaps that was what made him so dull.

Another country house visit I paid was also a racing one, to stay with some old friends of my godmother's in Yorkshire, the Matthews. Mrs Matthews was a non-stop talker, and rather alarming. The invitation was to a party for the St. Leger. By the time I went there I had got more used to racing, and in fact was beginning to enjoy it. Moreover – a silly thing to remember, but the sort of thing one does – I had a new coat-and-skirt bought for this particular occasion. I was vastly pleased with myself in it. It was of a greenish brown tweed of good quality. It came from a good tailoring house. It was the sort of thing my mother said was worth spending money on, because a good coat and skirt would do you for years. This one certainly did: I wore it for six years at least. The coat was long and had a velvet collar. With it I wore a smart little toque in greenish

brown shades of velvet and a bird's wing. I have no photographs of myself in this get-up; if I had I should no doubt think I looked highly ridiculous now, but my memories of myself are as looking smart, sporting, and well-dressed!

The height of my joy was reached when at the station where I had to change (I must, I think, have been coming from Cheshire, where I had been with my sister). There was a cold wind blowing, and the station-master approached me and asked if I would like to wait in his office. 'Perhaps,' he said, 'your maid would like to bring along your jewel-case or anything valuable.' I had of course never travelled with a maid in my life, and never should – nor was I the owner of a jewel case – but I was gratified by this treatment, putting it down to the smartness of my velvet toque. I said my maid was not with me this time – I could not avoid saying 'this time' in case I should go down in his eyes – but I gratefully accepted his offer, and sat in front of a good fire exchanging pleasant platitudes about the weather. Presently the next train came in and I was seen into it with much ceremony. I am convinced I owed this preferential treatment to my coat-and-skirt and hat. Since I was travelling second class and not first, I could hardly be suspected of great wealth or influence.

The Matthews lived at a house called Thorpe Arch Hall. Mr Matthews was much older than his wife – he must have been about seventy – and he was a dear, with a thatch of white hair, a great love of racing, and, in his time, hunting. Though extremely fond of his wife he was inclined to be greatly flustered by her. Indeed, my principal memory of him was saying irritably, 'Damme, dear, don't hustle me. Damme, don't hustle me, don't hustle me, Addie!'

Mrs Matthews was a born hustler and fusser. She talked and fussed from morning to night. She was kind, but at times I found her almost unbearable. She hustled poor old Tommy so much that he finally invited a friend of his to live permanently with them – a Colonel Wallenstein – always said by the surrounding County to 'be Mrs Matthews' second husband'. I am quite convinced that this was no case of 'the other man' or the wife's lover. Colonel Wallenstein was devoted to Addie Matthews – I think it had been a lifetime passion of his – but she had always kept him where she wanted him, as a convenient, platonic friend with a romantic devotion. Anyway, Addie Matthews lived a very happy life with her two devoted men. They indulged her, flattered her, and always arranged that she should have everything she wanted.

It was while staying there that I met Evelyn Cochran, Charles

Cochran's wife. She was a lovely little creature, just like a Dresden shepherdess, with big blue eyes, and fair hair. She had with her dainty but highly unsuitable shoes for the country, which Addie never let her forget, reproaching her for them every hour of the day: 'Really, Evelyn dear, why you don't bring proper shoes with you! Look at those things – pasteboard soles, only fit for London.' Evelyn looked sadly at her with large blue eyes, Her life was mostly spent in London, and was entirely wrapped up in the theatrical profession. She had, so I learnt from her, climbed out of a window to run away with Charles Cochran, who was heavily disapproved of by her family. She adored him with the kind of adoration that one seldom meets. She wrote to him every single day if she was away from home. I think, too, that, in spite of many other adventures, he always loved her. She suffered a good deal during her life with him, for with such a love as hers jealousy must have been hard to bear. But I think she found it worth it. To have such a passion for one person that lasts all your life is a privilege, no matter what it costs you in endurance.

Colonel Wallenstein was her uncle. She disliked him very much. She also disliked Addie Matthews, but was rather fond of old Tom Matthews. 'I have never liked my uncle,' she said, 'he is a most tiresome man. And as for Addie, she is the most aggravating and silly female I have ever met. She can't leave anyone alone; she is always scolding them or managing them, or doing *something* – she can't keep quiet.'

III

After our stay at Thorpe Arch, Evelyn Cochran asked me to come to see them in London. I did, feeling shy, and was thrilled by hearing so much theatrical gossip. Also, for the first time, I began to appreciate that there might be something in pictures. Charles Cochran had a great love of painting. When I first saw his Degas picture of ballet girls it stirred something in me that I had not known existed. The habit of marching girls to picture galleries willy-nilly, at too young an age, is much to be deprecated. It does not produce the wanted result, unless they are naturally artistic. Moreover, to the untutored eye or the unartistic one, the resemblance of great masters to one another is most depressing. They have a sort of shiny mustard gloom. Art was forced on me, first by

being made to learn to draw and paint when I didn't enjoy it, and then by having a kind of moral obligation to appreciate art laid on me.

An American friend of ours, herself a great devotee of pictures, music, and all kinds of culture, used to come over to London on periodical visits – she was a niece of my godmother, Mrs Sullivan, and also of Pierpont Morgan. May was a dear person with a terrible affliction – she had a most unsightly goitre. In the days when she had been a young girl – she must have been a woman of about forty when I first knew her – there was no remedy for goitre: surgery was supposed to be too dangerous. One day when May arrived in London, she told my mother that she was going to a clinic in Switzerland to be operated on.

She had already made arrangements. A famous surgeon, who made this his speciality, had said to her, 'Mademoiselle, I would not advise this operation to any man: it must be done with a local anaesthetic only, because during the course of it the subject has to talk the whole time. Men's nerves are not strong eough to endure this, but women can achieve the fortitude necessary. It is an operation that will take some time – perhaps an hour or more – and during that time you will have to talk. Have you the fortitude?'

May says she looked at him, thought a minute or two, and then said firmly, yes, she *had* the fortitude.

'I think you are right to try, May,' my mother said. 'It will be a great ordeal for you, but if it succeeds it will make such a difference to your life that it will be worth anything you suffer.'

In due course word came from May in Switzerland: the operation had been successful. She had now left the clinic and was in Italy, in a *pension* at Fiesole, near Florence. She was to remain there for about a month, and after go back to Switzerland to have a further examination. She asked whether my mother would allow me to go out and stay with her there, and see Florence and its art and architecture. Mother agreed, and arrangements were made for me to go. I was very excited, of course; I must have been about sixteen.

A mother and daughter were found who were travelling out by the train that I was taking. I was delivered over to them, introduced by Cook's agent at Victoria, and started off. I was lucky in one thing: both mother and daughter felt ill in trains if they were not facing the engine. As I did not care, I had the whole of the other side of the carriage on which to lie down flat. None of us had appreciated the fact of the hour's difference in time, so when the moment came in the early hours of the morning for me

to change at the frontier I was still asleep. I was bundled out by the conductor on to the platform, and mother and daughter shouted farewell. Assembling my belongings, I went to the other train, and immediately journeyed on through the mountains into Italy.

Stengel, May's maid, met me in Florence, and we went up together in the tram to Fiesole. It was inexpressibly beautiful on that day. All the early almond and peach blossom was out, delicate white and pink on the bare branches of the trees. May was in a villa there, and came out to meet me with a beaming face. I have never seen such a happy looking woman. It was strange to see her without that terrible bag of flesh jutting out under her chin. She had had to have a great deal of courage, as the doctor had warned her. For an hour and twenty minutes, she told me, she had lain there in a chair, her feet held up in a wrench above her head, while the surgeons carved at her throat and she talked to them, answering questions, speaking, grimacing if told. Afterwards the doctor had congratulated her: he told her she was one of the bravest women he had ever known.

'But I must tell you, Monsieur le docteur,' she said, 'just before the end I was feeling I had to scream, have hysterics, cry out and say I could not bear any more.'

'Ah,' said Doctor Roux, 'but you did *not* do so. You are a brave woman. I tell you.'

So May was unbelievably happy, and she did everything she could to make my stay in Italy agreeable. I went sightseeing into Florence every day. Sometimes Stengel went with me, but more often a young Italian woman engaged by May came up to Fiesole and escorted me into the town. Young girls had to be even more carefully chaperoned in Italy than in France, and indeed I suffered all the discomforts of being pinched in trams by ardent young men – most painful. It was then that I had been subjected to so large a dose of picture galleries and museums. Greedy as ever, what *I* looked forward to was the delicious meal in a *patisserie* before catching the tram back to Fiesole.

On several occasions in the later days May came in also, to accompany me on my artistic pilgrimage, and I remember well on the last day, when I was to return to England, she was adamant that I should see a wonderful St. Catherine of Siena, which had just been cleaned. I don't know if it was in the Uffizi or what gallery now, but May and I galloped through every room looking in vain for it. I couldn't have cared less about St. Catherine. I was fed up with St. Catherines, revolted by those inn-

umerable St. Sebastians struck all over with arrows – heartily tired of saints one and all, and their emblems and their unpleasant methods of death. I was fed up, too, with self-satisfied Madonnas, particularly with those of Raphael. I really am ashamed, writing now, to think what a savage I was in this respect, but there it is: Old Masters are an acquired taste. As we raced about looking for St. Catherine, my anxiety was mounting. Would we have time to go to the *patisserie* and have a final delicious meal of chocolate and whipped cream, and sumptuous *gateaux*? I kept saying: '*I* don't mind, May, really I don't mind. Don't bother any more. I've seen so many pictures of St. Catherine.'

'Ah, but this one, Agatha dear, it's so wonderful – you'll realise when you see it how sad it would be if you'd missed it.'

I knew I shouldn't realise, but I was ashamed to tell May so! However, fate was on my side – it transpired that this particular picture of St. Catherine would be absent from the gallery for some weeks longer. There was just time to stuff me with chocolate and cakes before catching our train – May expatiating at length upon all the glorious pictures, and I agreeing with her fervently as I pushed in mouthfuls of cream and coffee icing. I ought to have looked like a pig by now, with bulging flesh and tiny eyes; instead of which I had a most ethereal appearance, fragile and thin, with large dreamy eyes. Seeing me, you would have prophesied an early death in a state of spiritual ecstasy, like children in Victorian story-books. At any rate I did have the grace to feel ashamed at not appreciating May's artistic education. I *had* enjoyed Fiesole – but mostly the almond blossom – and I had got a lot of fun out of Doodoo, a tiny Pomeranian dog which accompanied May and Stengel everywhere. Doodoo was small and very clever. May often brought him to visit England. On those occasions he got inside a large muff of hers and always remained unsuspected by Customs officers.

May came to London on her way back to New York, and displayed her elegant new neck. Mother and Grannie both wept and kissed her repeatedly, and May wept too, because it was like an impossible dream come true. Only after she had left for New York did mother say to Grannie, 'How sad, though, how terribly sad, to think that she could have had this operation fifteen years ago. She must have been very badly advised by consultants in New York.'

'And now, I suppose, it's too late,' said my grandmother thoughtfully. 'She will never marry now.'

But there, I am glad to say, Grannie was wrong.

'Auntie-Grannie' in her old age

With my father and my dog Toby

Ashfield

My brother Monty in Truelove

Myself as a child

Dancing class, Torquay;
myself in the centre

In Paris in 1906

At a house party for Goodwood

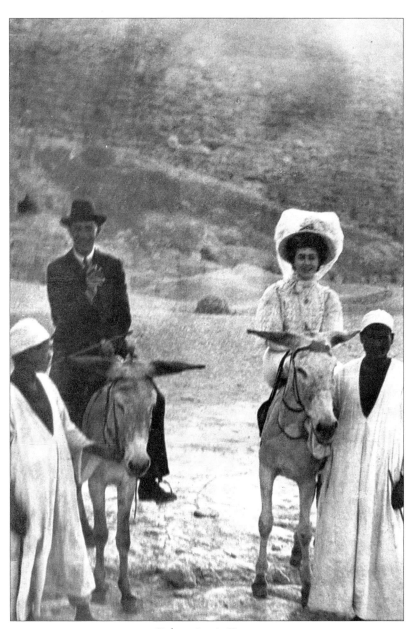

Sightseeing in Egypt

With my husband, Archie, after his investiture in 1919

I think May had been terribly sad that marriage was not to be for her, and I don't think for one moment she expected it so late in life. But some years later she came over to England bringing with her a clergyman who was the rector at one of the most important Episcopalian churches in New York, a man of great sincerity and personality. He had been told that he had only a year to live, but May, who had always been one of his most zealous parishioners, had insisted on getting together a subscription from the congregation and bringing him to London to consult doctors there. She said to Grannie: 'You know, I am convinced that he *will* recover. He's needed, badly needed. He does wonderful work in New York. He's converted gamblers and gangsters, he's gone into the most terrible brothels and places, he's had no fear of public opinion or of being beaten up, and a lot of extraordinary characters have been converted by him.' May brought him out to luncheon at Ealing. Afterwards, at her next visit, when she came to say goodbye, Grannie said to her, 'May, that man's in love with you.'

'Why, Aunty,' exclaimed May, 'how can you say such a terrible thing? He never thinks of marriage. He is a convinced celibate.'

'He may have been once,' said Grannie, 'but I don't think he is now. And what's all this about celibacy? He's not a Roman. He's got his eye on *you*, May.'

May looked highly shocked.

However, a year later, she wrote and told us that Andrew was restored to health and that they were getting married. It was a very happy marriage. No one could have been kinder, gentler and more understanding than Andrew was to May. 'She does so need to be happy,' he said once to Grannie. 'She has been shut off from happiness for most of her life, and she has become so afraid of it that it has turned her almost into a Puritan.' Andrew was always to be something of an invalid, but it did not stop his work. Dear May, I am so glad that happiness came to her as it did.

IV

In the year 1911 something that I considered fantastic happened. *I went up in an aeroplane*. Aeroplanes, of course, were one of the chief subjects of surmise, disbelief, argument, and all the rest of it. When I had been

at school in Paris, we were taken one day to see Santos Dumont endeavour to get up off the ground in the Bois de Boulogne. As far as I remember, the aeroplane got up, flew a few yards, then crashed. All the same, we were impressed. Then there were the Wright brothers. We read about them eagerly.

When taxis came into use in London, a system was introduced of whistling for cabs. You stood on your front doorstep: one whistle would produce a 'growler' (four-wheeled cab); two whistles a hansom, that gondola of the streets; three whistles (if you were very lucky) produced that new vehicle a taxi. A picture in *Punch* one week showed a small urchin saying to a butler standing on a stately doorstep, whistle in hand: 'Try whistling four times, Guv'nor, you *might* get an aeroplane!'

Now suddenly it seemed that that picture was not so funny or impossible as it had been. It might soon be *true*.

On the occasion I am talking about, mother and I had been staying somewhere in the country, and we went one day to see a flying exhibition – a commercial venture. We saw planes zoom up into the air, circle round, and vol-plane down to earth again. Then a notice was put up: '£5 a flight.' I looked at mother. My eyes grew large and pleading. 'Could I? Oh, mother, *couldn't* I? It would be so wonderful!' I think it was my mother who was wonderful. To stand and watch her beloved child going up in the air in a *plane*! At that time they were crashing every day. She said, 'If you really want to go, Agatha, you shall.'

£5 was a lot of money in our life, but it was well spent. We went to the barricade. The pilot looked at me, and said, 'Is that hat on tight? All right, get in.' The flight only lasted five minutes. Up we went in the air, circled round several times – oh, it was wonderful! Then that switch-back down, and the vol-plane to earth again. Five minutes of ecstasy – and half a crown extra for a photograph: a faded old photograph that I still have showing a dot in the sky that is *me* in an aeroplane on May 10, 1911.

The friends of one's life are divided into two categories. First there are those that spring out of one's environment; with whom you have in common the things you do. They are like the old-fashioned ribbon-dance. They wind and pass in and out of your life, and you pass in and out of theirs. Some you remember, some you forget. Then there are those whom I would describe as one's *elected* friends – not many in number – whom a real interest on either side brings together, and who usually remain, if circumstances permit, all through your life. I should

say I have had about seven or eight such friends, mostly men. My women friends have usually been environmental only.

I don't know exactly what brings about a friendship between man and woman – men do not by nature ever *want* a woman as a friend. It comes about by accident – often because the man is already sensually attracted by some other woman and quite wants to talk about her. Women *do* often crave after friendship with men – and are willing to come to it by taking an interest in someone else's love affair. Then there comes about a very stable and enduring relationship – you become interested in each other as *people*. There is a flavour of sex, of course, the touch of salt as a condiment.

According to an elderly doctor friend of mine, a man looks at every woman he meets and wonders what she would be like to sleep with – possibly proceeding to whether she'd be likely to sleep with *him* if he wanted it. 'Direct and coarse – that's a man,' he put it. They don't consider a woman as a possible wife.

Women, I think, quite simply try on, as it were, every man they meet as a possible husband. I don't believe *any* woman has ever looked across a room and fallen in love at first sight with a man; lots of men have with a woman.

We used to have a family game, invented by my sister and a friend of hers – it was called 'Agatha's Husbands'. The idea was that they picked out two or at most three of the most repellent-looking strangers in a room, and it was then put to me that I *had* to choose one of them as a husband, on pain of death or slow torture by the Chinese.

'Now then, Agatha, which will you have – the fat young one with pimples, and the scurfy head, or that black one like a gorilla with the bulging eyes?'

'Oh, I can't – they're *so* awful.'

'You must – it's got to be one of them. Or else red hot needles and water torture.'

'Oh dear, then the gorilla.'

In the end we got into a habit of labelling any physically hideous individual as 'an Agatha's husband': 'Oh! Look! That's a *really* ugly man – a real Agatha's husband.'

My one important woman friend was Eileen Morris. She was a friend of our family. I had in a way known her all my life, but did not get to know her properly until I was about nineteen and had 'caught up' with her, since she was some years older than I was. She lived with five maiden

aunts in a large house overlooking the sea, and her brother was a school-master. She and he were very alike, and she had a mind with the clarity of a man's rather than a woman's. Her father was a nice, quiet, dull man – his wife had been, my mother told me, one of the gayest and most beautiful women she had ever seen. Eileen was rather plain, but she had a remarkable mind. It ranged over so many subjects. She was the first person I had come across with whom I could discuss *ideas*. She was one of the most impersonal people I have ever known; one never heard anything about her own feelings. I knew her for many years, yet I often wonder in what her private life consisted. We never confided anything personal in each other, but whenever we met we had something to discuss, and plenty to talk about. She was quite a good poet, and knowledgeable about music. I remember that I had a song which I liked, because I enjoyed the music of it so much, but unfortunately it had remarkably silly words. When I commented on this to Eileen, she said she would like to try to write some different words for it. This she did, improving the song enormously from my point of view.

I, too, wrote poetry – perhaps everyone did at my age. Some of my earlier examples are unbelievably awful. I remember one poem I wrote when I was eleven:

I knew a little cowslip and a pretty flower too,
Who wished she was a bluebell and had a robe of blue.

You can guess how it.went on. She got a robe of blue, became a bluebell, and didn't like it. *Could* anything be more suggestive of a complete lack of literary talent? By the age of seventeen or eighteen, however, I was doing better. I wrote a series of poems on the Harlequin legend: Harlequin's song, Columbine's, Pierrot, Pierrette, etc. I sent one or two poems to *The Poetry Review*. I was very pleased when I got a guinea prize. After that, I won several prizes and also had poems printed there. I felt very proud of myself when I was successful. I wrote quite a lot of poems from time to time. A sudden excitement would come over me and I would rush off to write down what I felt gurgling round in my mind. I had no lofty ambitions. An occasional prize in *The Poetry Review* was all I asked. One poem of mine that I re-read lately I think is not bad; at least it has in it something of what I wanted to express. I reproduce it here for that reason:

DOWN IN THE WOOD
Bare brown branches against a blue sky
(And Silence within the wood),

Leaves that, listless, lie under your feet,
Bold brown boles that are biding their time
 (And Silence within the wood).
Spring has been fair in the fashion of youth,
Summer with languorous largesse of love,
Autumn with passion that passes to pain,
Leaf, flower, and flame – they have fallen and failed

 And Beauty – bare Beauty is left in the wood!

Bare brown branches against a mad moon
 (And Something that stirs in the wood),
Leaves that rustle and rise from the dead,
Branches that beckon and leer in the light
 (And Something that walks in the wood).
Skirling and whirling, the leaves are alive!
Driven by Death in a devilish dance!
Shrieking and swaying of terrified trees!
A wind that goes sobbing and shivering by . . .

 And Fear – naked Fear passes out of the wood!

I occasionally tried to set one of my poems to music. My composition
was not of a high order – a fairly simple ballad I could do not too badly.
I also wrote a waltz with a trite tune, and a rather extraordinary title – I
don't know where I got it from – 'One Hour With Thee.'

It was not until several of my partners had remarked that an hour was a
pretty hefty time for a waltz to last that I realised the title was somewhat
ambiguous. I was proud because one of the principal bands, Joyce's
Band, which played at most of the dances, included it occasionally in its
repertoire. However, that waltz, I can see now, is exceedingly bad music.
Considering my own feelings about waltzes, I cannot imagine why I tried
to write one.

The Tango was another matter. A deputy of Mrs Wordsworth started
a dancing evening for adults at Newton Abbot, and I and others used to
go over for instruction. There I made what I called 'my Tango friend'
– a young man whose Christian name was Ronald and whose last name I
cannot remember. We rarely spoke to each other or took the least interest

in each other – our whole mind was engrossed with our feet. We had been partnered together fairly early, had found the same enthusiasm, and danced well together. We became the principal exponents of the art of the Tango. At all dances where we met we reserved the Tango for each other without question.

Another excitement was Lily Elsie's famous dance in *The Merry Widow* or *The Count of Luxembourg,* I can't remember which, when she and her partner waltzed up a staircase and down again. This I practised with the boy next door. Max Mellor was at Eton at the time, about three years younger than I was. His father was a very ill man with tuberculosis, who had to lie out in the garden in an open-air hut where he slept at night. Max was their only son. He fell deeply in love with me as an older girl, and grown up, and used to parade himself for my benefit, or so his mother told me, wearing a shooting jacket and shooting boots, shooting sparrows with an airgun. He also began to wash (quite a novelty on his part, since his mother had had to worry him for several years about the state of his hands, neck, etc.), bought several pale mauve and lavender ties, and in fact showed every sign of growing up. We got together on the subject of dancing, and I would repair to the Mellors' house to practise with him on their stairs, which were more suitable than ours, being shallower and wider. I don't know that we were a great success. We had a lot of extremely painful falls, but persevered. He had a nice tutor, a young man called, I think, Mr Shaw, about whom Marguerite Lucy commented, 'A nice little nature – it's a pity his legs are so common.'

I must say that ever since I have been unable to stop myself applying this criterion to any male stranger. Good-looking, perhaps – but are his legs common?

V

One unpleasant winter's day, I was lying in bed recovering from influenza. I was bored. I had read lots of books, had attempted to do The Demon thirteen times, brought out Miss Milligan successfully, and was now reduced to dealing myself bridge hands. My mother looked in.

'Why don't you write a story?' she suggested.

'Write a story?' I said, rather startled.

'Yes,' said mother. 'Like Madge.'

'Oh, I don't think I could.'

'Why not?' she asked.

There didn't seem any reason why not, except that. . . .

'You don't know that you can't,' mother pointed out, 'because you've never tried.'

That was fair enough. She disappeared with her usual suddenness and reappeared five minutes later with an exercise book in her hand. 'There are only some laundry entries at one end,' she said. 'The rest of it is quite all right. You can begin your story now.'

When my mother suggested doing anything one practically always did it. I sat up in bed and began thinking about writing a story. At any rate it was better than doing Miss Milligan again.

I can't remember now how long it took me – not long, I think, in fact, I believe it was finished by the evening of the following day. I began hesitantly on various different themes, then abandoned them, and finally found myself thoroughly interested and going along at a great rate. It was exhausting, and did not assist my convalescence, but it was exciting too.

'I'll rout out Madge's old typewriter,' said mother, 'then you can type it.'

This first story of mine was called *The House of Beauty*. It is no master-piece but I think on the whole that it is good; the first thing I ever wrote that showed any sign of promise. Amateurishly written, of course, and showing the influence of all that I had read the week before. This is something you can hardly avoid when you first begin to write. Just then I had obviously been reading D. H. Lawrence. I remember that *The Plumed Serpent, Sons and Lovers, The White Peacock* etc. were great favourites of mine about then. I had also read some books by someone called Mrs Everard Cotes, whose style I much admired. This first story was rather precious, and written so that it was difficult to know exactly what the author meant, but though the style was derivative the story itself shows at least imagination.

After that I wrote other stories – *The Call of Wings* (not bad), *The Lonely God* (result of reading *The City of Beautiful Nonsense*: regrettably sentimental), a short dialogue between a deaf lady and a nervous man at a party, and a grisly story about a séance (which I re-wrote many years later). I typed all these stories on Madge's machine – an Empire type-writer, I remember – and hopefully sent them off to various magazines, choosing different pseudonyms from time to time as the fancy took me.

Madge had called herself Mostyn Miller; I called myself Mack Miller, then changed to Nathaniel Miller (my grandfather's name). I had not much hope of success, and I did not get it. The stories all returned promptly with the usual slip: 'The Editor regrets . . .' Then I would parcel them up again and send them off to some other magazine.

I also decided that I would try my hand at a novel. I embarked light-heartedly. It was to be set in Cairo. I thought of two separate plots, and at first could not choose between them. In the end, I hesitatingly made a decision and started on one. It had been suggested to my mind by three people we used to look at in the dining-room of the hotel in Cairo. There was an attractive girl – hardly a girl in my eyes, because she must have been close on thirty – and every evening after the dance she would come and have supper there with two men. One was a heavy-set, broad man, with dark hair – a Captain in the Sixtieth Rifles – the other a tall, fair young man in the Coldstream Guards, possibly a year or two younger than she was. They sat one on either side of her; she kept them in play. We learnt their names but we never discovered much more about them, though somebody did make the remark once: 'She will have to make up her mind between them, some time.' That was enough for my imag-ination: If I had known any more about them I don't think I should have wanted to write about them. As it was, I was able to make up an excellent story, probably far different from their characters, their actions, or anything else. Having gone a certain distance with it I became dissatisfied, and turned to my other plot. This was more light-hearted, dealing with amusing characters. I made, however, the fatal mistake of encumbering myself with a deaf heroine – really I can't think *why*: anyone can deal in an interesting manner with a blind heroine, but a deaf heroine is not so easy, because, as I soon found out, once you have described what she is thinking, and what people are thinking and saying of her, she is left with no possibility of conversation, and the whole business comes to a stop. Poor Melancy became ever more insipid and boring.

I went back to my first attempt – and I realised that it was not going to be nearly long enough for a novel. Finally, I decided to incorporate the two. Since the setting was the same, why not have two plots in one? Proceeding on these lines I finally brought my novel to the requisite length. Heavily encumbered by too much plot, I dashed madly from one set of characters to the other, occasionally forcing them to mix with each other in a way which they did not seem to wish to do. I called it – I can't think why – *Snow Upon the Desert*.

My mother then suggested, rather hesitantly, that I might ask Eden Philpotts if he could give me help or advice. Eden Philpotts was then at the height of his fame. His novels of Dartmoor were celebrated. As it happened, he was a neighbour of ours, and a personal friend of the family. I was shy about it, but in the end agreed. Eden Philpotts was an odd-looking man, with a face more like a faun's than an ordinary human being's: an interesting face, with its long eyes turned up at the corners. He suffered terribly from gout, and often when we went to see him was sitting with his leg bound up with masses of bandages on a stool. He hated social functions and hardly ever went out; in fact he disliked seeing people. His wife, on the other hand, was extremely sociable – a handsome and charming woman, who had many friends. Eden Philpotts had been very fond of my father, and was also fond of my mother, who seldom bothered him with social invitations but used to admire his garden and his many rare plants and shrubs. He said that of course he would read Agatha's literary attempt.

I can hardly express the gratitude I feel to him. He could so easily have uttered a few careless words of well-justified criticism, and possibly discouraged me for life. As it was, he set out to help. He realised perfectly how shy I was and how difficult it was for me to speak of things. The letter he wrote contained very good advice.

'Some of these things that you have written,' he said, 'are capital. You have a great feeling for dialogue. You should stick to gay natural dialogue. Try and cut all moralisations out of your novels; you are much too fond of them, and nothing is more boring to read. Try and leave your characters *alone*, so that *they* can speak for *themselves*, instead of always rushing in to tell them what they ought to say, or to explain to the reader what they mean by what they are saying. That is for the reader to judge for himself. You have two plots here, rather than one, but that is a beginner's fault; you soon won't want to waste plots in such a spendfree way. I am sending you a letter to my own literary agent, Hughes Massie. He will criticise this for you and tell you what chances it has of being accepted. I am afraid it is not easy to get a first novel accepted, so you mustn't be disappointed. I should like to recommend you a course of reading which I think you will find helpful. Read De Quincey's *Confessions of an Opium Eater* – this will increase your vocabulary enormously – he used some very interesting words. Read *The Story of my Life* by Jefferys, for descriptions and a feeling for nature.'

I forget now what the other books were: a collection of short stories, I remember, one of which was called *The Pirrie Pride*, and was written round a teapot. There was also a volume of Ruskin, to which I took a violent dislike, and one or two others. Whether they did me good or not, I don't know. I certainly enjoyed De Quincey and also the short stories.

I then went and had an interview in London with Hughes Massie. The original Hughes Massie was alive at that time, and it was he whom I saw. He was a large, swarthy man, and he terrified me. 'Ah,' he said, looking at the cover of the manuscript, '*Snow Upon the Desert*. Mm, a very suggestive title, suggestive of banked fires.'

I looked even more nervous, feeling that was far from descriptive of what I had written. I don't know quite why I had chosen that title, beyond the fact that I had presumably been reading *Omar Khayyam*. I think I meant it to be that, like snow upon the desert's dusty face, all the events that happen in life are in themselves superficial and pass without leaving any memory. Actually I don't think the book was at all like that when finished, but that had been my idea of what it was going to be.

Hughes Massie kept the manuscript to read, but returned it some months later, saying that he felt it unlikely that he could place it. The best thing for me to do, he said, was to stop thinking about it any more, and to start to write another book.

I have never been an ambitious person by nature, and I resigned myself to making no further struggle. I still wrote a few poems, and enjoyed them, and I think I wrote one or two more short stories. I sent them to magazines, but expected them to come back, and come back they usually did.

I was no longer studying music seriously. I practised the piano a few hours a day, and kept it up as well as I could to my former standard, but I took no more lessons. I still studied singing when we were in London for any length of time. Francis Korbay, the Hungarian composer, gave me singing lessons, and taught me some charming Hungarian songs of his own composition. He was a good teacher and an interesting man. I also studied English ballad singing with another teacher, a woman who lived near that part of the Regent Canal which they call Little Venice and which always fascinates me. I sang quite often at local concerts and, as was the fashion of the time, 'took my music' when I was asked out to dinner. There was, of course, no 'tinned' music in those days: no broadcasting, no tape-recorders, no stereophonic gramophones. For music you

relied on the private performer, who might be good, moderately good, bloody awful. I was quite a good accompanist, and could read by sight, so I often had to play accompaniments for other singers.

I had one wonderful experience when there were performances of Wagner's *Ring* in London with Richter conducting. My sister Madge had suddenly become very interested in Wagnerian music. She arranged for a party of four to go to *The Ring*, and paid for me. I shall always be grateful to her and remember that experience. Van Rooy sang Wotan. Gertrude Kappel sang the principal Wagnerian soprano roles. She was a big, heavy woman with a turned-up nose – no actress, but she had a powerful, golden voice. An American called Saltzman Stevens sang Sieglinde, Isolde, and Elizabeth. Saltzman Stevens I shall always find it hard to forget. She was a most beautiful actress in her motions and gestures, and had long graceful arms that came out of the shapeless white draperies Wagnerian heroines always wore. She made a glorious Isolde. I suppose her voice could not have been equal to that of Gertrude Kappel, but her acting was so superb that it carried one away. Her fury and despair in the first act of *Tristan*, the lyrical beauty of her voice in the second, and then – most unforgettable, to my mind – that great moment in the third act: that long music of Kurwenal, the anguish and the waiting, with Tristan and Kurwenal together, the looking for the ship on the sea. Finally that great soprano cry that comes from off-stage: '*Tristan!*'

Saltzman Stevens *was* Isolde. Rushing – yes, rushing one could feel – up the cliff and up on to the stage, running with those white arms outstretched to catch Tristan within their grasp. And then, a sad, almost bird-like stricken cry.

She sang the Liebestod entirely as a woman, not a goddess; sang it kneeling by Tristan's body, looking down at his face, seeing him with the force of her will and imagination come alive; and finally, bending, bending lower and lower, the last three words of the opera, '*with a kiss*', came as she bent to touch his lips with hers, and then to fall suddenly across his body.

Being me, every night before I dropped off to sleep I used to turn over and over in my mind the dream that one day I might be singing Isolde on a real stage. It did no harm, I told myself – at any rate to go through it in fantasy. Could I, would it *ever* be possible for me to sing in opera? The answer of course was no. An American friend of May Sturges' who was over in London, and connected with the Metropolitan Opera House, New York, very kindly came to hear me sing one day. I sang various

arias for her, and she took me through a series of scales, arpeggios and exercises. Then she said to me: 'The songs you sang told me nothing, but the exercises do. You will make a good concert singer, and should be able to do well and make your name at that. Your voice is *not* strong enough for opera, and never will be.'

So let us take it from there. My cherished secret fantasy to do something in music was ended. I had no ambition to be a concert singer, which was not an easy thing to do anyway. Musical careers for girls did not meet with encouragement. If there had been any chance of singing in opera I would have fought for it, but that was for the privileged few, who had the right vocal cords. I am sure there can be nothing more soul-destroying in life than to persist in trying to do a thing that you want desperately to do well, and to know you are at the best second-rate. So I put wishful thinking aside. I pointed out to mother that she could now save the expense of music lessons. I could sing as much as I liked, but there was no point in going on studying singing. I had never really believed that my dream could come true – but it is a good thing to have *had* a dream and to have enjoyed it, so long as you do not clutch too hard.

It must have been about this time that I began reading the novels of May Sinclair, by which I was much impressed – and, indeed, when I read them now I am still much impressed. I think she was one of our finest and most original novelists, and I cannot help feeling that there will be a revival of interest in her some day, and that her works will be republished. *A Combined Maze*, that classic story of a little clerk and his girl, I still think one of the best novels ever written. I also liked *The Divine Fire*; and *Tasker Jevons* I think a masterpiece. A short story of hers, *The Flaw in the Crystal*, impressed me so much, probably because I was addicted to writing psychic stories at the time, that it inspired me to write a story of my own somewhat in the same vein. I called it *Vision* (It was published with some other stories of mine in a volume much later), and I still like it when I come across it again.

I had formed a habit of writing stories by this time. It took the place, shall we say, of embroidering cushion-covers or pictures taken from Dresden china flower-painting. If anyone thinks this is putting creative writing too low in the scale, I cannot agree. The creative urge can come out in any form: in embroidery, in the cooking of interesting dishes, in painting, drawing and sculpture, in composing music, as well as in writing books and stories. The only difference is that you can be a great deal more grand about some of these things than others. I would agree

that the embroidering of Victorian cushion-covers is not equal to parti-
cipating in the Bayeux tapestry, but the urge is the same in both cases.
The ladies of the early Williams's court were producing a piece of original
work requiring thought, inspiration and tireless application; some parts
of it no doubt were dull to do, and some parts highly exciting. Though
you may say that a square of brocade with two clematis and a butterfly
on it is a ridiculous comparison, the artist's inner satisfaction was pro-
bably much the same.

The waltz I composed was nothing to be proud of; one or two of my
embroideries, however, *were* good of their kind, and I was pleased with
them. I don't think I went as far as being pleased with my stories – but
then there always has to be a lapse of time after the accomplishment of
a piece of creative work before you can in any way evaluate it.

You start into it, inflamed by an idea, full of hope, full indeed of con-
fidence (about the only times in my life when I *have* been full of con-
fidence). If you are properly modest, you will never write at all, so there
had to be one delicious moment when you have thought of something,
know just how you are going to write it, rush for a pencil, and start in an
exercise book buoyed up with exaltation. You then get into difficulties,
don't see your way out, and finally manage to accomplish more or less
what you first meant to accomplish, though losing confidence all the
time. Having finished it, you know that it is absolutely rotten. A couple
of months later you wonder whether it may not be all right after all.

VI

About then I had two near escapes from getting married. I call them near
escapes because, looking back now, I realise with certainty that either
of them would have been a disaster.

The first one was what you might call 'a young girl's high romance'.
I was staying with the Ralston Patricks. Constance and I drove to a cold
and windy meet, and a man mounted on a nice chestnut rode up to speak
to Constance and was introduced to me. Charles was, I suppose, about
thirty-five, a major in the 17th Lancers, and he came every year to
Warwickshire to hunt. I met him again that evening when there was a
fancy dress dance, to which I went dressed as Elaine. A pretty costume: I

still have it (and wonder how I could ever have got into it); it is in the chest in the hall which is full of 'dressing-up things'. It is quite a favourite – white brocade and a pearl cap. I met Charles several times during my visit, and when I went back home we both expressed polite wishes that we should meet again some time. He mentioned that he might be down in Devonshire later.

Three or four days after getting home I received a parcel. In it was a small silver-gilt box. Inside the lid was written: 'The Asps', a date, and 'To Elaine' below it. The Asps was where the meet had taken place, and the date was the date I had met him. I also got a letter from him saying that he hoped to come to see us the following week when he would be in Devon.

That was the beginning of a lightning courtship. Boxes of flowers arrived, occasional books, enormous boxes of exotic chocolates. Nothing was said that could not have been properly said to a young girl, but I was thrilled. He paid us two more visits, and on the third asked me to marry him. He had, he said, fallen in love with me the first moment he saw me. If one was arranging proposals in order of merit, this one would easily go to the top of my list. I was fascinated and partly carried off my feet by his technique. He was a man with a good deal of experience of women, and able to produce most of the reactions he wanted. I was ready for the first time to consider that here was my Fate, my Mr Right. And yet – yes, there it was – and *yet*. . . . When Charles was there, telling me how wonderful I was, how he loved me, what a perfect Elaine, what an exquisite creature I was, how he would spend his whole life making me happy, and so on, his hands trembling and his voice shaking – oh yes, I was charmed like a bird off a tree. And yet – yet, when he was gone away, when I thought of him in absence, there was nothing there. I did not yearn to see him again. I just felt he was – very nice. The alteration between the two moods puzzled me. How can you tell if you are in love with a person? If in absence they mean nothing to you, and in presence they sweep you off your feet, what is your *real* reaction?

My poor darling mother must have suffered a great deal at that time. She had, she told me later, prayed a great deal that shortly a husband would be provided for me; good, kind, and well-provided with this world's goods. Charles had appeared much like an answer to prayer, but somehow she wasn't satisfied. She always knew what people were thinking and feeling, and she must have known quite well that I didn't know myself what I *did* feel. While she held her usual maternal view that

no man in this world could be good enough for her Agatha, she had a feeling that, even allowing for that, this was not the right man. She wrote to the Ralston Patricks to find out as much as she could about him. She was handicapped by my father not being alive, and by my having no brother who could make what were in those days the usual inquiries as to a man's record with women, his exact financial position, his family, and so on and so on – very old-fashioned it seems nowadays, but I daresay it averted a good deal of misery.

Charles came up to standard. He had had a good many affairs with women, but that my mother did not really mind: it was an accepted principle that men sowed their wild oats before marriage. He was about fifteen years older than I was, but her own husband had been ten years older than she was, and she believed in that kind of gap in years. She told Charles that Agatha was still very young and that she must not come to any rash decisions. She suggested that we should see each other occasionally during the next month or two, without my being pressed for a decision.

This did not work well because Charles and I had absolutely nothing to talk about except the fact that he was in love with me. Since he was holding himself back on that subject, there was a great deal of embarrassed silence between us. Then he would go away, and I would sit and wonder. What *did* I want to do? Did I want to marry him? Then I would get a letter from him. He wrote, there was no doubt about it, the most glorious love letters, the kind of love letters that any woman would long to get. I pored over them, re-read them, kept them, decided that this was love at last. Then Charles would come back, and I would be excited, carried off my feet – and yet at the same time had a cold feeling at the back of my mind that it was all wrong. In the end my mother suggested that we should not see each other for six months, and that then I should decide definitely. That was adhered to, and during that period there were no letters – which was probably just as well, because I should have fallen for those letters in the end.

When the six months were up I received a telegram. 'Cannot stand this indecision any longer. Will you marry me, yes or no.' I was in bed with a slight feverish attack at the time. My mother brought me the telegram. I looked at it and at the reply-paid form. I took a pencil and wrote the word No. Immediately I felt an enormous relief: I had decided something. I should not have to go through any more of this uncomfortable up-and-down feeling.

'Are you sure?' asked mother.

'Yes,' I said. I turned over on my pillow and went immediately to sleep. So that was the end of that.

Life was rather gloomy during the next four or five months. For the first time everything I did bored me, and I began to feel that I had made a great mistake. Then Wilfred Pirie came back into my life.

I have mentioned Martin and Lilian Pirie, my father's great friends, whom we met again abroad, in Dinard. We had continued to meet, though I had not again seen the boys. Harold had been at Eton and Wilfred had been a midshipman in the Navy. Now Wilfred was a fully-fledged sub-lieutenant R.N. He was in a submarine, I think, at that time, and often came in with that portion of the Fleet which visited Torquay. He became an immense friend at once, one of the people in my life I have been fondest of. Within a couple of months we were unofficially engaged.

Wilfred was such a relief after Charles. With him there was no excitement, no doubt, no misery. Here was just a dear friend, somebody I knew well. We read books, discussed them, we had always something to talk about. I was completely at home with him. The fact that I was treating him and considering him exactly like a brother, did not occur to me. My mother was delighted, and Mrs Pirie too. Martin Pirie had died some years ago. It seemed a perfect marriage from everyone's point of view. Wilfred had a good career ahead of him in the Navy; our fathers had been the closest friends, and our mothers liked each other; mother liked Wilfred, Mrs Pirie liked me. I still feel I was a monster of ingratitude not to have married him.

My life was now settled for me. In a year or two, when it was suitable (young subalterns and young sub-lieutenants were not encouraged to marry too soon) we would be married. I liked the idea of marrying a sailor. I should live in lodgings at Southsea, Plymouth, or somewhere like that, and when Wilfred was away on foreign stations I could come home to Ashfield and spend my time with mother. Really, nothing in the world could have been so right.

I suppose there is a horrible kink in one's disposition that tends always to kick against anything that is too right or too perfect. I wouldn't admit it for a long time, but the prospect of marrying Wilfred induced in me a depressing feeling of boredom. I liked him, I would have been happy living in the same house with him, but somehow there wasn't any excitement about it; no excitement at all!

One of the first things that happens when you are attracted to a man and he is to you is that extraordinary illusion that you think exactly alike about everything, that you each say the things the other had been thinking. How wonderful it is that you like the same books, and the same music. The fact that one of you hardly ever goes to a concert or listens to music doesn't at that moment matter. He always *really* liked music, but he didn't know he did! In the same way, the books he likes you have never actually wished to read, but now you feel that really you do want to read them. There it is; one of Nature's great illusions. We both like dogs and hate cats. How wonderful! We both like cats and hate dogs, also wonderful.

So life went placidly on. Every two or three weeks Wilfred came for the weekend. He had a car and used to drive me around. He had a dog, and we both loved the dog. He became interested in spiritualism, therefore I became interested in spiritualism. So far all was well. But now Wilfred began to produce books that he was eager for me to read and pronounce on. They were very large books – theosophical mostly. The illusion that you enjoyed whatever your man enjoyed didn't work; naturally it didn't work – I wasn't really in love with him. I found the books on theosophy tedious; not only tedious, I thought they were completely false; worse still, I thought a great many of them were nonsense! I also got rather tired of Wilfred's descriptions of the mediums he knew. There were two girls in Portsmouth, and the things those girls saw you wouldn't believe. They could hardly ever go into a house without gasping, stretching, clutching their hearts and being upset because there was a terrible spirit standing behind one of the company. 'The other day,' said Wilfred, 'Mary – she's the elder of the two – she went into a house and up to the bathroom to wash her hands, and do you know she couldn't walk over the threshold? No, she absolutely couldn't. There were two figures there – one was holding a razor to the throat of the other. Would you believe it?'

I nearly said, 'No, I wouldn't,' but controlled myself in time. 'That's very interesting,' I said. '*Had* anyone ever held a razor to the throat of somebody there?'

'They must have,' said Wilfred. 'The house had been let to several people before, so an incident of that kind must have occurred. Don't you think so? Well, you can see it for yourself, can't you?'

But I didn't see it for myself. I was always of an agreeable nature however, and so I said cheerfully, of course, it certainly must have been so.

Then one day Wilfred rang up from Portsmouth and said a wonderful chance had come his way. There was a party being assembled to look for treasure trove in South America. Some leave was due to him and he would be able to go off on this expedition. Would I think it terrible of him if he went? It was the sort of exciting chance that might never happen again. The mediums, I gathered, had expressed approval. They had said that undoubtedly he would come back having discovered a city that had not been known since the time of the Incas. Of course, one couldn't take that as proof or anything, but it was very extraordinary, wasn't it? Did I think it awful of him, when he could have spent a good part of his leave with me?

I found myself having not the slightest hesitation. I behaved with splendid unselfishness. I said to him I thought it a wonderful opportunity, that of course he must go, and that I hoped with all my heart that he would find the Incas' treasures. Wilfred said I was wonderful; absolutely wonderful; not a girl in a thousand would behave like that. He rang off, sent me a loving letter, and departed.

But I was not a girl in a thousand; I was just a girl who had found out the truth about herself and was rather ashamed about it. I woke up the day after he had actually sailed with the feeling that an enormous load had slipped off my mind. I was delighted for Wilfred to go treasure-hunting, because I loved him like a brother and I wanted him to do what he wanted to do. I thought the treasure-hunting idea was rather silly, and almost certain to be bogus. That again was because I was not in love with him. If I had been, I would have been able to see it through his eyes. Thirdly, oh joy, oh joy! I would not have to read any more theosophy.

'What are you looking so cheerful about?' mother asked suspiciously.

'Listen, mother,' I said. 'I know it's awful, but I am really cheerful because Wilfred has gone away.'

The poor darling. Her face fell. I have never felt so mean, so ungrateful as I did then. She had been so happy about Wilfred and me coming together. For one misguided moment I almost felt that I must go through with it, just for the sake of making her happy. Fortunately, I was not quite so sunk in sentimentality as that.

I didn't write and tell Wilfred what I had decided, because I thought it might have a bad effect on him in the middle of hunting for Inca treasure in steamy jungles. He might have a fever, or some unpleasant animal might leap on him while his mind was distracted – and anyway it would

spoil his enjoyment. But I had a letter waiting for him when he came back. I told him how sorry I was, how fond of him I was, but I didn't think that there was really the proper kind of feeling between us to engage each other for life. He didn't agree with me, of course, but he took the decision seriously. He said he didn't think he could bear to see me often, but that we would always remain friendly towards each other. I wonder now if he was relieved as well. I don't think so, but on the other hand I do not think it cut him to the heart. *I* think he was lucky. He would have made me a good husband, and would always have been fond of me, and I think I should have made him quite happy in a quiet way, but he could do better for himself – and about three months later he did. He fell violently in love with another girl, and she fell as violently in love with him. They were married in due course, and had six children. Nothing could have been more satisfactory.

As for Charles, about three years later he married a beautiful girl of eighteen.

Really, what a benefactress I was to those two men.

The next thing that happened was that Reggie Lucy came back on leave from Hongkong. Though I had known the Lucys for so many years, I had never met their eldest brother, Reggie. He was a major in the Gunners, and had done his service mostly abroad. He was a shy and retiring person who seldom went out. He liked playing golf, but he had never cared for dances or parties. He was not fair-haired and blue-eyed like the others; he had dark hair and brown eyes. They were a closely-knit family, and enjoyed each other's society. We went out to Dartmoor together in the usual Lucy-ish fashion – missing trams, looking-up trains which didn't exist, missing them anyway, changing at Newton Abbot and missing the connection, deciding we'd go to a different part of the Moor, and so on.

Then Reggie offered to improve my golf. My golf at this stage might be said to have been practically non-existent. Various young men had done their best for me, but much to my own regret, I was not good at games. The irritating thing was that I was always a promising beginner. At archery, at billiards, at golf, at tennis, and at croquet I promised very well; but the promise was never fulfilled: another source of humiliation. The truth is, I suppose, that if you haven't got a good eye for balls you haven't. I played in croquet tournaments with Madge where I had the advantage of the utmost number of bisques that was allowed.

'With all your bisques,' said Madge, who played well, 'we ought to win *easily*.'

My bisques helped, but we didn't win. I was good at the theory of the game, but I invariably missed ridiculously easy shots. At tennis I developed a good forehand drive which sometimes impressed my partners, but my backhand was hopeless. You cannot play tennis with a forehand drive alone. At golf I had wild drives, terrible iron shots, beautiful approach shots, and completely unreliable putts.

Reggie, however, was extremely patient, and he was the kind of teacher who did not mind in the least whether you improved or not. We meandered gently round the links; we stopped whenever we felt like it. The serious golfers went by train to Churston golf course. The Torquay course was also the race-course three times a year, and was not much patronised or well kept-up. Reggie and I would amble round it, then we would go back to tea with the Lucys and have a sing-song, having made fresh toast because the old toast was now cold. And so on. It was a happy lazy life. Nobody ever hurried, and time didn't matter. Never any worry, never any fuss. I may be entirely wrong, but I feel certain that none of the Lucys ever had duodenal ulcers, coronary thromboses, or high blood pressure.

One day Reggie and I had played four holes of golf, and then, since the day was extremely hot, he suggested that really it would be much more agreeable to sit down under the hedge He got out his pipe, smoked companionably, and we talked in our usual way, which was never continuously, but a word or two on a subject or a person, then restful pauses. It is the way I most like holding a conversation. I never felt slow or stupid, or at a loss for things to say, when I was with Reggie.

Presently, after various puffs at his pipe, he said thoughtfully: 'You've got a lot of scalps, Agatha, haven't you? Well, you can put mine with them any time you like.'

I looked at him rather doubtfully, not quite sure of his meaning.

'I don't know whether you know I want to marry you,' he said, 'you probably do. But I may as well say it. Mind you, I'm not pushing myself forward in any way; I mean there's no hurry' – the famous Lucy phrase came easily from Reggie's lips – 'You are very young still, and it would be all wrong on my part to tie you down now.'

I said sharply that I was not so very young.

'Oh yes you are, Aggie, compared with me.' Though Reggie had been urged not to call me Aggie, he frequently forgot, because it was so natural

for the Lucys to call each other names like Margie, Noonie, Eddie, and Aggie. 'Well, you think about it,' went on Reggie. 'Just bear me in mind, and if nobody else turns up – there I am, you know.'

I said immediately that I didn't need to think about it; I would like to marry him.

'I don't think you can have thought properly, Aggie.'

'Of course I've thought properly. I can think in a moment about a thing like that.'

'Yes, but it's no good rushing into it, is it? You see, a girl like you – well, she could marry anybody.'

'I don't think I want to marry anybody. I think I'd rather marry you.'

'Yes, but you've got to be practical, you know. You've got to be practical in this world. You want to marry a man with a good lot of money, a nice chap, one you like, who can give you a good time and look after you properly, give you all the things you ought to have.'

'I only want to marry the person I want to marry; I don't mind about a lot of *things*.'

'Yes, but they are important, old girl. They are important in this world. It is no good being young and romantic.' He went on, 'My leave's up in another ten days. I thought I'd better speak before I went. Before that I thought I wouldn't . . . I thought that I'd wait. But I think you – well, I think I'd like you just to know that I'm here. When I come back in two years' time, if there isn't anybody – '

'There won't be anyone,' I said. I was quite positive.

And so Reggie and I became engaged. It was not called an engagement: it was on the 'understanding' system. Our families knew we were engaged, but it would not be announced or put in the paper, and we would not tell our friends about it, though I think most of them knew.

'I can't think,' I said to Reggie, 'why we can't be married. Why didn't you tell me sooner, then we would have had time to make preparations.'

'Yes, of course, you've got to have bridesmaids and a slap-up wedding and all the rest of it. But anyway, I shouldn't dream of letting you get married to me now. You must have your chance.'

I used to get angry over this, and we would almost quarrel. I said I didn't think it was flattering for him to be so ready to turn down my offer to marry him at once. But Reggie had fixed ideas as to what was due to the person he loved, and he had got it into his long, narrow head that the right thing for me to do was to marry a man with a place, money,

and all the rest of it. In spite of our disputes, though, we were very happy. The Lucys all seemed pleased, saying, 'We've thought Reggie had his eye on you, Aggie, for some time. He doesn't usually look at any of our girl friends. Still, there's no hurry. Better give yourself plenty of time.'

There were one or two moments when what I had enjoyed so much with the Lucys – their insistence on there being plenty of time for anything – roused a certain antagonism in me. Romantically, I would have liked Reggie to say that he couldn't possibly wait two years, that we must get married now. Unfortunately, it was the last thing Reggie would have dreamed of saying. He was a very unselfish man, and diffident about himself and his prospects.

My mother was, I think, happy about our engagement. She said, 'I have always been fond of him. I think he is one of the nicest people I have ever met. He will make you happy. He is gentle and kind, and he will never hurry you, or bother you. You won't be very well off, but you will have enough now that he has reached the rank of major – you'll manage all right. You're not the sort of person who cares very much about money, and who wants parties and a gay life. No, I think this will be a happy marriage.'

Then she said, after a slight pause, 'I wish he'd told you a little earlier, so that you could have married straight away.'

So she, too, felt as I did. Ten days later, Reggie left to go back to his Regiment and I settled down to wait for him.

Let me add here a kind of postscript to my account of my courtship days.

I have described my suitors – but, rather unfairly, have not commented on the fact that I, too, lost my heart. First to a very tall young soldier, whom I met when staying in Yorkshire. If he had asked me to marry him, I should probably have said yes before the words were out of his mouth! Very wisely from his point of view, he didn't. He was a penniless subaltern, and about to go to India with his regiment. I think he was more or less in love with me, though. He had that sheep-like look. I had to make do with that. He went off to India, and I yearned after him for at least six months.

Then, a year or so later, I lost my heart again, when acting in a musical play got up by friends in Torquay – a version of *Bluebeard*, with topical words, written by themselves. I was Sister Anne, and the object of my affections later became an Air Vice-Marshal. He was young then –

at the beginning of his career. I had the revolting habit of singing to a teddy bear in a coy fashion the song of the moment:

> I wish I had a Teddy Bear
> To sit upon my knee
> I'd take it with me everywhere
> To cuddle up to me.

All I can offer in excuse is that all the girls did that sort of thing – and it went down very well.

Several times in later life I came near meeting him again – since he was a cousin of friends – but I always managed to avoid it. I have my vanity.

I have always believed that he has a memory of me as a lovely girl at a moonlight picnic on Anstey's Cove on the last day of his leave. We sat apart from the rest on a rock sticking out to sea. We didn't speak – just sat there holding hands.

After he left he sent me a little gold Teddy Bear brooch.

I cared enough to want him still to remember me like that – and not to sustain the shock of meeting thirteen stone of solid flesh and what could only be described as 'a kind face'.

'Amyas always asks after you,' my friends would say. 'He would so like to meet you again.'

Meet me at a ripe sixty? No fear. I would like to be an illusion still to somebody.

VII

Happy people have no history, isn't that the saying? Well, I was a happy person during this period. I did mostly the same things as usual: met my friends, went to stay away occasionally – but there was anxiety about my mother's eyesight, which was getting progressively worse. She had great difficulty in reading now, and trouble seeing things in a bright light. Spectacles did not help. My grandmother at Ealing was also rather blind, and had to peer about for things. She was also getting, as elderly people do, progressively more suspicious of everybody: of her servants, of men who came to mend the pipes, of the piano tuner, and so on. I always remember Grannie leaning across the dining-table and saying, either to me or to my sister, 'Ssh!' – a deep hissing sound – 'Speak low, *where is your bag?*'

'In my room, Grannie.'

'You've *left* it there? You mustn't leave it there. I heard *her*, upstairs, just now.'

'Well, but that's all right, isn't it?'

'You never know, dear, you never know. Go up and fetch it.'

It must have been about this time that my mother's mother, Granny B., fell off a bus. She was addicted to riding on the top of buses, and I suppose by now must have been eighty. Anyway, the bus went on suddenly as she was coming downstairs, and she fell off; broke, I think, a rib, and possibly an arm as well. She sued the bus company with vigour, was awarded handsome compensation – and sternly forbidden by her doctor ever to ride on the top of a bus again. Naturally, being Granny B., she disobeyed him constantly. Up to the last Granny B. was always the old soldier. She had an operation, too, somewhere about this time. I imagine it was cancer of the uterus, but the operation was entirely successful, and she never had any recurrence. The only deep disappointment was her own. She had looked forward to having this 'tumour', or whatever it was, removed from her inside, because, she thought, she would be quite nice and slim after it. She was by this time an immense size, bigger than my other grandmother. The joke of the fat woman who was stuck in the bus door, with the bus conductor crying to her, 'Try sideways, ma'am, try sideways' – 'Lor, young man, I ain't *got* no sideways!' could have applied perfectly to her.

Though strictly forbidden to get out of bed by the nurses after she had come out of the anaesthetic, and they had left her to sleep, she rose from her bed and tiptoed to the pier-glass. What a disillusion. She appeared to be as stout as ever.

'I shall never get over the disappointment, Clara,' she said to my mother. 'Never. I counted on it! It carried me through that anaesthetic and everything. And look at me: just the same!'

It must have been about then that my sister Madge and I had a discussion which was to bear fruit later. We had been reading some detective story or other; I think – I can only say I think because one's remembrances are not always accurate: one is apt to rearrange them in one's mind and get things in the wrong date and sometimes in the wrong place – I think it was *The Mystery of the Yellow Room*, which had just come out, by a new author, Gaston Le Roux, with an attractive young reporter as detective – his name was Rouletabille. It was a particularly baffling

mystery, well worked out and planned, of the type some call unfair and others have to admit is almost unfair, but not quite: one *could* just have seen a neat little clue cleverly slipped in.

We talked about it a lot, told each other our views, and agreed it was one of the best. We were connoisseurs of the detective story: Madge had initiated me young to Sherlock Holmes, and I had followed hot-foot on her trail, starting with *The Leavenworth Case*, which had fascinated me when recounted to me by Madge at the age of eight. Then there was Arsene Lupin – but I never quite considered that a proper detective story, though the stories were exciting and great fun. There were also the Paul Beck stories, highly approved, *The Chronicles of Mark Hewitt* – and now *The Mystery of the Yellow Room*. Fired with all this, I said I should like to try *my* hand at a detective story.

'I don't think you could do it,' said Madge. 'They are very difficult to do. I've thought about it.'

'I should like to try.'

'Well, I bet you couldn't,' said Madge.

There the matter rested. It was never a definite bet; we never set out the terms – but the words had been said. From that moment I was fired by the determination that I would write a detective story. It didn't go further than that. I didn't start to write it then, or plan it out; the seed had been sown. At the back of my mind, where the stories of the books I am going to write take their place long before the germination of the seed occurs, the idea had been planted: *some day I would write a detective story*.

VIII

Reggie and I wrote to each other regularly. I gave him the local news, and tried to write him the best letter I could – letter writing has never been one of my strong points. My sister Madge, now, was what I can only describe as a model of the art! She could make the most splendid stories out of nothing at all. I do envy that gift.

My dear Reggie's letters were exactly like Reggie talking, which was nice and reassuring. He urged me at great length, always, to go about a lot.

'Now don't stay at home moping, Aggie. Don't think that is what *I*

want, because it isn't; you must go out and see people. You must go to
dances and things and parties. I do want you to have every chance, before
we get settled down.'

Looking back now, I wonder whether at the back of my mind I may
not have slightly resented this point of view. I don't think I recognised
it at the time; but does one *really* like to be urged to go about, to see other
people, 'to do better for yourself' (that extraordinary phrase)? Is it not
nearer to the truth that every female would prefer her love-letters to
exhibit a show of jealousy?

'Who is that fellow so-and-so you write about? You're not getting too
fond of him, are you?'

Isn't that what we really want as a sex? Can we take too much un-
selfishness? Or does one read back into one's mind things that perhaps
weren't there?

The usual dances were given in the neighbourhood. I didn't go to
them because, as we had no car, it would not have been practicable to
accept any invitations of more than a mile or two away. Hiring a cab or
car would have been too expensive except for a very special occasion.
But there were times when a hunt for girls was on, and then you would
be asked to stay, or fetched and returned.

The Cliffords at Chudleigh were giving a dance to which they were
asking members of the Garrison from Exeter, and they asked some of
their friends if they could bring a likely girl or two along. My old enemy
Commander Travers, who was now retired and living with his wife in
Chudleigh, suggested that they should bring me. Having been my pet
abomination as a small child, he had graduated from that into old family
friend. His wife rang up and asked if I would come and stay with them
and go to the Cliffords' dance. I was delighted to do so, of course.

I also got a letter from a friend called Arthur Griffiths, whom I had
met when staying with the Matthews at Thorpe Arch Hall in Yorkshire.
He was the local vicar's son, and a soldier – a gunner. He and I had
become great friends. Arthur wrote to say that he was now stationed at
Exeter, but that unfortunately he was not one of the officers going to the
dance, and that he was very sad about it because he would have liked to
dance with me again. 'However,' he said, 'there's a fellow from our Mess
going, Christie by name, so look out for him, won't you? He's a good
dancer.'

Christie came my way quite soon in the dance. He was a tall, fair young
man, with crisp curly hair, a rather interesting nose, turned up not down,

and a great air of careless confidence about him. He was introduced to me, asked for a couple of dances, and said that his friend Griffiths had told him to look out for me. We got on together very well; he danced splendidly and I danced again several more times with him. I enjoyed the evening thoroughly. The next day, having thanked the Travers, I was driven home by them as far as Newton Abbot, where I took the train back.

It must have been, I suppose, a week or ten days later; I was having tea with the Mellors at their house opposite ours. Max Mellor and I still practised our ballroom dancing, though mercifully waltzing upstairs was out of fashion. We were, I think, tango-ing, when I was summoned to the telephone. It was my mother.

'Come home at once, will you, Agatha?' she said. 'There's one of your young men here – I don't know him, never seen him before. I've given him tea, but he seems to be staying on and on hoping to see you.'

My mother was always intensely irritated if she had to look after my young men unaided; she regarded such entertainment as strictly my business.

I was cross at coming back; I was enjoying myself. Besides, I thought I knew who it was – a rather dreary young naval lieutenant, the one who used to ask me to read his poems. So I went unwillingly, with a sulky expression on my face.

I came into the drawing-room, and a young man stood up with a good deal of relief. He was rather pink in the face and clearly embarrassed, having had to explain himself. He was not even much cheered by seeing me – I think he was afraid I shouldn't remember him. But I did remember him, though I was intensely surprised. It had not occurred to me that I should ever see Griffiths' friend, young Christie, again. He made some rather hesitating explanations – he had had to come over to Torquay on his motor-bike, and thought he might as well look me up. He avoided mentioning the fact that he must have gone to a certain amount of trouble and embarrassment to find out my address from Arthur Griffiths. However, things went better after a minute or two. My mother was intensely relieved by my arrival. Archie Christie looked more cheerful, having got his explanations over, and I felt highly flattered.

The evening wore on as we talked. In the sacred code sign, common between women, the question was raised between mother and me as to whether this unasked visitor was going to be invited to stay to supper, and if so what food there was likely to be in the house. It must have been

soon after Christmas, because I know there was cold turkey in the larder. I signalled yes to mother, and she asked Archie if he would care to stay and have a scratch meal with us. He accepted promptly. So we had cold turkey and salad and something else, cheese I think, and spent a pleasant evening. Then Archie got on his motor-bike and went off in a series of explosive bumps to Exeter.

For the next ten days he made frequent and unexpected appearances. That first evening he had asked me if I would like to come to a concert at Exeter – I had mentioned at the dance that I was fond of music – and that he would take me to the Redcliffe Hotel to tea afterwards. I said I would like to come very much. Then there was a somewhat embarrassed moment when mother made it clear that her daughter did not accept invitations to come to Exeter for concerts by herself. That damped him a bit, but he hastily extended the invitation to her. Mother relented, decided she approved of him, and said that it would be quite all right for me to go to the *concert*, but that she was afraid that I could not go to tea with him at a *hotel*. (I must say, looking at it nowadays, I think we had peculiar rules. One could go alone with a young man to play golf, to ride a horse, or to roller-skate, but having tea with him in a hotel had a kind of *risqué* appearance which good mothers did not fancy for their daughters.) A compromise was made in the end, that he might give me tea in the refreshment room on Exeter station. Not a very romantic spot. Later, I asked him if he would like to come to a Wagnerian concert that was to take place at Torquay in four or five days' time. He said he would like it very much.

Archie told me all about himself, how he was waiting impatiently to get into the newly-formed Royal Flying Corps. I was thrilled by this. Everyone was thrilled by flying. But Archie was entirely matter-of-fact. He said it was going to be the service of the future: if there was a war, planes would be the first thing needed. It wasn't that he was mad keen on flying, but it was a chance to get on in your career. There was no future in the Army. As a Gunner, promotion was too slow. He did his best to take the romance out of flying for me, but didn't quite succeed. All the same it was the first time that my romanticism came up against a practical, logical mind. In 1912 it was still a fairly sentimental world. People *called* themselves hard-boiled, but they had no real idea what the term meant. Girls had romantic ideas about young men, and young men had idealistic views about young girls. We had, however, come a long way since my grandmother's day.

'You know, I like Ambrose,' she said, referring to one of my sister's suitors. 'The other day, after Madge had walked along the terrace, I saw Ambrose get up and follow her, and he bent down and picked up a handful of gravel, where her feet had trodden, and put it in his pocket. Very pretty I thought it was, very pretty. I could imagine that happening to me when *I* was young.'

Poor darling Grannie. We had to disillusion her. Ambrose, it turned out, was deeply interested in geology, and the gravel had been of a particular type which interested him.

Archie and I were poles apart in our reactions to things. I think that from the start that fascinated us. It is the old excitement of 'the stranger'. I asked him to the New Year Ball. He was in a peculiar mood the night of the dance: he hardly spoke to me. We were a party of four or six, I think, and every time I danced with him and we sat out afterwards he was completely silent. When I spoke to him he answered almost at random, in a way that did not make sense. I was puzzled, looking at him once or twice, wondering what was the matter with him, what he was thinking of. He seemed no longer interested in me.

I was rather stupid, really. I should have known by now that when a man looks like a sick sheep, completely bemused, stupid and unable to listen to what you say to him, he has, vulgarly, got it badly.

What did *I* know? Did I know what was happening to me? I remember picking up one of Reggie's letters when it came, saying to myself, 'I'll read this later,' and shoving it quickly into the hall drawer. I found it there some months afterwards. I suppose, deep down, I already knew.

The Wagnerian concert was two days after the ball. We went to it, and came back to Ashfield afterwards. As we went up to the schoolroom to play the piano, as was our usual custom, Archie spoke to me almost desperately. He was leaving in two days' time, he said: he was going to Salisbury Plain, to start his Flying Corps training. Then he said fiercely, 'You've got to marry me, you've *got* to marry me.' He said he had known it the first evening he danced with me. 'I had an awful time getting your address and finding you. Nothing could have been more difficult. There will never be anyone but you. You've got to marry me.'

I told him it was impossible, that I was already engaged to someone. He waved away engagements with a furious hand. 'What on earth does *that* matter?' he said. 'You'll just have to break it off, that's all.'

'But I can't. I couldn't *possibly* do that.'

'Of course you could. I'm not engaged to anyone else, but if I was I'd break it off in a minute without even thinking about it.'

'I couldn't do *this* to him.'

'Nonsense. You *have* to do things to people. If you were so fond of each other, why didn't you get married before he went abroad?'

'We thought – ' I hesitated – 'it better to wait.'

'I wouldn't have waited. I'm not going to wait either.'

'We couldn't be married for years,' I said. 'You're only a subaltern. And it would be the same in the Flying Corps.'

'I couldn't possibly wait years. I should like to be married next month or the month after.'

'You're mad,' I said. 'You don't know what you are talking about.'

I don't think he did. He had to come down to earth in the end. It was a terrible shock for my poor mother. I think she had been anxious, though no more than anxious, and she was deeply relieved to hear that Archie was going away to Salisbury Plain – but to be presented so suddenly with a *fait accompli* shook her.

I had said to her: 'I'm sorry, mother. I've got to tell you. Archie Christie has asked me to marry him, and I want to, I want to dreadfully.'

But we had to face facts – Archie unwillingly, but mother was very firm with him. 'What do you have to get married on?' she asked. 'Either of you.'

Our financial position could hardly have been worse. Archie was a young subaltern, only a year older than I was. He had no money, only his pay and a small allowance, which was all that his mother could afford. I had only the solitary hundred a year which I had inherited under my grandfather's will. It would be years at the best before Archie was in any position to marry.

He said to me rather bitterly before he went: 'Your mother's brought me down to earth. I thought nothing would matter! We would get married somehow or other, and things would be all right. She has made me see that we can't, not at present. We shall have to wait – but we won't wait a day longer than we can help. I shall do everything, everything I can think of. This flying business will help . . . only of course they don't like your being married either in the Army *or* the Flying Corps while you are young.' We looked at each other, we were young, desperate – and in love.

We had an engagement that lasted a year and a half. It was a tempestuous time, full of ups and downs and deep unhappiness, because we

had the feeling that we were reaching out for something we would never attain.

I put off writing to Reggie for nearly a month, mainly, I suppose, out of guilt, and partly because I could not bring myself to believe that what had suddenly happened to me could possibly have been *real* – soon I would wake up from it and go back to where I was.

But I had to write in the end – guilty, miserable, and without a single excuse. It made it worse, I think, the kindly and sympathetic way that Reggie took it. He told me not to distress myself; it wasn't my fault he was sure; I could not have helped it; these things happen.

'Of course,' he said, 'it's been a bit of a blow for me, Agatha, that you are marrying a chap who is even less able to support you than I am. If you were marrying somebody well off, a good match and everything, I should have felt that it didn't matter so much, because it would be more what you *ought* to have, but now I can't help wishing that I'd taken you at your word and that we'd got married and that I'd brought you out here with me straight away.'

Did I wish also that he'd done that? I suppose not – not by that time – and yet perhaps there was always the feeling of wanting to go back, wanting to have once more a safe foot on shore. Not to swim out into deep water. I had been so happy, so peaceful with Reggie, we had understood each other so well; we'd enjoyed and wanted the same things.

What had happened to me now was the opposite. I loved a stranger; mainly because he *was* a stranger, because I never knew how he would react to a word or a phrase and everything he said was fascinating and new. He felt the same. He said once to me, 'I feel I can't get *at* you. I don't know what you're *like*.' Every now and then we were overwhelmed by waves of despair, and one or other of us would write and break it off. We would both agree that it was the only thing to do. Then, about a week later, we would find ourselves unable to bear it, and we would be back on the old terms.

Everything that could go wrong, did go wrong. We were badly enough off anyway, but now a fresh financial blow fell upon my family. The H. B. Chaflin Company in New York, the firm of which my grandfather had been a partner, went suddenly into liquidation. It was an unlimited company too, and I gathered that the position was serious. In any case, it meant that the income which my mother had received from it, which was the only income she had, would now cease completely. My grandmother, by good fortune, was not quite in the same situation. Her money

had also been left to her in H. B. Chaflin shares, but Mr Bailey, who was
the member of the firm who looked after her affairs, had been worried for
some time. Charged with the care of Nathaniel Miller's widow, he felt
responsible for her. When Grannie wanted money she merely wrote to
Mr Bailey, and Mr Bailey, I think, sent it her in cash – it was as old-
fashioned as that. She was disturbed and upset when one day he sug-
gested to her that she should allow him to reinvest her money for her.

'Do you mean take my money out of Chaflin's?'

He was evasive. He said that you had to watch investments, that it was
awkward for her, being English by birth and living in England, as the
widow of an American. He said several things which, of course, were not
the real explanation at all, but Grannie accepted them. Like all women
of that time, you accepted completely any business advice that was given
you by anyone you trusted. Mr Bailey said leave it to him, he would
reinvest her money in a way that would give her nearly as much income
as she had now. Reluctantly Grannie agreed; and therefore, when the
crash came, her income was safe. Mr Bailey was dead by that time, but
he had done his duty for the partner's widow, without giving away his
fears about the solvency of the company. Younger members of the firm
had, I believe, launched out in a big way, and had seemed successful,
but actually they had expanded too much, had opened too many branches
all over the country, and spent too much money on salesmanship. What-
ever its cause, the crash was a complete one.

It was like a recurrence of my childhood's experience, when I had
heard mother and father talking together about money difficulties, and
had pranced down happily to announce to the household below stairs
that we were ruined. 'Ruin' had seemed to me then a fine and exciting
thing. It did not seem nearly so exciting now; it spelt final disaster for
Archie and myself. The £100 a year I had belonging to me must of
course go to support mother. No doubt Madge would help also. By
selling Ashfield she might just be able to exist.

Things turned out to be not quite so bad as we thought, because Mr
John Chaflin wrote from America to my mother and said how deeply
grieved he was. She might count on an income of £300 a year, sent to her
not from the firm, which was bankrupt, but from his own private
fortune, and this would last until her death. That relieved us of the first
anxiety. But when she died that money would cease. £100 a year and
Ashfield was all I could count upon for the future. I wrote and told
Archie that I could never marry him, that we should have to forget each

other. Archie refused to listen to this. Somehow or other he was going to make money. We would get married, and he might even be able to help support my mother. He made me confident and hopeful. We got engaged again.

My mother's eyesight became much worse, and she went to a specialist. He told her she had cataracts in both eyes, and that for various reasons it would be impossible to operate. They might not grow fast, but in time would certainly lead to blindness. Again I wrote to Archie, breaking off the engagement, saying that it was obviously not meant to be, and that I could never desert my mother if she were blind. Again he refused to concur. I was to wait and see how my mother's eyesight got on – there might be a cure for it, an operation might be possible, and anyway she wasn't blind *now* so we might as well remain engaged. We did remain engaged. Then *I* had a letter from Archie, saying, 'It's no good, I can never marry you. I am too poor. I have been trying one or two small investments with what I had, and it's no good whatsoever, I've lost it. You must give me up.' I wrote and said I would never give him up. He wrote back and said I must. We then agreed we *would* give each other up.

Four days later Archie managed to get leave and arrived suddenly on his motor-bicycle from Salisbury Plain. It was no good, we had got to be engaged again, we had got to be hopeful and wait – something would happen, even if we had to wait four or five years. We went through emotional storms, and in the end, once more, our engagement was on, though every month the possibility of marriage receded further into the distance. It was hopeless, I felt in my heart, but I wouldn't recognise it. Archie thought it was hopeless too, but we still clung desperately to the belief that we could not live without each other, so we might as well remain engaged and pray for some sudden stroke of fortune.

I had by now met Archie's family. His father had been a Judge in the Indian Civil Service, and had had a severe fall from a horse. He became rapidly ill after that – the fall had affected his brain – and had finally died in hospital in England. After some years of widowhood, Archie's mother had remarried William Hemsley. No one could have been kinder to us or more fatherly than he always was. Archie's mother, Peg, came from Southern Ireland, near Cork, and was one of twelve children. She had been staying with her eldest brother, who was in the Indian Medical, when she had met her first husband. She had two boys, Archie and Campbell. Archie had been head of the school at Clifton, and had passed

fourth into Woolwich: he had brains, resource, audacity. Both boys were in the Army.

Archie broke the news of his engagement to her, and sang my praises in the way that sons are apt to do in describing the girl of their choice. Peg looked at him with a doubtful eye, and said in a rich Irish voice: 'Would she now be one of those girls that's wearing one of these new-fangled Peter Pan collars?' Rather uneasily Archie had to admit that I did wear Peter Pan collars. They were rather a feature of the moment. We girls had at last abandoned the high collars to our blouses, which were stiffened by little zigzag bones, one up each side and one at the back, so as to leave red, uncomfortable marks on the neck. A day came when people determined to be daring and achieve comfort. The Peter Pan collar was designed, presumably, from the turned-down collar worn by Peter Pan in Barrie's play. It fitted round the bottom of the neck, was of soft material, had nothing like a bone about it, and was heaven to wear. It could hardly have been called daring. When I think of the reputation for possible fastness that we girls incurred, just by showing the four inches of neck from below the chin, it seems incredible. Looking round and seeing girls in bikinis on the beach now makes one realise how far one has gone in fifty years.

Anyway, I was one of these go-ahead girls who, in 1912, wore a Peter Pan collar.

'And she looks lovely in it,' said the loyal Archie.

'Ah, she would, no doubt,' said Peg. Whatever doubts she may have had about me on account of this, however, she greeted me with extreme kindness, and indeed what I almost thought of as gush. She professed to be so fond of me, so delighted – I was just the girl she had wanted for her boy, and so on and so on – that I didn't believe a word of it. The real truth was that she thought her son much too young to marry. She had no particular fault to find with me – I could no doubt have been much worse. I might have been a tobacconist's daughter (always accounted a symbol of disaster) or a young divorcée – there were some about by then – or even a chorus-girl. Anyway, she doubtless decided that with our prospects the engagement would come to nothing. So she was very sweet to me, and I was slightly embarrassed by her. Archie, true to temperament, was not particularly interested in what she thought of me or I of her. He had the happy attribute of going through life without the least interest in what anyone thought of him or his belongings: his mind was always entirely bent on what *he* wanted himself.

So there we were, still engaged, but no nearer getting married – in fact, rather further off. Promotion did not seem likely to come more quickly in the Flying Corps than anywhere else. Archie had been dismayed to find that he suffered a good deal from sinus trouble when flying a plane. He had a good deal of pain, but carried on. His letters were full of technical accounts of Farman biplanes and Avros: his opinions on the planes that meant more or less certain death for the pilot, and the ones that were pretty steady and ought to develop well. The names of his squadron became familiar to me: Joubert de la Ferté, Brooke-Popham, John Salmon. There was also a wild Irish cousin of Archie's who had by now crashed so many machines that he was more or less permanently grounded.

It seems odd that I don't remember being at all worried about Archie's safety. Flying was dangerous – but then so was hunting, and I was used to people breaking their necks in the hunting field. It was just one of the hazards of life. There was no great insistence on safety then; the slogan 'Safety first' would have been considered rather ridiculous. To be concerned with this new form of locomotion, flying, was glamorous. Archie was one of the first pilots to fly – his pilot's number was, I think, just over the hundred: 105 or 106. I was enormously proud of him.

I think nothing has disappointed me more in my life than the establishment of the aeroplane as a regular method of travel. One had dreamed about it as resembling the flying of a bird – the exhilaration of swooping through the air. But now, when I think of the boredom of getting in an aeroplane and flying from London to Persia, from London to Bermuda, from London to Japan – could anything be more prosaic? A cramped box with its narrow seats, the view from the window mostly wings and fuselage, and below you cotton-wool clouds. When you see the earth, it has the flatness of a map. Oh yes, a great disillusionment. Ships can still be romantic. As for trains – what can beat a train? Especially before the diesels and their smell arrived. A great puffing monster carrying you through gorges and valleys, by waterfalls, past snow mountains, alongside country roads with strange peasants in carts. Trains are wonderful; I still adore them. To travel by train is to see nature and human beings, towns and churches and rivers – in fact, to see life.

I don't mean that I am not fascinated by the conquering of air by man, by his adventures into space, possessed of that one gift that other forms of life do not have, the sense of adventure, the unconquerable spirit, and with it courage – not merely the courage of self-defence, which all animals

have, but the courage to take your life into your hands and go out into the unknown. I am proud and excited to feel that all this has happened in my lifetime, and I would like to be able to look into the future to see the next steps: one feels they will follow quickly on one another now, with a snowballing effect.

What will it all end in? Further triumphs? Or possibly the destruction of man by his own ambition? I think not. Man will survive, though possibly only in pockets here and there. There may be some great catastrophe – but not all mankind will perish. Some primitive community, rooted in simplicity, knowing of past doings only by hearsay, will slowly build up a civilisation once more.

IX

I don't remember in 1913 having any anticipation of war. Naval officers occasionally shook their heads and murmured '*Der Tag*', but we had been hearing that for years, and paid no attention. It served as a suitable basis for spy stories – it wasn't real. No nation could be so crazy as to fight another except on the N.W. frontier or some far away spot.

All the same, First Aid and Home Nursing classes were popular during 1913, and at the beginning of 1914. We all went to these, bandaged each other's legs and arms, and even attempted to do neat head-bandaging: much more difficult. We passed our exams, and got a small printed card to prove our success. So great was female enthusiasm at this time that if any man had an accident he was in mortal terror of ministerng women closing in on him.

'Don't let those First Aiders come near me!' the cry would rise. 'Don't touch me, girls. Don't *touch* me!'

There was one extremely snuffy old man amongst the examiners. With a diabolical smile he laid traps for us. 'Here is your patient,' he would say, pointing to a boy scout prostrate on the ground. 'Broken arm, fractured ankle, get busy on him.' An eager pair, I and another, swooped upon him and trotted out our bandages. We were good at bandaging – beautiful, neat bandages we had practised – carefully reversing as we went up a leg, so that the whole thing looked deliciously taut and tidy,

with a few figure-of-eights thrown in for good measure. In this case, however, we were taken aback – there was to be no neatness or beauty here: stuff was already bulkily wound round the limb. 'Field dressings,' said the old man. 'Put your bandages on top of them; you've nothing else to replace them by, remember.' We bandaged. It was much more difficult to bandage this way, making neat turns and twists. 'Get on with it,' said the old man. 'Use the figure-of-eight: you'll have to come to it in the end. No good trying to go by the text-books and reverse from top to bottom. You've got to keep the dressing *on*, girl, that's the point of it. Now then, the bed is through the hospital doors there.' We picked up our patient, having duly fixed, we hoped, the splints where splints should be fixed, and carried him to the bed.

Then we paused, slightly taken aback – neither of us had thought of opening up the bed clothes before arriving with the patient. The old man cackled with glee. 'Ha ha! Haven't thought of everything, have you, young ladies? Ha ha – always see your bed is ready for your patient before you start carrying him there.' I must say that, humiliated as he made us feel, that old man taught us a great deal more than we had learnt in six lectures.

Besides our text-books, there was some practical work arranged for us. Two mornings a week we were allowed to attend the local hospital in the out-patients ward. That was intimidating, because the regular nurses, who were in a hurry and had a lot to do, despised us thoroughly. My first job was to remove the dressing from a finger, prepare warm boracic and water for it, and soak the finger for the requisite time. That was easy. The next job was an ear that needed syringing, and that I was quickly forbidden to touch. Syringing an ear was a highly technical thing, said the Sister. Nobody unskilled should attempt it.

'Remember that. Don't think you're being useful by doing what you haven't learned to do. You might do a lot of harm.'

The next thing I had to do was to remove the dressings from the leg of a small child who had pulled over a boiling kettle on itself. That was the moment when I nearly gave up nursing for good. The bandages had, as I knew, to be soaked off gently in lukewarm water, and whatever way you did this, or touched them, the pain was agonising to the child. Poor little thing, she was only about three years old. She screamed and screamed: it was horrible. I felt so upset that I thought I was going to be sick then and there. The only thing that saved me was the sardonic gleam in

the eye of a staff nurse nearby. These stuck-up young fools, the eyes said, think they can come in here and know all about everything – and they can't manage the first thing they are asked to do. Immediately I determined that I *would* stick it. After all, it had *got* to be soaked off – not only the child had to bear her pain, but *I* had to bear her pain also. I went on with it, still feeling sick, setting my teeth, but managing it, and being as gentle as I could. I was quite taken aback when the staff nurse said suddenly to me: 'Not a bad job you've done there. Turned you up a bit at first, didn't it? It did me once.'

Another part of our education was a day with the District Nurse. Here again, two of us were taken on one day of the week. We went round a number of small cottages, all of them with windows tightly closed, some of them smelling of soap, others of something quite different – the yearning to throw open a window was sometimes almost irresistible. The ailments seemed rather monotonous. Practically everyone had what was tersely referred to as 'bad legs'. I was slightly hazy as to what bad legs were. The District Nurse said, 'Blood poisoning is very common – some the result of venereal disease, of course – some ulcers – bad blood all of it.' Anyway that was the generic name for it among the people themselves, and I understood much better in years to come when my daily help would always say, 'My mother's ill again.'

'Oh, what's the matter with her?'

'Oh, bad legs – she's always had bad legs.'

One day on our rounds we found one of the patients had died. The District Nurse and I laid out the body. Another experience. Not so heart-rending as scalded children, but unexpected if you had never done it before.

When, in far off Serbia, an archduke was assassinated, it seemed such a faraway incident – nothing that concerned us. After all, in the Balkans people were always being assassinated. That it should touch us here in England seemed quite incredible – and I speak here not only for myself but for almost everybody else. Swiftly, after that assassination, what seemed like incredible storm clouds appeared on the horizon. Extraordinary rumours got about, rumours of that fantastic thing – *War*! But of course that was only the newspapers, No civilised nations went to war. There hadn't been any wars for years; there probably never would be again.

No, the ordinary people, everyone in fact, apart from, I suppose, a few

senior Ministers and inner circles of the Foreign Office, had no conception that anything like war might happen. It was all rumours – people working themselves up and saying it really looked 'quite serious' – speeches by politicians. And then suddenly one morning *it had happened.*

England was at war.

PART V

WAR

I

England was at war. It had come.

I can hardly express the difference between our feelings then and now. Now we might be horrified, perhaps surprised, but not really astonished that war should come, because we are all conscious that war *does* come; that it has come in the past and that, at any moment, it might come again. But in 1914 there had been no war for – how long? Fifty years – more? True, there had been the 'Great Boer War', and skirmishes on the North-west Frontier, but those had not been wars involving one's own country – they had been large army exercises, as it were; the maintenance of power in far places. This was different – we were at war with Germany.

I received a wire from Archie: 'Come Salisbury if you can hope to see you.' The Flying Corps would be among the first to be mobilised.

'We *must* go,' I said to mother. 'We must.'

Without more ado we set off to the railway station. We had little money in hand; the banks were shut, there was a moratorium, and no means of getting money in the town. We got into the train, I remember, but whenever ticket collectors came, though we had three or four £5 notes that mother always kept by her, they refused them: nobody would take £5 notes. All over southern England, our names and addresses were taken by infinite numbers of ticket collectors. The trains were delayed and we had to change at various stations, but in the end we reached Salisbury that evening. We went to the County Hotel there. Half an hour after our arrival Archie came. We had little time together: he could

not even stay and dine. We had half an hour, no more. Then he said goodbye and left.

He was sure, as indeed all the Flying Corps was, that he would be killed, and that he would never see me again. He was calm and cheerful, as always, but all those early Flying Corps boys were of the opinion that a war would be the end, and quickly, of at least the first wave of them. The German Air Force was known to be powerful.

I knew less, but to me also it came with the same certainty that I was saying goodbye to him, I should never see him again, though I, too, tried to match his cheerfulness and apparent confidence. I remember going to bed that night and crying and crying until I thought I would never stop, and then, quite suddenly, without warning, falling exhausted into such a deep sleep that I did not wake till late the following morning.

We travelled back home, giving more names and addresses to ticket collectors. Three days later, the first war postcard arrived from France. It had printed sentences on it which anyone sending a card was only allowed to cross off or leave in: such things as AM WELL, AM IN HOSPITAL, and so on. I felt, when I got it, for all its meagre information, that it was a good omen.

I hurried to my detachment in the V.A.D.s to see that was going on. We made a lot of bandages and rolled them, prepared baskets full of swabs for hospitals. Some of the things we did were useful, far more of them were no use at all, but they passed the time, and soon – grimly soon – the first casualties began to arrive. A move was made to serve refreshments to the men as they arrived at the station. This, I must say, was one of the silliest ideas that any Commandant could possibly have had. The men had been heavily fed all the way along the line from Southampton, and when they finally arrived at Torquay station the main thing was to get them out of the train on to the stretchers and ambulances, and then to the hospital.

The competition to get into the hospital (converted from the Town Hall) and do some nursing had been great. For strictly nursing duties those chosen first had been mostly the middle-aged, and those considered to have had some experience of looking after men in illness. Young girls had not been felt suitable. Then there was a further consignment known as ward-maids, who did the house-work and cleaning of the Town Hall: brasses, floors, and such things; and finally there was the kitchen staff. Several people who did not want to nurse had applied for kitchen work; the ward-maids, on the other hand, were really a reserve force, waiting

eagerly to step up into nursing as soon as a vacancy should occur. There was a staff of about eight trained hospital nurses; all the rest were V.A.D.s.

Mrs Acton, a forceful lady, acted as Matron, since she was senior officer of the V.A.D.s. She was a good disciplinarian; she organised the whole thing remarkably well. The hospital was capable of taking over two hundred patients; and everyone was lined up to receive the first contingent of wounded men. The moment was not without its humour. Mrs Spragge, General Spragge's wife, the Mayoress, who had a fine presence, stepped forward to receive them, fell symbolically on her knees before the first entrant, a walking case, motioned him to sit down on his bed, and ceremonially removed his boots for him. The man, I must say, looked extremely surprised, especially as we soon found out that he was an epileptic, and not suffering from war wounds of any kind. Why the haughty lady should suddenly remove his boots in the middle of the afternoon was more than he could understand.

I got into the hospital, but only as a ward-maid, and set to zealously on the brass. However, after five days I was moved up to the ward. Many of the middle-aged ladies had done little real nursing at all, and though full of compassion and good works, had not appreciated the fact that nursing consists largely of things like bed-pans, urinals, scrubbing of mackintoshes, the clearing up of vomit, and the odour of suppurating wounds. Their idea of nursing had, I think, been a good deal of pillow-smoothing, and gently murmuring soothing words over our brave men. So the idealists gave up their tasks with alacrity: they had never thought they would have to do anything like *this*, they said. And hardy young girls were brought to the bedside in their places.

It was bewildering at first. The poor hospital nurses were driven nearly frantic by the number of willing but completely untrained volunteers under their orders. They had not got even a few fairly well-trained probationer nurses to help them. With another girl, I had two rows of twelve beds; we had an energetic Sister – Sister Bond – who, although a first-class nurse, was far from having patience with her unfortunate staff. We were not really unintelligent, but we were ignorant. We had been taught hardly anything of what was necessary for hospital service; in fact all we knew was how to bandage, and the general theories of nursing. The only things that did help us were the few instructions we had picked up from the District Nurse.

It was the mysteries of sterilisation that foxed us most – especially

as Sister Bond was too harassed even to explain. Drums of dressings came up, ready to be used in treatment on the wounds, and were given into our charge. We did not even know at this stage that kidney dishes were supposed to receive dirty dressings, and the round bowls pure articles. Also, as all the dressings looked extremely dirty, although actually surgically clean (they had been baked in the steriliser downstairs) it made it very puzzling. Things sorted themselves out, more or less, after a week. We discovered what was wanted of us, and were able to produce it. But Sister Bond by then had given up and left. She said her nerves wouldn't stand it.

A new Sister, Sister Anderson, came to replace her. Sister Bond had been a good nurse – quite first-class, I believe, as a surgical nurse. Sister Anderson was a first-class surgical nurse too, but she was also a woman of common sense and with a reasonable amount of patience. In her eyes we were not so much unintelligent as badly trained. She had four nurses under her on the two surgical rows, and she proceeded to get them into shape. It was Sister Anderson's habit to size up her nurses after a day or two, and to divide those whom she would take trouble to train and those who were, as she put, 'only fit to go and see if the crock is boiling'. The point of this latter remark was that at the end of the ward were about four enormous boiling urns. From these was taken boiling water for making fomentations. Practically all wounds were treated at that time with wrung-out fomentations, so seeing whether the crock was boiling was the first essential in the test. If the wretched girl who had been sent to 'see if the crock was boiling' reported that it was, and it was not, with enormous scorn Sister Anderson would demand: 'Don't you even know when water is boiling, Nurse?'

'It's got some steam puffing out of it,' said the nurse.

'*That's* not steam,' said Sister Anderson. 'Can't you hear the sound of it? The singing sound comes first, then it quietens down and doesn't puff, and *then* the real steam comes out.' She demonstrated, murmuring to herself as she moved away, 'If they send me any more fools like that I don't know what I shall do!'

I was lucky to be under Sister Anderson. She was severe but just. On the next two rows there was Sister Stubbs, a small sister, gay and pleasant to the girls, who often called them 'dear' and, having lured them into false security, lost her temper with them vehemently if anything went wrong. It was like having a bad-tempered kitten in charge of you: it may play with you, or it may scratch you.

From the beginning I enjoyed nursing. I took to it easily, and found it, and have always found it, one of the most rewarding professions that anyone can follow. I think, if I had not married, that after the war I should have trained as a real hospital nurse. Maybe there is something in heredity. My grandfather's first wife, my American grandmother, was a hospital nurse.

On entering the nursing world we had to revise our opinions of our status in life, and our present position in the hierarchy of the hospital world. Doctors had always been taken for granted. You sent for them when you were ill, and more or less did what they told you – except my mother: she always knew a great deal more than the doctor did, or so we used to tell her. The doctor was usually a friend of the family. Nothing had prepared me for the need to fall down and worship.

'Nurse, towels for the doctor's hands!'

I soon learned to spring to attention, to stand, a human towel-rail, waiting meekly while the doctor bathed his hands, wiped them with the towel, and, not bothering to return it to me, flung it scornfully on the floor. Even those doctors who were, by secret nursing opinion, despised as below standard, in the ward now came into their own and were accorded a veneration more appropriate to higher beings.

Actually to speak to a doctor, to show him that you recognised him in any way, was horribly presumptuous. Even though he might be a close friend of yours, you were not supposed to show it. This strict etiquette was mastered in due course, but once or twice I fell from grace· On one occasion a doctor, irritable as doctors always are in hospital life – not, I think because they feel irritable but because it is expected of them by the sisters – exclaimed impatiently, 'No, no, Sister, I don't want that kind of forceps. Give me . . .' I've forgotten the name of it now, but, as it happened, I had one in my tray and I proffered it. I did not hear the last of *that* for twenty-four hours.

'Really, Nurse, pushing yourself forward in that way. Actually handing the forceps to Doctor *yourself*!'

'I'm so sorry, Sister,' I murmured submissively. 'What ought I to have done?'

'Really, Nurse, I think you should know that by now. If Doctor requires anything which you happen to be able to provide, you naturally hand it to me, and *I* hand it to Doctor.'

I assured her that I would not transgress again.

The flight of the more elderly would-be nurses was accelerated by the

fact that our early cases came in straight from the trenches with field dressings on, and their heads full of lice. Most of the ladies of Torquay had never seen a louse – I had never seen one myself – and the shock of finding these dreadful vermin was far too much for the older dears. The young and tough, however, took it in their stride. It was usual for one of us to say to the other in a gleeful tone when the next one came on duty, 'I've done all my heads,' waving one's little tooth comb triumphantly.

We had a case of tetanus in our first batch of patients. That was our first death. It was a shock to us all. But in about three weeks' time I felt as though I had been nursing soldiers all my life, and in a month or so I was quite adept at looking out for their various tricks.

'Johnson, what have you been writing on your board?' Their boards, with the temperature charts pinned on them, hung on the bottom of the bed.

'Writing on my board, Nurse?' he said, with an air of injured innocence. 'Why nothing. What should I?'

'Somebody seems to have written down a very peculiar diet. I don't think it was Sister or Doctor. Most unlikely they would order you port wine.'

Then I would find a groaning man saying, 'I think I'm very ill, Nurse. I'm sure I am – I feel feverish.'

I looked at his healthy though rubicund face and then at his thermometer, which he held out to me, and which read between 104 and 105.

'Those radiators are very useful, aren't they?' I said. 'But be careful: if you put it on *too* hot a radiator the mercury will go completely.'

'Ah, Nurse,' he grinned, 'you don't fall for that, do you? You young ones are much more hard-hearted than the old ones were. They used to get in no end of a paddy when we had temperatures of 104; they used to rush off to Sister at once.'

'You should be ashamed of yourself.'

'Ah, Nurse, it's all a bit of fun.'

Occasionally they had to go to the X-ray department, at the other end of the town, or for physiotherapy there. Then one used to have a convoy of six to look after, and one had to watch out for a sudden request to cross the road 'because I've got to buy a pair of bootlaces, Nurse'. You would look across the road and see that the bootshop was conveniently placed next to *The George and Dragon*. However, I always managed to bring back my six, without one of them giving me the slip and turning up later in a state of exhilaration. They were terribly nice, all of them.

There was one Scotsman whose letters I used to have to write. It seemed astonishing that he should not be able to read or write, since he was practically the most intelligent man in the ward. However, there it was, and I duly wrote letters to his father. To begin with, he sat back and waited for me to begin. 'We'll write to my father now, Nurse,' he commanded.

'Yes. "Dear Father,"' I began. 'What do I say next?'

'Och, just say anything you think he'd like to hear.'

'Well – I think you had better tell me exactly.'

'I'm sure you know.'

But I insisted that some indication should be given me. Various facts were then revealed: about the hospital he was in, the food he had, and so on. He paused. 'I think that's all—'

'"With love from your affectionate son,"?' I suggested.

He looked deeply shocked.

'No, indeed, Nurse. You know better than *that*, I hope.'

'What have I done wrong?'

'You should say "From your respectful son." We won't mention *love* or *affection* or words like that – not to my father.'

I stood corrected.

The first time I had to accompany an operation case into the theatre I disgraced myself. Suddenly the theatre walls reeled about me, and only another nurse's firm arm closing round my shoulders and ejecting me rapidly saved me from disaster. It had never occurred to me that the sight of blood or wounds would make me faint. I hardly dared face Sister Anderson when she came out later. She was, however, unexpectedly kind. 'You mustn't mind, Nurse,' she said. 'It happened to many of us the first time or so. For one thing you are not prepared for the heat and the ether together; it makes you feel a bit squeamish – and that was a bad abdominal operation, and they are the most unpleasant to look at.'

'Oh Sister, do you think I shall be all right next time?'

'You'll have to try and be all right next time. And if not you'll have to go on until you are. Is that right?'

'Yes,' I said, 'that's right.'

The next one she sent me into was quite a short one, and I survived. After that I never had any trouble, though I used sometimes to turn my eyes away from the original incision with the knife. That was the thing that upset me – once it was over I could look on quite calmly and be interested. The truth of it is one gets used to anything.

II

'I think it so wrong, dear Agatha,' said one of my mother's elderly friends, 'that you should go and work in hospital on a *Sunday*. Sunday is the day of rest. You should have your Sundays off.'

'How do you suppose the men would have their wounds dressed, get themselves washed, be given bed-pans, have their beds made and get their teas if nobody worked on a Sunday?' I asked. 'After all, they couldn't do without all those things for twenty-four hours, could they?'

'Oh dear, I never thought of that. But there ought to be *some* arrangement.'

Three days before Christmas Archie suddenly got leave. I went up with my mother to London to meet him. It was in my mind, I think, that we might get married. A good many people were doing so now.

'I don't see,' I said, 'how we can go on being careful and thinking of the future with everyone getting killed like this.'

My mother agreed. 'No,' she said. 'I should feel just as *you* do. One can't think of risks and things like that.'

We did not say so, but the probabilities of Archie's being killed were fairly high. Already the casualties had startled and surprised people. A lot of my own friends had been soldiers, and had been called up at once. Every day, it seemed, one read in the paper that somebody one knew had been killed.

It was only three months since Archie and I had seen each other, yet those three months had been, I suppose, acted out in what might have been called a different dimension of time. In that short period I had lived through an entirely new kind of experience: the death of my friends, uncertainty, the background of life being altered. Archie had had an equal amount of new experience, though in a different field. He had been in the middle of death, defeat, retreat, fear. Both of us had lived a large tract on our own. The result of it was that we met almost as strangers.

It was like learning to know each other all over again. The difference between us showed up at once. His own determined casualness and flippancy – almost gaiety – upset me. I was too young then to appreciate that that was for him the best way of facing his new life. I, on the other

hand, had become far more earnest, emotional, and had put aside my own light flippancy of happy girlhood. It was as though we were trying to reach each other, and finding, almost with dismay, that we had forgotten how to do so.

Archie was determined on one thing – he made that clear from the first: there was no question of marriage. 'Entirely the wrong thing to do,' he said. 'All my friends think so. Just rushing into things, and then what happens? You stop one, you've had it, and you've left behind a young widow, perhaps a child coming – it's selfish and wrong.'

I didn't agree with him. I argued passionately on the other side. But one of Archie's characteristics was certainty. He was always sure of what he ought to do and what he was going to do. I don't mean that he never changed his mind – he could, and did, suddenly, and very quickly sometimes. In fact he could change right over, seeing black as white and white as black. But when he had done so he was just as sure about it. I accepted his decision and we set about enjoying those precious few days we would have together.

The plan was that after a couple of days in London I should go down with him to Clifton, and spend the actual days of Christmas with him at his stepfather's and mother's house. That seemed a very right and proper arrangement. Before leaving for Clifton, however, we had what was to all intents and purposes a quarrel. A ridiculous quarrel, but quite a heated one.

Archie arrived at the hotel on the morning of our departure for Clifton, with a present for me. It was a magnificent dressing-case, completely fitted inside, and a thing that any millionairess might have confidently taken to the Ritz. If he had brought a ring, or a bracelet, however expensive, I should not have demurred – I should have accepted it with eager pride and pleasure – but for some reason I revolted violently against the dressing-case. I felt it was an absurd extravagance, and not a thing I should ever use. What was the good of my going back home to continue nursing in a hospital with an exciting dressing-case suitable for a holiday in peacetime abroad? I said I didn't want it, and he would have to take it back. He was angry; I was angry. I made him take it away. An hour later he returned and we made it up. We wondered what on earth had come over us. How could we be so foolish? He admitted that it was a silly kind of present. I admitted that I had been ungracious to say so. As a result of the quarrel and the subsequent reconciliation we somehow felt closer than before.

My mother went back to Devon, and Archie and I travelled to Clifton. My future mother-in-law continued to be charming in a rather excessive Irish style. Her other son, Campbell, said to me once, 'Mother is a very dangerous woman.' I didn't understand at the time, but I think I know now what he meant. Hers was the kind of gushing affection which could change just as rapidly into its opposite. At one moment she wished to love her future daughter-in-law, and did so; at another moment nothing would be too bad for her.

We had a tiring journey to Bristol: the trains were in a state of chaos still, and usually hours late. Eventually, though, we arrived, and had a most affectionate welcome. I went to bed, exhausted by the emotions of the day and travelling, and also by contending with my natural shyness, so that I could say and do the right thing with my future in-laws.

It must have been half an hour later; perhaps an hour. I had gone to bed, but was not yet asleep, when there was a tap at the door. I went and opened it. It was Archie. He came inside, shut the door behind, and said abruptly: 'I've changed my mind. We've got to get married. At once. We will marry tomorrow.'

'But you said . . .'

'Oh, never mind what I said. You were right and I was wrong. Of course it is the only sensible thing to do. We'll have two days together before I go back.'

I sat down on the bed, my legs feeling rather weak. 'But – but you were so *certain*.'

'What *does* that matter? I've changed my mind.'

'Yes, but – ' there was so much that I could not bring out. I had always suffered from being tongue-tied when I most wanted to say things clearly.

'It's going to be all so difficult,' I said weakly. I could always see what Archie could not: the hundred and one disadvantages in a prospective action. Archie only saw the essential itself. At first it had seemed to him absolute folly to get married in the middle of wartime; now, a day later, he was equally determined that it was the only right thing for us to do. Difficulties in the actual accomplishment, the upset feelings of all our nearest relations, made no impact on him at all. We argued. We argued much as we had done twenty-four hours before, this time the opposite way round. Needless to say, again he won.

'But I don't believe we can get married so suddenly,' I said doubtfully.

'It's so difficult.'

'Oh yes we can,' said Archie cheerfully. 'We can get a special licence or something – the Archbishop of Canterbury.'

'Isn't that very expensive?'

'Yes, I believe it is, rather. But I expect we'll manage. Anyway, we've got to. No time for anything else. Tomorrow is Christmas Eve. So that's all right?'

I said weakly that it was. He left me, and I stayed awake most of the night worrying. What would mother say? What would Madge say? What would Archie's mother say? Why couldn't Archie have agreed to our marriage in London, where everything would have been easy and simple. Oh well, there it was. I finally fell asleep exhausted.

A great many of the things that I had foreseen came true the next morning. First of all our plans had to be broken to Peg. She immediately burst into hysterical tears, and retired to bed.

'That my own son should do this to me,' she gasped, as she went up the stairs.

'Archie,' I said, 'we'd better not. It's upset your mother terribly.'

'What do I care if it's upset her or not?' said Archie. 'We've been engaged for two years, she must be used to the idea.'

'She seems to feel it terribly now.'

'Rushing it on me in this way,' Peg sobbed, as she lay in a darkened room with a handkerchief soaked in eau-de-Cologne on her forehead. Archie and I looked at each other, rather like two guilty dogs. Archie's stepfather came to the rescue. He brought us down from Peg's room and said to us: 'I think you two are doing quite the right thing. Now don't worry about Peg. She always gets upset if she's startled. She is very fond of you, Agatha, and she will be pleased as anything about this afterwards. But don't expect her to be pleased *today*. Now you two go out and get on with your plans. I daresay you haven't got too much time. Remember, I am sure, quite sure, that you are doing the right thing.'

Though I had started the day faintly tearful and apprehensive myself, within another two hours I was full of fighting spirit. The difficulties in the way of our marriage were intense, and the more it seemed impossible that we could be married that day the more I, as well as Archie, became determined that we *would* be.

Archie first consulted a former ecclesiastical headmaster of his. A special licence was said to be obtainable from Doctor's Commons and cost £25. Neither Archie nor I had £25, but that we brushed aside, as we could no doubt borrow it. What was more difficult was that it had to be obtained

personally. One could not get such a thing on Christmas Day, so in the end a marriage that day appeared quite impossible. Special Licence was out. We next went to a registry office. There again we were rebuffed. Notice had to be given for a period of fourteen days before the ceremony could be performed. Time slipped away. Finally a kindly registrar, whom we had not seen before, back from his elevenses, came up with the answer. 'My dear chap,' he said to Archie, 'you *live* here, don't you? I mean, your mother and stepfather reside here?'

'Yes,' said Archie.

'Well then, you keep a bag here, you keep clothes here, you keep some of your effects here, don't you?'

'Yes.'

'Then you don't *need* a fortnight's notice. You can buy an ordinary licence and get married at your parish Church this afternoon.'

The licence cost £8. We could manage £8. After that it was a wild rush.

We hunted down the Vicar at the church at the end of the road. He was not in. We found him in a friend's house. Startled, he agreed to perform the ceremony. We rushed home to Peg, and to snatch a little sustenance. 'Don't speak to me,' she cried. 'Don't speak to me,' and locked her door.

There was no time to be lost. We hurried along to the church, Emmanuel, I think it was called. Then we found we had to have a second witness. Just about to rush out and catch a complete stranger, by utter chance I came across a girl whom I knew. I had stayed with her in Clifton a couple of years before. Yvonne Bush, though startled, was ready enough to be an impromptu bridesmaid and our witness. We rushed back. The organist was doing some practising, and offered to play the Wedding March.

Just as the ceremony was about to start, I thought for one sad moment that no bride could have taken less trouble about her appearance. No white dress, no veil, not even a smart frock. I was wearing an ordinary coat and skirt with a small purple velvet hat, and I had not even had time to wash my hands or face. It made us both laugh.

The ceremony was duly performed – and we tackled the next hurdle. Since Peg was still prostrated we decided we would go down to Torquay, stay at the Grand Hotel there, and spend Christmas Day with my mother. But I had first, of course, to ring her up and announce what had happened. It was extremely difficult to get through on the telephone, and the result

was not particularly happy. My sister was staying there and greeted my announcement with a great deal of annoyance.

'Springing it like this on mother! You know how weak her heart is! You are absolutely unfeeling!'

We caught the train – it was very crowded – and we arrived at last at Torquay at midnight, having managed to book ourselves a room by telephone. I still had a slightly guilty feeling: we had caused such a lot of trouble and inconvenience. Everybody we were most fond of was annoyed with us. I felt this but I don't think Archie did. I don't think it occurred to him for one moment; and if it did, I don't think he minded. A pity that everyone got upset and all that, he would have said, but why should they? Anyway, we had done the right thing – he was sure of that. But there was *one* thing that made him nervous. The moment had come. We climbed on the train, and he suddenly produced, rather like a conjuror, an extra suitcase. 'I hope,' he said nervously to his new young bride, 'I hope that you are not going to be cross about this.'

'Archie! *It's the dressing-case!*'

'Yes. I didn't take it back. You don't mind, do you?'

'Of course I don't mind. It's lovely to have it.'

There we were, going on a journey with it – and our wedding journey too. So that was got over safely, and Archie was enormously relieved: I think he thought that I was going to be angry about it.

If our wedding day had been one long struggle against odds, and a series of crises, Christmas Day was benign and peaceful. Everyone had had time to get over their shock. Madge was affectionate, had forgotten all censure; my mother had recovered from her heart condition and was thoroughly happy in our happiness. Peg, I hoped, had recovered. (Archie assured me that she would have.) And so we enjoyed Christmas Day very much.

The next day I travelled with Archie to London, and said goodbye to him as he went off to France again. I was not to see him for another six months of war.

I resumed work at the hospital, where news of my present status had preceded me.

'Nurrrse!' This was Scottie, rolling his r's a great deal and tapping on the foot of his bed with his little cane. 'Nurrrse, come here at once!' I came. 'What's this I hear? You've been getting yourself married?'

'Yes,' I said, 'I have.'

'D'ye hear that?' Scottie appealed to the whole row of beds. 'Nurse Miller's got married. What's your name now, Nurse?'

'Christie.'

'Ah, a good Scottish name, Christie. Nurse Christie – d'ye hear that, Sister? This is Nurse Christie now.'

'I heard,' said Sister Anderson. 'And I wish you every happiness,' she added formally. 'It's made plenty of talk in the ward.'

'You've done well for yourself, Nurse,' said another patient. 'You've married an officer, I hear?' I admitted that I had risen to that giddy height. 'Aye, you've done very well for yourself. Not that I'm surprised – you're a nice-looking girl.'

The months went on. The war settled down to a grisly stalemate. Half our patients seemed to be trench feet cases. It was intensely cold that winter, and I had terrible chilblains on both hands and feet. The eternal scrubbing of mackintoshes is not helpful to chilblains on the hands. I was given more responsibility as time went on, and I liked my work. One settled into a routine of doctors and nurses. One knew the surgeons one respected; one knew the doctors who were secretly despised by the Sisters. There were no more heads to delouse and no more field dressings; base hospitals were now established in France. But still we were nearly always crowded. Our little Scotsman who had been there with a fractured leg left at last, convalescent. Actually he had a fall on the station platform during the journey, but so anxious was he to get to his native town in Scotland that he never mentioned it and concealed the fact that his leg had been re-fractured. He suffered agonies of pain, but finally managed to arrive at his destination, and his leg had to be reset all over again.

It is all somewhat of a haze now, yet one recalls odd instances standing out in one's memory. I remember a young probationer who had been assisting in the theatre and had been left behind to clear up, and I had helped her take an amputated leg down to throw into the furnace. It was almost too much for the child. Then we cleared up all the mess and the blood together. She was, I think, too young and too new to it to have been given that task to do alone so soon.

I remember a serious-faced sergeant whose love letters I had to write for him. He could not read or write. He told me roughly what he wanted me to say. 'That will do very nicely, Nurse,' he would nod, when I read it over to him. 'Write it in triplicate, will you.'

'In triplicate?' I said.

'Ay,' he said. 'One for Nellie, and one for Jessie and one for Margaret.'

'Wouldn't it be better to vary them a little?' I asked. He considered. 'I don't think so,' he said. 'I've told them all the essentials.' So each letter began the same: 'Hope this finds you as it leaves me, but more in the pink' – and ended: 'Yours till Hell freezes.'

'Won't they find out about each other?' I asked with some curiosity.

'Och, I don't think so,' he said. 'They're in different towns, you see, and they don't know each other.'

I asked if he was thinking of marrying any of them.

'I might,' he said, 'and I might not. Nellie, she is a fine one to look at, a lovely girl. But Jessie, she's more serious, and she worships me – she thinks the world of me, Jessie does.'

'And Margaret?'

'Margaret? Well, Margaret,' he said, 'she makes you laugh, Margaret does – she's a gay girl. However, we'll see.'

I have often wondered whether he did marry any of those three, or whether he found a fourth who combined good looks, being a good listener and being gay as well.

At home things went on much the same. Lucy had come as a replacement to Jane, and always spoke of her in awe as 'Mrs Rowe': 'I do hope I shall be able to fill Mrs Rowe's place – it's such a big responsibility taking on after her.' She was dedicated to the future of coming to be cook to me and Archie after the war.

One day she came to my mother, looking very nervous, and said: 'I hope you won't mind, Ma'am, but I really feel I *must* go and join the WAAFs. I hope you won't think it wrong of me.'

'Well, Lucy,' said my mother, 'I think you are quite right. You are a young, strong girl: just what they want.'

So Lucy departed, in tears at the last, hoping we would get on all right without her and saying she didn't know *what* Mrs Rowe would think. With her, also, went the house-parlourmaid, the beautiful Emma. She went to get married. They were replaced by two elderly maid-servants to whom the hardships of wartime were unbelievable and deeply resented.

'I'm sorry, Madam,' said the elderly Mary, trembling with rage, after a couple of days, 'but it's not right, the food we're given. We've had fish two days this week, and we've had insides of animals. I've always had a good meat meal at least once a day.' My mother tried to explain that food was now rationed and that one had to eat fish and what was prettily called

'edible offal' on at least two or three days of the week. Mary merely shook her head, and said, 'It isn't *right*, it isn't treating one *right*.' She also said that she had never been asked to eat margarine before. My mother then tried the trick which many people tried during the war, of wrapping the margarine in the butter paper and the butter in the margarine paper.

'Now if you taste these two,' she said, 'I don't believe you'll be able to tell margarine from butter.'

The two old pussies looked scornful, then tried and tested. They had no doubts: 'It's absolutely plain which is which, Ma'am, no doubt about it.'

'You really think there is so much difference?'

'Yes, I do. I can't bear the taste of margarine – neither of us can. It makes us feel quite sick.' They handed it back to my mother with disgust.

'You do like the other?'

'Yes, Ma'am, very good butter. No fault to find with *that*.'

'Well, I might as well tell you,' said my mother, 'that *that* is the margarine; this is the butter.'

At first they wouldn't believe it. Then when they were convinced they were not pleased.

My grandmother was now living with us. She used to fret a great deal at my returning alone to the hospital at night.

'So dangerous, dear, walking home by yourself. Anything might happen. You must make some other arrangement.'

'I don't see what other arrangement I could make, Grannie. And anyway, nothing has happened to me. I've been doing it for several months.'

'It's not right. Somebody might speak to you.'

I reassured her as best I could. My hours of duty were two o'clock till ten, and it was usually about half-past ten before I left the hospital after the night shift had come on. It took about three-quarters of an hour to walk home, along, it must be admitted, fairly lonely roads. However, I never had any trouble. I once met a very drunken sergeant, but he was only too anxious to be gallant. 'Fine work you're doing,' he said, staggering slightly as he walked. 'Fine work you're doing at the hospital. I'll see you home, Nurse. I'll see you home because I wouldn't like anything to happen to you.' I told him that there was no need but that it was kind of him. Still home with me he duly tramped, saying goodbye in a most respectful manner at our gate.

I forget exactly when it was that my grandmother came to live with us.

Shortly after the outbreak of the war, I imagine. She had become very blind indeed with cataract, and she was, of course, too old to be operated on. She was a sensible woman, so though it was a terrible wrench for her to give up her house in Ealing and her friends and all the rest of it, she saw plainly that she would be helpless living there alone and that servants were unlikely to stay. So the great move had been made. My sister came down to help my mother, I came up from Devon, and we all became busy. I don't think I realised in the least at the time what poor Grannie suffered, but now I have a clear picture of her sitting helpless and half blind in the middle of her possessions and everything that she prized, while all round her were three vandals, rummaging in things, turning things out, deciding what to do away with. Little sad cries rose from her: 'Oh, you're *not* going to throw away that dress; Madame Poncereau's, my beautiful velvet.' Difficult to explain to her that the velvet was moth-eaten, and that the silk had disintegrated. There were trunkfuls and drawers full of things eaten by moth, their usefulness ended. Because of her worry, many things were kept which ought to have been destroyed. Trunk after trunk, filled with papers, needle-books, lengths of print for servants' dresses, lengths of silk and velvet bought at sales, remnants: so many many things that at one time could have been useful if they had been used, but which had simply piled up. Poor Grannie sat in her large chair and wept.

Then, after the clothes, her store-room was attacked. Jams that had gone mouldy, plums that had fermented, even packets of butter and sugar which had slipped down behind things and been nibbled by mice: all the things of her thrifty and provident life, all the things that had been bought and stored and saved for the future; and now, here they were, vast monuments of *waste*! I think that is what hurt her so much: the *waste*. Here were her home-made liqueurs – they at least, owing to the saving quality of alcohol, were in good condition. Thirty-six demijohns of cherry brandy, cherry gin, damson gin, damson brandy and the rest of it, went off in the furniture van. On arrival there were only thirty-one. 'And to think,' said Grannie, 'those men said they were all teetotallers!'

Perhaps the removers were taking their revenge: they had got little sympathy from my grandmother in moving things. When they wished to take the drawers out of the vast mahogany tallboy chests of drawers, Grannie was scornful. 'Take the drawers *out*? Why? The *weight*! You're three strong men, aren't you? Men carried them up these stairs full of things. Nothing was taken out then. The idea! Men aren't worth anything

at all nowadays.' The men pleaded they couldn't manage it. 'Weaklings,' said Grannie, giving in at last. 'Absolute weaklings. Not a man worth his salt nowadays.' The cases included comestibles purchased to save Grannie from starvation. The only thing that cheered her when we arrived at Ashfield was devising good hiding places for them. Two dozen tins of sardines were laid flat on top of a Chippendale escritoire. There they remained, some of them to be entirely forgotten – so much so that when my mother, after the war, was selling a piece of furniture, the man who came to fetch it away said with an apologetic cough: 'I think there is a large amount of sardines on the top of this.'

'Oh really,' said my mother. 'Yes, I suppose there *might* be.' She did not explain. The man did not ask. The sardines were removed. 'I suppose,' said mother, 'we'd better have a look on top of some of the other pieces of furniture.'

Things like sardines and bags of flour seemed to turn up in the most unexpected places for many years to come. A disused clothes-basket in the spare-room was full of flour, slightly weevily. The hams, at any rate, had been eaten in good condition. Jars of honey, bottles of French plums, and some, but not many, tinned goods were liable to be found – though Grannie disapproved of tinned goods, and suspected them of being a source of ptomaine poisoning. Only her own preserving in bottles and jars was felt by her to be a properly safe conserve.

Indeed, tinned food was regarded with disapproval by all in the days of my girlhood. All girls were warned when they went to dances: 'Be very careful you don't eat lobster for supper. You never know, *it may be tinned*!' – the word 'tinned' being spoken with horror. Tinned crab was such a terrible commodity as not even to need warning against. If anyone then could have envisaged a time where one's main nourishment was frozen food and tinned vegetables, with what apprehension and gloom it would have been regarded.

In spite of affection and willing service, how little I sympathised with my poor grandmother's sufferings. Even when technically unselfish, one is still so self-centred. It must have been, I see now, a terrible thing for my poor grandmother, by then, I suppose, well over eighty, to uproot herself from a house where she had lived for thirty or forty years, having gone there only a short time after her widowhood. Not so much perhaps leaving the house itself – that must have been bad enough, although her personal furniture came with her: the large four-poster bed, the two big chairs that she liked to sit in. But worse than anything was the loss of all

her friends. Many had died, but there were still a good many left: neighbours who came in often, people with whom to gossip over old days, or to discuss the news in the daily papers – all the horrors of infanticide, rape, secret vice and all the things that cheer the lives of the old. It is true that we read the papers to Grannie every day but we were not really interested in the horrible fate of a nursemaid, a baby abandoned in her perambulator, a young girl assaulted in a train. World affairs, politics, moral welfare, education, the topics of the day – none of these really interested my grandmother in the least; not because she was a stupid woman, nor because she revelled in disaster; it was rather that she needed something that contradicted the even tenor of everyday life: some drama, some terrible happenings, which, although she herself was shielded from them, were occurring perhaps not too far away.

My poor grandmother had nothing exciting now in her life except the disasters which she had read to her from the daily papers. She could no longer have a friend drop in with sad news of the awful behaviour of Colonel So-and-So to his wife, or the interesting disease from which a cousin suffered and for which no doctor had yet been able to find a cure. I see now how sad it was for her, how lonely, and how dull. I wish I had been more understanding.

She got up slowly in the morning after breakfast in bed. She came down about eleven and looked hopefully for someone who might have time to read the papers to her. Since she did not come down at a fixed time this was not always possible. She was patient, she sat in her chair. For a year or two she was still able to knit, because for knitting she did not have to see well; but as her eyesight grew worse she had to knit coarser and coarser types of garments, and even there she would drop a stitch and not know it. Sometimes one would find her weeping quietly in her armchair because she had dropped a stitch several rows back and it had all to be pulled out. I used to do it for her, pick it up and knit it up for her so that she could go on from where she had left off; but that did not really heal the sorrowful hurt that she was no longer able to be useful.

She could seldom be persuaded to go out for a little walk on the terrace, or anything like that. Outside air she considered definitely harmful. She sat in the dining-room all day because she had always sat in the dining-room in her own house. She would come and join us for afternoon tea, but then she would go back again. Yet sometimes, especially if we had a party of young people in for supper, when we went up to the schoolroom afterwards, suddenly Grannie would appear, creeping slowly and with

difficulty up the stairs. On these occasions she did not want, as usual, to go to an early bed: she wanted to be *in* it, to hear what was going on, to share our gaiety and laughter. I suppose I wished she wouldn't come. Although she wasn't actually deaf, a good many things had to be repeated to her, and it placed a slight constraint over the company. But I am glad at least that we never discouraged her from coming up. It was sad for poor Grannie, and yet it was inevitable. The trouble with her, as with so many old people, was the loss of her independence. I think it is the sense of being a dispaced person that makes so many elderly people indulge in the illusion that they are being poisoned or their belongings stolen. I don't think really it is a weakening of the mental faculties – it is an excitement that they need, a kind of stimulant: life would be more interesting if someone *were* trying to poison you. Little by little Grannie began to indulge in these fancies. She assured my mother that the servants were 'putting things in my food'. 'They want to get rid of me!'

'But Auntie dear, why should they want to get rid of you? They like you very much.'

'Ah, that's what you think, Clara. But – come a little nearer: they are always listening at doors, that I *know*. My egg yesterday – scrambled egg it was. It tasted very peculiar – *metallic*. I know!' she nodded her head. 'Old Mrs Wyatt, you know, *she* was poisoned by the butler and his wife.'

'Yes dear, but that was because she had left them a lot of money. You haven't left any of the servants any money.'

'No fear,' said Grannie. 'Anyway, Clara, in future I want a boiled egg only for my breakfast. If I have a boiled egg they can't tamper with that.' So a boiled egg Grannie had.

The next thing was the sad disappearance of her jewellery. This was heralded by her sending for me. 'Agatha? Is that you? Come in, and *shut the door*, dear.'

I came up to the bed. 'Yes, Grannie, what is the matter?' She was sitting on her bed crying, her handkerchief to her eyes. 'It's gone,' she said. 'It's all gone. My emeralds, my two rings, my beautiful ear-rings – *all gone!* Oh dear!'

'Now look, Grannie, I'm sure that they haven't really gone. Let's see, where were they.'

'They were in that drawer – the top drawer on the left – wrapped up in a pair of mittens. That's where I always keep them.'

'Well, let's see, shall we?' I went across to the dressing-table, and looked through the drawer in question. There were two pairs of mittens

rolled up in balls, but nothing inside them. I transferred my attention to the drawer below. There was a pair of mittens in there, with a hard satisfactory feeling to them. I brought them over to the foot of the bed, and assured Grannie that here they were – the ear-rings, the emerald brooch, and her two rings.

'It was in the third drawer down instead of the second.' I explained.

'They must have put them back.'

'I don't think they could have managed that,' I said.

'Well, you be careful, Agatha dear. Very careful. Don't leave your bag lying about. Now tiptoe over to the door, will you, and see if they are listening.'

I obeyed and assured Grannie that nobody was listening.

How terrible it is, I thought, to be old! It was a thing, of course, that would happen to me, but it did not seem real. Strong in one's mind is always the conviction: '*I* shall not be old. *I* shall not die.' You know you will, but at the same time you are sure you won't. Well, now I *am* old. I have not yet begun to suspect that my jewellery is stolen, or that anyone is poisoning me, but I must brace myself and know that that too will probably come in time. Perhaps by being forewarned I shall know that I am making a fool of myself before it does begin to happen.

One day Grannie thought that she heard a cat, somewhere near the back stairs. Even if it *had* been a cat, it would have been more sensible either to leave it there or to mention it to one of the maids, or to me, or to mother. But Grannie had to go and investigate herself – with the result that she fell down the back stairs and fractured her arm. The doctor was doubtful when he set it. He hoped, he said, it would knit again all right, but at her age – over eighty . . . However, Grannie rose triumphantly to the occasion. She could use her arm quite well in due course, though she was not able to lift it high above her head. No doubt about it, she was a tough old lady. The stories she always told me of her extreme delicacy in youth, and the fact that the doctors despaired of her life on several occasions between the ages of fifteen and thirty-five were, I feel sure, quite untrue. They were a Victorian assertion of interesting illness.

What with ministering to Grannie, and late hours on duty in the hospital, life was fairly full.

In the summer Archie got three days' leave, and I met him in London. It was not a very happy leave. He was on edge, nervy, and full of knowledge of the conditions of the war which must have been causing everyone anxiety. The big casualties were beginning to come in, though it had not

yet dawned upon us in England that, far from being over by Christmas, the war would in all probability last for four years. Indeed, when the demand came out for conscription – Lord Derby's three years or for the duration – it seemed ridiculous to contemplate as much as three years.

Archie never mentioned the war or his part in it: his one idea in those days was to forget such things. We had as pleasant meals as we could procure – the rationing system was much fairer in the first war than in the second. Then, whether you dined in a restaurant or at home, you had to produce your meat coupons etc. if you wanted a meat meal. In the second war the position was much more unethical: if you cared, and had the money, you could eat a meat meal every day of the week by going to a restaurant, where no coupons were required at all.

Our three days passed in an uneasy flash. We both longed to make plans for the future, but both felt it was better not. The one bright spot for me was that shortly after that leave Archie was no longer flying. His sinus condition not permitting such work, he was instead put in charge of a depot. He was always an excellent organiser and administrator. He had been mentioned several times in despatches, and was finally awarded the C.M.G., as well as the D.S.O. But the one award he was always most proud of was the first issued: being mentioned in despatches by General French, right at the beginning. That, he said, was really worth something. He was also awarded a Russian decoration – the order of St. Stanislaus – which was so beautiful that I would have liked to have worn it myself as a decoration at parties.

Later that year I had flu badly, and after it congestion of the lungs which rendered me unable to go back to the hospital for three weeks or a month. When I did go back a new department had been opened – the dispensary – and it was suggested that I might work there. It was to be my home from home for the next two years.

The new department was in the charge of Mrs Ellis, wife of Dr Ellis, who had dispensed for her husband for many years, and my friend Eileen Morris. I was to assist them, and study for my Apothecary's Hall examination, which would enable me to dispense for a medical officer or a chemist. It sounded interesting, and the hours were much better – the dispensary closed down at six o'clock and I would be on duty alternate mornings and afternoons – so it would combine better with my home duties as well.

I can't say I enjoyed dispensing as much as nursing. I think I had a

real vocation for nursing, and would have been happy as a hospital nurse. Dispensing was interesting for a time, but became monotonous – I should never have cared to do it as a permanent job. On the other hand, it was fun being with my friends. I had great affection and an enormous respect for Mrs Ellis. She was one of the quietest and calmest women I had ever known, with a gentle, rather sleepy voice and a most unexpected sense of humour which popped out at different moments. She was also a very good teacher, since she understood one's difficulties – and the fact that she herself, as she confessed, usually did her sums by long division made one feel on comfortable terms with her. Eileen was my instructress in chemistry, and was frankly a great deal too clever for me to begin with. She started not from the practical side but from the theory. To be introduced suddenly to the Periodic Table, Atomic Weight, and the ramifications of coal-tar derivatives was apt to result in bewilderment. However, I found my feet, mastered the simpler facts, and after we had blown up our Cona coffee machine in the process of practising Marsh's test for arsenic our progress was well on the way.

We were amateurish, but perhaps being so made us more careful and conscientious. The work was uneven in quality, of course. Every time we had a fresh convoy of patients in, we worked furiously hard. Medicines, ointments, jars and jars of lotions to be filled, replenished and turned out every day. After working in a hospital with several doctors, one realises how medicine, like everything else in this world, is very much a matter of fashion: that, and the personal idiosyncrasy of every medical practitioner.

'What is there to do this morning?'

'Oh, five of Dr Whittick's, and four of Dr James's, and two of Dr Vyner's specials.'

The ignorant layman, or laywoman, as I suppose I ought to call myself, believes that the doctor studies your case individually, considers what drugs would be best for it, and writes a prescription to that effect. I soon found that the tonic prescribed by Dr Whittick, and the tonic prescribed by Dr James and the tonic prescribed by Dr Vyner were all quite different, and particular, not to the patient, but to the doctor. When one comes to think of it, it is quite reasonable, though it does not perhaps make a patient feel quite as important as he did before. The chemists and dispensers take rather a lofty view where doctors are concerned: they have their opinions also. One might think that Dr James's is a good prescription and Dr Whittick's below contempt – but, they have to

make them up just the same. Only when it comes to ointments do doctors really become experimental. That is mainly because skin afflictions are enigmas to the medical profession and to everyone else. A calamine type of application cures Mrs D. in a sensational manner; Mrs C., however, coming along with the same complaint, does not respond to calamine at all – it only produces additional irritation – but a coal tar preparation, which only aggravated the trouble with Mrs D. has unexpected success with Mrs C.; so the doctor has to keep on trying until he finds the appropriate preparation. In London, skin patients also have their favourite hospitals. 'Tried the Middlesex? I did, and the stuff they gave me did no good at all. Now here, at U.C.H., I'm nearly cured already.' A friend then chimes in: 'Well, I'm beginning to think there is something in the Middlesex. My sister was treated here and it did her no good, so she went to the Middlesex and she was as right as rain after two days.'

I still have a grudge against one particular skin specialist, a persistent and optimistic experimenter, belonging to the school of 'try anything once', who conceived the idea of a concoction of cod liver oil to be smeared all over a baby just a few months old. The mother and the other members of the household must have found poor baby's proximity very hard to bear. It did no good whatsoever and was discontinued after the first ten days. The making of it also rendered me a pariah in the home, for you cannot deal with large quantities of cod liver oil without returning home smelling to high heaven of noisome fish.

I was a pariah on several occasions in 1916 – more than once as the result of the fashion for Bip's Paste, which was applied to all wounds treated. It consisted of bismuth and iodoform worked into a paste with liquid paraffin. The smell of the iodoform was with me in the dispensary, on the tram, in the home, at the dinner table, and in my bed. It has a pervasive character which oozed up from your finger tips, wrists, arms, and over your elbows, and of course was quite impossible to wash off as far as the smell went. To save my family's feelings I used to have a meal tray in the pantry. Towards the end of the war, Bip's Paste went out of favour – it was replaced by other more innocuous preparations, and finally was succeeded by enormous demijohns of hypochlorous lotion. This, arising from ordinary chloride of lime with soda and other ingredients, caused a penetrating smell of chlorine to pervade all your clothes. Many of the disinfectants of sinks, etc., nowadays have this kind of basis. The mere sniff of them is enough to sicken me. I furiously attacked a very obstinate manservant we had at one time:

'What have you been putting down the sink in the pantry? It smells horrible!'

He produced a bottle proudly. 'First class disinfectant, Madam,' he said.

'This isn't a hospital,' I cried. 'You'll be hanging up a carbolic sheet next. Just rinse the sink out with good hot water, and a little soda occasionally if you must. Throw that filthy chloride of lime preparation away!'

I gave him a lecture on the nature of disinfectants and the fact that anything which is harmful to a germ is usually equally harmful to human tissue; so that spotless cleanliness and not disinfection was the thing to aim at. 'Germs are tough,' I pointed out to him. 'Weak disinfectants won't discourage any good sturdy germ. Germs will flourish in a solution of one in sixty carbolic.' He was not convinced, and continued to use his nauseous mixture whenever he was sure I was safely out of the house.

As part of my preparation for my examination at Apothecaries Hall, it was arranged that I should have a little outside instruction from a proper commercial chemist. One of the principal pharmacists in Torquay was gracious enough to say that I could come in on certain Sundays and that he would give me instruction. I arrived meek and frightened, anxious to learn.

A chemist's shop, the first time that you go behind the scenes, is a revelation. Being amateurs in our hospital work, we measured every bottle of medicine with the utmost accuracy. When the doctor prescribed twenty grains of bismuth carbonate to a dose, exactly twenty grains the patient got. Since we were amateurs, I think this was a good thing, but I imagine that any chemist who has done his five years, and got his minor pharmaceutical degree, knows his stuff in the same way as a good cook knows hers. He tosses in portions from the various stock bottles with the utmost confidence, without bothering to measure or weigh at all. He measures his poisons or dangerous drugs carefully, of course, but the harmless stuff goes in in the approximate dollops. Colouring and flavouring are added in much the same way. This sometimes results in the patients coming back and complaining that their medicine is a different colour from last time. 'It is a deep pink I have as a rule, not this pale pink,' or 'This doesn't taste right; it is the peppermint mixture I have – a nice peppermint mixture, not nasty, sweet, sickly stuff.' Then chloroform water has clearly been added instead of peppermint water.

The majority of patients in the out-patient department at University

College Hospital, where I worked in 1948, were particular as to the exact colour and taste of their preparations. I remember an old Irish woman who leant into the dispensary window, pressed half-a-crown into my palm, and murmured: 'Make it double strong, dearie, will you? Plenty of peppermint, double strong.' I returned her the half-a-crown, saying priggishly that we didn't accept that sort of thing, and added that she had to have the medicine exactly as the doctor had ordered it. I did, however, give her an extra dollop of peppermint water, since it could not possibly do her any harm and she enjoyed it so much.

Naturally, when one is a novice at this kind of job, one has a nervous horror of making mistakes. The addition of poison to a medicine is always checked by one of the other dispensers, but there can still be frightening moments. I remember one of mine. I had been making up ointments that afternoon, and for one of them I had placed a little pure carbolic in a convenient ointment pot lid, then carefully, with a dropper, added it to the ointment that I was mixing on the slab. Once it was duly bottled, labelled, and put out on a slab, I went on with my other work. It was about three in the morning, I think, that I woke up in bed and said to myself, *'What did I do with that ointment pot lid: the one I put the carbolic in?'* The more I thought the less I was able to remember having taken it and washed it. Had I perhaps clapped it on some other ointment I had made, not noticing that it had anything in it? Again, the more I thought, the more I was sure that that was what I had done. I had put it out on the ward shelf with the others to be collected on the following morning by the ward-boy in his basket, and one ointment for one patient would have a layering of strong carbolic in the top. Worried to death, I could bear it no longer. I got out of bed, dressed, walked down to the hospital, went in – fortunately I did not have to go through the ward, since the staircase to the dispensary was outside it – went up, surveyed the ointments I had prepared, opened the lids, and sniffed cautiously. To this day I don't know whether I imagined it or not, but in one of them I seemed to detect a faint odour of carbolic which there should not have been. I took out the top layer of the ointment, and so made sure that all was well. Then I crept out again and walked home and back to bed.

On the whole it is not usually the novices who make mistakes in chemists' shops. They are nervous, and always asking advice. The worst cases of poisoning through mistakes arise with the reliable chemists who have worked for many years. They are so familiar with what they are

doing, so able to do it without really thinking any more, that the time does come when one day, preoccupied perhaps with some trouble of their own, they make a slip. This happened in the cases of the grandchild of a friend of mine. The child was ill and the doctor came and wrote a prescription which was taken to the chemist to be made up. In due course the dose was administered. That afternoon the grandmother did not like the look of the child; she said to the nannie, 'I wonder whether there is anything wrong with that medicine?' After a second dose, she was still more worried. 'I think there is something wrong,' she said. She sent for the doctor; he took a look at the child, examined the medicine – and took immediate action. Children tolerate opium and its preparations very badly. The chemist had blundered; had put in quite a serious overdose. He was terribly upset, poor man; he had worked for this particular firm for fourteen years and was one of their most careful and trusted dispensers. It shows what can happen to anybody.

During the course of my pharmaceutical instruction on Sunday afternoons, I was faced with a problem. It was incumbent upon the entrants to the examination to deal with both the ordinary system and the metric system of measurements. My pharmacist gave me practice in making up preparations to the metric formula. Neither doctors nor chemists like the metrical system in operation. One of our doctors at the hospital never learned what 'containing 0.1' really meant, and would say, 'Now let me see, is this solution one in a hundred or one in a thousand?' The great danger of the metric system is that if you go wrong you go ten times wrong.

On this particular afternoon I was having instruction in the making of suppositories, things which were not much used in the hospital, but which I was supposed to know how to make for the exam. They are tricky things, mainly owing to the melting point of the cocoa butter, which is their base. If you get it too hot it won't set; if you don't get it hot enough it comes out of the moulds the wrong shape. In this case Mr P. the pharmacist was giving me a personal demonstration, and showed me the exact procedure with the cocoa butter, then added one metrically calculated drug. He showed me how to turn the suppositories out at the right moment, then told me how to put them into a box and label them professionally as so-and-so *one in a hundred*. He went away then to attend to other duties, but I was worried, because I was convinced that what had gone into those suppositories was 10% and made a dose of *one in ten* in each, not one in a hundred. I went over his calculations and

they *were* wrong. In using the metric system he had got his dot in the wrong place. But what was the young student to do? I was the merest novice, he was the best-known pharmacist in the town. I couldn't say to him: 'Mr P., *you have made a mistake.*' Mr P. the pharmacist was the sort of person who does *not* make a mistake, especially in front of a student. At this moment, re-passing me, he said, 'You can put those into stock; we do need them sometimes.' Worse and worse. I couldn't let those suppositories go into stock. It was quite a dangerous drug that was being used. You can stand far more of a dangerous drug if it is being given through the rectum, but all the same . . . I didn't like it, and what was I to do about it? Even if I suggested the dose was wrong, would he believe me? I was quite sure of the answer to that: he would say, 'It's quite all right. Do you think I don't know what I'm doing in matters of this kind?'

There was only one thing for it. Before the suppositories cooled, I tripped, lost my footing, upset the board on which they were reposing, and *trod on them* firmly.

'Mr P.,' I said, 'I'm terribly sorry; I've knocked over those suppositories and stepped on them.'

'Dear, dear, dear,' he said vexedly. 'This one seems all right.' He picked up one which had escaped the weight of my beetle-crushers. 'It's dirty,' I said firmly, and without more ado tipped them all into the waste-bin. 'I'm very sorry,' I repeated.

'That's all right, little girl,' he said. 'Don't worry too much,' and patted me tenderly on the shoulders. He was too much given to that kind of thing – pats on the shoulders, nudges, occasionally a faint attempt to stroke my cheek. I had to put up with it because I was being instructed, but I was as stand-offish as possible, and usually managed to engage the other dispenser in conversation so that I could not be alone with him.

He was a strange man, Mr P. One day, seeking perhaps to impress me, he took from his pocket a dark-coloured lump and showed it to me, saying, 'Know what this is?'

'No,' I said.

'It's curare,' he said. 'Know about curare?'

I said I had read about it.

'Interesting stuff,' he said. 'Very interesting. Taken by the mouth, it does you no harm at all. Enter the bloodstream, it paralyses and kills you. It's what they use for arrow poison. Do you know why I carry it in my pocket?'

'No,' I said, 'I haven't the slightest idea.' It seemed to me an extremely foolish thing to do, but I didn't add that.

'Well, you know,' he said thoughtfully, 'it makes me feel powerful.'

I looked at him then. He was a rather funny-looking little man, very roundabout and robin redbreast looking, with a nice pink face. There was a general air of childish satisfaction about him.

Shortly afterwards I finished my instructional course, but I often wondered about Mr P. afterwards. He struck me, in spite of his cherubic appearance, as possible rather a dangerous man. His memory remained with me so long that it was still there waiting when I first conceived the idea of writing my book *The Pale Horse* – and that must have been, I suppose, nearly fifty years later.

III

It was while I was working in the dispensary that I first conceived the idea of writing a detective story. The idea had remained in my mind since Madge's earlier challenge – and my present work seemed to offer a favourable opportunity. Unlike nursing, where there always was something to do, dispensing consisted of slack or busy periods. Sometimes I would be on duty alone in the afternoon with hardly anything to do but sit about. Having seen that the stock bottles were full and attended to, one was at liberty to do anything one pleased except leave the dispensary.

I began considering what kind of a detective story I could write. Since I was surrounded by poisons, perhaps it was natural that death by poisoning should be the method I selected. I settled on one fact which seemed to me to have possibilities. I toyed with the idea, liked it, and finally accepted it. Then I went on to the dramatis personae. Who should be poisoned? Who would poison him or her? When? Where? How? Why? And all the rest of it. It would have to be very much of an *intime* murder, owing to the particular way it was done; it would have to be all in the family, so to speak. There would naturally have to be a detective. At that date I was well steeped in the Sherlock Holmes tradition. So I considered detectives. Not like Sherlock Holmes, of course: I must invent one of my own, and he would also have a friend as a kind of butt or stooge – that would not be too difficult. I returned

to thoughts of my other characters. Who was to be murdered? A husband could murder his wife – that seemed to be the most usual kind of murder. I could, of course, have a very *unusual* kind of murder for a very *unusual* motive, but that did not appeal to me artistically. The whole point of a *good* detective story was that it must be somebody obvious but at the same time, for some reason, you would then find that it was *not* obvious, that he could not possibly have done it. Though really, of course, he *had* done it. At that point I got confused, and went away and made up a couple of bottles of extra hypochlorous lotion so that I should be fairly free of work the next day.

I went on playing with my idea for some time. Bits of it began to grow. I saw the murderer now. He would have to be rather sinister-looking. He would have a black beard – that appeared to me at that time very sinister. There were some acquaintances who had recently come to live near us – the husband had a black beard, and he had a wife who was older than himself and who was very rich. Yes, I thought, that might do as a basis. I considered it at some length. It might do, but it was not entirely satisfactory. The man in question would, I was sure, never murder anybody. I took my mind away from them and decided once and for all that it is no good thinking about real people – you must create your characters for yourself. Someone you see in a tram or a train or a restaurant is a possible starting point, because you can make up something for yourself about them.

Sure enough, next day, when I was sitting in a tram, I saw just what I wanted: *a man with a black beard, sitting next to an elderly lady who was chattering like a magpie*. I didn't think I'd have *her*, but I thought *he* would do admirably. Sitting a little way beyond them was a large, hearty woman, talking loudly about spring bulbs. I liked the look of her too. Perhaps I could incorporate her? I took them all three off the tram with me to work upon – and walked up Barton Road muttering to myself just as in the days of the Kittens.

Very soon I had a sketchy picture of some of my people. There was the hearty woman – I even knew her name: Evelyn. She could be a poor relation or a lady gardener or a companion – perhaps a lady house-keeper? Anyway, I was going to have her. Then there was the man with the black beard whom I still felt I didn't know much about, except for his beard, which wasn't really enough – or *was* it enough? Yes, perhaps it was; because you would be seeing this man from the *outside* – so you could only see what he liked to show – not as he really was: that

ought to be a clue in itself. The elderly wife would be murdered more for her money than her character, so she didn't matter very much. I now began adding more characters rapidly. A son? A daughter? Possibly a nephew? You had to have a good many suspects. The family was coming along nicely.

I left it to develop, and turned my attention to the detective. Who could I have as a detective? I reviewed such detectives as I had met and admired in books. There was Sherlock Holmes, the one and only – I should never be able to emulate *him*. There was Arsene Lupin – was he a criminal or a detective? Anyway, not my kind. There was the young journalist Rouletabille in *The Mystery of the Yellow Room* – that was the *sort* of person whom I would like to invent: someone who hadn't been used before. Who could I have? A schoolboy? Rather difficult. A scientist? What did I know of scientists? Then I remembered our Belgian refugees. We had quite a colony of Belgian refugees living in the parish of Tor. Everyone had been bursting with loving kindness and sympathy when they arrived. People had stocked houses with furniture for them to live in, had done everything they could to make them comfortable. There had been the usual reaction later, when the refugees had not seemed to be sufficiently grateful for what had been done for them, and complained of this and that. The fact that the poor things were bewildered and in a strange country was not sufficiently appreciated. A good many of them were suspicious peasants, and the last thing they wanted was to be asked out to tea or have people drop in upon them; they wanted to be left alone, to be able to keep to themselves; they wanted to save money, to dig their garden and to manure it in their own particular and intimate way.

Why not make my detective a Belgian? I thought. There were all types of refugees. How about a refugee police officer? A retired police officer. Not too young a one. What a mistake I made there. The result is that my fictional detective must really be well over a hundred by now.

Anyway, I settled on a Belgian detective. I allowed him slowly to grow into his part. He should have been an inspector, so that he would have a certain knowledge of crime. He would be meticulous, very tidy, I thought to myself, as I cleared away a good many untidy odds and ends in my own bedroom. A tidy little man. I could see him as a tidy little man, always arranging things, liking things in pairs, liking things square instead of round. And he should be very brainy – he should have little grey cells of the mind – that was a good phrase: I must remem-

ber that – yes, he would have little grey cells. He would have rather a grand name – one of those names that Sherlock Holmes and his family had. Who was it his brother had been? Mycroft Holmes.

How about calling my little man Hercules? He would be a small man – Hercules: a good name. His last name was more difficult. I don't know why I settled on the name Poirot, whether it just came into my head or whether I saw it in some newspaper or written on something – anyway it came. It went well not with Hercules but Hercule – Hercule Poirot. That was all right – settled, thank goodness.

Now I must get names for the others – but that was less important. Alfred Inglethorpe – that might do: it would go well with the black beard. I added some more characters. A husband and wife – attractive – estranged from each other. Now for all the ramifications – the false clues. Like all young writers, I was trying to put far too much plot into one book. I had too many false clues – so many things to unravel that it might make the whole thing not only more difficult to solve, but more difficult to read.

In leisure moments, bits of my detective story rattled about in my head. I had the beginning all settled, and the end arranged, but there were difficult gaps in between. I had Hercule Poirot involved in a natural and plausible way. But there had to be more reasons why other people were involved. It was still all in a tangle.

It made me absent-minded at home. My mother was continually asking why I didn't answer questions or didn't answer them properly. I knitted Grannie's pattern wrong more than once; I forgot to do a lot of the things that I was supposed to do; and I sent several letters to the wrong addresses. However, the time came when I felt I could at last begin to write. I told mother what I was going to do. Mother had the usual complete faith that her daughters could do anything.

'Oh?' she said. 'A detective story? That will be a nice change for you, won't it? You'd better start.'

It wasn't easy to snatch much time, but I managed. I had the old typewriter still – the one that had belonged to Madge – and I battered away on that, after I had written a first draft in longhand. I typed out each chapter as I finished it. My handwriting was better in those days and my longhand was readable. I was excited by my new effort. Up to a point I enjoyed it. But I got very tired, and I also got cross. Writing has that effect, I find. Also, as I began to be enmeshed in the middle part of the book, the complications got the better of me instead of my

being the master of them. It was then that my mother made a good suggestion.

'How far have you got?' she asked.

'Oh, I think about halfway through.'

'Well, I think if you really want to finish it you'll have to do so when you take your holidays.'

'Well, I did mean to go on with it then.'

'Yes, but I think you should go away from home for your holiday, and write with nothing to disturb you.'

I thought about it. A fortnight quite undisturbed. It *would* be rather wonderful.

'Where would you like to go?' asked my mother. 'Dartmoor?'

'Yes,' I said, entranced. 'Dartmoor – that is exactly it.'

So to Dartmoor I went. I booked myself a room in the Moorland Hotel at Hay Tor. It was a large, dreary hotel with plenty of rooms. There were few people staying there. I don't think I spoke to any of them – it would have taken my mind away from what I was doing. I used to write laboriously all morning till my hand ached. Then I would have lunch, reading a book. Afterwards I would go out for a good walk on the moor, perhaps for a couple of hours. I think I learnt to love the moor in those days. I loved the tors and the heather and all the wild part of it away from the roads. Everybody who went there – and of course there were not many in wartime – would be clustering round Hay Tor itself, but I left Hay Tor severely alone and struck out on my own across country. As I walked I muttered to myself, enacting the chapter that I was next going to write; speaking as John to Mary, and as Mary to John; as Evelyn to her employer, and so on. I became quite excited by this. I would come home, have dinner, fall into bed and sleep for about twelve hours. Then I would get up and write passionately again all morning.

I finished the last half of the book, or as near as not, during my fortnight's holiday. Of course that was not the end. I then had to rewrite a great part of it – mostly the over-complicated middle. But in the end it was finished and I was reasonably satisfied with it. That is to say it was roughly as I had intended it to be. It could be much better, I saw that, but I didn't see just how *I* could make it better, so I had to leave it as it was. I re-wrote some very stilted chapters between Mary and her husband John who were estranged for some foolish reason, but whom I was determined to force together again at the end so as to make a

kind of love interest. I myself always found the love interest a terrible bore in detective stories. Love, I felt, belonged to romantic stories. To force a love motif into what should be a scientific process went much against the grain. However, at that period detective stories always had to have a love interest – so there it was. I did my best with John and Mary, but they were poor creatures. Then I got it properly typed by somebody, and having finally decided I could do no more to it, I sent it off to a publisher – Hodder and Stoughton – who returned it. It was a plain refusal, with no frills on it. I was not surprised – I hadn't expected success – but I bundled it off to another publisher.

IV

Archie came home for his second leave. It must have been nearly two years, since I had seen him last. This time we had a happy leave together. We had a whole week, and we went to the New Forest. It was autumn, with lovely colourings in the leaves. Archie was less nervy this time, and we were both less fearful for the future. We walked together through the woods and had a kind of companionship that we had not known before. He confided to me that there was one place he had always wanted to go – to follow a signpost that said 'To No Man's Land'. So we took the path to No Man's Land, and we walked along it, then came to an orchard, with lots of apples. There was a woman there and we asked her if we could buy some apples from her.

'You don't need to buy from me, my dears,' she said. 'You're welcome to the apples. Your man is in the Air Force, I see – so was a son of mine who was killed. Yes, you go and help yourselves to all the apples you can eat and all you can take away with you.' So we wandered happily through the orchard eating apples, and then went back through the Forest again and sat down on a fallen tree. It was raining gently – but we were very happy. I didn't talk about the hospital or my work, and Archie didn't talk much about France, but he hinted that, perhaps, before long, we might be together again.

I told him about my book and he read it. He enjoyed it and said he thought it good. He had a friend in the Air Force, he said, who was a director of Methuen's, and he suggested that if the book came back

again he should send me a letter from this friend which I could enclose
with the MS and send to Methuen's.

So that was the next port of call for *The Mysterious Affair at Styles*.
Methuen's, no doubt in deference to their director, wrote much more
kindly. They kept it longer – I should think about six months – but,
though saying that it was very interesting and had several good points,
concluded it was not quite suitable for their particular line of production.
I expect really they thought it pretty awful.

I forget where I sent it next, but once again it came back. I had rather
lost hope by now. The Bodley Head, John Lane, had published one or
two detective stories recently – rather a new departure for them – so I
thought I might as well give them a try. I packed it off to them, and
forgot all about it.

The next thing that happened was sudden and unexpected. Archie
arrived home, posted to the Air Ministry in London. The war had gone
on so long – nearly four years – and I had got so used to working in
hospital and living at home that it was almost a shock to think I might
have a different life to live.

I went up to London. We got a room at a hotel, and I started round,
looking for some kind of a furnished flat to live in. In our ignorance we
started with rather grand ideas – but were soon taken down a peg or
two. This was wartime.

We found two possibles in the end. One was in West Hampstead – it
belonged to a Miss Tunks: the name stuck in my mind. She was ex-
ceedingly doubtful of us, wondering whether we would be careful
enough – young people were so careless – she was very particular about
her things. It was a nice little flat – three and a half guineas a week.
The other one that we looked at was in St. John's Wood – Northwick
Terrace, just off Maida Vale (now pulled down). That was just two
rooms, as against three, on the second floor, and rather shabbily furnished,
though pleasant, with faded chintz and a garden outside. It was in one
of those biggish old-fashioned houses, and the rooms were spacious.
Moreover it was only two and a half guineas as against three and a half
a week. We settled for that. I went home and packed up my things.
Grannie wept, mother wanted to weep but controlled it. She said;
'You are going to your husband now, dear, and beginning your married
life. I hope everything will go well.'

'And if the beds are of wood, be sure there are no bed bugs,' said
Grannie.

So I went back to London and Archie, and we moved into 5 Northwick Terrace. It had a microscopic kitchenette and bathroom, and I planned to do a certain amount of cooking. To start with, however, we would have Archie's soldier servant and batman, Bartlett, who was a kind of Jeeves – a perfection. He had been valet to dukes in his time. Only the war had brought him into Archie's service, but he was devoted to 'The Colonel' and told me long tales of his bravery, his importance, his brains, and the mark he had made. Bartlett's service was certainly perfect. The drawbacks of the flat were many, the worst of which was the beds, which were full of large, iron lumps – I don't know how any beds could have got into such a state. But we were happy there, and I planned to take a course of shorthand and book-keeping which would occupy my days. So it was goodbye to Ashfield and the start of my new life, my married life.

One of the great joys of 5 Northwick Terrace was Mrs Woods. In fact I think it was partly Mrs Woods which decided us in favour of Northwick Terrace rather than the West Hampstead flat. She reigned in the basement – a fat, jolly, cosy sort of woman. She had a smart daughter who worked in one of the smart shops, and an invisible husband. She was the general caretaker and, if she felt like it, would 'do for' the members of the flats. She agreed to 'do for' us, and she was a tower of strength. From Mrs Woods I learned details of shopping which had so far never crossed my horizon. 'Fishmonger done you down again, Love', she would say to me. 'That fish isn't fresh. You didn't poke it the way I told you to. You've got to poke it and look at its eye, and poke its eye'. I looked at the fish doubtfully; I felt that to poke it in its eye was taking somewhat of a liberty.

'Stand it up on its end too, stand it up on its tail. See if it flops or if it's stiff. And those oranges now. I know you fancy an orange sometimes as a bit of a treat, in spite of the expense, but that kind there has just been soaked in boiling water to make them look fresh. You won't find any juice in that orange.' I didn't.

The big excitement of my and Mrs Woods' life was when Archie drew his first rations. An enormous piece of beef appeared, the biggest piece I had seen since the beginning of the war. It was of no recognisable cut or shape, did not seem to be topside or ribs or sirloin; it was apparently chopped up according to weight by some Air Force butcher. Anyway, it was the handsomest thing we'd seen for ages. It reposed on the table and Mrs Woods and I walked round it admiringly. There was no question of

if going in my tiny oven. Mrs Woods agreed kindly to cook it for me. 'And there's such a lot,' I said, 'you can have it as well as us.'

'Well, that's very nice of you, I'm sure – we'll enjoy a good go of beef. Groceries, mind you, that's easy. I've got a cousin, Bob, in the grocery – as much sugar and butter as we want we get, *and* marge. Things like that, family gets served first.' It was one of my introductions to the time-honoured rule which holds good through the whole of life: what matters is who you know. From the open nepotism of the East to the slightly more concealed nepotism and 'old boys' club' of the Western democracies, everything in the end hinges on that. It is not, mind you, a recipe for complete success. Freddy So-and-So gets a well-paid job because his uncle knows one of the directors in the firm. So Freddy moves in. But if Freddy is no good, the claims of friendship or relationship having been satisfied, Freddy will be gently eased out, possibly passed on to some other cousin or friend, but in the end finding his own level.

In the case of meat, and the general luxuries of wartime, there were some advantages for the rich, but on the whole, I think, there were infinitely more advantages for the working class, because nearly everyone had a cousin or a friend, or a daughter's husband, or someone useful who was either in a dairy, a grocery, or something of that kind. It didn't apply to butchers, as far as I could see, but grocers were certainly a great family asset. Nobody that I came across at that time ever seemed to keep to the rations. They drew their rations, but they then drew an extra pound of butter and an extra pot of jam, and so on, without any feeling of behaving dishonestly. It was a family perk. Naturally Bob would look after his family and his family's family first. So Mrs Woods was always offering us extra titbits of this and that.

The serving of the first joint of meat was a great occasion. I cannot think it was particularly good meat or tender, but I was young, my teeth were strong, and it was the most delicious thing I had had for a long time. Archie, of course, was surprised at my greed. 'Not a very interesting joint,' he said.

'Interesting?' I said. 'It's the most interesting thing I have seen for three years.'

What I may call serious cooking was done for us by Mrs Woods. Lighter meals, supper dishes, were prepared by me. I had attended cookery classes, like most girls, but they are not particularly useful to you, when you come down to it. Everyday practice is what counts. I had made batches of jam pies, or toad-in-the-hole, or etceteras of various

kinds, but these were not what were really needed now. There were National Kitchens in most quarters of London, and these were useful. You called there and got things ready cooked in a container. They were quite well cooked – not very interesting ingredients, but they filled up the gaps. There were also National Soup Squares with which we started our meals. These were described by Archie as 'sand and gravel soup', recalling the skit by Stephen Leacock on a Russian short story – 'Yog took sand and stones and beat it to make a cake.' Soup squares were rather like that. Occasionally I made one of my specialities, such as a very elaborate soufflé. I didn't realise at first that Archie suffered badly with nervous dyspepsia. There were many evenings when he came home and was unable to eat anything at all, which rather discouraged me if I had prepared a cheese soufflé, or something at which I fancied myself.

Everyone has their own ideas of what they like to eat when they feel ill, and Archie's, to my mind, were extraordinary. After lying groaning on his bed for some time, he would suddenly say: 'I think I'd like some treacle or golden syrup. Could you make me something with that?' I obliged as best I could.

I started a course of book-keeping and shorthand to occupy my days. As everyone knows by now, thanks to those interminable articles in Sunday papers, newly married wives are usually lonely. What surprises me is that newly married wives should ever expect not to be. Husbands work; they are out all day; and a woman, when she marries, usually transfers herself to an entirely different environment. She has to start life again, to make new contacts and new friends, find new occupations. I had had friends in London before the war, but by now all were scattered. Nan Watts (now Pollock) was living in London, but I felt rather diffident about approaching her. This sounds silly, and indeed it *was* silly, but one cannot pretend that differences in income do not separate people. It is not a question of snobbishness or social position, it is whether you can afford to follow the pursuits that your friends are following. If they have a large income and you have a small one, things become embarrassing.

I *was* slightly lonely. I missed the hospital and my friends there and the daily goings on, and I missed my home surroundings, but I realised that this was unavoidable. Companionship is not a thing that one needs every day – it is a thing that grows upon one, and sometimes becomes as destroying as ivy growing round you. I enjoyed learning shorthand and book-keeping. I was humiliated by the ease with which little girls of

fourteen and fifteen progressed in shorthand; at book-keeping, however, I could hold my own, and it was fun.

One day at the business school where I took my courses the teacher stopped the lesson, went out of the room and returned, saying 'Everything ended for today. The War is over!'

It seemed unbelievable. There had been no real sign of this being likely to happen – nothing to lead you to believe that it would be over for another six months or a year. The position in France never seemed to change. One won a few yards of territory or lost it.

I went out in the streets quite dazed. There I came upon one of the most curious sights I had ever seen – indeed I still remember it, almost, I think with a sense of fear. Everywhere there were women dancing in the street. English women are not given to dancing in public: it is a reaction more suitable to Paris and the French. But there they were, laughing, shouting, shuffling, leaping even, in a sort of wild orgy of pleasure: an almost brutal enjoyment. It was frightening. One felt that if there had been any Germans around the women would have advanced upon them and torn them to pieces. Some of them I suppose were drunk, but all of them looked it. They reeled, lurched and shouted. I got home to find Archie was already home from his Air Ministry.

'Well, that's that', he said, in his usual calm and unemotional fashion.

'Did you think it would happen so soon?' I asked.

'Oh well, rumours have been going around – we were told not to say anything. And now,' he said, 'we'll have to decide what to do next.'

'What do you mean, do next?'

'I think the best thing to do will be to leave the Air Force.'

'You really mean to leave the Air Force?' I was dumbfounded.

'No future in it. You must see that. There can't be any future in it. No promotion for years.'

'What will you do?'

'I'd like to go into the City. I've always wanted to go into the City. There are one or two opportunities going.'

I always had an enormous admiration for Archie's practical outlook. He accepted everything without surprise, and calmly put his brain, which was a good one, to work on the next problem.

At the moment, Armistice or no Armistice, life went on as before. Archie went every day to the Air Ministry. The wonderful Bartlett, alas, got himself demobbed very quickly. I suppose the dukes and earls

were pulling strings to regain his services. Instead, we had a rather terrible creature called Verrall. I think he did his best, but he was inefficient, quite untrained, and the amount of dirt, grease and smears on the silver, plates, knives and forks, was beyong anything I had seen before. I was really thankful when he, too, got his demobilisation papers.

Archie got some leave and we went to Torquay. It was while I was there that I went down with what I thought at first was a terrific attack of tummy sickness and general misery. However, it was something quite different. It was the first sign that I was going to have a baby.

I was thrilled. My ideas of having a baby had been that they were things that were practically automatic. After each of Archie's leaves I had been deeply disappointed to find that no signs of a baby appeared. This time I had not even expected it. I went to consult a doctor – our old Dr Powell had retired, so I had to choose a new one. I didn't think I would choose any of the doctors whom I had worked with in the hospital – I felt I knew rather too much about them and their methods. Instead I went to a cheery doctor who rejoiced in the somewhat sinister name of Stabb.

He had a very pretty wife, with whom my brother Monty had been deeply in love since the age of nine. 'I have called my rabbit,' he said then, 'after Gertrude Huntly, because I think she is the most beautiful lady I have ever seen'. Gertrude Huntly, afterwards Stabb, was nice enough to show herself deeply impressed, and to thank him for this honour accorded her.

Dr Stabb told me that I seemed a healthy girl, and nothing should go wrong, and that was that. No further fuss was made. I cannot help being rather pleased that in my day there were none of those ante-natal clinics in which you are pulled about every month or two. Personally, I think we were much better off without them. All Dr Stabb suggested was that I should go to him or to a doctor in London about a couple of months before the baby was due, just to see that everything was the right way up. He said I might go on being sick in the morning, but after three months that it would disappear. There, I regret to say, he was wrong. My morning sickness never disappeared. It was not only a morning ailment. I was sick four or five times every day, and it made life in London quite embarrassing. To have to skip off a bus when you had perhaps only just got on it, and be violently sick in the gutter, is humiliating for a young woman. Still, it had to be put up with. Fortunately nobody thought in those days of giving you things like Thalidomide. They just accepted

the fact that some people were sicker than others having a baby. Mrs Woods, as usual omniscient on all subjects to do with birth and death, said, 'Ah well, Dearie, I'd say myself that you are going to have a girl. Sickness means girls. Boys you go dizzy and faint. It's better to be sick.'

Of course I did not think it was better to be sick. I thought to swoon away would be more interesting. Archie, who had never liked illness – and was apt to sheer off if people were ill, saying: 'I think you'll do better without me bothering you' – was on this occasion most unexpectedly kind. He thought of all sorts of things to cheer me up. I remember he bought a lobster, at that time an excessively expensive luxury, and placed it in my bed to surprise me. I can still remember coming in and seeing the lobster with its head and whiskers lying on my pillow. I laughed like anything. We had a splendid meal with it. I lost it soon afterwards, but at any rate I had *had* the pleasure of eating it. He was also noble enough to make me Benger's Food, which had been recommended by Mrs Woods as more likely to 'keep down' than other things. I remember Archie's hurt face when he had made me some Benger's, and allowed it to go cold because I could not drink it hot. I had had it, and had said it was very nice – 'No lumps in it tonight, and you've made it beautifully' – then half an hour later there was the usual tragedy.

'Well, look here,' said Archie, in an injured manner. 'What's the *good* of my making you these things? I mean, you might just as well not take them at all.'

It seemed to me, in my ignorance, that so much vomiting would have a bad effect on our coming child – that it would be starved. This, however, was far from the case. Although I continued to be sick up to the day of the birth, I had a strapping eight-and-a-half-pound daughter, and I myself, though never seeming to retain any nourishment at all, had put on rather than lost weight. The whole thing was like a nine-month ocean voyage to which you never got acclimatised. When Rosalind was born, and I found a doctor and a nurse leaning over me, the doctor saying, 'Well, you've got a daughter all right,' and the nurse, more gushing, 'Oh, what a lovely little daughter!' I responded with the important announcement: 'I don't feel sick any more. How wonderful!'

Archie and I had had great arguments the preceding month about names, and about which sex we wanted. Archie was very definite that he must have a daughter.

'I'm not going to have a boy,' he said, 'because I can see I should be jealous of it. I'd be jealous of your paying attention to it.'

'But I should pay just as much attention to a girl.'

'No, it wouldn't be the same thing.'

We argued about a name. Archie wanted Enid. I wanted Martha. He shifted to Elaine – I tried Harriet. Not till after she was born did we compromise on Rosalind.

I know all mothers rave about their babies, but I must say that, though I personally consider new-born babies definitely hideous, Rosalind actually was a *nice looking* baby. She had a lot of dark hair, and she looked rather like a Red Indian; she had not that pink, bald look that is so depressing in babies, and she seemed, from an early age, both gay and determined.

I had an extremely nice nurse, who took grave exception to the ways of our household. Rosalind was born, of course, at Ashfield. Mothers did not go to nursing-homes in those days; the whole birth, with attendance, cost fifteen pounds, which seems to me, looking back, extremely reasonable. I kept the nurse, on my mother's advice, for an extra two weeks, so that I could get full instructions in looking after Rosalind, and also go to London and find somewhere else to live.

The night when we knew Rosalind would be born we had a curious time. Mother and Nurse Pemberton were like two females caught up in the rites of Nativity: happy, busy, important, running about with sheets, setting things to order. Archie and I wandered about, a little timid, rather nervous, like two children who were not sure they were wanted. We were both frightened and upset. Archie, as he told me afterwards, was convinced that if I died it would be all his fault. I thought I possibly *might* die, and if so I would be extremely sorry because I was enjoying myself so much. But it was really just the unknown that was frightening. It was also exciting. The first time you do a thing is always exciting.

Now we had to make plans for the future. I left Rosalind at Ashfield with Nurse Pemberton still in charge, and went to London to find a) a place to live in; b) a nurse for Rosalind; and c) a maid to look after whatever house or flat we should find. The last was really no problem at all, for a month before Rosalind's birth who should burst in but my dear Devonshire Lucy; just out of the WAAFs, breathless, warm-hearted, full of exuberance: the same as ever, and a tower of strength. 'I've heard the news,' she said. 'I've heard you are going to have a baby – and I'm ready. The moment you want me, I'll move in.'

After consultation with my mother, I decided that Lucy must be offered a wage such as never before, in my mother's or my experience,

had been paid to a cook or a general maid. It was thirty-six pounds a year – an enormous sum in those days – but Lucy was well worth it and I was delighted to have her.

By this time, nearly a year after the armistice, finding anywhere to live was about the most difficult thing in the world. Hundreds of young couples were scouring London to find anything that would suit them at a reasonable price. Premiums, too, were being asked. The whole thing was very difficult. We decided to take a furnished flat first while we looked around for something that would really suit us. Archie's plans were working out. As soon as he got his demobilisation he was going in with a City firm. I have forgotten the name of his boss by this time; I will call him for convenience Mr Goldstein. He was a large, yellow man. When I had asked Archie about him that was the first thing he had said: 'Well, he's very yellow. Fat too, but very yellow.'

At that time the City firms were being forward in offering postings to young demobilised officers. Archie's salary was to be £500 a year. I had £100 a year which I still received under my grandfather's will, and Archie had his gratuity and sufficient savings to bring him in a further £100 a year. It was not riches, even in those days; in fact it was far from riches, because rents had risen so enormously, and also the price of food. Eggs were eightpence each, which was no joke for a young couple. However, we had never expected to be rich, and had no qualms.

Looking back, it seems to me extraordinary that we should have contemplated having both a nurse and a servant, but they were considered essentials of life in those days, and were the last things we would have thought of dispensing with. To have committed the extravagance of a car, for instance, would never have entered our minds. Only the rich had cars. Sometimes, in the last days of my pregnancy, when I was waiting in queues for buses, elbowed aside because of my cumbrous movements – men were not particularly gallant at that period – I used to think as cars swept past me; 'How wonderful it would be if *I* could have one one day.'

I remember a friend of Archie's saying bitterly: 'Nobody ought to be allowed to have a car unless they are on very essential business.' I never felt like that. It is always exciting, I think, to see *someone* having luck, someone who is rich, someone who has *jewels*. Don't the children in the street all press their faces against the windows to spy on parties, to see people with diamond tiaras? Somebody has got to win the Irish Sweepstake. If the prizes for it were only £30 there would be no excitement.

The Calcutta Sweep, the Irish Sweep, nowadays the football pools; all those things are romance. That, too, is why there are large crowds on the pavements watching film stars as they arrive at the *premières* of film shows. To the watchers they are heroines in wonderful evening dresses, made up to the back teeth: figures of glamour. Who wants a drab world where nobody is rich, or important, or beautiful, or talented? Once one stood for hours to look at kings and queens; nowadays one is more inclined to gasp at pop stars, but the principle is the same.

As I said, we were prepared to have a nurse and a servant as a necessary extravagance, but would never have dreamed of having a car. If we went to theatres it would be to the pit. I would have perhaps one evening dress, and that would be a black one so as not to show the dirt, and when we went out on muddy evenings, I would always of course, have, black shoes for the same reason. We would never take a taxi anywhere. There is a fashion in the way you spend your money, just as there is a fashion in everything. I'm not prepared to say now whether ours was a worse or a better way. It made for less luxury, plainer food, clothes and all those things. On the other hand, in those days you had more leisure – there was leisure to think, to read, and to indulge in hobbies and pursuits. I think I am glad that I was young in those times. There was a great deal of freedom in life, and much less hurry and worry.

We found a flat, rather luckily, quite soon. It was on the ground floor of Addison Mansions, which were two big blocks of buildings situated behind Olympia. It was a big flat, four bedrooms and two sitting-rooms. We took it furnished for five guineas a week. The woman who let it to us was a terrifically peroxided blonde of forty-five, with an immense swelling bust. She was very friendly and insisted on telling me a lot about her daughter's internal ailments. The flat was filled with particularly hideous furniture, and had some of the most sentimental pictures I have ever seen. I made a mental note that the first thing Archie and I would do would be to take them down and stack them tidily to await the owner's return. There was plenty of china and glass and all that kind of thing, including one egg-shell tea-set which frightened me because I thought it so fragile that it was sure to get broken. With Lucy's aid, we stored it away in one of the cupboards as soon as we arrived.

I then visited Mrs Boucher's Bureau, which was the recognised rendez-vous – indeed I believe it still is – for those who want nannies. Mrs Boucher managed to bring me down to earth rather quickly. She sniffed at the wages I was willing to pay, inquired about conditions and what

staff I kept, and then sent me to a small room where prospective employees were interviewed. A large, competent woman was the first to come in. The mere sight of her filled me with alarm. The sight of me, however, did not fill her with any alarm whatever. 'Yes, Madam? How many children would it be?' I explained that it would be one baby.

'And from the month, I hope? I never consent to taking any baby unless it is from the month. I get my babies into good ways as soon as possible.'

I said it would be from the month.

'And what staff do you keep, Madam?'

I said apologetically that as staff I kept one maid. She sniffed again. 'I'm afraid, Madam, that would hardly suit me. You see, I have been accustomed to having my nurseries waited on and looked after, and a fully equipped and pleasant establishment.' I agreed that my post was not what she was looking for, and got rid of her with some relief. I saw three more, but they all despised me.

However, I returned for further interviews the next day. This time I was lucky. I came across Jessie Swannell, thirty-five, sharp of tongue, kind of heart, who had lived most of her time as nurse with a family in Nigeria. I broke to her, one by one, the shameful conditions of my employment. Only one maid, one nursery, not a day and night nursery, the grate attended to, but otherwise she would have to do her own nursery and – final and last straw – the wages.

'Ah well,' she said, 'it doesn't sound too bad. I'm used to hard work, and that doesn't bother me. A little girl, is it? I like girls.'

So Jessie Swannell and I fixed it up. She was with me two years, and I liked her very much, though she had her disadvantages. She was one of those who by nature dislike the parents of the child they are looking after. To Rosalind she was goodness itself, and would have died for her, I think. Me she regarded as an interloper, though she grudgingly did as I wanted her to do, even if she did not always agree with me. On the other hand, if any disaster occurred, she was splendid; kind, ready to help, and cheerful. Yes, I respect Jessie Swannell, and I hope she has had a good life and done the kind of thing she wanted to do.

So all was settled, and Rosalind, myself, Jessie Swannell, and Lucy all arrived at Addison Mansions and started family life. Not that my search was ended. I had now to look for an unfurnished flat to be our permanent home. That of course was not so easy: in fact it was hellishly difficult. As soon as one heard of anything one rushed off, rang up, wrote

letters, yet there really seemed to be nothing possible. Sometimes they were dirty, shabby, so broken down that you could hardly imagine living in them. Time after time someone got in just ahead of you. We circled London: Hampstead, Chiswick, Pimlico, Kensington, St. John's Wood – my day seemed one long bus tour. We visited all the estate agents; and before long we began to get anxious. Our furnished let was only two months. When the peroxided Mrs N. and her married daughter and children returned they would not be likely to let it to us for any longer. We *must* find something.

At last it seemed we were lucky. We secured, or more or less secured, a flat near Battersea Park. Its rent was reasonable, the owner, Miss Llewellyn, was moving out in about a month's time, but would actually be content to go a little sooner. She was moving to a flat in a different part of London. All seemed settled, but we had counted our chickens too soon. A terrible blow befell us. Only about a fortnight before the date of moving we heard from Miss Llewellyn that she was unable to get into *her* new flat, because the people in it were in their turn unable to get into theirs! It was a chain reaction.

It was a severe blow. Every two or three days we telephoned to Miss Llewellyn for news. The news was worse each time. Always, it seemed, the other people were having more difficulty getting into their flat, so she was equally full of doubt about leaving her own. It finally seemed as though it might be three or four months before we would be able to get possession, and even that date was uncertain. Feverishly, we began once again studying the advertisements, ringing up house agents, and all the rest of it. Time went on, and by now we were desperate. Then a house agent rang up and offered us not a flat but a house. A small house in Scarsdale Villas. It was for sale though, not to let. Archie and I went and saw it. It was a charming little house. It would mean selling out practically all the small capital we had – a terrible risk. However, we felt we had to risk *something*, so we duly agreed to buy it, signed on a dotted line and went home to decide what securities we should sell.

It was two mornings later when, at breakfast, I was glancing through the paper, turning first to the flat column, which by now was such a habit with me that I was unable to stop it, and saw an advertisement: 'Flat to let unfurnished, 96 Addison Mansions, £90 per annum.' I uttered a hoarse cry, dashed down my coffee cup, read the advertisement to Archie, and said, 'There's no time to lose!'

I rushed from the breakfast table, crossed the grass courtyard between

the two blocks at a run, and went up the stairs of the opposite block, four flights of them, like a maniac. The time was a quarter past eight in the morning. I rang the bell of No. 96. It was opened by a startled-looking young woman in a dressing-gown.

'I've come about the flat,' I said, with as much coherence as I could manage in my breathlessness.

'About *this* flat? *Already*? I only put the advertisement in yesterday. I didn't expect anyone so soon.'

'Can I see it?'

'Well . . . Well, it's a little early.'

'I think it will do for us,' I said. 'I think I'll take it.'

'Oh, well, I suppose you can look round. It's not very tidy.' She drew back.

I charged in regardless of her hesitations, took one rapid look round the flat; I was not going to run any risk of losing it.

'£90 per annum?' I asked.

'Yes, that's the rent. But I must warn you it's only a quarterly lease.'

I considered that for a moment, but it did not deter me. I wanted somewhere to live, and *soon*.

'And when is possession?'

'Oh well, any time really – in a week or two? My husband's got to go abroad suddenly. And we want a premium for the linoleum and fittings.'

I did not much take to the linoleum surrounds, but what did that matter? Four bedrooms, two sitting-rooms, a nice outlook on green – four flights of stairs to come up and down, true, but plenty of light and air. It wanted doing up, but we could do that ourselves. Oh, it was wonderful – a godsend.

'I'll take it,' I said. 'That's definite.'

'Oh, you're sure? You haven't told me your name.'

I told her, explained that I was living in a furnished flat opposite, and all was settled. I rang up the agents there and then from her flat. I had been beaten to the punch too often before. As I descended the stairs again I met three couples coming up; each of them, I could see at a glance, going to No. 96. This time *we* had won. I went back and told Archie in triumph.

'Splendid,' he said. At that moment the telephone rang. It was Miss Llewellyn. 'I think,' she said, 'that you will be able to have the flat quite certainly in a month now.'

'Oh,' I said. 'Oh yes, I see.' I put back the receiver. 'Good Lord,'

said Archie. 'Do you know what we've got? We've now taken *two* flats *and* bought a house!'

It seemed something of a problem. I was about to ring up Miss Llewellyn and tell her we didn't want the flat, but then a better idea occurred to me. 'We'll try to get out of the Scarsdale Villa house,' I said, '*but we'll take the Battersea flat, and we'll ask a premium for it from someone else*. That will pay the premium on this one.'

Archie approved highly of this idea, and I think myself it was a moment of high financial genius on my part, because we could ill afford the £100 premium. Then we went to see the agents about the house we had bought in Scarsdale Villas. They were really very amiable. They said it would be quite easy to sell it to someone else – in fact there were several people who had been bitterly disappointed about it. So we got out of that with no more than a small fee to the agents.

We had a flat, and in two weeks time we moved into it. Jessie Swannell was a brick. She made no trouble at all about having to go up and down four flights of stairs, which was more than I would have believed possible of any other nurse from Mrs Boucher's.

'Ah well,' she said, 'I'm used to lugging things about. Mind you, I could do with a nigger or two. That's the best of Nigeria – plenty of niggers.'

We loved our flat, and threw ourselves heartily into the business of decoration. We spent a good portion of Archie's gratuity on furniture: good modern furniture for Rosalind's nursery from Heal's, good beds from Heal's for us – and quite a lot of things came up from Ashfield, which was far too crowded with tables and chairs and cabinets, plate and linen. We also went to sales and bought odd chests of drawers and old-fashioned wardrobes for a song.

When we got into our new flat we chose papers and decided on paint – some of the work we did ourselves, part we got in a small painter and decorator to help us with. The two sitting-rooms – a quite large drawing-room and a rather smaller dining-room – faced over the court, but they faced north. I preferred the rooms at the end of a long passage at the back. They were not quite so big, but they were sunny and cheerful, so we decided to have our sitting-room and Rosalind's nursery in the two back rooms. The bathroom was opposite them, and there was a small maid's room. Of the two large rooms we made the larger our bedroom and the smaller a dining-room and possible emergency spare-room. Archie chose the bathroom decoration: a brilliant scarlet and

white tiled paper. Our decorator and paper-hanger was extremely kind to me. He showed me how to cut and fold wallpaper in the proper way ready for pasting, and, as he put it, 'not to be afraid of it' when we papered the walls. 'Slap it on, see? You can't do any harm. If it tears, you paste it over. Cut it all out first, and have it all measured, and write the number on the back. That's right. Slap it on. A hairbrush is a very good thing to use to take the bubbles out.' I became quite efficient in the end. The ceilings we left to him to deal with – I didn't feel ready to do a ceiling.

Rosalind's room had pale yellow water paint on the walls, and there again I learnt a little about decoration. One thing our mentor did not warn me about was that if you did not get spots of water paint off the floor quickly it hardened up and you could only remove it with a chisel. However, one learns by experience. We did Rosalind's nursery with an expensive frieze of paper from Heal's with animals round the top of the walls. In the sitting-room I decided to have very pale pink shiny walls and to paper the ceiling with a black glossy paper with hawthorn all over it. It would make me feel, I thought, that I was in the country. It would also make the room look lower, and I liked low rooms. In a small room they looked more cottagey. The ceiling paper was to be put on by the professional of course, but he proved unexpectedly averse to doing it.

'Now, look here, Missus, you've got it wrong, you know. What you want is the ceiling done pale pink and the black paper on the walls.'

'No, I don't,' I said, 'I want the black paper on the ceiling and the pink distemper on the walls.'

'But that's not the way you *do* rooms. See? You're going light up to dark. That's the wrong way. You should do dark up to light.'

'You don't have to dark up to light if you *prefer* light up to dark,' I argued.

'Well, I can only tell you, Ma'am, that it's the wrong way and that nobody ever does it.'

I said that *I* was going to do it.

'It will bring the ceiling right down, you see if it doesn't. It will make the ceiling come down towards the floor. It will make the room look quite low.'

'I *want* it to look low.'

He gave me up then, and shrugged his shoulders. When it was finished I asked him if he didn't like it.

'Well,' he said, 'it's odd. No, I can't say I *like* it, but . . . well, it's odd like, but it is quite pretty if you sit in a chair and look up.'

'That's the idea,' I said.

'But if I was you, and you wanted to do that sort of thing, I'd have had one of them bright blue papers with stars.'

'I don't want to think I'm out of doors at night,' I said. 'I like to think I'm in a cherry blossom orchard or under a hawthorn tree.'

He shook his head sadly.

Most of the curtains we had made for us. The loose covers I had decided to make myself. My sister Madge – now renamed Punkie: her son's name for her – assured me in her usual positive fashion that this was quite easy to do. 'Just pin and cut them wrong side out,' she said, 'then stitch them, and turn them outside in. It's quite simple; anyone could do it.'

I had a try. They did not look very professional, and I did not dare to attempt any piping, but they looked bright and nice. All our friends admired our flat, and we never had such a happy time as when settling in there. Lucy thought it was marvellous, and enjoyed every minute of it. Jessie Swannell grumbled the whole time, but was surprisingly helpful. I was quite content for her to hate us, or rather me – I don't think she disapproved of Archie quite so much. 'After all,' as I explained to her one day, 'a baby has got to *have* parents or you wouldn't have one to look after.'

'Ah well, I suppose you've got something there,' said Jessie, and she gave a grudging smile.

Archie had started his job in the City. He said he liked it and seemed quite excited about it. He was delighted to be out of the Air Force, which, he continued to repeat, was absolutely no good for the future. He was determined to make a lot of money. The fact that we were at the moment hard up did not worry us. Occasionally Archie and I went to the Palais de Danse at Hammersmith, but on the whole we did without amusements, since we really couldn't afford them. We were a very ordinary young couple, but we were happy. Life seemed well set ahead of us. We had no piano, which was a pity – but I made up for it by playing the piano madly whenever I was at Ashfield.

I had married the man I loved, we had a child, we had somewhere to live, and as far as I could see there was no reason why we shouldn't live happily ever after.

One day I got a letter. I opened it quite casually and read it without at first taking it in. It was from John Lane, The Bodley Head, and it asked if I would call at their office in connection with the manuscript I had submitted entitled *The Mysterious Affair at Styles*.

To tell the truth, I had forgotten all about *The Mysterious Affair at Styles*. By this time it must have been with The Bodley Head for nearly two years, but in the excitement of the war's ending, Archie's return and our life together such things as writing and manuscripts had gone far away from my thoughts.

I went off to keep the appointment, full of hope. After all they must like it a bit or they wouldn't have asked me to come. I was shown into John Lane's office, and he rose to greet me; a small man with a white beard, looking somehow rather Elizabethan. All round him there appeared to be pictures – on chairs, leaning against tables – all with the appearance of old masters, heavily varnished and yellow with age. I thought afterwards that he himself would look quite well in one of those frames with a ruff around his neck. He had a benign, kindly manner, but shrewd blue eyes, which ought to have warned me, perhaps, that he was the kind of man who would drive a hard bargain. He greeted me, told me gently to take a chair. I looked round – it was quite impossible: every chair was covered with a picture. He suddenly saw this and laughed. 'Dear me,' he said, 'there isn't much to sit on, is there?' He removed a rather grimy portrait, and I sat down.

Then he began to talk to me about the MS. Some of his readers, he said, had thought it showed promise; something *might* be made of it. But there would have to be considerable changes. The last chapter, for instance; I had written it as a court scene, but it was quite impossible written like that. It was in no way like a court scene – it would be merely ridiculous. Did I think I could do something to bring about the dénouement in another way? Either someone could help me with the law aspect, though that would be difficult, or I might be able to change it in some other way. I said immediately that I thought I could manage something. I would think about it – perhaps have a different setting. Anyway, I would try. He made various other points, none of them really serious apart from the final chapter.

Then he went on to the business aspect, pointing out what a risk a publisher took if he published a novel by a new and unknown writer, and how little money he was likely to make out of it. Finally he produced from his desk drawer an agreement which he suggested I should sign.

I was in no frame of mind to study agreements or even think about them. He would publish my book. Having given up hope for some years now of having anything published, except the occasional short story or poem, the idea of having a book come out in print went straight to my head. I would have signed anything. This particular contract entailed my not receiving any royalties until after the first 2000 copies had been sold – after that a small royalty would be paid. Half any serial or dramatic rights would go to the publisher. None of it meant much to me – the whole point was, *the book would be published.*

I didn't even notice that there was a clause binding me to offer him my next five novels, at an only slightly increased rate of royalty. To me it was success, and all a wild surprise. I signed with enthusiasm. Then I took the MS away to deal with the anomalies of the last chapter. I managed that quite easily.

And so it was that I started on my long career; not that I suspected at the time that it was going to be a long career. In spite of the clause about the next five novels, this was to me a single and isolated experiment. I had been dared to write a detective story; I had written a detective story; it had been accepted, and was going to appear in print. There, as far as I was concerned, the matter ended. Certainly at that moment I did not envisage writing any more books, I think if I had been asked I would have said that I would probably write stories from time to time. I was the complete amateur – nothing of the professional about me. For me, writing was fun.

I went home, jubilant, and told Archie, and we went to the Palais de Danse at Hammersmith that night to celebrate.

There was a third party with us, though I did not know it. Hercule Poirot, my Belgian invention, was hanging round my neck, firmly attached there like the old man of the sea.

V

After I had dealt satisfactorily with the last chapter of *The Mysterious Affair at Styles*, I returned it to John Lane, then, once I had answered a few more queries and agreed to a few more alterations, the excitement receded into the background, and life went on as it would with any other

young married couple who are happy, in love with each other, rather badly off, but not too much hampered by the fact. Our times off at weekends were usually spent in going to the country by train and walking somewhere. Sometimes we made a round trip of it.

The only serious blow that befell us was that I lost my dear Lucy. She had been looking worried and unhappy, and finally she came to me rather sadly one day and said, 'I'm terribly sorry to let you down, Miss Agatha – I mean, Ma'am, and I don't know what Mrs Rowe would think of me, but – well, there it is, I'm going to get married.'

'Married, Lucy? Who to?'

'Someone I knew before the war. I always fancied him.'

I got more enlightenment from my mother. As soon as I told her, she exclaimed, 'It's not that Jack again, is it?' It appeared that my mother had not much approved of 'that Jack'. He'd been an unsatisfactory suitor of Lucy's, and it had been decided by her family that it was a good thing when the couple quarrelled and parted company. However, they had come together again now. Lucy had been faithful to the unsatisfactory Jack and there it was: she was going to get married and we should have to look for another maid.

By this time such a thing was even more impossible. No maids were to be found anywhere. However, at last, whether through an agency or a friend – I can't remember – I came across someone called Rose. Rose was highly desirable. She had excellent references, a round pink face, a nice smile, and looked as though she was quite prepared to like us. The only trouble was she was highly averse to going anywhere where there was a child and a nurse. I felt that she had to be prevailed upon. She had been with people in the Flying Corps, and when she heard that my husband had been in the Flying Corps too she obviously softened towards me. She said that she expected my husband knew her own employer, Squadron-Leader G. I rushed home and said to Archie, 'Did you ever know a Squadron-Leader G.?'

'Not that I can remember,' said Archie.

'Well, you must remember,' I said. 'You must say that you came across him, or that you were buddies, or something like that – we've got to have Rose. She's wonderful, she really is. If you knew the awful creatures I have seen.'

So in due course Rose came to look upon us with favour. She was introduced to Archie, who said some complimentary things about Squadron-Leader G., and was finally prevailed upon to accept the position.

'But I don't like nurses,' she said warningly. 'Don't really mind children – but nurses, they always make trouble.'

'Oh I'm sure,' I said, 'that Nurse Swannell won't make trouble.' I was not so sure, but on the whole I thought that all would be well. The only person Jessie Swannell would make trouble for would be me, and that I could stand by now. As it happened, Rose and Jessie got along well together. Jessie told her all about her life in Nigeria, and the joy it had been to have endless niggers under her control, and Rose told her all that she had suffered in her various situations. 'Starved, I was, sometimes,' said Rose to me one day. 'Starved. Do you know what they gave me for breakfast?'

I said that I didn't know.

'Kippers,' said Rose gloomily. 'Nothing but tea and a kipper, and toast and butter and jam. Well, I mean, I got so thin I was wasting away.'

There was no sign of Rose wasting away now – she was pleasantly plump. However, I made sure that when we had kippers for breakfast two kippers were always pressed upon Rose, or even three, and that eggs and bacon were served to her in lavish quantities. She was, I think, happy with us and fond of Rosalind.

My grandmother died soon after Rosalind's birth. She had been much herself up to the end, but then got a bad attack of bronchitis, and her heart was not strong enough to recover from it. She was ninety-two, still able to enjoy life, not too deaf, though very blind by this time. Her income, like my mother's, had been reduced by the Chaflin failure in New York, but Mr Bailey's advice had saved her from losing all of it. This now came to my mother. It was not much by this time, because some of the shares had depreciated through the war, but it gave her £3 – 400 a year, which, with her allowance from Mr Chaflin, made things possible for her. Of course everything got far more expensive in the years after the war. Still, she was able to keep on Ashfield. It made me rather unhappy not to be able to contribute my small income towards the upkeep of Ashfield, as my sister did. But it was really impossible in our case – we needed every penny we had to live on.

One day, when I was speaking in a worried voice about the difficulties of keeping up Ashfield, Archie said (very sensibly): 'You know, really it would be much better for your mother to sell it and live elsewhere.'

'Sell Ashfield!' I spoke in a voice of horror.

'I can't see what good it is to you. You can't go there very often.'

'I couldn't *bear* to sell Ashfield, I love it. It's – it's – it means every-thing.'

'Then why don't you try and *do something* about it?' said Archie.

'What do you mean, *do something* about it?'

'Well, you could write another book.'

I looked at him in some surprise. 'I suppose I *might* write another book one of these days, but it wouldn't do much good to Ashfield, would it?'

'It might make a lot of money,' said Archie.

I didn't think that was likely. *The Mysterious Affair at Styles* had sold close on 2000 copies, which was not bad at that time for a detective story by an unknown author. It had brought me in the meagre sum of £25 – and this not for the royalties on the book, but from a half share of the serial rights, which had been sold, rather unexpectedly, to *The Weekly Times* for £50. Very good for my prestige, said John Lane. It was a good thing for a young author to have a serial accepted by *The Weekly Times*. That might be, but £25 as the total income from writing a book did not encourage me to feel that I was likely to earn much money in a literary career.

'If a book has been good enough to take, and the publisher has made *some* money by it, which I presume he has, he will want another. You ought to get a bit more every time.' I listened to this and agreed. I was full of admiration for Archie's financial know-how. I considered writing another book. Supposing I did – what should it be about?

The question was solved for me one day when I was having tea in an A.B.C. Two people were talking at a table nearby, discussing somebody called Jane Fish. It struck me as a most entertaining name. I went away with the name in my mind. Jane Fish. That, I thought, would make a good beginning to a story – a name overheard at a tea shop – an unusual name, so that whoever heard it remembered it. A name like Jane Fish – or perhaps Jane Finn would be even better. I settled for Jane Finn – and started writing straight away. I called it *The Joyful Venture* first – then *The Young Adventurers* – and finally it became *The Secret Adversary*.

Archie had been quite right to settle in a job before he resigned from the Flying Corps. Young people were desperate. They had come out of the Services and had no jobs to go to. Young men were always ringing our doorbell, trying to sell stockings or offering some household gadget. It was a pathetic sight. One felt so sorry for them that one often bought a pair of rather nasty stockings, just to cheer them up. They had been

lieutenants, naval and military, and now they were reduced to this. Sometimes they even wrote poems and tried to sell them.

I conceived the idea of having a pair of this kind – a girl who had been in the A.T.S. or the V.A.D. and a young man who had been in the army. They would both be rather desperate, looking for a job, and then they would meet each other – perhaps they would already have met in the past? And then? Then, I thought, they would be involved in – yes, espionage: this would be a spy book, a thriller, not a detective story. I liked the idea – it was a change after the detective work involved in *The Mysterious Affair at Styles*. So I started writing, in a sketchy kind of way. It was fun, on the whole, and much easier to write than a detective story, as thrillers always are.

When I had finished it, which was not for some time, I took it to John Lane, who didn't like it much: it was not the same type as my first book – it would not sell nearly so well. In fact they were undecided whether to publish it or not. However, in the end they decided to do so. I did not have to make so many changes in this one.

As far as I remember it sold quite well. I made a little in royalties, which was something, and again I sold the serial rights to *The Weekly Times*, and this time got £50 doled out to me by John Lane. It was encouraging – though not encouraging enough to make me think that I had as yet adopted anything so grand as a profession.

My third book was *Murder on the Links*. This, I think, must have been written not long after a *cause célèbre* which occurred in France. I can't remember the name of any of the participants by now. It was some tale of masked men who had broken into a house, killed the owner, tied up and gagged the wife – the mother-in-law had also died, but only apparently because she had choked on her false teeth. Anyway, the wife's story was disproved, and there was a suggestion that it was the wife who had killed her husband, and that she had never been tied up at all, or only by an accomplice. It struck me as a good plot on which to weave my own story, starting with the wife's life after she had been acquitted of the murder. A mysterious woman would appear somewhere, having been the heroine of a murder case years ago. I set it in France, this time.

Hercule Poirot had been quite a success in *The Mysterious Affair at Styles*, so it was suggested that I should continue to employ him. One of the people who liked Poirot was Bruce Ingram, editor at the time of *The Sketch*. He got in touch with me, and suggested that I should write a

series of Poirot stories for *The Sketch*. This excited me very much indeed. At last I was becoming a success. To be in *The Sketch* – wonderful! He also had a fancy drawing made of Hercule Poirot which was not unlike my idea of him, though he was depicted as a little smarter and more aristocratic than I had envisaged him. Bruce Ingram wanted a series of twelve stories. I produced eight before long, and at first it was thought that that would be enough, but in the end it was decided to increase them to twelve, and I had to write another four rather more hastily than I wanted.

It had escaped my notice that not only was I now tied to the detective story, I was also tied to two people: Hercule Poirot and his Watson, Captain Hastings. I quite enjoyed Captain Hastings. He was a stereotyped creation, but he and Poirot represented my idea of a detective team. I was still writing in the Sherlock Holmes tradition – eccentric detective, stooge assistant, with a Lestrade-type Scotland Yard detective, Inspector Japp – and I now added a 'human foxhound', Inspector Giraud, of the French police. Giraud despises Poirot as being old and *passé*.

Now I saw what a terrible mistake I had made in starting with Hercule Poirot so *old* – I ought to have abandoned him after the first three or four books, and begun again with someone much younger.

Murder on the Links was slightly less in the Sherlock Holmes tradition, and was influenced, I think, by *The Mystery of the Yellow Room*. It had rather that high-flown, fanciful type of writing. When one starts writing, one is much influenced by the last person one has read or enjoyed.

I think *Murder on the Links* was a moderately good example of its kind – though rather melodramatic. This time I provided a love affair for Hastings. If I *had* to have a love interest in the book, I thought I might as well marry off Hastings! Truth to tell, I think I was getting a little tired of him. I might be stuck with Poirot, but no need to be stuck with Hastings too.

The Bodley Head were pleased with *Murder on the Links*, but I had a slight row with them over the jacket they had designed for it. Apart from being in ugly colours, it was badly drawn, and represented, as far as I could make out, a man in pyjamas on a golf-links, dying of an epileptic fit. Since the man who had been murdered had been fully dressed and stabbed with a dagger, I objected. A book jacket *may* have nothing to do with the plot, but if it does it must at least not represent a false plot. There was a good deal of bad feeling over this, but I was really furious

and it was agreed that in future I should see the jacket first and approve of it. I had already had one slight difference with The Bodley Head, and that was in *The Mysterious Affair at Styles*, over the spelling of the word cocoa. For some strange reason, the house spelling of cocoa – meaning by that a cup of cocoa – was *coco*, which, as Euclid would have said, is absurd. I was sternly opposed by Miss Howse, the dragon presiding over all spelling in The Bodley Head books. Cocoa, she said, in their publications, was always spelt *coco* – it was the proper spelling and was a rule of the firm. I produced tins of cocoa and even dictionaries – they had no impression on her. Coco was the proper spelling, she said. It was not until many years later, when I was talking to Allen Lane, John Lane's nephew, and begetter of Penguin Books, that I said, 'You know I had terrible fights with Miss Howse over the spelling of cocoa.'

He grinned. 'I know, we had great trouble with her as she got older. She got very opinionated about certain things. She argued with authors and would never give way.'

Innumerable people wrote to me and said, 'I can't understand, Agatha, why you spelled cocoa 'coco' in your book. Of course you were never a good speller.' Most unfair. I was not a good speller, I am still not a good speller, but at any rate I could spell cocoa the proper way. What I was, though, was a weak character. It was my first book – and I thought *they* must know better than I did.

I had had some nice reviews for *The Mysterious Affair at Styles*, but the one which pleased me best appeared in *The Pharmaceutical Journal*. It praised 'this detective story for dealing with poisons in a knowledgeable way, and not with the nonsense about untraceable substances that so often happens. Miss Agatha Christie,' they said, 'knows her job.'

I had wanted to write my books under a fancy name – Martin West or Mostyn Grey – but John Lane had been insistent on keeping my own name, Agatha Christie – particularly the Christian name: he said, 'Agatha is an unusual name which remains in peoples' memories.' So I had to abandon Martin West and label myself henceforth as Agatha Christie. I had the idea that a woman's name would prejudice people against my work, especially in detective stories; that Martin West would be more manly and forthright. However, as I have said, when you are publishing a first book you give way to whatever is suggested to you, and in this case I think John Lane was right.

I had now written three books, was happily married, and my heart's desire was to live in the country. Addison Mansions was a long way from the park. Pushing the pram there and back was no joke, either for Jessie Swannell or for me. Also there was one permanent snag: the flats were scheduled to come down. They belonged to Lyons, who intended to build new premises on the site. That is why the lease was only a quarterly one. At any moment notice might be given that the block was to be pulled down. Actually, thirty years later, our particular block of Addison Mansions was still standing – though now it has disappeared. Cadby Hall reigns in its stead.

Among our other activities at the weekend, Archie and I sometimes went by train to East Croydon and played golf there. I had never been much of a golfer, and Archie had played little, but he became keenly appreciative of the game. After a while, we seemed to go *every* weekend to East Croydon. I did not really mind, but I missed the variety of exploring places and going long walks. In the end that choice of recreation was to make a big difference to our lives.

Both Archie and Patrick Spence – a friend of ours who also worked at Goldstein's – were getting rather pessimistic about their jobs: the prospects as promised or hinted at did not seem to materialise. They were given certain directorships, but the directorships were always of hazardous companies – sometimes on the brink of bankruptcy. Spence once said, 'I think these people are a lot of ruddy crooks. All quite legal, you know. Still, I don't like it, do you?'

Archie said that he thought that some of it was *not* very reputable. 'I rather wish,' he said thoughtfully, 'I could make a change.' He liked City life and had an aptitude for it, but as time went on he was less and less keen on his employers.

And then something completely unforeseen came up.

Archie had a friend who had been a master at Clifton – a Major Belcher. Major Belcher was a character. He was a man with terrific powers of bluff. He had, according to his own story, bluffed himself into the position of Controller of Potatoes during the war. How much of Belcher's stories was invented and how much true, we never knew, but anyway he made a good story of this one. He had been a man of forty or fifty odd when the war broke out, and though he was offered a stay-at-home job in the War Office he did not care for it much. Anyway, when dining with a V.I.P. one night, the conversation fell on potatoes, which were really a great problem in the 1914 – 18 war. As far as I can remem-

ber, they vanished quite soon. At the hospital, I know, we never had them. Whether the shortage was entirely due to Belcher's control of them I don't know, but I should not be surprised to hear it.

'This pompous old fool who was talking to me,' said Belcher, 'said the potato position was going to be serious, very serious indeed. I told him that something had to be done about it – too many people messing about. Somebody had got to take the whole thing over – one man to take control. Well, he agreed with me. "But mind you," I said, "he'd have to be paid pretty highly. No good giving a mingy salary to a man and expecting to get one who's any good – you've got to have someone who's the tops. You ought to give him at least –"' and here he mentioned a sum of several thousands of pounds. 'That's very high,' said the V.I.P. 'You've got to get a good man,' said Belcher. 'Mind you, if you offered it to me, I wouldn't take it on myself, at that price.'

That was the operative sentence. A few days later Belcher was begged, on his own valuation, to accept such a sum, and control potatoes.

'What did you know about potatoes?' I asked him.

'I didn't know a thing,' said Belcher. 'But I wasn't going to let on. I mean, you can do anything – you've only got to get a man as second-in-command who knows a bit about it, and read it up a bit, and there you are!' He was a man with a wonderful capacity for impressing people. He had a great belief in his own powers of organisation – and it was sometimes a long time before anyone found out the havoc he was causing. The truth is that there never was a man less able to organise. His idea, like that of many politicians, was first to disrupt the entire industry, or whatever it might be, and having thrown it into chaos, to reassemble it, as Omar Khayyam might have said, 'nearer to the heart's desire'. The trouble was that, when it came to reorganising, Belcher was no good. But people seldom discovered that until too late.

At some period of his career he went to New Zealand, where he so impressed the governors of a school with his plans for reorganisation that they rushed to engage him as headmaster. About a year later he was offered an enormous sum of money to give up the job – not because of any disgraceful conduct, but solely because of the muddle he had introduced, the hatred which he aroused in others, and his own pleasure in what he called 'a forward-looking, up-to-date, progressive administration'. As I say, he was a character. Sometimes you hated him, sometimes you were quite fond of him.

Belcher came to dinner with us one night, being out of the potato job,

and explained what he was about to do next. 'You know this Empire Exhibition we're having in eighteen months' time? Well, the thing has got to be properly organised. The Dominions have got to be alerted, to stand on their toes and to co-operate in the whole thing. I'm going on a mission – the British Empire Mission – going round the world, starting in January.' He went on to detail his schemes. 'What I want,' he said, 'is someone to come with me as financial adviser. What about you, Archie? You've always had a good head on your shoulders. You were Head of the School at Clifton, you've had all this experience in the City. You're just the man I want.'

'I couldn't leave my job,' said Archie.

'Why not? Put it to your boss properly – point out it will widen your experience and all that. He'll keep the job open for you, I expect.'

Archie said he doubted if Mr Goldstein would do anything of the kind.

'Well, think it over, my boy. I'd like to have you. Agatha could come too, of course. She likes travelling, doesn't she?'

'Yes,' I said – a monosyllable of understatement.

'I'll tell you what the itinerary is. We go first to South Africa. You and me, and a secretary, of course. With us would be going the Hyams. I don't know if you know Hyam – he's a potato king from East Anglia. A very sound fellow. He's a great friend of mine. He'd bring his wife and daughter. They'd only go as far as South Africa. Hyam can't afford to come further because he has got too many business deals on here. After that we push on to Australia; and after Australia New Zealand. I'm going to take a bit of time off in New Zealand – I've got a lot of friends out there; I like the country. We'd have, perhaps, a month's holiday. You could go on to Hawaii, if you liked, Honolulu.'

'Honolulu,' I breathed. It sounded like the kind of phantasy you had in dreams.

'Then on to Canada, and so home. It would take about nine to ten months. What about it?'

We realised at last that he really meant it. We went into the thing fairly carefully. Archie's expenses would, of course, all be paid, and outside that he would be offered a fee of £1000. If I accompanied the party practically all my travelling costs would be paid, since I would accompany Archie as his wife, and free transport was being given on ships and on the national railways of the various countries.

We worked furiously over finances. It seemed, on the whole, that it

could be done. Archie's £1000 ought to cover my expenses in hotels, and a month's holiday for both of us in Honolulu. It would be a near thing, but we thought it was just possible.

Archie and I had twice gone abroad for a short holiday: once to the south of France, to the Pyrenees, and once to Switzerland. We both loved travelling – I had certainly been given a taste for it by that early experience when I was seven years old. Anyway, I longed to see the world, and it seemed to me highly probable that I never should. We were now committed to the business life, and a business man, as far as I could see, never got more than a fortnight's holiday a year. A fortnight would not take you far. I longed to see China and Japan and India and Hawaii, and a great many other places, but my dream remained, and probably always would remain, wishful thinking.

'The question is,' said Archie, 'whether old Yellowface will look kindly on the scheme.'

I said hopefully that Archie must be very valuable to him. Archie thought he could probably be replaced with somebody just as good – heaps of people were milling about wanting jobs still. Anyway, 'old Yellowface' did not play. He said that he *might* re-employ Archie on his return – it would depend – but he certainly could not guarantee to keep the job open. That would be too much for Archie to ask. He would have to take the risk of finding his place filled. So we debated it.

'It's a risk,' I said. 'A terrible risk.'

'Yes, it's a risk. I realise we shall probably land up back in England without a penny, with a little over a hundred a year between us, and nothing else; that jobs will be hard to get – probably even harder than now. On the other hand, well – if you don't take a risk you never get anywhere, do you?'

'It's rather up to you,' Archie said. 'What shall we do about Teddy?' Teddy was our name for Rosalind at that time – I think because we had once called her in fun The Tadpole.

'Punkie' – the name we all used for Madge now – would take Teddy. Or mother – they would be delighted. And she's got Nurse. Yes – yes – that part of it is all right. It's the only chance we shall ever have, I said wistfully.

We thought about it, and thought about it.

'Of course – *you* could go,' I said, bracing myself to be unselfish, 'and I stay behind.'

I looked at him. He looked at me.

'I'm not going to leave you behind,' he said. 'I wouldn't enjoy it if I did that. No, either you risk it and come too, or not – but it's up to you, because *you* risk more than I do, really.'

So again we sat and thought, and I adopted Archie's point of view.

'I think you're right,' I said. 'It's our chance. If we don't do it we shall always be mad with ourselves. No, as you say, if you can't take the risk of doing something you want, when the chance comes, life isn't worth living.'

We had never been people who played safe. We had persisted in marrying against all opposition, and now we were determined to see the world and risk what would happen on our return.

Our home arrangements were not difficult. The Addison Mansions flat could be let advantageously, and that would pay Jessie's wages. My mother and my sister were delighted to have Rosalind and Nurse. The only opposition of any kind came at the last moment, when we learnt that my brother Monty was coming home on leave from Africa, My sister was outraged that I was not going to stay in England for his visit.

'Your only brother, coming back after being wounded in the war, and having been away for *years*, and you choose to go off round the world at that moment. I think it's disgraceful. You ought to put your brother first.'

'Well, *I* don't think so,' I said. 'I ought to put my husband first. He is going on this trip and I'm going with him. Wives *should* go with their husbands.'

'Monty's your only brother, and it's your only chance of seeing him, perhaps for *years* more.'

She quite upset me in the end; but my mother was strongly on my side. 'A wife's duty is to go with her husband,' she said. 'A husband must come first, even before your children – and a brother is further away still. Remember, if you're not with your husband, if you leave him too much, *you'll lose him*. That's specially true of a man like Archie.'

'I'm sure that's not so,' I said indignantly. 'Archie is the most faithful person in the world.'

'You never know with any man,' said my mother, speaking in a true Victorian spirit. 'A wife *ought* to be with her husband – and if she isn't, then he feels he has a *right* to forget her.'

PART VI

ROUND THE WORLD

I

Going round the world was one of the most exciting things that ever happened to me. It was so exciting that I could not believe it was true. I kept repeating to myself, 'I am going round the world.' The highlight, of course, was the thought of our holiday in Honolulu. That I should go to a South Sea island was beyond my wildest dream. It is hard for anyone to realise how one felt then, only knowing what happens nowadays. Cruises, and tours abroad, are a matter of course. They are arranged reasonably cheaply, and almost anyone appears to be able to manage one in the end.

When Archie and I had gone to stay in the Pyrenees, we had travelled second-class, sitting up all night. (Third class on foreign railways was considered to be much the same as steerage on a boat. Indeed, even in England, ladies travelling alone would never have travelled third class. Bugs, lice, and drunken men were the least to be expected if you did so, according to Grannie. Even ladies' maids always travelled second.) We had walked from place to place in the Pyrenees and stayed at cheap hotels. We doubted afterwards whether we would be able to afford it the following year.

Now there loomed before us a luxury tour indeed. Belcher, naturally, had arranged to do everything in first-class style. Nothing but the best was good enough for the British Empire Exhibition Mission. We were what would be termed nowadays V.I.P.s, one and all.

Mr Bates, Belcher's secretary, was a serious and credulous young man. He was an excellent secretary, but had the appearance of a villain in a

melodrama, with black hair, flashing eyes and an altogether sinister aspect.

'Looks the complete thug, doesn't he?' said Belcher. 'You'd say he was going to cut your throat any moment. Actually he is the most respectable fellow you have ever known.'

Before we reached Cape Town we wondered how on earth Bates could stand being Belcher's secretary. He was unceasingly bullied, made to work at any hour of the day or night Belcher felt like it, and developed films, took dictation, wrote and re-wrote the letters that Belcher altered the whole time. I presume he got a good salary – nothing else would have made it worth while, I am sure, especially since he had no particular love of travel. Indeed he was highly nervous in foreign parts – mainly about snakes, which he was convinced we would encounter in large quantities in every country we went to. They would be waiting particularly to attack *him*.

Although we started out in such high spirits, my enjoyment at least was immediately cut short. The weather was atrocious. On board the *Kildonan Castle* everything seemed perfect until the sea took charge. The Bay of Biscay was at its worst. I lay in my cabin groaning with sea-sickness. For four days I was prostrate, unable to keep a thing down. In the end Archie got the ship's doctor to have a look at me. I don't think the doctor had ever taken sea-sickness seriously. He gave me something which 'might quieten things down,' he said, but as it came up as soon as it got inside my stomach it was unable to do me much good. I continued to groan and feel like death, and indeed *look* like death; for a woman in a cabin not far from mine, having caught a few glimpses of me through the open door, asked the stewardess with great interest: 'Is the lady in the cabin opposite dead yet?' I spoke seriously to Archie one evening. 'When we get to Madeira,' I said, 'if I am still alive, I am going to get off this boat.'

'Oh I expect you'll feel better soon.'

'No, I shall never feel better. I must get off this boat. I must get on dry land.'

'You'll still have to get back to England,' he pointed out, 'even if you did get off in Madeira.'

'I needn't,' I said, 'I could stay there. I could do some work there.'

'What work?' asked Archie, disbelievingly.

It was true that in those days employment for women was in short supply. Women were daughters to be supported, or wives to be supported,

or widows to exist on what their husbands had left or their relations could provide. They could be companions to old ladies, or they could go as nursery governesses to children. However, I had an answer to that objection. 'I could be a parlour-maid,' I said. 'I would quite *like* to be a parlour-maid.'

Parlour-maids were always needed, especially if they were tall. A tall parlour-maid never had any difficulty in finding a job – read that delightful book of Margery Sharp's, *Cluny Brown* – and I was quite sure that I was well enough qualified. I knew what wine glasses to put on the table. I could open and shut the front door. I could clean the silver – we always cleaned our own silver photograph frames and bric-à-brac at home – and I could wait at table reasonably well. 'Yes,' I said faintly, 'I could be a parlour-maid.'

'Well, we'll see,' said Archie, 'when we get to Madeira.'

However, by the time we arrived I was so weak that I couldn't even contemplate getting off the bed. In fact I now felt that the only solution was to remain on the boat and die within the next day or two. After the boat had been in Madeira about five or six hours, however, I suddenly felt a good deal better. The next morning out from Madeira dawned bright and sunny, and the sea was calm. I wondered, as one does with sea-sickness, what on earth I had been making such a fuss about. After all, there was nothing the matter with me really; I had just been sea-sick.

There is no gap in the world as complete as that between one who is sea-sick and one who is not. Neither can understand the state of the other. I was never really to get my sea-legs. Everyone always assured me that after you got through the first few days you were all right. It was not true. Whenever it was rough again I felt ill, particularly if the boat pitched – but since on our cruise it was mostly fair weather, I had a happy time.

My memories of Cape Town are more vivid than of other places; I suppose because it was the first real port we came to, and it was all so new and strange. The Kaffirs, Table Mountain with its queer flat shape, the sunshine, the delicious peaches, the bathing – it was all wonderful. I have never been back there – really I cannot think why. I loved it so much. We stayed at one of the best hotels, where Belcher made himself felt from the beginning. He was infuriated with the fruit served for breakfast, which was hard and unripe. 'What do you call these?' he roared. 'Peaches? You could bounce them and they wouldn't come to any harm.' He suited his action to the word, and bounced about five

unripe peaches. 'You see?' he said. 'They don't squash. They ought to squash if they were ripe.'

It was then that I got my inkling that travelling with Belcher might not be as pleasant as it had seemed in prospect at our dinner-table in the flat a month before.

This is no travel book – only a dwelling back on those memories that stand out in my mind; times that have mattered to me, places and incidents that have enchanted me. South Africa meant a lot to me. From Cape Town the party divided. Archie, Mrs Hyam, and Sylvia went to Port Elizabeth, and were to rejoin us in Rhodesia. Belcher, Mr Hyam and I went to the diamond mines at Kimberley, on through the Matopos, to rejoin the others at Salisbury. My memory brings back to me hot dusty days in the train going north through the Karroo, being ceaselessly thirsty, and having iced lemonades. I remember a long straight line of railway in Bechuanaland. Vague thoughts come back of Belcher bullying Bates and arguing with Hyam. The Matopos I found exciting, with their great boulders piled up as though a giant had thrown them there.

At Salisbury we had a pleasant time among happy English people, and from there Archie and I went on a quick trip to the Victoria Falls. I am glad I have never been back, so that my first memory of them remains unaffected. Great trees, soft mists of rain, its rainbow colouring, wandering through the forest with Archie, and every now and then the rainbow mist parting to show you for one tantalising second the Falls in all their glory pouring down. Yes, I put that as one of *my* seven wonders of the world.

We went to Livingstone and saw the crocodiles swimming about, and the hippopotami. From the train journey I brought back carved wooden animals, held up at various stations by little native boys, asking threepence or sixpence for them. They were delightful. I still have several of them, carved in soft wood and marked, I suppose, with a hot poker: elands, giraffes, hippopotami, zebras – simple, crude, and with a great charm and grace of their own.

We went to Johannesburg, of which I have no memory at all; to Pretoria, of which I remember the golden stone of the Union Buildings; then on to Durban, which was a disappointment because one had to bathe in an enclosure, netted off from the open sea. The thing I enjoyed most, I suppose, in Cape Province, was the bathing. Whenever we could steal time off – or rather when Archie could – we took the train and went to Muizenberg, got our surf boards, and went out surfing together.

The surf boards in South Africa were made of light, thin wood, easy to carry, and one soon got the knack of coming in on the waves. It was occasionally painful as you took a nose dive down into the sand, but on the whole it was easy sport and great fun. We had picnics there, sitting in the sand dunes. I remember the beautiful flowers, especially, I think, at the Bishop's house or Palace, where we must have been to a party. There was a red garden, and also a blue garden with tall blue flowers. The blue garden was particularly lovely with its background of plumbago.

Finances went well in South Africa, which cheered us up. We were the guests of the Government in practically every hotel, and we had free travel on the railways – so only our personal trip to the Victoria Falls involved us in serious expenses.

From South Africa we set sail for Australia. It was a long, rather grey voyage. It was a mystery to me why, as the Captain explained, the shortest way to Australia was to go down towards the Pole and up again. He drew diagrams which eventually convinced me, but it is difficult to remember that the earth is round and has flat poles. It is a geographical fact, but not one that you appreciate the point of in real life. There was not much sunshine, but it was a fairly calm and pleasant voyage.

It always seems to me odd that countries are never described to you in terms which you recognise when you get there. My own sketchy ideas of Australia comprised kangaroos in large quantities, and a great deal of waste desert. What startled me principally, as we came into Melbourne, was the extraordinary aspect of the trees, and the difference Australian gum trees make to a landscape. Trees are always the first things I seem to notice about places, or else the shape of hills. In England one becomes used to trees having dark trunks and light leafy branches; the reverse in Australia was quite astonishing. Silvery white-barks everywhere, and the darker leaves, made it like seeing the negative of a photograph. It reversed the whole look of the landscape. The other thing that was exciting was the macaws: blue and red and green, flying through the air in great clustering swarms. Their colouring was wonderful: like flying jewels.

We were at Melbourne for a short time, and took various trips from there. I remember one trip particularly because of the gigantic tree ferns. This sort of tropical jungle foliage was the last thing I expected in Australia. It was lovely, and most exciting. The food was not as pleasing. Except for the hotel in Melbourne, where it was very good, we seemed always to be eating incredibly tough beef or turkey. The sanitary arrange-

ments, too, were slightly embarrassing to one of Victorian upbringing. The ladies of the party were politely ushered into a room where two chamber pots sat in isolation in the middle of the floor, ready for use as desired. There was no privacy, and it was quite difficult . . .

A social gaffe that I committed in Australia, and once again in New Zealand, arose in taking my place at table. The Mission was usually entertained by the Mayor or the Chamber of Commerce in the various places we visited, and the first time this happened, I went, in all innocence, to sit by the Mayor or some other dignitary. An acid-looking elderly female then said to me: 'I think, Mrs Christie, you will *prefer* to sit by your husband.' Rather shame-faced, I hurried round to take my place by Archie's side. The proper arrangements at these luncheons was that every wife sat by her husband. I forgot this once again in New Zealand, but after that I knew my place and went to it.

We stayed in New South Wales at a station called, I think, Yanga, where I remember a great lake with black swans sailing on it. It was a lovely picture. Here, while Belcher and Archie were busy putting forth the claims of the British Empire, migration within the Empire, the importance of trade within the Empire, and so on and so forth, I was allowed to spend a happy day sitting in the orange groves. I had a nice long deck-chair, there was delicious sunshine, and as far as I remember I ate twenty-three oranges – carefully selecting the very best from the trees round me. Ripe oranges plucked straight from the trees, are the most delicious things you can imagine. I made a lot of discoveries about fruit. Pineapples, for instance, I had always thought of as hanging down gracefully from a tree. I was so astonished to find that an enormous field I had taken to be full of cabbages was in fact of pineapples. It was in a way rather a disappointment. It seemed such a prosaic way of growing such a luscious fruit.

Part of our journey was by train, but a good deal of it by car. Driving through those enormous stretches of flat pasture land, with nothing to break the horizon except periodic windmills, I realised how frightening it could be: how easy to get lost – 'bushed', as the saying was. The sun was so high over your head that you had no idea of north, south, east or west. There were no landmarks to guide you. I had never imagined a green grassy desert – I had always thought of deserts as a sandy waste – but there seem to be far more landmarks and protuberances by which you can find your way in desert country than there are in the flat grass-lands of Australia.

We went to Sydney, where we had a gay time, but having heard of Sydney and Rio de Janeiro as having the two most beautiful harbours in the world, I found it disappointing. I had expected too much of it, I suppose. Luckily I have never been to Rio, so I can still make a fancy picture of that in my mind's eye.

It was in Sydney that we first came in contact with the Bell family. Whenever I think of Australia I think of the Bells. A young woman, somewhat older than I was, approached me one evening in the hotel in Sydney, introduced herself as Una Bell, and said that we were all coming to stay at their station in Queensland at the end of the following week. As Archie and Belcher had a round of rather dull townships to go to first, it was arranged I should accompany her back to the Bell station at Couchin Couchin and await their arrival there.

We had a long train journey, I remember – several hours – and I was dead tired. At the end we drove and finally arrived at Coochin Coochin, near Boona in Queensland. I was still half asleep when suddenly I came into a scene of exuberant life. Rooms, lamp-lit, were filled with good-looking girls sitting about, pressing drinks on you – cocoa, coffee, anything you wanted – and all talking at once, all chattering and laughing. I had that dazed feeling in which you see not double but about quadruple of everything. It seemed to me that the Bell family numbered about twenty-six. The next day I cut it down to four daughters and the equivalent number of sons. The girls all resembled each other slightly, except for Una, who was dark. The others were fair, tall, with rather long faces; all graceful in motion, all wonderful riders, and all looking like energetic young fillies.

It was a glorious week. The energy of the Bell girls was such that I could hardly keep pace, but I fell for each of the brothers in turn: Victor, who was gay and a wonderful flirt; Bert, who rode splendidly, but was more solid in quality; Frick, who was quiet and fond of music. I think it was Frick to whom I really lost my heart. Years later, his son Guilford was to join Max and me on our archaeological expeditions to Iraq and Syria, and Guilford I still regard almost as a son.

The dominant figure in the Bell household was the mother, Mrs Bell, a widow of many years standing. She had something of the quality of Queen Victoria – short, with grey hair, quiet but authoritative in manner, she ruled with absolute autocracy, and was always treated as though she was royalty.

Amongst the various servants, station hands, general helpers, etc.,

most of whom were half-caste, there were one or two pure-bred Abori-
gines. Aileen Bell, the youngest of the Bell sisters, said to me almost the
first morning: 'You've got to see Susan.' I asked who Susan was. 'Oh,
one of the Blacks.' They were always called 'the Blacks'. 'One of the
Blacks, but she's a real one, absolutely pure-bred, and she does the
most wonderful imitations.' So a bent, aged Aborigine came along.
She was as much a queen in her own right as Mrs Bell in hers. She did
imitations of all the girls for me, and of various of the brothers, children
and horses: she was a natural mimic, and she enjoyed very much doing
her show. She sang, too, queer, off-key tunes.

'Now then, Susan,' said Aileen. 'Do mother going out to look at the
hens.' But Susan shook her head, and Aileen said, 'She'll never imitate
mother. She says it wouldn't be respectful and she couldn't possibly do a
thing like that.'

Aileen had several pet kangaroos and wallabies of her own, as well as
large quantities of dogs, and, naturally, horses. The Bells all urged me to
ride, but I didn't feel that my experience of rather amateurish hunting in
Devon entitled me to claim to be a horsewoman. Besides, I was always
nervous of riding other people's horses in case I should damage them.
So they gave in, and we dashed round everywhere by car. It is an exciting
experience seeing cattle rounded up, and all the various aspects of station
life. The Bells seemed to own large portions of Queensland, and if we
had had time Aileen said she would have taken me to see the Northern
out-station, which was much wilder and more primitive. None of the
Bell girls ever stopped talking. They adored their brothers, and hero-
worshipped them openly in a way quite novel to my experience. They
were always dashing about, to various stations, to friends, down to
Sydney, to race meetings; and flirting with various young men whom they
referred to always as 'coupons' – I suppose a relic of the war.

Presently Archie and Belcher arrived, looking jaded by their efforts.
We had a cheerful and carefree weekend with several unusual pastimes,
one of which was an expedition in a small-gauge train, of which I was
allowed, for a few miles, to drive the engine. There was a party of Austra-
lian Labour M.P.s, who had had such a festive luncheon that they were
all slightly the worse for drink, and when they took it in turns to drive
the engine we were all in mortal danger as it was urged to enormous
speeds.

Sadly we said farewell to our friends – or to the greater portion of them,
for a quota was going to accompany us to Sydney. We had a brief glimpse

of the Blue Mountains, and there again I was entranced by landscape coloured as I have never seen landscape coloured before. In the distance the hills really *were* blue – a cobalt blue, not the kind of grey blue that I associated with hills. They looked as if they had just been put on a piece of drawing-paper, straight from one's paint-box.

Australia had been fairly strenuous for the British Mission. Every day had been taken up with speech-making, dinners, luncheons, receptions, long journeys between different places. I knew all Belcher's speeches by heart by this time. He was good at speech-making, delivering everything with complete spontaneity and enthusiasm as though it had only just come into his head. Archie made quite a good contrast to him by his air of prudence and financial sagacity. Archie, at an early date – in South Africa I think – had been referred to in the newspapers as the Governor of the Bank of England. Nothing he said in contradiction of this was ever printed, so Governor of the Bank of England he remained as far as the press was concerned.

From Australia we went to Tasmania, driving from Launceston to Hobart. Incredibly beautiful Hobart, with its deep blue sea and harbour, and its flowers, trees and shrubs. I planned to come back and live there one day.

From Hobart we went to New Zealand. I remember that journey well, for we fell into the clutches of a man known to us all as 'The Dehydrator'. It was in the days when the idea of dehydrating food was all the rage. this man never looked at anything in the food line without thinking how he could dehydrate it, and at every single meal platefuls were sent over from his table to ours, begging us to sample them. We were given dehydrated carrots, plums, everything – all, without exception, tasted of nothing.

'If I have to pretend to eat any more of his dehydrated foods,' said Belcher, 'I shall go mad.' But as the Dehydrator was rich and powerful, and could prove of great benefit to the British Empire Exhibition, Belcher had to control his feelings and continue to toy with dehydrated carrots and potatoes.

By now the first amenities of travelling together had worn off. Belcher was no longer our friend who had seemed a pleasant dinner companion. He was rude, overbearing, bullying, inconsiderate, and mean in curiously small matters. For instance, he was always sending me out to buy him white cotton socks or other necessities of underwear, and never by any chance did he pay me back for what I bought.

If anything put him in a bad temper he was so impossible that one loathed him with a virulent hatred. He behaved exactly like a spoilt and naughty child. The disarming thing was that when he recovered his temper he could display so much *bonhomie* and charm that somehow we forgot our teeth-grinding and found ourselves back on the pleasantest terms. When he was going to be in a bad temper one always knew, because he began to swell up slowly and go red in the face like a turkey cock. Then, sooner or later, he would lash out at everybody. When he was in a good humour he told lion stories, of which he had a large stock.

I still think New Zealand the most beautiful country I have ever seen. Its scenery is extraordinary. We were in Wellington on a perfect day; something which, I gathered from its inhabitants, seldom happened. We went to Nelson and then down the South Island, through the Buller Gorge and the Kawarau Gorge. Everywhere the beauty of the countryside was astonishing. I vowed then that I would come back one day, in the spring – their spring, I mean, not ours – and see the *rata* in flower: all golden and red. I have never done so. For most of my life New Zealand has been so far away. Now, with the coming of air travel, it is only two or three days' journey, but my travelling days are over.

Belcher was pleased to be back in New Zealand. He had many friends there, and was happy as a schoolboy. When Archie and I left for Honolulu he gave us his blessing and urged us to enjoy ourselves. It was heaven for Archie to have no more work to do, no more contending with a crotchety and ill-tempered colleague. We had a lazy voyage, stopping at Fiji and other islands, and finally arrived at Honolulu. It was far more sophisticated than we had imagined with masses of hotels and roads and motor-cars. We arrived in the early morning, got into our rooms at the hotel, and straight away, seeing out of the window the people surfing on the beach, we rushed down, hired our surf-boards, and plunged into the sea. We were, of course, complete innocents. It was a bad day for surfing – one of the days when only the experts go in – but we, who had surfed in South Africa, thought we knew all about it. It is very different in Honolulu. Your board, for instance, is a great slab of wood, almost too heavy to lift. You lie on it, and slowly paddle yourself out towards the reef, which is – or so it seemed to me – about a mile away. Then, when you have finally got there, you arrange yourself in position and wait for the proper kind of wave to come and shoot you through the sea to the shore. This is not so easy as it looks. First you have to recognise the proper wave when it comes, and secondly, even more important, you

have to know the *wrong* wave when it comes, because if *that* catches you and forces you down to the bottom, Heaven help you!

I was not as powerful a swimmer as Archie, so it took me longer to get out to the reef. I had lost sight of him by that time, but I presumed he was shooting into shore in a negligent manner as others were doing. So I arranged myself on my board and waited for a wave. The wave came. It was the wrong wave. In next to no time I and my board were flung asunder. First of all the wave, having taken me in a violent downward dip, jolted me badly in the middle. When I arrived on the surface of the water again, gasping for breath, having swallowed quarts of salt water, I saw my board floating about half a mile away from me, going into shore. I myself had a laborious swim after it. It was retrieved for me by a young American, who greeted me with the words: 'Say, sister, if I were you I wouldn't come out surfing today. You take a nasty chance if you do. You take this board and get right into shore now.' I followed his advice.

Before long Archie rejoined me. He too had been parted from his board. Being a stronger swimmer, though, he had got hold of it rather more quickly. He made one or two more trials, and succeeded in getting one good run. By that time we were bruised, scratched and completely exhausted. We returned our surf-boards, crawled up the beach, went up to our rooms, and fell exhausted on our beds. We slept for about four hours, but were still exhausted when we awoke. I said doubtfully to Archie: 'I *suppose* there is a great deal of pleasure in surfing?' Then sighing, 'I wish I was back at Muizenberg.'

The second time I took the water, a catastrophe occurred. My handsome silk bathing dress, covering me from shoulder to ankle was more or less torn from me by the force of the waves. Almost nude, I made for my beach wrap. I had immediately to visit the hotel shop and provide myself with a wonderful, skimpy, emerald green wool bathing dress, which was the joy of my life, and in which I thought I looked remarkably well. Archie thought I did too.

We spent four days of luxury at the hotel, and then had to look about for something cheaper. In the end we rented a small chalet on the other side of the road from the hotel. It was about half the price. All our days were spent on the beach and surfing, and little by little we learned to become expert, or at any rate expert from the European point of view. We cut our feet to ribbons on the coral until we bought ourselves soft leather boots to lace round our ankles.

I can't say that we enjoyed our first four or five days of surfing – it was far too painful – but there were, every now and then, moments of utter joy. We soon learned, too, to do it the easy way. At least I did – Archie usually took himself out to the reef by his own efforts. Most people, however, had a Hawaiian boy who towed you out as you lay on your board, holding the board by the grip of his big toe, and swimming vigorously. You then stayed, waiting to push off on your board, until your boy gave you the word of instruction. 'No, not this, not this, Missus. No, no, wait – *now*!' At the word 'now' off you went, and oh, it was heaven! Nothing like it. Nothing like that rushing through the water at what seems to you a speed of about two hundred miles an hour; all the way in from the far distant raft, until you arrived, gently slowing down, on the beach, and foundered among the soft flowing waves. It is one of the most perfect physical pleasures that I have known.

After ten days I began to be daring. After starting my run I would hoist myself carefully to my knees on the board, and then endeavour to stand up. The first six times I came to grief, but this was not painful – you merely lost your balance and fell off the board. Of course, you had lost your board, which meant a tiring swim, but with luck your Hawaiian boy had followed and retrieved it for you. Then he would tow you out again and you would once more try. Oh, the moment of complete triumph on the day that I kept my balance and came right into shore standing upright on my board!

We proved ourselves novices in another way which had disagreeable results. We completely underestimated the force of the sun. Because we were wet and cool in the water we did not realise what the sun could do to us. One ought normally, of course, to go surfing in the early morning or late afternoon, but we went surfing gloriously and happily at mid-day – at noon itself, like the mugs we were – and the result was soon apparent. Agonies of pain, burning back and shoulders all night – finally enormous festoons of blistered skin. One was ashamed to go down to dinner in an evening dress. I had to cover my shoulders with a gauze scarf. Archie braved ribald looks on the beach and went down in his pyjamas. I wore a type of white shirt over my arms and shoulders. So we sat in the sun, avoiding its burning rays, and only cast off these outer garments at the moment we went in to swim. But the damage was done by then, and it was a long time before my shoulders recovered. There is something rather humiliating about putting up one hand and tearing off an enormous strip of dead skin.

Our little chalet bungalow had banana trees all round it – but bananas, like pineapples, were a slight disappointment. I had imagined putting out a hand, pulling a banana off the stem and eating it. Bananas are not treated like that in Honolulu. They are a serious source of profit, and they are always cut down green. Nevertheless, even though one couldn't eat bananas straight off the tree one could still enjoy an enormous variety such as one had never known existed. I remember Nursie, when I was a child of three or four, describing bananas in India to me, and the difference between the plantains, which were large and uneatable, and the bananas which were small and delicious – or was it the other way about? Honolulu offered about ten varieties. There were red bananas, large bananas, small bananas called ice-cream bananas, which were white and fluffy inside, cooking bananas, and so on. Apple bananas were another flavour, I think. One became very choosy as to what one ate.

The Hawaiians themselves were also slightly disappointing. I had imagined them as exquisite creatures of beauty. I was slightly put off to begin with by the strong smell of coconut oil with which all the girls smeared themselves and a good many of them were not good-looking at all. The enormous meals of hot meat stews were not at all what one had imagined either. I had always thought that Polynesians lived mostly on delicious fruits of all kinds. Their passion for stewed beef much surprised me.

Our holiday drew to a close, and we sighed a good deal at the thought of resuming our servitude. We were also growing slightly apprehensive financially. Honolulu had proved excessively expensive. Everything you ate or drank cost about three times what you thought it would. Hiring your surf-board, paying your boy – everything cost money. So far we had managed well, but now the moment had come when a slight anxiety for the future entered our minds. We had still to tackle Canada, and Archie's £1000 were dwindling fast. Our sea fares were paid for already so there was no worry over that. I could get to Canada, and I could get back to England. But there were my living expenses during the tour across Canada. How was I going to manage? However, we pushed this worry out of our minds and continued to surf desperately whilst we could. Much too desperately, as it happened.

I had been aware for some time of a bad ache in my neck and shoulder and began to be awakened every morning about five o'clock with an almost unbearable pain in my right shoulder and arm. I was suffering from neuritis, though I did not yet call it by that name. If I'd had any

sense at all I should have stopped using that arm and given up surfing, but I never thought of such a thing. There were only three days to go and I could not bear to waste a moment. I surfed, stood up on my board, displayed my prowess to the end. I now could not sleep at night at all because of the pain. However, I still had an optimistic feeling that it would go away as soon as I left Honolulu and had stopped surfing. How wrong I was. I was to suffer neuritis, and almost unendurable pain, for the next three weeks to a month.

Belcher was far from beneficent when we met again. He appeared to grudge us our holiday. Time we did some work, he said. 'Hanging about all this time, doing nothing. My goodness! It's extraordinary the way this thing has been fitted out, paying people to do nothing all the time!' He ignored the fact that he himself had had a good time in New Zealand and was regretting leaving his friends.

Since I was continually in pain, I went to see a doctor. He was not at all helpful. He gave me some ferocious ointment to rub into the hollow of my elbow when the pain was really bad. It must have been capsicum, I presume; it practically burnt a hole in my skin, and didn't do the pain much good. I was thoroughly miserable by now. Constant pain gets one down. It started every morning early. I used to get out of bed and walk about, since that seemed to make the pain more bearable. It would go off for an hour or two, and then come back with redoubled vigour.

At least the pain took my mind off our increasing financial worries. We were really up against it now. Archie was practically at the end of his £1000, and there were still over three weeks to go. We decided that the only thing was that I should forego travelling to Nova Scotia and Labrador and instead get myself to New York as soon as the money ran out. Then I could live with Aunt Cassie or May while Archie and Belcher were inspecting the silver fox industry.

Even then things were not easy. I could afford to stay in the hotels, but it was the *meals* that were so expensive. However, I hit on quite a good plan: I would make breakfast my meal. Breakfast was a dollar – at that time about four shillings in English money. So I would have breakfast down in the restaurant, and I would have everything that was on the menu. That, I may say, was a good deal. I had grapefruit, and sometimes pawpaw as well. I had buckwheat cakes, waffles with maple syrup, eggs and bacon. I came out from breakfast feeling like an overstuffed boa constrictor. But I managed to make that last until evening.

We had been given several gifts during our stay in the Dominions: a lovely blue rug for Rosalind with animals on it, which I was looking forward to putting in her nursery, and various other things – scarves, a rug, and so on. Among these gifts was an enormous jar of meat extract from New Zealand. We had carried this along with us, and I was thankful now that we had, for I could see that I was going to depend on it for sustenance. I wished heartily that I had flattered the Dehydrator to the extent that he would have pressed large quantities of dehydrated carrots, beef, tomatoes, and other delicacies upon me.

When Belcher and Archie departed to their Chambers of Commerce dinners, or wherever they were dining officially, I would retire to bed, ring the bell, say I was not feeling well, and ask for an enormous jug of boiling water as a remedy for my indigestion. When this came I would add some meat extract to it and nourish myself on that until the morning. It was a splendid jar, and lasted me about ten days. Sometimes, of course, I was asked out to luncheons or dinners too. Those were the red letter days. I was particularly fortunate in Winnipeg, where the daughter of one of the civic dignitaries called for me at my hotel and took me out to lunch at a very expensive hotel. It was a glorious meal. I accepted all the most substantial viands that were offered me. She ate rather delicately herself. I don't know what she thought of my appetite.

I think it was at Winnipeg that Archie went with Belcher on a tour of grain elevators. Of course, we should have known that anyone with a sinus condition ought never to go near a grain elevator, but I suppose it didn't occur to him or to me. He returned that day, his eyes streaming, and looking so ill that I was thoroughly alarmed. He managed the journey the next day as far as Toronto, but once there he collapsed completely, and it was out of the question for him to continue on the tour.

Belcher, of course, was in a towering rage. He expressed no sympathy. Archie was letting him down, he said. Archie was young and strong, it was all nonsense to go down like this. Yes, of course, he knew Archie had a high temperature. If he had such poor health he ought never to have come. Now Belcher was left to hold the baby all by himself. Bates was no use, as anyone knew. Bates was only of use for packing one's clothes, and even then he packed them all wrong. He couldn't fold trousers the right way, silly fool.

I called in a doctor, advised by the hotel, and he pronounced that Archie had congestion of the lungs, must not be moved, and could not be

fit for any kind of activity for at least a week. Fuming, Belcher took his departure, and I was left, with hardly any money, alone in a large, impersonal hotel, with a patient who was by now delirious. His temperature was over 103. Moreover, he came out with nettlerash. From head to foot he was covered with it, and suffered agony from the irritation, as well as the high fever.

It was a terrible time, and I am only glad now that I have forgotten the desperation and loneliness. The hotel food was not suitable, but I went out and got him invalid diet: a barley water, and thin gruel, which he quite liked. Poor Archie, I have never seen a man so maddened by what he went through with that appalling nettlerash. I sponged him all over, seven or eight times a day, with a weak solution of bicarbonate of soda and water, which gave him some relief. The third day the doctor suggested calling in a second opinion. Two owlish men stood on either side of Archie's bed, looking serious, shaking their heads, saying it was a grave case. Ah well, one goes through these things. A morning came when Archie's temperature had dropped, his nettlerash was slightly less obtrusive, and it was clear he was on the way to recovery. By this time I was feeling as weak as a kitten, mainly, I think, owing to anxiety.

In another four or five days Archie was restored to health, though still slightly weak, and we rejoined the detestable Belcher. I forget now where we went next; possibly Ottawa, which I loved. It was the fall, and the maple woods were beautiful. We stayed in a private house with a middle-aged admiral, a charming man who had a most lovely Alsatian dog. He used to take me out driving in a dog-cart through the maple trees.

After Ottawa we went to the Rockies, to Lake Louise and Banff. Lake Louise was for a long time my answer when I was asked which was the most beautiful place I had ever seen: – a great, long, blue lake, low mountains on either side, all of a most glorious shape, closing in with snow mountains at the end of it. At Banff I had a great piece of luck. My neuritis was still giving me a lot of pain and I resolved to try the hot sulphur waters which many people assured me might do good. Every morning I soaked myself in them. It was a kind of swimming pool, and by going up to one end of it you could get the hot water as it came out of the spring, smelling powerfully of sulphur. I ran this on to the back of my neck and shoulder. To my joy, by the end of four days my neuritis left me for all practical purposes, for good. To be free of pain once more was an unbelievable pleasure.

So there we were, Archie and I, at Montreal. Our roads were to part: Archie to go with Belcher and inspect silver fox farms, I to take a train south to New York. My money had by now completely run out.

I was met by darling Aunt Cassie at New York. She was so good to me, sweet and affectionate. I stayed with her in the apartment she had in Riverside Drive. She must have been a good age by then – nearly eighty, I should think. She took me to see her sister-in-law, Mrs Pierpont Morgan, and some of the younger Morgans of the family. She also took me to splendid restaurants and fed me delicious food. She talked much of my father and his early days in New York. I had a happy time. Aunt Cassie asked me towards the end of the stay what I would like to do as a treat on my last day. I told her that what I really longed to do was to go and have a meal in a cafeteria. Cafeterias were unknown in England, but I had read about them in New York, and I longed to try one. Aunt Cassie thought this a most extraordinary desire. She could not imagine *anybody* wanting to go to a cafeteria, but since she was full of willingness to please she went there with me. It was, she said, the first time she had been to one herself. I got my tray and collected things from the counter, and found it all a most amusing new experience.

Then the day came when Archie and Belcher were to reappear in New York. I was glad they were coming, because in spite of all Aunt Cassie's kindness, I was beginning to feel like a bird in a golden cage. Aunt Cassie never dreamed of allowing me to go out by myself anywhere. This was so extraordinary to me, after moving about freely in London, that it made me feel restless.

'But why, Aunt Cassie?'

'Oh, you never know what might happen to someone young and pretty like you are, who doesn't know New York.'

I assured her I was quite all right, but she insisted on either sending me in the car with a chauffeur or taking me herself. I felt inclined sometimes to play truant for three or four hours, but I knew that that would have worried her, so I restrained myself. I began to look forward, though, to being soon in London and able to walk out of my front door any moment I pleased.

Archie and Belcher spent one night in New York, and the next day we embarked on the *Berengaria* for our voyage back to England. I can't say I liked being on the sea again, but I was only moderately sea-sick this time. The rough weather happened at rather a bad moment, however, because we had entered a bridge tournament, and Belcher

insisted that I should partner him. I didn't want to, for although Belcher was a good bridge player he disliked losing so much that he always became extremely sulky. However, I was going to be free of him soon, so he and I started on our tournament. Unexpectedly we arrived at the final. That was the day that the wind freshened and the boat began to pitch. I did not dare to think of scratching, and only hoped that I would not disgrace myself at the bridge table. Hands were dealt as we started on what might well be the last hand, and almost at once Belcher, with a terrible scowl, slammed his cards down on the table.

'No use my playing this game really,' he said. 'No use at all.' He was scowling furiously, and I think for two pins would have thrown in the hand and allowed the game as a walkover to our opponents. However, I myself appeared to have picked up every ace and king in the pack. I played atrociously, but fortunately the cards played themselves. I couldn't lose. In the qualms of sea-sickness I pulled out the wrong card, forgot what trumps were, did everything foolish possible – but my hand was too good. We were triumphant winners of the tournament. I then retired to my cabin, to groan miserably until we docked in England.

I add, as a postscript to the year's adventures, that we did not keep to our vow of never speaking to Belcher again. I am sure everyone who reads this will understand. The furies that take hold of one when cooped up with somebody evaporate when the time of stress is over. To our enormous surprise we found that we actually *liked* Belcher, that we enjoyed his company. On many occasions he dined with us and we with him. We reminisced together in perfect amity over the various happenings of the world tour, saying occasionally to him: 'You really did behave atrociously, you know.'

'I daresay, I daresay,' said Belcher. 'I'm like that, you know.' He waved a hand. 'And anyway I had a lot to try me. Oh, not you two. You didn't worry me much – except Archie being such an idiot as to make himself ill. Absolutely lost I was, that fortnight when I had to do without him. Can't you have something done to your nose and your sinus? What's the good of going through life with a sinus like that? I wouldn't.'

Belcher had come back from his tour, most unexpectedly engaged to be married. A pretty girl, daughter of one of the officials in Australia, had worked with him as his secretary. Belcher was fifty at least, and she,

I should say, was eighteen or nineteen. At any rate he announced to us quite suddenly, 'I've a piece of news for you. I'm getting married to Gladys!' And get married to Gladys he did. She arrived by ship shortly after our return. Strangely enough I think it was quite a happy marriage, at least for some years. Gladys was good-tempered, enjoyed living in England, and managed the cantankerous Belcher remarkably well. It must have been, I think, eight or ten years later when we heard the news that a divorce was in progress.

'She's found another chap she liked the look of,' Belcher announced. 'Can't say I blame her, really. She's very young, and of course I am rather an elderly curmudgeon for her. We've remained good friends, and I'm fixing up a nice little sum for her. She's a good girl.'

I remarked to Belcher on one of the first occasions we dined together after our return: 'Do you know you still owe me two pounds eighteen and fivepence for white socks?'

'Dear, dear,' he said. 'Do I really? Are you expecting to get it?'

'No,' I said.

'Quite right,' said Belcher. 'You won't.' And we both laughed.

II

Life is really like a ship – the interior of a ship, that is. It has watertight compartments. You emerge from one, seal and bolt the doors, and find yourself in another. My life from the day we left Southampton to the day we returned to England was one such compartment. Ever since that I have felt the same about travel. You step from one life into another. You are yourself, but a different self. The new self is untrammelled by all the hundreds of spiders' webs and filaments that enclose you in a cocoon of day-to-day domestic life: letters to write and bills to pay, chores to do, friends to see, photographs to develop, clothes to mend, nurses and servants to placate, tradesmen and laundries to reprove. Your travel life has the essence of a dream. It is something outside the normal, yet you are in it. It is peopled with characters you have never seen before and in all probability will never see again. It brings occasional homesickness, and loneliness, and pangs of longing to see some dearly loved person – Rosalind, my mother, Madge. But you are like the Vikings or the Master

Mariners of the Elizabethan age, who have gone into the world of adventure, and home is not home until you return.

It was exciting to go away; it was wonderful to return. Rosalind treated us, as no doubt we deserved, as strangers with whom she was unacquainted. Giving us a cold look, she demanded: 'Where's my Auntie Punkie?' My sister herself took her revenge on me by instructing me on exactly what Rosalind was allowed to eat, what she should wear, the way she should be brought up, and so on.

After the first joys of reunion, the snags unfolded. Jessie Swannell had fallen by the wayside, unable to get on with my mother. She had been replaced by an elderly nannie, who was always known between ourselves as Cuckoo. I think she had acquired this name from the fact that when the changeover had taken place, and Jessie Swannell had departed weeping bitterly, the new nurse attempted to ingratiate herself with her new charge by shutting and opening the nursery door and hopping in and out, exclaiming brightly: 'Cuckoo, cuckoo!' Rosalind took a poor view of this and howled every time it happened. She became, however, exceedingly fond of her new attendant. Cuckoo was a born fusser, and an incompetent one at that. She was full of love and kindness, but she lost everything, broke everything, and made remarks of such idiocy that one could occasionally hardly believe them. Rosalind enjoyed this. She kindly took charge of Cuckoo and ran Cuckoo's affairs for her.

'Dear, dear,' I would hear from the nursery. 'Now where have I put the little dear's brush. Now then, where could it be? In the clothes basket?'

'I'll find it for you, Nannie,' Rosalind's voice rose. 'Here it is, in your bed.'

'Dear, dear, how could I have put it there, I wonder?'

Rosalind found things for Cuckoo, tidied away things for Cuckoo, and even gave her instructions from the pram when they were out together: 'Don't cross now, Nannie, it's just the wrong moment – there's a bus coming . . . You're taking the wrong turning, Nannie . . . I thought you said you were going to the wool-shop, Nannie. That's not the way to the wool-shop.' These instructions were punctuated by Cuckoo's 'Dear, dear, now why ever . . . What could I have been thinking of to do that?' etc.

The only people who found Cuckoo hard to endure were Archie and myself. She kept up a continual stream of conversation. The best way was to close your ears and not listen to it, but occasionally, maddened, you

interrupted. Going in a taxi to Paddington, Cuckoo would keep up a continual stream of observations. 'Look, little dear. You look out of the window now. You see that big place? That's Selfridges. That's a lovely place, Selfridges. You can buy anything there.'

'It's Harrods, Nurse,' I would say coldly.

'Dear, dear, now, so it is! It was Harrods all the time, wasn't it? Now isn't that funny, because we know Harrods quite well, don't we, little dear?'

'I knew it was Harrods,' said Rosalind.

I think it possible now that the ineptitude and general inefficiency of Cuckoo were responsible for making Rosalind an efficient child. She had to be. Somebody had got to keep the nursery in a vague semblance of order.

III

Arriving home may have started with joyous reunions, but reality soon raised its ugly head. We were without any money at all. Archie's job with Mr Goldstein was a thing of the past and another young man was now installed in his place. I still had, of course, my grandfather's nest-egg, so we could count on £100 a year, but Archie hated the idea of touching any of the capital. He *must* get a job of some kind, and at once, before demands for rent, Cuckoo's salary, and the weekly food bills began to come in. Finding a job was not easy – in fact it was even more difficult than it had been immediately after the war. My memories of that particular crisis are by now fortunately dim. I do know that it was an unhappy time because Archie was unhappy, and Archie was one of those people whom unhappiness does not suit. He knew this himself. I remember he had once warned me in the early days of our marriage: 'I'm no good, remember, if things go wrong. I'm not much good in illness, I don't like ill people, and I can't bear people to be unhappy or upset.'

We had taken our risk with our eyes open, content to take our chance. All that we could do now was to accept that the enjoyment was over and that the payment, in worry, frustration, etc., had now begun. I felt too, very inadequate, because I seemed to be of such little help to Archie. We would face all this together, I had told myself. I had to accept almost from the first that he would be every day in a state of irritation, or else

completely silent and sunk in melancholy. If I attempted to be cheerful I was told I had no sense of the gravity of the position; if I was gloomy I was told, 'No use pulling a long face. You knew what you were letting yourself in for!' In fact, nothing I could do seemed to be right.

Finally Archie said firmly, 'Look here, what I really want you to do, the only thing that would help at all, is to go right away.'

'Go right away? Where?'

'I don't know. Go to Punkie – she'd be pleased to have you and Rosalind. Or go home to your mother.'

'But, Archie, I want to be with you; I want to share this – can't we? Can't we share it together? Isn't there something *I* could do?'

Nowadays I suppose I could have said, 'I'll get a job,' but it was not a thing one even thought of saying in 1923. In the war there had been WAAFs, WRAFS, and WAACs, or jobs in munitions factories, or in the hospitals. But they were temporary; There were no jobs for women now in offices or ministries. Shops were fully staffed. Still I dug my toes in, and refused to go away. I could at least cook and clean. We had now no maid. I kept quiet and well out of Archie's way, which seemed the only attitude that was of any help to him.

He roamed round the City offices and saw various people who might know of a job that was going. In the end he got one. It was not one that he liked – indeed he was slightly apprehensive about the firm that engaged him: they were, he said, well known to be crooks. They kept for the most part on the right side of the law, but one never knew. 'The point is,' said Archie, 'that I'll have to be very careful that they don't ever leave me holding the can.' Anyway, it was employment and brought some money in, and Archie's mood improved. He was even able to find some of his daily experiences funny.

I tried to settle down to do some writing, since I felt that that was the only thing I could do that might bring in a little money. I still had no idea of writing as a profession. The stories published in *The Sketch* had encouraged me: that had been real money coming directly to me. Those stories, however, had been bought, paid for, and the money spent by now. I settled down and started to write another book.

Belcher had urged me, when we dined with him at his house, the Mill House at Dorney, before our trip, to write a detective story about it. '*The Mystery of the Mill House*,' he said. 'Jolly good title – don't you think?'

I said yes, I thought *Mystery in the Mill House* or *Murder in the Mill*

House would be very good, and I would consider the matter. When we had started on our tour he often referred to the subject.

'But mind you,' he said, 'if you write *The Mystery of the Mill House I*'ve got to be in it.'

'I don't think I *could* put you in it,' I said. 'I can't do anything with real people. I have to imagine them.'

'Nonsense,' said Belcher. 'I don't mind if it isn't particularly like me, but I've always wanted to be in a detective story.'

At intervals he would ask: 'Have you begun that book of yours yet? Am I in it?' At one moment, when we were feeling exasperated, I said: 'Yes. *You're* the victim.'

'What? Do you mean I'm the chap that gets murdered?'

'Yes,' I said, with some pleasure.

'I don't want to be the victim,' said Belcher. 'In fact I won't be the victim – I insist on being the murderer.'

'Why do you want to be the murderer?'

'Because the murderer is always the most interesting character in the book. So you've got to make me the murderer, Agatha – do you understand?'

'I understand that you *want* to be the murderer,' I said, choosing my words carefully. In the end, in a moment of weakness, I promised that he *should* be the murderer.

I had sketched out the-plot of this book when I was in South Africa. It was to be again, I decided, more in the nature of a thriller than a detective story, comprising a good deal of the South African scene. There was some kind of revolutionary crisis on while we were there, and I noted down a few useful facts. I pictured my heroine as a gay, adventurous, young woman, an orphan, who started out to seek adventure. Tentatively writing a chapter or two, I found it terribly difficult to make the picture based on Belcher come alive. I could *not* write about him objectively and make him anything but a complete dummy. Then suddenly an idea came to me. The book should be written in the first person, alternately by the heroine, Ann, and the villain, Belcher.

'I don't believe he *will* like being the villain,' I said to Archie dubiously.

'Give him a title,' suggested Archie. 'I think he'd like that.'

So he was christened Sir Eustace Pedler, and I found that if I made Sir Eustace Pedler write his own script the character began to come alive. He wasn't Belcher, of course, but he used several of Belcher's phrases, and told some of Belcher's stories. He too was a master of the art of

bluff, and behind the bluff could easily be sensed an unscrupulous and interesting character. Soon I had forgotten Belcher and had Sir Eustace Pedler himself wielding the pen. It is, I think, the only time I have tried to put a real person whom I knew well into a book, and I don't think it succeeded. Belcher didn't come to life, but someone called Sir Eustace Pedler did. I suddenly found that the book was becoming rather fun to write. I only hoped The Bodley Head would approve of it.

My chief handicap in the writing of this book was Cuckoo. Cuckoo, of course, in the habit of nurses in those days, did no kind of housework, cooking, or cleaning. She was a child's nurse; she cleaned her own nursery and did the little dear's washing, but that was all. I did not expect anything else, and I arranged my day quite well. Archie only came home in the evening, and Rosalind and Cuckoo's lunch was simple and easy to deal with. That left me time in the mornings and afternoons to put in two or three hours work. Cuckoo and Rosalind were then *en route* to the park or to some shopping programme outdoors. However, there were, of course, wet days when they had to remain in the flat, and although the point was made that 'Mummy is working' Cuckoo was not so easily diverted. She would stand outside the door of the room where I was writing, and keep up a kind of soliloquy, ostensibly addressed to Rosalind.

'Now, little dear, we mustn't make a noise, must we, because Mummy is working. We mustn't disturb Mummy when she's working, must we? Though I *should* like to ask her if I should send that dress of yours to the laundry. I do think, you know, that it's not one I can manage very well myself. Well, we must remember to ask her at teatime, mustn't we, little dear? I mean we mustn't go in *now* and ask her, must we? Oh no, she wouldn't like that, would she? Then I want to ask about the pram too, You know it lost a nut again yesterday. Well, perhaps, little dear, we could make one little tap at the door. Now what do you think, little dear?'

Usually Rosalind would make a brief response which had no connection with what was being discussed, confirming me in my belief that she never listened to Cuckoo.

'Blue Teddy is going to have his dinner now,' she would declare.

Rosalind had been given dolls, a dolls' house, and various other toys, but she only really cared for animals. She had a silk creature called Blue Teddy, and another called Red Teddy, and these were joined later by a much larger rather sickly mauve teddy bear called Edward Bear.

Of these three Rosalind loved with a complete and utter passion Blue Teddy. He was a limp animal, made of blue stockinette silk, with black eyes set flat into his flat face. He accompanied her everywhere, and I had to tell stories about him every night. The stories concerned both Blue Teddy and Red Teddy. Every night they had a fresh adventure. Blue Teddy was good and Red Teddy was very, very naughty. Red Teddy did some splendidly naughty things, such as putting glue on the school-teacher's chair so that when she sat down she could not get up again. One day he put a frog in the school-teacher's pocket, and she screamed and had hysterics. These tales met with great approval, and frequently I had to repeat them. Blue Teddy was of a nauseating and priggish virtue. He was top of his class in school and never did a naughty deed of any kind. Every day, when the boys left for school, Red Teddy promised his mother that he would be good today. On their return their mother would ask, 'Have you been a good boy, Blue Teddy?'

'Yes, Mummy, very good.'

'That's my dear boy. Have you been good, Red Teddy?'

'No, Mummy, I have been very naughty.'

On one occasion Red Teddy had gone fighting with some bad boys and come home with an enormous black eye. A piece of fresh steak was put on it and he was sent to bed. Later Red Teddy blotted his copybook still further by eating the piece of steak that had been placed on his eye.

Nobody could have been more delightful to tell stories to than Rosalind. She chuckled, laughed, and appreciated every minor point.

'Yes, little dear' – Cuckoo, showing no signs of helping Rosalind to give Blue Teddy his dinner, continued to quack – 'Perhaps before we go we might just *ask* Mummy, if it doesn't disturb her, because you know I *would* like to know about the pram.'

At this point, maddened, I would rise from my chair, all ideas of Ann in deadly peril in the forests of Rhodesia going out of my mind, and jerk open the door.

What *is* it, Nurse? What do you want?'

'Oh, I'm so sorry, Ma'am. I am very sorry indeed. I didn't mean to disturb you.'

'Well, you have disturbed me. What is it?'

'Oh, but I didn't knock on the door or *anything*.'

'You've been talking outside,' I said, 'and I can hear every word you say. What is the matter with the pram?'

'Well, I do think, Ma'am, that we really *ought* to have a new pram.

You know I'm quite ashamed going to the park and seeing all the nice prams that the other little girls have. Oh yes indeed, I do feel that Miss Rosalind ought to have as good as anyone.'

Nurse and I had a permanent battle about Rosalind's pram. We had originally bought it second-hand. It was a good, strong pram, perfectly comfortable; but it was not what could be called smart. There is a fashion in prams, I learned, and every year or two the makers give them a different 'line', a different cut of the jib, as it were – very much, of course, like motor cars nowadays. Jessie Swannell had not complained, but Jessie Swannell had come from Nigeria, and it is possible that they did not keep up so much with the Joneses in prams out there.

I was to realise now that Cuckoo was a member of that sorority of nurses who met in Kensington Gardens with their infant charges, where they would sit down and compare notes as to the merits of their situations and the beauty and cleverness of their particular child. The baby had to be well dressed, in the proper fashion for babies at that moment, or Nurse would be shamed. That was all right. Rosalind's clothes passed muster. The overalls and dresses I had made her in Canada were the *dernier cri* in children's wear. The cocks and hens and pots of flowers on their black background filled everybody with admiration and envy. But where smart prams were concerned, poor Cuckoo's pram was regrettably below the proper standard, and she never missed telling me when somebody had come along with a brand new vehicle. 'Any nurse would be proud of a pram like that!' However, I was hardhearted. We were very badly off, and I was *not* going to get a fancy pram at large expense just to indulge Cuckoo's vanity.

'I don't even think that pram's safe,' said Cuckoo, making a last try. 'There's always nuts coming off.'

'That's going on and off the pavement so much,' I said. 'You don't screw them up before you go out. In any case, I am not going to get a new pram.' And I went in again and banged the door.

'Dear, dear,' said Cuckoo. 'Mummy doesn't seem at all pleased, does she? Well, my poor little dear, it doesn't seem as if we're going to have a nice new carriage, does it?'

'Blue Teddy wants his dinner,' said Rosalind. 'Come along, Nanny.'

The Trade Mission bathing at Banff: Bates, Belcher, Archie
and myself

Archie and myself with our surf boards at Honolulu

With Rosalind

Madge and Jimmy Watts in the drawing room at Abney

Our house in Baghdad

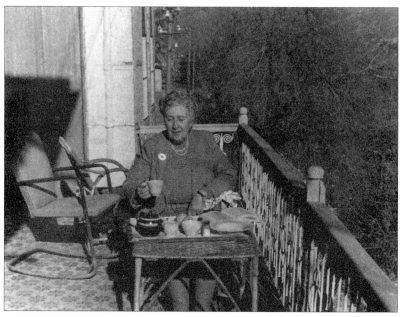

Breakfast in Baghdad overlooking the Tigris

With Sheikh Abdullah at Nimrud in
1951 inspecting a tray of ivories

Excavating at Nimrud.
Max is in the foreground

Max with my Sealyham, James, just before the Second World War

In the Old Bailey – on the set of *Witness for the Prosecution*

Greenway

Rosalind and Mathew at Pwllywrach in 1947

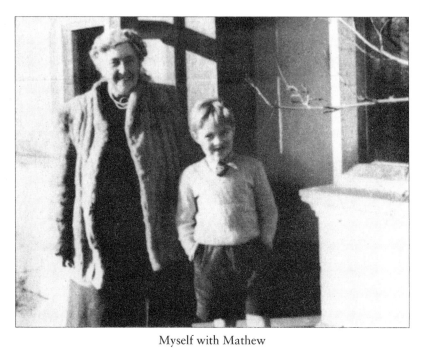

Myself with Mathew

Mathew in 2009 with Agatha's tape recorder

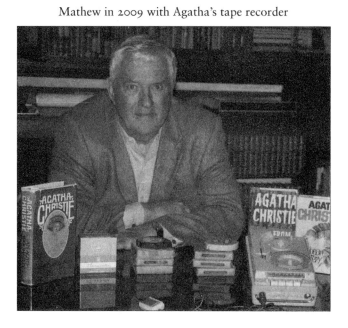

IV

In the end *The Mystery of the Mill House* got finished somehow or other, in spite of the difficulties of Cuckoo's *obbligato* outside the door. Poor Cuckoo! Shortly afterwards she consulted a doctor and moved to a hospital where she had an operation for cancer of the breast. She was a good deal older than she had said she was, and there was no question of her returning to work as a nurse. She went to live, I believe, with a sister.

I had decided that the next nurse should not be selected at Mrs Boucher's Bureau, or from anyone of that ilk. What I needed was a Mother's Help, so a Mother's Help I advertised for.

From the moment which brought Site into our family, our luck seemed to change for the better. I interviewed Site in Devonshire. She was a strapping girl, with a large bust, broad hips, a flushed face and dark hair. She had a deep contralto voice, with a particularly lady-like and refined accent, so much so that you couldn't help feeling that she was acting a part on the stage. She had been a Mother's Help to two or three different establishments for some years now, and radiated competence in the way she spoke of the infant world. She seemed good-natured, good-tempered, and full of enthusiasm. She asked a low salary, and seemed quite willing to do anything, go anywhere – as they say in the advertisements. So Site returned with us to London, and became the comfort of my life.

Naturally her name at that time was not Site – it was Miss White – but after a few months of being with us Miss White became in Rosalind's rapid pronunciation 'Swite'. For a while we called her Swite; then Rosalind made another contraction, and thereafter she was known as Site. Rosalind was very fond of her, and Site liked Rosalind. She liked all small children, but she kept her dignity and was a strict disciplinarian in her own way. She would not stand for any disobedience or rudeness.

Rosalind missed her role as controller and director of Cuckoo. I suspect now that she transferred these activities to me – taking me in her same beneficent charge, finding things for me that I had lost, pointing out to me that I had forgotten to stamp an envelope, and so on. Certainly, by the time that she was five years old, I was conscious that she was

much more efficient than I was. On the other hand she had no imagination. If we were playing a game with each other, in which two figures took part – for instance, a man taking a dog for a walk (I may say that I would be the dog and she would be the man) – there might come a moment when the dog had to be put on a lead.

'We haven't got a lead,' Rosalind would say. 'We'll have to change that part.'

'You can pretend you have a lead,' I suggested.

'How *can* I pretend I have a lead when I've nothing in my hand?'

'Well, take the waist-belt of my dress and pretend that's a lead.'

'It's not a dog lead, it's the waist-belt of a dress.' Things had to be real to Rosalind. Unlike me, she never read fairy stories as a child. 'But they're not *real*,' she would protest. 'They're about people who aren't there – they don't really happen. Tell me about Red Teddy at the picnic.'

The curious thing is that by the time she was fourteen she adored fairy stories, and would read books of them again and again.

Site fitted into our household extremely well. Dignified and competent as she looked, she did not really know much more about cooking than I did. She had been an assistant always. We had to be assistants to each other in our present way of living. Although we each had dishes that we made well – I made cheese soufflé, Bearnaise sauce, and old English syllabub, Site made jam tartlets and could pickle herrings – we were neither of us adept at producing what I believe is termed 'a balanced meal'. To assemble a joint, a vegetable such as carrots, or brussels sprouts, potatoes, and a pudding afterwards, we would suffer from the fact that we did not know exactly how long these various things took to cook. The brussels sprouts would be reduced to a soggy mess, while the carrots were still hard. However, we learnt as we went along.

We divided duties. One morning I took Rosalind in charge and we set off in the serviceable, but not fashionable pram to the park – though by now we used the push-chair more often – while Site prepared the lunch and made the beds. Next morning I would stay at home and do the domestic chores and Site would depart for the park. On the whole I found the first activity more tiring than the second. It was a long way to the park, and when you got there you couldn't sit still and rest and make your mind a blank. You had either to converse with Rosalind and play with her, or see she was suitably occupied playing with somebody else and that nobody was taking away her boat or knocking her down. During

domestic chores I could relax my mind completely. Robert Graves once said to me that washing up was one of the best aids to creative thought. I think he is quite right. There is a monotony about domestic duties – sufficient activity for the physical side, so that it releases your mental side, allowing it to take off into space and make its own thoughts and inventions. That doesn't apply to cooking, of course. Cooking demands all your creative abilities and complete attention.

Site was a welcome relief after Cuckoo. She and Rosalind occupied themselves quite happily without my hearing a peep out of them. They were either in the nursery or down on the green below, or doing some shopping.

It was a shock to me when about six months after she came to us I discovered Site's age. I had not asked her. She seemed obviously between twenty-four and twenty-eight, which was about the age I wanted, and it did not occur to me to be more definite. I was startled when I learnt that at the time of coming into my employment she was seventeen, and was now only just eighteen. It seemed incredible; she had such an air of maturity about her. But she had worked as a Mother's Help since she had been about thirteen. She had a natural liking for her job and full proficiency in it; and her air of experience came from *really* being experienced, very much in the way that the eldest child of a large family has had great experience in dealing with small brothers and sisters.

Young as Site was, I would never have hesitated to go off for long periods and leave Rosalind in her charge. She was eminently sensible. She would send for the right doctor, take a child to a hospital, find out if anything was worrying her, deal with any emergency. Her mind was always on her job. In good old-fashioned terms, she had a vocation.

I heaved an enormous sigh of relief as I finished *The Mystery of the Mill House*. It had not been an easy book to write, and I considered it rather patchy when I had finished it. But there it was, finished, and, like Uncle Tom Cobley and all, with old Eustace Pedler and all. The Bodley Head hemmed and hawed a bit. It was not, they pointed out, a proper detective story, as *Murder on the Links* had been. However, graciously, they accepted it.

It was about then that I noticed a slight change in their attitude. Though I had been ignorant and foolish when I first submitted a book for publication, I had learnt a few things since. I was not as stupid as I must have appeared to many people. I had found out a good deal about writing and publishing. I knew about the Authors' Society and I had

read their periodical. I realised that you had to be extremely careful in making contracts with publishers, and especially with certain publishers. I had learnt of the many ways in which publishers took unfair advantage of authors. Now that I knew these things, I made my plans.

Shortly before bringing out *The Mystery of the Mill House*, The Bodley Head threw out certain proposals. They suggested that they might scrap the old contract and make another one with me, also for five books. The terms of this would be much more favourable. I thanked them politely, said I would think about it, and then refused, without giving any definite reason. They had not treated a young author fairly, I considered. They had taken advantage of her lack of knowledge and her eagerness to publish a book. I did not propose to quarrel with them on this point – I had been a fool. Anyone is a fool who does not find out a little bit about the proper remuneration for the job. On the other hand, would I, in spite of my acquired wisdom, still have refused the chance to publish *The Mysterious Affair at Styles*? I thought not. I would still have published with them on the terms they had suggested, but I would not have agreed to so long a contract for so many books. If you have trusted people once and been disappointed, you do not wish to trust them any more. That is only common sense, I was willing to finish my contract, but after that I was certainly going to find a new publisher. Also, I thought, I was going to have a literary agent.

I had a request from the Income Tax about this time. They wanted to know the details of my literary earnings. I was astonished. I had never considered my literary earnings as income. All the income I had, I thought, was £100 a year from £2000 invested in War Loan. Yes, they said, they knew about that, but they meant my earnings from published books. I explained that these were not something that came in every year – I had just happened to write three books just as I had happened to write short stories before, or poems. I wasn't an author. I wasn't going on writing all my life. I thought, I said, coming on a phrase from somewhere, that this sort of thing was called 'casual profit'. They said they thought by now I really was an established author, even though as yet I might not have made much from my writing. They wanted details. Unfortunately I could not give them details – I had not kept any of the royalty statements sent me (if they had even been sent me, which I could not remember). I occasionally received an odd cheque, but I had usually cashed it straight away and spent it. However, I unravelled things to the best of my ability. The Inland Revenue seemed amused, on the

whole, but suggested that in future I should keep more careful accounts. It was then that I decided I must have a literary agent.

As I didn't know much about literary agents, I thought I had better go back to Eden Philpotts' original recommendation – Hughes Massie. So back I went. It wasn't Hughes Massie now – apparently he had died – instead I was received by a young man with a slight stammer, whose name was Edmund Cork. He was not nearly so alarming as Hughes Massie had been – in fact I could talk to him quite easily. He seemed suitably horrified at my ignorance, and was willing to guide my footsteps in future. He told me the exact amount of his commission, of the possibility of serial rights, and publication in America, of dramatic rights, and all sorts of unlikely things (or so it seemed to me). It was quite an impressive lecture. I placed myself in his hands, unreservedly, and left his office with a sigh of relief. I felt as if an enormous weight had been lifted from my shoulders.

That was the beginning of a friendship which has lasted for over forty years.

An almost unbelievable thing then occurred. I was offered £500 by *The Evening News* for the serial rights of *The Mystery of the Mill House*. It was no longer *The Mystery of the Mill House*: I had rechristened it *The Man in the Brown Suit*, because the other title seemed too like *Murder on the Links*. *The Evening News* proposed to change the title yet again. They were going to call it *Anna The Adventuress* – as silly a title as I had ever heard, I thought; though I kept my mouth shut, because, after all, they were willing to pay me £500, and though I might have certain feelings about the title of a book, nobody could be bothered about the title of a serial in a newspaper. It seemed the most unbelievable luck. I could hardly believe it, Archie could hardly believe it, Punkie could hardly believe it. Mother, of course, could easily believe it: any daughter of hers could earn £500 for a serial in *The Evening News* with the utmost ease – there was nothing surprising about it.

It always seems to be the pattern of life that all the bad things and all the good things come together. I had my stroke of luck with *The Evening News*, now Archie was to have his. He received a letter from an Australian friend, Clive Baillieu, who had long before suggested Archie might join his firm. Archie went to see him and was offered the job he had been yearning for for so many years. He shook off the dust of his present job,

and went in with Clive Baillieu. He was immediately, wonderfully, completely happy. Here at last were sound and interesting enterprises, no sharp practice, and proper entry into the world of finance. We were in the seventh heaven.

Immediately I pressed for the project that I had cherished for so long, and about which Archie had hitherto been indifferent. We would try to find a small cottage in the country from which Archie could go to the City every day, and in the garden of which Rosalind could be turned out to grass, as it were, instead of having to be pushed to the park or confined to activities on the grass strip between the flats. I longed to live in the country. If we could find a cheap enough cottage we decided we would move.

Archie's ready agreement to my plan was mostly, I think, because golf was now occupying more and more of his attention. He had been recently elected to Sunningdale Golf Club, and our weekends together of going off by train and making expeditions on foot had palled. He thought of nothing but golf. He played with various friends at Sunningdale, and now lesser and minor courses were treated by him with scorn. He could get no fun out of playing with a rabbit like me, so little by little, though not aware of the fact yet, I was becoming that well-known figure, a golf widow.

'I don't mind living in the country,' said Archie. 'Indeed, I think I'd quite like it, and of course it would be good for Rosalind. Site likes the country, and I know you do. If so, there is really only one possible place where we *can* live, and that is Sunningdale.'

'Sunningdale,' I said with slight dismay, for Sunningdale was not quite what I meant by the country. 'But surely that is terribly expensive, isn't it? It's all rich people who live there.'

'Oh, I expect we could find something,' said Archie, optimistically.

A day or two later he asked me how I was going to spend my £500 from *The Evening News*. 'It's a lot of money,' I said. 'I suppose –' I admit I spoke grudgingly, with no conviction: 'I suppose we *ought* to save it for a rainy day.'

'Oh, I don't think we need worry too much about that now. In with the Baillieus I shall have very good prospects, and you seem to be getting on with your writing.'

'Yes,' I said. 'Perhaps I could spend it – or spend some of it.' Vague ideas of an new evening dress, perhaps gold or silver evening shoes instead of black ones, something rather ambitious like a fairy cycle for Rosalind.

Archie's voice broke into these musings. 'Why don't you buy a car?' he asked.

'Buy a car?' I looked at him with amazement. The last thing I dreamed of was a car. Nobody I knew in our circle of friends had a car. I was still imbued with the notion that cars were for the rich. They rushed past you at twenty, thirty, forty, fifty miles an hour, containing people with their hats tied on with chiffon veils, speeding to impossible places. 'A *car*?' I repeated, looking more like a zombie than ever.

'Why not?'

Why not indeed? It was possible. I, Agatha, could have a car, a car of my own. I will confess here and now that of the two things that have excited me most in my life the first was my car: my grey bottle-nosed Morris Cowley.

The second was dining with the Queen at Buckingham Palace about forty years later.

Both of those happenings, you see, had something of a fairy-tale quality about them. They were things that I thought could never happen to *me*: to have a car of my own, and to dine with the Queen of England.

Pussycat, Pussycat, where have you been?

I've been to London to visit the Queen.

It was almost as good as having been born the Lady Agatha!

Pussycat, Pussycat, what did you there?

I frightened a little mouse under her chair.

I had no chance of frightening any mouse under Queen Elizabeth II's chair, but I did enjoy my evening. So small, and slender, in her simple dark red velvet gown with one beautiful jewel – and her kindness and easiness in talking. I remember she told us one story of how they used a small drawing-room one night, and in the middle of the evening a terrific fall of soot came down the chimney and they had to rush out of the room. It is cheering to know that domestic disasters happened in the highest circles.

PART VII

THE LAND OF LOST CONTENT

I

While we were looking for our country cottage, bad news came from Africa of my brother Monty. He had not featured largely in any of our lives since before the war when he had a scheme to run cargo boats on Lake Victoria. He sent Madge letters from various people out there, all enthusiastic about the idea. If she could just put up a little capital . . . My sister believed that here was something that Monty might succeed in. Anything to do with boats he was good at. So she paid his fare to England. The plan was to build a small boat in Essex. It was true that there was a great opening for this type of craft. There were no small cargo boats on the Lake at that time. The weak part of the scheme, however, was that Monty was to be the Captain, and nobody had any confidence that the boat would run to time, or the service be reliable.

'It's a splendid idea. Lots of oof to be made. But good old Miller – suppose he just didn't feel like getting up one day? Or didn't like a fellow's face? I mean he's just a law unto himself.'

But my sister, who was of a perennially optimistic nature, agreed to invest the greater part of her capital in getting the boat built.

'James gives me a good allowance, and I can use some of that to help with Ashfield, so I shan't miss the income.'

My brother-in-law was livid. He and Monty disliked each other intensely. Madge, he felt certain, would lose her money.

The boat was taken in hand. Madge went down to Essex several times. Everything seemed to be going well.

The only thing that worried her was the fact that Monty was always

coming up to London, staying at an expensive hotel in Jermyn Street, buying quantities of luxurious silk pyjamas, a couple of specially designed Captain's uniforms, and bestowing on her a sapphire bracelet, an elaborate *petit point* evening bag, and other charming and expensive presents.

'But, Monty, the money is for the *boat* – not to give me presents.'

'But I want you to have a nice present. You never buy anything for yourself.'

'And what's that thing on the window sill?'

'That? It's a Japanese dwarf tree.'

'But they're terribly expensive, aren't they?'

'It was £75. I've always wanted one. Look at the shape. Lovely, isn't it?'

'Oh Monty, I wish you wouldn't.'

'The trouble with you is that living with old James you've forgotten how to enjoy yourself.'

The tree had disappeared when she next visited him.

'Did you take it back to the shop?' she asked hopefully.

'Take it back to the shop?' said Monty horrified. 'Of course not. As a matter of fact I gave it to the receptionist here. Awfully nice girl. She admired it so much, and she'd been worried about her mother.'

Words failed Madge.

'Come out to lunch,' said Monty.

'All right – but we'll go to Lyons.'

'Very well.'

They went through to the street. Monty asked the doorman for a taxi. He hailed one that was passing by, they got in, Monty handed him a half a crown, and told the driver to go to the Berkeley. Madge burst into tears.

'The truth of it is,' said Monty to me later, 'that James is such a miserably mean chap that poor old Madge has got her spirit completely broken. She seems to think of nothing but saving.'

'Hadn't *you* better begin to think, of saving? Suppose the money runs out before the boat's built?'

Monty grinned wickedly.

'Wouldn't matter. Old James would have to fork up.'

Monty stayed with them for a difficult five days, and drank enormous amounts of whisky. Madge went out secretly, bought several more bottles, and put them in his room, which amused Monty very much.

Monty was attracted by Nan Watts, and took her out to theatres and expensive restaurants.

'This boat will never get to Uganda,' Madge would say sometimes in despair.

It might have done. It was Monty's own fault that it didn't. He loved the *Batenga* as he called it. He wanted it to be more than a cargo boat. He ordered fittings of ebony and ivory, a teak-panelled cabin for himself, and specially-made brown fireproof china with the name *Batenga*. All this delayed its dispatch.

And so – the war broke out. There could be no shipping of the *Batenga* to Africa. Instead it had to be sold to the Government at a low price. Monty went back to the Army – this time to the King's African Rifles.

So ended the saga of the *Batenga*.

I still have two of the coffee cups.

Now a letter came from a doctor. Monty had, as we knew, been wounded in the arm in the war. It seemed that during his treatment in hospital, the wound had become infected – carelessness of a native dresser. The infection had persisted, and had recurred even after he was discharged. He had continued with his life as a hunter, but in the end had been picked up and taken to a French hospital run by nuns, very seriously ill.

He had not wished at first to communicate with any of his relations, but he was now almost certainly a dying man – six months was the longest he could hope to live – and he had a great wish to come home to die. It was also possible that the climate in England might prolong his life a little.

Arrangements were quickly made for Monty's passage from Mombassa by sea. My mother started making preparations at Ashfield. She was transported with joy – she would look after him devotedly – her dearest boy. She began to envisage a mother-and-son relationship which I felt quite sure was entirely unrealistic. Mother and Monty had never really got on together harmoniously. In many ways they were too much alike. They both wanted their own way. And Monty was one of the most difficult people in the world to live with.

'It will be different now,' said my mother. 'You forget how ill the poor boy is.'

I thought that Monty ill would be just as difficult as Monty well. People's natures don't change. Still, I hoped for the best.

Mother had a little difficulty in reconciling her two elderly maids to the idea of having Monty's African servant in the house also.

'I don't think, Madam – I really don't think that we could sleep in the same house with a *black* man. It's not what me and my sister have been accustomed to.'

Mother went into action. She was a woman not easy to withstand. She talked them round to staying. The lure she held out to them in the end was the possibility that they might be able to convert the African from Mohammedanism to Christianity. They were very religious women.

'We could read the Bible to him,' they said, their eyes lighting up.

Mother, meanwhile, prepared a self-contained suite of three rooms and a new bathroom.

Archie very kindly said he would go to meet Monty's boat docked at Tilbury. He had also taken a small flat in Bayswater for him to go to with his servant.

As Archie departed from Tilbury, I called after him: 'Don't let Monty make you take him to the Ritz.'

'What did you say?'

'I said "Don't let him make you take him to the Ritz" – I'll see that the flat is all ready, and the landlady alerted and plenty of stores in.'

'Well, that's all right then.'

'I hope so. But he might prefer the Ritz.'

'Don't worry. I'll have him all settled in before lunch.'

The day wore on. At 6.30 Archie returned. He looked exhausted.

'It's all right. I've got him settled in. It was a bit of a job getting him off the boat. He wasn't packed up or anything – kept saying there was plenty of time – what was the hurry? Everybody else was off the ship, and he was holding things up – but he didn't seem to care. That Shebani is a good chap – very helpful. He managed to get things moving in the end.'

He paused, and cleared his throat.

'As a matter of fact, I didn't take him to Powell Square. He seemed absolutely set on going to some hotel in Jermyn Street. He said it would be much less trouble to everyone.'

'So that's where he is.'

'Well – yes.'

I looked at him.

'Somehow,' said Archie, 'it seemed so reasonable the way he put it.'

'That is Monty's strong point,' I informed him.

Monty was taken to a specialist in tropical diseases to whom he had been recommended. The specialist gave full directions to my mother. There was a chance of partial recovery: good air – continual soaking in hot baths – a quiet life. What might prove difficult was that, having considered him almost certainly a dying man, they had kept him under drugs to such an extent that he would find it difficult to break the habit now.

We got Monty and Shebani into the Powell Square flat after a day or two, and they settled down quite happily – although Shebani created quite a stir by dropping into neighbouring tobacconists, seizing a packet of fifty cigarettes, saying, 'For my master', and leaving the shop. The Kenya system of credit was not appreciated in Bayswater.

Then, after the London treatments were over, Monty and Shebani moved down to Ashfield – and the mother-and-son 'ending his days in peace' concept was tried out. It nearly killed my mother. Monty had his African way of life. His idea of meals was to call for them whenever he felt like eating, even if it was four in the morning. This was one of his favourite times. He would ring bells, call to the servants, and order chops and steaks.

'I don't understand what you mean, mother, by "considering the servants". You pay them to cook for you, don't you?'

'Yes – but not in the middle of the night.'

'It was only an hour before sunrise. I always used to get up then. It's the proper start to the day.'

It was Shebani who really succeeded in making things work. The elderly maids adored him. They read the Bible to him, and he listened with the greatest interest. He told them stories of life in Uganda and of the prowess of his master in shooting elephants.

He gently took Monty to task for his treatment of his mother.

'She is your mother, Bwana. You must speak to her with reverence.'

After a year Shebani had to go back to Africa to his wife and family, and things became difficult. Male attendants were not a success, either with Monty or my mother. Madge and I went down alternately to try to soothe them down.

Monty's health was improving, and as a result he was much more difficult to control. He was bored, and for relaxation took to shooting out of his window with a revolver. Tradespeople and some of mother's visitors complained. Monty was unrepentant. 'Some silly old spinster

going down the drive with her behind wobbling. Couldn't resist it – I sent a shot or two right and left of her. My word, how she ran!'

He even sent shots all round Madge one day on the drive, and she was frankly terrified.

'I can't think why!' said Monty. 'I shouldn't have hurt her. Does she think I can't aim?'

Someone complained, and we had a visit from the police. Monty produced his firearm licence and talked very reasonably about his life as a hunter in Kenya, and his wish to keep his eye in. Some silly woman had got the idea he had been firing at *her*. Actually he had seen a rabbit. Being Monty, he got away with it. The police accepted his explanation as quite natural for a man who had led the life that Captain Miller had.

'The truth is, kid, I can't stand being cooped up here. This tame sort of existence. If I could only have a little cottage on Dartmoor – that's what I'd like. Air and space – room to breathe.'

'Is that what you'd really like?'

'Of course it is. Poor old mother drives me mad. Fussy – all these set times for meals. Everything cut and dried. It's not what I've been used to.'

I found Monty a small granite bungalow on Dartmoor. We also found, by a kind of miracle, the right housekeeper to look after him. She was a woman of sixty-five – and when we saw her first she looked wildly unsuitable. She had bright peroxided yellow hair, curls, and a lot of rouge. She was dressed in black silk. She was the widow of a doctor who had been a morphia addict. She had lived most of her life in France, and had had thirteen children.

She was the answer to a prayer – she could manage Monty as no one else had been capable of doing. She rose and cooked his chops in the middle of the night if he wanted them. But, said Monty after a while, I've rather given up that, kid – bit hard on Mrs Taylor, you know. She's a good sport, but she's not young.'

Unasked and unbidden, she dug up the small garden and produced peas, new potatoes and French beans. She listened when Monty wanted to talk, and paid no attention when he was silent. It was wonderful.

Mother recovered her health. Madge stopped worrying. Monty enjoyed visits from his family, and always behaved beautifully on those occasions, very proud of the delicious meals produced by Mrs Taylor.

£800 for the Dartmoor bungalow was a cheap price for Madge and me to have paid.

II

Archie and I found our cottage in the country – though it wasn't a cottage. Sunningdale, as I had feared, was an excessively expensive place to live. It was full of luxurious modern houses built round the golf-course, there weren't any country cottages at all. But we found a large Victorian house, Scotswood, situated in a big garden, which was being divided into four flats. Two of these were already taken – the two on the ground floor – but there were two flats upstairs in the course of being adapted, and we looked over them. Each contained three rooms on the first floor and two on the floor above, and a kitchen and bathroom, of course. One flat was more attractive than the other – having better shaped rooms and a better outlook – but the other had a small extra room and was also cheaper, so we settled on the cheaper one. Tenants had the use of the garden, and constant hot water was supplied. The rent was more than that of our Addison Road flat, but not much so. It was, I think, £120. So we signed a lease and prepared to move in.

We came down constantly to see how the decorators and painters were getting on – which was always much less than they had promised. Every time we did so we found that something had been done wrong. Wall-papers were the most foolproof. You cannot do anything too awful to a wallpaper, unless you put the wrong one on altogether – but you can put every shade of wrong paint on, and we weren't on the spot to see what was happening. However, all was settled in time. We had a big sitting-room, with new cretonne curtains of lilac – made by me. In the small dining-room we had some rather expensive curtains, because we fell in love with them, of tulips on a white ground. Rosalind and Site's larger room behind it had curtains with buttercups and daisies. On the floor above, Archie had a dressing-room and emergency spare-room very virulently coloured – scarlet poppies and blue cornflowers – and in our bedroom I chose curtains of bluebells, which was not really a good choice, because since this particular room faced north the sun seldom shone through. The only time they were pretty was when one lay in bed in mid-morning and saw the light shining through them, pulled back on either side of the window, or seen at night, the blue rather faded out. In fact it was like

bluebells in nature. As soon as you bring them into the house they turn grey and dispirited and refuse to hold up their heads. A bluebell is a flower that refuses to be captured and is only gay when it is in the woods. I consoled myself by writing a ballad about bluebells:

BALLAD OF THE MAYTIME

The King, he went a-walking, one merry morn in May.
The King, he laid him down to rest, and fell asleep, they say.
And when he woke, 'twas even,
(The hour of magic mood)
And Bluebell, wild Bluebell, was dancing in the wood.

The King, he gave a banquet to all the flowers (save one),
With hungry eyes he watched them, a-seeking one alone.
The Rose was there in satin,
The Lily with green hood,
But Bluebell, wild Bluebell, only dances in the wood.

The King, he frowned in anger, his hand upon his sword.
He sent his men to seize her, and bring her to their Lord.
With silken cords they bound her,
Before the King she stood,
Bluebell, wild Bluebell, who dances in the wood.

The King, he rose to greet her, the maid he'd sworn to wed.
The King, he took his golden crown and set it on her head.
And then he paled and shivered,
The courtiers gazed in fear,
At Bluebell, grey Bluebell, so pale and ghostly there.

'O King, your crown is heavy, 'twould bow my head with care.
Your palace walls would shut me in, who live as free as air.
The wind, he is my lover,
The sun my lover too,
And Bluebell, wild Bluebell, shall ne'er be Queen to you.'

The King, he mourned a twelvemonth, and none could ease his pain.
The King, he went a-walking a-down a lovers' lane.
He laid aside his golden crown,
Into the wood went he,
Where Bluebell, wild Bluebell, dances ever wild and free.

The Man in the Brown Suit went very well indeed. The Bodley Head pressed me again to make a splendid new contract with them. I refused.

The next book I sent them was one made from a long short story that I had written a good many years before. I was rather fond of it myself: it dealt with various supernatural happenings. I elaborated it a little, brought a few more characters into it, and sent it off to them. They did not accept it. I had been sure that they would not. There was no clause in the contract which decreed that any book I offered them had to be either a detective story or a thriller. It merely said 'the next novel'. This had been made a full novel – just – and it was up to them to take it or refuse it. They refused it, so I had only one more book to write for them. After that, freedom. Freedom, and the advice of Hughes Massie – and from then onwards I should have first-class advice as to what to do, and, even more important, what not to do.

The next book I wrote was a completely light-hearted one, rather in the style of *The Secret Adversary*. They were more fun and quicker to write, and my work reflected the light-heartedness that I felt at this particular period, when everything was going so well. My life at Sunningdale, the fun of Rosalind developing every day, getting more amusing and more interesting. I have never understood people who want to keep their children as babies and regret every year that they grow older. I myself sometimes felt that I could hardly wait: I wanted to see exactly what Rosalind would be like in a year's time, a year after that, and so on. There is nothing more thrilling in this world, I think, than having a child that is yours, and yet is mysteriously a stranger. You are the gate through which it came into the world, and you will be allowed to have charge of it for a period: after that it will leave you and blossom out into its own free life – and there it is, for you to watch, living its life in freedom. It is like a strange plant which you have brought home, planted, and can hardly wait to see how it will turn out.

Rosalind took happily to Sunningdale. She had the delight of her fairy cycle, on which she bicycled with great ardour all round the garden, falling off occasionally, but never caring. Site and I had both warned her not to go outside the gate, but I don't think that either of us had made it a definite prohibition. Anyway, go outside the gate she did, on an early morning when we were both busy in the flat. She cycled out full steam down the hill towards the main road and, rather fortunately, fell off just before she got there. The fall drove her two front teeth inward, and would probably, I feared, prejudice her next teeth when they arrived. I took her to the dentist, and Rosalind, though not complaining, sat in the dentist's chair with her lips firmly clasped over her teeth, refusing to

open her mouth for anyone. Anything that I said, Site said, or the the dentist said was received without a word, and her teeth remained firmly clenched. I had to take her away. I was furious. Rosalind received all reproaches in silence. After some lecturing with Site and some from me, two days later she announced that she *would* go to the dentist.

'Do you really mean it this time, Rosalind, or will you do the same thing when you get there?'

'No, I'll open my mouth this time.'

'I suppose you were frightened?'

'Well, you can't be sure, can you,' said Rosalind, '*what* anyone is going to do to you?'

I acknowledged this, but assured her that everybody that she knew and that I knew in England went to dentists, opened their mouths, and had things done to their teeth which resulted in ultimate benefit. Rosalind went, and behaved beautifully this time. The dentist removed the loosened teeth, and said she might have to wear a plate later, but he thought probably not.

Dentists, I could not help feeling, were not made of the same stern stuff that they used to be in my childhood. Our dentist was called Mr Hearn, a small man, exceedingly dynamic, and with a personality that overawed his patients at once. My sister was taken to him at the tender age of three. Madge, ensconced in the dentist's chair, immediately began to cry.

'Now then,' said Mr Hearn, 'I can't allow that. I never allow my patients to cry.'

'Don't you?' said Madge, so surprised that she stopped at once.

'No,' said Mr Hearn, 'it is a bad thing, so I don't allow it.' He had no more trouble.

We were all terribly pleased to get to Scotswood: It was so exciting to be in the country again: Archie was delighted, because he was now in close proximity to Sunningdale Golf Course. Site was pleased because she was saved the long treks to the park, and Rosalind because she had the garden for her fairy cycle. So everyone was happy. This in spite of the fact that when we arrived with the furniture van nothing was ready for us. Electricians were still burrowing about in the passages, and there was the greatest difficulty in moving any furniture in. Problems with baths, taps, and electric light were incessant, and the general level of inefficiency was unbelievable.

Anna the Adventuress had now appeared in *The Evening News* and I had

bought my Morris Cowley – and a very good car it was: much more reliable and better made than cars are nowadays. The next thing I had to do was to learn to drive it.

Almost immediately, however, the General Strike was upon us, and before I had had more than about three lessons with Archie he informed me that I would have to drive him to London.

'But I can't. I don't know how to drive!'

'Oh yes, you do. You're coming along quite well.'

Archie was a good teacher, but there was no question in those days of having to pass any test. There was no such thing as an L-driver. From the moment you took the controls of the car you were responsible for what you did with it.

'I don't think I can really reverse at all,' I said doubtfully. 'The car never seems to go where I think it's going.'

'You won't have to back,' said Archie with assurance. 'You can steer quite well – that's all that matters. If you go at a reasonable pace you'll be all right. You know how to put the brake on.'

'You taught me that first of all,' I said.

'Yes, of course I did. I don't see why you should have any trouble.'

'But the traffic,' I said falteringly.

'Oh no, you needn't do the traffic at all to begin with.'

He had heard that there were electric trains going from Hounslow Station, and so my task would be to motor to Hounslow with Archie at the wheel; then he would turn the car round, put it in position for the return journey, and leave me to get on by my own devices while he went to the City.

The first time I did this was one of the worst ordeals I have ever known. I was shaking with fright, but I managed, nevertheless, to get on reasonably well. I stalled the engine once or twice by braking rather more violently than I need, and I was rather chary about passing things, which was probably just as well. But of course the traffic on the roads then was not anything like what it would be nowadays, and called for no special skill. As long as you could steer reasonably, and didn't have to park, or turn, or reverse too much, all was well. The worst moment was when I had to turn into Scotswood and get myself into an extremely narrow garage, next to our neighbour's car. These people lived in the flat below us – a young couple called the Rawncliffes. The wife reported to her husband: 'I saw the first floor driving back this morning. I don't think she has ever driven a car before. She drove into that garage absolutely

shaking and as white as a sheet. I thought she was going to ram the wall, but she just didn't!'

I don't think anyone but Archie could have given me assurance under these conditions. He always took it for granted that I could do things about which I myself had a good deal of doubt. 'Of course you can do it,' he would say. 'Why shouldn't you? If you always think you can't do things you never will do them.'

I gained a little confidence and after three or four days was able to penetrate further into London and to brave the dangers of the traffic. Oh the joy that car was to me! I don't suppose anyone nowadays could believe the difference it made to one's life. To be able to go anywhere you chose; to places beyond the reach of your legs – it widened your whole horizon. One of the greatest pleasures I had out of the car was going down to Ashfield and taking mother out for drives. She enjoyed it passionately, just as I did. We went to all sorts of places – Dartmoor, the house of friends she had never been able to see because of the difficulties of transport – and the sheer joy of driving was enough for us both. I don't think anything has given me more pleasure, more joy of achievement, than my dear bottle-nosed Morris Cowley.

Though helpful with most practical things in life, Archie was of no use in my writing. Occasionally I felt the urge to outline to him some idea I had for a new story, or the plot of a new book. When I had described it haltingly, it sounded, even to my ears, extraordinarily banal, futile, and a great many other adjectives which I will not particularize. Archie would listen with the kind benevolence he displayed when he had decided to give his attention to other people. Finally, 'What do you think?' I asked timidly. 'Do you think it will be all right?'

'Well, I suppose it might be,' said Archie, in a completely damping manner. 'It doesn't seem to have much *story* to it, does it? Or much excitement either?'

'You don't really think it will do, then?'

'I think you can do much better.'

That plot thereupon fell dead, slain for ever, I felt. As it happened, I resurrected it, or rather it resurrected itself, five or six years later. This time, not subjected to criticism before the act, it blossomed most satisfactorily, and turned out to be one of my best books. The trouble is that it is awfully hard for an author to put things in words when you have to do it in the course of conversation. You can do it with a pencil in your

hand, or sitting in front of your typewriter – then the thing comes out already formed as it should come out – but you can't describe things that you are only *going* to write; or at least I can't. I learnt in the end never to say *anything* about a book before it was written. Criticism *after* you have written it is helpful. You can argue the point, or you can give in, but at least you know how it has struck one reader. Your own description of what you are going to write, however, sounds so futile, that to be told kindly that it won't do meets with your instant agreement.

I will never agree to the hundreds of requests that reach me asking me to read someone's MS. For one thing, of course, you would never do anything else *but* read MSS if you once started agreeing to do so! But the real point is that I don't think an author is competent to criticise. Your criticism is bound to be that you yourself would have written it in such and such a way, but that does not mean that that would be right for another author. We all have our own ways of expressing ourselves.

Also, there is the frightening thought that you may be discouraging someone who ought not to be discouraged. An early story of mine was shown to a well-known authoress by a kindly friend. She reported on it sadly but adversely, saying that the author would never make a writer. What she really *meant*, though she did not know it herself because she was an author and not a critic, was that the person who was writing was still an immature and inadequate writer who could not as yet produce anything worth *publishing*. A critic or an editor might have been more perceptive, because it is their profession to notice the germs of what may be. So I don't like criticising and I think it can easily do harm.

The only thing I will advance as criticism is the fact that the would-be writer has not taken any account of the market for his wares. It is no good writing a novel of 30,000 words – that is not a length which is easily publishable at present. 'Oh,' replies the author, 'but this book has got to be that length.' Well, that is probably all right if you're a genius, but you are more likely to be a tradesman. You have got something you feel you can do well and that you enjoy doing well, and you want to sell it well. If so, you must give it the dimensions and the appearance that is wanted. If you were a carpenter, it would be no good making a chair, the seat of which was five feet up from the floor. It wouldn't be what anyone wanted to sit on. It is no good saying that you think the chair looks handsome that way. If you want to write a book, study what sizes books are, and write within the limits of that size. If you want to write a certain type of short story for a certain type of magazine you have to make it the length,

and it has to be the type of story, that is printed in that magazine. If you like to write for yourself only, that is a different matter – you can make it any length, and write it in any way you wish; but then you will probably have to be content with the pleasure alone of having written it. It's no good starting out by thinking one is a heaven-born genius – some people are, but very few. No, one is a tradesman – a tradesman in a good honest trade. You must learn the technical skills, and then, within that trade, you can apply your own creative ideas; but you must submit to the discipline of form.

It was by now just beginning to dawn on me that perhaps I *might* be a writer by profession. I was not sure of it yet. I still had an idea that writing books was only the natural successor to embroidering sofa-cushions.

Before we left London for the country I had taken lessons in sculpture. I was a great admirer of the art – much more than of pictures – and I had a real yearning to be a sculptor myself. I was early disillusioned in that hope: I saw that it was not within my capacity because I had no eye for visual form. I couldn't draw, so I couldn't sculpt. I had thought it might be different with sculpture, that feeling and handling clay would help with form. But I realised I couldn't really *see* things. It was like being tone deaf in music.

I composed a few songs by way of vanity, setting some of my verses to music. I had a look at the waltz I composed again, and thought I had never heard anything more banal. Some of the songs were not so bad. One of the series of Pierrot and Harlequin verses pleased me. I wished that I had learnt harmony and knew something about composition. But writing seemed to be indicated as my proper trade and self-expression.

I wrote a gloomy play, mainly about incest. It was refused firmly by every manager I sent it to. 'An unpleasant subject.' The curious thing is that, nowadays, it is the kind of play which might quite likely appeal to a manager.

I also wrote an historical play about Akhnaton. I liked it enormously. John Gielgud was later kind enough to write to me. He said it had interesting points, but was far too expensive to produce and had not enough humour. I had not connected humour with Akhnaton, but I saw that I was wrong. Egypt was just as full of humour as anywhere else – so was life at any time or place – and tragedy had its humour too.

III

We had been through so much worry since we came back from our world tour that it seemed wonderful to enter on this halcyon period. Perhaps it was then that I ought to have felt misgiving. Things went too well. Archie had the work he enjoyed, with an employer who was his friend; he liked the people he worked with; he had what he had always wanted, to belong to a first-class golf club, and to play every weekend. My writing was going well, and I began to consider that perhaps I should be able to go on writing books and making money by it.

Did I realise that there might be something not quite right in the even tenor of our days? I don't think so. And yet there was a certain lack, though I don't think I ever put it into definite terms to myself. I missed the early companionship of our time together, Archie and I. I missed the weekends when we had gone by bus or by train and had explored places.

Our weekends now were the dullest time for me. I often wanted to ask people down for the weekend, so as to see some of our London friends again. Archie discouraged that, because he said it spoilt *his* weekends. If we had people staying he would have to be more at home and perhaps miss his second round of golf. I suggested that he should play tennis sometimes instead of golf, because we had several friends with whom he had played tennis on public courts in London. He was horrified. Tennis, he said, would completely spoil his eye for golf. He was taking the game so seriously now that it might have been a religion.

'Look here, you ask any of your friends down if you like, but don't let's ask down a married couple, because then *I* have to do something about it.'

That was not so easy to do, because most of our friends were married couples, and I couldn't very well ask the wife without the husband. I was making friends in Sunningdale, but Sunningdale society was mainly of two kinds: the middle-aged, who were passionately fond of gardens and talked of practically nothing else; or the gay, sporting rich, who drank a good deal, had cocktail parties, and were not really my type, or indeed, for that matter, Archie's.

One couple who could and did stay with us for a weekend were Nan

Watts and her second husband. She had married a man called Hugo Pollock during the war, and had one daughter, Judy; but the marriage had not turned out well, and in the end she had divorced her husband. She re-married a man called George Kon, who was also a keen golfer, so that solved the weekend problem. George and Archie played together; Nan and I gossiped, talked and played some desultory golf on the ladies' links. Then we would go up and meet the men at the club-house and have a drink there. At least Nan and I would take up our own drinks: half a pint of raw cream thinned down with milk – just as we had drunk it down at the farm at Abney in early days.

It was a great blow when Site left us, but she took her career seriously, and for some time she had wanted to take a post abroad. Rosalind, she pointed out, would be going to school the following year, and so would need her less. She had heard of a good post in the Embassy in Brussels, and would like to take it. She hated leaving us, she said, but she did want to get on so that she could go as a governess to places all over the world and see something of the life. I could not help being sympathetic towards this point of view, and sadly we agreed that she should go to Belgium.

I thought then, remembering how happy I had been with Marie and how nice it had been to learn French without tears, that I might get a French nursery governess for Rosalind. Punkie wrote to me enthusiastically saying that she knew just the person but she was Swiss, not French. She had met her, and a friend of hers knew her family in Switzerland. 'She is a sweet girl, Marcelle. Very gentle.' She thought that she was just the person for Rosalind, would be sorry for her because she was shy and nervous, and would look after her. I don't know that Punkie and I agreed exactly in our estimate of Rosalind's character!

Marcelle Vignou duly arrived. I had slight misgivings from the first. Punkie's account of her was of a gentle, charming, little thing. She made a different impression on me. She seemed to be lethargic, though quite good-natured, lazy, and uninteresting. She was the sort of person who was incapable of managing children. Rosalind, who was reasonably well-behaved and polite, and on the whole quite satisfactory in daily life, became, almost overnight, what I can only describe as possessed by a devil.

I couldn't have believed it. I learnt then what no doubt most child-trainers know instinctively, that a child reacts just as a dog or any other animal: it knows authority. Marcelle had no authority. She shook her head gently occasionally and said 'Rosalind! *Non, non*, Rosalind!' without the least effect.

To see them out for walks together was pitiful. Marcelle, as I discovered before long, had both feet covered with corns and bunions. She could only limp along at a funeral pace. When I did discover this I sent her off to a chiropodist, but even that did not make much difference in her pace. Rosalind, an energetic child, strode ahead, looking extremely British, with her chin in the air, Marcelle trailing miserably behind, murmuring: 'Wait for me – *attendez-moi!*'

'We're going for a walk, aren't we?' Rosalind would throw back over her shoulder.

Marcelle, in an extremely foolish fashion, would then buy Rosalind peace offerings of chocolate in Sunningdale – the worst thing she could have done. Rosalind would accept the chocolate, murmuring 'Thank you' quite politely, and afterwards would behave as badly as ever. In the house she was a little fiend. She would take off her shoes and throw them at Marcelle, make faces at her, and refuse to eat her dinner.

'What am I to do?' I asked Archie. 'She is simply *awful*. I punish her, but it doesn't seem to make her any better. She is really beginning to like torturing the poor girl.'

'I don't think the girl really cares,' said Archie. 'I've never seen anyone more apathetic.'

'Perhaps things will get better,' I said.

But things did not get better, they got worse. I was really worried because I did not want to see my child turn into a raging demon. After all, if Rosalind could behave properly with two nurses and a nursery governess, there must be some fault on the other side which led her to behave so badly to this particular girl.

'Aren't you sorry for Marcelle, coming to a strange country like this, where nobody speaks her language?' I asked.

'She wanted to come,' said Rosalind. 'She wouldn't have come if she hadn't wanted to. She speaks English quite well. She really is so awfully, awfully stupid.' Nothing, of course, could have been truer than that.

Rosalind was learning a little French, but not much. Sometimes, on wet days, I would suggest they played games together, but Rosalind assured me it was impossible even to teach Marcelle Beggar My Neighbour. 'She just can't remember it's four for an ace and three for a king,' she said with scorn.

I told Punkie that it wasn't being a success.

'Oh dear, I thought she'd simply love Marcelle.'

'She doesn't,' I said. 'Far from it. And she thinks up ways of tormenting the poor girl, and she throws things at her.'

'Rosalind *throws* things at her?'

'Yes,' I said. 'And she's getting worse.'

In the end I decided that we could not bear it any longer. Why should *our* lives be ruined? I spoke to Marcelle, murmuring that I thought things were not being a great success and that perhaps she would be happier in some other post; that I would recommend her and try to find her a position, unless she would rather go back to Switzerland. Unperturbed, Marcelle said she had quite enjoyed seeing England, but she thought on the whole she would go back to Berne. She said goodbye, I pressed upon her an extra month's wages – and determined to seek someone else.

What I thought I would now have was a combined secretary and governess. Rosalind would go to school every morning when she was five, at a small local school, and I could then have a secretary shorthand-typist for some hours at my beck and call. Perhaps I should be able to dictate my literary works. It seemed a good idea. I put an advertisement in the paper, asking for someone who would look after a child of five, shortly to go to school, and act as secretary shorthand-typist – I added 'Scottish preferred'. I had noticed, now that I saw more of other children and their attendants, that the Scottish seemed to be particularly good with the young. The French were hopeless disciplinarians, and were always bullied by their charges; Germans were good and methodical, but it was not German that I really wanted Rosalind to learn. The Irish were gay but made trouble in the house; the English were of all kinds. I had a yearning for somebody Scottish.

I sorted out various answers to my advertisement, and in due course went to London to a small private hotel near Lancaster Gate to interview a Miss Charlotte Fisher. I liked Miss Fisher as soon as I saw her. She was tall, brown-haired, about twenty-three, I judged; had had experience with children, looked extremely capable, and had a nice-looking twinkle behind her general decorum. Her father was one of the Chaplains to the King in Edinburgh, and Rector of St. Columba's there. She knew shorthand and typing, but had not had much experience recently in shorthand. She liked the idea of a post where she could do secretarial work as well as looking after a child.

'There's one other thing,' I said rather doubtfully. 'Do you – er – do you think you can – I mean, are you good at getting on with old ladies?'

Miss Fisher gave me rather an odd look. I suddenly noticed that we were sitting in a room containing about twenty old ladies, knitting, crocheting, and reading picture papers. Their eyes all slowly swivelled to me as I put this question. Miss Fisher bit her lip to stop herself laughing. I had been oblivious of my surroundings because I had been wondering how to frame my question. My mother was now definitely difficult to get on with – most people are as they get older, but mother, who had always been most independent and who got tired and bored with people easily, was more difficult than most. Jessie Swannell, particularly, had not been able to stand it.

'I think so,' Charlotte Fisher replied in a matter-of-fact voice. 'I've never found any difficulty.'

I explained that my mother was elderly, slightly eccentric, inclined to think she knew best – and not easy to get on with. Since Charlotte seemed to view this without alarm, we settled that she would come to me as soon as she was free from her present job, which was, I gather, looking after the children of a millionaire domiciled in Park Lane. She had a sister rather older than herself, who lived in London, and she would be glad if the sister could occasionally come down and see her. I said that would be quite all right.

So Charlotte Fisher came to be my secretary and Mary Fisher came as a help in trouble when necessary, and they remained with me as friend and secretary and governess and dogsbody and everything else for many years. Charlotte is still one of my best friends.

The coming of Charlotte, or Carlo, as Rosalind began to call her after a month, was like a miracle. She had no sooner stepped inside the door of Scotswood than Rosalind was mysteriously transformed to her old self in the days of Site. She might have been sprinkled with holy water! Her shoes remained on her feet and were not thrown at anybody, she replied politely, and she appeared to take a good deal of pleasure in Carlo's company. The raging demon had disappeared. 'Though I must say,' said Charlotte to me later, 'she looked a little like a wild animal when I arrived, because nobody seemed to have cut her fringe for a long time: it was hanging down in front of her eyes, and she was peering through it.'

So the period of halcyon days began. As soon as Rosalind started school I began to prepare to start dictating a story. I was so nervous about it that I put it off from day to day. Finally the time came: Charlotte and I sat down opposite each other, she with her note-book and pencil.

I stared unhappily at the mantelpiece, and began uttering a few tentative sentences. They sounded dreadful. I could not say more than a word without hesitating and stopping. Nothing I said sounded natural. We persisted for an hour. Long afterwards Carlo told me that she herself had been dreading the moment when literary work should begin. Although she had taken a shorthand-typing course she had never had much practice in it, and indeed had tried to refresh her skills by taking down sermons. She was terrified that I would rush along at a terrific pace – but nobody could have found any difficulty in taking down what I was saying. They could have written it in longhand.

After this disastrous start things went better but for creative work I usually feel happier either writing things in longhand or typing them. It is odd how hearing your own voice makes you self-conscious and unable to express yourself. It was only about five or six years ago, after I had broken a wrist and was unable to use my right hand, that I started using a dictaphone, and gradually became used to the sound of my own voice. The disadvantage of a dictaphone or tape recorder, however, is that it encourages you to be much too verbose.

There is no doubt that the effort involved in typing or writing does help me in keeping to the point. Economy of wording, I think, is particularly necessary in detective stories. You don't want to hear the same thing rehashed three or four times over. But it is tempting when one is speaking into a dictaphone to say the same thing over and over again in slightly different words. Of course, one can cut it out later, but that is irritating, and destroys the smooth flow which one gets otherwise. It is important to profit by the fact that a human being is naturally lazy and so won't write more than is absolutely necessary to convey his meaning.

Of course, there is a right length for everything. I think myself that the *right* length for a detective story is 50,000 words. I know this is considered by publishers as too short. Possibly readers feel themselves cheated if they pay their money and only get 50,000 words – so 60,000 or 70,000 are more acceptable. If your book runs to more than that I think you will usually find that it would have been better if it had been shorter. 20,000 words for a long short story is an excellent length for a thriller. Unfortunately there is less and less market for stories of that size, and the authors tend not to be particularly well paid. One feels therefore that one would do better to continue the story, and expand it to a full-length novel. The short story technique, I think, is not really suited to the detective story at all. A thriller, possibly – but a detective story no.

The Mr Fortune stories of H. C. Bailey were good in that line, because they were longer than the average magazine story.

By now Hughes Massie had settled me with a new publisher, William Collins, with whom I still remain as I am writing this book.

My first book for them, *The Murder of Roger Ackroyd*, was far and away my most successful to date; in fact it is still remembered and quoted. I got hold of a good formula there – and I owe it in part to my brother-in-law, James, who some years previously had said somewhat fretfully as he put down a detective story; 'Almost everybody turns out to be a criminal nowadays in detective stories – even the detective. What *I* would like to see is a Watson who turned out to be the criminal.' It was a remarkably original thought and I mulled over it lengthily. Then, as it happened, very much the same idea was also suggested to me by Lord Louis Mountbatten, as he then was, who wrote to suggest that a story should be narrated in the first person by someone who later turned out to be the murderer. The letter arrived when I was seriously ill and to this day I am not certain whether I acknowledged it.

I thought it was a good idea, and considered it for a long time. It had enormous difficulties, of course. My mind boggled at the thought of Hastings murdering anybody, and it was anyway going to be difficult to do it in such a way that it would not be cheating. Of course, a lot of people say that *The Murder of Roger Ackroyd is* cheating; but if they read it carefully they will see that they are wrong. Such little lapses of time as there have to be are nicely concealed in an ambiguous sentence, and Dr Sheppard, in writing it down, took great pleasure himself in writing nothing but the truth, though not the whole truth.

Quite apart from *The Murder of Roger Ackroyd*, it was success all along the line at this period. Rosalind went to her first school, and enjoyed it enormously. She had pleasant friends; we had a nice flat and garden; I had my lovely bottle-nosed Morris; I had Carlo Fisher, and domestic peace. Archie thought, talked, dreamt, slept and lived for golf; his digestion improved so that he suffered less from nervous dyspepsia. All was for the best in the best of all possible worlds, as Dr Pangloss so happily says.

There was one lack in our lives: a dog. Dear Joey had died whilst we were abroad, so we now purchased a wire-haired terrier puppy whom we named Peter. Peter, of course, became the life and soul of the family. He slept on Carlo's bed, and ate his way through a variety of slippers and so-called indestructible balls for terriers.

The lack of worry about finances was pleasant after all we had undergone in the past – and possibly it went to our heads a bit. We thought of things we would not have thought of otherwise. Archie electrified me one day by suddenly saying that he thought he would like to get a really fast car. He had been excited, I think, by the Strachans' Bentley.

'But we've *got* a car,' I said, shocked.

'Ah, but I mean something really special.'

'We could afford another baby now,' I pointed out. I had been contemplating this for some time with a good deal of pleasure.

Archie waved aside another baby. 'I don't want anyone but Rosalind,' he said. 'Rosalind is absolutely satisfactory, quite enough.'

Archie was mad about Rosalind. He enjoyed playing with her, and she even cleaned his golf clubs. They understood each other, I think, better than Rosalind and I did. They had the same sense of humour, and saw each other's point of view. He liked her toughness and her suspicious attitude of mind: the way she would never take anything for granted. He had been worried about the advent of Rosalind beforehand, being afraid, as he said, that nobody would take any notice of *him* any more. 'That's why I hope we have a daughter,' he said. 'A boy would be much worse. I could bear a daughter; it would be very hard with a son.'

Now he said, 'If we were to have a son it would be just as bad as ever. And anyway,' he added, 'there's lots of time.'

I agreed that there was plenty of time, and rather reluctantly gave into his desire for the second-hand Delage which he had already seen and marked down. The Delage gave us both great pleasure. I loved driving it, and Archie naturally did, though there was so much golf in his life that he had little time for it.

'Sunningdale is a perfect place to live,' said Archie. 'It's got everything we want. It's the right distance from London, and now they're opening Wentworth golf course as well, and developing that estate there. I think we might have a real house of our own.'

This was an exciting idea. Comfortable though we were in Scotswood, it had a few disadvantages. The management were not particularly reliable. The wiring of the electricity gave us trouble; the advertised constant hot water was neither constant nor hot; and the place suffered from a general lack of maintenance. We were enamoured of the idea of having a home of our very own.

We considered at first having a new house built on Wentworth Estate, which had just been taken over by a builder. It was going to be laid out

with two golf courses – probably a third later – and the rest of the sixty-
acre estate was to be covered by houses of all sizes and kinds. Archie and
I used to spend happy summer evenings tramping over Wentworth
looking out for a site which we thought would suit us. In the end, we
decided on a choice between three. We then got into touch with the
builder in charge of the estate. We decided that we wanted about an
acre and a half of ground. We preferred a natural pine and wooded area,
so that we should not have too much upkeep of a garden. The builder
seemed most kind and helpful. We explained that we wanted quite a
small house – I don't know what we thought it would cost us: about,
I suppose, £2000. He produced plans of a remarkably nasty-looking
little house, full of every unpleasant modern ornamental feature, for
which he asked what seemed to us the colossal price of £5,300. We
were crestfallen. There seemed no chance of getting anything built
more cheaply – that was the bottom limit. Sadly, we withdrew. We
decided, however, that I should buy a debenture share in Wentworth for
£100 – which would entitle me to play on Saturdays and Sundays on the
links there – as a kind of stake for the future. After all, since there would
be two courses there, one would be able to play on at least one of them
without feeling too much of a rabbit.

As it happened, my golfing ambitions got a sudden boost at this
moment – I actually won a competition. Such a thing had never happened
to me before, and never happened again. My L.G.U Golf handicap was
35 (the limit), but even with that it seemed unlikely I should ever win
anything. However, I met in the finals a Mrs Burberry – a nice woman a
few years older than myself – who also had a handicap of 35, and was just
as nervous and unreliable as I was.

We met quite happily, pleased with ourselves for having reached the
point we had. We halved the first hole. Thereafter Mrs Burberry,
surprising herself and depressing me, succeeded in winning not only the
next hole, but the hole after that, a further hole, and so on, until, at the
ninth, she was eight up. Any faint hopes of even putting up a good show
deserted me, and having reached that pitch I became much happier.
I could now go on with the round without bothering very much, until
the moment, certainly not far off, when Mrs Burberry would have won the
match. Mrs Burberry now began to go to pieces. Anxiety took over. She
lost hole after hole. I, still not caring, won hole after hole. The unbeliev-
able happened. I won the next nine holes, and therefore won by one up
on the last green. I think somewhere I have still got my silver trophy.

After a year or two, having looked at innumerable houses – always one of my favourite pastimes – we narrowed our choice down to two. One was rather a long way out, not too big, and had a nice garden. The other one was near the station; a sort of millionaire-style Savoy suite transferred to the country and decorated regardless of expense. It had panelled walls and quantities of bathrooms, basins in bedrooms, and every other luxury. It had passed through several hands in recent years and was said to be an unlucky house – everybody who lived there always came to grief in some way. The first man lost his money; the second his wife. I don't know what happened to the third owners – they just separated, I think, and departed. Anyway, it was going cheap as it had been on the market for some time. It had a pleasant garden – long and narrow, comprising first a lawn, then a stream with a great many water plants, then wild garden with azaleas and rhododendrons, and so on to the end, where there was a good solid kitchen garden, and beyond it a tangle of gorse bushes. Whether we could afford it or not was another matter. Although we were both making fair incomes – mine perhaps a little doubtful and uneven, Archie's well assured – we were lamentably short of capital. However, we arranged for a mortgage, and in due course moved in.

We bought such additional curtains and carpets as were necessary, and embarked on a course of living that was undoubtedly above our means, though our calculations looked all right on paper. We had both the Delage and the bottle-nosed Morris to keep up. We also had more servants: a married couple and a housemaid. The wife of the married couple had been a kitchenmaid in some ducal household, and it was assumed, though never actually stated, that her husband had been the butler there. He certainly did not know much about being a butler, though his wife was a most excellent cook. We discovered in the end that he had been the luggage porter. He was a man of colossal laziness. Most of the day he spent lying on his bed, and apart from waiting rather badly at table that was virtually all he ever did. In the intervals of lying on his bed he also went down to the pub. We had to decide whether to get rid of them or not. On the whole the cooking seemed more important, however, and we kept them on.

So we proceeded on our course of grandeur – and exactly what we might have expected happened. Within a year we were getting worried. Our bank account seemed to be melting in a most extraordinary way. With a few economies though, we said to each other, we should do all right.

At Archie's suggestion, we called the house Styles, since the first book which had begun to bring me a stake in life, had been *The Mysterious Affair at Styles*. On the wall we hung the painting which had been done for the jacket of *Styles* – which had been presented to me by The Bodley Head.

But Styles proved what it had been in the past to others. It was an unlucky house. I felt it when I first went into it. I put my fancy down to the fact that the decorations were so flashy and unnatural for the countryl When we could afford to have it done up in a country style, without all this panelling and paint and gilt, *then* I said, it would feel quite different.

IV

The next year of my life is one I hate recalling. As so often in life, when one thing goes wrong, everything goes wrong. About a month after I got home from a short holiday in Corsica my mother had bronchitis very badly. She was at Ashfield at the time. I went down to her, and then Punkie replaced me. Soon afterwards she sent me a telegram to say she was moving mother up to Abney, where she thought she could be better looked after, Mother seemed to improve, but she was never the same again. She moved very little from her room. I suppose her lungs were affected, she was seventy-two by that time. I did not think it was as serious as it turned out to be – I don't believe Punkie did, either – but a week or two later I was telegraphed for, Archie was away in Spain on business.

It was going up in the train to Manchester that I knew, quite suddenly, that my mother was dead. I felt a *coldness*, as though I was invaded all over, from head to feet, with some deadly chill – and I thought: '*Mother is dead*'.

I was right. I looked down at her as she lay on the bed, and thought how true it was that, once dead, it is only the *shell* that remains. All my mother's eager, warm, impulsive personality was far away somewhere. She had said to me several times in the past few years, 'Sometimes one feels so eager to get out of this body – so outworn, so old, so *useless*. One longs to be released from this prison.' That is what I felt about her now. She had been released from her prison. But for us there was the sadness of her passing.

Archie could not come to the funeral, because he was still in Spain. I was back at Styles when he returned a week later. I had always realised that he had a violent dislike of illness, death, and trouble of any kind. One knows these things, yet one hardly realises them, or pays much attention to them, until an emergency arises. He came into the room, I remember, acutely embarrassed, and it made him put on an appearance of jollity – a kind of 'Hullo, her we are. Now then, we must all try and cheer up' attitude. It is very hard to bear when you have lost a person who is one of the three you love best in the world.

He said: 'I've got a very good idea. How would it be – I've got to go back to Spain next week – how would it be if I took you out there with me? We could have great fun, and I am sure it would distract you.'

I didn't want to be distracted. I wanted to be with my sorrow and learn to get used to it. So I thanked him and said I'd rather stay at home. I see now that I was wrong. My life with Archie lay ahead of me. We were happy together, assured of each other, and neither of us would have dreamed that we could ever part. But he hated the feeling of sorrow in the house, and it left him open to other influences.

Then there was the problem of clearing up Ashfield. For the last four or five years all kinds of rubbish had accumulated; my grandmother's things; all the things that my mother had been unable to cope with and had locked away. There had been no money for repairs; the roof was falling in; and some of the rooms were dripping with rain. My mother had lived at the end in only two rooms. *Somebody* had to go down and cope with all this and that person had to be me. My sister was too embroiled in her own concerns though she promised to come down for two or three weeks in August. Archie thought it would be best if we let Styles for the summer, which would give us a large rent and put us out of the red again. He would stay at his club in London, I would go to Torquay to clear up Ashfield. He would join me there in August – and when Punkie came we would leave Rosalind with her and go abroad. We decided on Italy – a place we had never been to before, called Alassio.

So I left Archie in London, and went down to Ashfield.

I suppose I was already run down and slightly ill, but turning out that house, with the memories, the hard work, the sleepless nights, reduced me to such a nervous state that I hardly knew what I was doing. I worked for ten or eleven hours a day, opening every room, and carrying things around. It was frightful: the moth-eaten garments, Granny's old trunks full of her old dresses – all the things that nobody had wanted to throw

away but had now got to be disposed of. We had to pay the dustman extra every week to take everything. There were difficult items such as the large wax-flower crown which was my grandfather's memorial wreath. It lay under an enormous glass dome. I did not want to go through life with this enormous trophy but what can one do with a thing of that kind? You can't throw it away. Finally a solution was found. Mrs Potter – mother's cook – had always admired it. I presented it to her and she was delighted.

Ashfield was the first house that father and mother had lived in after their marriage. They went there about six months after Madge was born, and had stayed there ever since, continually adding fresh cupboards for storage. Little by little, every room in the house had become a store-room. The school-room, which had been the scene of so many happy days in my youth, was now one vast box-room: all the trunks and boxes that Grannie could not cram into her bedroom had gone up there.

A further blow dealt me by Fate was the loss of my dear Carlo. Her father and step mother had been travelling in Africa, and she suddenly heard from Kenya that her father was very ill and that the doctor said he had cancer. Though he did not yet know it himself, Carlo's stepmother knew, and apparently he was not expected to live longer than about six months. Carlo had to go back to Edinburgh as soon as her father returned, and be with him during his last months. I bade her farewell tearfully. She hated to leave me in all this confusion and unhappiness, but it was one of those priorities that cannot be evaded. Still, another six weeks or so, and I would get it all finished. Then I could begin to live again.

I worked like a demon, I was so anxious to get through. All the trunks and cases had to be examined carefully: one could not just throw things out. Among Grannie's things you were never sure *what* you would find. She had insisted on doing a good deal of her packing herself when she left Ealing, considering us sure to throw away her dearest treasures. Old letters abounded I was about to throw them all away; then a crumpled old envelope turned out to contain a dozen £5 notes! Grannie had been like a squirrel, hiding away her little nuts here and there so that they might escape the rigours of war. On one occasion there was a diamond brooch wrapped up in an old stocking.

I began to get confused and muddled over things. I never felt hungry and ate less and less. Sometimes I would sit down, put my hands to my head, and try to remember *what* it was I was doing. If Carlo had been there I would have been able to go to London for an occasional weekend

and see Archie, but I couldn't leave Rosalind alone in the house, and I had nowhere else to stay.

I suggested to Archie that he should come down for a weekend occasionally: it would make all the difference. He wrote back pointing out that it would ·be rather a foolish thing to do. After all it was an expensive journey, and, as he could not get off before Saturday and would have to go back Sunday night, it would hardly be worth it. I suspected that he would hate to miss a Sunday's golf – but put that aside as an unworthy thought. It was not for long, he added cheerfully.

A terrible sense of loneliness was coming over me. I don't think I realised that for the first time in my life I was really ill. I had always been extremely strong, and I had no understanding of how unhappiness, worry and overwork could affect your physical health. But I *was* upset one day when I was just about to sign a cheque and could not remember the name to sign it with. I felt exactly like Alice in Wonderland touching the tree.

'But of course,' I said. 'I know my name *perfectly* well. But – but what is it?' I sat there with the pen in my hand feeling an extraordinary frustration. What initial did it begin with? Was it perhaps Blanche Amory? It seemed familiar. Then I remembered that was some lesser character in *Pendennis*, a book I hadn't read for years.

I had another warning a day or two later. I went to start the car, which usually had to be started with a starting handle – in fact, I am not sure that cars did not always have to be started with the handle in those days. I cranked and cranked, and nothing happened. Finally I burst into tears, came into the house, and lay on the sofa sobbing. That worried me. Crying just because a car wouldn't start; I must be crazy.

Many years later, someone going through a period of unhappiness said to me: 'You know, I don't know what is the matter with me. I cry for nothing at all. The other day the laundry didn't come and I cried. And the next day the car wouldn't start –' Something stirred in me then, and I said, 'I think you had better be very careful; it is probably the beginning of a nervous breakdown. You ought to go and see someone about it.'

I had no such knowledge in those days. I knew I was desperately tired, and that the sorrow of losing my mother was still there deep down, though I tried – perhaps too much – to put it out of my mind. If *only* Archie would come, or Punkie, or *someone*, to be with me.

I had Rosalind, but of course I could not say anything to upset her, or talk to her about being unhappy, worried or ill. She was particularly

happy herself, enjoying Ashfield very much, as she always did – and extremely helpful in my chores. She loved carrying things down the stairs and stuffing them into the dustbin, and occasionally allocating something to herself. 'I don't think anyone wants *this* – and it *might* be rather fun.'

Time went on, things got almost straight, and at last I could look forward to the end of my drudgery. August came – Rosalind's birthday was on the 5th of August. Punkie came down two or three days before it, and Archie arrived on the 3rd. Rosalind was very contented at the prospect of having her Auntie Punkie with her during the two weeks Archie and I were in Italy.

V

What shall I do to drive away
Remembrance from mine eyes?

wrote Keats. But *should* one drive it away? If one chooses to look back over the journey that has been one's life, is one entitled to ignore those memories that one dislikes? Or is that cowardice?

I think, perhaps, one should take one brief look, and say: 'Yes, this *is* part of my life; but it's done with. It is a strand in the tapestry of my existence. I must recognise it because it is *part* of me. But there is no need to dwell upon it.'

When Punkie arrived at Ashfield I felt wonderfully happy. Then Archie came.

I think the nearest I can get to describing what I felt at that moment is to recall that old nightmare of mine – the horror of sitting at a tea table, looking across at my best loved friend, and suddenly realising that the person sitting there *was a stranger*. That, I think, describes best what Archie was like when he came.

He went through the motions of ordinary greetings, but he was, quite simply, *not Archie*. I did not know what was the matter with him. Punkie noticed, and said, 'Archie seems very queer – is he ill, or something?' I said perhaps he might be. Archie, however, said he was quite all right. But he spoke little to us, and went off by himself. I asked him about our tickets for Alassio and he said, 'Oh yes, well – well, that's all settled. I'll tell you about it later.'

Still he was a stranger. I racked my brains to think what could have happened. I had a momentary fear that something had gone wrong in the firm. It wasn't possible that Archie could have embezzled any money? No, I couldn't believe *that*. But had he, perhaps, embarked on some transaction for which he had not had proper authority? Could he be in a hole financially? Something he didn't mean to tell me about? I had to ask him in the end.

'What is the matter, Archie?'

'Oh, nothing particular.'

'But there must be something.'

'Well, I suppose I'd better tell you one thing. We – I – haven't got any tickets for Alassio. I don't feel like going abroad.'

'We're not going abroad?'

'No. I tell you I don't feel like it.'

'Oh, you want to stay here, do you, and play with Rosalind? Is that it? Well, I think that would be just as nice.'

'You don't understand,' he said irritably.

It was, I think, another twenty-four hours before he told me, straight out.

'I'm desperately sorry,' he said, 'that this thing has happened. You know that dark girl who used to be Belcher's secretary? We had her down for a weekend once, a year ago with Belcher, and we've seen her in London once or twice.'

I couldn't remember her name, but I knew who he meant. 'Yes?' I said.

'Well, I've been seeing her again since I've been alone in London. We've been out together a good deal . . .'

'Well,' I said, 'why shouldn't you?'

'Oh, you still don't understand,' he said impatiently. 'I've fallen in love with her, and I'd like you to give me a divorce as soon as it can be arranged.'

I suppose, with those words, that part of my life – my happy, successful confident life – ended. It was not as quick as that, of course – because I couldn't believe it. I thought it was something that would pass. There had never been any suspicion of anything of that kind in our lives. We had been happy together, and harmonious. He had never been the type who looked much at other women. It was triggered off, perhaps – by the fact that he had missed his usual cheerful companion in the last few months.

He said: 'I did tell you once, long ago, that I hate it when people are ill or unhappy – it spoils everything for me.'

Yes, I thought, I should have known that. If I'd been cleverer, if I had known more about my husband – had troubled to know more about him, instead of being content to idealise him and consider him more or less perfect – then perhaps I might have avoided all this. If I had been given a second chance, could I have avoided what had happened? If I had not gone to Ashfield and left him in London he would probably never have become interested in this girl. Not with this particular girl. But it might have happened with someone else, because I must in some way have been inadequate to fill Archie's life. He must have been ripe for falling in love with someone else, though he perhaps didn't even know it himself. Or *was* it just this particular girl? Was it just fate with him, falling in love with her quite suddenly? He had certainly not been in love with her on the few occasions we had met her previously. He had even objected to my asking her down to stay, he said it would spoil his golf. Yet when he did fall in love with her, he fell with the suddenness with which he had fallen in love with me. So perhaps it *was* bound to be.

Friends and relations are of little use at a time like this. Their point of view was, 'But it's absurd. You've always been so happy together. He'll get over it. Lots of husbands this happens with. They get over it.'

I thought so too. I thought he would get over it. But he didn't. He left Sunningdale. Carlo had come back to me by then – the English specialists had declared that her father did *not* have cancer after all – and it was a terrific comfort to have her there. But she was clearer sighted than I was. She said Archie wouldn't get over it. When he finally packed up and went I had a feeling almost of relief – he had made up his mind.

However, he came back after a fortnight. Perhaps, he said, he had been wrong. Perhaps it was the wrong thing to do. I said I was sure it was as far as Rosalind was concerned. After all, he was devoted to her, wasn't he? Yes, he admitted, he really did love Rosalind.

'And she is fond of *you*. She loves you better than she loves me. Oh, she wants me if she's ill, but you are the parent that she *really* loves and depends upon; you have the same sense of humour and are better companions than she and I are. You *must* try to get over it. I do know these things happen.'

But his coming back was, I think, a mistake, because it brought home to him how keen his feeling was. Again and again he would say to me:

'I can't stand not having what I want, and I can't stand not being happy. Everybody can't be happy – somebody has got to be unhappy.'

I managed to forbear saying, 'But why should it be me and not you?' Those things don't help.

What I could not understand was his continued unkindness to me during that period. He would hardly speak to me or answer when he was spoken to. I understand it much better now, because I have seen other husbands and wives and learned more about life. He was unhappy because he was, I think, deep down fond of me, and he did really hate to hurt me – so he *had* to assure himself that this was *not* hurting me, that it would be much better for me in the end, that I should have a happy life, that I should travel, that I had my writing, after all, to console me. Because his conscience troubled him he could not help behaving with a certain ruthlessness. My mother had always said he was ruthless. I had always seen so clearly his many acts of kindness, his good nature, his helpfulness when Monty came home from Kenya, the trouble he would take for people. But he was ruthless now, because he was fighting for his happiness. I had admired his ruthlessness before. Now I saw the other side of it.

So, after illness, came sorrow, despair and heartbreak. There is no need to dwell on it. I stood out for a year, hoping he would change. But he did not.

So ended my first married life.

VI

In February of the following year Carlo, Rosalind and I went to the Canary Islands. I had some difficulty in getting my way over this, but I knew that the only hope of starting again was to go right away from all the things that had wrecked life for me. There could be no peace for me in England now after all I had gone through. The bright spot in my life was Rosalind. If I could be alone with her and my friend Carlo, things would heal again, and I could face the future. But life in England was unbearable.

From that time, I suppose, dates my revulsion against the Press, my dislike of journalists and of crowds. It was unfair, no doubt, but I think it was natural under the circumstances. I had felt like a fox, hunted, my earths dug up and yelping hounds following me everywhere. I had

M

always hated notoriety of any kind, and now I had had such a dose of it
that at some moments I felt I could hardly bear to go on living.

'But you could live quietly at Ashfield,' my sister suggested.

'No,' I said. 'I couldn't. If I am quiet there and all alone I shall do
nothing but remember – remember every happy day I ever had there
and every happy thing I did.'

The important thing, once you have been hurt, is not to remember the
happy times. You can remember the sad times – that doesn't matter – but
something that reminds you of a *happy* day or a *happy* thing – that's
the thing that almost breaks you in two.

Archie continued to live at Styles for a time, but he was trying to sell
it – with my consent, of course, since I owned half of it. I needed the
money badly now, because I was in serious financial trouble again.

Ever since my mother's death I had been unable to write a word.
A book was due this year, and having spent so much on Styles I had no
money in hand: what little capital I had had was gone in the purchase of
the house. I had no money coming in now from anywhere except what
I could make or had made myself. It was vital that I should write another
book as soon as possible, and get an advance on it.

My brother-in-law, Archie's brother Campbell Christie, who had
always been a great friend and was a kind and lovable person, helped
me here. He suggested that the last twelve stories published in *The Sketch*
should be run together, so that they would have the appearance of a
book. That would be a stop-gap. He helped me with the work – I was
still unable to tackle anything of the kind. In the end it was published
under the title of *The Big Four*, and turned out to be quite popular.
I thought now that once I got away and had calmed down I could perhaps,
with Carlo's help, write another book.

The one person who was entirely on my side, and reassured me in all
that I was doing, was my brother-in-law, James.

'You're doing quite right, Agatha,' he said in his quiet voice. 'You
know what is best for yourself, and I would do the same in your place.
You must get away. It is possible that Archie may change his mind and
come back – I hope so – but I don't really think so. I don't think he is
that kind of person. When he makes up his mind it is definite, so I
shouldn't count on it.'

I said no, I wasn't counting on it, but I thought it only fair to Rosalind
to wait at least a year so that he could be quite sure that he knew what he
was doing.

I had been brought up, of course, like everyone in my day, to have a horror of divorce, and I still have it. Even today I have a sense of guilt because I acceded to his persistent demand and did agree to divorce him. Whenever I look at my daughter. I feel still that I *ought* to have stood out, that I ought perhaps to have refused. One is so hampered when one doesn't want a thing oneself. *I* didn't want to divorce Archie – I hated doing it. To break up a marriage is wrong – I am sure of it – and I have seen enough marriages broken up, and heard enough of the inner stories of them, to know that while it matters little if there are no children, it does matter if there are.

I came back to England myself again – a hardened self, a self suspicious of the world, but better attuned now to deal with it. I took a small flat in Chelsea, with Rosalind and Carlo and went with my friend Eileen Morris, whose brother was now Headmaster of Horris Hill School, to look at various girls' preparatory schools. I felt that as Rosalind had been uprooted from her home and friends, and as there were few children of her own age whom I now knew in Torquay, it would be better for her to go to boarding school. It was what she wanted to do anyway. Eileen and I saw about ten different schools. My head was quite addled by the time we had finished, though some of them had made us laugh. Nobody, of course, could have known less about schools than I did, for I had never been near one. I had no feeling about schooling one way or the other. I had never missed it myself. But after all, I said to myself, you may have missed something – you don't know. Perhaps it would be better to give your daughter the chance.

Since Rosalind was a person of the utmost good sense, I consulted her on the subject. She was quite enthusiastic. She enjoyed the day school she was going to in London, but she thought it would be nice to go to a preparatory school the following autumn. After that, she said, she would like to go to a very large school – the largest school there was. We agreed that I should try to find a nice preparatory school, and we settled tentatively on Cheltenham, which was the largest school I could think of, for the future.

The first school I liked was at Bexhill: Caledonia, run by a Miss Wynne and her partner, Miss Barker. It was conventional, obviously well run, and I liked Miss Wynne. She was a person of authority and personality. All the school rules seemed to be cut and dried, but sensible, and Eileen had heard through friends of hers that the food was exceptionally good. I liked the look of the children too.

The other school I liked was of a completely opposite type. Girls could
have their own ponies and keep their own pets, if they liked, and more or
less choose what subjects to study. There was a great deal of latitude in
what they did, and if they did not want to do a thing they were not pressed
to do it, because, so the Headmistress said, they then came to want to
do things of their own accord. There was a certain amount of artistic
training, and, again, I liked the Headmistress. She was an original-
minded person, warm-hearted, enthusiastic, and full of ideas.

I went home, thought about it, and finally decided to take Rosalind
with me and visit each of them once more. We did this. I left Rosalind
to consider for a couple of days, then said: 'Now, which do you think
you'd like?'

Rosalind, thank goodness, has always known her own mind. 'Oh,
Caledonia,' she said, 'every time. I shouldn't like the other; it would be
too much like being at a party. One doesn't want being at school to be
like being at a party, does one?'

So we settled on Caledonia, and it was a great success. The teaching
was extremely good, and the children were interested in what they
learned. It was highly organised, but Rosalind was the kind of child who
liked to be highly organised. As she said with gusto in the holidays,
'There's never a moment's leisure for *anyone*.' Not at all what *I* should
have liked.

Sometimes the answers I would get to questions seemed quite extra-
ordinary:

'What time do you get up in the morning, Rosalind?'

'I don't know, really. A bell rings.'

'Don't you *want* to know the time the bell rings?'

'Why should I?' said Rosalind. 'It's to get us up, that's all. And then
we have breakfast about half an hour afterwards, I suppose.'

Miss Wynne kept parents in their place. I asked her once if Rosalind
could come out with us on Sunday dressed in her everyday clothes instead
of her Sunday silk frock, because we were going to have a picnic and a
ramble over the downs.

Miss Wynne replied: 'All my pupils go out on Sunday in their Sunday
clothes.' And that was that. However, Carlo and I would pack a small
bag with Rosalind's rougher country clothes, and in a convenient wood
or copse she would change from her silk Liberty frock, straw hat and
neat shoes into something more suitable to the rough and tumble of our
picnic. No one ever found us out.

She was a woman of remarkable personality. Once I asked her what she did on Sports Day if it rained. 'Rain?' said Miss Wynne in a tone of surprise, 'It has never rained on Sports Day that I can remember.' She could, it seemed, dictate even to the elements: or, as one of Rosalind's friends said, 'I expect, you know, God *would* be on Miss Wynne's side.'

I had managed to write the best part of a new book, *The Mystery of The Blue Train*, while we were in the Canary Islands. It had not been easy, and had certainly not been rendered easier by Rosalind. Rosalind, unlike her mother, was not a child who could amuse herself by any exercise of imagination: she required something concrete. Give her a bicycle and she would go off for half an hour. Give her a difficult puzzle when it was wet, and she would work on it. But in the garden of the hotel at Oratava in Tenerife there was nothing for Rosalind to do but walk around the flower-beds, or occasionally bowl a hoop – and a hoop meant little to Rosalind, again unlike her mother. To her it was only a hoop.

'Look here, Rosalind,' I said, 'you must *not* interrupt. I've got some work to do. I've got to write another book. Carlo and I are going to be busy for the next hour with that. You must not interrupt.'

'Oh, all right,' said Rosalind, gloomily, and went away. I looked at Carlo, sitting there with pencil poised, and I thought, and thought, and thought – cudgelling my brain. Finally, hesitantly, I began. After a few minutes, I noticed that Rosalind was just across the path, standing there looking at us.

'What is it, Rosalind?' I asked. 'What do you want?'

'Is it half an hour yet,' she said.

'No, it isn't. It's exactly nine minutes. Go away.'

'Oh, all right.' And she departed.

I resumed my hesitant dictation.

Presently Rosalind was there again.

'I'll call you when the time is up. It's not up yet.'

'Well, I can stay here, can't I? I can just stand here. I won't interrupt.'

'I suppose you can stand there,' I said, unwillingly. And I started again.

But Rosalind's eye upon me had the effect of a Medusa. I felt more strongly than ever that everything I was saying was idiotic! (Most of it was, too.) I faltered, stammered, hesitated, and repeated myself. Really, how that wretched book ever came to be written, I don't know!

To begin with, I had no joy in writing, no *élan*. I had worked out the plot – a conventional plot, partly adapted from one of my other stories.

I knew, as one might say, where I was going, but I could not see the scene in my mind's eye, and the people would not come alive. I was driven desperately on by the desire, indeed the necessity, to write another book and make some money.

That was the moment when I changed from an amateur to a professional. I assumed the burden of a profession, which is to write even when you don't want to, don't much like what you are writing, and aren't writing particularly well. I have always hated *The Mystery of the Blue Train*, but I got it written, and sent off to the publishers. It sold just as well as my last book had done. So I had to content myself with that – though I cannot say I have ever been proud of it.

Oratava was lovely. The big mountain towered up; there were glorious flowers in the hotel grounds – but two things about it were wrong. After a lovely early morning, mists and fog came down from the mountain at noon, and the rest of the day was grey. Sometimes it even rained. And the bathing, to keen bathers, was terrible. You lay on a sloping volcanic beach, on your face, and you dug your fingers in and let waves come up and cover you. But you had to be careful they did not cover you too much. Masses of people had been drowned there. It was impossible to get into the sea and swim; that could only be done by one or two of the very strongest swimmers, and even one of those had been drowned the year before. So after a week we changed, and moved to Las Palmas in Gran Canaria.

Las Palmas is still my ideal of the place to go in the winter months. I believe nowadays it is a tourist resort and has lost its early charm. Then it was quiet and peaceful. Very few people came there except those who stayed for a month or two in winter and preferred it to Madeira. It had two perfect beaches. The temperature was perfect too: the average was about 70°, which is, to my mind, what a summer temperature should be. It had a nice breeze most of the day, and it was warm enough in the evenings to sit out of doors after dinner.

It was in those evenings with Carlo that I made two close friends, Dr Lucas and his sister Mrs Meek. She was a good deal older than her brother, and had three sons. He was a tuberculosis specialist, was married to an Australian, and had a sanatorium on the east coast. He had himself been crippled in youth – whether by tuberculosis or by polio, I do not know – but he was slightly hunch-backed, and had a delicate constitution. He was by nature a born healer, though, and was extraordinarily successful with his patients. He said once: 'My partner, you know, is a better

doctor than I am – better in his qualifications, knows more than I do – but he cannot do for his patients what I can. When I go away, they droop and fall back. I just *make* them get well.'

He was always known as Father to all his family. Soon Carlo and I were calling him Father too. I had a bad ulcerated throat when we were there. He came to see me and said, 'You are very unhappy about something, aren't you? What is it? Husband trouble?'

I said yes it was, and told him something of what had happened. He was cheering and invigorating. 'He'll come back if you want him,' he said. 'Just give him time. Give him plenty of time. And when he does come back, don't reproach him.'

I said I didn't think he would come back, that he wasn't the type. No, he agreed, some weren't. Then he smiled and said: 'But most of us are, I can tell you that. I've been away and come back. Anyway, *whatever* happens, accept it and *go on*. You've got plenty of strength and courage. You'll make a good thing out of life yet.'

Dear Father. I owe him so much. He had enormous sympathy for all human ailments and failings. When he died, five or six years later, I felt I had lost one of my best friends.

Rosalind's one fear in life was that the Spanish chamber-maid would speak to her!

'But why shouldn't she?' I said. 'You can speak to her.'

'I can't – she's *Spanish*. She says "Señorita" and then she says a lot of things I can't understand.'

'You mustn't be so silly, Rosalind.'

'Oh, it's all right. You can go to dinner. I don't mind being left alone as long as I'm in *bed*. Then I can shut my eyes and pretend to be asleep when the chamber-maid comes in.'

It is odd what children like or don't like. When we got on a boat to come back it was rough, and a large, hideously ugly Spanish sailor took Rosalind in his arms, and jerked up with her from the boat to the gang-way. I thought she would roar with disapprobation, but not at all. She smiled at him with the utmost sweetness.

'*He's* foreign, and you didn't mind,' I said.

'Well, he didn't *talk* to me. And anyway I liked his face – a nice, *ugly* face.'

Only one incident of note happened as we left Las Palmas for England. We arrived at Puerto de la Cruz to catch the Union Castle boat, and the discovery was made that Blue Teddy had been left behind. Rosalind's

face immediately blanched. 'I won't leave without Teddy,' she said. The bus driver who had brought us was approached. Largesse was pressed upon him, though he hardly even seemed to want it. Of course he would find the little one's blue monkey – of course, he would drive back like the wind. In the meantime he was sure the sailors would not let the boat leave – not without the favourite toy of a child. I did not agree with him. I thought the boat *would* leave. It was an English boat, *en route* from South Africa. If it had been a Spanish boat, no doubt it would have remained a couple of hours if necessary. However, all was well. Just as whistles began blowing, and everyone was told to go ashore, the bus was seen approaching in a cloud of dust. Out jumped the driver; Blue Teddy was passed to Rosalind on the gangway; and she clasped him to her heart. A happy ending to our stay there.

VII

My plan of life henceforward was more or less established, but I had to make one last decision.

Archie and I met by appointment. He looked ill and tired. We talked of ordinary things and people we knew. Then I asked him what he felt now; whether he was quite sure he could not come back to live with Rosalind and me. I said once again that he knew how fond of him she was, and how much she had been puzzled over his absence.

She had said once, with the devastating truthfulness of childhood: 'I *know* Daddy likes *me*, and would like to be with me. It's *you* he doesn't seem to like.'

'That shows you,' I said, 'that she needs you. Can't you manage to do it?'

He said, 'No, no, I'm afraid I can't. There's only one thing that I really want. I want madly to be happy, and I can't be happy unless I can get married to Nancy. She's been round the world on a trip for the last ten months, because her people hoped it would get her out of it too, but it hasn't. That's the only thing I want or can do.'

It was settled at last. I wrote to my lawyers and went to see them. Things were put in train. There was nothing more to do, except to decide what to do with myself. Rosalind was at school, and she had Carlo and

Punkie to visit her. I had till the Christmas holidays – and I decided that I would seek sunshine. I would go to the West Indies and Jamaica. I went to Cook's and fixed up my tickets. It was all arranged.

Here we come to Fate again. Two days before I was to leave I went out to dinner with friends in London. They were not people I knew well, but they were a charming couple. There was a young couple there, a naval officer, Commander Howe, and his wife. I sat next to the Commander at dinner, and he talked to me about Baghdad. He had just come back from that part of the world, since he had been stationed in the Persian Gulf. After dinner his wife came and sat by me and we talked. She said people always said Baghdad was a horrible city, but she and her husband had been entranced by it. They talked about it, and I became more and more enthusiastic. I said I supposed one had to go by sea.

'You can go by train – by the Orient Express.'

'The Orient Express?'

All my life I had wanted to go on the Orient Express. When I had travelled to France or Spain or Italy, the Orient Express had often been standing at Calais, and I had longed to climb up into it. *Simplon-Orient Express – Milan, Belgrade, Stamboul . . .*

I was bitten. Commander Howe wrote down for me places I must go and see in Baghdad. 'Don't get trapped into too much Alwiyah and Mem-sahibs and all that. You must go to Mosul – Basra you must visit – and you certainly ought to go to Ur.'

'Ur?' I said. I had just been reading in *The Illustrated London News* about Leonard Woolley's marvellous finds at Ur. I had always been faintly attracted to archaeology, though knowing nothing about it.

Next morning I rushed round to Cook's, cancelled my tickets for the West Indies, and instead got tickets and reservations for a journey on the Simplon-Orient Express to Stamboul; from Stamboul to Damascus; and from Damascus to Baghdad across the desert. I was wildly excited. It would take four or five days to get the visas and everything, and then off I should go.

'All by yourself?' said Carlo, slightly doubtful. 'All by yourself to the Middle East? You don't know anything about it.'

'Oh, that will be all right,' I said. 'After all, one must do things by oneself sometime, mustn't one?' I never had before – I didn't much want to now – but I thought: 'It's now or never. Either I cling to everything that's safe and that I know, or else I develop more initiative, do things on my own.'

And so it was that five days later I started for Baghdad.

It is the name, really, that so fascinates one. I don't think I had any clear picture in my mind of what Baghdad was like. I was certainly not expecting it to be the city of Haroun-al-Raschid. It was just a place that I had never thought of going to, so it held for me all the pleasures of the unknown.

I had been round the world with Archie; I had been to the Canary Islands with Carlo and Rosalind; now I was going *by myself.* I should find out now what kind of person I was – whether I had become entirely dependent on other people as I feared. I could indulge my passion for seeing places – any place I wanted to see. I could change my mind at a moment's notice, just as I had done when I chose Baghdad instead of the West Indies. I would have no one to consider but myself. I would see how I liked that. I knew well enough that I was a dog character: dogs will not go for a walk unless someone takes them. Perhaps I was always going to be like that. I hoped not.

PART VIII

SECOND SPRING

I

Trains have always been one of my favourite things. It is sad nowadays that one no longer has engines that seem to be one's personal friends.

I entered my *wagon lit* compartment at Calais, the journey to Dover and the tiresome sea voyage disposed of, and settled comfortably in the train of my dreams. It was then that I became acquainted, with one of the first dangers of travel. With me in the carriage was a middle-aged woman, a well-dressed, experienced traveller, with a good many suitcases and hat-boxes – yes, we still travelled with hat-boxes in those days – and she entered into conversation with me. This was only natural, since we were to share the carriage, which, like all second-class ones, had two berths. It was in some ways much nicer to travel by second rather than first class, since it was a much bigger carriage, and enabled one to move about.

Where was I going? my companion asked. To Italy? No, I said, further than that. Where then *was* I going? I said that I was going to Baghdad. Immediately she was all animation. She herself lived in Baghdad. What a coincidence. If I was staying there with friends, as she presumed, she was almost sure to know them. I said I wasn't going to stay with friends.

'But where are you going to stay, then? You can't possibly stay in a hotel in Baghdad.'

I asked why not. After all, what else are hotels for? That at least was my private thought, though not uttered aloud.

Oh! the hotels were all *quite* impossible. 'You can't possibly do that. I tell you what you must do: you must come to us!'

I was somewhat startled.

'Yes, yes, I won't take any denial. How long did you plan to stay there?'

'Oh, probably quite a short time,' I said.

'Well, at any rate you must come to us to start with, and then we can pass you on to someone else.'

It was very kind, very hospitable, but I felt an immediate revolt. I began to understand what Commander Howe had meant when he advised me not to let myself be caught up in the social life of the English colony. I could see myself tied hand and foot. I tried to give a rather stammering account of what I planned to do and see, but Mrs C. – she had told me her name, that her husband was already in Baghdad, and that she was one of the oldest residents there – quickly put aside all my ideas.

'Oh, you'll find it quite different when you get there. One has a very good life indeed. Plenty of tennis, plenty going on. I think you really will enjoy it. People always say that Baghdad is terrible, but I can't agree. And one has lovely gardens, you know.'

I agreed amiably to everything. She said, 'I suppose you are going to Trieste, and will take a boat there on to Beirut?'

I said no, I was going the whole way through by the Orient Express. She shook her head a bit over that. 'I don't think that's advisable, you know. I don't think you would like it. Oh well, I suppose it can't be helped now. Anyway, we shall meet, I expect. I'll give you my card, and as soon as you get to Baghdad, if you just wire ahead from Beirut, when you are leaving, my husband will come down and meet you and bring you straight back to our house.'

What could I say except thank you very much and add that my plans were rather unsettled? Fortunately Mrs C. was not going to make the whole journey with me – thank God for that, I thought, as she would never have stopped talking. She was going to get out at Trieste, and take a boat to Beirut. I had prudently not mentioned my plans for staying in Damascus and Stamboul, so she would probably come to the conclusion that I had changed my mind about travelling to Baghdad. We parted on the most friendly terms the next day in Trieste, and I settled down to enjoy myself.

The journey was all that I had hoped for. After Trieste we went through Yugoslavia and the Balkans, and there was all the fascination of looking out at an entirely different world: going through mountain gorges, watching ox-carts and picturesque wagons, studying groups of people on the station platforms, getting out occasionally at places like Nish and

Belgrade and seeing the large engines changed and new monsters coming on with entirely different scripts and signs. Naturally I picked up a few acquaintances *en route*, but none of them, I am glad to say, took charge of me in the same way as my first had done. I passed the time of day agreeably with an American missionary lady, a Dutch engineer, and a couple of Turkish ladies. With the last I could not do much conversing, though we managed a little sporadic French. I found myself in what was the obviously humiliating position of having only had one child, and that a daughter. The beaming Turkish lady had had, as far as I could understand her, thirteen children, five of whom were dead, and at least three, if not four miscarriages. The sum total seemed to her quite admirable though I gathered that she was not giving up hope of continuing her splendid record of fertility. She pressed on me every possible remedy for increasing my family. The things with which I was urged to stimulate myself: tisanes of leaves, concoctions of herbs, the use of certain kinds of what I thought might be garlic, and finally the address of a doctor in Paris, who was 'absolutely wonderful'.

Not until you travel by yourself do you realise how much the outside world will protect and befriend you – not always quite to one's own satisfaction. The missionary lady urged various intestinal remedies on me: she had a wonderful supply of aperient salts. The Dutch engineer took me seriously to task as to where I was going to stay in Stamboul, warning me of all the dangers in that city. 'You have to be careful,' he said. 'You are well brought up lady, living in England, protected I think always by husband or relations. You must not believe what people say to you. You must not go out to places of amusement unless you know where you are being taken.' In fact he treated me like an innocent of seventeen. I thanked him, but assured him that I would be fully on my guard.

To save me from worse dangers he invited me out to dinner on the night I arrived. 'The Tokatlian,' he said, 'is a very good hotel. You are quite safe *there*. I will call for you about 9 o'clock, and will take you to a very nice restaurant, very correct. It is run by Russian ladies – White Russians they are, all of noble birth. They cook very well and they keep the utmost decorum in their restaurant.' I said that would be very nice, and he was as good as his word.

Next day, when he had finished his business, he called for me, showed me some of the sights in Stamboul, and arranged a guide for me. 'You will not take the one from Cook's – he is too expensive – but I assure you this one is very respectable.'

After another pleasant evening, with the Russian ladies sailing about, smiling aristocratically and patronising my engineer friend, he showed me more of the sights of Stamboul and finally delivered me once more at the Tokatlian Hotel. 'I wonder,' he said, as we paused on the threshold. He looked at me inquiringly. 'I wonder now –' and the inquiry became more pronounced as he sized up my likely reaction. Then he sighed, 'No. I think it will be wiser that I do not ask.'

'I think you are very wise,' I said, 'and very kind.'

He sighed again. 'It would have been pleasant if it had been otherwise, but I can see – yes, this is the right way.' He pressed my hand warmly, raised it to his lips, and departed from my life for ever. He was a nice man – kindness itself – and I owe it to him that I saw the sights of Constantinople under pleasant auspices.

Next day I was called on by Cook's representatives in the most conventional fashion, and taken across the Bosphorus to Haidar Pasha, where I resumed my journey on the Orient Express. I was glad to have my guide with me, for anything more like a lunatic asylum than Haidar Pasha Station cannot be imagined. Everyone shouted, screamed, thumped, and demanded the attention of the Customs Officer. I was introduced then to the technique of Cook's Dragomen. 'You give me one pound note *now*,' he said. I gave him one pound note. He immediately sprang up on the Customs benches and waved the note aloft. 'Here, here,' he called. 'Here, here!' His cries proved effective. A customs gentleman covered with gold braid hurried in our direction, put large chalk marks all over my baggage, said to me 'I wish you good voyage' – and departed to harry those who had not as yet adopted the Cook's one pound procedure. 'And now I settle you in train,' said Cook's man. 'And now?' I was a little doubtful how much, but as I was looking among my Turkish money – some change, in fact, which had been given me on the *wagon lit* – he said with some firmness, 'It is better that you keep that money. It may be useful. You give me another pound note.' Rather doubtful about this but reflecting that one has to learn by experience, I yielded him another pound note, and he departed with salutation and benedictions.

There was a subtle difference on passing from Europe into Asia. It was as though time had less meaning. The train ambled on its way, running by the side of the Sea of Marmara, and climbing mountains – it was incredibly beautiful all along this way. The people in the train now were different too – though it is difficult to describe in what the difference lay. I felt cut off, but far more interested in what I was doing and where I

was going. When we stopped at the stations I enjoyed looking out, seeing the motley crowd of costumes, peasants thronging the platform, and the strange meals of cooked food that were handed up to the train. Food on skewers, wrapped in leaves, eggs painted various colours – all sorts of things. The meals became more unpalatable and fuller of hot, greasy, tasteless morsels as we went further East.

Then, on the second evening, we came to a halt, and people got out of the train to look at the Cilician Gates. It was a moment of incredible beauty. I have never forgotten it. I was to pass that way many times again. both going to and coming from the Near East and, as the train schedules changed, I stopped there at different times of day and night: sometimes in the early morning, which was indeed beautiful; sometimes, like this first time, in the evening at six o'clock; sometimes, regrettably, in the middle of the night. This first time I was lucky. I got out with the others and stood there. The sun was slowly setting, and the beauty indescribable. I was so glad then that I had come – so full of thankfulness and joy. I got back into the train, whistles blew, and we started down the long side of a mountain gorge, passing from one side to the other, and coming out on the river below. So we came slowly down through Turkey and into Syria at Aleppo.

Before we reached Aleppo, however, I had a short spell of bad luck. I was, as I thought, badly bitten by mosquitoes, up my arms and the back of my neck, and on my ankles and knees. I was still so innocent of travel abroad that I did not recognise that what I had been bitten by was not mosquitoes but bed-bugs, and that I was going to be all my life peculiarly susceptible to such bites. They came out of the old-fashioned wooden railway carriages, and fed hungrily on the juicy travellers in the train. My temperature rose to 102 and my arms swelled. Finally, with the aid of a kindly French commercial traveller, I slit the sleeves of my blouse and coat – my arms were so swelled inside them that there was nothing else one could do. I had fever, headache and misery, and thought to myself, 'What a mistake I have made to come on this journey!' However, my French friend was very helpful: he got out and purchased some grapes for me – the small sweet grapes which you get in that part of the world. 'You will not want to eat,' he said. 'I can see that you have fever. It is better that you stick to these grapes.'

Though trained by mother and grandmothers to wash all food before eating it abroad, I no longer cared about this advice. I fed myself with grapes every quarter of an hour, and they relieved a lot of the fever.

I certainly did not want to eat anything else. My kind Frenchman said goodbye to me at Aleppo, and by the next day my swelling had abated and I was feeling better.

When I finally arrived at Damascus, after a long weary day in a train that never seemed to go more than five miles an hour, and constantly paused at something hardly distinguishable from the surroundings but which was called a station, I emerged into the midst of clamour, porters seizing baggage off me, screaming and yelling, and other ones seizing it from them in turn, the stronger wrestling with the weaker. I finally discerned outside the station a handsome looking motor-bus labelled Orient Palace Hotel, A grand person in livery rescued me and my baggage, and together with one or two other bewildered voyagers we piled in and were driven to the hotel, where a room had been reserved for me. It was a most magnificent hotel, with large marble glittering halls – but with such poor electric light: that one could hardly see one's surroundings. Having been ushered up marble steps and shown into an enormous apartment, I mooted the question of a bath with a kindly-looking female who came in answer to a bell, and who seemed to understand a few words of French.

'Man arrange,' she said. She elucidated further: '*Un homme – un type – il va arranger.*' She nodded reassuringly and disappeared.

I was a little doubtful as to what '*un type*' was, but it seemed in the end that it was the bath attendant, the lowest of the low, dressed in a great deal of striped cotton, who finally ushered my dressing-gowned form into a kind of basement apartment. Here he turned various taps and wheels. Boiling water ran out all over the stone floor, and steam filled the air so that I was unable to see. He nodded, smiled, gestured, gave me to understand that all was well, and departed. He had turned off everything before going, and the water had all run away through the trough in the floor. I was uncertain as to what I was meant to do next. I really dared not turn on the boiling water again. There were about eight or ten small wheels and knobs round the walls, any one of which, I felt, might produce a different phenomenon – such as a shower of boiling water on my head. In the end I took off my bedroom slippers and other garments and padded about, washing myself in steam rather than risking the dangers of actual water. For a moment I felt homesick. How long would it be before I should enter a familiar shiny-papered apartment with a solid white porcelain tub and two taps labelled hot and cold which one turned on according to one's taste?

As far as I remember, I had three days in Damascus, during which I duly did my sight-seeing, shepherded by the invaluable Cook's. On one occasion I made an expedition to some Crusader castle, in company with an American engineer – engineers seemed pretty thick on the ground all through the Near East – and a very aged clergyman. We met for the first time as we took our places in the car at 8.30. The aged clergyman, beneficence itself, had made up his mind that the American engineer and I were man and wife. He addressed us as such. 'I hope you don't mind,' said the American engineer. 'Not at all,' I replied. 'I am so sorry that he thinks you are my husband.' The phrase seemed somewhat ambiguous, and we both laughed.

The old clergyman treated us to a dissertation on the merits of married life, the necessity of give and take, and wished us all happiness. We gave up explaining, or trying to explain – he appeared so distressed when the American engineer shouted into his ear that we were *not* married that it seemed better to leave things as they were. 'But you ought to get married,' he insisted, shaking his head. 'Living in sin, you know, it doesn't do – it really doesn't do.'

I went to see lovely Baalbek, I visited the bazaars, and the Street called Straight, bought many of the attractive brass plates they make there. Each plate was made by hand, and each pattern peculiar to the one family that made it. Sometimes it was a design of fish, with threads of silver and brass raised in a pattern running all over it. There is something fascinating in thinking of each family with its pattern handed down from father to son and to grandson, with no one else ever copying it and nobody mass-producing it. I imagine that if you were to go to Damascus now you would find few of the old craftsmen and their families left: there would be factories instead. Already in those days the inlaid wooden boxes and tables had become stereotyped and universally reproduced – still done by hand, but in conventional patterns and ways.

I also bought a chest of drawers – a huge one, inlaid with mother-of-pearl and silver – the sort of furniture that reminds one of fairyland. It was despised by the Dragoman who was guiding me.

'Not good work that,' he said. 'Quite old – fifty years old, sixty years old, more perhaps. Old-fashioned, you understand. Very old-fashioned. Not new.'

I said I could see that it wasn't new and that there weren't many of them. Perhaps there would never be another one made.

'No. Nobody make that now. You come and look at this box. See?

Very good. And this here. Here is a chest of drawers here. You see? It has many woods in it. You see how many different woods it has? Eighty-five different woods.' The net result, I thought, was hideous. I wanted my mother-of-pearl, ivory and silver chest.

The only thing that worried me was how I was ever going to get it home to England – but that apparently held no difficulties. I was passed on through Cook's to somebody else, to the hotel, to a firm of shippers, and finally made various arrangements and calculations, with the result that nine or ten months later an almost forgotten mother-of-pearl and silver chest turned up in South Devon.

That was not the end of the story. Though it was a glorious thing to look at, and capacious inside, it produced in the middle of the night a strange noise, as if large teeth were champing something. Some creature was eating my beautiful chest. I took the drawers out and examined them. There seemed no sign of tooth-marks or holes. Yet night after night, after the witching hour of midnight, I could hear '*Crump, crump, crump*'.

At last I took one of the drawers out and carried it to a firm in London which was said to specialize in tropical wood-pests. They agreed immediately that something sinister was at work in the recesses of the wood. The only thing would be to remove the wood entirely and re-line it. This, I may say, was going to add heavily to the expense – in fact it would probably cost three times as much as the chest itself had done and twice as much as its fare to England. Still, I could no longer bear that ghostly munching and gnawing.

About three weeks later I was rung up and an excited voice said 'Madam, can you come down to the shop here. I should really like you to see what I have got.' I was in London at the time, so I hurried round immediately – and was shown with pride a repulsive cross between a worm and a slug. It was large and white and obscene, and had clearly enjoyed its diet of wood so much as to make it obese beyond belief. It had eaten nearly all the surrounding wood in two of the drawers. After a few more weeks my chest was returned to me, and thereafter the night hours held only silence.

After intensive sightseeing that only increased my determination to return to Damascus and explore much more there, the day came when I was to undertake my journey across the desert to Baghdad. At this time the service was done by a big fleet of six-wheeler cars or buses which were operated by the Nairn Line. Two brothers, Gerry and Norman

Nairn, ran this. They were Australians, and the most friendly of men. I became acquainted with them on the night before my trip, when they were both busy in an amateurish way making up cardboard boxes of lunch, and invited me to help them.

The bus started at dawn. Two hefty young drivers were on the job, and when I came out following my baggage they were busy stowing a couple of rifles into the car, carelessly throwing an armful of rugs over them.

'Can't advertise that we've got these, but I wouldn't care to cross the desert without them,' said one.

'Hear we've got the Duchess of Alwiyah on this run,' said the other.

'God Almighty,' said the first. 'We'll have trouble there, I expect. What does she want this time, do you think?'

'Everything upside down and down side up,' said the other.

At that moment a procession arrived down the steps of the hotel. To my surprise, and I am afraid not to my pleasure, the leading figure was none other than Mrs C., from whom I had parted at Trieste. I had imagined that by now she would have already got to Baghdad, since I had lingered to see the sights.

'I thought you would be on this run,' she said, greeting me with pleasure. 'Everything is fixed up, and I am carrying you back with me to Alwiyah. It would have been *quite* impossible for you to have stayed in any hotel in Baghdad.'

What could I say? I was captured. I had never been to Baghdad, and never seen the hotels there. They might, for all I knew, be one seething mass of fleas, bed-bugs, lice, snakes, and the kind of pale cockroach that I particularly abhor. So I had to stammer some thanks. We ensconced ourselves, and I realised that 'The Duchess of Alwiyah' was none other than my friend Mrs C. She refused at once the seat she had been given as too near the rear of the bus, where she was always sick. She must have the front seat behind the driver. But that had been reserved by an Arab lady weeks ago. The Duchess of Alwiyah merely waved a hand. Nobody counted, apparently, but Mrs C. She gave the impression that she was the first European woman ever to set foot in the city of Baghdad, before whose whims all else must fall down. The Arab lady arrived and defended her seat. Her husband took her part, and a splendid free-for-all ensued. A French lady also made claim, and a German general, too, made himself difficult. I don't know what arguments were urged, but, as usual on this earth, four of the meek were dispossessed of the better

seats and more or less thrown into the back of the car. The German general, the French lady, the Arab lady, shrouded in veils, and Mrs C. were left with the honours of war. I have never been a good fighter and did not stand a chance, though actually my seat number would have entitled me to one of these desirable positions.

In due course we rumbled off. Having been fascinated by rolling across the yellow sandy desert, with its undulating sand-dunes and rocks, I finally became more or less hypnotised by the sameness of the surroundings, and opened a book. I had never been car-sick in my life but the action of the six-wheeler, if you were sitting towards the back of it, was much the same motion as a ship, and what with that and reading I was severely sick before I knew what had happened to me. I felt deeply disgraced, but Mrs C. was very kind to me, and said it often took people unawares. Next time she would see to it that *I* had one of the front seats.

The forty-eight hour trip across the desert was fascinating and rather sinister. It gave one the curious feeling of being enclosed rather than surrounded by a void. One of the first things I was to realise was that at noon it was impossible to tell whether you were going north, south, east or west, and I learnt that it was at this time of day when the big six-wheeled cars most often went off the track. On one of my later journeys across the desert this did actually happen. One of the drivers – one of the most experienced too – discovered himself, after two or three hours, driving across the desert in the direction of Damascus, with his back turned to Baghdad. It happened at the point where the tracks divided. There was a maze of tracks all over the surface. On that occasion a car appeared in the distance, shooting off a rifle, and the driver took an even wider loop than usual. He thought he had got back on to the track, but actually he was driving in the opposite direction.

Between Damascus and Baghdad there is nothing but a great stretch of desert – no landmarks, and only one halt in the whole place: the big fort of Rutbah. We reached there, I think, about midnight. Suddenly, out of the darkness, there loomed a flickering light. We had arrived. The great gates of the fortress were unbarred. Beside the door, on the alert, their rifles raised, were the Guards of the Camel Corps, prepared for bandits masquerading as bona fide travellers. Their wild dark faces were rather frightening. We were scrutinised and allowed to pass in, and the gates were shut behind us. There were a few rooms there with bedsteads, and we had three hours' rest, five or six women to a room. Then we went on again.

About five or six in the morning, when dawn came, we had breakfast in the desert. Nowhere in the world is there such a good breakfast as tinned sausages cooked on a primus stove in the desert in the early morning. That and strong black tea fulfilled all one's needs, and revived one's flagging energy; and the lovely colours all over the desert – pale pinks, apricots and blues – with the sharp-toned air, made a wonderful ensemble. I was entranced. This was what I longed for. This was getting away from everything – with the pure invigorating morning air, the silence, the absence even of birds, the sand that ran through one's fingers, the rising sun, and the taste of sausages and tea. What else could one ask of life?

Then we moved on, and came at last to Felujah on the Euphrates, went over the bridge of boats, past the air station at Habbaniyah, and on again, until we began to see palm-groves and a raised road. In the distance, on the left, we saw the golden domes of Kadhimain, then on and over another bridge of boats, over the river Tigris, and so into Baghdad – along a street full of rickety buildings, with a beautiful mosque with turquoise domes standing, it seemed to me, in the middle of the street.

I never had a chance even to look at a hotel. I was transferred by Mrs C. and her husband Eric, to a comfortable car, and driven along the one main street that is Baghdad, past the statue of General Maude and out from the city, with great rows of palms on either side of the road, and herds of black beautiful buffaloes watering in pools of water. It was like nothing I had seen before.

Then we came to houses and gardens full of flowers – not so many as there would have been later in the year ... And there I was – in what I sometimes thought of as Mem-Sahib Land.

II

They were so nice to me in Baghdad. Everyone was kind and pleasant – and I felt ashamed of myself for the caged feeling from which I suffered. Alwiyah is now part of a continuous city, full of buses and other means of transport, but was then divided by some miles from the city itself. To get there, somebody would have to drive you in. It was always a fascinating ride.

One day I was taken to see Buffalo Town, which you can still see from the train as you come into Baghdad from the north. To the uninitiated eye it looks a place of horror – a slum, a vast enclosure full of buffaloes and their excreta. The stench is terrific, and the shacks made of petrol cans lead one to believe that it is an extreme example of poverty and degradation. Actually this is far from being the case. Owners of buffaloes are very well to do. Although they may live in squalor, a buffalo is worth £100 or more – probably far more nowadays. The owners of them consider themselves lucky people, and as the women squelch about in the mud, handsome bracelets of silver and turquoise can be seen decorating their ankles.

I learnt soon enough that nothing in the Near East is what it appears to be. One's rules of life and conduct, observation and behaviour, have all to be reversed and relearnt. When you see a man gesticulating at you violently to go away, you retreat rapidly – actually he is inviting you to *approach*. On the other hand, if he beckons you, he is telling you to go away. Two men at opposite ends of the field, yelling fiercely at each other, would appear to be threatening each other with sudden death. Not at all. They are two brothers passing the time of day, and raising their voices because they are too lazy to approach each other. My husband Max once told me that he had determined on his first visit, shocked at the way everybody shouted at Arabs, that *he* would never shout at them. However, before he had been working long with the workmen he discovered that any remark uttered in an ordinary tone of voice was unheard – not so much through deafness as a belief that anyone talking like that was talking to himself, and that any man who really wished to make a remark would take the trouble to make it in a loud enough voice for you to hear.

The people of Alwiyah offered me charming hospitality. I played tennis, I drove to races, I was shown sights, taken to shop – and I felt that I might just as well be in England. Geographically I might be in Baghdad, spiritually I was in England still; and my idea of travelling had been to get away from England and see other countries. I decided that something must be done.

I wanted to visit Ur. I made inquiries, and was delighted to find that here I was encouraged, not rebuffed. My journey was arranged for me, as I discovered later, with a good many unnecessary additional adornments. 'You must take a bearer with you, of course,' said Mrs C. 'We'll reserve your train journey for you, and we'll wire to Ur junction to tell Mr and Mrs Woolley that you will be arriving and would like to be shown

things. You can spend a couple of nights in the rest-house there, and then Eric will meet you when you come back.'

I said it was very kind of them to take so much trouble and felt guiltily that it was a good thing they did not know that I was also taking trouble with my arrangements for when I came back.

In due course I set off. I eyed my bearer with slight alarm. He was a tall, thin man, with an air of having accompanied Mem-Sahibs all over the Near East and knowing a great deal more about what was good for them than they knew themselves. Splendidly attired, he settled me in my bare and not particularly comfortable carriage, salaamed, and left me, explaining that at a suitable station he would return to usher me to the platform dining-room.

The first thing I did when left to my own devices was extremely ill-judged: I threw open the window. The stuffiness of the compartment was more than I could bear; I longed for fresh air. What came in was not so much fresh air as much hotter, infinitely dustier air and a troupe of about twenty-six large hornets. I was horrified. The hornets zoomed round in a menacing fashion. I could not make up my mind whether to leave the window open and hope they would go out, or shut the window and at least confine myself to the twenty-six that were in already. It was all very unfortunate, and I sat cramped in one corner for about an hour and a half till my bearer came to rescue me and take me to the platform restaurant.

The meal was greasy and not particularly good, and there was not much time to eat it. Bells clanged, my faithful servant reclaimed me, and I returned to my carriage. The window had been shut and the hornets dispossessed. After that I was more careful what I tampered with. I had the whole compartment to myself – that seemed to be usual – and the time passed rather slowly, since it was impossible to read because the whole train shook so much, and there was nothing much to be seen out of the window except bare scrub or sandy desert. It was a long and wearisome journey, punctuated by meals, and uncomfortable sleep.

The times of day for arriving at Ur junction have varied during the many years that I have made the journey, but have invariably been inconvenient. On this occasion, I think, 5 a.m. was the appointed hour. Awakened, I descended, proceeded to the station guest-house, and passed the time there in a clean, stern-looking bedroom until I felt disposed for breakfast at 8 o'clock. Shortly after that a car arrived which was said to be taking me up to the dig, about a mile and a half away.

Although I did not know it, I was greatly honoured. After the experience now of being on digs for many years myself, I realise, as I certainly did not then, how loathed visitors were – always arriving at awkward times, wanting to be shown things, wanting to be talked to, wasting valuable time, and generally incommoding everything. On a successful dig such as Ur, every minute was occupied and everyone was working flat out. To have a lot of dithering females wandering round was the most irritating thing that could occur. By now the Woolleys had got things pretty well taped: people went round in a party of their own, being shown what was necessary, and were shooed off afterwards. But I was received most kindly as a valued guest, and I ought to have appreciated it far more than I did.

This treatment was due entirely to the fact that Katharine Woolley, Leonard Woolley's wife, had just finished reading one of my books, *The Murder of Roger Ackroyd*, and was so enthusiastic about it that I was given the V.I.P. treatment. Other members of the expedition were asked if they had read the book, and if they said they had not, were severely reprimanded.

Leonard Woolley, in his kindly fashion, showed me things, and I was also taken around by Father Burrows, a Jesuit priest and epigraphist. He, too, was a most original character, and the way he described things to me made a rather delightful contrast. Leonard Woolley saw with the eye of imagination: the place was as real to him as if it had been 1500 B.C., or a few thousand years earlier. Wherever we happened to be, he could make it come alive. While he was speaking I felt in my mind no doubt whatever that that house on the corner had been Abraham's – it was his reconstruction of the past and he believed in it, and anyone who listened to him believed in it also. Father Burrows' technique was entirely different. With an apologetic air, he described the big courtyard, a temenos, or a street of shops, and just as you became interested would always say: 'Of course we don't know if it *is* that really. Nobody can be sure. No, I think probably it was *not*.' And in the same way: 'Yes, yes, they were shops, but I don't suppose they were constructed as we think they were – they might have been quite different.' He had a passion for denigrating everything. He was an interesting person – clever, friendly and yet aloof: there was something faintly inhuman about him.

Once, for no reason, he spoke to me at luncheon, describing to me the sort of detective story which he thought I could write very well, and which he urged me to write. Until that moment I had had no idea that he

enjoyed detective stories. The story he was outlining, though vague in fact, somehow built up a picture of an intriguing problem, and I determined that one day I would do something about it. A great many years passed, but one day, perhaps twenty-five years later, the whole idea came back to me, and I wrote, not a book, but a long short story based on the particular combination of circumstances he had outlined. Father Burrows had been long dead by then, but I hoped that somehow he could realise that I used his idea with gratitude. As with all writers, it turned into my idea, and ended up by being not much like his; still, his inspiration was what had made it.

Katharine Woolley, who was to become one of my great friends in the years to come, was an extraordinary character. People have been divided always between disliking her with a fierce and vengeful hatred, and being entranced by her – possibly because she switched from one mood to another so easily that you never knew where you were with her. People would declare that she was impossible, that they would have no more to do with her, that it was insupportable the way she treated you; and then, suddenly, once again they would be fascinated. Of one thing I am quite positive, and that is if one had to choose one woman to be a companion on a desert island, or some place where you would have no one else to entertain you, she would hold your interest as practically no one else could. The things she wanted to talk about were never banal. She stimulated your mind into thinking along some pathway that had not before suggested itself to you. She was capable of rudeness – in fact she had an insolent rudeness, when she wanted to, that was unbelievable – but if she wished to charm you she would succeed every time.

I fell in love with Ur, with its beauty in the evenings, the ziggurrat standing up, faintly shadowed, and that wide sea of sand with its lovely pale colours of apricot, rose, blue and mauve changing every minute. I enjoyed the workmen, the foremen, the little basket-boys, the pickmen – the whole technique and life. The lure of the past came up to grab me. To see a dagger slowly appearing, with its gold glint, through the sand was romantic. The carefulness of lifting pots and objects from the soil filled me with a longing to be an archaeologist myself. How unfortunate it was, I thought, that I had always led such a frivolous life. And it was then that I remembered with deep shame how in Cairo as a girl my mother had tried to persuade me to go to Luxor and Aswan to see the past glories of Egypt, and how I had wanted only to meet young men and

dance till the small hours of the morning. Well, I suppose there is a time for everything.

Katharine Woolley and her husband urged me to stay one more day and see more of the excavations, and I was only too delighted to agree. My bearer, wished upon me by Mrs C., was completely unnecessary. Katharine Woolley directed him to return to Baghdad and say that my day of return was still unsure. In that way I hoped to return unnoticed by my former kind hostess, and establish myself firmly in the Tigris Palace Hotel (if that was its name at the moment – it has had so many names that I forget its first one).

This plan did not come off, because Mrs C.'s wretched husband had been sent to meet the train from Ur every day. However, I disposed of him quite easily. I thanked him enormously, said how kind his wife had been, but that I really felt it was better for me to go to the hotel, and that I had already made arrangements there. So he drove me there. I settled myself in, thanked Mr C. once more, and accepted an invitation to tennis in three or four days' time. In this way I escaped from the thraldom of social life in the English manner. I was no longer a Mem-Sahib, I had become a tourist.

The hotel was not at all bad. You passed first into deep gloom: a big lounge and dining-room, with curtains permanently drawn. On the first floor there was a kind of veranda all round the bedrooms, from where, as far as I could see, anyone going by could look in and pass the time of day with you as you lay in bed. One side of the hotel gave on to the river Tigris, which was a dream of delight, with the ghufas and various boats on the river. At meal-times you went down into the sirdab of complete darkness with very weak electric lights. Here you had several meals in one; course after course, all bearing a strange resemblance to each other – large lumps of fried meat and rice, hard, little potatoes, tomato omelettes, rather leathery, immense pale cauliflowers, and so on, *ad lib*.

The Howes, that pleasant couple who had set me off on my voyage, had given me one or two introductions. These I valued as not being social ones: they were to people whom they themselves had found it well worth while to meet, and who had shown them some of the more interesting parts of the city. Baghdad, in spite of the English life of Alwiyah, was the first really oriental city I had ever seen – and it *was* oriental. You could turn off Rashid Street and wander down the narrow little alley-ways, and so into different *suqs*: the copper *suq*, with the copper-

smiths beating and hammering; or the piled up spices of all kinds in the spice *suq*.

One of the Howes' friends, an Anglo-Indian, Maurice Vickers, who led, I think, a rather solitary life, proved a good friend to me also. He took me to see the golden domes of Kadhimain from an upper room; he led me to different parts of the *suq* – not those you usually see – and he drove me to the potters' quarters and many other places. We went for walks down to the river through palm-groves and date gardens. Perhaps I appreciated more what he talked about than what he showed me. It was from him that I first learnt to think of *time* – something I had never thought of before; never impersonally, that is. But for him time, and the relationships of time, were of particular significance.

'Once you think of time and infinity, personal things will cease to affect you in the same way. Sorrow, suffering, all the finite things of life, show in an entirely different perspective.'

He asked me if I had ever read Dunne's *Experiment with Time*. I had not. He lent it to me, and from that moment I realise that something happened to me – not a change of heart, not quite a change of outlook, but somehow I saw things more in proportion; myself less large; as only one facet of a whole, in a vast world with hundreds of inter-connections. Every now and then one could be aware of oneself observing, from some other plane of existence, oneself existing. It was all crude and amateurish to begin with, but I did feel from that moment onwards a great sensation of comfort and a truer knowledge of serenity than I had ever obtained before. It is to Maurice Vickers that I am grateful for that introduction to a wider view of life. He had a large library of books, philosophy and otherwise, and was, I think, a remarkable young man. Sometimes I wondered whether we should ever meet again, but I think on the whole I was satisfied that we should not. We had been ships that pass in the night. He had handed me a gift that I had accepted; the kind of gift that I had never had before, since it was a gift from the intellect – from the mind, not just from the heart.

I did not have much more time to spend in Baghdad, because I was anxious to get home to prepare for Christmas. I was told that I ought to go to Basra, and particularly to Mosul – Maurice Vickers urged the latter on me, and said that if he could find time he would take me there himself. One of the surprising things about Baghdad, and about Iraq generally, was that there was always someone to escort you to places. Except for renowned travellers, women seldom went about alone. As soon as you

wished to travel, somebody produced a friend, a cousin, a husband or an uncle who would manage to make time and escort you there.

At the hotel I met a Colonel Dwyer, in the King's African Rifles. He had travelled a great deal all over the world. He was an elderly man, but there was little he did not know about the Middle East. Our talk happened to fall on Kenya and Uganda, and I mentioned that I had a brother who had lived out there for many years. He asked his name, and I told him it was Miller. He stared at me then, an expression on his face with which I was already acquainted: a kind of incredulous doubt.

'Do you mean to say that you are Miller's sister? That your brother was Puffing Billy Miller?'

I had not heard the epithet of Puffing Billy.

'Mad as a hatter?' he added, interrogatively.

'Yes,' I said, heartily agreeing. 'He has always been as mad as a hatter.'

'And you are his sister! My goodness, he must have put you through it now and again!'

I said that that was a pretty fair assessment.

'One of the greatest characters I ever met. You couldn't push him, you know. You couldn't make him change his mind – obstinate as a pig – but you couldn't help respecting him. One of the bravest chaps I have ever known.'

I considered, and said yes, I thought he well might be.

'But hell to manage during a war,' he said. 'Mind you, I commanded that regiment later, and I sized him up from the beginning. I've met his kind often, travelling about the world on their own. They're eccentric, pig-headed, almost geniuses but not quite, so they are usually failures. They're the best conversationalists in the world – but only when they feel like it, mind. At other times they won't even answer you – won't speak.'

Every word he was saying was absolutely true.

'You're a good deal younger than he is, aren't you?'

'Ten years younger.'

'He went abroad when you were still a kid – is that right?'

'Yes. I didn't ever know him really very well. But he came home on leave.'

'What happened to him eventually? The last I heard of him he was ill in hospital.'

I explained the circumstances of my brother's life, and how he had

been finally sent home to die but had succeeded in living for some years afterwards in spite of all that the doctors had prophesied.

'Naturally,' he said. 'Billy wouldn't die until he felt like it. Put him in a hospital train, I remember, arm in a sling, badly wounded . . . He got an idea in his head he didn't want to go to hospital. Every time they put him in one side he got out the other – had a terrible job with him. They got him there at last, but on the third day he managed to walk out of the hospital without anyone seeing him. He had a battle called after him – did you know that ?'...

I said I had had some vague idea.

'Got across his commanding officer. He would, of course. A conventional chap – bit of a stuffed shirt – not Miller's kind at all. He was in charge of mules at that time – wonderful hand with mules Billy was. Anyway, he said suddenly this was the place to give battle to the Germans, and his mules were halting there – nothing would do better. His commanding officer said he would have him up for mutiny – he was to obey orders or else! Billy just sat down and said he wouldn't move, and his mules wouldn't either. Quite right about the mules: they wouldn't move – not unless Miller wanted them to. Anyway, he was scheduled for court martial. But just then a great force of Germans arrived.'

'And they had a battle ?' I asked.

'Certainly they did – and won it. The most decisive victory so far in the campaign. Well then, of course, the Colonel, old Whatsisname – Rush – something – was mad with rage, mad as could be. There he had been with a battle on his hands entirely due to an insubordinate officer whom he was going to court martial! Only, he couldn't court martial him as things turned out, so there it was. Anyway, there was a lot of face-saving all round – but it's always remembered as Miller's Battle.'

'Did you like him ?' he once asked abruptly.

It was a difficult question.

'Part of the time I did,' I said. 'I don't think I have ever known him for long enough to have what you might call family affection for him. Sometimes I despaired of him, sometimes I was maddened by him, sometimes – well I was fascinated by him – charmed.'

'He could charm women very easily,' said Colonel Dwyer. 'Came and ate out of his hand, they did. Wanted to marry him, usually. You know, marry him and reform him, train him and settle him down to a nice steady job. I gather he's not still alive ?'

'No, he died some years ago.'

'Pity! Or is it?'

'I've often wondered,' I said.

What actually is the border between failure and success? By all outward showing, my brother Monty's life had been a disaster. He had not succeeded at anything he had attempted. But was that perhaps only from the financial view? Had one not to admit that, despite financial failure, he had for the greater part of his life enjoyed himself?

'I suppose,' he had said to me once cheerfully, 'I've led rather a wicked life. I owe people a lot of money all over the world. Broken the laws of a lot of countries. Got a nice little hoard of illicit ivory tucked away in Africa. They know I have, too! But they won't be able to find it! Given poor old mother and Madge a good deal of worry. Don't suppose the parsons would approve of me. But, my word, kid, I've enjoyed myself. I've had a thundering good time. Never been satisfied with anything but the best.'

Where Monty's luck had always held was that right up to old Mrs Taylor some woman would turn up in his hour of need to minister to him. Mrs Taylor and he had lived peacefully together on Dartmoor. Then she had gone down badly with bronchitis. She had been slow to recover and the doctor had shaken his head over her passing another winter on Dartmoor. She ought to go somewhere warm – perhaps the south of France.

Monty was delighted. He sent for every travel brochure imaginable. Madge and I agreed that to ask Mrs Taylor to stay on Dartmoor was too much – although she assured us she did not mind, she would be quite willing to do so.

'I couldn't leave Captain Miller now.'

So, meaning for the best, we rebuffed Monty's wilder ideas, and arranged instead for rooms at a small *pension* in the south of France for both Mrs Taylor and him. I sold the granite bungalow and saw them off on the Blue Train. They looked radiantly happy, but, alas, Mrs Taylor caught a chill on the journey, developed pneumonia, and died in hospital a few days later.

They took Monty into hospital at Marseilles too. He was broken down by Mrs Taylor's death. Madge went out knowing that something would have to be arranged, but at her wits' end to know *what*. The nurse who was looking after him was sympathetic and helpful. She would see what could be done.

A week later we had a wire from the bank manager in whose hands

financial arrangements had been left, saying that he thought a satisfactory solution had been found. Madge could not go to see him, so I went along. The manager met me and took me out to lunch. No one could have been nicer or more sympathetic. He was, however, curiously evasive. I couldn't think why. Presently the cause of his embarrassment came out. He was nervous of what Monty's *sisters* would say to the proposal. The nurse, Charlotte, had offered to take Monty to her apartment and be responsible for him. The bank manager must have feared an outburst of prudish disapproval from us both – but how little he knew! Madge and I would have fallen on Charlotte's neck in gratitude. Madge got to know her well and became attached to her. Charlotte managed Monty – and he was very fond of her too. She kept control of the purse strings – whilst tactfully listening to Monty's grandiose plans for living on a large yacht and so on.

He died quite suddenly of a cerebral haemorrhage at a café on the front one day, and Charlotte and Madge wept together at the funeral. He was buried at the Military Cemetery at Marseilles.

I think, being Monty, he enjoyed himself to the end.

Colonel Dwyer and I became close friends after that. Sometimes I would go and dine with him; sometimes he would dine with me in my hotel; and our talk always seemed to come back to Kenya, Kilimanjaro, and Uganda and the Lake, and stories about my brother.

In a masterful and military manner Colonel Dwyer made arrangements for my entertainment on my next trip abroad. 'I have planned three good *safaris* for you,' he said. 'I'll have to fix it for you some time when I can get away at a time that suits you. I think I shall meet you somewhere in Egypt – then I'd fix a trek on a camel convoy right across North Africa. It would take two months but it would be a wonderful trip – something you would never forget. I can take you where none of these ridiculous trumped-up guides would be able to – I know every inch of that country. Then there is the interior.' And he outlined further travel plans, mostly in a bullock cart.

From time to time I had doubts in my own mind as to whether I would ever be tough enough to carry out these programmes. Perhaps we both knew that they were in the realms of wishful thinking. He was a lonely man, I think. Colonel Dwyer had risen from the ranks, had a fine military career, had gradually grown apart from a wife who refused to leave England – all she cared for, he said, was living in a neat little house in a neat little road – and his children had not cared for him when he came

home on leave. They had thought his ideas of travelling in wild places silly and unrealistic.

'In the end I sent her home whatever money she wanted for herself and for educating the children. But my life is out here, round these parts. Africa, Egypt, North Africa, Iraq, Saudi Arabia – all of that. This is the life for me.'

He was, I think, though lonely, satisfied. He had a dry sense of humour and told me several extremely funny stories about the various intrigues that went on. At the same time he was in many ways highly conventional. He was a religious, upright martinet, with stern ideas of right and wrong. An old Covenanter would describe him best.

It was November now, and the weather was beginning to change. There were no longer blistering hot sunlit days; occasionally there was even rain. I had booked my trip home, and I would be leaving Baghdad with regret – but not too much regret, because I was already forming plans for coming back again. The Woolleys had thrown out a hint that I might like to visit them next year, and perhaps travel part of the way home again with them; and there had been other invitations and encouragement.

The day came at last when I once more embarked on the six-wheeler, this time being careful to have reserved a seat near the front of the bus so that I should not again disgrace myself. We started off, and I was soon to learn some of the antics of the desert. The rain came, and, as is customary in that country, firm going at 8.30 a.m. had within hours become a morass of mud. Every time you took a step, an enormous pancake of mud weighing perhaps twenty pounds attached itself to each foot. As for the six-wheeler, it skidded unceasingly, swerved, and finally stuck. The drivers sprang out, spades were lifted, boards came down and were fixed under wheels, and the whole business of digging out the bus began. After about forty minutes or an hour's work a first attempt was made. The bus shuddered, lifted itself, and relapsed. In the end, with the rain increasing in violence, we had to turn back, and arrived once more in Baghdad. Our second attempt the next day was better. We still had to dig ourselves out once or twice, but finally we passed Ramadi, and when we got to the fortress of Rutbah we were out in clear desert again, and there was no more difficulty underfoot.

III

One of the nicest parts of travelling is coming home again. Rosalind, Carlo, Punkie and her family – I looked upon them all with new appreciation.

We went for Christmas to stay with Punkie in Cheshire. After that we came to London, where Rosalind had one of her friends to stay – Pam Druce, whose mother and father we had met originally in the Canary Islands. We planned that we would go to a pantomime, and then Pam would come down to Devonshire with us till the end of the holidays.

We had a happy evening after Pam arrived, until in the small hours I was awakened by a voice saying: 'Do you mind if I come into your bed, Mrs Christie? I feel as though I am having rather queer dreams.'

'Why, of course, Pam,' I said. I switched the light on and she got in and lay down with a sigh. I was slightly surprised, because Pam had not struck me as being a nervous child. However, it was the most comforting thing for her, no doubt, so we both went to sleep till morning.

After the curtains were drawn and my tea brought, I switched on my light and looked at Pam. Never have I seen a face so completely covered with spots. She noticed something rather peculiar in my expression, and said: 'You *are* staring at me!'

'Well,' I said, 'well, yes, I am.'

'Well, *I'm* surprised too,' said Pam. 'How did I get into your bed?'

'You came in in the night, and said you had had some nasty dreams.'

'Did I? I don't remember a thing about it. I couldn't think what I was doing in your bed.' She paused, and then said, 'Is there anything else the matter?'

'Well, yes,' I said, 'I'm afraid there is. Do you know, Pam, I think you've got the measles.' I brought a hand-glass and she examined her face. 'Oh,' she said, 'I do look peculiar, don't I?' I agreed.

'And what's going to happen, now?' Pam asked. 'Can't I go to the theatre tonight?'

'I'm afraid not,' I said. 'I think the first thing we'd better do is telephone your mother.'

I telephoned Beda Druce, who came round at once. She immediately

cancelled her departure, and took Pam off. I put Rosalind into the car and drove down to Devonshire, where we would wait ten days and see whether she was going to have measles or not. The drive was not made easier by the fact that I had been vaccinated only a week previously in the leg and driving was somewhat painful.

The first thing that happened at the end of the ten days was that I proceeded to have a violent headache and every sign of fever.

'Perhaps *you* are going to have the measles and not me,' suggested Rosalind.

'Nonsense,' I said. 'I had measles very badly myself when I was fifteen.' But I did feel slightly uneasy. People *did* have measles twice – and why should I feel so ill otherwise?

I rang up my sister, and Punkie, always ready to come to the rescue, said that on receipt of a telegram she would come at once and deal with either me or Rosalind, or both, and anything else that should happen. Next day I felt worse, and Rosalind complained of having a cold – her eyes watered and she sneezed.

Punkie arrived, full of her usual enthusiasm for dealing with disasters. In due course Dr Carver was summoned and pronounced that Rosalind had the measles.

'And what's the matter with you?' he said. 'You don't look too well.' I said I felt pretty dreadful, and thought I had a temperature. He put a few more searching inquiries. 'Been vaccinated, have you?' he said. '*And* you motored down here. Vaccinated in the leg, too? Why weren't you vaccinated in the arm?'

'Because vaccination marks look so dreadful in evening dress.'

'Well there's no harm being vaccinated in the leg, but it's silly to motor over two hundred miles when you have had that done. Let's have a look.' He had a look. 'Your leg is enormously swollen,' he said. 'Hadn't you realised that?'...

'Well, yes, I had, but I thought it was just the vaccination feeling sore.'

'Sore? It's a good deal more than *that*. Let's take your temperature.' He did, then exclaimed, 'Good Lord! Haven't you taken it?'

'Well, I did take it yesterday, and it was 102, but I thought perhaps it would go down. I do feel a bit odd.'

'Odd! I should think you do. It's over 103 now. You lie here on your bed and wait while I fix up a few things.'

He came back to say that I was to go into a nursing home immediately

and that he would send round an ambulance. I said an ambulance was nonsense. Why couldn't I just go in a car or a taxi?

'You will do as you are told,' said Dr Carver, not perhaps quite as sure of this as he might have been. 'I'll have a word with Mrs Watts first.' Punkie, came in and said, 'I'll look after Rosalind while she has the measles. Dr Carver seems to think you are in rather a bad way though. What have they done? Poisoned you with the vaccination?'

Punkie packed a few necessities for me, and I lay on my bed waiting for the ambulance and wishing that I could collect my thoughts. I had a terrible feeling of being on a slab in a fishmonger's shop: all round me were filleted, quivering fish on ice, but at the same time I was encased in a log of wood which was on fire and smoking – the combination of the two was most unfortunate. Every now and then, with an enormous effort, I came out of this unpleasant nightmare, saying to myself, 'I'm just Agatha lying on my bed – there are no fish here, no fishmonger's shop, and I am *not* a blazing log.' However, soon I was slithering about on a slippery sheepskin, and the fishes' heads were around me. There was one very unpleasant fish-head, I remember – it was a large turbot, I think, with protuberant eyes and a gaping mouth, and it looked at me in a most disagreeable way.

Then the door opened and into the room came a woman in nurse's uniform, what appeared to be an ambulance attendant, and with them a kind of portable chair. I made a good many protests – I had no intention of going anywhere in a portable chair. I could perfectly well walk downstairs and get into an ambulance. I was overborne by the nurse, saying in a snappish voice: 'Doctor's orders. Now dear, just sit here and we will strap you in.'

I never remember anything more frightening than being conveyed down the flight of steep stairs to the hall. I was a good weight – well over eleven stone – and the ambulance attendant was an extaordinarily weakly young man. He and the nurse between them got me into the chair and began carrying me downstairs. The chair creaked and showed every sign of falling to pieces, and the ambulance man kept slipping and clutching at the stair-rail . The moment came when the chair did begin to disintegrate in the middle of the stairs. 'Dear, dear, Nurse,' panted the attendant, 'I do believe it's coming to pieces.'

'Let me out of it,' I shouted. 'Let me walk down.'

They had to give in. They undid the strap, I took hold of the banisters, and marched valiantly down the stairs, feeling a great deal safer and

happier, and only just containing myself from saying what absolute fools I thought they were.

The ambulance drove off, and I arrived at the nursing home. A pretty little probationer nurse with red hair put me to bed. The sheets were cold, but not cold enough. Visions of fish and ice began to recur, and also a blazing cauldron.

'Ooh!' said the probationer nurse, looking at my leg with great interest. 'Last time we had a leg in like that it came off on the third day.'

Fortunately, by this time I was so delirious that the words hardly registered at all – in any case at that moment I couldn't have cared less if they had cut off both my legs and arms and even my head. But it passed through my mind as the little probationer arranged the bed-clothes and tucked me in tightly that possibly she had mistaken her vocation and that her bedside manner was not going to go down well with all the patients in a hospital.

Fortunately my leg did not come off on the third day. After four or five days of high fever and delirium from bad blood posioning the whole thing began to mend. I was convinced, and still believe, that some batch of vaccine had been sent out double strength. The doctors tended to believe that it was occasioned entirely by the fact that I had not been vaccinated since I was a baby, and that I had strained my leg by driving down from London.

After about a week I was more or less myself again, and interested to hear over the telephone progress of Rosalind's measles. They had been like Pam's – a splendid display of rash. Rosalind had much enjoyed her Auntie Punkie's ministrations, and had called in a clear voice nearly every night saying: 'Auntie Punkie! Would you like to sponge me down again like you did last night? I found it very very comforting.'

So in due course I came home, still with a large dressing on my left thigh, and we all had a cheerful convalescence together. Rosalind did not go back to school until two weeks after the opening, when she was quite herself again and strong and cheerful. I took another week, while my leg healed, and then I too departed, first to Italy and then to Rome, I could not stay there as long as I had planned, because I had to catch my boat for Beirut.

IV

This time I travelled by Lloyd Triestino boat to Beirut, spent a few days there, then once more took the Nairn Transport across the desert. It was somewhat rough along the coast from Alexandretta, and I had not been feeling too well. I had also noticed another woman on the boat. Sybil Burnett, the woman in question, told me afterwards that she had not been feeling too good in the swell either. She had looked at me and thought: '*That* is one of the most unpleasant women I have ever seen.' At the same time I had been thinking the same about her. I had said to myself, 'I don't like that woman. I don't like the hat she is wearing, and I don't like her mushroom-coloured stockings.'

On this mutual tide of dislike we proceeded to cross the desert together. Almost at once we became friends – and were to remain friends for many years. Sybil, usually called 'Bauff' Burnett, was the wife of Sir Charles Burnett, at that time Air Vice-Marshal, and was going out to join her husband. She was a woman of great originality, who said exactly what came into her head, loved travelling and foreign places, had a beautiful house in Algiers, four daughters and two sons by a previous marriage, and an inexhaustible enjoyment of life. With us there was a party of Anglo-Catholic ladies who were being shepherded out to Iraq to make tours of various Biblical places. In charge of them was an excessively fierce-looking woman, a Miss Wilbraham. She had large feet, encased in flat black shoes, and wore an enormous topee. Sybil Burnett said that she looked exactly like a beetle, and I agreed. She was the kind of woman that one cannot help wanting to contradict. Sybil Burnett contradicted her at once.

'Forty women I have with me,' said Miss Wilbraham, 'and I really must congratulate myself. Every one of them is a *sahib* except one. So important, don't you agree?'

'No,' said Sybil Burnett. 'I think to have them all *sahibs* is very dull. You want a good many of the other kind.'

Miss Wilbraham paid no attention – that was her strong point: she never paid attention. 'Yes,' she said, 'I really do congratulate myself.'

Bauff and I then put our heads together to see if we could spot the

one black sheep who did not pass the test and was labelled for the trip as not being a *sahib*.

With Miss Wilbraham was her second-in-command and friend, Miss Amy Ferguson. Miss Ferguson was devoted to all Anglo-Catholic causes, and even more so to Miss Wilbraham, whom she regarded as a super-woman. The only thing that upset her was her own incapacity to live up to Miss Wilbraham. 'The trouble is,' she confided, 'Maude is so splendidly strong. Of course, my health is good, but I must confess I *do* get tired sometimes. Yet I'm only sixty-five, and Maude is nearly seventy.'

'A very good creature,' said Miss Wilbraham of Amy. 'Most able, most devoted. Unfortunately she is continually feeling fatigued – most annoying. She can't help it, I suppose, poor thing, but there it is. Now I,' said Miss Wilbraham, 'never feel fatigue.' We felt quite sure of it.

We arrived in Baghdad. I met several old friends, and enjoyed myself there for four or five days, then, on receipt of a telegram from the Woolleys, went down to Ur.

I had seen the Woolleys in London the preceding June, when they were home, and indeed had lent them the little mews house which I had recently bought, in Cresswell Place. It was a delightful house, or so I thought – one of four or five houses in the mews which had been built like cottages: old-fashioned country cottages. When I bought it it had stables still, with the loose-boxes and mangers all round the wall, a big harness-room also on the ground floor, and a little bedroom squeezed between them. A ladder-like stair lead to two rooms above, with a sketchy bathroom and another tiny room next to that. With the help of a biddable builder it had been transformed. The big stable downstairs had had the loose-boxes and the wood-work arranged flat against the wall, and above that I had a big frieze of a kind of wallpaper which happened to be in fashion at that moment, of a herbaceous border, so that to enter the room was like walking into a small cottage garden. The harness-room was turned into the garage and the room between the two was a maid's room. Upstairs the bathroom was made splendid with green dolphins prancing round the walls and a green porcelain bath; and the bigger bedroom was turned into a dining-room, with a divan that turned into a bed at night. The very small room was a kitchen, and the other room a second bedroom.

It was while the Woolleys were installed in this house that they had made a lovely plan for me. I was to come to Ur about a week before the end of the season, when they were packing up, and after that I would

travel back with them, through Syria, on to Greece, and in Greece go to Delphi with them. I was very happy at this prospect.

I arrived at Ur in the middle of a sandstorm. I had endured a sandstorm when visiting there before, but this was far worse and went on for four or five days. I had never known that sand could permeate to the extent it did. Although the windows were shut, and mosquito-wired as well, one's bed at night was full of sand. You shook it all out on the floor, got in, and in the morning there was more sand weighing down on your face, your neck, and everywhere else. It was five days of near torture. However, we had interesting talks, everyone was friendly, and I enjoyed my time there enormously.

Father Burrows was there again, and Whitburn, the architect – and this time there was Leonard Woolley's assistant, Max Mallowan, who had been with him for five years, but who had been absent the previous year when I came down. He was a thin, dark, young man, and very quiet – he seldom spoke, but was perceptive to everything that was required of him.

I noticed this time something I had not taken in before: the extraordinary silence of everyone at table. It was as though they were afraid to speak. After a day or two I began to find out why. Katharine Woolley was a temperamental woman, and she had a great facility either for putting people at their ease or for making them nervous. I noticed that she was extremely well waited on: there was always someone to offer her more milk with her coffee or butter for her toast, to pass the marmalade, and so on. Why I wondered, were they all so scared of her?

One morning when she was in a bad mood I began to discover a little more.

'I suppose no one is ever going to offer me the salt,' she said. Immediately four willing hands shoved it across the table, almost upsetting it in the process. A pause ensued, then nervously Mr Whitburn leaned forward and pressed toast upon her.

'Don't you see my mouth is full, Mr Whitburn?' was the only response he got. He sat back, blushing nervously, and everybody ate toast feverishly before offering it to her again. She refused. 'But I really think,' she said. 'that you might occasionally not finish all the toast before Max has had a chance to have a piece.'

I looked at Max. The remaining piece of toast was offered to him. He took it quickly, without protest. Actually he had already had two

pieces, and I wondered why he did not say so. That again I was to realise more fully later.

Mr Whitburn initiated me into some of these mysteries: 'You see,' he said, 'she always has favourites.'

'Mrs Woolley?'

'Yes. They don't stay the same, you know. Sometimes one person, sometimes another. But, I mean, either everything you do is wrong, or everything is right. I'm the one in the doghouse at present.'

It was equally clear that Max Mallowan was the person who did everything right. It may have been because he had been away the preceding season, and so was more of a novelty than the others, but I think myself it was because in the course of five years he had learnt the way to treat the two Woolleys. He knew when to keep quiet; he knew when to speak.

I soon realised how good he was at managing people. He managed the workmen well, and, what was far more difficult, he managed Katharine Woolley well. 'Of course,' said Katharine to me, 'Max is the perfect assistant. I don't know what we would have done without him all these years. I think you'll like him very much. I am sending him with you to Nejef and Kerbala. Nejef is the Moslem holy city of the dead, and Kerbala has a wonderful mosque. So when we pack up here and go to Baghdad he will take you there. You can go and see Nippur on the way.'

'Oh,' I said, 'but — won't he want to go to Baghdad too? I mean, he will have friends there to see before he goes home.' I was dismayed at the thought of being sent off with a young man who was probably yearning for freedom and some fun in Baghdad after the strain of a three months season at Ur.

'Oh no,' said Katharine firmly. 'Max will be delighted.'

I didn't think Max *would* be delighted, though I had no doubt that he would conceal the fact. I felt very uncomfortable. I regarded Whitburn as a friend, having seen him the year before, and so I spoke to him about it.

'Don't you think it's rather high-handed? I hate to do that sort of thing. Do you think I could say I didn't want to see Nejef and Kerbala?'

'Well, I think you ought to see them,' said Whitburn. 'It will be quite all right. Max won't mind. And anyway, I mean, if Katharine has made up her mind, then that's settled, you see.'

I saw, and an enormous admiration spread over me. How wonderful to be the sort of woman who, as soon as she had made up her mind, had

everybody within sight immediately falling in with it, not grudgingly, but as a matter of course.

Many months later, I remember speaking to Katharine with some admiration of her husband Len. 'It's wonderful,' I said, 'how unselfish he is. The way he gets up on the boat at night and goes off and makes you Benger's or hot soup. There aren't many husbands who would do that.'

'Really?' said Katharine, looking surprised. 'Oh, but Len thinks it's a privilege.' And he *did* think it was a privilege. In fact, everything that one did for Katharine felt, at any rate for the moment, like a privilege. Of course, when you got home and realised you had parted with the two library books you had just fetched and were looking forward to reading, profering them to her eagerly because she sighed and said she had nothing to read, and not even grudging the fact until later, you realised what a remarkable woman she was.

Only exceptional people did not fall under her sway. One was, I remember, Freya Stark. Katharine was ill one day and wanted a lot of things fetched and done for her. Freya Stark, who was staying with her, was firm, cheerful and friendly: 'I can see you are not awfully well, dear, but I am absolutely *no* good with illness, so the best thing I can do for you is to go out for the day.' And go out for the day she did. Strangely enough, Katharine did not resent this; she merely thought it a splendid example of what force of character Freya had. And it certainly did show that.

To get back to Max, everybody seemed to agree it was perfectly natural that a young man, who had worked hard on an arduous dig and was about to be released for rest and a good time, should sacrifice himself and drive off into the blue to show a strange woman a good many years older than him, who knew little about archaeology, the sights of the country. Max seemed to take it as a matter of course. He was a grave-looking young man, and I felt slightly nervous of him. I worried whether I should offer some apology. I *did* essay some kind of stumbling phrase to the effect that I had not myself suggested this tour, but Max was calm about it all. He said he had nothing particular to do. He was going back home by degrees, first travelling with the Woolleys, and then, since he had already been to Delphi, dividing from them and going up to see the Temple of Bassae and other places in Greece. He himself would quite enjoy going to Nippur. It was a most interesting site, where he always enjoyed going – and also Nejef and Kerbala, which were well worth seeing.

So the day came when we started off. I enjoyed the day at Nippur very much, though it was extremely exhausting. We motored for hours over rough ground, and walked round what seemed acres of excavations. I don't suppose I would have found it very interesting had I not had someone with me to explain it all. As it was I became more enamoured of digging than ever.

Finally, at about seven o'clock at night, we came to Diwaniya, where we were to stay the night with the Ditchburns. I was reeling on my feet with the desire to sleep, but somehow or other managed to comb the sand out of my hair, wash it off my face, apply a little restorative powder, and struggle into some kind of evening dress.

Mrs Ditchburn loved entertaining guests. She was a great talker – indeed never stopped talking, in a bright and cheerful voice. I was introduced to her husband, and placed next to him. He seemed to be a quiet man, which was perhaps to be expected, and for a long time sat in lowering silence. I made a few rather inane remarks about my sightseeing, to which he did not respond. On the other side of me was an American missionary. He too was very taciturn. When I looked sideways at him, I noticed that his hands were twisting and turning beneath the table, and that he was slowly tearing a handkerchief to shreds. I found that rather alarming, and wondered what occasioned it. His wife sat across the table, and she too seemed in a highly nervous condition.

It was a curious evening. Mrs Ditchburn was in full social flight, chatting with her neighbours, talking to me and to Max. Max was responding reasonably well. The two missionaries, husband and wife, remained tongue-tied, the wife watching her husband desperately, and he still tearing his handkerchief to smaller and smaller shreds.

In a dazed dream of half-sleep, ideas of a superb detective story came into my head. A missionary slowly going mad with the strain. The strain of what? The strain of something, at any rate. And wherever he has been, torn-up handkerchiefs, reduced to shreds, provide clues. Clues, handkerchiefs, shreds – the room reeled around me, as I nearly slipped off my chair with sleep.

At this moment a harsh voice spoke in my left ear. 'All archaeologists,' said Mr Ditchburn with a kind of bitter venom, 'are liars.'

I woke up and considered him and his statement. He threw it at me in the most challenging manner. I did not feel in the least competent to defend the veracity of archaeologists, so I merely said mildly. 'Why do you think they are liars? What do they tell lies about?'

'Everything,' said Mr Ditchburn. 'Everything. Saying they know the dates of things, and when things happened – that this is 7,000 years old, and the other is 3,000 years old, that this king reigned then, and another king reigned afterwards! Liars! All liars, every one of them!'

'Surely,' I said. 'that can't be so?'

'Can't it?' Mr Ditchburn uttered a sardonic laugh and relapsed into silence.

I addressed a few more words to my missionary, but I got little more response. Then Mr Ditchburn broke the silence once more, and incidentally revealed a possible clue to his bitterness by saying: 'As usual, I have had to turn out of my dressing-room for this archaeological chap.'

'Oh,' I said uncomfortably, 'I am so sorry. I didn't realise . . .'

'It happens every time,' said Mr Ditchburn. 'She's always doing it – my wife, I mean. Has to be asking someone or other to put up with us. No, it's not you – you've got one of the regular guest-rooms. We've got three of those, but that isn't enough for Elsie. No, she's always got to fill up all the rooms there are, and then have my dressing-room as well. How I stand it I don't know.'

I said again I was sorry. I could not have been more uncomfortable, but presently I was once more bending all my energies on keeping awake. I could only just manage it.

After dinner I pleaded to be allowed to go to bed. Mrs Ditchburn was much disappointed, because she had had plans for a splendid rubber of bridge, but by this time my eyes were practically closed, and I only just managed to stumble upstairs, throw off my clothes, and fall into bed.

We left at five o'clock next morning. Travelling in Iraq was my introduction to a somewhat strenuous way of living. We visited Nejef, which was indeed a wonderful place: a real necropolis, a city of the dead, with the dark figures of the black-veiled Muslim women wailing and moving about it. It was a hot-bed of extremists, and it was not always possible to visit it. You had to inform the police first, and they would then be on the lookout to see that no outbreaks of fanaticism occurred.

From Nejef we went to Kerbala, where there was a beautiful mosque, with a gold and turquoise dome. It was the first that I had seen close up. We stayed the night there at the police post. A roll of bedding that Katharine had lent me was unfastened on the floor and my bed was made in a small police cell. Max had another police cell, and urged me to invoke his assistance if needed during the night. In the days of my

Victorian upbringing I should have thought it most strange that I should awaken a young man whom I hardly knew and ask him to be kind enough to escort me to the lavatory, yet this soon seemed a matter of course. I woke Max, he summoned a policeman, the policeman fetched a lantern, and we three tramped along long corridors and finally arrived at a remarkably evil-smelling room containing a hole in the floor. Max and the policeman waited politely outside the door to light me back to my couch.

Dinner was served at the police post on a table outside, with a large moon above us, and the constant monotonous yet musical croaking of frogs. Whenever I hear frogs I think of Kerbala and that evening. The policeman sat down with us. Now and again he said a few words of English rather carefully, but mostly spoke Arabic with Max, who occasionally translated a few words which were addressed to me. After one of the refreshing silences that always form part of Eastern contacts and accord so harmoniously with one's feelings, our companion suddenly broke his silence. 'Hail to thee, blithe spirit!' he said. 'Bird thou never wert.' I looked at him, startled. He proceeded to finish the poem. 'I learned that,' he said, nodding his head. 'Very good, in English.' I said it was very good. That seemed to end that part of the conversation. I should never have envisaged myself coming all the way to Iraq so as to have Shelley's 'Ode to a Skylark' recited to me by an Iraqi policeman in an Eastern garden at midnight.

We breakfasted early the next morning. A gardener, who was picking some roses, advanced with a bouquet. I stood expectantly, ready to smile graciously. Somewhat to my discomposure he passed me without a glance and handed them with a deep bow to Max. Max laughed, and pointed out to me that I was now in the East, where offerings were made to men and not to women.

We embarked with our belongings, bedding, stack of fresh bread, and the roses, and started off again. We were going to make a detour on our way back to Baghdad to see the Arab city of Ukhaidir. This lay far out in the desert. The scenery was monotonous, and to pass the time we sang songs, calling upon a repertoire of things we both knew, starting with *Frère Jacques*, and proceeding to various other ballads and ditties. We saw Ukhaidir, wonderful in its isolation, and about an hour or two after we had left it came upon a desert lake of clear, sparkling blue water. It was outrageously hot, and I longed to bathe. 'Would you really like to?' said Max. 'I don't see why you shouldn't.'

'Could I ?' I looked thoughtfully at my roll of bedding and small suit-case. 'But I haven't got any bathing-dress –'

'Haven't you got anything that would – well – *do*?' asked Max deli-cately. I considered, and in the end, dressed in a pink silk vest and a double pair of knickers. I was ready. The driver, the soul of politeness and delicacy, as indeed all Arabs are, moved away. Max, in shorts and a vest, joined me, and we swam in the blue water.

It was heaven – the world seemed perfect – or at least it did until we went to start the car again. It had sunk gently into the sand and refused to move, and I now realised some of the hazards of desert driving. Max and the driver, pulling out steel mats, spades, and various other things from the car, endeavoured to free us, but with no success. Hour succeeded hour. It was still ragingly hot. I lay down in the shelter of the car, or what shelter there was on one side of it, and went to sleep.

Max told me afterwards, whether truthfully or not, that it was at that moment he decided that I would make an excellent wife for him. 'No *fuss*!' he said. 'You didn't complain or say that it was my fault, or that we never should have stopped there. You seemed not to care whether we went on or not. Really it was at that moment I began to think you were wonderful.'

Ever since he said that to me I have tried to live up to the reputation I had made for myself. I am fairly good at taking things as they come, and not getting in a state. Also I have the useful art of being able to go to sleep at any moment, anywhere.

We were not on a caravan route here, and it was possible that no lorries or anything else might come this way for days, perhaps as long as a week. We had with us a guard, one of the Camel Corps, and in the end he said he would go and get help within, presumably, twenty-four hours, or at any rate within forty-eight. He left us what water he had. 'We of the Desert Camel Corps,' he said loftily, 'do not need to drink in emer-gency.' He stalked off, and I looked after him with some foreboding. This was adventure, but I hoped it was going to turn out a pleasant one. The water did not seem very much, and the thought of not having water made me thirsty straight away. However, we were lucky. A miracle happened. One hour later, a T Ford with fourteen passengers drove out of the horizon. Sitting beside the driver was our Camel Corps friend, waving an exuberant rifle.

At intervals on our journey back to Baghdad we stopped to look at *tells*, and walked round them picking up sherds of pottery. I was parti-

cularly enchanted with all the glazed fragments. The brilliant colours: green, turquoise, blue, and a sort of golden patterned one – they were all of a much later period than that in which Max was interested, but he was indulgent of my fancies, and we collected a large bag of them.

After we arrived in Baghdad, and I had been returned to my hotel, I spread out my mackintosh, dipped all the sherds in water, and arranged them in glistening iridescent patterns of colour. Max, kindly falling in with my whim, supplied his own mackintosh and added four sherds to the display. I caught him looking at me with the air of an indulgent scholar looking kindly at a foolish but not unlikeable child – and, really, I believe at that time that *was* his attitude towards me. I have always loved things like seashells or little bits of coloured rock – all the odd treasures one picks up as a child. A bright bird's feather, a variegated leaf – these things, I sometimes feel, are the *true* treasures of life, and one enjoys them better than topazes, emeralds, or expensive little boxes by Fabergé.

Katharine and Len Woolley had already arrived in Baghdad, and were not at all pleased with us for having arrived twenty-four hours late – this owing to our detour to Ukhaidir. I was exonerated from blame since I had been merely a parcel carried about and taken to places with no knowledge of where I was going.

'Max might have *known* that we should be worried,' Katharine said. 'We might have sent out a search party or done something silly.' Max repeated patiently that he was sorry; it had not occurred to him that they would be alarmed.

A couple of days later we left Baghdad by train for Kirkuk and Mosul, on the first leg of our journey home. My friend Colonel Dwyer came to Baghdad North Station to see us off. 'You'll have to stand up for yourself, you know,' he remarked to me, confidentially.

'Stand up for myself? What do you mean?'

'With Her Ladyship there.' He nodded to where Katharine Woolley was talking to a friend.

'But she's been so nice to me.'

'Oh yes, I can see you feel the charm. All of us have felt it from time to time. To be honest, I feel it still. That woman could get me where she wants me any time, but, as I say, *you've* got to stand up for yourself. She could charm the birds off a tree and make them feel it was only natural.' The train was making those peculiar banshee-like wails which I soon learnt were characteristic of the Iraqi railways. It was a piercing, eerie noise – in fact, a woman wailing for her demon lover would have

expressed it exactly. However, it was nothing so romantic: merely a locomotive raring to go. We climbed aboard – Katharine and I shared one sleeping compartment, Max and Len the other – and we were off.

We reached Kirkuk the following morning, had breakfast in the rest-house, and motored to Mosul. It was at that time a six to eight-hour run, most of it on a very rutted road, and included the crossing of the river Zab by ferry. The ferry-boat was so primitive that one felt almost Biblical embarking upon it.

At Mosul, too, we stayed at the rest-house, which had a charming garden. Mosul was to be the centre of my life for many years in the future, but it did not impress me then, mainly because we did little sightseeing.

Here I met Dr and Mrs MacLeod, who ran the hospital, and were to be great friends. They were both doctors, and whilst Peter MacLeod was in charge of the hospital his wife Peggy would occasionally assist him with certain operations. These had to be performed in a peculiar fashion owing to the fact that he was not allowed to see or touch the patient. It was impossible for a Muslim woman to be operated on by a man, even though he was a doctor. Screens, I gather, had to be rigged up; Dr MacLeod would stand outside the screen with his wife inside; he would direct her how to proceed, and she, in turn, would describe to him the conditions of the organs as she arrived at them, and all the various details.

After two or three days in Mosul we started on our travels proper. We spent one night at a rest-house at Tell Afar, which was two hours or so from Mosul, then at five the following morning motored off in a trek across country. We visited some sites on the Euphrates, and departed to the north, in search of Len's old friend Basrawi, who was Sheikh of one of the tribes there. After a good many crossings of wadis, losing and finding our way again, we finally arrived towards the evening, and were given a great welcome, a terrific meal, and at last retired for the night. There were two tumble-down rooms in a mud-brick house which were apportioned to us, with two small iron beds diagonally in the corners of each. A slight difficulty arose here. One room had a corner bed with an excellent ceiling above it – that is to say no water actually dripped through or fell on the bed: a phenomenon we were able to observe because it had started to rain. The other bed, however, was in a draughty corner with a good deal of water dripping on to it. We had a look at the second room. This one had an equally doubtful roof, and was smaller; the beds were narrower and there was less air and light.

'I think, Katharine,' said Len, 'that you and Agatha had better have

the smaller room with the two dry beds, and we'll have the other.'

'I think,' said Katharine, 'that I really *must* have the larger room and the good bed. I won't sleep a wink if there is water dripping on my face.' She went firmly across to the delectable corner and placed her things on the bed.

'I expect I can pull my bed out a bit and avoid the worst,' I said.

'I really don't see,' said Katharine, 'why Agatha should be forced to have this bad bed with the roof dripping on it. One of you men can have it. Either Max or Len had better go in the bad bed in this room, and the other one can go in the other room with Agatha.' This suggestion was considered, and Katharine, sizing up Max and Len to see which she thought would be the more useful to her, finally decided on the privilege of loving Len, and sent Max to share the small room. Only our cheerful host seemed to be amused by this arrangement – he made several remarks of a ribald nature in Arabic to Len. 'Please yourselves,' he said. 'Please yourselves! Divide up how you like – either way the man will be happy.'

However, by the morning nobody was happy. I woke at about six with rain pouring on my face. In the other corner Max was fully exposed to a deluge. He dragged my bed away from the worst leak, and pushed his own also out of the corner. Katharine had come off no better than anyone else: she, too, now had a leak. We had a meal, and took a tour round with Basrawi, surveying his domain, then went on our way once more. The weather was really bad now; some of the wadis were much swollen, and difficult to cross.

We arrived at last, wet and extremely tired, at Aleppo, to the comparative luxury of Baron's Hotel, where we were greeted by the son of the house, Coco Baron. He had a large round head, faintly yellow face, and mournful dark eyes.

The one thing I yearned for was a hot bath. I discovered the bathroom to be of a semi-western, semi-eastern type, and managed to turn on some hot water, which, as usual, came out in clouds of steam and frightened me to death. I tried to turn it off but did not succeed, and had to yell to Max for help. He arrived down the passage, subdued the water, then told me to go back to my room. He would call me when he had got the bath sufficiently under control for me to enjoy it. I went back to my room and waited. I waited a long time and nothing happened. Finally I sallied forth in my dressing-gown, sponge clasped under my arm. The door was locked. At that moment Max appeared.

'Where's my bath?' I demanded.

'Oh, Katharine Woolley is in there now,' said Max.

'Katharine?' I said, 'Did you let her have *my* bath that you were running for *me*?'

'Well, yes,' said Max. 'She wanted it,' he explained.

He looked me straight in the eye with a certain firmness of manner. I saw that I was up against something like the laws of the Medes and Persians. I said: 'Well, I think it is very unfair. *I* was running that bath. It was *my* bath.'

'Yes,' said Max, 'I know that. But Katharine wanted it.'

I went back to my room and reflected upon Colonel Dwyer's words.

I was to reflect on them again the next day. Katharine's bedside lamp gave her trouble. She was not feeling well, and was staying in bed with a miserable headache. This time of my own accord, I proffered her my bedside lamp in exchange. I took it into her room, fixed it up and left her with it. It seemed there was a shortage of lamps, so I had to read as best I could the next night with only one feeble lamp in the ceiling high above me. It was only on the next day that some slight indignation arose on my part. Katharine decided to change her room for one which would have less noise from the traffic. Since there was a perfectly good bedside lamp in her new room she had not bothered to return the other lamp to me, and it was now firmly in the possession of some third party. However, Katharine was Katharine, take it or leave it. I decided in future to do a little more to protect my own interests.

The next day, though Katharine had hardly any fever, she said she felt much worse. She was in a mood when she could not bear anyone to come near her.

'If only you would all go *away*,' she wailed. 'All go away and leave me. I cannot *stand* people coming in and out of my bedroom all day, asking me if I want anything – continually bothering me. If I could just be *quite* quiet, with nobody coming near me, then I might feel all right by this evening.' I thought I knew just how she felt, because it was very much how I feel when I am ill: I want people to go away and leave me. It is the feeling of the dog who crawls away to a quiet corner and hopes to be left undisturbed until the miracle happens and he feels himself again.

'I don't know what to do,' said Len helplessly. 'Really I don't know what to do for her.'

'Well,' I said consolingly, for I was very fond of Len, 'I expect she knows herself what she feels is best for her. I think she does want to be

left alone. I should leave her until this evening, and then see if she feels better.'

So this was arranged. Max and I went out together on an expedition to visit a Crusader's castle at Kalaat Siman. Len said he would remain at the hotel so as to be at hand if Katharine wanted anything.

Max and I set off happily. The weather had improved, and it was a lovely drive. We drove over hills with scrub and red anemones, with flocks of sheep and later, as the road went higher, black goats and kids. Finally we arrived at Kalaat Siman, and had our picnic lunch. Sitting there and looking round, Max told me a little more about himself, his life, and the luck he had had in getting the job with Leonard Woolley, just as he was leaving the University. We picked up a few bits of pottery here and there, and finally made our way back just as the sun was setting.

We arrived home to trouble. Katharine was enormously incensed at the way in which we had gone off and left her.

'But you *said* you wanted to be alone,' I said.

'One *says* things when one doesn't feel well. To think you and Max *could* go off in that heartless way. Oh well, perhaps it's not so bad of *you*, because you don't understand so well, but Max – that Max, who knows me well, who knows that I might have needed *anything* – could go off like that.' She closed her eyes and said, 'You had better leave me now.'

'Can't we get you anything, or stay with you?'

'No, I don't want you to get me *anything*. Really, I feel very hurt about all this. As for Len, his behaviour was absolutely disgraceful.'

'What has he done?' I asked, with some curiosity.

'He left me here without a single drop to drink – not a drop of water not lemonade, nothing at *all*. Just lying here, helpless, parched with thirst.'

'But couldn't you have rung the bell and asked for some water?' I asked. It was the wrong thing to say. Katharine gave me a withering glance: 'I can see you don't understand the first thing about it. To think that Len could be as heartless as that. Of course, if a *woman* had been here, it would have been different. *She* would have thought.'

We hardly dared approach Katharine in the morning, but she behaved in the most Katharine-like manner. She was in a charming mood, smiled, was pleased to see us, grateful for anything we did for her, gracious if slightly forgiving, and all was well.

She was indeed a remarkable woman. I grew to understand her a little better as the years went on, but could never predict beforehand in what

mood she would be. She ought, I think, to have been a great artist of some kind – a singer or an actress – then her moods would have been accepted as natural to her temperament. As it was, she was nearly an artist: she had done a sculptured head of Queen Shubad, which was exhibited with the famous gold necklace and head-dress on it.

She did a good head of Hamoudi, of Leonard Woolley himself, and a beautiful head of a young boy, but she was diffident of her own powers, always apt to invite other people to help her, or to accept their opinions. Leonard waited on her hand and foot – nothing he could do was good enough. I think she despised him a little for that. Perhaps any woman would do so. No woman likes a doormat, and Len, who could be extremely autocratic on his dig, was butter in her hands.

One early Sunday morning before we left Aleppo, Max took me on a tour of assorted religions. It was quite strenuous.

We went to the Maronites, the Syrian Catholics, the Greek Orthodox, the Nestorians, the Jacobites, and more that I can't remember. Some of them were what I called 'Onion Priests' – that is to say, having a kind of round onion-like head-dress. The Greek Orthodox I found the most alarming, since there I was firmly parted from Max and herded with the other women on one side of the church. One was pushed into something which looked like a horse-stall, with a kind of halter looped round one, and attached to the wall. It was a splendidly mysterious service, most of which took place behind an altar curtain or veil. Rich sonorous sounds came from behind this and out into the church, accompanied by clouds of incense. We all bobbed and bowed at prescribed intervals. In due course Max reclaimed me.

When I look back over my life, it seems that the things that have been most vivid, and which remain most clearly in my mind, are the *places* I have been to. A sudden thrill of pleasure comes into my mind – a tree, a hill, a white house tucked away somewhere, by a canal, the shape of a distant hill. Sometimes I have to think a moment to remember *where*, and *when*. Then the picture comes clearly, and I *know*.

People, I have never had a good memory for. My own friends are dear to me, but people that I merely meet and like pass out of my mind again almost at once. Far from being able to say, 'I never forget a face' I might more truly say, 'I never remember a face.' But places remain firmly in my mind. Often, returning somewhere after five or six years, I remember quite well the road to take, even if I have only been there once before.

I don't know why my memory for places should be good, and for people so faint. Perhaps it comes from being far-sighted. I have always been far-sighted, so that people have a rather sketchy appearance, because they are near at hand, while places I have seen with accuracy because they are further away.

I am quite capable of disliking a place just because the hills seem to me the wrong shape — it is very, very important that hills should be the *right* shape. Practically all the hills in Devonshire are the right shape. Most of the hills in Sicily are the wrong shape, so I do not care for Sicily. The hills of Corsica are sheer delight; the Welsh hills, too, are beautiful. In Switzerland the hills and mountains stand about you *too* closely. Snow mountains can be incredibly dull; they owe any excitement they have to the varying effects of light. 'Views' can be dull, too. You climb up a path to a hill top – and there! A panorama is spread before you. *But it is all there.* There is nothing further. You have seen it. 'Superb,' you say. And that is that. It's all below you. You have, as it were, conquered it.

V

From Aleppo we went on by boat to Greece, stopping at various ports on the way. I remember best going ashore with Max at Mersin, and spending a happy day on the beach, bathing in a glorious warm sea. It was on that day that he picked me enormous quantities of yellow marigolds. I made them into a chain and he hung them around my neck, and we had a picnic lunch in the midst of a great sea of yellow marigolds.

I was looking forward enormously to seeing Delphi with the Woolleys; they spoke of it with such lyric rapture. They had insisted that I was to be their guest there, which I thought extremely kind of them. I have rarely felt so happy and full of anticipation as when we arrived at Athens.

But things come always at the moment one does not expect them. I can remember, standing at the hotel desk and being handed my mail, on top of it a pile of telegrams. The moment I saw them a sharp agony seized me, because seven telegrams could mean nothing but bad news. We had been out of touch for the last fortnight at least, and now bad news had caught up with me. I opened one telegram – but the first was actually the last. I put them into order. They told me that Rosalind was

very ill with pneumonia. My sister had taken the responsibility of removing her from school and motoring her up to Cheshire. Further ones reported her condition as serious. The last one, the one I had opened first, stated that her condition was slightly better.

Nowadays, of course, one could have been home in less than twelve hours, with air services going from the Piraeus every day, but then, in 1930, there were no such facilities. At the very earliest, if I could book a seat, the next Orient Express, would not get me to London for four days.

My three friends all reacted to my bad news with the utmost kindness. Len laid aside what he was doing and went out to contact travel agencies and find the earliest seat that could be booked. Katharine spoke with deep sympathy. Max said little, but he, too, went out with Len to the travel agency.

Walking along the street, half dazed with shock, I put my foot into one of those square holes in which trees seemed eternally to be being planted in the streets of Athens. I sprained my ankle badly, and was unable to walk. Sitting in the hotel, receiving the commiserations of Len and Katharine, I wondered where Max was. Presently he came in. With him he had two good solid crepe bandages and an elastoplast. Then, he explained quietly that he would be able to look after me on the journey home and help me with my ankle.

'But you are going up to the Temple of Bassae,' I said. 'Weren't you meeting somebody?'

'Oh, I've changed my plans,' he said. 'I think I really ought to get home, so I will be able to travel with you. I can help you along to the dining-car or bring meals along to you, and get things done for you.'

It seemed too marvellous to be true. I thought then, and indeed have thought ever since, what a wonderful person Max is. He is so quiet, so sparing with words of commiseration. He *does* things. He does just the things you want done and that consoles you more than anything else could. He didn't condole with me over Rosalind or say she would be all right and that I mustn't worry. He just accepted that I was in for a bad time. There were no sulpha drugs then, and pneumonia was a real menace.

Max and I left the next evening. On our journey he talked to me a great deal about his own family, his brothers, his mother, who was French and very artistic and keen on painting, and his father, who sounded a little like my brother Monty – only fortunately more stable financially.

At Milan we had an adventure. The train was late. We got out – I

could limp about now, my ankle supported by elastoplast – and asked the *wagon lit* conductor how long the wait would be. 'Twenty minutes,' he said. Max suggested we should go and buy some oranges – so we walked along to a fruit-stall, then walked back to the platform again. I suppose about five minutes had elapsed, but there was no train at the platform. We were told it had left.

'Left? I thought it waited here twenty minutes,' I said.

'Ah yes, Signora, but it was very much in lateness – it waited only a short time.'

We looked at each other in dismay. A senior railway official then came to our aid. He suggested that we hire a powerful car and race the train. He thought we would have a sporting chance of catching it at Domodossola.

A journey rather like one on the cinema then began. First we were ahead of the train, then the train was ahead of us. Now we felt despair, the next moment we felt comfortably superior, as we went through the mountain roads and the train popped in and out of tunnels, either ahead of or behind us. Finally we reached Domodossola about three minutes after the train. All the passengers it seemed, were leaning out of the windows – certainly all in our own *wagon lit* coach – to see whether we had arrived.

'Ah, Madame,' said an elderly Frenchman as he helped me into the train. '*Que vous avez dû éprouver des émotions!*' The French have a wonderful way of putting things.

As a result of hiring this excessively expensive car, about which we had no time to bargain, Max and I had practically no money left. Max's mother was meeting him in Paris, and he suggested hopefully I should be able to borrow money from her. I have often wondered what my future mother-in-law thought of the young woman who jumped out of the train with her son, and after the briefest of greetings borrowed practically every *sou* she happened to have on her. There was little time to explain because I had to take the train on to England, so with confused apologies I vanished, clutching the money I had extracted from her. It cannot, I think, have prejudiced her in my favour.

I remember little of that journey with Max except his extraordinary kindness, tact, and sympathy. He managed to distract me by talking a good deal about his own doings and thoughts. He bandaged my ankle repeatedly, and helped me along to the dining-car, which I do not think I could have reached by myself, especially with the jolting of the Orient

Express as it gathered strength and speed. One remark I do remember. We had been running alongside the sea on the Italian Riviera. I had been half asleep, sitting back in my corner, and Max had come into my carriage and sitting opposite me. I woke up and found him studying me, thoughtfully. 'I think,' he said, 'that you really have a *noble* face.' This so astonished me that I woke up a little more. It was a way I should never have thought of describing myself – certainly nobody else had ever done so. A noble face – had I? It seemed unlikely. Then a thought occurred to me. 'I suppose,' I said, 'that is because I have rather a Roman nose.' Yes, I thought, a Roman nose. That *would* give me a slightly noble profile. I was not quite sure that I liked the idea. It was the kind of thing that was difficult to live up to. I am many things: good-tempered, exuberant, scatty, forgetful, shy, affectionate, completely lacking in self-confidence, moderately unselfish; but *noble* – no, I can't see myself as noble. However, I relapsed into sleep, rearranging my Roman nose to look its best – full-face, rather than profile.

VI

It was a horrible moment when I first lifted the telephone on my arrival in London. I had had no news now for five days. Oh, the relief when my sister's voice told me that Rosalind was much better, out of danger, and making a rapid recovery. Within six hours I was in Cheshire.

Although Rosalind was obviously mending fast, it was a shock to see her. I had had little experience then of the rapidity with which children go up and down in illness. Most of my nursing experience had been amongst grown men, and the frightening way in which children can look half dead one moment and in the pink the next was practically unknown to me. Rosalind had the appearance of having grown much taller and thinner, and the listless way she lay back in an arm-chair was so unlike my girl.

The most notable characteristic of Rosalind was her energy. She was the kind of child who was never still for a moment; who, if you returned from a long and gruelling picnic, would say brightly: 'There's at least half an hour before supper – what can we *do*?' It was not unusual to come round the corner of the house and find her standing on her head. 'What on earth are you doing that for, Rosalind?'

'Oh, I don't know, just putting in time. One must do *something*.'

But here was Rosalind lying back, looking frail and delicate, and completely devoid of energy. All my sister said was, 'You should have seen her a week ago. She really looked like death.'

Rosalind mended remarkably quickly. Within a week of my return she was down in Devonshire, at Ashfield, and seemed almost back to her old self – though I did my best to restrain her from the perpetual motion which she wished to renew.

Apparently Rosalind had gone back to school in good health and spirits. All had gone well until an epidemic of influenza passed over the school, and half the children went down with it. I suppose flu on top of the natural weakness after measles had led to pneumonia. Everybody was worried about her though a little doubtful about my sister's removing her by car to the north. But Punkie had insisted, being sure that it was the best thing – and so indeed it had proved to be.

Nobody could have made a better recovery than Rosalind did. The doctor pronounced her as strong and fit as she had ever been – if not more so, 'She seems,' he added, 'a very live wire.' I assured him that toughness had always been one of Rosalind's qualities. She was never one to admit she was ill. In the Canary Islands, she had suffered from tonsilitis but never breathed a word about it except to say: 'I am feeling very *cross*.'

I had learnt by experience that when Rosalind said she was feeling very cross, there were two possibilities: either she was ill or it was a literal statement of fact – she *was* feeling cross, and thought it only fair to warn us of the fact.

Mothers are, of course, partial towards their children – why should they not be – but I cannot help believing that my daughter was more fun than most. She had a great talent for the unexpected answer. So often you know beforehand what children are going to say, but Rosalind usually surprised me. Possibly it was the Irish in her. Archie's mother was Irish, and I think it was from the Irish side of her ancestry that she got her unexpectedness.

'Of course,' said Carlo to me with that air of impartiality she liked to assume, 'Rosalind can be maddening sometimes. I get furious with her. All the same I find other children very boring after her. She may be maddening, but she is never boring.' That, I think, has held true throughout her life.

We are all the same people as we were at three, six, ten or twenty years

old. More noticeably so, perhaps, at six or seven, because we were not pretending so much then, whereas at twenty we put on a show of being someone else, of being in the mode of the moment. If there is an intellectual fashion, you become an intellectual; if girls are fluffy and frivolous, you are fluffy and frivolous. As life goes on, however, it becomes tiring to keep up the character you invented for yourself, and so you relapse into individuality and become more like yourself every day. This is sometimes disconcerting for those around you, but a great relief to the person concerned.

I wonder if the same holds good for writing. Certainly, when you begin to write, you are usually in the throes of admiration for some writer, and, whether you will or no, you cannot help copying their style. Often it is not a style that suits you, and so you write badly. But as time goes on you are less influenced by admiration. You still admire certain writers, you may even wish you could write like them, but you know quite well that you can't. Presumably, you have learnt literary humility. If I could write like Elizabeth Bowen, Muriel Spark or Graham Greene, I should jump to high heaven with delight, but I know that I can't, and it would never occur to me to attempt to copy them. I have learnt that I am *me*, that I can do the things that, as one might put it, *me* can do, but I cannot do the things that *me* would like to do. As the Bible say, 'Who by taking thought can add one cubit to his stature?'

Often there flashes through my head a picture of the plate which hung upon my nursery wall: one which I think I must have won at a coconut shy at one of the regattas. '*Be a wheel-greaser if you can't drive a train*' is written across it – and never was there a better motto with which to go through life. I think I have kept to it. I have had a few tries at this and that, mind you, but I have never stuck to trying to do things which I do badly, and for which I do not have a natural aptitude. Rumer Godden, in one of her books, once wrote down a list of the things she liked and the things she didn't like. I found it entertaining, and immediately wrote down a list of my own. I think I could add to that now by writing down things I *can't* do and things I *can* do. Naturally, the first list is much the longer.

I was never good at games; I am not and never shall be a good conversationalist; I am so easily suggestible that I have to get away by myself before I know what I really think or need to do. I can't draw; I can't paint; I can't model or do any kind of sculpture; I can't hurry without getting rattled; I can't say what I mean easily – I can write it better.

I can stand fast on a matter of principle, but not on anything else. Although I know tomorrow is Tuesday, if somebody tells me more than four times that tomorrow is Wednesday, after the fourth time I shall accept that it is Wednesday, and act accordingly.

What *can* I do? Well, I can write. I could be a reasonable musician, but not a professional one. I am a good accompanist to singers. I can improvise things when in difficulties – this has been a most useful accomplishment; the things I can do with hairpins and safety pins when in domestic difficulties would surprise you. It was I who fashioned bread into a sticky pill, stuck it on a hairpin, attached the hairpin with sealing wax on the end of a window pole, and managed to pick up my mother's false teeth from where they had fallen on to the conservatory roof! I successfully chloroformed a hedgehog that was entangled in the tennis net and so managed to release it. I can claim to be useful about the house. And so on and so forth. And now for what I like and don't like.

I don't like crowds, being jammed up against people, loud voices, noise, protracted talking, parties, and especially cocktail parties, cigarette smoke and smoking generally, any kind of drink except in cooking, marmalade, oysters, lukewarm food, grey skies, the feet of birds, or indeed the feel of a bird altogether. Final and fiercest dislike: the taste and smell of hot milk.

I like sunshine, apples, almost any kind of music, railway trains, numerical puzzles and anything to do with numbers, going to the sea, bathing and swimming, silence, sleeping, dreaming, eating, the smell of coffee, lilies of the valley, most dogs, and going to the theatre.

I could make much better lists, much grander-sounding, much more *important*, but there again it wouldn't be me, and I suppose I must resign myself to *being* me.

Now that I was starting life again, I had to take stock of my friends. All that I had gone through made for a kind of acid test. Carlo and I compiled between us two orders: the Order of the Rats and the Order of the Faithful Dogs. We would sometimes say of someone, 'Oh yes, we will give him the Order of the Faithful Dogs, first class,' or, 'We will give him the Order of the Rats, third class.' There were not many Rats, but there were some rather unexpected ones: people who you had thought were your true friends, but who turned out anxious to disassociate themselves from anybody who had attracted notoriety of the wrong sort. This discovery, of course, made me more sensitive and more inclined to

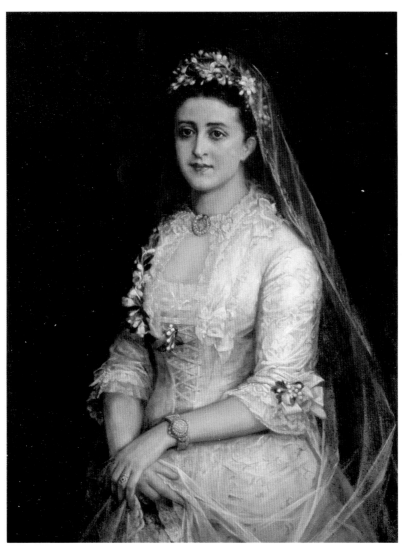

My mother wearing her wedding dress in about 1877

Myself as a child, painted by Connah

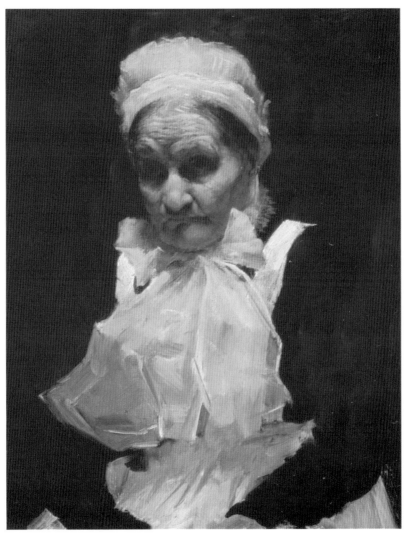

Nursie, painted by N. H. J. Baird in 1895

My brother Monty, painted by N. H. J. Baird

My sister Madge, painted by N. H. J. Baird

Monty's Dandy Dinmont, Scotty, painted by N. H. J. Baird

Myself at the age of sixteen, painted by N. H. J. Baird

My portrait, painted by Olive Snell

withdraw from people. On the other hand, I found many most unexpected friends, completely loyal, who showed me more affection and kindness than they had ever done before.

I think I admire loyalty almost more than any other virtue. Loyalty and courage are two of the finest things there are. Any kind of courage, physical or moral, arouses my utmost admiration. It is one of the most important virtues to bring to life. If you can bear to live at all, you can bear to live with courage. It is a must.

I found many worthy members of the Order of Faithful Dogs amongst my men friends. There are faithful Dobbins in most women's lives, and I was particularly touched by one of these who arrived at a Dobbin-like gallop. He sent me enormous bunches of flowers, wrote me letters, and finally asked me to marry him. He was a widower, and some years older than I was. He told me that when he had first met me earlier, he had thought me far too young, but that now he could make me happy and give me a good home. I was touched by this, but I had no wish to marry him, nor indeed had I ever had any such feelings towards him. He had been a good, kind friend, and that was all. It is heartening to know that someone cares – but it is most foolish to marry someone simply because you wish to be comforted, or to have a shoulder to cry upon.

In any case, I did not wish to be comforted. I was scared of marriage. I realised, as I suppose many women realise sooner or later, that the only person who can really hurt you in life is a husband. Nobody else is close enough. On nobody else are you so dependent for the everyday companionship, affection, and all that makes up marriage. Never again, I decided, would I put myself at *anyone*'s mercy.

One of my Air Force friends in Baghdad had said something to me that disquieted me. He had been discussing his own marital difficulties, and said at the end: 'You think you have arranged your life, and that you can carry it on in the way you mean to do, but it will come to one of two things in the end. You will have either to take a lover or to take several lovers. You can make a choice between those two.' Sometimes I had an uneasy feeling that what he said was right. But better either of those alternatives, I thought, than marriage. Several lovers could not hurt you. One lover could, but not in the way a husband could. For me, husbands would be out. At the moment all men were out – but that, my Air Force friend had insisted, would not last.

What did surprise me was the amount of passes that were made as soon as I was in the slightly equivocal position of being separated from or having

divorced a husband. One young man said to me, with the air of finding me thoroughly unreasonable: 'Well, you're separated from your husband, and I gather probably divorcing him, so what else can you expect?'

At first I couldn't make up my mind whether I was pleased or annoyed by these attentions. I thought on the whole that I was pleased. One is never too old to be insulted. On the other hand it made sometimes for tiresome complications – in one case with an Italian. I brought it on myself by not understanding Italian conventions. He asked me if I found the noise of the coaling of the boat kept me awake at night, and I said no because my cabin was on the starboard side away from the quay. 'Oh,' he said, 'I thought you had cabin thirty-three.' 'Oh no,' I said, 'mine's an even number: sixty-eight.' That was surely an innocent enough conversation from my point of view? I did not realise that to ask the number of your cabin was the convention by which an Italian asked if he might visit you there. Nothing more was said, but some time after midnight my Italian appeared. A very funny scene ensued. I did not speak Italian, he spoke hardly any English, so we both argued in furious whispers in French, I expressing indignation, he also expressing indignation but of a different kind. The conversation ran something like:

'How dare you come to my cabin.'

'You invited me here.'

'I did nothing of the sort.'

'You did. You told me your cabin number was sixty-eight.'

'Well, you asked me what it was.'

'Of course I asked you what it was. I asked you what it was because I wanted to come to your cabin. And you told me I could.'

'I did nothing of the sort.'

This proceeded for some time, every now and then rising heatedly, until I hushed him down. I was quite sure that a rather prim Embassy doctor and his wife, who were in the next cabin to me, were forming the worst possible conjectures. I urged him angrily to go away. He insisted that he should stay. In the end his indignation rose to the point when it became greater than mine, and I began apologising to *him* for not realising that his question had been in effect a proposition. I got rid of him at last, still injured but finally accepting that I was not the experienced woman of the world he had thought. I also explained to him, which seemed to calm him down even more, that I was English and therefore frigid by nature. He condoled with me on this, and so honour – his honour – was satisfied. The Embassy doctor's wife gave me a cold look the next morning.

It was not until a good deal later that I discovered that Rosalind had sized up my various admirers from the beginning in a thoroughly practical fashion. 'Well I thought of course you'd marry again some time, and naturally I was a bit concerned as to who it would be,' she explained.

Max had now returned from his stay in France with his mother. He said he would be working at the British Museum, and hoped I would let him know if I was up in London. This did not seem likely just at present, as I was settled at Ashfield. But then it happened that my publishers, Collins, were throwing a large party at the Savoy to which they particularly wanted me to come to meet my American publishers and other people. I would have appointments pretty well all that day, so in the end I went up by the night train, and invited Max to come and have breakfast with me at the Mews house.

I was delighted at the thought of seeing him again, but strangely enough, the moment he arrived I was stricken with shyness. After the journey we had done together and the friendly terms on which we had been, I could not imagine why I was so thoroughly paralysed. He too, I think, was shy. However, by the end of breakfast, which I cooked for him, we were getting back to our old terms. I asked him if he could stay with us in Devon, and we fixed up a weekend when he could come. I was very pleased that I was not going to lose touch with him.

I had followed up *The Murder of Roger Ackroyd* with *The Seven Dials Mystery*. This was a sequel to my earlier book *The Secret of Chimneys*, and was one of what I called 'the light-hearted thriller type'. These were always easy to write, not requiring too much plotting and planning.

I was gaining confidence over my writing now. I felt that I would have no difficulty in producing a book every year, and possibly a few short stories as well. The nice part about writing in those days was that I directly related it to money. If I decided to write a story, I knew it would bring me in £60, or whatever it was. I could deduct income tax – at that time 4/- or 5/- in the pound – and therefore I knew that I had a good £45 which was mine. This stimulated my output enormously. I said to myself, 'I should like to take the conservatory down and fit it up as a loggia in which we could sit. How much will that be?' I got my estimate, I went to my typewriter, I sat, thought, planned, and within a week a story was formed in my mind. In due course I wrote it, and then I had my loggia.

How different from the last ten or twenty years of my life. I never know what I owe. I never know what money I have. I never know what money I shall have next year – and anyone who is looking after my income tax is always arguing over problems arising several years previously, which have not yet been 'agreed'. What can one do in circumstances like this?

But those were the sensible days. It was what I always call my plutocratic period. I was beginning to be serialised in America, and the money that came in from this, besides being far larger than anything I ever made from serial rights in Britain, was also at that time free of income tax. It was regarded as a capital payment. I was not getting the sums I was to receive later, but I could see them coming, and it seemed to me that all I had to do was to be industrious and rake in the money.

Now I often feel that it might be as well if I never wrote another word, because if I do it will only make further complications.

Max came down to Devon. We met at Paddington and went down by the midnight train. Things always happened when I was away. Rosalind greeted us with her usual bouncing good spirits, and immediately announced disaster. 'Peter,' she said, 'has bitten Freddie Potter in the face.'

That one's precious resident cook-housekeeper has had her precious child bitten in the face by one's precious dog is the last news one wishes to hear on returning to one's household.

Rosalind explained that it had not really been Peter's fault: she had told Freddie Potter not to put his face near Peter and make whooping noises.

'He came nearer and nearer to Peter, zooming, so of course Peter bit him.'

'Yes,' I said, 'but I don't suppose Mrs Potter understands that.'

'Well, she's not been too bad about it. But of course, she's not pleased.'

'No, she wouldn't be.'

'Anyway,' said Rosalind, 'Freddie was very brave about it. He always is,' she added, in loyal defence of her favourite playmate. Freddie Potter, the cook's little boy, was junior to Rosalind by about three years, and she enormously enjoyed bossing him about, taking care of him, and acting the part of the munificent protector, as well as being a complete tyrant in arranging what games they played. 'It's lucky, isn't it,' she said, 'that Peter didn't bite his nose right off? If so, I suppose I should have had to look for it and stick it on some way or other – I don't know quite how – I

mean, I suppose you would have to sterilise it first, or something, wouldn't you? I don't see quite how you would sterilise a nose. I mean you can't *boil* it.'

The day turned out to be one of those indecisive days which might be fine, but, to those experienced in Devonshire weather, was almost certain to be wet. Rosalind proposed we should go for a picnic on the moor. I was keen on this, and Max agreed, with an appearance of pleasure.

Looking back, I can see that one of the things my friends had to suffer out of affection for me was my optimism about weather, and my misplaced belief that on the moor it would be finer than in Torquay. Actually the reverse was almost certain to be the case. I used to drive my faithful Morris Cowley, which was of course an open touring car, and which had an elderly hood with several gaps in its structure, so that, sitting in the back, water coursed steadily down the back of your neck. In all, going for a picnic with the Christies was a distinct endurance test.

So we started off and the rain came on. I persisted, however, and told Max of the many beauties of the moor, which he could not quite see through the driving mist and rain. It was a fine test for my new friend from the Middle East. He certainly must have been fond of me to have endured it and preserve his air of enjoying himself.

When we eventually got home and dried ourselves, then had got wet all over again in hot baths, we played a great many games with Rosalind. And next day, since it was also rather wet, we put on our mackintoshes and went for rousing walks in the rain with the unrepentant Peter, who was, however, by now on the best of terms once more with Freddie Potter.

I was very happy being with Max again. I realised how close our companionship had been; how we seemed to understand each other almost before we spoke. Nevertheless, it was a shock to me when the next night, after Max and I had said goodnight and I had gone to bed, as I was lying there reading, there was a tap at the door and Max came. He had a book in his hand which I had lent him.

'Thank you for lending me this,' he said. 'I enjoyed it.' He put it down beside me. Then he sat down on the end of my bed, looked at me thoughtfully, and said that he wanted to marry me. No Victorian Miss exclaiming, 'Oh, Mr Simpkins, this is so sudden!' could have looked more completely taken aback than I did. Most females, of course, know pretty well what is in the wind – in fact they can see a proposal coming days ahead and can deal with it in one of two ways: either they can be so off-putting and disagreeable that their suitor becomes disgusted with his choice or they

can let him gently come to the boil and get it over. But I know now that one *can* say perfectly genuinely, 'Oh Mr Simpkins, this is so sudden!'

It had never occurred to me that Max and I would be or ever could be on those terms. We were *friends*. We had become instant and closer friends, it seemed to me, than I and any friend had ever been before.

We had a ridiculous conversation that there seems not much point in writing down here. I said immediately that I couldn't. He asked why couldn't I? I said for every reason. I was years older than he was – he admitted that, and said he had always wanted to marry someone older than he was. I said that was nonsense and it was a bad thing to do. I pointed out he was a Catholic, and he said he had considered that also – in fact, he said, he had considered everything. The only thing, I suppose, that I didn't say, and which naturally I would have said if I had felt it, was that I didn't want to marry him – because, quite suddenly, I felt that nothing in the world would be as delightful as being married to him. If only he was older or I was younger.

We argued, I think, for about two hours. He gradually wore me down – not so much with protestations as with gentle pressure.

He departed the next morning by the early train, and as I saw him off he said: 'I think you *will* marry me, you know – when you have had plenty of time to think it over.'

It was too early in the morning to marshal my arguments again. Having seen him off I went back home in a state of miserable indecision.

I asked Rosalind if she liked Max. 'Oh yes,' she said, 'I like him very much. I like him better than Colonel R. and Mr B.' One could trust Rosalind to know what was going on, but to have the good manners not to mention it openly.

How awful those next few weeks were. I was so miserable, so uncertain, so confused. First I decided that the last thing I wanted to do was to marry again, that I must be *safe*, safe from ever being hurt again; that nothing could be more stupid than to marry a man many years younger than myself; that Max was far too young to know his own mind; that it wasn't fair to him – he ought to marry a nice young girl; that I was just beginning to enjoy life on my own. Then, imperceptibly, I found my arguments changing. It was true that he was much younger than I was, but we had so much in common. He was not fond of parties, gay, a keen dancer; to keep up with a young man like that would have been very difficult for me. But surely I could walk round museums as well as anyone, and probably with more interest and intelligence than a younger woman.

I could go round all the churches in Aleppo and enjoy it; I could listen to Max talking about the classics; could learn the Greek alphabet and read translations of the *Aeneid* – in fact I could take far more interest in Max's work and his ideas than in any of Archie's deals in the City.

'But you *mustn't* marry again,' I said to myself. 'You *mustn't* be such a *fool*.'

The whole thing had happened so insidiously. If I had considered Max as a possible husband when I first met him, then I should have been on my guard. I should never have slipped into this easy, happy relationship. But I hadn't seen this coming – and there we were, so happy, finding it all as much fun and as easy to talk to each other as if we had been married already.

Desperately I consulted my home oracle. 'Rosalind,' I said, 'would you mind if I married again?'

'Well, I expect you will sometime,' said Rosalind, with the air of one who always considers all possibilities. 'I mean, it is the natural thing to do, isn't it?'

'Well, perhaps.'

'I shouldn't have liked you to marry Colonel R.,' said Rosalind thoughtfully. I found this interesting, as Colonel R. had made a great fuss of Rosalind and she had appeared delighted with the games he had played for her enjoyment.

I mentioned the name of Max.

'I think he'd be much the best,' said Rosalind. 'In fact I think it would be a very good thing if you *did* marry him.' Then she added: 'We might have a boat of our own, don't you think? And he would be useful in a lot of ways. He is rather good at tennis, isn't he? He could play with me.' She pursued the possibilities with the utmost frankness, considering them entirely from her own utilitarian point of view. '*And* Peter likes him ' said Rosalind, in final approval.

All the same, that summer was one of the most difficult of my life. One person after another was against the idea. Perhaps really, at bottom, that encouraged me. My sister was firmly against it. The age difference! Even my brother-in-law, James, sounded a note of prudence.

'Don't you think,' he said, 'that you may have been rather well – influenced by the life you enjoyed so much? The archaeological life? That you enjoyed being with the Woolleys at Ur? Perhaps you have mistaken that for what isn't quite such a warm feeling as you think.'

But I knew that wasn't so.

o

'Of course, it's entirely your own business,' he added gently. Dear Punkie, of course, did not at all think it was my own business – she thought it was her own particular business to save me from making a silly mistake. Carlo, my own very dear Carlo, and her sister, were towers of strength. They supported me, though entirely through loyalty, I think. I believe they, too, probably, thought it a silly thing to do, but they would never have said so because they were not the kind of people who wanted to influence anyone in their plans. I am sure they thought it a pity that I had not the desire to marry an attractive colonel of forty-two, but as I had decided otherwise, well, they would back me up.

I finally broke the news to the Woolleys. They seemed pleased. Certainly Len was pleased; with Katharine it was always more difficult to tell.

'Only,' she said firmly, 'you mustn't marry him for at least two years.'

'Two years?' I said, dismayed.

'No, it would be fatal.'

'Well, *I* think,' I said, 'that's very silly. I am already a great many years older than he is. What on earth is the point of waiting until I am older still? He might as well have such youth as I've got.'

'I think it would be very bad for him,' said Katharine. 'Very bad for him at his age to think he can have everything he wants at once. I think it would be better to make him wait for it – a good long apprenticeship.'

This was an idea that I could not agree with. It seemed to me to be a severe and puritanical point of view.

To Max I said that I thought his marrying me was all wrong, and that he must think it over very carefully.

'What do you suppose I've been doing for the last three months?' he said. 'I've been thinking about it all the time I was in France. Then I thought: "Well, I shall know when I see her again, in case I have imagined everything." But I hadn't. You were just as I remembered you, and you were just as I want you.'

'It's a terrible risk.'

'It's not a risk for *me*. You may think it a risk for you. But does it matter taking risks? Does one get anywhere if one doesn't take risks?'

To that I agreed. I have never refrained from doing anything on the grounds of security. I was happier after that. I felt, 'Well, it is *my* risk, but I believe it is worth taking a risk to find a person with whom you are happy. I shall be sorry if it goes wrong for him, but after all that is *his* risk, and he is regarding it quite sensibly.' I suggested we might wait for

six months. He said he did not think that would be any good. 'After all,' he added, 'I've got to go abroad again, to Ur. *I* think we ought to get married in September.' I talked to Carlo and we made our plans.

I had had so much publicity, and been caused so much misery by it, that I wanted things kept as quiet as possible. We agreed that Carlo and Mary Fisher, Rosalind and I should go to Skye and spend three weeks there. Our marriage banns could be called there, and we would be married quietly in St. Columba's Church in Edinburgh.

Then I took Max up to visit Punkie and James – James, resigned but sad, Punkie actively endeavouring to prevent our marriage.

In fact I came very near to breaking the whole thing off just before, in the train going up, as Max, paying more attention to my account of my family than he had so far, said: 'James Watts, did you say? I was at New College with a Jack Watts. Could that have been your one's son? A terrific comedian – did wonderful imitations.' I felt shattered that Max and my nephew were contemporaries. Our marriage seemed impossible. 'You are too young,' I said desperately. 'You are too young.' This time Max was really alarmed. 'Not at all,' he said. 'Anyway, I went to the University rather young, and all my friends were so serious; I wasn't at all in Jack Watts' gay set.' But I felt conscience-stricken.

Punkie did her best to reason with Max, and I began to be afraid that he would take a dislike to her, but the contrary proved true. He said she was so genuine, and so desperately anxious for me to be happy – and also, he added, so funny. That was always the final verdict on my sister. 'Dear Punkie,' my nephew Jack used to say to his mother, 'I do love you — you are so funny and so sweet.' And really that described her very well.

The visit finished with Punkie retiring in storms of tears, and James being very kind to me. Fortunately my nephew Jack was not there – he might have upset the applecart.

'Of course I knew at once that you had made up your mind to marry him,' said my brother-in-law. 'I know that you don't change your mind.'

'Oh Jimmy, you don't know. I seem to be changing it all day long.'

'Not really. Well, I hope it turns out all right. It's not what I would have chosen for you, but you have always shown good sense, and I think he is the sort of young man who might go far.'

How much I loved dear James, and how patient and long-suffering he always was. 'Don't mind Punkie,' he said. 'You know what she is like – she'll turn right round when it's really done.'

Meanwhile we kept it a secret.

AN AUTOBIOGRAPHY

420

I asked Punkie if she would like to come to Edinburgh to our marriage, but she thought she had better not. 'I shall only cry,' she said, 'and upset everyone.' I was really rather thankful. I had my two good, calm Scottish friends to provide a stalwart background for me. So I went to Skye with them and with Rosalind.

I found Skye lovely, I did sometimes wish it wouldn't rain every day, though it was only a fine misty rain which did not really count. We walked miles over the moor and the heather, and there was a lovely soft earthy smell with a tang of peat in it.

One of Rosalind's remarks caused some interest in the hotel dining-room a day or two after our arrival. Peter, who was with us, did not, of course, attend meals in the public rooms, but Rosalind, in a loud voice, in the middle of lunch, announced to Carlo: 'Of course, Carlo, Peter really ought to be your husband, oughtn't he? I mean, he sleeps in your bed, doesn't he?' The clientele of the hotel, mostly old ladies, as one person turned a barrage of eyes upon Carlo.

Rosalind also gave me a few words of advice on the subject of marriage: 'You know,' she said, 'when you are married to Max, you will have to sleep in the same bed as him?'

'I know,' I said.

'Well, yes, I supposed you did know, because after all you were married to Daddy, but I thought you might not have thought of it.' I assured her I had thought of everything relevant to the occasion.

So the weeks passed. I walked on the moor and had fits of occasional misery when I thought I was doing the wrong thing and ruining Max's life.

Meanwhile Max threw himself into an extra amount of work at the British Museum and elsewhere, finishing off his drawings of pots and archaeological work. The last week before the marriage he stayed up till five in the morning every night, drawing. I have a suspicion that Katharine Woolley induced Len to make the work even heavier than it might have been: she was much annoyed with me for not postponing the marriage.

Before we left London, Len had called round to see me. He was so embarrassed that I couldn't think what was the matter with him.

'You know,' he said, 'it is perhaps going to make it rather awkward for us. I mean at Ur and in Baghdad. I mean it wouldn't be – you do understand? – it wouldn't be in any way possible for you to come on the expedition. I mean, there is no room for anyone but archaeologists.'

'Oh, no,' I said, 'I quite understand that – we've talked it over. I've

no useful knowledge of any kind. Both Max and I thought it would be much better this way, only he didn't want to leave you high and dry at the beginning of the season, where there would be very little time to find anybody else to replace him.'

'I thought . . . I know . . .' Len paused. 'I thought perhaps that – well, I mean people might think it rather odd if you didn't come to Ur.'

'Oh, I don't know why they should think that,' I said. 'After all, I shall come out at the end of the season to Baghdad.'

'Oh yes, and I hope you will come down then and spend a few days at Ur.'

'So that's all right, isn't it?' I said encouragingly.

'What I thought – what we thought – I mean, what Katharine – I mean, what we both thought . . .'

'Yes?' I said.

'– was that it might be better if you didn't come to Baghdad – *now*. I mean, if you are coming with him as far as Baghdad, and then he goes to Ur and you go home, don't you think that perhaps it would look odd? I mean, I don't know that the Trustees would think it a good idea.'

That suddenly aroused my annoyance. I was quite willing not to come to Ur. I should never have suggested it, because I thought it would be a very unfair thing to do: but I could see no reason why I could not come to Baghdad if I wanted to.

Actually I had already decided with Max that I did not want to come to Baghdad: it would be a rather meaningless journey. We were going to Greece for our honeymoon, and from Athens he would go to Iraq and I should return to England. We had already arranged this, but at this moment I was not going to say so.

I replied with some asperity: 'I think Len, it is hardly for you to suggest to me where I should and should not travel in the Middle East. If I want to come to Baghdad, I shall come there with my husband, and it is nothing to do with the dig or with you.'

'Oh! Oh, I do hope you don't mind. It was just that Katharine thought . . .'

I was quite sure that it was Katharine's thought, not Len's. Though I was fond of her, I was not going to have her dictate my life. When I saw Max, therefore, I said that though I did not propose to come to Baghdad, I had carefully not told Len that that was so. Max was furious. I had to calm him down.

'I'm almost inclined to insist that you come,' he said,

'That would be silly. It would mean a lot of expense, and it would be rather miserable parting from you there.'

It was then that he told me that he had been approached by Dr Campbell-Thompson and that there was a possibility that in the following year he would go and dig at Nineveh in the north of Iraq. In all probability I should be able to accompany him there. 'Nothing is settled,' he said. 'It all has to be arranged. But I am not going to be parted from you for another six months the season after this. Len will have had plenty of time to find a successor by then.'

The days passed in Skye, my banns were duly read in church, and all the old ladies sitting round beamed on me with the kindly pleasure all old ladies take in something romantic like marriage.

Max came up to Edinburgh, and Rosalind and I, Carlo, Mary, and Peter came over from Skye. We were married in the small chapel of St Columba's Church. Our wedding was quite a triumph – there were no reporters there and no hint of the secret had leaked out. Our duplicity continued, because we parted, like the old song, at the church door. Max went back to London to finish his Ur work for another three days, while I returned the next day with Rosalind to Cresswell Place, where I was received by my faithful Bessie, who was in on the secret. Max kept away, then two days later drove up to the door of Cresswell Place in a hired Daimler. We drove off to Dover and from thence crossed the Channel to the first stopping-place of our honeymoon, Venice.

Max had planned the honeymoon entirely himself: it was going to be a surprise. I am sure nobody enjoyed a honeymoon better than we did. There was only one jarring spot on it, and that was that the Orient Express, even in its early stages before Venice, was once again plagued by the emergence of bed-bugs from the woodwork.

PART IX

LIFE WITH MAX

I

Our honeymoon took us to Dubrovnik, and from there to Split. Split I have never forgotten. We were wandering round the place in the evening, from our hotel, when we came round the corner into one of the squares, and there, looming up to the sky, was the figure of St Gregory of Nin, one of the finest works of the sculptor Mestrovic. It towered over everything, one of those things that stand out in your memory as a permanent landmark.

We had enormous fun with the menus there. They were written in Yugoslavian, and of course we had no idea what they meant. We used to point to some entry and then wait with some anxiety to see what would be delivered. Sometimes it was a colossal dish of chicken, on another occasion poached eggs in a highly seasoned white sauce, another time again a sort of super-goulash. All the helpings were enormous, and none of the restaurants ever wished you to pay the bill. The waiter would murmur in broken French or English or Italian: 'Not tonight, not tonight. You can come in and pay tomorrow.' I don't know what happened when people had meals for a week without paying and then went off on a boat. Certainly on the last morning when we did go to pay we had the utmost difficulty in getting our favourite restaurant to accept the money. 'Ah, you can do it later,' they said. 'But,' we explained, or tried to explain, 'we cannot do it later, because we are going off by boat at twelve o'clock.' The little waiter sighed sadly at the prospect of having to do some arithmetic. He retired to a cubicle, scratched his head, used several pencils in turn, groaned, and after about five minutes brought us what

seemed a very reasonable account for the enormous amounts we had eaten. Then he wished us good luck and we departed.

The next stage of our journey was down the Dalmatian coast and along the coast of Greece to Patras. It was just a little cargo boat, Max explained. We stood on the quay waiting for its arrival, and became a little anxious. Then we suddenly saw a boat so minute – such a cockleshell – that we could hardly believe it was what we were waiting for. It had an unusual name, composed entirely of consonants – Srbn – how it was pronounced we never learnt. But this was the boat sure enough. There were four passengers on board – ourselves in one cabin and two others in a second. They left at the next port, so we then had the boat to ourselves.

Never have I tasted such food as we had on that boat: delicious lamb, very tender, in little cutlets, succulent vegetables, rice, sumptuous sauce, and savoury things on skewers. We chatted to the captain in broken Italian. 'You like the food?' he said. 'I am glad. I have English food I ordered. It is very English food for you.' I sincerely hoped he would never come to England, in case he discovered what English food was really like. He said that he had been offered promotion to a bigger passenger boat, but he preferred to stay on this one because he had a good cook here, and he enjoyed his peaceful life: he was not worried by passengers. 'Being on a boat with passengers is having trouble all the time,' he explained. 'So I prefer not to be promoted.'

We had a happy few days on that little Serbian boat. We stopped at various ports – Santa Anna, Santa Maura, Santi Quaranta. We would go ashore and the captain would explain that he would blow the funnel half an hour before he was due to depart again. So, as we wandered through olive groves or sat among the flowers, we would suddenly hear the ship's funnel, turn round and hurry back to the ship. How lovely it was, sitting in those olive groves, feeling so completely peaceful and happy together. It was a Garden of Eden, a Paradise on earth.

We arrived at last at Patras, bade cheerful farewells to the Captain, and got into a funny little train which was to take us to Olympia. It not only took us as passengers, it took a great many more bed-bugs. This time they got up the legs of the trousers I was wearing. The following day I had to slit the cloth because my legs were so swollen.

Greece needs no description. Olympia was as lovely as I thought it would be. The next day we went on mules to Andritsena – and that, I must say, very nearly tore the fabric of our married life.

With no previous training in mule-back riding, a fourteen hours'

journey resulted in such agony as is hardly to be believed! I got to a stage when I didn't know if it would be more painful to walk or to sit on the mule. When we finally arrived, I fell off the mule, so stiff that I could not walk, and I reproached Max, saying: 'You are really not fit to marry anybody if you don't know what someone feels after a journey like this!'

Actually, Max was quite stiff and in pain himself. Explanations that the journey ought not to have taken more than eight hours by his calculations were not well received. It took me seven or eight years to realise that his estimates of journeys were always to prove vastly lower than they proved to be in reality, so that one immediately added a third at least to his prognostication.

We took two days to recover at Andritsena. Then I admitted that I was not sorry to have married him after all, and that perhaps he could learn the proper way to treat a wife – by not taking her on mule rides until he had carefully calculated the distance. We proceeded on a rather more cautious mule ride of not more than five hours, to the Temple of Bassae, and that I did not find exhausting at all.

We went to Mycenae, to Epidaurus, and we stayed in what seemed the Royal Suite in a hotel at Nauplia – it had red velvet hangings and an enormous four-poster with gold brocaded curtains. We had breakfast on a slightly insecure but ornamented balcony, looking out towards an island in the sea, and then went down to bathe, rather doubtfully, among large quantities of jelly-fish.

Epidaurus seemed particularly beautiful to me, but it was there really that I ran up against the archaeological character for the first time. It was a heavenly day, and I climbed up to the top of the theatre and sat there, having left Max in the museum looking at an inscription. A long time passed and he did not come to join me. Finally I got impatient, came down again, and went into the museum. Max was still lying flat on his face on the floor, pursuing his inscription with complete delight.

'Are you still reading that thing?' I asked.

'Yes, rather an unusual one,' he said. 'Look here – shall I explain it to you?'

'I don't think so,' I said firmly. 'It's lovely outside – absolutely beautiful.'

'Yes, I'm sure it is,' said Max absently.

'Would you mind,' I said, 'if I went back outside?'

'Oh no,' said Max, slightly surprised, 'that's quite all right. I just thought you might find this inscription interesting.'

'I don't think I should find it as interesting as all that,' I said, and went back to my seat at the top of the theatre. Max rejoined me about an hour later, very happy, having deciphered one particular obscure Greek phrase which, as far as he was concerned, had made his day.

Delphi was the highlight, though. It struck me as so unbelievably beautiful that we went round trying to select a site where we might build a little house one day. We marked out three, I remember. It was a nice dream: I don't know that we believed in it ourselves even at the time. When I went there a year or two ago and saw the great buses travelling up and down, and the cafés, the souvenirs, and the tourists, how glad I was that we had *not* built our house there.

We were always choosing sites for houses. This was mainly owing to me, houses having always been my passion – there was indeed a moment in my life, not long before the outbreak of the second war, when I was the proud owner of eight houses. I had become addicted to finding broken-down, slummy houses in London and making structural alterations, decorating and furnishing them. When the second war came and I had to pay war damage insurance on all these houses, it was not so funny. However, in the end they all showed a good profit when I sold them. It had been an enjoyable hobby while it lasted – and I am always interested to walk past one of 'my' houses, to see how they are being kept up, and to guess the sort of person who is living in them now.

On the last day we walked down from Delphi to the sea at Itea below. A Greek came with us to show us the way, and Max talked to him. Max has a very inquiring mind, and always has to ask a lot of questions of any native who is with him. On this occasion he was asking our guide the names of various flowers. Our charming Greek was only too anxious to oblige. Max would point out a flower and he would say the name, then Max would carefully write it down in his notebook. After he had written down about twenty-five specimens he noticed that there was a certain amount of repetition. He repeated the Greek name which was now being given him for a blue flower with spiky thorns on it, and recognised it as the same name as had been used for one of the first flowers, a large yellow marigold. It then dawned upon us that, in his anxiety to please, the Greek was merely telling us the names of as many flowers as he *knew*. As he did not know many he was beginning to repeat them for each new flower. With some disgust Max realised that his careful list of wild flowers was completely useless.

We ended up at Athens, and there, with separation only four or five

days ahead of us, disaster struck the happy inhabitants of Eden. I went down with what I took at first to be one of the ordinary tummy complaints that often strike one in the Middle East, known as Gyppy Tummy, Baghdad Tummy, Teheran Tummy, and so on. This I took to be Athens Tummy – but it proved to be worse than that.

I got up after a few days, but when driving out on an excursion I felt so ill that I had to be driven straight back again. I found I had quite a high fever, and in the end, after many protests on my part, and when all other remedies had failed, we got hold of a doctor. Only a Greek doctor was obtainable. He spoke French, and I soon learnt that, though my French was socially adequate, I did not know any medical terms.

The doctor attributed my downfall to the heads of red mullet, in which, according to him, there lurked great danger, especially for strangers who were not used to dissecting this fish in the proper way. He told me a gruesome tale about a cabinet minister who suffered from this to the point almost of death and only made a last moment recovery. I certainly felt ill enough to die at any minute! I went on having a temperature of 105 and being unable to keep anything down. However, my doctor succeeded in the end. Suddenly I lay there feeling human once more. The thought of eating was horrible, and I did not feel I ever wanted to move again – but I was on the mend and knew it. I assured Max that he would be able to get off the following day.

'It's awful. How can I leave you, dear?'

Our trouble was that Max had been entrusted with the responsibility of reaching Ur in time to build on various additions to the burnt-brick expedition house so as to be ready for the Woolleys and the other members of the expedition when they arrived in a fortnight's time. He was to build a new dining-room and a new bathroom for Katharine.

'They will understand, I'm sure,' said Max. But he said it doubtfully, and I knew quite well that they wouldn't. I got terrifically worked up, and pointed out that they would lay dereliction of duty on Max's part on *me*. It became a point of honour with us both that Max should be there on time. I assured him that now I should be quite all right. I would lie there, quietly recovering for another week perhaps, and then go straight home by the Orient Express.

Poor Max was torn to bits. He, too, was invested with a terrific English sense of duty. It had been put to him firmly by Leonard Woolley: 'I *trust* you, Max. You may be enjoying yourself and all that, but it is really

serious that you should give me your word that you will be there on the right day and take charge.'

'You know what Len will say,' I pointed out.

'But you're really ill.'

'I know I'm ill, but *they* won't believe it. They'll think that I'm just keeping you away, and I can't have that. And if you go on arguing, my temperature will go up again and I really *shall* be very ill indeed.'

So, in the end, both of us feeling heroic, Max departed on the path of duty.

The one person who did not agree with any of this was the Greek doctor, who threw his hands up to Heaven and burst into torrents of indignant French. 'Ah, yes, they are all alike, the English. I have known many of them, oh, so many of them – they are all the same. They have a devotion to their work, to their duty. What is work, what is duty, compared with *human beings*? A wife is a human being, is she not? A wife is ill, and she is a human being, and that is what matters. That is *all* that matters – a human being in distress!'

'You don't understand,' I said. 'This is really important. He gave his word he would be there. He has a heavy responsibility.'

'Ah, what is responsibility? What is work, what is duty? Duty? It is nothing, duty, to affection. But Englishmen are like that. Ah, what coldness, what *froideur*. What horror to be married to an Englishman! I would not wish that on any woman – no indeed, I would not!'

I was much too limp to argue more, but I assured him that I should get on all right.

'You will have to be very careful,' he warned me. 'But it is no good saying things like that. This cabinet minister of whom I tell you – do you know how long it was before he returned to duty? A whole month.'

I was not impressed. I told him that English stomachs were not like that. English stomachs, I assured him, recovered very quickly. The doctor threw up his hands once again, vociferated more French, and departed, more or less washing his hands of me. If I felt like it, he said, I could at any time have a small plate of plain boiled macaroni. I didn't want anything. Least of all did I want plain boiled macaroni. I lay like a log in my green wall-papered bedroom, feeling sick as a cat, painful round the waist and stomach, and so weak that I hated to move an arm. I sent for plain boiled macaroni. I ate about three winding strings of it, and then put it aside. It seemed to me impossible that I should ever fancy eating again.

I thought of Max. He would have arrived at Beirut by now. The following day he would be starting by Nairn convoy across the desert. Poor Max, he would be worried about me.

Fortunately I was no longer worried about myself. In fact I felt stirring in me a determination to do something or get somewhere. I ate more plain boiled macaroni; progressed to having a little grated cheese on it; and walked three times round the room each morning to get back some strength into my legs. I told the doctor I was much better when he arrived.

'That is good. Yes, you are better, I see.'

'In fact,' I said, 'I shall be able to go home the day after tomorrow.'

'Ah, do not talk such folly. I tell you, the cabinet minister –'

I was getting very tired of the cabinet minister. I summoned the hotel clerk and made him book me a seat on the Orient Express in three days' time. I did not break my intention to the doctor until the night before I left. Then his hands went up again. He accused me of ingratitude, of foolhardiness, and warned that I would probably be taken off the train *en route* and die on a railway platform. I knew quite well it was not as bad as that. English stomachs, I said again, recover quickly.

In due course, I left. My tottering footsteps were supported by the hotel porter into the train. I collapsed in my bunk, and more or less remained there. Occasionally I got them to bring me some hot soup from the dining-car, but as it was usually greasy I did not fancy it. All this abstention would have been good for my figure a few years later, but at that time I was still slender, and at the end of my journey home I looked like a mass of bones. It was wonderful to get back and to flop into my own bed. All the same, it took me nearly a month to recover my old health and spirits.

Max had reached Ur safely, though with tremendous trepidation about me, dispatching various telegrams *en route*, and waiting for the telegrams from me to arrive, which they never did. He put such energy into the work that he did far more than the Woolleys had expected.

'I'll show them,' he said. He built Katharine's bathroom entirely to his own specifications, as small and cramped as possible, and added such other embellishments to it and the dining-room as he thought fit.

'But we didn't mean you to do all this,' Katharine exclaimed, when they arrived.

'I thought I had better get on with it as I was here,' said Max grimly. He explained that he had left me at death's door in Athens.

'You should have stayed with her,' said Katharine.

'I think probably I should,' said Max. 'But you both impressed on me how important this work was.'

Katharine took it out of Len by telling him that the bathroom was not at all to her liking and would have to be taken down and rebuilt – and this was done, at considerable inconvenience. Later, however, she congratulated Max on the superior design of the living-room, and said what a difference it had made to her.

At my present age I have learnt pretty well how to deal with temperamental people of all kinds – actors, producers, architects, musicians, and natural *prima donnas* such as Katharine Woolley. Max's mother was what I should call a *prima donna* in her own right. My own mother came near to being one: she could work herself into terrific states, but had invariably forgotten all about them by the next day. 'But you seemed so desperate!' I would say to her. 'Desperate?' said my mother, highly surprised. 'Was I? Did I sound like that?'

Several of our acting friends can throw a temperament as well as anyone. When Charles Laughton was playing Hercule Poirot in *Alibi*, and sipping ice-cream sodas with me during a break in rehearsal, he explained his method. 'It's a good thing to pretend to have a temperament, even if you haven't. I find it very helpful. People will say, "Don't let's do anything to annoy *him*. You know how he throws temperaments."'

'It's tiring sometimes,' he added, 'especially if you don't happen to want to. But it pays. It pays every time.'

II

My literary activities at this period seem curiously vague in my memory. I don't think, even then, that I considered myself a *bona fide* author. I wrote things – yes – books and stories. They were published, and I was beginning to accustom myself to the fact that I could count upon them as a definite source of income. But never, when I was filling in a form and came to the line asking for Occupation, would it have occurred to me to fill it in with anything but the time-honoured 'Married woman'. I was a married woman, that was my status, and *that* was my occupation. As a sideline, I wrote books. I never approached my writing by dubbing it with the grand name of 'career'. I would have thought it ridiculous.

My mother-in-law could not understand this. 'You write so well, Agatha dear, and because you write so well, surely you ought to write something – well – more *serious*?' Something 'worth while' was what she meant. I found it difficult to explain to her, and indeed did not really try, that my writing was for entertainment.

I wanted to be a good detective story writer, yes, and indeed by this time I was conceited enough to think that I *was* a good detective story writer. Some of my books satisfied and pleased me. They never pleased me entirely, of course, because I don't suppose that is what one ever achieves. Nothing turns out quite in the way you thought it would when you are sketching out notes for the first chapter, or walking about muttering to yourself and seeing a story unroll.

My dear mother-in-law would, I think, have liked me to write a biography of some world-famous figure. I cannot think of anything I should be worse at doing. Anyway, I remained sufficiently modest to say occasionally, without thinking, 'Yes, but then of course I am not really an author.' This was usually corrected by Rosalind, who would say: 'But you *are* an author, mother. You are quite definitely an author by this time.'

Poor Max had one serious penalty laid on him by marriage. He had, as far as I could find out, never read a novel. Katharine Woolley had forced *The Murder of Roger Ackroyd* upon him, but he had got out of reading it. Somebody had discussed the dénouement in front of him, and after that, he said, 'What on earth is the good of reading a book when you know the end of it?' Now, however, as my husband, he started manfully on the task.

By that time I had written ten books at least, and he started slowly to catch up with them. Since a really erudite book on archaeology or on classical subjects was Max's idea of light reading, it was funny to see what heavy weather he made of reading light fiction. However, he stuck to it, and I am proud to say appeared to enjoy his self-imposed task in the end.

The funny thing is that I have little memory of the books I wrote just after my marriage. I suppose I was enjoying myself so much in ordinary living that writing was a task which I performed in spells and bursts. I never had a definite place which was *my* room or where I retired specially to write. This has caused much trouble for me in the ensuing years, since whenever I had to receive an interviewer their first wish would always be to take a photograph of me at my work. 'Show me where you write your books.'

'Oh, anywhere.'

'But surely you have a place where you always work?'

But I hadn't. All I needed was a steady table and a typewriter. I had begun now to write straight on to the typewriter, though I still used to do the beginning chapters and occasionally others in long-hand and then type them out. A marble-topped bedroom washstand table made a good place to write; the dining-room table between meals was also suitable.

My family usually noticed a time of approaching activity by saying, 'Look, Missus is broody again.' Carlo and Mary always called me Missus, supposedly in Peter the dog's language, and Rosalind, too, more often called me Missus than Mummy or Mother. Anyway, they all recognised the signs when I was broody, looked at me hopefully, and urged me to shut myself up in a room somewhere and get busy.

Many friends have said to me, 'I never know when you write your books, because I've never seen you writing, or even seen you go away to write.' I must behave rather as dogs do when they retire with a bone: they depart for an odd half hour. They return self-consciously with mud on their noses. I do much the same. I felt slightly embarrassed if I was going to write. Once I could get away, however, shut the door and get people not to interrupt me, then I was able to go full speed ahead, completely lost in what I was doing.

Actually my output seems to have been rather good in the years 1929 to 1932: besides full-length books I had published two collections of short stories. One consisted of Mr Quin stories. These are my favourite. I wrote one, not very often, at intervals perhaps of three or four months, sometimes longer still. Magazines appeared to like them, and I liked them myself, but I refused all offers to do a series for any periodical. I didn't want to do a series of Mr Quin: I only wanted to do one when I felt like it. He was a kind of carry-over for me from my early poems in the Harlequin and Columbine series.

Mr Quin was a figure who just entered into a story – a catalyst, no more – his mere presence affected human beings. There would be some little fact, some apparently irrelevant phrase, to point him out for what he was: a man shown in a harlequin-coloured light that fell on him through a glass window; a sudden appearance or disappearance. Always he stood for the same things: he was a friend of lovers, and connected with death. Little Mr Satterthwaite, who was, as you might say, Mr Quin's emissary, also became a favourite character of mine.

I had also published a book of short stories called *Partners in Crime*.

Each story here was written in the manner of some particular detective of the time. Some of them by now I cannot even recognise. I remember Thornley Colton, the blind detective – Austin Freeman, of course; Freeman Wills Croft with his wonderful timetables; and inevitably Sherlock ·Holmes. It is interesting in a way to see who of the twelve detective story writers that I chose are still well known – some are household names, others have more or less perished in oblivion. They all seemed to me at the time to write well and entertainingly in their different fashions. *Partners in Crime* featured in it my two young sleuths, Tommy and Tuppence, who had been the principal characters in my second book, *The Secret Adversary*. It was fun to get back to them for a change.

Murder at the Vicarage was published in 1930, but I cannot remember where, when or how I wrote it, why I came to write it, or even what suggested to me that I should select a new character – Miss Marple – to act as the sleuth in the story. Certainly at the time I had no intention of continuing her for the rest of my life. I did not know that she was to become a rival to Hercule Poirot.

People never stop writing to me nowadays to suggest that Miss Marple and Hercule Poirot should meet – but *why* should they? I am sure they would not enjoy it at all. Hercule Poirot, the complete egoist, would not like being taught his business by an elderly spinster lady. He was a professional sleuth, he would not be at home at all in Miss Marple's world. No, they are both *stars*, and they are stars in their own right. I shall not let them meet unless I feel a sudden and unexpected urge to do so.

I think it is possible that Miss Marple arose from the pleasure I had taken in portraying Dr Sheppard's sister in *The Murder of Roger Ackroyd*. She had been my favourite character in the book – an acidulated spinster, full of curiosity, knowing everything, hearing everything: the complete detective service in the home. When the book was adapted as a play, one of the things that saddened me most was Caroline's removal. Instead, the doctor was provided with another sister – a much younger one – a pretty girl who could supply Poirot with romantic interest.

I had no idea when the idea was first suggested what terrible suffering you go through with plays, owing to the alterations made in them. I had already written a detective play of my own, I can't remember exactly when. It was not approved of by Hughes Massie; in fact they suggested it would be better to forget it entirely, so I didn't press on with it. I had called it *Black Coffee*. It was a conventional spy thriller, and although full of

clichés, it was not, I think, at all bad. Then, in due course, it came into its own. A friend of mine from Sunningdale days, Mr Burman, who was connected with the Royalty Theatre, suggested to me that it might perhaps be produced.

It always seems strange to me that whoever plays Poirot is always an outsize man. Charles Laughton had plenty of avoirdupois, and Francis Sullivan was broad, thick, and about 6'2" tall. He played Poirot in *Black Coffee*. I think the first production was at the Everyman in Hampstead, and the part of Lucia was played by Joyce Bland, whom I always thought a very good actress.

Black Coffee ran for a mere four or five months when it finally came to the West End, but it was revived twenty-odd years later, with minor alterations and it did quite well in repertory.

Thriller plays are usually much alike in plot – all that alters is the Enemy. There is an international gang *à la* Moriarty – provided first by the Germans, the 'Huns' of the first war; then the Communists, who in turn were succeeded by the Fascists. We have the Russians, we have the Chinese, we go back to the international gang again, and the Master Criminal wanting world supremacy is always with us.

Alibi, the first play to be produced from one of my books – *The Murder of Roger Ackroyd* – was adapted by Michael Morton. He was a practised hand at adapting plays. I much disliked his first suggestion, which was to take about twenty years off Poirot's age, call him Beau Poirot and have lots of girls in love with him. I was by this time so stuck with Poirot that I realised I was going to have him with me for life. I strongly objected to having his personality completely changed. In the end, with Gerald Du Maurier, who was producing, backing me up, we settled on removing that excellent character Caroline, the doctor's sister, and replacing her with a young and attractive girl. As I have said, I resented the removal of Caroline a good deal: I liked the part she played in village life: and I liked the idea of village life reflected through the life of the doctor and his masterful sister.

I think at that moment, in St. Mary Mead, though I did not yet know it, Miss Marple was born, and with her Miss Hartnell, Miss Wetherby, and Colonel and Mrs Bantry – they were all there lined up below the border-line of consciousness, ready to come to life and step out on to the stage.

Reading *Murder at the Vicarage* now, I am not so pleased with it as I was at the time. It has, I think, far too many characters, and too many

sub-plots. But at any rate the *main* plot is sound. The village is as real to me as it could be – and indeed there are several villages remarkably like it, even in these days. Little maids from orphanages, and well-trained servants on their way to higher things have faded away, but the daily women who have come to succeed them, are just as real and human – though not, I must say, nearly as skilled as their predecessors.

Miss Marple insinuated herself so quietly into my life that I hardly noticed her arrival. I wrote a series of six short stories for a magazine, and chose six people whom I thought might meet once a week in a small village and describe some unsolved crime. I started with Miss Jane Marple, the sort of old lady who would have been rather like some of my grandmother's Ealing cronies – old ladies whom I have met in so many villages where I have gone to stay as a girl. Miss Marple was not in any way a picture of my grandmother; she was far more fussy and spinsterish than my grandmother ever was. But one thing she did have in common with her – though a cheerful person, she always expected the worst of everyone and everything, and was, with almost frightening accuracy, usually proved right.

'I shouldn't be surprised if so-and-so isn't going on,' my grandmother used to say, nodding her head darkly, and although she had no grounds for these assertions, so-and-so was exactly what *was* going on. 'A downy fellow, that – I don't trust him,' Grannie would remark, and when later a polite young bank-clerk was found to have embezzled some money, she was not at all surprised, but merely nodded her head.

'Yes,' she said, 'I've known one or two like him.'

Nobody would ever have wheedled my grandmother out of her savings or put up a proposition to her which she would swallow gullibly. She would have fixed him with a shrewd eye and have remarked later: 'I know his kind. I knew what he was after. I think I'll just ask a few friends to tea and mention that a young man like that is going around.'

Grannie's prophecies were much dreaded. My brother and sister had had a tame squirrel as a pet in the house for about a year, when Grannie, after picking it up with a broken paw in the garden one day, had said sapiently: 'Mark my words! That squirrel will be off up the chimney one of these days!' It went up the chimney five days later.

Then there was the case of the jar on a shelf over the drawing-room door. 'I shouldn't keep that there, if I were you, Clara,' said Grannie. 'One of these days someone will slam the door, or the wind will slam it, and down it will come.'

'But dear Auntie-Grannie, it has been there for ten months.'

'That may be,' said my grandmother.

A few days later we had a thunderstorm, the door banged, and the jar fell down. Perhaps it was second sight. Anyway, I endowed my Miss Marple with something of Grannie's powers of prophecy. There was no unkindness in Miss Marple, she just did not trust people. Though she expected the worst, she often accepted people kindly in spite of what they were.

Miss Marple was born at the age of sixty-five to seventy – which, as with Poirot, proved most unfortunate, because she was going to have to last a long time in my life. If *I* had had any second sight, I would have provided myself with a precocious schoolboy as my first detective; then he could have grown old with me.

I gave Miss Marple five colleagues for the series of six stories. First was her nephew; a modern novelist who dealt in strong meat in his books, incest, sex, and sordid descriptions of bedrooms and lavatory equipment – the stark side of life was what Raymond West saw. His dear, pretty, old, fluffy Aunt Jane he treated with an indulgent kindness as one who knew nothing of the world. Secondly I produced a young woman who was a modern painter, and was just getting on very special terms with Raymond West. Then there were Mr Pettigrew, a local solicitor, dry, shrewd, elderly; the local doctor – a useful person to know of cases which would make a suitable story for an evening's problem; and a clergyman.

The problem told by Miss Marple herself bore the somewhat ridiculous title of *The Thumb Mark of St. Peter*, and referred to a haddock. Some time later I wrote another six Miss Marple stories, and the twelve, with an extra story, were published in England under the title of *The Thirteen Problems*, and in America as *The Tuesday Club Murders*.

Peril at End House was another of my books which left so little impression on my mind that I cannot even remember writing it. Possibly I had already thought out the plot some time previously, since this has always been a habit of mine, and often confuses me as to when a book was written or published. Plots come to me at such odd moments: when I am walking along a street, or examining a hat-shop with particular interest, suddenly a splendid idea comes into my head, and I think, 'Now that would be a neat way of covering up the crime so that nobody would see the point.' Of course, all the practical details are still to be worked out, and the people have to creep slowly into my consciousness, but I jot down my splendid idea in an exercise book.

So far so good – but what I invariably do is lose the exercise book. I usually have about half a dozen on hand, and I used to make notes in them of ideas that had struck me, or about some poison or drug, or a clever little bit of swindling that I had read about in the paper. Of course, if I kept all these things neatly sorted and filed and labelled it would save me a lot of trouble. However, it is a pleasure sometimes, when looking vaguely through a pile of old note-books, to find something scribbled down, as: *Possible plot – do it yourself – Girl and not really sister – August –* with a kind of sketch of a plot. What it's all about I can't remember now; but it often stimulates me, if not to write that identical plot, at least to write something else.

Then there are the plots that tease my mind, that I like to think about and play with, knowing that one day I am going to write them. *Roger Ackroyd* played about in my mind for a long time before I could get the details fixed. I had another idea that came to me after going to a performance by Ruth Draper. I thought how clever she was and how good her impersonations were; the wonderful way she could transform herself from a nagging wife to a peasant girl kneeling in a cathedral. Thinking about her led me to the book *Lord Edgware Dies.*

When I began writing detective stories I was not in any mood to criticise them or to think seriously about crime. The detective story was the story of the chase; it was also very much a story with a moral; in fact it was the old Everyman Morality Tale, the hunting down of Evil and the triumph of Good. At that time, the time of the 1914 war, the doer of evil was not a hero: the *enemy* was wicked, the *hero* was good: it was as crude and as simple as that. We had not then begun to wallow in psychology. I was, like everyone else who wrote books or read them, *against* the criminal and *for* the innocent victim.

There was one exception in the popular hero Raffles, a sporting cricketer and successful cracksman, with his rabbit-like associate Bunny. I think I always felt slightly shocked by Raffles, and in looking back now I feel much more shocked than I did then, though it was certainly in the tradition of the past – he was the Robin Hood type. But Raffles was a light-hearted exception. No one could have dreamt then that there would come a time when crime books would be read for their love of violence, the taking of sadistic pleasure in brutality for its own sake. One would have thought that the community would rise up in horror against such things; but now cruelty seems almost everyday bread and butter. I wonder still how it *can* be so, when one considers that the vast majority of people one

knows, girls and boys as well as the older folk, are extraordinarily kind and helpful: they will do things to help older people; they are willing and anxious to be of service. The minority of what I call 'the haters' is quite small, but, like all minorities, it makes itself felt far more than the majority does.

As a result of writing crime books one gets interested in the study of criminology. I am particularly interested in reading books by those who have been in contact with criminals, especially those who have tried to benefit them or to find ways of what one would have called in the old days 'reforming' them – for which I imagine one uses far more grand terms nowadays! There seems no doubt that there are those, like Richard III as Shakespeare shows him, who do indeed say: 'Evil be thou my Good.' They have chosen Evil, I think, much as Milton's Satan did: he wanted to be great, he wanted power, he wanted to be as high as God. He had no love in him, so he had no humility. I would say myself, from the ordinary observation of life, that where there is no humility *the people perish*.

One of the pleasures of writing detective stories is that there are so many types to choose from: the light-hearted thriller, which is particularly pleasant to do; the intricate detective story with an involved plot which is technically interesting and requires a great deal of work, but is always rewarding; and then what I can only describe as the detective story that has a kind of passion behind it – that passion being to help save innocence. Because it is *innocence* that matters, not *guilt*.

I can suspend judgment on those who kill – but I think they are evil for the community; they bring in nothing except hate, and take from it all they can. I am willing to believe that they are made that way, that they are born with a disability, for which, perhaps, one should pity them; but even then, I think, not spare them – because you cannot spare them any more than you could spare the man who staggers out from a plague-stricken village in the Middle Ages to mix with innocent and healthy children in a nearby village. The *innocent* must be protected; they must be able to live at peace and charity with their neighbours.

It frightens me that nobody seems to care about the innocent. When you read about a murder case, nobody seems to be horrified by the picture, say, of a fragile old woman in a small cigarette shop, turning away to get a packet of cigarettes for a young thug, and being attacked and battered to death. No one seems to care about her terror and her pain, and the final merciful unconsciousness. Nobody seems to go through the agony of

the *victim* – they are only full of pity for the young killer, because of his youth.

Why should they not execute him? We have taken the lives of wolves, in this country; we didn't try to teach the wolf to lie down with the lamb – I doubt really if we could have. We hunted down the wild boar in the mountains before he came down and killed the children by the brook. Those were our enemies – and we destroyed them.

What can we do to those who are tainted with the germs of ruthlessness and hatred, for whom other people's lives go for nothing? They are often the ones with good homes, good opportunities, good teaching, yet they turn out to be, in plain English, *wicked*. Is there a cure for wickedness? What one can do with a killer? Not imprisonment for life – that surely is far more cruel than the cup of hemlock in ancient Greece. The best answer we ever found, I suspect, was transportation. A vast land of emptiness, peopled only with primitive human beings, where man could live in simpler surroundings.

Let us face the thought that what we regard as defects were once qualities. Without ruthlessness, without cruelty, without a complete lack of mercy, perhaps man would not have continued to exist; he would have been wiped out quite soon. The evil man nowadays may be the successful man of the past. He was necessary then, but he is not necessary and is a danger now.

The only hope, it seems to me, would be to sentence such a creature to compulsory service for the benefit of the community in general. You might allow your criminal the choice between the cup of hemlock and offering himself for experimental research, for instance. There are many fields of research especially in medicine and healing, where a human subject is vitally necessary – animals will not do. At present, it seems to me, the scientist himself, a devoted researcher, risks his own life, but there *could* be human guinea-pigs, who accepted a certain period of experiment in lieu of death, and who, if they survived it, would then have redeemed themselves, and could go forth free men, with the mark of Cain removed from their foreheads.

This might make no difference to their lives; they might only say, 'Well, I had good luck – anyway – I got away with it.' Yet the fact of society owing them thanks *might* make some faint difference. One should never hope too much, but one can always hope a little. They would at least have had a chance to do a worthwhile act, and to escape the retribution they had earned – it would be up to them to start again. Mightn't

they start a little differently? Might they not even feel a certain pride in themselves?

If not, one can only say, God pity them. Not in this life, perhaps, but in the next, they may move 'on the upward way'. But the important thing is still the innocent; those who live sincerely and fearlessly in the present age, who demand that they should be protected and saved from harm. *They* are the ones that matter.

Perhaps Wickedness may find its physical cure – they can sew up our hearts, deep-freeze us – some day they may rearrange our genes, alter our cells. Think of the number of cretins there used to be, dependent for intellect on the sudden discovery of what thyroid glands, deficient or in excess, could do to you.

This seems to have taken me a long way from detective stories, but explains, perhaps, why I have got more interest in my victims than my criminals. The more passionately alive the victim, the more glorious indignation I have on his behalf, and am full of a delighted triumph when I have delivered a near-victim out of the valley of the shadow of death.

Returning from the valley of the shadow of death, I have decided not to tidy up this book too much. For one thing I am elderly. Nothing is more wearying than going over things you have written and trying to arrange them in proper sequence or turn them the other way round. I am perhaps talking to myself – a thing one is apt to do when one is a writer. One walks along the street, passing all the shops one meant to go into, or all the offices one ought to have visited, talking to oneself hard – not too loud, I hope – and rolling one's eyes expressively, and then one suddenly sees people looking at one and drawing slightly aside, clearly thinking one is mad.

Oh well, I suppose it is just the same as when I was four years old talking to the kittens. I am still talking to the kittens, in fact.

III

In March of the following year, as arranged, I went out to Ur. Max met me at the station. I had wondered if I should feel shy – after all we had been married only a short time before parting. Rather to my surprise, it was as if we had met the day before. Max had written me full letters, and

I felt as well informed on the archaeological progress of that year's dig as anyone possibly could be who was a novice in the subject. Before our journey home I spent some days at the Expedition House. Len and Katharine greeted me warmly and Max took me determinedly over the dig.

We were unlucky in our weather, for there was a dust-storm blowing. It was then that I noticed that Max's eyes were impervious to sand. While I stumbled along behind him, blinded by this wind-blown horror, Max, with his eyes apparently wide open, pointed out this, that and the other feature. My first idea was to race for the shelter of the house, but I stuck to it manfully, because in spite of great discomfort I was extremely interested to see all the things about which Max had written.

With the season's expedition at an end, we decided to go home by way of Persia. There was a small air service – German – which had just started running from Baghdad to Persia, and we went by that. It was a single-engined machine, with one pilot, and we felt extremely adventurous. Probably it *was* rather adventurous – we seemed to be flying into mountain peaks the entire time.

The first stop was at Hamadan, the second at Teheran.

From Teheran we flew to Shiraz, and I remember how beautiful it looked – like a dark emerald-green jewel in a great desert of greys and browns. Then, as one circled nearer, the emerald grew even more intense, and finally we came down to find a green city of oasis, palms, and gardens. I had not realised how much desert there was in Persia, and I now understood why the Persians so appreciated gardens – it was because it was so very difficult to *have* gardens.

We went to one beautiful house, I remember. Years later, on our second visit to Shiraz, I tried hard to find it again, but failed. Then the third time we succeeded. I identified it because one of the rooms had various pictures painted in medallions on the ceiling and walls. One of them was of Holborn Viaduct. Apparently a Shah of Victorian times, after visiting London, had sent an artist back there with instructions to paint various medallions of scenes he wanted portrayed – and there, among them, many years later, was Holborn Viaduct still, a little bruised and scratched with wear. The house was already dilapidated, and was not lived in by then, but it was still beautiful, even if dangerous to walk about in. I used it as the setting for a short story called *The House at Shiraz*.

From Shiraz we went by car to Isfahan. It was a long drive on a

rough track, through desert the whole time, with now and then a meagre village. We had to stop the night in an excessively primitive rest-house. We had a rug from the car and bare boards to sleep on, and a rather doubtful-looking bandit in charge, aided by some ruffianly peasants.

We passed an excessively painful night. The hardness of a board to sleep on is unbelievable; one would not think that one's hips, elbows, and shoulders could get so bruised as they do in a few hours. Once, sleeping uncomfortably in my Baghdad hotel bedroom, I investigated the cause, and found that under the mattress a heavy board had been placed to combat the sagging of the wired springs. An Iraqi lady had used the room last, so the house-boy explained, and had been unable to sleep because of the softness, so the board had been put in to enable her to have a good night's rest.

We resumed our drive, and arrived, rather weary, in Isfahan, and Isfahan, from that time forward, has been listed by me as the *most* beautiful city in the world. Never have I seen anything like its glorious colours, of rose, blue and gold – the flowers, birds, arabesques, lovely fairy-tale buildings, and everywhere beautiful coloured tiles – yes, a fairyland city. After I saw it that first time I did not visit it again for nearly twenty years, and I was terrified to go there then because I thought it would be completely different. Fortunately it had changed very little. Naturally there were more modern streets, and a few slightly more modern shops, but the noble Islamic buildings, the courts, the tiles and the fountains – they were all there still. The people were less fanatical by this time, and one could visit many of the interiors of the mosques which were inaccessible before.

Max and I decided we would continue our journey home through Russia, if that did not prove too difficult as regards passports, visas, money, and everything else. In pursuit of this idea we went to the Bank of Iran. This building is so magnificent that you could not help considering it more as a palace than a mere financial establishment – and indeed it was hard to find where in it the banking was going on. When, finally, you arrived through the corridors set with fountains in a vast antechamber, there in the distance was a counter behind which smartly dressed young men in European suits were writing in ledgers. But as far as I could see, in the Middle East you never transacted business at the counter of a bank. You were always passed on to a manager, a sub-manager, or at least to someone who looked like a manager.

A clerk would beckon to one of the bank messengers who stood about in

picturesque attitudes and costumes, and he would then wave you to any one of several enormous leather divans, and disappear. By and by he would return, beckon you towards him, take you up marble stairs of great magnificence, and lead you to some presumably sacred door. Your guide would tap on it, go in leaving you standing outside, to return presently, beaming all over his face and showing himself delighted that you had passed the test successfully. You would enter the room feeling that you were no less than a Prince of Ethiopia.

A charming man, usually rather portly, would rise to his feet, greet you in perfect English or French, beckon you to a seat, offer you tea or coffee; ask when you had arrived, whether you liked Teheran, where you had come from, and finally – quite, as it were, by accident – proceed to the question of what you might happen to want. You would mention such things as travellers' cheques. He would sound a little bell on his desk, another messenger would enter and would be told: 'Mr Ibrahim.' Coffee would arrive, there would be more conversation on travel, the general state of politics, failure or success of crops.

Presently Mr Ibrahim would arrive. He would be wearing a puce-coloured European suit, and would be about thirty years of age. The bank manager would explain your requirements and you would mention what money you would like the payment to be made in. He would then produce six or more different forms which you would sign. Mr Ibrahim would then disappear and another long interlude would take place.

It was at this moment on the present occasion that Max began to talk about the possibility of our going to Russia. The bank manager sighed and raised his hands.

'You will have difficulties,' he said.

'Yes,' Max said, he expected there would be difficulties, but surely it was not impossible? There was no actual bar, was there, to crossing the frontier?

'You have no diplomatic representation at present, I believe. You have no Consulates there.'

Max said, no, he knew we had no consuls there, but he understood there was no prohibition on English people entering the country if they wanted to.

'No, there is no prohibition at all. Of course, you would have to take money with you.'

Naturally, Max said, he expected he would have to take money with him.

'And no financial transaction that you can make with us will be legal,' said the bank manager sadly.

This startled me a little. Max, of course, was not new to Oriental ways of doing business, but I was. It seemed to me odd that in a bank a financial transaction could be both illegal and yet practised.

'You see,' explained the bank manager, 'they alter the laws; they alter them the whole time. And anyway the laws contradict each other. One law says you shall not take out money in one particular form, but another law says that is the only form in which you *can* take it out – so what is one to do? One does what seems best on that particular day of the month. I tell you this,' he added, 'so that you may understand beforehand that though I can arrange a transaction, I can send out to the bazaar, I can get you the most suitable kind of money to take, it will all be illegal.'

Max said that he quite understood that. The bank manager cheered up, and told us that he thought we would enjoy the journey very much. 'Let me see now – you want to go down to the Caspian by car? Yes? That is a beautiful drive. You will go to Resht, and from Resht you will go by boat to Baku. It is a Russian boat. I know nothing about it, nothing whatsoever, but people go by it, yes.'

His tone suggested that people who went by it disappeared into space, and nothing was known of what happened to them afterwards. 'You will not only have to take money,' he warned us, 'you will have to take food. I do not know if there are any arrangements for getting food in Russia. At any rate there are no arrangements for buying food on the train from Baku to Batum – you must take everything with you.'

We discussed hotel accommodation and other problems, and all seemed equally difficult.

Presently another gentleman in a puce suit arrived. He was younger than Mr Ibrahim, and his name was Mr Mahomet. Mr Mahomet brought with him several more forms, which Max signed, and also demanded various small sums of money to purchase the necessary stamps. A messenger was summoned, and sent to the bazaar for currency.

Mr Ibrahim then reappeared. He set out the amount of money we had asked for in a few notes of large denomination instead of the notes of small denomination we had requested.

'Ah! but it is always very difficult,' he said sadly. 'Very difficult indeed. You see sometimes we have a lot of one denomination, and some days we have a lot of another. It is just your good fortune or your bad fortune what you get.' We were obviously to accept our bad fortune in this case.

The manager attempted to cheer us by sending for yet more coffee. Turning to us, he went on, 'It is best that you take all the money you can to Russia in tomans. Tomans,' he added, 'are illegal in Persia, but they are the only things we can use here because they are the only things they will take in the bazaar.'

He sent yet another myrmidon out into the bazaar to change large quantities of our newly-acquired money into tomans. Tomans turned out to be Maria Theresa dollars – pure silver and excessively heavy.

'Your passport, it is in order?' he asked.

'Yes.'

'It is valid for the Soviet Union?' We said yes, it was valid for all countries in Europe including the Soviet Union.

'Then that is all right. The visa, no doubt, will be easy. It is understood then? You must make your arrangements for a car – the hotel will do that for you – and you must take with you sufficient food for three or four days. The journey from Baku to Batum lasts several days.'

Max said he would also like to break his journey at Tiflis.

'Ah, for that you will have to inquire when you get your visa. I do not think it is possible.'

That rather upset Max. However, he accepted it. We said goodbye and thanked the manager. Two hours and a half had passed.

We went back to our hotel, where our diet was somewhat monotonous. Whatever we ordered, or whatever we asked for, the waiter would say: 'There is very good caviare today – very good, very fresh.' Eagerly we used to order caviare. It was amazingly cheap, and though we used to have enormous amounts of it, it always seemed to cost us only five shillings. We did, however, occasionally baulk at having it for breakfast – somehow one does not want caviare for breakfast.

'What have you got for breakfast?' I would ask.

'Caviare – très frais.'

'No, I don't want caviare, I want something else. Eggs? Bacon?'

'There is nothing else. There is bread.'

'Nothing else at all? What about eggs?'

'Caviare, très frais,' said the waiter firmly.

So we had a little caviare and a great deal of bread. The only other thing offered us for a meal at lunch except caviare was something called La Tourte, which was a large and excessively sweet kind of jam tart, heavy, but of pleasant flavour.

We had to consult this waiter as to what food we should take into

Russia with us. On the whole the waiter recommended caviare. We agreed to take two enormous tins of it. The waiter also suggested taking six cooked ducks. In addition we took bread, a tin of biscuits, pots of jam and a pound of tea – 'for the engine,' the waiter explained. We did not quite see what the engine had to do with it. Perhaps it was usual to offer the engine-driver a present of tea? Anyway we took tea and coffee essence.

After dinner that evening we fell into conversation with a young Frenchman and his wife. He was interested to hear of our proposed journey, and shook his head in horror. '*C'est impossible! C'est impossible pour Madame. Ce bateau, le bateau de Resht à Baku, ce bateau russe, c'est infecte! Infecte, Madame!*' French is a wonderful language. He made the word *infecte* sound so depraved and filthy that I could hardly bear to contemplate the prospect.

'You cannot take Madame there,' the Frenchman insisted firmly. But Madame did not shrink.

'I don't suppose it's nearly so *infecte* as he says,' I remarked later to Max. 'Anyway, we've got lots of bug powder and things like that.'

So in due course we started, laden with quantities of tomans and given our credentials by the Russian consulate, who were quite adamant about not letting us get off at Tiflis. We hired a good car, and off we went.

It was a lovely drive down to the Caspian. We climbed first up bare and rocky hills, and then as we came over the top and down the other side discovered ourselves in another world – finally arriving in soft warm weather and falling rain at Resht.

We were ushered on to the *infecte* Russian boat feeling rather nervous. Everything was as different as could be from Persia and Iraq. First, the boat was scrupulously clean; as clean as a hospital, indeed rather like a hospital. Its little cabins had high iron beds, hard straw palliasses, clean coarse-cotton sheets, and a simple tin jug and basin. The crew of the boat were like robots; they seemed all to be six foot high, with fair hair and impassive faces. They treated us politely, but as though we were not really *there*. Max and I felt exactly like the suicide couple in the play, *Outward Bound* – the husband and wife who move about the boat like ghosts. Nobody spoke to us, looked at us, or paid the least attention to us.

Presently, however, we saw that food was being served in the saloon. We went hopefully to the door and looked in. Nobody made any sign to us or appeared to see us. Finally, Max took his courage in both hands and asked if we could have some food. The demand was clearly not understood.

Max tried French, Arabic, and such Persian as he knew, but with no effect. Finally he pointed his finger firmly down his throat in that age-old gesture which cannot fail to be recognised. Immediately the man pulled forward two seats at the table, we sat down, and the food was brought to us. It was quite good, though very plain, and it cost an incredible amount.

Then we arrived at Baku. Here we were met by an Intourist agent. He was charming, full of information, and spoke French fluently. He thought, he said, that we might like to go to a performance of *Faust* at the Opera. This, however, I did not want to do. I felt I had not come all the way to Russia to see *Faust* performed. So he said he would arrange some other entertainment for us. Instead of *Faust* we were forced to go and look at various building sites and half-built blocks of flats.

When getting off the boat, the procedure was simple. Six robot-like porters advanced in order of seniority. The charge, said the Intourist man, was one rouble for each piece. They advanced upon us, and each porter took one piece. An unlucky one had Max's heavy suitcase full of books; the luckiest one had only an umbrella – but they both had to be paid the same.

The hotel we went to was curious also. It was a relic of more luxurious days, I should imagine, and the furniture was grand but old-fashioned. It had been painted white, and was carved with roses and cherubs. For some reason it was all standing in the middle of the room, rather as though furniture movers had just pushed a wardrobe, a table, and a chest of drawers in and left them. Even the beds were not against the wall. These last were magnificently handsome in style, and most comfortable, but they had on them coarse cotton sheets, too small to cover the mattress.

Max asked for hot water for shaving the next morning, but had not much luck. Hot water were the only words he knew in Russian – apart from the words for 'please' and 'thank you'. The woman he asked shook her head vigorously and brought us along a large jug of cold water. Max used the word for hot several times hopefully, explaining, as he put his razor to his chin, what he needed it for. She shook her head and looked shocked and disapproving.

'I think,' I said, 'that you are being a luxurious aristocrat by asking for hot water to shave in. You'd better stop.'

Everything in Baku seemed like a Scottish Sunday. There was no pleasure in the streets; most of the shops were shut; the one or two that were open had long queues, and people were standing waiting patiently for unattractive articles.

Our Intourist friend saw us off at the train. The queue for tickets was enormous. 'I will just see about some reserved seats,' he said, and moved away. We edged slowly forward in the queue.

Suddenly someone patted us on the arm. It was a woman from the front of the queue. She was smiling broadly. In fact all these people seemed ready to smile if there was anything to smile at. They were kindliness itself. Then, with a good deal of pantomime, the woman urged us to step up to the top of the queue. We didn't like to do this, and hung back, but the whole of the queue insisted. They patted us on the arm and on the shoulder, nodded and beckoned, and finally one man took us up by the arm and moved us forcibly forward, and the woman at the front stepped aside and bowed and smiled. We purchased our tickets at the *Surchet*.

The Intourist man came back. 'Ah, you are ready,' he said.

'These kind people gave us their places,' said Max rather doubtfully. 'I wish you would explain that we didn't want to take them.'

'Ah, but they always do that,' said he. 'In fact, they enjoy going to the back of the queue. It is a great occupation standing in a queue, you know. They like to make it as long as possible. They are always very polite to strangers.'

They were indeed. They nodded and waved at us as we left for the train. The platform was crowded; we discovered later, however, that practically nobody was going by train except ourselves. They had just come to see the fun and enjoy their afternoon there. We finally got into our carriage. The Intourist man said goodbye to us and assured us that we would be met at Batum in three days' time, and that everything would go well.

'You have not a teapot with you, I see,' he said. 'But one of the women will doubtless lend you one.'

I discovered what this meant when the train made its first stop after about two hours' run. Then an old woman in our compartment patted me violently on the shoulder, showed me her teapot, and explained, with the help of a boy in the corner who spoke German, that the thing to do was to put a pinch of tea in your teapot and take it along to the engine where the driver would supply hot water. We had cups with us, and the woman assured us she would do the rest. She returned with two steaming cups of tea, and we unpacked our provisions. We offered some to our new friends and our journey was well on its way.

Our food held out moderately well – that is to say we got through the ducks, fortunately before they went bad, and ate some bread which

grew staler and staler. We had hoped to be able to buy bread on the way, but that did not seem to be possible. We had, of course, got down to the caviare as soon as possible. Our last day brought semi-starvation because we had nothing left but the wing of a duck and two pots of pineapple marmalade. There is something rather sickly in eating a whole pot of pineapple marmalade neat, but it assuaged the pangs of hunger.

We arrived at Batum at midnight, in pouring rain. We had, of course, no hotel booking. We passed out of the station into the night with our baggage. No signs of anyone from Intourist to meet us. There was a droshky waiting, a dilapidated horse-cab rather like an old-fashioned Victoria. Obliging as always, the driver helped us to get in, and piled our baggage over and upon us. We then said we wanted a hotel. He nodded encouragingly, cracked his whip, and we set off at a ramshackle trot through the wet streets.

Soon we came to a hotel, and the driver made signs for us to go in first. We soon saw why. As soon as we got inside we were told there were no rooms. We asked where else we should go, but the man merely shook his head uncomprehendingly. We went out and the driver started off once more. We went to about seven hotels; every one was full up.

At the eighth Max said we would have to take sterner measures, we had *got* to find somewhere to sleep. On arrival we plonked ourselves down on the plush couch in the hall, and looked half-wittedly uncomprehending when we were told that there was no room. In the end, the receptionists and clerks threw up their hands and looked at us in despair. We continued to look uncomprehending, and to say at intervals in such languages as we thought might possibly be understood that we wanted a room for the night. Finally they left us. The driver came in, put our bags down by us, and went off, waving a cheerful farewell.

'Don't you think we have rather burnt our boats now?' I asked dolefully.

'It's the only hope,' said Max. 'Once we haven't got any transport to take us away, and our luggage is here, I think they will do something about us.'

Twenty minutes passed, and suddenly an angel of succour arrived in the form of a vast man over six foot high, with a terrific black moustache, wearing riding boots and looking exactly like a figure out of a Russian ballet. I gazed at him in admiration. He smiled at us, patted us on the shoulder in a friendly fashion, and beckoned us to follow him. He went up two flights of stairs to the top floor, then pushed up a trapdoor in the

P

roof and hung a ladder to it. It seemed unconventional, but there was nothing for it; Max pulled me up after him, and we came out upon the roof. Still beckoning and smiling, our host led us across the roof on to the roof of the next house, and finally down through another trapdoor. We were shown into a large attic room, quite nicely furnished, with two beds in it. He patted the beds, pointed to us, disappeared, and shortly afterwards our luggage arrived. Luckily we had not much luggage with us by this time; it had been taken from us at Baku and we had been told by the Intourist man that we should find it waiting at Batum. We hoped that that would happen next day, in the meantime the only thing we wanted was bed and sleep.

Next morning we wanted to find our way to the French boat which was sailing that day to Stamboul, and on which we had tickets booked. Though we tried to explain this to our host, he did not understand, and there appeared to be nobody there who did. We went out and searched the streets ourselves. I never realised before how difficult it was to find the sea if you can get no view from any kind of hill. We walked one way, then another, then a third at intervals asking for things like 'boat' in as many languages as we knew – 'harbour', 'quay': nobody understood French or German or English. In the end we managed to find our way back to the hotel.

Max drew a picture of a boat on a piece of paper, and our host expressed immediate comprehension. He took us up to a sitting-room on the first floor, sat us down on a sofa, and explained in dumb show that we were to wait there. At the end of half an hour he reappeared with a very old man in a peaked blue cap who spoke to us in French. This ancient had apparently been a porter in a hotel in former days and still dealt with visitors. He expressed immediate readiness to lead us to our boat, and to carry our luggage there.

First of all we had to reclaim the luggage which should have arrived from Baku. The old man took us straight to what was clearly a prison, and we were led into a heavily barred cell with our luggage, sitting demurely in the middle of it. The old man collected it, and led us off to the harbour. He grumbled the whole way, and we became rather nervous, as the last thing we wished to do was to criticise the government in a country where we had no consul to get us out of a mess.

We tried to hush the old man down, but it was no good. 'Ah, things are not what they used to be,' he said. 'Why, what do you think? Do you see this coat I have now? It is a good coat, yes, but does it belong to me?

No, it belongs to the government. In the old days I had not one coat – I had four coats. Perhaps they were not as good as this coat, but they were *my* coats. Four coats – a winter coat, a summer coat, a rain-coat and a smart coat. Four coats I had!'

Finally he lowered his voice slightly and said: 'It is strictly forbidden to give any tips to the service here, so if you *were* thinking of giving me anything it would be as well to do it while we walk down this little street here.' Such a plain hint could not be ignored, and as his services had been invaluable we hastily parted with a generous sum of money to him. He expressed approbation, grumbled about the government some more, and finally gestured proudly to the docks, where a smart Messageries Maritimes boat was waiting by the quay.

We had a lovely trip down the Black Sea, The thing I remember best was putting in to the port of Inebolu, where they took on board eight or ten darling little brown bears. They were going, I heard, to a zoo at Marseilles, and I felt sad about them: they were so completely teddy-bearish. Still they might have had a worse fate – shot perhaps, and stuffed, or something equally disagreeable. As it was they had at least a pleasant voyage on the Black Sea. It makes me laugh still to remember a rugged French sailor solemnly feeding one little bear after another with milk from a feeding bottle.

IV

The next thing of importance that happened in our lives was my being taken to visit Dr and Mrs Campbell-Thompson for the week-end, so that I could be vetted before being allowed to go to Nineveh. Max was now practically fixed up to go and dig with them the following autumn and winter. The Woolleys were not pleased at his leaving Ur, but he was determined on the change.

C. T., as he was usually known, had certain tests which he applied to people. One of them was the cross-country scramble. When he had anyone like me staying, he would take them out on the wettest day possible over rough country, and notice what kind of shoes they wore, whether they were tireless, whether they were agreeable to burrowing through hedges, and forcing their way through woods. I was able to pass that test success-fully, having done so much walking and exploring on Dartmoor. Rough

country held no terrors for me. But I was glad it was not entirely over ploughed fields, which I think *are* very tiring.

The next test was to find if I was fussy about eating. C. T. soon discovered that I could eat anything, and that again pleased him. He also was fond of reading my detective stories, which prejudiced him in my favour. Having decided, presumably, that I would fit in well enough at Nineveh, things were fixed up. Max was to go there late in September, and I was to join him at the end of October.

My plan was to spend a few weeks writing and relaxing in Rhodes and then to sail to the port of Alexandretta, where I knew the British Consul. There I would hire a car to drive me to Aleppo. At Aleppo I would take the train to Nisibin on the Turkish – Iraqi frontier, and there would then be an eight-hour drive to Mosul.

It was a good plan, and agreed with Max, who would meet me at Mosul – but arrangements in the Middle East seldom run true to plan. The sea can be very rough in the Mediterranean, and after we had put in at Mersin, the waves were rising high and I was lying groaning in my bunk. The Italian steward was full of compassion, and much upset by the fact that I no longer wished to eat anything. At intervals he would put his head in and tempt me with something on the current day's menu. 'I bring you lovely spaghetti. Very good, very nice rich tomato sauce – you like it very much.' 'Oh,' I groaned, the mere thought of hot greasy spaghetti with tomato sauce practically finishing me. He would return later. 'I have something you like now. Vine leaves in olive oil – rolled up in olive oil with rice. Very good.' More groans from me. He did once bring me a bowl of soup, but the inch of grease on the top of it made me turn green once more.

As we were approaching Alexandretta I managed to get myself on my feet, dressed, packed, and then staggered out uncertainly on deck to revive myself with fresh air. As I stood there, feeling rather better in the cold sharp wind, I was told I was wanted in the Captain's cabin. He broke the news to me that the steamer would not be able to put in to Alexandretta. 'It is too rough,' he said. 'It is not easy there, you see, to land.' This was serious indeed. It seemed that I could not even communicate with the Consul.

'What shall I do?' I asked.

The Captain shrugged his shoulders. 'You will have to go on to Beirut. There is nothing else for it.'

I was dismayed. Beirut was entirely in the wrong direction. However, it had to be endured.

'We do not charge you any more,' the Captain said, encouragingly. 'Since we are unable to land you there, we take you on to the next port.'

The sea had abated somewhat by the time we got to Beirut, but it was still rough. I was decanted into an excessively slow train which carried me to Aleppo. It took, as far as I can remember, all day and more – sixteen hours at least. There was no kind of lavatory on the train, and when you stopped at a station you never knew if there was a lavatory there or not. I had to endure the entire sixteen hours, but I was fortunately gifted in that direction.

Next day I took the Orient Express on to Tel Kochek, which was at that time the terminus of the Berlin-Baghdad railway. At Tel Kochek there was more bad luck. They had had such bad weather that the track to Mosul was washed away in two places, and the *wadis* were up. I had to spend two days at the rest-house – a primitive place, with absolutely nothing to do there. I wandered round a barbed-wire entanglement, walked a short distance into the desert, and the same distance back again. Meals were the same every time: fried eggs and tough chicken. I read the only book I had left; after that, I was reduced to thinking!

At last I arrived at the rest-house in Mosul. Word seemed mysteriously to have reached there, for Max was standing on the steps to greet me.

'Weren't you terribly worried,' I asked, 'when I didn't arrive three days ago?'

'Oh no, said Max, 'It often happens.'

We drove off to the house that the Campbell-Thompsons had taken, near the big mound of Nineveh. It was a mile and a half out of Mosul, and altogether charming – one that I shall always think of with love and affection. It had a flat roof with a square tower room on one side of it, and a handsome marble porch. Max and I had the upstairs room. It was sparsely furnished, mainly with orange boxes, and had two camp-beds. All round the little house was a mass of rose bushes. They had lots of pink rose-buds on them when we arrived. Tomorrow morning, I thought, the roses will be fully out; how lovely they will look. But no, next morning they were rose-buds still. This phenomenon of nature I could not understand – a rose is surely not a night-blooming cereus – but the truth was that these were grown for making ottar of roses and men came at four o'clock in the morning to pick them as they opened. By daybreak, the next crop of buds was all that remained.

Max's work involved being able to ride a horse. I doubt much if he had often ridden at that time, but he insisted he could and before coming out had attended a riding-stable in London. He would have been more apprehensive if he had realised that C.T.'s passion in life was economy – although in many ways a most generous man he paid his workmen the lowest wage possible. One of his economies was never to pay much for a horse, therefore any beast that he purchased was likely to have some unpleasant personal characteristic that remained hidden until its owner had managed to clinch the sale. It usually reared, bucked, shied, or did some trick or other. This one was no exception, and having to ride up a slippery, muddy path to the top of the mound every morning was some-what of an ordeal, especially as Max did it with an appearance of the utmost insouciance. All went well, however, and he *never* fell off. That, indeed, would have been the supreme disgrace.

'Remember,' C.T. said to him, before leaving England, 'that to fall off your horse means that not a single workman will have a scrap of respect for you.'

The ritual started at 5 a.m. C.T. would mount to the roof, Max would join him, and, after consultation, would signal with a lamp to the night-watchman on top of the mound of Nineveh. This message conveyed whether the weather was such that work could proceed. Since it was now autumn and the rainy season, this was a matter of some anxiety; a great many of the workmen had to come from two or three miles away, and they looked for the beacon light on the mound to know whether to start from home or not. In due course Max and C.T. departed on their horses to ride up to the top of the mound.

Barbara Campbell-Thompson and I would walk up to the mound at about 8 a.m. where we had breakfast together: hard-boiled eggs, tea and native bread. In those October days it was very pleasant, though in another month it was chilly and we were then well wrapped up. The country round was lovely: the hills and mountains in the distance, the frowning Jebel Maqlub, sometimes the Kurdish mountains with snow on them. Looking the other way, you saw the river Tigris and the city of Mosul with its minarets. We would return to the house, and later would go up for a picnic lunch again.

I had one battle with C.T. He gave in to me with courtesy, but I think I went down in his estimation. All I wanted was to buy myself a table in the bazaar. I could keep my clothes in orange-boxes, I used orange-boxes to sit on, and I kept an orange-box by my bed, but what I *had* to have,

if I was going to do my own work, was a solid table at which I could type-write, and under which I could get my knees. There was no question of C.T. paying for the table – *I* was going to buy it – it was just that he looked down on me for being willing to spend money on something not absolutely necessary. But I insisted that it *was* absolutely necessary.

Writing books, I pointed out, was my work, and I had to have certain tools for it: a typewriter, a pencil, and a table at which I could sit. So C.T. gave way, but he was sad about it. I insisted also on having a *solid* table, not a mere affair of four legs and a top that rocked when you touched it, so the table cost £10 – an unheard-of sum. I think it took him quite a fortnight to forgive me for this luxurious extravagance. However, once I had my table, I was very happy, and C.T. used to inquire kindly after the progress of my work. The book in question was *Lord Edgware Dies*, and a skeleton which came to light in a grave on the mound was promptly christened Lord Edgware.

The point of coming to Nineveh, for Max, was to dig down a deep pit through the mound of Nineveh. C.T. was not nearly so enthusiastic, but they had agreed beforehand that Max should have a shot at this. In archaeology, pre-history had suddenly become the fashion. Nearly all excavations up to then had been of an historical nature, but now everyone was passionately interested in pre-historic civilisation, about which as yet so little was known.

They examined small, obscure mounds all over the country, picked up fragments of painted pottery wherever they went, labelling them, tying them up in bags, and examining the patterns – it was endlessly interesting. Although it was so old – it was *new*!

Since writing had not been invented when this pottery was made, the dating of it was exceptionally difficult. It was hard to tell whether one type of pottery preceded or followed another. Woolley, at Ur, had dug down to the Flood levels and below, and the exciting painted pottery of Tell 'Ubaid was causing enormous speculation. Max was bitten with the bug as badly as anyone – and indeed the results of our deep pit in Nineveh *were* very exciting, because it soon became apparent that the enormous mound, ninety feet high, was three-quarters pre-historic, which had never been suspected before. Only the top levels were Assyrian.

The deep pit became rather frightening after a while, because they had to dig down ninety feet to virgin soil. It was just completed by the end of the season. C.T., who was a brave man, always made a point of going down himself with the workmen once a day. He hadn't a good head for

heights, and it was agony to him. Max, had no trouble about heights, and was quite happy going up and down. The workmen like all Arabs were oblivious to any kind of vertigo. They rushed up and down the narrow spiral causeway, wet and slippery in the morning; throwing baskets to each other, carrying up the dirt, making playful pushes and passes at each other about an inch from the edge.

'Oh, my God!' C.T. used to groan, and clasped his hands to his head, unable to look down at them. 'Someone will be killed soon.'

But nobody was killed. They were as surefooted as mules.

On one of our rest days we decided to hire a car and go to find the great mound of Nimrud, which had last been dug by Layard, getting on for a hundred years before. Max had some difficulty in getting there, for the roads were very bad. Most of the way had to be across country, and the *wadis* and irrigation ditches were often impassable. But in the end we arrived and picnicked there – and oh, what a beautiful spot it was then. The Tigris was just a mile away, and on the great mound of the Acropolis, big stone Assyrian heads poked out of the soil. In one place there was the enormous wing of a great genie. It was a spectacular stretch of country – peaceful, romantic, and impregnated with the past.

I remember Max saying, 'This is where I would like to dig, but it would have to be on a very big scale. One would have to raise a lot of money but if I could, this is the mound I would choose, out of all the world.' He sighed: 'Oh well, I don't suppose it will ever happen.'

Max's book lies before me now: *Nimrud and its Remains*. How glad I am that the wish of his heart has been fulfilled. Nimrud has woken from its hundred years sleep. Layard began the work, my husband finished it.

He discovered its further secrets: the great Fort Shalmaneser out at the boundary of the town; the other palaces on other parts of the mound. The story of Calah, the military capital of Assyria, has been laid bare. Historically, Nimrud is now known for what it was, and, in addition to this, some of the most beautiful objects ever made by craftsmen – or artists, as I would rather call them – have been brought to the museums of the world. Delicate, exquisitely fashioned ivories: they are such beautiful things.

I had my part in cleaning many of them. I had my own favourite tools, just as any professional would: an orange stick, possibly a very fine knitting needle – one season a dentist's tool, which he lent, or rather gave me – and a jar of cosmetic face-cream, which I found more useful

than anything else for gently coaxing the dirt out of the crevices without harming the friable ivory. In fact there was such a run on my face cream that there was nothing left for my poor old face after a couple of weeks!

How thrilling it was; the patience, the care that was needed; the delicacy of touch. And the most exciting day of all – one of the most exciting days of my life – when the workmen came rushing into the house from their work clearing out an Assyrian well, and cried: 'We have found a woman in the well! There is a woman in the well!' And they brought in, on a piece of sacking, a great mass of mud.

I had the pleasure of gently washing the mud off in a large wash-basin. Little by little the head emerged, preserved by the sludge for about 2,500 years. There it was – the biggest ivory head ever found: a soft, pale brownish colour, the hair black, the faintly coloured lips with the enigmatic smile of one of the maidens of the Akropolis. The Lady of the Well – the Mona Lisa, as the Iraqi Director of Antiquities insisted on calling her – she has her place now in the new museum at Baghdad: one of the most exciting things ever to be found.

There were many other ivories, some perhaps of even greater beauty than the head, if not so spectacular. The plaques of cows with turned heads suckling their calves; ivory ladies at the window, looking out, no doubt like Jezebel the wicked; two wonderful plaques of a negro being killed by a lioness. He lies there, in a golden loin-cloth, gold points in his hair, and his head lifted in what seems like ecstasy as the lioness stands over him for the kill. Behind them is the foliage of the garden: lapis, carnelian and gold form the flowers and foliage. How fortunate that two of these were found. One is now in the British Museum, the other in Baghdad.

One does feel proud to belong to the human race when one sees the wonderful things human beings have fashioned with their hands. They have been creators – they must share a little the holiness of the Creator, who made the world and all that was in it, and saw that it was good. But he left more to be made. He left the things to be fashioned by men's hands. He left *them* to fashion them, to follow in his footsteps because they were made in his image, to see what they made, and see that it was good.

The pride of creation is an extraordinary thing. Even the carpenter who once fashioned a particularly hideous towel-rail of wood for one of our expedition houses had the creative spirit. When asked *why* he had put such enormous feet on it against orders, he said reproachfully: 'I

had to make it that way because it was so beautiful like that!' Well, it
seemed hideous to us, but it was beautiful to him, and he made it in the
spirit of creation, *because* it was beautiful.

Men can be evil – more evil than their animal brothers can ever be – but
they can also rise to the heavens in the ecstasy of creation. The cathedrals
of England stand as monuments to man's worship of what is above himself.
I like that Tudor rose – it is, I think, on one of the capitals of King's
College Chapel, Cambridge – where the stone-carver, against orders,
put the Madonna's face in the centre of it, because, he thought the
Tudor Kings were being worshipped too much, and that the Creator, the
God for whom this place of worship was built, was not honoured enough.

This was to be Dr Campbell-Thompson's final season. He was, of course,
mainly an epigraphist himself, and to him the written word, the historical
record, was far more interesting than the archaeological side of digging.
Like all epigraphists, he was always hoping to find a hoard of tablets.

There had been so much excavation done on Nineveh, that it was
difficult to make sense of all the buildings. For Max, the palace buildings
were not particularly interesting: it was his deep pit in the pre-historic
period that really interested him, because so little was known about it.

He had already formed the plan, which I found a very exciting one,
of digging a small mound on his own in this part of the world. It would
have to be small, since it would be difficult to raise much money, but he
thought it could be done, and that it was enormously important that it
should be done. So he had a special interest, as time went on, in the pro-
gress of the deep pit down towards virgin soil. By the time it was reached
the base was a tiny patch of ground, only a few yards across. There had
been a few sherds – not many, owing to the small space – and they were of
a different period to those found higher up. From then on Nineveh was
re-labelled from the bottom upwards: Ninevite 1, next to virgin soil,
then Ninevite 2, Ninevite 3, Ninevite 4, and Ninevite 5. Ninevite 5 in
which period the pottery was turned on a wheel, had beautiful pots with
both painted and incised patterns. Vessels like chalices were particularly
characteristic of it, and the decorations and paintings were vigorous and
charming. Yet the pottery itself – the texture – was of not nearly so fine a
quality as that made possibly several thousand years earlier: the beautiful
apricot-coloured delicate ware, almost like Greek pottery to handle, with
its smooth glazed surface and its mainly geometric decorations, in parti-
cular a pattern of dots. It was, Max said, like the pottery found at Tell

Halaf in Syria, but that had always been thought to be much later, and in any case this was of finer quality.

He got the workmen to bring him various bits of pottery from villages where they lived all within a radius of one to eight miles. On some mounds the pottery was mostly of late Ninevite 5 quality, and in addition to the painted variety there was another very beautiful type of incised pot, delicately worked. Then there was red ware, of an earlier period and grey ware, both plain and not painted.

Evidently one or two of the small pimples which covered the country all the way up to the mountains, had been abandoned early, before there was any question of pottery being made on the wheel: and this fine early pottery was hand-made. There was in particular a very small mound called Arpachiyah – it was only about four miles east of the great circle of Nineveh. On this little pimple there was hardly any trace of anything later than the fine painted sherds of Ninevite 2. Apparently that was its last main period of occupation.

Max was attracted by it. I egged him on, because I thought the pottery so beautiful that it would be tremendously exciting to find out something about it. It would be a gamble, said Max. It must be a very small village indeed and could hardly have been an important one, so it was doubtful what you would find. But still, the people who made that pottery must have lived there. Their occupation was perhaps primitive, but the pottery was not: it was of the finest quality. They could not have made it for the great city of Nineveh, nearby, like some local Swansea or Wedgwood, for Nineveh did not exist when they were moulding their clay. It would not exist for several thousand years to come. So what *did* they make it for? Sheer love of making something so beautiful?

Naturally, C.T. thought Max was mistaken in attaching so much importance to the pre-historic days, and to all this 'modern fuss' about pottery. Historical records, he said, were the only things that mattered; man telling his own story, not in spoken words but in written ones. They were both right in a sense: C.T. because historical records were indeed uniquely revealing, and Max because to find out something new about the history of man one must use what he himself can tell you, in this case by what he made with his hands. And I was right too to notice that the pottery in this tiny hamlet was beautiful, and to mind about that. And I think I was right to be continually asking myself 'Why?' all the time, because to people like me, asking why is what makes life interesting.

I enjoyed my first experience of living on a dig enormously. I had liked Mosul; I had become deeply attached to both C.T. and Barbara; I had completed the final demise of Lord Edgware, and had tracked down his murderer successfully. On a visit to C.T. and his wife I had read them the whole manuscript aloud, and they had been very appreciative. I think they were the only people to whom I ever did read a manuscript – except, that is, my own family.

I could only half believe it, when, in February of the following year, Max and I were once again in Mosul, staying this time at the guest-house. Negotiations were under way for digging at our pimple of a mound, Arpachiyah; little Arpachiyah, that nobody as yet cared or knew about, but which was to become a name known throughout the archaeological world. Max had persuaded John Rose, who had been architect at Ur, to work with us. He was a friend of us both: a beautiful draughtsman, with a quiet way of talking, and a gentle humour that I found irresistible. John was undecided at first whether or not to join us: he did not want to return to Ur, certainly, but was doubtful whether to continue with archaeological work or return to the practice of architecture. However, as Max pointed out to him, it would not be a long expedition – two months at the most – and there probably wouldn't be much to do.

'In fact,' he said persuasively, 'you can consider it a holiday. Lovely time of year, lovely flowers, good climate – not dust-storms like at Ur – mountains and hills. You'll enjoy it enormously. An absolute rest for you.' John was convinced.

'It's a gamble, of course,' said Max. It was an anxious time for him, because he was at the start of his career. He had taken upon himself to make this choice, and would stand or fall by its result.

Everything started unpropitiously. To begin with, the weather was awful. The rain poured down; it was almost impossible to go anywhere by car; and it proved incredibly difficult to find out who owned the land on which we proposed to dig. Questions of land-ownership in the Middle East are always fraught with difficulty. If far enough away from cities, the land is under the jurisdiction of a sheikh, and you make your arrangements, financial and otherwise, with him; with some backing from the Government to lend you authority. All land scheduled as a *tell* – that is to say, which was occupied in antiquity – is the property of the Government, not the property of the land-owner. But I doubt if Arpachiyah, being such a small pimple on the surface of the ground, would have been so labelled, so we had to get in touch with the land owner.

It seemed simple. A vast cheerful man came along, and assured us he was the owner. But the next day we heard that he was not – that a second cousin of his wife's was the actual owner. The day after that we heard that the land was not in fact the property of the second cousin of the wife, and that several other people were involved. On the third day of incessant rain, when everyone had behaved in an extremely difficult manner, Max threw himself down on the bed with a great groan. 'What do you think?' he said. 'There are *nineteen owners.*'

'Nineteen owners of that tiny bit of land?' I said incredulously.

'So it seems.'

We got the whole tangle undone in the end. The real owner was found – she was a second cousin of somebody's aunt's husband's cousin's aunt, who, being quite incapable of doing any business on her own, had to be represented by her husband and several other relatives. With the help of the Mutassarif of Mosul, the Department of Antiquities in Baghdad; the British Consul, and a few other assistants, the whole thing was settled, and a contract of extreme severity drawn up. Terrible penalties were to be exacted on either side if anyone failed to keep to their agreement. What pleased the land-owner's husband most was the insertion of a clause which stated that, if in any way our work of excavation was interfered with, or the contract was voided, he would have to pay £1000 down. He immediately went away and boasted of this to all his friends.

'It is a matter of such importance,' he said proudly, 'that unless I give all the assistance in my power, and keep all the promises I have made on my wife's behalf, I shall lose £1000.'

Everybody was enormously impressed.

'£1000,' they said. 'It is possible he will lose £1000! have you heard that? They can extract from him £1000 if anything goes wrong!'

I should say that if any penalty of a financial nature *had* been demanded from the good man, about ten dinars would have been all that he could have produced.

We rented a small house which was much like the one we had had with the C.T.'s. It was a little further from Mosul and nearer to Nineveh, but it had the same flat roof and a marble verandah, with Mosul marble windows of a slightly ecclesiastical nature, and marble sills on which pottery could be laid out. We had a cook and a house-boy; a large fierce dog to bark at the other dogs in the neighbourhood and anyone who approached the house – and in due course six puppies which belonged to the dog. We also had a small lorry and an Irishman called Gallagher as a

driver. He had stayed behind here after the 1914 war, and had never taken himself home again.

He was an extraordinary person, was Gallagher. He told us wonderful tales sometimes. He had a saga about his discovery of a sturgeon on the shores of the Caspian, and how he and a friend had managed to bring it, packed with ice, across the mountains and down into Iran to sell it for a large price. It was like listening to the *Odyssey* or the *Aenead*, with innumerable adventures that happened on the way.

He gave us such useful information as the exact price of a man's life. 'Iraq is better than Iran,' he said. 'In Iran it costs you £7, cash down, to kill a man. In Iraq only £3.'

Gallagher had still remembrances of his wartime-service and he always drilled the dogs in the most military fashion. The six puppies had their names called out one at a time, and came up to the cook-house in order. Swiss Miss was Max's favourite, and she was always called first. All the puppies were excessively ugly, but they had the charm that puppies have all the world over. They used to come along to the verandah after tea and we used to de-tick them with great attention. They were always just as full of ticks the next day, but we did our best for them.

Gallagher also turned out to be an omnivorous reader. I used to have parcels of books sent out by my sister, every week – and I passed them on to him in due course. He read quickly, and seemed to have no preference whatsoever as to *what* he read: biographies, fiction, love stories, thrillers, scientific works, almost anything. He was like a starving man who would say that any kind of food is the same: you don't mind what it is, you just want *food*. He wanted food for his mind.

He once told us about his 'Uncle Fred', 'A crocodile got him in Burma,' he said sadly. 'I didn't know what to do about it really. However, we thought the best thing was to have the crocodile stuffed, so we did, and we got it sent home to his wife.'

He spoke in a quiet matter-of-fact voice. At first I thought he was romancing, but finally I came to the conclusion that practically everything he told us was true. He was just the sort of man to whom extraordinary things happen.

It was an anxious time for us. As yet there was nothing to show whether Max's gamble was going to pay off. We uncovered only buildings of a poor and decrepit nature – not even really mud-brick: pisé walls, difficult to trace. There were charming sherds of pottery everywhere, and some

lovely black obsidian knives with delicately knotched edges, but nothing as yet out of the ordinary in the way of finds.

John and Max bolstered each other up, murmuring that it was too soon to tell, and that before Dr Jordan, the German Director of Antiquities in Baghdad, arrived, we would at any rate get all our levels nicely measured up and labelled, so that the whole thing would show that digging had been done properly and scientifically.

And then, out of the blue, the great day came. Max rushed back to the house to fetch me from where I was busy, mending some of the pottery.

'A wonderful find,' he said. 'We've found a burnt potter's shop. You must come back with me. It's the most wonderful sight you have ever seen.'

And it was indeed; a crowning piece of luck. The potter's shop was all there, under the soil. It had been abandoned when burnt, and the burning had preserved it. There were glorious dishes, vases, cups and plates, polychrome pottery, all shining in the sun – scarlet and black and orange – a magnificent sight.

From then on, we were so frantically busy we didn't know how to cope. Vessel after vessel came up. They were smashed by the fall of the roof – but they were there, and could nearly all be reconstructed. Some of them were slightly charred, but the walls had fallen on top of them and preserved them, and there for about six thousand years they had lain untouched. One enormous burnished dish, in a lovely deep red with a petalled rosette centre and beautiful designs all round it, very geometrical, was in 76 pieces. Every piece was there, and was reassembled, and it is now a wonderful sight to see in the museum where it lies. There was another bowl I loved, with an all-over pattern rather like a Union Jack; it was in deep, soft, tangerine.

I was bursting with happiness. So was Max, and so, in his quieter way, was John. But, oh, how we worked, from then on until the end of the season!

I had done some homework that autumn, trying to learn to draw to scale. I had gone to the local secondary school, and had instruction there from a charming little man, who could not believe that I knew as little as I did.

'You don't seem to have even heard of a right-angle,' he said to me, disapprovingly. I admitted that that was true. I hadn't.

'It makes it hard to describe things,' he said.

However, I learnt to measure and calculate, and work out things to

two thirds of the actual size, or whatever it had to be. Now the time had
come when I had to put what I had learnt to the test. There was far too
much to be done unless we all pulled our weight. I took, of course, two or
three times as long as either of the others but John had to have some
assistance, and I was able to provide it.

Max had to be out on the dig all day, while John drew. He would
stagger down to dinner at night, saying, 'I *think* I'm going blind. My
eyes feel queer, and I am so dizzy I can hardly walk. I have been drawing
without ceasing at top speed since eight o'clock this morning.'

'And we'll all have to go on after dinner,' said Max.

'And you are the man who told me,' said John accusingly, '*you* are the
man who said that this was going to be a holiday!'

To celebrate the end of the season we decided to organise a race for the
men. This had never been done before. There were to be several splendid
prizes and it was open to all the men to compete.

There was a great deal of talk about it. To begin with, some of the
grave, older men questioned whether they might not lose dignity by
competing in such an event. Dignity was always very important. To
compete with younger men, possibly beardless boys, was not the sort of
thing that a dignified man, a man of substance, ought to do. However,
they all came round to it in the end, and we arranged the details. The
course was to be about three miles, and they would cross the Khosr River
just beyond the mound of Nineveh. Rules were drawn up carefully.
The main rule was that there were to be no fouls; nobody was to throw
anybody down, do any bumping or boring, crossing, or any such thing.
Although we hardly expected that such a rule would be respected, we
hoped that the worst excesses would be avoided.

The prizes were *first*, a cow and calf; *second*, a sheep; *third*, a goat.
There were several smaller prizes – hens, sacks of flour, and from a
hundred eggs down to ten. There was also, for everyone who completed
the course, a handful of dates and as much halva as a man could hold
clasped in his two hands. These prizes, I may say, cost us £10. Those
were the days, no doubt about it.

We called it the A.A.A.A. – the Arpachiyah Amateur Athletic Associa-
tion. The river was in flood at the moment, and nobody could cross the
bridge to attend, but the R.A.F. was invited to watch the race from the sky.

The day came, and it was a memorable sight. The first thing that hap-
pened, of course, was that everyone made a concerted rush forward when
the starting pistol went, and most of them fell flat on their faces into the

Khosr. Others disentangled themselves from the swarming mass and ran on. The foul play was not too bad; nobody actually knocked anybody down There had been a great deal of betting on the race, but none of the favourites was even placed or looked like being placed. Three dark horses won – and the applause was terrific. First was a strong and athletic man; second – a most popular win – a very poor man, who always looked half-starved; and third was a young boy. That night there was immense rejoicing: the foremen danced, the men danced; and the man who had won the second prize of the sheep killed it immediately and feasted all his family and friends. It was a great day for the Arpachiyah Amateur Athletic Association.

We departed to cries of good will: 'God bless you!', 'You will come again' 'God is very merciful' and so on. We then went to Baghdad, where all our finds were waiting in the Museum, and there Max and John Rose unpacked them and the division took place. It was by then May, and in Baghdad it was 108 in the shade. The heat did not suit John, and he looked terribly ill each day. I was fortunate in that I was not part of the packing squad. I could stay in the house.

Times in Baghdad were gradually worsening politically and though we hoped to return next year, either to move on to another mound or to excavate Arpachiyah a little further, we were already doubtful whether it would be possible. After we left trouble arose over the shipping of the antiquities, and there was great difficulty in getting our cases out. Things were smoothed over at last, but it took many months, and for that reason it was declared inadvisable for us to come out and dig the following year. For some years practically no one excavated in Iraq any longer; everyone went to Syria. And so it was that the following year we too decided to choose a suitable site in Syria.

One last thing I remember which was like a portent of things to come. We had been having tea in Dr Jordan's house in Baghdad. He was a good pianist, and was sitting that day playing us Beethoven. He had a fine head, and I thought, looking at him, what a splendid man he was. He had seemed always gentle and considerate. Then there was a mention by someone, quite casually, of Jews. His face changed; changed in an extraordinary way that I had never noticed on anyone's face before.

He said: 'You do not understand. Our Jews are perhaps different from yours. They are a danger. They should be exterminated. Nothing else will really do but that.'

I stared at him unbelievingly. He meant it. It was the first time I

had come across any hint of what was to come later from Germany. People who had travelled there were, I suppose, already realising it at that time, but for ordinary people, in 1932 and 1933, there was a complete lack of fore-knowledge.

On that day as we sat in Dr Jordan's sitting-room and he played the piano, I saw my first Nazi – and I discovered later that his wife was an even fiercer Nazi than he was. They had a duty to perform there: not only to be Director of Antiquities or even to work for their country, but also to spy on their own German Ambassador. There are things in life that make one truly sad when one can make oneself believe them.

V

We came home to England, flushed with triumph, and Max began a busy summer writing up his account of the campaign. We had an exhibition at the British Museum of some of our finds; and Max's book on Arpachiyah came out either that year or the next – there was to be no time lost in publishing it, Max said: all archaeologists tend to put off publishing for too long, and knowledge ought to be released as soon as possible.

During the Second World War, when I was working in London, I wrote an account of our time in Syria. I called it *Come, Tell Me How You Live*, and I get pleasure in reading it over from time to time, and remembering our days in Syria. One year on a dig is very like another – the same sort of things happen – so repetition would not avail much. They were happy years, we enjoyed ourselves immensely, and had a great measure of success in our digging.

Those years, between 1930 and 1938, were particularly satisfying because they were so free of outside shadows. As the pressure of work, and especially success in work, piles up, one tends to have less and less leisure; But these were carefree years still, filled with a good deal of work, yes, but not as yet all-absorbing. I wrote detective stories, Max wrote archaeological books, reports and articles. We were busy but we were not under intense strain.

Since it was difficult for Max to get down to Devonshire as much as he wanted to, we spent Rosalind's holidays there, but lived most of the time

in London, moving to one or other of my houses, trying to decide which one we liked the best. Carlo and Mary had searched for a suitable house while we were out in Syria one year, and had a listful for me. They said I must certainly go and look at No. 48 Sheffield Terrace. When I saw it I wanted to live there as badly as I had ever wanted to live in any house. It was perfect, except perhaps for the fact that it had a basement. It had not many rooms, but they were all big and well-proportioned. It was just what we needed. As one went in there was a large dining-room on the right. On the left was the drawing-room. On the half-landing there was a bathroom and lavatory, and on the first floor, to the right, over the dining-room, the same-sized room for Max's library – plenty of space for large tables to take the papers and bits of pottery. On the left, over the drawing-room, was a large double bedroom for us. On the floor above were two more big rooms and a small room between them. The small room was to be Rosalind's; the big room over Max's study was to be a double spare-room when we wanted it; and the left-hand room, I declared, I was going to have for *my* own workroom and sitting-room. Everybody was surprised at this, since I had never thought of having such a thing before, but they all agreed that it was quite time for poor old Missus to have a room of her own.

I wanted somewhere where I would not be disturbed. There would not be a telephone in the room. I was going to have a grand piano; large, firm table; a comfortable sofa or·divan; a hard upright chair for typing; and one armchair to recline in, and there was to be *nothing else*. I bought myself a Steinway grand, and I enjoyed 'my room' enormously. Nobody was allowed to use the Hoover on that floor while I was in the house, and short of the house being on fire, I was not to be approached. For once, I had a place of my own, and I continued to enjoy it for the five or six years until the house was bombed in the war. I don't know why I never had anything of the kind again. I suppose I got used to using the dining-room table or the corner of the washstand once more.

48 Sheffield Terrace was a happy house; I felt it the moment I came into it. I think if one has been brought up with large rooms, such as we had at Ashfield, one misses that feeling of space very much. I had lived in several charming small houses – both the Campden Street houses and the little Mews house – but they were never quite right. It is not a question of grandeur; you can have a very smart, tiny flat, or you can rent a large, shabby, country vicarage, rapidly falling to pieces, for much less money. It is the feeling of space round you – of being able to deploy yourself.

Indeed, if you have any cleaning to do yourself it is much easier to clean a large room than to get round all the corners and bits of furniture in a small room, where one's behind is always getting terribly in the way.

Max indulged himself by personally superintending the building of a new chimney in his library. He had dealt with so many fire-places and chimneys in burnt-brick in the Middle East that he rather fancied himself at the job. The builder looked doubtfully at the plans. You never can tell with chimneys or flues, he said, according to all the rules they ought to go right, but they didn't.

'And this one of yours here isn't going to go right, I can tell you that,' he said to Max.

'You build it exactly as I say,' said Max, 'and you'll see.'

Much to Mr Withers' sorrow, he did see. Max's chimney never smoked once. It had a great Assyrian brick with cuneiform writing on it inset over the mantelpiece, and the room was therefore clearly labelled as an archaeologist's private den.

Only one thing disturbed me after moving in to Sheffield Terrace, and that was a pervasive smell in our bedroom. Max couldn't smell it and Bessie thought I was imagining things, but I said firmly that I wasn't: I smelt *gas*. There was no gas in the house, Max pointed out. There was no gas laid on.

'I can't help it,' I said, 'I smell gas.'

I had the builders in, and the gas-men, and they all lay down on their stomachs and sniffed under the bed and told me I was imagining it.

'Of course, what it may turn out to be, if there *is* anything – though I can't smell it, lady,' said the gas-man, 'is a dead mouse, or maybe it's a dead rat. I don't think it's a rat, though, because *I'd* smell if it were – but it might be a mouse. A very *small* mouse.'

'It might, I suppose,' I said. 'If so, it is a very *dead* small mouse, at any rate.'

'We'll have the boards up.'

So they had the boards up, but they couldn't find any dead mouse, large or small. Yet, whether gas or dead mouse, *something* continued to smell.

I went on sending for builders, gas people, plumbers, and everybody I could think of. They looked at me with loathing in the end. Everyone got fed up with me – Max, Rosalind, Carlo – they all said it was 'Mother's imagination'. But Mother knew gas when she smelt it, and she continued to say so. Finally, after I had driven everyone nearly insane, I was

vindicated. There was an obsolete gas pipe under the floor of my bedroom, and gas was continuing to escape from it. Whose meter it was being charged on, nobody knew – there was no gas meter in our house – but there was a disused gas pipe still connected and gas was quietly seeping away. I was so conceited about having been proved right on this point that I was unbearable to live with for some time – and more than ever, I may say, confident in the prowess of my nose.

Before the acquisition of Sheffield Terrace, Max and I had bought a house in the country. We wanted a small house or cottage, because travelling to and from Ashfield for weekends was impracticable. If we could have a country cottage not too far from London, it would make all the difference.

Max's two favourite parts of England were near Stockbridge, where he had stayed as a boy, or else near Oxford. His time at Oxford had been one of the happiest times of his life. He knew all the country round there, and he loved the Thames. So we also went up and down the Thames in our search. We looked at Goring, Wallingford, Pangbourne. Houses were difficult on the Thames, because they were either hideous late Victorian or else the kind of cottage that was completely submerged during the winter.

In the end I saw an advertisement in *The Times*. It was about a week before we were going abroad to Syria one autumn.

'Look, Max,' I said. 'There's a house advertised in Wallingford. You know how much we liked Wallingford? Now, if this should be one of those houses on the river. There was nothing to let when we were there.' We rang up the agent, and dashed down.

It was a delightful, small, Queen Anne house, rather close to the road, but behind it was a garden with a walled kitchen section – bigger than we wanted – and below that again what Max has always thought of as ideal: meadows sweeping right down to the river. It was a pretty bit of river, about a mile out of Wallingford. The house had five bedrooms, three sitting-rooms, and a remarkably nice kitchen. Looking out of the drawing-room window, through the pouring rain, we saw a particularly fine cedar tree, a cedar of Lebanon. It was actually in the field, but the field came right up to a ha-ha near the house, and I thought to myself that we would have a lawn beyond the ha-ha, and would push the meadows further down, so that the cedar tree would be in the middle of the lawn, and on hot days in summer we could have tea under it.

We hadn't much time to dilly-dally. The house was remarkably cheap,

for sale freehold, and we made up our minds then and there. We rang up the agent, signed things, spoke to lawyers and surveyors, and, subject to the usual surveyor's approval, bought the house.

Unfortunately we were not able to see it again for about nine months. We left for Syria, and spent the whole time there wondering whether we had been terribly foolish. We had meant to buy a tiny cottage, instead we had bought this Queen Anne house with gracious windows and good proportions. But Wallingford was a nice place. It had a poor railway service, and was therefore not at all the sort of place people came to, either from Oxford or from London. 'I think,' said Max, 'we are going to be very happy there.'

And sure enough we have been very happy there, for nearly thirty-five years now, I suppose. Max's library has been enlarged to twice its length, and he looks right down the length of it to the river. Winterbrook House, Wallingford, is Max's house, and always has been. Ashfield was my house, and I think Rosalind's.

So our lives went on. Max with his archaeological work and his enthusiasm for it, and I with my writing, which was now becoming more professional and therefore a great deal less enthusiastic.

It had been exciting, to begin with, to be writing books – partly because, as I did not feel I was a real author, it was each time astonishing that I should be able to write books that were actually *published*. Now I wrote books as a matter of course. It was my business to do so. People would not only publish them – they would urge me to get on with writing them. But the eternal longing to do something that is not my proper job, was sure to unsettle me; in fact it would be a dull life if it didn't.

What I wanted to do now was to write something other than a detective story. So, with a rather guilty feeling, I enjoyed myself writing a straight novel called *Giant's Bread*. It was mainly about music, and betrayed here and there that I knew little about the subject from the technical point of view. It was well reviewed and sold reasonably for what was thought to be a 'first novel'. I used the name of Mary Westmacott, and nobody knew that it was written by me. I managed to keep that fact a secret for fifteen years.

I wrote another book under the same pseudonym a year or two later, called *Unfinished Portrait*. Only one person guessed my secret: Nan Watts – now Nan Kon. Nan had a very retentive memory, and some

phrase I had used about some children, and a poem in the first book, attracted her attention. Immediately she said to herself, 'Agatha wrote that, I am certain of it.'

One day she nudged me in the ribs and said in a slightly affected voice: 'I read a book I liked very much the other day; now let me see – what was it ? *Dwarf's Blood* – that's it – *Dwarf's Blood*!' Then she winked at me in the most wicked manner. When I got her home, I said: 'Now – how did you guess about *Giant's Bread*?'

'Of course I knew it was you – I know the way you talk,' said Nan.

I wrote songs from time to time, mostly ballads – but I had no idea that I was going to have the stupendous luck to step straight into an entirely different department of writing, and to do it, too, at an age when fresh adventures are not so easily undertaken.

I think what started me off was annoyance over people adapting my books for the stage in a way I disliked. Although I had written the play *Black Coffee*, I had never thought seriously of play-writing – I had enjoyed writing *Akhnaton*, but had never believed that it would ever be produced. It suddenly occurred to me that if I didn't like the way other people had adapted my books, I should have a shot at adapting them *myself*. It seemed to me that the adaptations of my books to the stage failed mainly because they stuck far too closely to the original book. A detective story is particularly unlike a play, and so is far more difficult to adapt than an ordinary book. It has such an intricate plot, and usually so many characters and false clues, that the thing is bound to become confusing and overladen. What was wanted was *simplification*.

I had written the book *Ten Little Niggers* because it was so difficult to do that the idea had fascinated me. Ten people had to die without it becoming ridiculous or the murderer being obvious. I wrote the book after a tremendous amount of planning, and I was pleased with what I had made of it. It was clear, straightforward, baffling, and yet had a perfectly reasonable explanation; in fact it had to have an epilogue in order to explain it. It was well received and reviewed, but the person who was really pleased with it was myself, for I knew better than any critic how difficult it had been.

Presently I went one step farther. I thought to myself it would be exciting to see if I could make it into a play. At first sight that seemed impossible, because no one would be left to tell the tale, so I would have to alter it to a certain extent. It seemed to me that I could make a perfectly good play of it by one modification of the original story. I must make

two of the characters innocent, to be reunited at the end and come safe out of the ordeal. This would not be contrary to the spirit of the original nursery rhyme, since there is one version of 'Ten Little Nigger Boys' which ends: '*He got married and then there were none*'.

I wrote the play. It did not get much encouragement. 'Impossible to produce' was the verdict. Charles Cochran, however, took an enormous fancy to it. He did his utmost to get it produced, but unfortunately could not persuade his backers to agree with him. They said all the usual things – that it was unproduceable and unplayable, people would only laugh at it, there would be no tension. Cochran said firmly that he disagreed with them – but there it was.

'I hope you have better luck some time with it,' he said, 'because I would like to see that play on.'

In due course I got my chance. The person who was keen on it was Bertie Mayer, who had originally put on *Alibi* with Charles Laughton. Irene Henschell produced the play, and did so remarkably well, I thought. I was interested to see her methods of production, because they were so different from Gerald Du Maurier's. To begin with, she appeared to my inexperienced eye to be fumbling, as though unsure of herself, but as I saw her technique develop I realised how sound it was. At first she, as it were, *felt* her way about the stage, *seeing* the thing, not hearing it; seeing the movements and the lighting, how the whole thing would *look*. Then, almost as an afterthought, she concentrated on the actual script. It was effective, and very impressive. The tension built up well, and her lighting, with three baby spots, of one scene when they are all sitting with candles burning as the lights have failed, worked wonderfully well.

With the play also well acted, you could feel the tension growing up, the fear and distrust that rises between one person and another; and the deaths were so contrived that never, when I have seen it, has there been any suggestion of laughter or of the whole thing being too ridiculously thrillerish. I don't say it is the play or book of mine I like best, or even that I think it is my best, but I do think in some ways that it is a better piece of *craftsmanship* than anything else I have written. I suppose it was *Ten Little Niggers* that set me on the path of being a playwright as well as a writer of books. It was then I decided that in future no one was going to adapt my books except myself: I would choose what books should be adapted, and only those books that were suitable for adapting.

The next one that I tried my hand on, though several years later, was *The Hollow*. It came to me suddenly one day that *The Hollow* would make

a good play. I said so to Rosalind, who has had the valuable role in life of eternally trying to discourage me without success.

'Making a *play* of *The Hollow*, Mother!' said Rosalind in horror. 'It's a good book, and I like it, but you can't *possibly* make it into a play.'

'Yes, I can,' I said, stimulated by opposition.

'Oh, I wish you wouldn't,' said Rosalind, sighing.

Anyway, I enjoyed myself scribbling down ideas for *The Hollow*. It was, of course, in some ways rather more of a novel than a detective story. *The Hollow* was a book I always thought I had ruined by the introduction of Poirot. I had got used to having Poirot in my books, and so naturally he had come into this one, but he was all wrong there. He did his stuff all right, but how much better, I kept thinking, would the book have been without him. So when I came to sketch out the play, out went Poirot.

The Hollow got written, in spite of opposition from others beside Rosalind. Peter Saunders, who has produced so many of my plays since then, was the man who liked it.

When *The Hollow* proved a success, I had the bit between my teeth. Of course I knew that writing books was my steady, solid profession. I could go on inventing my plots and writing my books until I went gaga. I never felt any desperation as to whether I could think of one more book to write.

There is always, of course, that terrible three weeks, or a month, which you have to get through when you are trying to get started on a book. There is no agony like it. You sit in a room, biting pencils, looking at a typewriter, walking about, or casting yourself down on a sofa, feeling you want to cry your head off. Then you go out, you interrupt *someone* who is busy – Max usually, because he is so good-natured – and you say: 'It's awful, Max, do you know I have quite forgotten how to write – I simply can't *do* it any more! I shall never write another book.'

'Oh yes, you will,' Max would say consolingly. He used to say it with some anxiety at first; now his eyes stray back again to his work while he talks soothingly.

'But I know I won't. I can't think of an idea. I had an idea, but now it seems no good.'

'You'll just have to get through this phase. You've had all this before. You said it last year. You said it the year before.'

'It's different this time,' I say, with positive assurance.

But it wasn't different, of course, it was just the same. You forget every time what you felt before when it comes again. Such misery and

despair, such inability to do anything that will be in the least creative. And yet it seems that this particular phase of misery has got to be lived through. It is rather like putting the ferrets in to bring out what you want at the end of the rabbit burrow. Until there has been a lot of subterranean disturbance, until you have spent long hours of utter boredom – you can never feel normal. You can't think of what you want to write, and if you pick up a book you find you are not reading it properly. If you try to do a crossword your mind isn't on the clues; you are possessed by a feeling of paralyzed hopelessness.

Then, for some unknown reason, an inner 'starter' gets you off at the post. You begin to function, you know then that 'it' is coming, the mist is clearing up. You know suddenly, with absolute certitude, *just* what A wants to say to B. You can walk out of the house, down the road, talking to yourself violently, repeating the conversation that Maud, say, is going to have with Aylwin, and exactly where they will be, just where the other man will be watching them from the trees, and how the little dead pheasant on the ground makes Maud think of something that she had forgotten, and so on and so on. And you come home bursting with pleasure; you haven't done anything at all yet, but you are – triumphantly – *there*.

At that moment writing plays seemed to me entrancing, simply because it wasn't my job, because I hadn't got the feeling that I *had* to think of a play – I only had to write the play that I was already thinking of. Plays are much easier to *write* than books, because you can *see* them in your mind's eye, you are not hampered with all that description which clogs you so terribly in a book and stops you getting on with what's happening. The circumscribed limits of the stage simplifies things for you. You don't have to follow the heroine up and down the stairs, or out to the tennis lawn and back, thinking thoughts that have to be described. You have only what can be seen and heard and done to deal with. Looking and listening and feeling is what you have to deal with.

I should always write my one book a year – I was sure of that. Dramatic writing would be my adventure – that would always be, and always must be hit and miss. You can have play after play a success, and then, for no reason, a series of flops. Why? Nobody really knows. I've seen it happen with many playwrights. I have seen a play which to my mind was just as good or better than one of their successes fail – because it did not catch the fancy of the public; or because it was written at the wrong time; or because the cast made such a difference to it. Yes, play-writing was not

a thing I could be sure of. It was a glorious gamble every time, and I liked it that way.

I knew after I had written *The Hollow* that before long I should want to write another play, and if possible, I thought to myself, I was going to write a play that was not adapted from a book. I was going to write a play as a play.

Caledonia had been a great success for Rosalind. It was, I think, one of the most remarkable schools that I have known. All its teachers seemed the best of their kind. They certainly brought out the best in Rosalind. She was the head of the school at the end, though, as she pointed out to me, this was unfair, because there was a Chinese girl there who was much cleverer than she was. 'And I know what they think – they think it ought to be an English girl who is head of the school.' I expect she was right too.

From Caledonia Rosalind went to Benenden. She was bored by it from the start. I don't know why – it was by all accounts a very good school. She was not interested in learning for its own sake – there was nothing of the scholar about her. She cared least of all for the subjects I would have been interested in, such as history, but she was good at mathematics. When I was in Syria I used to get letters from her urging me to let her leave Benenden. 'I really can't stick another year of this place,' she wrote. However, I felt that having embarked on a school career she must at least terminate it in the proper way, so I wrote back to her and said that, once she had passed her School Certificate – she could leave Benenden and proceed to some other form of education.

Miss Sheldon, Rosalind's headmistress, had written to me and said that, though Rosalind was anxious to take her School Certificate next term, she did not think she would have any chance of passing it, but that there was no reason why she should not try. Miss Sheldon was proved wrong, however, because Rosalind passed her School Certificate with ease. I had to think up a next step for a daughter of barely fifteen.

Going abroad was what we both agreed on. Max and I went on what I found an intensely worrying mission to inspect various scholastic establishments: a family in Paris, a few carefully nurtured girls in Evian, at least three highly recommended educators in Lausanne, and an establishment in Gstaad, where the girls would get skiing and other winter sports. I was bad at interviewing people. The moment I sat down I became tongue-tied. What I *felt* was: 'Shall I send my daughter to you or not?

How can I find out what you are really *like*? How on earth can I find out if *she* would like being with *you*? And anyway, what's it all about?' Instead, I used to stammer and say 'er – er' – and ask what I could hear were thoroughly idiotic questions.

After much family consultation, we decided on Mademoiselle Tsch-umi's Pension at Gstaad. It proved a fiasco. I seemed to get letters from Rosalind twice a week; 'This place is awful, Mother, absolutely *awful*. The girls here – you've no idea what they are like! They wear *snoods* – that will show you?'

It *didn't* show me. I didn't see why girls shouldn't wear snoods, and I didn't know what snoods were anyway.

'We walk about two by two – two by two – fancy! At *our* age! And we're never even allowed in the village for a second to buy anything at a shop. It's awful! Absolute imprisonment! They don't teach us anything either. And as for those bathrooms you talk about, it's an absolute swizzle! They're never used. None of us has ever had a bath *once*! There isn't even any hot water laid on yet! And for skiing, of course, it's far too far down. There may be a bit in February, but I don't believe they will ever take us there even then.'

We rescued Rosalind from her durance and sent her first to a pension at Château d'Oex and then to a pleasantly old-fashioned family in Paris. On our way back from Syria we picked her up in Paris, and said we hoped she now spoke French. 'More or less,' said Rosalind, careful not to allow us to hear her speak a word. Then it occurred to her that the taxi-driver taking us from the Gare de Lyon to Madame Laurent's house was following an unnecessarily devious route. Rosalind flung down the window, stuck out her head, and addressed him in vivid and idiomatic French, asking him why on earth he thought he was taking those particular streets and telling him what streets he ought to take. He was vanquished at once, and I was delighted to find out what otherwise I might have had some difficulty in establishing: *that Rosalind could speak French.*

Madame Laurent and I had amicable conversations. She assured me that Rosalind had comported herself extremely well, had behaved always *très comme il faut* – but, she said, 'Madame, *elle est d'une froideur – mais d'une froideur excessive! C'est peut-être le phlegme brittanique.*'

I said hurriedly that I was quite sure that it was *le phlegme britannique*. Again Madame Laurent assured me that she had tried to be like a mother to Rosalind. '*Mais cette froideur – cette froideur anglaise!*'

Madame Laurent sighed with the memory of the rejection of her demonstrative heart.

Rosalind still had six months, or possibly a year, of education to put in. She passed it with a family near Munich learning German. Next came a London season.

At this she was a decided success, was called one of the best looking debutantes of her year, and had plenty of fun. I think, myself, that it did her a great deal of good, and gave her self-confidence and nice manners. It also cured her of any mad wish to continue the social racket indefinitely. She said she had enjoyed the experience, but had no intention of doing any more of that silly kind of thing.

I raised the subject of a job with Rosalind and her great friend, Susan North.

'You've got to choose something to do,' I said to Rosalind dictatorially. 'I don't care what it is. Why don't you train as a *masseuse*? That would be useful later in life. Or I suppose you could go and arrange flowers.'

'Oh, everybody is doing that,' said Susan.

Finally, the girls came to me and said they thought they would like to take up photography. I was overjoyed; I had been wishing to study photography myself. I had been doing most of the photography on the dig, and I thought it would be useful for me to have some lessons in studio photography, about which I knew little. So many of our objects had to be photographed in the open, and not in studio conditions, and since some of them would remain in Syria it was important that we should have the best photographs of them possible. I enlarged enthusiastically on the subject and the girls went into fits of laughter.

'We don't mean what *you* mean,' they said. 'We don't mean photography *classes*, at all.'

'What do you mean?' I asked, bewildered.

'Oh, being photographed in bathing-dresses and things, for advertisements.'

I was horribly shocked, and showed it.

'You are *not* going to be photographed for advertisements for bathing-dresses,' I said. 'I won't hear of anything like that.'

'Mother is so terribly old-fashioned,' said Rosalind, with a sigh. 'Lots of girls are photographed for advertisements. They are terribly jealous of each other.'

'And we do know some photographers,' Susan said. 'I think we could persuade one of them to do one of us for soap.'

I continued to veto the project. In the end Rosalind said she would think about photography classes. After all, she said, she could do model photography classes – it needn't be for bathing-dresses. 'It could be real clothes, buttoned up to the neck, if you like!'

So I went off one day to the Reinhardt School of Commercial Photography, and I became so interested that when I came home I had to confess that I had booked *myself* for a course of photography and not *them*. They roared with laughter. 'Mother's got caught by it, instead of us!' said Rosalind.

'Oh, you poor dear, you will be so tired,' said Susan. And tired I was! After the first day running up and down stone flights of stairs, developing and retaking my particular subject, I was worn out.

The Reinhardt School of Photography had many different departments, including one on commercial photography, and one of my courses was in this. There was a passion at that time for making everything look as unlike itself as possible. You would place six tablespoons on a table, then climb on a stepladder, hang over the top of it, and achieve some fore-shortened view or out of focus effect. There was also a tendency to photograph an object not in the middle of the plate but somewhere in the left-hand corner, or running off it, or a face that was only a portion of a face. It was all very much the latest thing. I took a beechwood sculptured head to the School, and did various experiments in photographing that, using all kinds of filters – red, green, yellow – and seeing the extraordinarily different effects you could get using various cameras with the various filters.

The person who did not share my enthusiasm was the wretched Max. He wanted his photography to be the opposite of what I was now doing. Things had to look exactly what they were, with as much detail as possible, exact perspective, and so on.

'Don't you think this necklace looks rather *dull* like that?' I would say.

'No, I don't,' said Max. 'The way you've got it, it's all blurred and twisted.'

'But it looks so exciting that way!'

'I don't want it to look exciting,' said Max. 'I want it to look like what it is. And you haven't put a scale rod in.'

'It ruins the artistic aspect of a photograph if you have to have a scale rod. It looks awful.'

'You've got to show what size it is,' said Max. 'It is most important.'

'You can put it underneath, can't you, in the caption?'

'It's not the same thing. You want to see exactly the scale.'

I sighed. I could see I had been betrayed by my artistic fancies into straying from what I had promised to do, so I got my instructor to give me extra lessons on photographing things in exact perspective. He was rather bored at having to do this, and disapproving of the results. However, it was going to be useful to me.

I had learnt one thing at least: there was no such thing as taking a photograph of something, and later taking another one because that one didn't come out well. Nobody at the Reinhardt School ever took less than ten negatives of *any* subject; a great many of them took twenty. It was singularly exhausting, and I used to come home so weary that I wished I had never started. However, that had gone by the next morning.

Rosalind came out to Syria one year, and I think enjoyed being on our dig. Max got her to do some of the drawings. Actually she draws exceptionally well, and she made a good job of it, but the trouble with Rosalind is that, unlike her slap-happy mother, she is a perfectionist. Unless she could get a thing perfectly as she wanted it, she would immediately tear it up. She did a series of these drawings, and then said to Max: 'They are no good really – I shall tear them up.'

'You are not to tear them up,' said Max.

'I shall tear them up,' said Rosalind.

They then had an enormous fight, Rosalind trembling with rage, Max also really angry. The drawings of the painted pots were salvaged, and appeared in Max's book of Tell Brak – but Rosalind never professed herself satisfied with them.

Horses were procured from the Sheikh, and Rosalind went riding, accompanied by Guilford Bell, the young architect nephew of my Australian friend, Aileen Bell. He was a very dear boy and he did some extraordinarily lovely pencil drawings of our amulets at Brak. They were beautiful little things – frogs, lions, rams, bulls – and the delicate shading of his pencil drawings made a perfect medium for them.

That summer Guilford came to stay with us at Torquay, and one day we saw that a house was up for sale that I had known when I was young – Greenway House, on the Dart, a house that my mother had always said, and I had thought also, was the most perfect of the various properties on the Dart.

'Let's go and look at it,' I said. 'It would be lovely to see it again. I haven't seen it since I went there calling with Mother when I was a child.'

So we went over to Greenway, and very beautiful the house and grounds
were. A white Georgian house of about 1780 or 90, with woods sweeping
down to the Dart below, and a lot of fine shrubs and trees – the ideal
house, a dream house. Since we had an order to view, I asked its price,
though without much interest. I didn't think I had heard the answer
correctly.

'*Sixteen* thousand, did you say?'

'Six thousand.'

'Six thousand?' I could hardly believe it. We drove home talking
about it. 'It's incredibly cheap,' I said. 'It's got thirty-three acres. It
doesn't look in bad condition either; wants decorating, that's all.'

'Why don't you buy it?' asked Max.

I was so startled, this coming from Max, that it took my breath away.

'You've been getting worried about Ashfield, you know,'

I knew what he meant. Ashfield, my home, had changed. Where our
neighbours' houses had once been ringed round us – other villas of the
same kind – there was now, blocking the view in the narrowest part of the
garden, a large secondary school, which stood between us and the sea. All
day there were noisy shouting children. On the other side of us there was
now a mental nursing home. Sometimes queer sounds would come from
there, and patients would appear suddenly in the garden. They were not
certified, so I presume they were free to do as they liked, but we had had
some unpleasant incidents. A brawny colonel in pyjamas appeared, waving
a golf-club, determined he was going to kill all the moles in the garden;
another day he came to attack a dog who had barked. The nurses apolo-
gised, fetched him back, and said he was quite all right, just a little
'disturbed', but it was alarming, and once or twice children staying with
us had been badly frightened.

Once it had been all countryside out of Torquay: three villas up the
hill and then the road petered out into country. The lush green fields
where I used to go to look at the lambs in spring had given way to a mass of
small houses. No one we knew lived in our road any longer. It was as
though Ashfield had become a parody of itself.

Still, that was hardly a reason for buying Greenway House. Yet, how it
appealed to me. I had known always that Max did not really like Ashfield.
He had never told me so – but I knew it. I think in some way he was
jealous of it because it was a part of my life that I hadn't shared with
him – it was all my own. And he had said, unprompted, of Greenway,
'*Why don't you buy it?*'

And so we made inquiries. Guilford helped us. He looked over the house professionally, and said: 'Well, I'll give you *my* advice. Pull half of it down.'

'Pull half of it down!'

'Yes. You see, the whole of that back wing is Victorian. You could leave the 1790 house and take away all that addition – the billiard room, the study, the estate room, those bedrooms and new bathrooms upstairs. It would be a far better house, far lighter. The original is a very beautiful house, as a matter of fact.'

'We shan't have any bathrooms left if we pull the Victorian ones down,' I pointed out.

'Well, you can easily make bathrooms on the top floor. Another thing, too; it would bring your rates down by quite a lot.'

And so we bought Greenway. We put Guilford in charge, and he redesigned the house on its original lines. We added bathrooms upstairs, and downstairs we affixed a small cloakroom, but the rest of it we left untouched. I only wish now that I had had the gift of foresight – if so I would have taken off *another* large chunk of the house: the vast larder, the great caverns in which you soaked pigs, the kindling store, the suite of sculleries. Instead I would have put on a nice, small kitchen from which I could go to the dining-room in a few steps, and which would be easy to run with no help. But it would never have occurred to me that a day would come when there was no domestic help. So we left the kitchen wing as it was. When the alterations were all done, and the house decorated plainly in white, we moved in.

Just after we had done so, and were exulting in it, the second war came. It was not quite so much out-of-the-blue as in 1914. We had had warnings: there had been Munich; but we had listened to Chamberlain's reassurances, and we had thought then that when he said, 'Peace in our time', it might be the truth.

But Peace in our time was not to be.

PART X

THE SECOND WAR

I

And so we were back again in wartime. It was not a war like the last one. One expected it to be, because I suppose one always does expect things to repeat themselves. The first war came with a shock of incomprehension, as something unheard of, impossible, something that had never happened in living memory, that never would happen. This war was different.

At first, there was an almost incredulous surprise that nothing happened. One expected to hear that London was bombed that first night. London was not bombed.

I think everyone was trying to ring up everyone else. Peggy MacLeod, my doctor friend from Mosul days, rang up from the east coast, where she and her husband practised, to ask if I would have their children. She said: 'We are so frightened here – this is where it will all start, they say. If you can have the children, I'll start off in the car to bring them down to you.' I said that would be quite all right: she could bring them and the nurse too if she liked; so that was settled.

Peggy MacLeod arrived next day, having motored day and night across England with Crystal, my godchild, who was three years old, and David, who was five. Peggy was worn out. 'I don't know what I would have done without benzedrine,' she said. 'Look here, I've got an extra thing of it here. I had better give it to you. It may be useful to you some time when you are absolutely exhausted.' I have still got that small flat tin of benzedrine: I have never used it. I have kept it, perhaps as an insurance against the moment when I *should* be utterly exhausted.

We got organised, more or less, and there we sat, waiting for something

to happen. But since nothing did happen, little by little we went on with our own pursuits and some additional war activities.

Max joined the Home Guard, which was really like a comic opera at that time. There were hardly any guns – one between eight men, I think. Max used to go out with them every night. Some of the men enjoyed themselves very much – and some of the wives were deeply suspicious as to what their husbands were doing under this pretence of guarding the country. Indeed, as months passed and nothing happened, it became an uproarious and cheerful gathering. In the end, Max decided to go to London. Like everybody else, he was clamouring to be sent abroad, to be given some work to do – but all anyone seemed to want to do was to say: 'Nothing could be done at the present' – 'Nobody was wanted.'

I went to the hospital at Torquay and asked if they would let me work in the dispensary there to freshen up my knowledge in case I should be useful to them later. Since casualty cases were expected all the time, the chief dispenser there was quite willing to have me. She brought me up to date with the various medicines and things that were prescribed nowadays. On the whole it was much simpler than it had been in my young days, there were so many pills, tablets, powders and things already prepared in bottles.

The war started, when it did start, not in London or on the east coast, but down in our part of the world. David MacLeod, a most intelligent boy, was crazy about aeroplanes, and did a great deal towards teaching me the various types. He showed me pictures of Messerschmitts and others, and pointed out Hurricanes and Spitfires in the sky.

'Now have you got it right, this time?' he would say anxiously. 'You see what *that* is up there?'

It was so far away it was only a speck, but I said hopefully it was a Hurricane.

'No,' said David, disgusted. 'You make a mistake every time. That is a Spitfire.'

On the following day he remarked, looking up at the sky, 'That is a Messerschmitt coming over now.'

'No, no, dear,' I said, 'it isn't a Messerschmitt. It's one of ours – it's a Hurricane.'

'It's not a Hurricane.'

'Well it's a Spitfire, then.'

'It is not a Spitfire, it's a Messerschmitt. Can't you *tell* a Hurricane or a Spitfire from a Messerschmitt?'

'But it can't be a Messerschmitt,' I said. At that moment two bombs dropped on the hillside.

David looked very like weeping. 'I told you it was a Messerschmitt,' he said, in a voice of lament.

That same afternoon, when the children were going across the ferry in the boat with nurse, a plane swooped down and machine-gunned all the craft on the river. Bullets had gone all round nurse and the children, and she came back somewhat shaken. 'I think you had better ring up Mrs MacLeod,' she said. So I did ring up Peggy, and we wondered what to do.

'Nothing has happened here,' said Peggy. 'I suppose it *may* start any time. I don't think they ought to come back here do you?'

'Perhaps there won't be any more,' I said.

David had been excited over the bombs, and insisted on going to see where they had fallen. Two had fallen in Dittisham by the river, and some others up on the hill behind us. We found one of these by scrambling through a lot of nettles and a hedge or two, and finally came upon three farmers, all looking at a bomb crater in the field, and at another bomb which appeared to have dropped without exploding.

'Dang it all,' said one farmer, administering a hearty kick to the unexploded bomb, 'regular nasty it is, I call it, sending those things down – nasty!

He kicked it again. It seemed to me it would be much better if he did not kick it, but he obviously wished to show his contempt for all the works of Hitler.

'Can't even explode properly,' he said with disparagement.

They were, of course, all very small bombs, compared to what we were to get later in the war – but there it was: hostilities *had* begun. Next day there was news from Cornworthy, a little village further up the Dart: a plane there had swooped down and sprayed the school playground when the children were out at play. One of the mistresses had been hit in the shoulder.

Peggy rang me again, and said she had arranged for the children to go to Colwyn Bay, where their grandmother lived. It seemed to be peaceful there, at any rate.

The children departed, and I was terribly sorry to lose them. Soon afterwards a Mrs Arbuthnot wrote to me and wanted me to let the house to her. Now that the bombing had started, children were being evacuated to various parts of England. She wished to have Greenway for a nursery for children evacuated from St. Pancras.

The war seemed to have shifted from our part of the world; there was

no more bombing; and in due course Mr and Mrs Arbuthnot arrived, took over my butler and his wife, and established two hospital nurses and ten children under five. I had decided that I would go to London and join Max, who was working there on Turkish Relief.

I arrived in London, just after the raids, and Max, having met me at Paddington, drove me to a flat in Half Moon Street. 'I'm afraid,' he said apologetically, 'it is a pretty nasty one. We can look around for something else.'

What slightly put me off, when I arrived, was the fact that the house in question stood up like a tooth – the houses on either side of it were missing. They had apparently been hit by a bomb about ten days before, and for that reason the flat was available for rent, its owners having cleared out quickly. I can't say I felt very comfortable in that house. It smelt horribly of dirt and grease and cheap scent.

Max and I moved after a week into Park Place, off St. James's Street, which had once been rather an expensive service flat. We lived there for some little time, with noisy sessions of bombs going off all round us. I was particularly sorry for the waiters, who had to serve meals in the evening and then take themselves home through the air raids.

Presently our tenants in Sheffield Terrace asked if they could give up the lease of our house, so we moved back in.

Rosalind had filled in forms for the Womens' Auxiliary Air Force, but she was not particularly enthusiastic about it, and thought on the whole that she would prefer to go as a landgirl.

She went for an interview with the W.A.A.F. and showed herself lamentably lacking in tact. When asked why she wanted to join she merely said: 'Because one must do something and this will do as well as anything else.' That, though candid, was not, I think, well received. A little later, after a brief period delivering school meals and doing work in a military office somewhere, she said she thought she might as well join the A.T.S. They weren't, she said, as bossy as the W.A.A.F. She filled up a fresh set of papers.

Then Max, to his great joy, got into the Air Force, helped by our friend Stephen Glanville, who was a Professor of Egyptology. He and Max were both at the Air Ministry, where they shared a room, both of them smoking – Max a pipe – without ceasing. The atmosphere was such that it was called by all their friends 'the small cat-house'.

Events happened in confusing order. I remember that Sheffield Terrace

was bombed on a weekend when we were away from London. A land-mine came down exactly opposite it, on the other side of the street, and completely destroyed three houses. The effect it had on 48 Sheffield Terrace was to blow up the basement, which might have been presumed the safest place, and to damage the roof and the top floor, leaving the ground and first floors almost unharmed. My Steinway was never quite the same afterwards.

Since Max and I had always slept in our own bedroom, and never went down to the basement, we should not have suffered any personal damage even if we had been in the house. I myself never went down to any shelter during the war. I always had a horror of being trapped underground – so I slept in my own bed no matter where I was. I became used in the end to raids on London – so much so, that I hardly woke up. I would think, half drowsily, that I heard the siren, or bombs not too far away.

'Oh dear, there they are again!' I would mutter, and turn over.

One of the difficulties with the bombing of Sheffield Terrace was that by this time it was difficult to get storage space anywhere in London. As the house now was, it was difficult to get into it through the front door and one could only get access to it by ladder. In the end, I prevailed upon a firm to move me, and hit upon the idea of storing the furniture at Wallingford, in the squash court which we had built a year or two previously. So everything was moved down there. I had builders in attendance ready to take out the squash court door and its framework if necessary – and this they had to do because the sofa and chairs would not go through the narrow doorway.

Max and I moved to a block of flats in Hampstead – Lawn Road Flats – and I started work at University College Hospital as a dispenser.

When Max broke to me what he had already known, I think, for some time, that he would have to go abroad to the Middle East, probably North Africa or Egypt, I was glad for him. I knew how he had been fretting to go, and it seemed right, too, that his knowledge of Arabic should be used. It was our first parting for ten years.

Lawn Road Flats was a good place to be since Max had to be away. They were kindly people there. There was also a small restaurant, with an informal and happy atmosphere. Outside my bedroom window, which was on the second floor, a bank ran along behind the flats planted with trees and shrubs. Exactly opposite my window was a big, white, double cherry-tree which came to a great pyramidal point. The effect of the

bank was much like that in the second act of Barrie's *Dear Brutus*, when they turn to the window and find that Lob's wood has come right up to the window-panes. The cherry-tree was especially welcome. It was one of the things in spring that cheered me every morning when I woke.

There was a little garden at one end of the flats, and on summer evenings one could have meals out there, or sit out. Hampstead Heath, too, was only about ten minutes' walk away, and I used to go there and take Carlo's James for walks. I had the Sealyham with me because Carlo was now working in a munition factory and unable to have him there. They were very good to me at University College Hospital: they let me bring him to the dispensary. James behaved impeccably. He laid his white sausage-like body out under the shelves of bottles and remained there, occasionally accepting kind attentions from the charwoman when she was cleaning.

Rosalind had successfully not been accepted for the W.A.A.F. and various other kinds of war work, without settling, as far as I could see, to anything in particular. With a view to joining the A.T.S. she filled up a large number of forms with dates, places, names, and all the unnecessary information officialdom has to have. Then she suddenly remarked: 'I tore up all those forms this morning. I am not going to join the A.T.S. after all.'

'Really, Rosalind!' I said severely. 'You must make up your mind about things. I don't care what you do – do exactly the sort of thing you fancy – but don't keep starting to do things, then tearing forms up and changing your mind.'

'Well, I've thought of something better to do,' said Rosalind. She added, with the extreme reluctance that all young people of her generation seem to have in imparting any information to their parents: 'As a matter of fact, I am going to marry Hubert Prichard next Tuesday.'

This was not completely a surprise, except for the fact that the date was fixed for Tuesday of the following week.

Hubert Prichard was a Major in the regular Army, a Welshman; Rosalind had met him at my sister's, where he had come originally as a friend of my nephew Jack. He had been down once to stay with us at Greenway, and I liked him very much. He was quiet, dark, extremely intelligent, and owned a number of greyhounds. He and Rosalind had been friends for some time now, but I had rather given up the idea that anything was coming of it.

'I suppose,' said Rosalind, 'I suppose *you* want to come to the wedding, Mother?'

'Of course I want to come to the wedding,' I said.

'I supposed you would . . . But really it is a quite unnecessary fuss, *I* think. I mean, don't you think it would really be simpler for you and less tiring if you didn't? We'll have to get married up at Denbigh, you know, because he can't get leave.'

'That's all right,' I assured her. 'I'll come to Denbigh.'

'You are sure you really want to?' said Rosalind, as a last hope.

'Yes,' I said firmly. Then I said: 'I'm rather surprised that you told me you were going to get married, instead of announcing it afterwards.'

Rosalind blushed, and I saw I had touched upon the truth.

'I suppose,' I said, 'Hubert made you tell me.'

'Well – well, yes,' said Rosalind, 'in a way. He said, too, that I am under twenty-one still.'

'All right,' I said, 'you had better resign yourself to my being there.'

There was something oyster-like about Rosalind that always made one laugh, and I couldn't help laughing now.

I travelled with Rosalind to Denbigh by train. Hubert came and picked her up at the hotel in the morning. He had one of his brother officers with him, and we went to the Registrar's office, where the ceremony was performed, with the minimum of *fuss*! The only hitch in the whole proceedings was that the aged Registrar flatly refused to believe that Rosalind's father's name and title were correctly styled: 'Colonel Archibald Christie, C.M.G., D.S.O., R.F.C.'

'If he was in the Air Force, he can't be a Colonel,' said the Registrar.

'But he is,' said Rosalind, 'that is his proper rank and title.'

'He must be a Wing-Commander,' said the Registrar.

'No, he is *not* a Wing-Commander.' Rosalind did her best to explain that twenty years ago the Royal Air Force had not yet come into being. The Registrar continued to say that he had never heard of it, so I added my testimony to Rosalind's, and finally he grudgingly wrote it down.

II

So time went on, now not so much like a nightmare as something that had been always going on, had *always* been there. It had become, in fact, natural to expect that you yourself might be killed soon, that the people you loved best might be killed, that you would hear of deaths of friends. Broken windows, bombs, land-mines, and in due course flying-bombs and rockets – all these things would go on, not as something extraordinary, but as perfectly natural. After three years of war, they were an everyday happening. You could not really envisage a time when there would not be a war any more.

I had plenty to keep me occupied. I worked two whole days, three half-days, and alternate Saturday mornings at the Hospital. The rest of the time I wrote.

I had decided to write two books at once, since one of the difficulties of writing a book is that it suddenly goes stale on you. Then you have to put it by, and do other things – but I had no other things to do. I had no wish to sit and brood. I believed that if I wrote two books, and alternated the writing of them, it would keep me fresh at the task. One was *The Body in the Library*, which I had been thinking of writing for some time, and the other one was *N or M?*, a spy story, which was in a way a continuation of the second book of mine, *The Secret Adversary*, featuring Tommy and Tuppence. Now with a grown-up son and daughter, Tommy and Tuppence were bored by finding that nobody wanted them in wartime. However, they made a splendid come-back as a middle-aged pair, and tracked down spies with all their old enthusiasm.

I never found any difficulty in writing during the war, as some people did; I suppose because I cut myself off into a different compartment of my mind. I could live in the book amongst the people I was writing about, and mutter their conversations and see them striding about the room I had invented for them.

Once or twice I went down to stay with Francis Sullivan, the actor, and his wife. They had a house at Haslemere, with Spanish chestnut woods all round it.

I always found it restful to stay with actors in wartime, because to

them, acting and the theatrical world were the *real* world, any other world
was not. The war to them was a long drawn-out nightmare that prevented
them from going on with their own lives, in the proper way, so their entire
talk was of theatrical people, theatrical things, what was going on in the
theatrical world, who was going into E.N.S.A. – it was wonderfully
refreshing.

Then I would be back again in Lawn Road, my face covered with a
pillow as a protection against flying glass, and on a chair by my side,
my two most precious possessions: my fur coat, and my hot-water-bottle –
a rubber hot-water-bottle, something at that time quite irreplaceable.
Thus I was ready for all emergencies.

Then something unexpected happened. I opened a letter and found it
was a notification that the Admiralty were preparing to take over Green-
way, practically at a moment's notice.

I went down there, and met a polite young naval lieutenant. He could
give me hardly any time at all, he said. He had been unimpressed by the
plight of Mrs Arbuthnot, who, having first tried to fight against the order,
was now pleading for time to confer with the Ministry of Health as to
where to move her nursery. The Ministry of Health cut no ice at all
when it came into opposition with the Admiralty. They all moved out,
and there I was left, with a household of furniture to move! The trouble
was that there was nowhere to move it to. Again, no removal or storage
firm anywhere had any room: every warehouse was already full to the
ceiling. Finally, I got on to the Admiralty and they agreed that I should
have the use of the drawing-room, in which all the furniture could be
stored, and also one small room on the top floor.

While the work of furniture-moving was in progress Hannaford, the
gardener, who was a faithful old rogue, devoted to anyone he had served
for long enough, took me aside and said, 'You look now what I've saved
for you from Her.' I had no idea who Her might be, but I accompanied
him to the clock tower above the stables. There, leading me through a
kind of secret door, he showed me with great pride an enormous quantity
of onions on the floor, covered with straw, and also a mass of apples.

'Come to me afore she went, she did, and said, were there any onions
and apples, because as she'd take 'em with her, but I wasn't going to let
Her have them – no fear, I wasn't. Said most of the crop had failed, and
I just gave her enough as was good for her. Why, they apples were grown
here, and so were those onions – she's not going to have 'em, take them
away to the Midlands or the East Coast or wherever she's going.'

I was touched by Hannaford's feudal spirit, though nothing could have been more embarrassing. I would a thousand times rather Mrs Arbuthnot had taken away all the apples and onions; now they were landed on my hands, with Hannaford wagging his tail like a dog who has retrieved something you don't want from the river.

We packed up cases of apples, and I sent them to relations who had children and might like them. I could not face returning to Lawn Road with two hundred odd onions. I tried to wish them on to various hospitals, but there were far too many onions for anyone to want.

Though our Admiralty was conducting the negotiations, it would be the United States Navy which would take over Greenway. Maypool, the big house above us on the hill, was to accommodate the ratings, and the officers of the flotilla were to take over our house.

I cannot speak too highly of the kindness of the Americans, and the care they took of our house. It was inevitable, of course, that the kitchen quarters should be more or less a shambles – they had to cook for about forty people, and they put in some ghastly great smoky stoves – but they were very careful with our mahogany doors; in fact the Commander had them all walled up in ply-wood. They appreciated the beauty of the place too. A good many of this particular flotilla came from Louisiana, and the big magnolias, and especially the *magnolia grandiflora*, made them feel at home.

Ever since the war, relations of some officer or other who was at Greenway have come along to see where their son or cousin or whoever it was had been stationed. They have told me how he wrote about it and how he had described the place. I have been round the garden with them sometimes, trying to identify certain parts of it he had particularly loved, though it is not always easy because of the way things have grown up.

By the third year of the war of all my various houses none was available to me at the moment I wanted it. Greenway was taken by the Admiralty; Wallingford was full of evacuees, and as soon as they went back to London, some other friends of ours – an elderly invalid and his wife – rented Wallingford from me, and their daughter and her child joined them there. 48 Campden Street I had sold at an excellent profit. Carlo, had shown the people over it. 'I won't take less than £3,500 for it,' I had said to her. It seemed a lot to us at that time. Carlo came back rather pleased with herself. 'I've made them pay an extra £500,' she said. 'I thought they deserved to.'

'What do you mean, deserved to?'

'They were rude,' said Carlo, who had a real Scottish dislike of what she called insolence.

'They said disparaging things about it in front of me, which they shouldn't have done. They said *"What hideous decorations! All this flowered wallpaper – I'll soon change that!" "How extraordinary some people are – fancy taking that partition wall down!"* So I thought,' said Carlo, 'they had better have a lesson – and I put up the price £500.' Apparently they had paid without a qualm.

I have a war memorial of my own at Greenway. In the library, which was their mess-room, an artist has done a fresco round the top of the walls. It depicts all the places where that flotilla went, starting at Key West, Bermuda, Nassau, Morocco, and so on, finally ending with a slightly glorified exaggeration of the woods of Greenway and the white house showing through the trees. Beyond that again is an exquisite nymph, not quite finished – a pin-up girl in the nude – which I have always supposed to represent the hopes of houris at journey's end when the war was at last over. The Commander wrote and asked me if I would like this fresco painted out and the wall put back as it was. I hurriedly replied it would be an historic memorial, and that I was delighted to have it. Over the mantelpiece were sketched out roughly the heads of Winston Churchill, Stalin and President Roosevelt. I wish I knew the name of the artist.

When I left Greenway I felt sure that it would be bombed and that I would never see it again, but, luckily, all my presentiments were wrong. Greenway was untouched. Fourteen lavatories were added, instead of the larder, and I had to fight the Admiralty to take them away again.

III

My grandson Mathew was born in Cheshire, on Sept 21, 1943, at a nursing home close by my sister's house. Punkie, devoted to Rosalind as she always had been, was delighted that she should come back for the baby to be born. My sister was the most indefatigable woman I have ever known; a kind of human dynamo. Since her father-in-law's death, she and James had come to live in Abney, which, as I have already mentioned, was an enormous house, with fourteen bedrooms, masses of sitting-rooms, and in my young days, when I first went to stay there, sixteen indoor

servants. Now there was nobody in the house except my sister and a former kitchen-maid, since married, who came in and cooked the meals every day.

When I stayed there, I would hear my sister moving around at about half-past five any morning. She did the whole house then – dusted it, tidied it, swept it, did the fires, cleaned brass, and polished furniture, and then started calling people with early tea. After breakfast she cleaned the baths, then finished up the bedrooms. By half-past ten there was no more housework to do, so she then rushed into the kitchen garden – which was filled with new potatoes, rows of peas, French beans, broad beans, asparagus, little carrots, and all the rest of it. A weed never dared lift its head in Punkie's kitchen garden. The rosebeds and beds around the house never had a weed either.

She had taken on a chow dog whose officer master had been unable to look after it, and the chow always slept in the billiard room. One morning, when she came down and looked into the billiard room, she saw the chow sitting quietly in his basket, but the main part of the floor had an enormous bomb nestling cosily in it. The night before there had been a lot of incendiaries on the roof, and everybody had been up there helping to put them out. This particular bomb had come down into the billiard room, unheard among the general din, and had not exploded.

My sister rang up the disposal people, who rushed along. After examining it, they said everybody must be out of there in twenty minutes.

'Just take anything essential.'

'And what do you think I took?' asked my sister, 'Really one is *quite* mad when one gets rattled.'

'Well, what *did* you take?' I asked.

'Well, first I took Nigel and Ronnie's personal things' – those were her two billeted officers at that time – 'because I thought it would be so awful if anything happened to them. And I took my toothbrush and washing things, of course – and then I couldn't think of anything else to take. I looked all over the house, but my brain went blank. So for some reason I took that great bouquet of wax flowers in the drawing-room.'

'I never knew you were particularly fond of that,' I said.

'But I'm not,' said Punkie, 'that's the curious part of it.'

'Didn't you take your jewellery or a fur-coat?'

'Never thought of it,' she said.

The bomb was taken away and duly exploded, and fortunately no more incidents of that kind occurred.

In due course I got a telegram from Punkie and rushed up there, to find Rosalind looking very proud of herself in a nursing-home and inclined to be boastful of her baby's strength and size.

'He's a monster,' she said with a face of delight. 'A terrifically big baby – a real monster!'

I looked at the monster. He was looking well and happy, with a crinkled-up face and a slight grin which was probably wind but looked like amiability.

'You see?' said Rosalind; 'I forget what length they told me he was – but he's a monster!'

So there the monster was, and everybody was happy. And when Hubert and his faithful batman Barry came to see the baby, there was indeed jubilation. Hubert was as pleased as Punch, and so was Rosalind.

It had been arranged that Rosalind would go to live in Wales after the baby was born. Hubert's father had died in December, 1942, and his mother was moving to a smaller house nearby. Now the plans went ahead. Rosalind was to remain in Cheshire for three weeks after the birth, then a nurse, who was 'between babies' as she put it, would be with her to look after her and the baby while she settled in Wales. There I also would assist her, as soon as things were ready for her to go.

Nothing, of course, was easy in wartime. Rosalind and the nurse came to London, and I put them in 47 Campden Street. Since Rosalind was still slightly weak, I used to come over from Hampstead and cook dinner for them in the evening. To begin with I did breakfast in the morning as well, but Nurse, once she was sure that her status as a hospital-nurse-who-did-no-work-in-the-house was not assailed, declared herself willing to deal with breakfast herself. Unfortunately, though, the bombs were getting worse again. Night after night, it seemed, we sat there anxiously. When the alarm went off we pushed Mathew in his carry-cot underneath a solid papier-mâché table with a thick glass top, as the heaviest thing we could find to put him under. It was worrying for a young mother, and I wished badly that I had either Winterbrook House or Greenway.

Max was now in North Africa. He had started in Egypt, but was now in Tripoli. Later he went down to the Fezzan Desert. Letters were slow, and I sometimes did not hear from him for over a month. My nephew Jack was also abroad in Iran.

Stephen Glanville was still in London, and I was glad to have him there. Sometimes he would call for me at the Hospital and take me back to his

house at Highgate to dine. We usually celebrated if one or other of us had received a food parcel.

'I've got some butter from America – can you bring a tin of soup?'

'I've been sent two tins of lobster, and a whole dozen eggs – *brown*.'

One day he announced *real* fresh herrings – from the East Coast. We arrived in the kitchen, and Stephen unwrapped his parcel. Alas – alas! O lovely herrings that might have been. There was only one place for them now – the hot water boiler. A sad evening.

One's friends and acquaintances had begun to vanish by this stage of the war. You could no longer keep in touch with the people you used to know; you seldom even wrote to your friends.

Two close friends I did contrive to see were Sidney and Mary Smith. He was Keeper of the Department of Egyptian and Assyrian Antiquities at the British Museum; a *prima donna* by temperament, and a man of most interesting thoughts. His views on anything were unlike anybody else's, and if I spent half an hour talking to him I went away so stimulated by the ideas he had put into my head that I left the house feeling as though I was walking on air. He always aroused violent resistance in me, so that I had to argue every point with him. He could not and did not want to agree with people. Once he disapproved of people, or disliked them, he never relented. On the other hand, if you were once really a friend of his, you *were* a friend of his. That was that. His wife, Mary, was an extremely clever painter, and a beautiful woman, with lovely grey hair, and a long slender neck. She had also the most devastating common sense, like the tang of a really good savoury served for dinner.

The Smiths were extremely good to me. They lived not far away, and I was always welcome to come there after I had left the Hospital, and talk to Sidney for an hour. He would lend me books that he thought it would interest me to read, and would sit there, rather like a Grecian philosopher of old, while I sat at his feet, feeling like a humble disciple.

He enjoyed my detective stories, though his criticisms of them were unlike anybody else's. About something that I didn't think good he would often say, 'That's the best point in that book of yours.' Anything that I was pleased with he would say, 'No, it's not up to your best – you were below standard there.'

One day Stephen Glanville attacked me. 'I've got a project I've thought out for you.'

'Oh, what's that?'

'I want you to write a detective story about ancient Egypt.'

'About ancient Egypt?'

'Yes.'

'But I couldn't'

'Oh yes, you could. There is no difficulty at all. There is no reason why a detective story shouldn't be just as easy to place in ancient Egypt as in 1943 in England.'

I saw what he meant. People are the same in whatever century they live, or where.

'And it would be so interesting,' he said. 'One ought to have a detective story written so that someone who enjoys reading detective stories and reading about those times can combine his pleasures.'

Again I said I couldn't do anything of that kind. I didn't know enough. But Stephen was an extraordinarily persuasive man, and by the end of the evening he had almost convinced me that I could.

'You've read a lot of Egyptology,' he said. 'You are not only interested in Mesopotamia.'

It was true that one of the books I had been fondest of in the past, was Breasted's *The Dawn of Conscience*, and that I had read a good deal of Egyptian history when I had written my play about Akhnaton.

'All you want to do is fix on a period, or an incident, some definite setting,' said Stephen.

I had a terrible feeling that the die was cast.

'But you would have to give me some ideas,' I said weakly, 'as to what time or place.'

'Well,' said Stephen, 'there is an incident or two here that might do –' He pointed out one or two things in one of the books he took from his shelves. Then he gave me half a dozen or so more books, drove me and the books home to Lawn Road Flats, and said: 'Tomorrow's Saturday. You can have a nice two days reading through these and see what strikes your imagination.'

In the end I had marked down three possibly interesting points – none of them particularly well-known incidents, or about well-known figures, because I think that is what so often makes novels set in historic periods seem so phoney. After all, one doesn't really know anything of what King Pepi or Queen Hatshepsut was like, and to pretend you do is a kind of arrogance. But you can place a character of your own creation *in those times*, and as long as you know enough of the local colour and the general feeling of the period it would be all right. One of my choices was a fourth

dynasty incident, another very much later – in the time, I think, of one of the later Rameses – and the third one, the one which I finally decided upon, was drawn from recently published letters from a Ka priest in the 11th Dynasty.

These letters painted to perfection the picture of a living family: the father, fussy, opinionated, annoyed with his sons who did not do what he said; the sons, one obedient but obviously not bright, and the other, sharp-tempered, showy, and extravagant. The letters the father wrote to his two sons were about how he must take care of a certain middle-aged woman, obviously one of those poor relations who all through the ages live with families, to whom the heads of families are always kindly, whereas the children usually grow up disliking them because they are often sycophants and makers of mischief.

The old man laid down rules about how they were to do so-and-so with the oil, and so-and-so with the barley. They were not to let this person or that person cheat them over the quality of certain foods. The whole family grew clearer and clearer in my mind. I added a daughter, and some details from one or two other texts – the arrival of a new wife, by whom the father was besotted. I also threw in a spoilt small boy and a greedy but shrewd grandmother.

Excited, I started work. I had no book on hand at the moment. *Ten Little Niggers* had been successfully running at the St. James' Theatre until that theatre was bombed; it then transferred to the Cambridge for some further months. I was just playing about with a new idea for a book, so this was just the moment to get started on an Egyptian detective story.

There is no doubt that I was bullied into it by Stephen. There was no doubt, either, that if Stephen was determined that I should write a detective story set in ancient Egypt, I should have to do so. He was that kind of man.

As I pointed out to him in the ensuing weeks and months, he must have become extremely sorry that he had urged me to do anything of the sort. I was continually ringing him up and demanding information which, as he said, only took me three minutes to ask for, but which he usually had to look through eight different books to find. 'Stephen, what did they eat for meals? How did they have their meat cooked? Were there any special things for special feasts? Did the men and women eat together? What sort of rooms did they sleep in?'

'Oh dear,' Stephen would groan, and then he would have to look up things, pointing out to me that one has to deduce a great deal from little

evidence. There were pictures of reed birds on spits being served, pictures of loaves, of bunches of grapes being picked – and so on. Anyway, I got enough to make my daily life of the period sound all right, and then I came back with a few more queries.

'Did they eat at the table, or on the floor? Did the women occupy a separate part of the house? Did they keep linen in chests or in cupboards? What sort of houses did they have?'

Houses were far more difficult to find out about than temples or palaces, owing to the fact that the temples and palaces were still there, being built of stone, whereas houses had been of more perishable material.

Stephen argued with me a great deal on one point of my *dénouement*, and I am sorry to say that I gave in to him in the end. I was always annoyed with myself for having done so. He had a kind of hypnotic influence about that sort of thing; He was so positive himself that he was *right* that you couldn't help having doubts yourself. Up to then, on the whole, though I have given in to people on every subject under the sun, *I have never given in to anyone over what I write.*

If I think I have got a certain thing *right* in a book – the way it should be – I'm not easily moved from it. In this case, against my better judgment, I *did* give in. It was a moot point, but I still think now, when I re-read the book, that I would like to re-write the end of it – which shows that you should stick to your guns in the first place, or you will be dissatisfied with yourself. But I was a little hampered by the gratitude I felt to Stephen for all the trouble he had taken, and the fact that it had been *his* idea to start with. Anyway, *Death Comes as the End* was duly written.

Shortly after that, I wrote the one book that has satisfied me completely. It was a new Mary Westmacott, the book that I had always wanted to write, that had been clear in my mind. It was the picture of a woman with a complete image of herself, of what she was, but about which she was completely mistaken. Through her own actions, her own feelings and thoughts, this would be revealed to the reader. She would be, as it were, continually *meeting herself*, not recognising herself, but becoming increasingly uneasy. What brought about this revelation would be the fact that for the first time in her life she was *alone* – completely alone – for four or five days.

I had the background now, which I had not had in my mind before. It would be one of those resthouses on journeys through Mesopotamia, where you are immobilised, you cannot travel on, there is no one there but natives who hardly speak English – who bring you meals and nod

their heads and agree to what you say. There is nowhere to go, no one to see, and you are stuck there till you can go on. So you sit and think about *yourself*, having read the only two books you have with you. You think about yourself. And my starting point – I had always known what that would be – was when she was leaving Victoria, going out to see one of her daughters who was married abroad, looking back as the train moved out of the station, at her husband's back retreating up the platform, and the sudden pang it gave her as he went striding along, striding along just like a man who was terrifically relieved, who was released from bondage, who was going to have a holiday. It was so surprising that she could hardly believe her eyes. Of course she was mistaken, of course Rodney was going to miss her terribly, and yet – that little seed – it would stay in her mind worrying her; and then, she was all alone and began thinking, the pattern of her life would unroll little by little. It was going to be technically difficult to do, the way I wanted it; lightly, colloquially, but with a growing feeling of tension, of uneasiness, the sort of feeling one has – everyone has, sometime, I think – of *who am I*? What am I like *really*? What do all the people I love think of me? Do they think of me as I think they do?

The whole world looks different; you begin to see it in different terms. You keep reassuring yourself, but the suspicion, the anxiety comes back.

I wrote that book in three days flat. On the third day, a Monday, I sent an excuse to the Hospital, because I did not dare leave my book at that point – I had to go on until I had finished it. It was not a long book – a mere fifty thousand words – but it had been with me a long time.

It is an odd feeling to have a book growing inside you, for perhaps six or seven years knowing that one day you will write it, knowing that it is building up, all the time, to what it already *is*. Yes, it is there already – it just has to come more clearly out of the mist. All the people are there, ready, waiting in the wings, ready to come on to the stage when their cues are called – and then, suddenly, one gets a clear and sudden command: *Now*!

Now is when you are ready. Now, you know all about it. Oh, the blessing that for once one is able to do it then and there, that *now* is *really* now.

I was so frightened of interruptions, of anything breaking the flow of continuity, that after I had written the first chapter in a white heat, I proceeded to write the last chapter, because I knew so clearly where I was going that I felt I must get it down on paper. Otherwise I did not have to interrupt anything – I went straight through.

I don't think I have ever been so tired. When I finished, when I had seen that the chapter I had written earlier needed not a word changed, I fell on my bed, and as far as I remember slept more or less for twenty-four hours straight through. Then I got up and had an enormous dinner, and the following day I was able to go to the Hospital again.

I looked so peculiar that everyone was upset about me there. 'You must have been really ill,' they said, 'you have got the most enormous circles under your eyes.' It was only fatigue and exhaustion, but to have that fatigue and exhaustion was worth-while when for once writing had been no difficulty – no difficulty at all, that is, beyond the physical effort. Anyway, it was a very rewarding experience to have had.

I called the book *Absent in the Spring*, from that sonnet of Shakespeare's which begins with those words: '*From you have I been absent in the spring.*' I don't know myself, of course, what it is really like. It may be stupid, badly written, no good at all. But it was written with integrity, with sincerity, it was written as I meant to write it, and that is the proudest joy an author can have.

A few years later I wrote another book of Mary Westmacott – called *The Rose and the Yew Tree*. It is one I can always read with great pleasure, though it was not an imperative, like *Absent in the Spring*. But there again, the idea behind the book had been with me a long time – in fact since about 1929. Just a sketchy picture, that I knew would come to life one day.

One wonders where these things come *from* – I mean the ones that are a must. Sometimes I think that is the moment one feels nearest to God, because you have been allowed to feel a little of the joy of pure creation. You have been able to make something that is not yourself. You know a kinship with the Almighty, as you might on a seventh day, when you see that what you have made is good.

I was to make one more variation from my usual literary work. I wrote a book out of nostalgia, because I was separated from Max, could so seldom get news of him, and recalled with such poignant remembrance the days we had spent in Arpachiyah and in Syria. I wanted to re-live our life, to have the pleasure of remembering – and so I wrote *Come, Tell Me How You Live*, a light-hearted frivolous book; but it does mirror the times we went through, so many little silly things one had forgotten. People have liked that book very much. There was only a small edition of it, because paper was short.

Sidney Smith, of course, said to me: 'You can't publish that, Agatha.'

'I'm going to,' I said.

'No,' he said. 'You had better not publish that.'

'But I want to.' Sidney Smith looked at me disapprovingly. It was not the kind of sentiment he would approve of. Doing what you personally wanted did not go with Sidney's somewhat Calvinist outlook.

'Max might not like it.'

I considered that doubtfully.

'I don't think he'll mind. He'll probably like remembering about all the things we did, too. I would never try to write a *serious* book about archaeology; I know that I'd make far too many silly mistakes. But this is different, this is *personal*. And I am going to publish it,' I continued. 'I want something to hold on to, to remember. You can't trust your own memory. Things go. So that's why I want to publish it.'

'Oh! well,' said Sidney. He still sounded doubtful. However, 'Oh! well' was a concession when it came from Sidney.

'Nonsense,' said his wife Mary. 'Of course you can publish it. Why not? It is very amusing. And I quite see what you mean about liking to remember and read back over it.'

The other people who didn't like it were my publishers. They were suspicious and disapproving, afraid that I was getting completely out of hand. They had hated Mary Westmacott writing anything. They were now prepared to be suspicious of *Come, Tell Me How You Live*, or anything, in fact, that enticed me away from mystery stories. However, the book was a success, and I think they then regretted that paper was so short. I published it under the name of Agatha Christie Mallowan so that it should not be confused with any of my detective books.

IV

There are things one does not want to go over in one's mind again. Things that you have to accept because they have happened, but you don't want to think of them again.

Rosalind rang me up one day and told me that Hubert, who had been in France now for some time, had been reported missing, believed killed.

That is, I think, the most cruel thing that can happen to any young wife in wartime. The awful suspense. To have your husband killed is bad enough; but it is something you have got to live with, and you know that

you have. This fatal holding out of hope is cruel, *cruel* . . . And no one can help you.

I went down to join her, and stayed at Pwllywrach for some time. We hoped – of course one always hopes – but I don't think Rosalind, in her own heart, ever did quite hope. She had always been one to expect the worst. And I think, too, that there had always been something about Hubert – not exactly melancholy, but that touch or look of someone who is not fated for long life. He was a dear person; good to me always, with, I think, a great vein, not exactly of poetry, but of something of that kind in him. I wish I had had a greater chance to know him better; not just a few short visits and encounters.

It was not for a good many months that we got any further news. Rosalind, I think, had had the news for a full twenty-four hours before she said anything to me. She had behaved just the same as usual; she was and always has been a person of enormous courage. Finally, hating to do so but knowing it had to be done, she said abruptly: 'You had better see this, I suppose,' and she handed me the telegram which reported that he was now definitely classified as killed in action.

The saddest thing in life and the hardest to live through, is the knowledge that there is someone you love very much whom you cannot save from suffering. You can do things to aid people's physical disabilities; but you can do little to help the pain of the heart. I thought, I may have been wrong, that the best thing I could do to help Rosalind was to say as little as possible, to go on as usual. I think that would have been my own feeling. You hope no one will speak to you, or enlarge upon things. I hope that *was* best for her, but you cannot know for another person. It may be it would have been easier for her if I had been the determined kind of mother who broke her down and insisted on her being more demonstrative. Instinct cannot be infallible. One wants so badly not to hurt the person one loves – not to do the wrong thing for them. One feels one ought to *know*, but one can never be sure.

She continued to live at Pwllywrach in the big empty house with Mathew – an enchanting little boy, and always, in my memory, such a happy little boy: he had a great knack for happiness. He still has. I was so glad that Hubert saw his son; that he knew he had a son, though it sometimes seemed more cruel to know that he was not to come back and live in the home he loved, or to bring up the son whom he had wanted so much.

Sometimes one cannot help a tide of rage coming over one when one thinks of war. In England we had too much war in too short a time.

The first war seemed unbelievable, amazing; it seemed so unnecessary. But one did hope and believe that the thing had been scotched then, that the wish for war would never arise again in the same German hearts. But it did – we know now, from the documents which are part of history, that Germany was planning for war in the years before the Second War came.

But one is left with the horrible feeling now that war settles *nothing*; that to *win* a war is as disastrous as to lose one! War, I think, has *had* its time and place; when, unless you *were* warlike, you would not live to perpetuate your species – you would die out. To be meek, to be gentle, to give in easily, would spell disaster; war was a necessity then, because either you or the others would perish. Like a bird or animal, you had to fight for your territory. War brought you slaves, land, food, women – the things you needed to survive. But now we have got to learn to avoid war, not because of our nicer natures or our dislike of hurting others, but because war is not profitable, we shall not survive war, but shall, as well as our adversaries, be *destroyed* by war. The time of the tigers is over; now, no doubt, we shall have the time of the rogues and the charlatans, of the thieves, the robbers and pickpockets; but that is better – it is a stage on the upward way.

There is at least the dawn, I believe, of a kind of good will. We mind when we hear of earthquakes, of spectacular disasters to the human race. We *want* to help. That is a real achievement; which I think must lead somewhere. Not quickly – nothing happens quickly – but at any rate we can hope. I think sometimes we do not appreciate that second virtue which we mention so seldom in the trilogy – faith, hope and charity. Faith we have had, shall we say, almost *too* much of – faith can make you bitter, hard, unforgiving; you can abuse faith. Love we cannot but help knowing in our own hearts is the essential. But how often do we forget that there is hope as well, and that we seldom think about hope? We are ready to despair too soon, we are ready to say, 'What's the good of doing anything?' Hope is the virtue we should cultivate most in this present day and age.

We have made ourselves a Welfare State, which has given us freedom from fear, security, our daily bread and a little more than our daily bread; and yet it seems to me that now, in this Welfare State, every year it becomes more difficult for anybody to look forward to the future. Nothing is worthwhile. Why? Is it because we no longer have to fight for existence? Is living not even interesting any more? We cannot appreciate the fact of being alive. Perhaps we need the difficulties of space, of new worlds

opening up, of a different kind of hardship and agony, of illness and pain, and a wild yearning for survival?

Oh well, I am a hopeful person myself. The one virtue that would never, I think, be quenched for me, would be hope. That is where I always have found my dear Mathew such a rewarding person to be with. He has always had an incurably optimistic temperament. I remember once when he was at his prep school, and Max was asking him whether he thought he had any chance of getting into the First Cricket Eleven. 'Oh well,' said Mathew, with a beaming smile, 'there's always hope!'

One should adopt something like that, I think, as one's motto in life. It made me mad with anger to hear of one middle-aged couple who had been living in France when the war broke out. When they thought the Germans might be approaching on their march across France, they decided the only thing to be done was to commit suicide, which they did. But the waste! The pity of it! They did no *good* to anyone by their suicide. They could have lived through a difficult life of enduring, of surviving. Why should one give up any hope until one is dead?

It reminds me of the story that my American godmother used to tell me years and years ago about two frogs who fell into a pail of milk. One said: 'Ooh, I'm drowning, I'm drowning!' The other frog said, '*I'm* not going to drown.' 'How can you stop drowning?' asked the other frog. 'Why, I'm going to hustle around, and hustle around, and hustle around like mad,' said the second frog. Next morning the first frog had given up and drowned, and the second frog, having hustled around all night, was sitting there in the pail, right on top of a pat of butter.

Everyone, I think, got a bit restless towards the last years of the war. Ever since D-day there was a feeling that there could be an end to the war, and many people who had said there couldn't were beginning to eat their words.

I began to feel restless. Most patients had moved out of London, though of course there were still the out-patients. Even there, one sometimes felt, it was not as it had been in the last war, where you were patching up wounded men straight from the trenches. Half the time, now, you had only to give out large quantities of pills to epileptics – necessary work, but it lacked that involvement with war that one felt one needed. The mothers brought their babies to the Welfare – and I used to think they often would have done much better to have kept them at home. In this the chief pharmacist entirely agreed with me.

I considered one or two projects at this time. One young friend of mine who was in the W.A.A.F. arranged for me to see a friend of hers with a view to doing some intelligence photographic work. I was furnished with an impressive pass which enabled me to wander through what seemed miles of subterranean corridors underneath the War Office, and I was finally received by a grave young lieutenant who frightened me to death. Although I had had a lot of experience in photography, the one thing I had never done and knew nothing about was aerial photography. In consequence, I found it practically impossible to recognise any photograph that was shown me. The only one I was reasonably sure of was one of Oslo, but I had become so defeatist by that time that I didn't dare say so, having made several boss shots already. The young man sighed, looked at me as the complete moron I was, and said gently: 'I think perhaps you had better go back to hospital work.' I departed feeling completely deflated.

Towards the beginning of the war, Graham Greene had written to me and asked if I would like to do propaganda work. I did not think I was the kind of writer who would be any good at propaganda, because I lacked the single-mindedness to see only one side of the case. Nothing could be more ineffectual than a lukewarm propagandist. You want to be able to say 'X is black as night' and *feel* it. I didn't think I could ever be like that.

But every day now I was getting more restless. I wanted work that had at least something to do with the war. I got an offer to be a dispenser to a doctor in Wendover; it was near where some friends of mine were living. I thought that that would be very nice for me, and I would like being in the country. Only, if Max were to come home from North Africa – and after three years, he might come – I should feel I was treating my doctor badly.

I also had a theatrical project. It was possible that I might go with E.N.S.A. as a sort of extra producer or something on a tour of North Africa. I was thrilled by that idea. It would be wonderful if I got out to North Africa. It was fortunate that I did nothing of the kind. About a fortnight before I would have left England, I got a letter from Max saying that he quite probably would be coming back from North Africa to the Air Ministry in two to three weeks' time. What misery, if I had arrived out in North Africa with E.N.S.A. just at the moment he came home.

The next few weeks were agony. There I was, all keyed up, waiting. In a fortnight, in three weeks, no, perhaps longer – I told myself that these things always took longer than one expected.

I went down for a weekend to Rosalind in Wales and came back by a late train on the Sunday night. It was one of those trains one had so often to endure in wartime, freezing cold, and of course when one got to Paddington there was no means of getting anywhere. I took some complicated train which finally landed me at a station in Hampstead not too far away from Lawn Road Flats, and from there I walked home, carrying some kippers and my suitcase. I got in, weary and cold, and started by turning on the gas, throwing off my coat and putting my suitcase down. I put the kippers in the frying pan. Then I heard the most peculiar clanking noise outside, and wondered what it could be. I went out on the balcony and I looked down the stairs. Up them came a figure burdened with everything imaginable – rather like the caricatures of Old Bill in the first war – clanking things hung all over him. Perhaps the White Knight would have been a good description of him. It seemed impossible that anyone could be hung over with so much. But there was no doubt who it was – it was my husband! Two minutes later I knew that all my fears that things might be different, that he would have changed, were baseless. This was Max! He might have left yesterday. He was back again. *We* were back again. A terrible smell of frying kippers came to our noses and we rushed into the flat.

'What on earth are you eating?' asked Max.

'Kippers,' I said. 'You had better have one.' Then we looked at each other. 'Max!' I said. 'You are two stone heavier.'

'Just about. And you haven't lost any weight yourself,' he added.

'It's because of all the potatoes,' I said. 'When you haven't meat and things like that, you eat too many potatoes and too much bread.'

So there we were. Four stone between us more than when he left. It seemed all wrong. It ought to have been the other way round.

'Living in the Fezzan Desert *ought* to be very slimming,' I said. Max said that deserts were not at all slimming, because one had nothing else to do but sit and eat oily meals, and drink beer.

What a wonderful evening it was! We ate burnt kippers, and were happy.

PART XI

AUTUMN

I

I am writing this in 1965. And that was in 1945. Twenty years, but it does not seem like twenty years. The war years do not seem like real years, either. They were a nightmare in which reality stopped. For some years afterwards I was always saying, 'Oh, so-and-so happened five years ago,' but each time, really, I ought to have added another five. Now, when I say a few years ago, I mean quite a lot of years. Time has altered for me, as it does for the old.

My life began again, first with the ending of the German war. Though technically the war continued with Japan, *our* war ended then. Then came the business of picking up the pieces, all the bits and pieces scattered everywhere – bits of one's life.

After having some leave, Max went back to the Air Ministry. The Admiralty decided to derequisition Greenway – as usual, at a moment's notice – and the date they chose for it was Christmas Day. There could not have been a worse day for having to take over an abandoned house. We narrowly missed one bit of good fortune. Our electric generator engine, by which we made our own electricity, had been on its last legs when the Admiralty took over. The American Commander had told me several times he was afraid it would conk out altogether before long. 'Anyway,' he said, 'we'll put you in a jolly good new one when we do replace it, so you will have something to look forward to.' Unfortunately the house was derequisitioned just three weeks before the electric generator was scheduled to be replaced.

Greenway was beautiful when we went down there again on a sunny

winter's day – but it was wild, wild as a beautiful jungle. Paths had disappeared, the kitchen garden, where carrots and lettuces had been grown, was all a mass of weeds, and the fruit-trees had not been pruned. It was sad in many ways to see it like that, but its beauty was still there. The inside of the house was not as bad as we had feared. There was no linoleum left, which was tiresome, and we could not obtain a permit to get any more because the Admiralty had taken it over and paid us for it when they moved in. The kitchen was indescribable, with the blackness and oily soot of the walls – and there were, as I have said, fourteen lavatories along the stone passage down there.

I had a splendid man who battled for me with the Admiralty, and I must say the Admiralty needed some battling with. Mr Adams was a firm ally of mine. Somebody had told me that he was the only man capable of wringing blood from a stone or money from the Admiralty!

They refused to allow sufficient to redecorate rooms on the absurd pretext that the house had been freshly painted only a year or two before they took over – therefore they'd only allow for a portion of each room. How can you decorate three quarters of a room? However, it turned out the boat house had been a good deal damaged, with stones removed, steps broken down, and various things like that, and this was costly structural damage, for which they *had* to pay – so when I got the money for that I was able to redecorate the kitchen.

We had another desperate battle about the lavatories, because they said they ought to be charged against *me* as *improvements*. I said it was no improvement to have fourteen lavatories that you didn't need along a kitchen passage. What you needed there was the larder and the wood shed and the pantry that had been there originally. They said all those lavatories would be an enormous improvement if the place was going to be turned into a girls' school. I pointed out it was *not* going to be turned into a girls' school. They *could* leave me *one* extra lavatory, I said, very graciously. However, they wouldn't do that. Either they were going to take *all* the lavatories away, or I should have to pay the cost of them as installed against what was allowed for other damage. So, like the Red Queen, I said, 'Take them all away!'

This meant a lot of trouble and expense for the Admiralty, but they had to take them away. Then Mr Adams got their people to come back again and again to take them away *properly*, as they always left pipes and bits of things sticking out, and to replace the pantry and larder fittings. It was a long dreary battle.

In due course, the removers came and redistributed the furniture all over the house. It was amazing how little anything had been damaged or spoilt, apart from the destruction by moths of carpets. They had been told to mothproof them, but had neglected to do so through false optimism: 'It will be all over by Christmas.' A few books had been damaged by damp – but surprisingly few. Nothing had come through the roof of the drawing-room, and all the furniture had remained in remarkably good condition.

How beautiful Greenway looked in its tangled splendour; but I did wonder if we would ever clear any of the paths again, or even find where they were. The place became more of a wilderness every day, and was regarded as such in the neighbourhood. We were always turning people out of the drive. They would often walk up there in the spring, pulling off great branches of rhododendrons, and carelessly ruining the shrubs. Of course the place was empty for a time after the Admiralty moved out. We were in London, and Max was still at the Air Ministry. There was no caretaker, and everybody came in to help themselves freely to everything – not just *picking* flowers, but breaking off the branches anyhow.

We were able to settle in at last, and life began again, though not as it had been before. There was the relief that peace had at last come, but no certainty in the future of peace, or indeed of anything. We went gently, thankful to be together, and tentatively trying out life, to see what we would be able to make of it. Business was worrying too. Forms to fill up, contracts to sign, tax complications – a whole welter of stuff one didn't understand.

It is only now that I fully realise, looking back over my wartime output, that I produced an *incredible* amount of stuff during those years. I suppose it was because there were no distractions of a social nature; one practically never went out in the evenings.

Besides what I have already mentioned, I had written an extra two books during the first years of the war. This was in anticipation of my being killed in the raids, which seemed to be in the highest degree likely as I was working in London. One was for Rosalind, which I wrote first – a book with Hercule Poirot in it – and the other was for Max – with Miss Marple in it. Those two books, when written, were put in the vaults of a bank, and were made over formally by deed of gift to Rosalind and Max. They were, I gather, heavily insured against destruction.

'It will cheer you up,' I explained to them both, 'when you come back from the funeral, or the Memorial Service, to think that you have got a

couple of books, one belonging to each of you!' They said they would rather have *me*, and I said: 'I should hope so, indeed!' And we all laughed a good deal.

I cannot see why people are always so embarrassed by having to discuss anything to do with death. Dear Edmund Cork, my agent, always used to look most upset when I raised the question of 'Yes, but supposing I should *die*?' But really the question of death is so important nowadays, that one has to discuss it. As far as I could make out from what lawyers and tax people told me about death duties – very little of which I ever under-stood – my demise was going to be an unparalleled disaster for all my relations, and their only hope was to keep me alive as long as possible!

Seeing the point to which taxation has now risen, I was pleased to think it was no longer really worth-while for me to work so hard: one book a year was ample. If I wrote two books a year I should make hardly more than by writing one, and only give myself a great deal of extra work. Certainly there was no longer the old incentive. If there was something out of the ordinary that I really *wanted* to do, that would be different.

About then the B.B.C. rang me up and asked me if I would like to do a short radio play for a programme they were putting on for some function to do with Queen Mary. She had expressed the wish to have something of mine, as she liked my books. Could I manage that for them quite soon? I was attracted by the idea. I thought hard, walked up and down, then rang them back and said Yes. An idea came to me that I thought would do, and I wrote the little radio sketch called *Three Blind Mice*. As far as I know Queen Mary was pleased with it.

That would seem to be the end of that, but shortly afterwards it was suggested I might enlarge it into a short story. *The Hollow*, which I had adapted for the stage, had been produced by Peter Saunders, and had been successful. I had so enjoyed it myself that I began to think about further essays in play-writing. Why not write a play instead of a book? Much more fun. One book a year would take care of finances, so I could now enjoy myself in an entirely different medium.

The more I thought of *Three Blind Mice*, the more I felt that it might expand from a radio play lasting twenty minutes to a three-act thriller. It wanted a couple of extra characters, a fuller background and plot, and a slow working up to the climax. I think one of the advantages *The Mouse-trap*, as the stage version of *Three Blind Mice* was called, has had over other plays is the fact that it was really written from a *précis*, so that it

had to be the bare bones of the skeleton coated with flesh. It was all there in proportion from the first. That made for good construction.

For its title, I must give full thanks to my son-in-law, Anthony Hicks. I have not mentioned Anthony before, but of course he is not really a memory, because he is with us. Indeed I do not know what I would do without him in my life. Not only is he one of the kindest people I know –he is a most remarkable and interesting character. He has ideas. He can brighten up any dinner table by suddenly producing a 'problem'. In next to no time, everyone is arguing furiously.

He once studied Sanskrit and Tibetan, and can also talk knowledge-ably on butterflies, rare shrubs, the law, stamps, birds, Nantgar as china, antiques, atmosphere and climate. If he has a fault, it is that he discusses wine at too great length; but then I am prejudiced because I don't like the stuff.

When the original title of *Three Blind Mice* could not be used – there was already a play of that name – we all exhausted ourselves in thinking of titles. Anthony came up with 'The Mousetrap'. It was adopted. He ought to have shared in the royalties, I think, but then we never dreamed that this particular play was going to make theatrical history.

People are always asking me to what I attribute the success of *The Mousetrap*. Apart from replying with the obvious answer, 'Luck!' – be-cause it *is* luck, ninety per cent. luck, at least, I should say – the only reason I can give is that there is a bit of something in it for almost every-body: people of different age groups and tastes can enjoy seeing it. Young people enjoy it, elderly people enjoy it, Mathew and his Eton friends, and later Mathew and his University friends, went to it and enjoyed it, dons from Oxford enjoy it. But I think, considering it and trying to be neither conceited nor over-modest, that, of its kind – which is to say a light play with both humour and thriller appeal – it is well constructed. The thing unfolds so that you want to know what happens next, and you can't quite see where the next few minutes will lead you. I think, too, though there is a tendency for all plays that have run a long time to be acted, sooner or later, as if the people in them were caricatures, the people in *The Mousetrap* could all be real people.

There was a case once where three children were neglected and abused, after they had been placed by the Council on a farm. One child did die, and there had been a feeling that a slightly delinquent boy might grow up full of the desire for revenge. There was another murder case, too,

remember, where someone had cherished a childish grudge of some kind for many years and had come back to try to avenge it. That part of the plot was not impossible.

Then the characters themselves: a young woman, bitter against life, determined to live only for the future; the young man who refuses to face life and yearns to be mothered; and the boy who childishly wanted to get his own back on the cruel woman who hurt Jimmy – and on his young school teacher – all those seem to me real, natural, when one watches them.

Richard Attenborough and his enchanting wife Sheila Sim played the two leads in the first production. What a beautiful performance they gave. They loved the play, and believed in it and Richard Attenborough gave a great deal of thought to playing his part. I enjoyed the rehearsals – I enjoyed *all* of it.

Then finally it was produced. I must say that I had no feeling whatsoever that I had a great success on my hands, or anything remotely resembling that. I thought it went quite well, but I remember – I forget if it was at the first performance or not; I think it was the beginning of the tour at Oxford – when I went with some friends, that I thought sadly it had fallen between two stools. I had put in too many humorous situations; there was too much laughter in it; and that must take away from the thrill. Yes, I was a little depressed about it, I remember.

Peter Saunders, on the other hand, nodded his head gently at me, and said, 'Don't worry! My pronouncement is that it will run over a year - fourteen months I am going to give it.'

'It won't run that long,' I said. 'Eight months perhaps. Yes, I think eight months.'

And now, as I write, it is just coming to the end of its thirteenth year, and has had innumerable casts. The Ambassadors Theatre has had to have entirely new seating – and a new curtain. I now hear it has got to have a new set – the old one is too shabby. And people are *still* going to it.

I must say it seems to me incredible. Why should a pleasant, enjoyable evening's play go on for *thirteen years*. No doubt about it, miracles happen.

And to whom do the profits go? Mainly, of course, they go out in tax, like everything else, but apart from that who is the gainer? I have given many of my books and stories to other people. The serial rights in one short story, *Sanctuary*, were given to the Westminister Abbey Appeal Fund, and other stories have been given to one or other among my friends.

The fact that you can sit down and write something, and that then it passes direct from you to someone else, is a much happier and more natural feeling than handing out cheques or things of that kind. You may say it is all the same in the end, but it is *not* the same. One of my books belongs to my husband's nephews; though that was published many years ago they are still doing nicely out of it. I gave my share in the film rights of *Witness for the Prosecution* to Rosalind.

The play, *The Mousetrap*, was given to my grandson. Mathew, of course, was always the most lucky member of the family, and it *would* be Mathew's gift that turned out the big money winner.

One thing that gave me particular pleasure was writing a story – a long-short I think they call it: something between a book and a short story – the proceeds of which went to put a stained glass window in my local church at Churston Ferrers. It is a beautiful little church and the plain glass east window always gaped at me like a gap in teeth. I looked at it every Sunday and used to think how lovely it would look in pale colours. I knew nothing about stained glass, and I had a most difficult time visiting studios and getting different sketches made by stained glass artists. It was narrowed down in the end to a glass artist called Patterson, who lived in Bideford and who sent me a design for a window that I really admired very much – particularly his colours, which were not the ordinary red and blue but predominantly mauve and pale green, my favourite ones. I wanted the central figure to be the Good Shepherd. I had a little difficulty over this with the Diocese of Exeter, and, I may say, with Mr Patterson; both insisting that the central pattern of an east window *had* to be the Crucifixion. However, the Diocese, on making some research into the matter, agreed that I could have Jesus as the Good Shepherd, since it was a pastoral parish. I wanted this to be a happy window which children could look at with pleasure. So in the centre is the Good Shepherd with His lamb, and the other panels are the manger and the Virgin with the Child, the angels appearing to the shepherds in the field, the fishermen in their boat with their nets, and the Figure walking on the sea. They are all the simpler scenes of the Gospel story, and I love it and enjoy looking at it on Sundays. Mr Patterson has made a fine window. It will, I think, stand the test of the centuries because it is simple. I am both proud and humble that I have been permitted to offer it with the proceeds of my work.

R

II

One night at the theatre stands out in my memory especially; the first night of *Witness for the Prosecution*. I can safely say that that was the only first night I have enjoyed.

First nights are usually misery, hardly to be borne. One has only two reasons for going to them. One is – a not ignoble motive – that the poor actors have got to go through with it, and if it goes badly it is unfair that the author should not be there to share their torture. I learnt about some of these agonies on the first night of *Alibi*. The script calls for the butler and the doctor to beat on a locked study door, and then, in growing alarm, to force it open. On the first night the study door did not wait to be forced – it opened obligingly before anyone had put a fist on it, displaying the corpse just arranging himself in a final attitude. This made me nervous ever afterwards of locked doors, lights that do not go out when the whole point is that they *should* go out, and lights that do not go *on* when the whole point is that they *should* go on. These are the real agonies of the theatre.

The other reason for going to first nights is, of course, curiosity. You know you will hate it; that you will be miserable; that you will notice all the things that go wrong, all the lines that are muffed, all the fluffs and the gaps and the drying up. But you go because of that 'elephant's child' insatiable curiosity – you have to know for *yourself*. Nobody else's account is going to be any good. So there you are, shivering, feeling cold and hot alternately, hoping to heaven that nobody will notice you where you are hiding yourself in the higher ranks of the Circle.

The first night of *Witness for the Prosecution* was not misery. It was one of my plays that I liked best myself. I was as nearly satisfied with that play as I have been with any. I didn't want to write it; I was terrified of writing it. I was forced into it by Peter Saunders, who has wonderful powers of persuasion. Gentle bullying, subtle cajoling. 'Of course you can do it.'

'I don't know a thing about legal procedure. I should make a fool of myself.'

'That's quite easy. You can read it up, and we'll have a barrister on hand to clear up anomalies and make it go right.'

'I couldn't write a court scene.'

'Yes, you could – you've seen court scenes played. You can read up trials.'

'Oh I don't know . . . I don't think I *could*.'

Peter Saunders continued to say that of course I could, and that I must begin because he wanted the play quickly. So, hypnotised and always amenable to the power of suggestion, I read quantities of the *Famous Trials* series; I asked questions of solicitors as well as barristers; and finally I got interested, and suddenly felt I was enjoying myself – that wonderful moment in writing which does not usually last long but which carries one on with a terrific verve as a large wave carries you to shore. 'This is lovely – I am doing it – it's working – now, where shall we get to next?' There is that priceless moment of seeing the thing – not on the stage but in your mind's eye. There it all is, the real thing, in a real court – not the Old Bailey because I hadn't been there yet – but a real court sketchily etched in the background of my mind. I saw the nervous, desperate young man in the dock, and the enigmatic woman who came into the witness box to give evidence not for her lover but for the Crown. It is one of the quickest pieces of writing that I have done – I think it only took me two or three weeks after my preparatory reading.

Naturally it had to have some changes in the procedure, and I had also to fight desperately for my chosen end to the play. Nobody liked it, nobody wanted it, everyone said it would spoil the whole thing. Everyone said: 'You can't get away with that,' and wanted a different end – preferably one used in the original short story I had written years ago. But a short story is not a play. The short story had no court scene in it, no trial for murder. It was a mere sketch of an accused person and an enigmatic witness. I stuck out over the end. I don't often stick out for things, I don't always have sufficient conviction, but I had here. I wanted that end. I wanted it so much that I wouldn't agree to have the play put on without it.

I got my end, and it was successful. Some people said it was a double cross, or dragged in, but I knew it wasn't; it was logical. It was what could have happened, what might have happened, and in my view probably would have happened – possibly with a little less violence, but the psychology would have been right, and the one little fact that lay beneath it had been implicit all through the play.

A barrister and his managing clerk duly gave advice and came to the rehearsals of the play on two occasions. The severest criticism came from the managing clerk. He said, 'Well, it's all wrong, to my mind, because, you see, a trial like this would take three or four days at least. You can't squeeze it into an hour and a half or two hours.' He couldn't, of course, have been more right, but we had to explain that all court scenes in plays had to be given the benefit of theatrical licence, and three days had to be condensed into a period counted in hours not in days. A dropped curtain here and there helped, but in *Witness for the Prosecution* the continutiy kept in the court scene, I think, was valuable.

Anyway, I enjoyed that evening when the play was first produced. I suppose I went to it with my usual trepidation, but once the curtain rose my pleasure began. Of all the stage pieces I have had produced, this came closest in casting to my own mental picture: Derek Bloomfield as the young accused; the legal characters whom I had never really visualised clearly, since I knew little of the law, but who suddenly came alive; and Patricia Jessel, who had the hardest part of all, and on whom the success of the play most certainly depended. I could not have found a more perfect actress. The part was a difficult one, especially in the first act, where the lines cannot help. They are hesitant, reserved, and the whole force of the acting has to be in the eyes, the reticence, the feeling of something malign held back. She suggested this perfectly – a taut, enigmatic personality. I still think her acting of the part of Romaine Helder was one of the best performances I have seen on the stage.

So I was happy, radiantly happy, and made even more so by the app-lause of the audience. I slipped away as usual after the curtain came down on my ending and out into Long Acre. In a few moments, while I was looking for the waitin gcar, I was surrounded by crowds of friendly people, quite ordinary members of the audience, who recognised me, patted me on the back, and encouraged me – 'Best you've written, dearie!' 'First class – thumbs up, I'd say!' 'V-signs for this one!' and 'Loved every minute of it!' Autograph books were produced and I signed cheer-fully and happily. My self-consciousness and nervousness, just for once, were not with me. Yes, it was a memorable evening. I am proud of it still. And every now and then I dig into the memory chest, bring it out, take a look at it, and say 'That was the night, that was!'

Another occasion I remember with great pride, but I must admit with suffering all the same, is the tenth anniversary of *The Mousetrap*. There was a party for it – there had to be a party for it, and what is more *I* had

to go to the party. I did not mind going to small theatrical parties just for the cast, or something of that kind; one was among friends then, and, although nervous, I could get through it. But this was a grand, a super-party at the Savoy. It had everything that is most awful about parties: masses of people, television, lights, photographers, reporters, speeches, this, that and the other – nobody in the world was more inadequate to act the heroine than I was. Still, I saw that it had to be got through. I would have not exactly to make a speech, but to say a few words – a thing I had never done before. I *cannot* make speeches, I *never* make speeches, and I *won't* make speeches, and it is a very good thing that I *don't* make speeches because I should be so bad at them.

I knew any speech I made that night would be bad. I tried to think of something to say, and then gave it up, because thinking of it would make it worse. Much better not to think of anything at all, and then when the awful moment came I should just *have* to say something – it wouldn't much matter what, and it couldn't be worse than a speech I had thought out beforehand and stammered over.

I started the party in an inauspicious manner. Peter Saunders had asked me to get to the Savoy about half an hour before the scheduled time. (This, I found, when I got there, was for an ordeal of photography. A good thing to get it over, perhaps, but something I had not quite realised was going to happen on such a large scale.) I did as I was told, and arrived, bravely alone, at the Savoy. But when I tried to enter the private room reserved for the party, I was turned back. 'No admission yet, Madam. Another twenty minutes before anyone is allowed to go in.' I retreated. Why I couldn't say outright, 'I am Mrs Christie and I have been told to go in,' I don't know. It was because of my miserable, horrible inevitable shyness.

It is particularly silly because ordinary social occasions do not make me shy. I do not enjoy big parties, but I can go to them, and whatever I feel is not really shyness. I suppose, actually, the feeling is – I don't know whether every author feels it, but I think quite a lot do – that I am pretending to be something I am not, because, even nowadays, I do not quite feel as though I *am* an author. I still have that overlag of feeling that I am *pretending* to be an author. Perhaps I am a little like my grandson, young Mathew, at two years old, coming down the stairs and reassuring himself by saying: *'This is Mathew coming downstairs!'* And so I got to the Savoy and said to myself: 'This is Agatha pretending to be a successful author, going to her own large party, having to look as though she is

someone, having to make a speech that she can't make, having to be something that she's no good at.'

Anyway, like a coward, I accepted the rebuff, turned tail and wandered miserably round the corridors of the Savoy, trying to get up my courage to go back and say – in effect, like Margot Asquith – 'I'm Me!' I was, fortunately, rescued by dear Verity Hudson, Peter Saunders' general manager. She laughed – she couldn't help laughing – and Peter Saunders laughed a great deal. Anyway, I was brought in, subjected to cutting tapes, kissing actresses, grinning from ear to ear, simpering, and having to suffer the insult to my vanity that occurs when I press my cheek against that of some young and good-looking actress and know that we shall appear in the news the next day – she looking beautiful and confident in her role, and I looking frankly *awful*. Ah well, good for one's vanity, I suppose!

All passed off well, though not as well as it would have done if the queen of the party had had some talent as an actress and could give a good performance. Still I made my 'speech' without disaster. It was only a few words, but people were kind about it: everybody told me it was all right. I couldn't go as far as believing them, but I think it served sufficiently well. People were sorry for my inexperience, realised I was trying to do my best, and felt kindly towards my effort. My daughter, I may say, did not agree with this. She said, 'You ought to have taken more trouble, Mother, and prepared something *properly* beforehand.' But she is she, and I am I, and preparing something properly beforehand often leads in my case to much greater disaster than trusting to the spur of the moment, when at any rate chivalry is aroused.

'You made theatrical history tonight,' said Peter Saunders, doing his best to encourage me. I suppose that is true, in a way.

III

We were staying some years ago at the Embassy in Vienna, when Sir James and Lady Bowker were there and Elsa Bowker took me seriously to task when reporters had come for an interview.

'But, Agatha!' she cried in her delightful foreign voice, 'I do not understand you! If it were me I should rejoice, I should be proud. I

should say yes! come, come, and sit down! It is wonderful what I have done, I know it. I am the best detective story writer in the world. Yes, I am proud of the fact. Yes, yes, of course I will tell you. But I am delighted. Ah yes, I am very clever indeed. If I were you I should feel clever, I should feel so clever that I could not stop talking about it all the time.'

I laughed like anything, and said, 'I wish to goodness, Elsa, you and I could change into each other's skins for the next half-hour. You would do the interview so beautifully, and they would love you for it. But I just am not qualified at all to do things properly if I have to do them in public.'

On the whole I have had sense enough *not* to do things in public, except when it has been absolutely necessary, or would hurt people's feelings badly if I didn't. When you don't do a thing well it is so much more sensible not to attempt it, and I don't really see any reason why writers should – it's not part of their stock-in-trade. There are many careers where personalities and public relations matter – for instance if you are an actor, or a public figure. An author's business is simply to write. Writers are diffident creatures – they need encouragement.

The third play that I was to have running in London (all at the same time) was *Spider's Web*. This was specially written for Margaret Lockwood. Peter Saunders asked me to meet her and talk about it. She said that she liked the idea of my writing a play for her, and I asked her exactly what *kind* of play she wanted. She said at once that she didn't want to continue being sinister and melodramatic, that she had done a good many films lately in which she had been the 'wicked lady'. She wanted to play comedy. I think she was right, because she has an enormous flair for comedy, as well as being able to be dramatic. She is a very good actress, and has that perfect timing which enables her to give lines their true weight.

I enjoyed myself writing the part of Clarissa in *Spider's Web*. There was a little indecision at first as to the title; we hesitated between 'Clarissa Finds a Body' and 'Spider's Web', but in the end 'Spider's Web' got it. It ran for over two years, and I was very pleased with it. When Margaret Lockwood proceeded to lead the Police-Inspector up the garden path she was enchanting.

Later I was to write a play called *The Unexpected Guest*, and another which, though not a success with the public, satisfied me completely. It was put on under the title of *Verdict* – a bad title. I had called it *No*

Fields of Amaranth, taken from the words of Walter Landor's: '*There are no flowers of amaranth on this side of the grave*'. I still think it is the best play I have written, with the exception of *Witness for the Prosecution*. It failed, I think, because it was *not* a detective story or a thriller. It *was* a play that concerned murder, but its real background and point was that an idealist is always dangerous, a possible destroyer of those who love him – and poses the question of how far you can sacrifice, not yourself, but those you love, to what you believe in, even though they do not.

Of my detective books, I think the two that satisfy me best are *Crooked House* and *Ordeal by Innocence*. Rather to my surprise, on re-reading them the other day, I find that another one I am really pleased with is *The Moving Finger*. It is a great test to re-read what one has written some seventeen or eighteen years later. One's view changes. Some do not stand the test of time, others do.

An Indian girl who was interviewing me once (and asking, I must say, a good many silly questions), included among them, 'Have you ever written and published a book you consider really bad?' I replied with indignation that I had not. No book, I said, was exactly as I wanted it to be, and I was never quite satisfied with it, but if I thought a book I had written was *really* bad I should not publish it.

However, I have come near it, I think, in *The Mystery of the Blue Train*. Each time I read it again, I think it commonplace, full of clichés, with an uninteresting plot. Many people, I am sorry to say, *like* it. Authors are always said to be no judge of their own books

How sad it will be when I can't write any more, though I should not be greedy. After all, to be able to continue writing at the age of seventy-five is very fortunate. One ought to be content and prepared to retire by then. In fact, I played with the idea that perhaps I *would* retire this year, but I was lured on by the fact that my last book had sold more than any of the previous ones: it seemed rather a foolish moment to stop writing. Perhaps now I had better make a deadline of eighty?

I have enjoyed greatly the second blooming that comes when you finish the life of the emotions and of personal relations; and suddenly find – at the age of fifty, say – that a whole new life has opened before you, filled with things you can think about, study, or read about. You find that you like going to picture exhibitions, concerts and the opera, with the same enthusiasm as when you went at twenty or twenty-five. For a period, your personal life has absorbed all your energies, but now you are free

again to look around you. You can enjoy leisure; you can enjoy *things*. You are still young enough to enjoy going to foreign places, though you can't perhaps put up with living quite as rough as you used to. It is as if a fresh sap of ideas and thoughts was rising in you. With it, of course, goes the penalty of increasing old age – the discovery that your body is nearly always hurting somewhere: either your back is suffering from lumbago; or you go through a winter with rheumatism in your neck so that it is agony to turn your head; or you have trouble with arthritis in your knees so that you cannot stand long or walk down hills – all these things happen to you, and have to be endured. But one's thankfulness for the gift of life is, I think, stronger and more vital during those years than it ever has been before. It has some of the reality and intensity of dreams – and I still enjoy dreaming enormously.

IV

By 1948 archaeology was rearing its erudite head once more. Everyone was talking of possible expeditions, and making plans to visit the Middle East. Conditions were now favourable again for digging in Iraq.

Syria had provided the cream of the finds before the war, but now the Iraqi authorities and the Department of Antiquities were offering fair terms. Though any unique objects found would go to the Baghdad Museum, any 'duplicates', as they were called, would be divided up and the excavator would get a fair share. So, after a year's tentative digging on a small scale here and there, people began to resume work in that country. A Chair of Western Asiatic Archaeology had been created after the war, of which Max became Professor at the Institute of Archaeology at London University. He would have time for so many months every year for work in the field.

With enormous pleasure we started off once more, after a lapse of ten years, to resume our work in the Middle East. No Orient Express this time, alas! It was no longer the cheapest way – indeed one could not take a through journey by it now. This time we flew – the beginning of that dull routine, travelling by air. But one could not ignore the time it saved. Still sadder, there were no more journeys across the desert by Nairn; you flew from London to Baghdad and that was that. In those early years one still spent a night here or there on the way, but it was the beginning of

what one could see plainly was going to become a schedule of excessive boredom and expense without pleasure.

Anyway, we got to Baghdad, Max and I, together with Robert Hamilton, who had dug with the Campbell-Thompsons and later had been Curator of the Museum in Jerusalem. In due course we went up together, visiting sites in the North of Iraq, between the lesser and the greater Zab, until we arrived at the picturesque mound and town of Erbil. From there we went on towards Mosul, and on the way paid our second visit to Nimrud.

Nimrud was just as lovely a part of the country as I remembered it on our visit long ago. Max examined it with particular zeal this time. Before it had not been even a practical possibility, but now, although he did not say so at this moment, something might be done. Once again we picnicked there. We visited a few other mounds, and then reached Mosul.

The result of this tour was that Max finally came into the open and said firmly that all he wanted to do was to dig Nimrud. 'It's a big site, and an historic site – a site that *ought* to be dug. Nobody has touched it for close on a hundred years, not since Layard, and Layard only touched the fringe of it. He found some beautiful fragments of ivory – there must be heaps more. It is one of *the* three important cities of Assyria. Assur was the religious capital, Nineveh was the political capital, and Nimrud, or Calah, as its name was then, was the military capital. *It ought to be dug.* It will mean a lot of men, a lot of money, and it will take several years. It has every chance, if we are lucky, of being one of the *great* sites, one of the historic digs which will add to the world's knowledge.'

I asked him if he had now had his fun with pre-historic pottery. He said Yes; so many of the questions had been answered now that he was wholly interested in Nimrud as a historic site to dig.

'It will rank,' he said, 'with Tut-ankh-amun's Tomb, with Knossos in Crete, and with Ur. For a site like this, too,' he said, 'you *can* ask for money.'

Money was forthcoming; not much to start with, but as our finds grew, it increased. The Metropolitan Museum in New York was one of our biggest contributors; there was money from the Gertrude Bell School of Archaeology in Iraq; and many other contributors: the Ashmolean, the Fitzwilliam, Birmingham. So we began what was to be our work for the next ten years.

This year, this very month, my husband's book *Nimrud and its Remains* will be published. It has taken him ten years to write. He has always had the fear that he might not live to complete it. Life is so uncertain, and

things like coronary thrombosis, high blood-pressure and all the rest of the modern ills seem to be lying in wait, particularly for men. But all is well. It is his life work: what he has been moving steadily towards ever since 1921. I am proud of him and happy for him. It seems a kind of miracle that both he and I should have succeeded in the work we wanted to do.

Nothing could be further apart than our work. I am a lowbrow and he a highbrow, yet we complement each other, I think, and have both helped each other. Often he has asked me for my judgment on certain points, and whilst I shall always remain an amateur I do know quite a lot about his special branch of archaeology – indeed, many years ago, when I was once saying sadly to Max it was a pity I couldn't have taken up archaeology when I was a girl, so as to be more knowledgeable on the subject, he said, 'Don't you realise that at this moment you know more about pre-historic pottery than almost any woman in England.'

At that moment perhaps I did, though things did not remain like that. I shall never have a professional attitude or remember the exact dates of the Assyrian kings, but I do take an enormous interest in the personal aspects of what archaeology reveals. I like to find a little dog buried under the threshold, inscribed on which are the words: '*Don't stop to think, Bite him!*' Such a good motto for a guard-dog; you can see it being written on the clay, and someone laughing. The contract tablets are interesting, throwing light on how and where you sell yourself into slavery, or the conditions under which you adopt a son. You can see Shalmaneser building up his zoo, sending back foreign animals from his campaigns, trying out new plants and trees. Always greedy, I was fascinated when we discovered a stele describing a feast given by the King in which he lists all the things they had to eat. The oddest thing seemed to me, after a hundred sheep, six hundred cows and quantities of that kind, to come down to a mere twenty loaves of bread. Why should it be such a small number? Indeed why have loaves of bread at all?

I have never been a scientific enough digger really to enjoy levels, plans, and all the rest of it, which are discussed with such gusto by the modern school. I am unabashedly devoted to the objects of craftsmanship and art which turn up out of the soil. I daresay the first is more important, but for me there will never be any fascination like the work of human hands: the little pyxis of ivory with musicians and their instruments carved round it; the winged boy; the wonderful head of a woman, ugly, full of energy and personality.

We lived in a portion of the Sheikh's house in the village between the *tell* and the Tigris. We had a room downstairs for eating in and stacking things, a kitchen next door to it, and two rooms upstairs – one for Max and myself and a little one over the kitchen for Robert. I had to do the developing in the dining-room in the evenings, so Max and Robert would go upstairs. Every time they walked across the room, bits of mud used to fall off the ceiling and drop into the developing dish. Before starting the next batch, I would go up and say furiously: '*Do* remember that I'm *developing* underneath you. Every time you move something falls. Can't you just talk without moving?'

They always used, in the end, to get excited, and rush off to a suit-case to take out a book and consult it, and down would fall the dried mud again.

In the courtyard was a storks' nest, and the storks used to make a terrific noise mating, with their wings flapping and a noise like the rattling of bones. Storks are highly thought of in most of the Middle East, and everyone treats them with great respect.

When we left at the end of the first season, we got everything settled for building a house of mud-brick actually on the mound. The bricks were made and laid out to be dried, and the roofing was arranged for.

When we came out the following year we were very proud of our house. There was a kitchen; next to it a long mess-room and sitting-room, and next to that a drawing-office and antica-room. We slept in tents. A year or two later we built on to the house: a small office with a desk and a window in front of it through which one could pay the men on pay-day, and on the other, side an epigraphist's desk. Next to this was the drawing-office and work-room, with trays of things being repaired. Beyond that again was the usual dog-hole in which the wretched photographer had to develop and do loading. Every now and then there was a terrific dust-storm and a wind which came up from nowhere. Immediately we would rush out and hang on to the tents with all our might while all the dust-bin lids blew away. In the end the tents usually came down with a flop, burying someone underneath their folds.

Finally, a year or two later still, I petitioned to be allowed to have a small room added on of my own. This I would pay for myself. So, for £50, I built on a small, square, mud-brick room, and it was there that I began writing this book. It had a window, a table, an upright chair, and the collapsed remains of a former 'Minty' chair, so decrepit it was difficult to sit on, but still quite comfortable. On the wall I had hung two pictures by young Iraqi artists. One was of a sad-looking cow by a tree; the other a

kaleidoscope of every colour imaginable, which looked like patchwork at first, but suddenly could be seen to be two donkeys with men leading them through the Suq – a most fascinating picture, I have always thought. I left it behind in the end, because everyone was attached to it, and it was moved into the main sitting-room. But some day I think I want to have it back again.

On the door, Donald Wiseman, one of our epigraphists, fixed the placard in cuneiform, which announces that this is the Beit Agatha – Agatha's House, and in Agatha's house I went every day to do a little of my own work. Most of the day, however, I spent on photography or on mending and cleaning ivories.

We had a splendid succession of cooks. One of them was mad. He was a Portuguese Indian. He cooked well, but he became quieter and quieter as the season went on. Finally the kitchen boys came and said they were worried about Joseph – he was becoming very peculiar. One day he was missing. We searched for him, and notified the police, but in the end it was the Sheikh's people who brought him back. He explained that he had had a command from the Lord and had to obey, but he had now been told that he must come back and ascertain the Lord's wishes. There seemed to be some slight confusion in his mind between the Almighty and Max. He strode round the house, fell on his knees before Max, who was expounding something to some workmen, and kissed the bottom of his trousers, much to Max's embarrassment.

'Get up, Joseph,' said Max.

'I must do what you command me, Lord. Tell me where to go and I will go there. Send me to Basra and I will go to Basra. Tell me to visit Baghdad and I will visit Baghdad; to go to the snows of the north and I will go to the snows of the north.'

'I tell you,' said Max, accepting the role of the Almighty. 'I tell you to go forthwith to the kitchen, to cook us food for our needs.'

'I go, Lord,' said Joseph, who then kissed the turn-up of Max's trousers once more and left for the kitchen. Unfortunately the wires seemed crossed, for other commands kept coming to Joseph and he used to stray away. In the end we had to send him back to Baghdad. His money was sewn up in his pocket and a wire was dispatched to his relations.

Thereupon our second house-boy, Daniel, said he had a little knowledge of cooking and would carry on for the last three weeks of the season. We had permanent indigestion as a result. He fed us entirely on what he called 'Scotch eggs'; excessively indigestible, and cooked in most peculiar

fat. Daniel disgraced himself before leaving. He had a row with our driver, who then split on him and informed us that he had already salted away in his luggage twenty-four tins of sardines and sundry other delicacies. The riot act was read, Daniel was told that he was disgraced both as a Christian and a servant, that he had lowered the Christian in Arab eyes, and that he would no more be engaged by us. He was the worst servant we ever had.

To Harry Saggs, one of the epigraphists, Daniel went, saying 'You are the only good man on this dig; you read your Bible – I have seen you. Therefore since you are a good man, you will give me your best pair of trousers.'

'Indeed,' said Harry Saggs, 'I shall do nothing of the sort.'

'You will be a Christian if you give me your best trousers.'

'Not my best trousers, nor my worst trousers,' said Harry Saggs. 'I need both my pairs of trousers.' Daniel retired to try to cadge something elsewhere. He was extremely lazy, and always managed to clean the shoes after dark so that no one would see that he was not really cleaning them at all but just sitting and humming to himself, smoking.

Our best house-boy was Michael, who had been in service with the British Consulate in Mosul. He looked like an El Greco, with a long, melancholy face and enormous eyes. He was always having great trouble with his wife. Occasionally she tried to kill him with a knife. In the end the doctor persuaded him to take her to Baghdad.

'He has written to me,' said Michael, appearing one day, 'and he says it is only a matter of money. If I will give him £200 he will try to cure her.'

Max urged him to take her to the main hospital to which he had already given him a chit, and not to be victimised by quacks.

'No,' said Michael, 'this is a very grand man, he lives in a grand street in a grand house. He must be the best.'

Life at Nimrud for the first three or four years was relatively simple. Bad weather often separated us from the so-called road, which, kept a lot of visitors away. Then one year, owing to our growing importance, a kind of track was made to link us to the main road, and the actual road to Mosul itself was tarmacked for a good length of its way.

This was very unfortunate. For the last three years we could have employed one person to do nothing but show people round, do the courtesies, offer drinks of tea or coffee, and so on. Whole charabancs of school-children came out. This was one of the worst headaches, because

there were large excavations everywhere and the crumbling tops of these were unsafe unless you knew exactly where you were walking. We begged the school-teachers to keep the children away from the actual excavations, but they, of course, adopted the usual attitude of 'Inshallah, all will be well.' In time a great many babies got brought out by their parents.

'This place,' Robert Hamilton said in a dissatisfied tone as he looked round the drawing-office, which was filled up with three carry-cots containing squalling infants, 'this place is nothing but a crèche!' he sighed. 'I shall go out and measure up those levels.'

We all screamed at Robert in protest. 'Now then, Robert, you are a father of five. You are the right person to be in charge of the crèche. You can't leave these young bachelors to look after babies!'

Robert looked coldly at us and departed.

They were good days. Every year had its fun, though in a sense, every year life became more complicated, more sophisticated, more urban.

As for the mound itself, it lost its early beauty, owing to all the great dumps. Gone was that innocent simplicity, with the stone heads poking up out of the green grass, studded with red ranunculus. The flocks of bee-eaters – lovely little birds of gold, green and orange, twittering and fluttering over the mound – still came every spring, and a little later the rollers, bigger birds, also blue and orange, which had a curious way of falling suddenly and clumsily from the sky – hence their name. In the legend, they had been punished by Ishtar by being bitten through the wing because they had insulted her in some way.

Now Nimrud sleeps.

We have scarred it with our bull-dozers. Its yawning pits have been filled in with raw earth. One day its wounds will have healed, and it will bloom once more with early spring flowers.

Here was once Calah, that great City. Then Calah slept . . .

Here came Layard to disturb its peace. And again Calah-Nimrud slept . . .

Here came Max Mallowan and his wife. Now again Calah sleeps . . .

Who shall disturb it next?

We do not know.

I have not yet mentioned our house in Baghdad. We had an old Turkish house on the West bank of the Tigris. It was thought a very curious taste on our part to be so fond of it, and not to want one of the modern boxes, but our Turkish house was cool and delightful, with its courtyard and the

palm-trees coming up to the balcony rail. Behind us were irrigated palm-gardens, and a tiny squatter's house, made of *tutti* (petrol tins). Children played there happily. The women came in and out and went down to the river to wash their pots and pans. The rich and the poor live cheek by jowl in Baghdad.

How enormously it has grown since I first saw it. Most of the modern architecture is very ugly, wholly unsuitable for the climate. It is copied from modern magazines – French, German, Italian. You no longer go down into a cool *sirdab* in the heat of the day; the windows are not small windows in the top of the walls, keeping you cool from the sunlight. Possibly their plumbing is better now – it could hardly be worse – but I doubt it. Modern plumbing looks all right, has the proper lilac or orchid lavatory basins and fittings, but the sewerage has nowhere much to go. It has to discharge itself into the Tigris in the old way, and the amount of water for flushing seems, as always, woefully inadequate. There is something peculiarly irritating about handsome modern bathroom and lavatory fixtures which do not function owing to the lack of proper disposal and an ample water intake.

I must mention the first visit we paid to Arpachiyah after an interval of fifteen years. We were recognised at once. The whole village came out. There were cries, shouts, greetings, welcome. 'You remember me, Hawajah,' said one man. 'I was basket-boy when you left. Now I am twenty-four, I have a wife, I have big son, grown-up son – I show you.'

They were astonished that Max could not remember every face and every name. They recalled the famous race that had passed into history. We were always meeting our friends of fifteen years before.

One day as I drove through Mosul in the lorry, the policeman directing traffic suddenly held it all up with his baton, and yelling out, 'Mama! Mama!' advanced upon the lorry, seizing me by the hand, and shaking it wildly.

'What joy to see you, Mama! I am Ali! I am Ali the pot-boy – you remember me? Yes? Now I am policeman!'

And so, every time I drove into Mosul, there was Ali, and the moment he recognised us, all the traffic in the street was held up, we exchanged greetings, and then our lorry proceeded with full priority. How good it is to have these friends. Warm-hearted, simple, full of enjoyment of life, and so well able to laugh at everything. Arabs are great ones for laughing, great ones for hospitality too. Whenever you happen to pass through a village where one of your workmen lives, he rushes out and insists you

should come in and drink sour milk with him. Some of the town *effendis* in purple suits are tiresome, but the men of the land are good fellows and splendid friends.

How much I have loved that part of the world.

I love it still and always shall.

EPILOGUE

The longing to write my autobiography assailed me suddenly at my 'house' at Nimrud, Beit Agatha.

I have looked back to what I wrote then and I am satisfied. I have done what I wanted to do. I have been on a journey. Not so much a journey *back* through the past, as a journey *forward* – starting again at the beginning of it all – going back to the Me who was to embark on that journey forward through time. I have not been bounded by time or space. I have been able to linger where I wanted, jump backwards and forwards as I wished.

I have remembered, I suppose, what I wanted to remember; many ridiculous things for no reason that makes sense. That is the way we human creatures are made.

And now that I have reached the age of seventy-five, it seems the right moment to stop. Because, as far as life is concerned, that is all there is to say.

I live now on borrowed time, waiting in the ante-room for the summons that will inevitably come. And then – I go on to the next thing, whatever it is. One doesn't luckily have to bother about that.

I am ready now to accept death. I have been singularly fortunate. I have with me my husband, my daughter, my grandson, my kind son-in-law – the people who make up my world. I have not yet quite reached the time when I am a complete nuisance to them all.

I have always admired the Esquimaux. One fine day a delicious meal is cooked for dear old mother, and then she goes walking away over the ice – *and doesn't come back* . . .

One should be proud of leaving life like that – with dignity and resolution.

It is, of course, all very well to write these grand words. What will

really happen is that I shall probably live to be ninety-three, drive everyone mad by being unable to hear what they say to me, complain bitterly of the latest scientific hearing aids, ask innumerable questions, immediately forget the answers and ask the same questions again. I shall quarrel violently with some patient nurse-attendant and accuse her of poisoning me, or walk out of the latest establishment for genteel old ladies, causing endless trouble to my suffering family. And when I finally succumb to bronchitis, a murmur will go around of 'One can't help feeling that it really is a merciful relief . . .'

And it *will* be a merciful relief (to them) and much the best thing to happen.

Until then, while I'm still comfortably waiting in Death's ante-chamber, I am enjoying myself. Though with every year that passes, *something* has to be crossed off the list of pleasures.

Long walks are off, and, alas, bathing in the sea; fillet steaks and apples and raw blackberries (teeth difficulties) and reading fine print. But there is a great deal left. Operas and concerts, and reading, and the enormous pleasure of dropping into bed and going to sleep, and dreams of every variety, and quite often young people coming to see you and being surprisingly nice to you. Almost best of all, sitting in the sun – gently drowsy . . . And there you are again – remembering. '*I remember, I remember, the house where I was born . . .*'

I go back to that always in my mind. Ashfield.

> *O ma chère maison, mon nid, mon gîte*
> *Le passé l'habite . . . O! ma chère maison . . .*

How much that means. When I dream, I hardly ever dream of Greenway or Winterbrook. It is always Ashfield, the old familiar setting where one's life first functioned, even though the people in the dream are the people of today. How well I know every detail there: the frayed red curtain leading to the kitchen, the sunflower brass fender in the hall grate, the Turkey carpet on the stairs, the big, shabby schoolroom with its dark blue and gold embossed wallpaper.

I went to see – not Ashfield, but where Ashfield had been, a year or two ago. I knew I would have to go sooner or later. Even if it caused me pain, I had to go.

Three years ago now someone wrote to me, asking if I knew that the house was to be pulled down, and a new estate developed on the site. They wondered if I couldn't do something to save it – such a lovely house – as they had heard I had lived there once.

I went to see my lawyer. I asked if it would be possible for me to buy the house and make a gift of it to an old people's home, perhaps? But that was not possible. Four or five big villas and gardens had been sold *en bloc* – all to be demolished, and the new 'estate' put up. So there could be no respite for dear Ashfield.

It was a year and a half before I summoned up the resolution to drive up Barton Road . . .

There was nothing that could even stir a memory. They were the meanest, shoddiest little houses I had ever seen. None of the great trees remained. The ash-trees in the wood had gone, the remains of the big beech-tree, the Wellingtonia, the pines, the elms that bordered the kitchen garden, the dark ilex – I could not even determine in my mind where the house had stood. And then I saw the only clue – the defiant remains of what had once been a monkey puzzle, struggling to exist in a cluttered back yard. There was no scrap of garden anywhere. All was asphalt. No blade of grass showed green.

I said 'Brave monkey puzzle' to it, and turned away.

But I minded less after I had seen what had happened. Ashfield had existed once but its day was over. And because whatever *has* existed still *does* exist in eternity, Ashfield is still Ashfield. To think of it causes me no more pain.

Perhaps some child sucking a plastic toy and banging on a dustbin lid, may one day stare at another child, with pale yellow sausage curls and a solemn face. The solemn child will be standing in a green grass fairy ring by a monkey puzzle holding a hoop. She will stare at the plastic space ship that the first child is sucking, and the first child will stare at the hoop. She doesn't know what a hoop is. And she won't know that she's seen a ghost . . .

Goodbye, dear Ashfield.

So many other things to remember: walking up through a carpet of flowers to the Yezidis shrine at Sheikh Adi . . . the beauty of the great tiled mosques of Isfahan – a fairy-story city . . . a red sunset outside the house at Nimrud . . . getting out of the train at the Cilician gates in the hush of evening . . . the trees of the New Forest in autumn . . . swimming in the sea in Torbay with Rosalind . . . Mathew playing in the Eton and Harrow match . . . Max arriving home from the war and eating kippers with me . . . So many things – some silly, some funny, some beautiful. Two summits of ambition fulfilled: dining with the Queen of England

(how pleased Nursie would have been. 'Pussy cat, pussy cat, where have you been?'); and the proud ownership of a bottle-nosed Morris – a car of my own! Most poignant of experiences: Goldie the canary hopping down from the curtain pole after a day of hopeless despair.

A child says 'Thank God for my good dinner'.

What can I say at seventy-five? 'Thank God for my good life, and for all the love that has been given to me.'

Wallingford. October 11th 1965

INDEX

Agatha Christie

Short Stories for Your E-Reader

HERCULE POIROT

The Jewel Robbery at the Grand Metropolitan

The King of Clubs

The Plymouth Express

The Adventure of the 'Western Star'

The Tragedy of Marsdon Manor

The Kidnapped Prime Minister

The Million Dollar Bond Robbery

The Disappearance of Mr. Davenheim

The Under Dog

Triangle at Rhodes

Yellow Iris

The Mystery of the Spanish Chest

Four-and-Twenty Blackbirds

Poirot and the Regatta Mystery

The Dream

The Second Gong

MISS MARPLE

The Tuesday Night Club

The Idol House of Astarte

Ingots of Gold

The Blood-Stained Pavement

Motive v. Opportunity

The Thumb Mark of St. Peter

Strange Jest

Tape-Measure Murder

The Case of the Caretaker

The Case of the Perfect Maid

Sanctuary

Explore more at www.AgathaChristie.com

Agatha Christie

Short Stories for Your E-Reader

PARKER PYNE

The Case of the Middle-Aged Wife

The Case of the Discontented Soldier

The Gate of Baghdad

The House at Shiraz

HARLEY QUIN

The Coming of Mr. Quin

The Shadow on the Glass

The Dead Harlequin

The Love Detectives

The Harlequin Tea Set

TOMMY AND TUPPENCE

The Affair of the Pink Pearl

Finessing the King

The Adventure of the Sinister Stranger

The Case of the Missing Lady

The Man in the Mist

The House of Lurking Death

STAND ALONE

The Mystery of the Blue Jar

The Mystery of the Spanish Shawl

Jane in Search of a Job

The Manhood of Edward Robinson

The Witness for the Prosecution

Philomel Cottage

The Red Signal

The Rajah's Emerald

Explore more at www.AgathaChristie.com

Agatha Christie®

See your favorite detectives come to life on screen!

These and other DVDs and
downloads available now at:

www.acornonline.com

Programs licensed by ITV Global Entertainment Limited. AGATHA CHRISTIE™ Copyright ©2010 Agatha Christie Limited (a Chorion company). All rights reserved.

Agatha Christie®

THE LIFE OF A LEGEND
Mysteries in the Making

An Autobiography
ISBN 978-0-06-220457-8

An engaging and illuminating chronicle of the life of the "Queen of Mystery."

Agatha Christie's Secret Notebooks
by John Curran
ISBN 978-0-06-198837-0

A fascinating exploration of the contents of Agatha Christie's long hidden notebooks, including illustrations, analyses, and two previously unpublished short stories.

Agatha Christie: Murder in the Making
by John Curran
ISBN 978-0-06-206543-8

A must for every Christie aficionado, *Murder in the Making* is a glimpse into the mind and craft of one of the world's most prolific and beloved authors, offering a deeper understanding of her impressive body of work.

Explore more at www.AgathaChristie.com

The *Agatha Christie* Collection

THE HERCULE POIROT MYSTERIES
Match your wits with the famous Belgian detective.

The Mysterious Affair at Styles

The Murder on the Links

Poirot Investigates

The Murder of Roger Ackroyd

The Big Four

The Mystery of the Blue Train

Peril at End House

Lord Edgware Dies

Murder on the Orient Express

Three Act Tragedy

Death in the Clouds

The A.B.C. Murders

Murder in Mesopotamia

Cards on the Table

Murder in the Mews

Dumb Witness

Death on the Nile

Appointment with Death

Hercule Poirot's Christmas

Sad Cypress

One, Two, Buckle My Shoe

Evil Under the Sun

Five Little Pigs

The Hollow

The Labors of Hercules

Taken at the Flood

The Under Dog and
Other Stories

Mrs. McGinty's Dead

After the Funeral

Hickory Dickory Dock

Dead Man's Folly

Cat Among the Pigeons

The Clocks

Third Girl

Hallowe'en Party

Elephants Can Remember

Curtain: Poirot's Last Case

Explore more at www.AgathaChristie.com

The *Agatha Christie* Collection

THE MISS MARPLE MYSTERIES

Join the legendary spinster sleuth from
St. Mary Mead in solving murders far and wide.

The Murder at the Vicarage

The Body in the Library

The Moving Finger

A Murder Is Announced

They Do It with Mirrors

A Pocket Full of Rye

4:50 From Paddington

The Mirror Crack'd from Side to Side

A Caribbean Mystery

At Bertram's Hotel

Nemesis

Sleeping Murder

Miss Marple: The Complete Short Stories

THE TOMMY AND TUPPENCE MYSTERIES

Jump on board with the entertaining crime-solving
couple from Young Adventurers Ltd.

The Secret Adversary

Partners in Crime

N or M?

By the Pricking of My Thumbs

Postern of Fate

Explore more at www.AgathaChristie.com

The Agatha Christie Collection

Don't miss a single one of Agatha Christie's stand-alone novels and short-story collections.

The Man in the Brown Suit

The Secret of Chimneys

The Seven Dials Mystery

The Mysterious Mr. Quin

The Sittaford Mystery

Parker Pyne Investigates

Why Didn't They Ask Evans?

Murder Is Easy

The Regatta Mystery and Other Stories

And Then There Were None

Towards Zero

Death Comes as the End

Sparkling Cyanide

The Witness for the Prosecution and Other Stories

Crooked House

Three Blind Mice and Other Stories

They Came to Baghdad

Destination Unknown

Ordeal by Innocence

Double Sin and Other Stories

The Pale Horse

Star over Bethlehem: Poems and Holiday Stories

Endless Night

Passenger to Frankfurt

The Golden Ball and Other Stories

The Mousetrap and Other Plays

The Harlequin Tea Set and Other Stories

Explore more at www.AgathaChristie.com